THE STORY OF ART WITHOUT MEN

THE STORY OF ART WITHOUT MEN
KATY HESSEL

HUTCHINSON
HEINEMANN

1 3 5 7 9 10 8 6 4 2

Hutchinson Heinemann
20 Vauxhall Bridge Road
London SW1V 2SA

Hutchinson Heinemann is part of the Penguin Random House
group of companies whose addresses can be found at
global.penguinrandomhouse.com.

First published by Hutchinson Heinemann in 2022

www.penguin.co.uk

A CIP catalogue record for this book is available from the British Library.

ISBN 9781529151145

Designed by Tom Etherington

Printed and bound in Italy by L.E.G.O. SpA

The authorised representative in the EEA is Penguin Random House
Ireland, Morrison Chambers, 32 Nassau Street, Dublin D02 YH68.

Penguin Random House is committed to a sustainable future for our
business, our readers and our planet. This book is made from
Forest Stewardship Council® certified paper.

'I'll show you what a woman can do'
Artemisia Gentileschi, 1649

CONTENTS

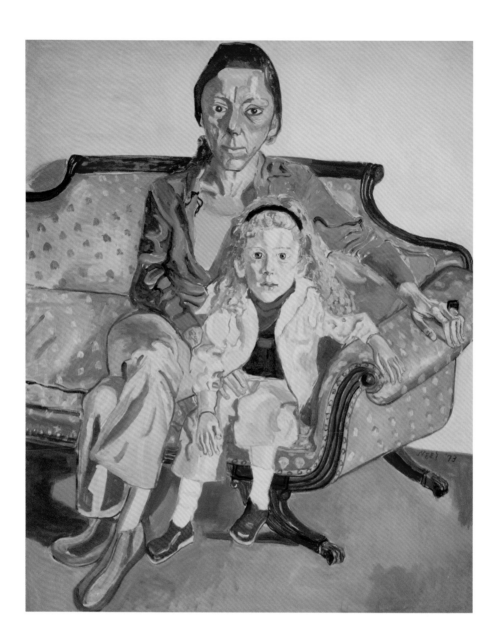

Alice Neel, *Linda Nochlin and Daisy*, 1973

INTRODUCTION

In October 2015, I walked into an art fair and realised that, out of the thousands of artworks before me, not a single one was by a woman. This sparked a series of questions: could I name twenty women artists off the top of my head? Ten pre-1950? Any pre-1850? The answer was no. Had I essentially been looking at the history of art from a male perspective? The answer was yes.

At the time, the exclusion of women artists (and other under-represented figures) from the history of art was becoming an urgent issue. I had just graduated from my BA in Art History and had chosen to study Alice Neel (1900–1984, p. 346), a great American painter of psychologically charged portraits of people from all walks of life. But Neel was only recognised as a major painter by the art establishment when she was already in her seventies. Studying Neel helped me notice the overwhelming under-representation of women artists – they weren't in galleries, they weren't in museums, they weren't in contemporary shows and they weren't to be found in art history.

Why was this? The lack of women recognised as significant artists has been a subject of debate since at least the 1970s, when Linda Nochlin's groundbreaking essay *Why Have There Been No Great Women Artists?* was published at the dawn of the second-wave feminist movement. Over forty years later, it didn't seem that enough had changed.

When listing the artists who are typically said to 'define' the art-historical canon, it is the following names that most often come up: Giotto, Botticelli, Titian, Leonardo, Caravaggio, Rembrandt, David, Delacroix, Manet, Gauguin, Van Gogh, Kandinsky, Pollock, Freud, Hockney, Hirst.

I am sure that many of you will have heard of them. But how many of these artists would you recognise: Anguissola, Fontana, Sirani, Peeters, Gentileschi, Kauffman, Powers, Lewis, Macdonald Mackintosh, Valadon, Höch, Asawa, Krasner, Mendieta, Pindell, Himid? If I hadn't actively studied women artists for the past seven years, I doubt I would know more than a fraction of these names.

Should any of this be surprising? Not according to statistics. A study published in 2019 found that in the collections of eighteen major US art museums, 87 per cent of artworks were by men, and 85 per cent by white artists. Currently, women artists make up just 1 per cent of London's National Gallery collection. This same museum only staged their first ever major solo exhibition by a historic female artist, Artemisia Gentileschi, in 2020 (p. 35). And 2023 will mark the first time the Royal Academy of Arts in London has ever hosted a solo exhibition by a woman in their main space (Marina Abramović, p. 310). Just one woman of colour has individually won the Turner Prize (Lubaina Himid, p. 393), in 2017, and it took until 2022 for the first women of colour to represent the US (Simone Leigh, p. 429) and the UK (Sonia Boyce, p. 396) at the Venice Biennale, the most prestigious art event in the world. When I conducted a YouGov survey in early 2022 to find out the British public's knowledge of women artists, results showed that 30% could name no more than three (83% of 18–24-year-olds could name not even three), and more than half said they'd never been taught about women artists at school.

The night of the art fair I couldn't sleep. Frustrated and angry about what I'd just witnessed, I typed the words 'women artists' into Instagram. Nothing appeared. And so, @thegreatwomenartists (a name that pays homage to Nochlin) was born. I set myself the task of writing daily posts spotlighting artists ranging from young graduates to Old Masters working across every medium, from painting to sculpture, photography to textiles. Adopting an accessible style, my aim was then, as it is now, to appeal to anyone of any art-historical level interested in learning the stories of these mostly overshadowed artists, just as I have done, on a more expansive scale, in a podcast of the same name which launched in 2019. I do this to break down the

stigma around elitism in art – art can be for anyone, and anyone can be part of this conversation – and to showcase artists so often excluded from the history books and courses I studied. It's not that I believe there to be anything inherently 'different' about work created by artists of any particular gender – it's more that society and its gatekeepers have always prioritised one group in history. And I think it is vital for this to be addressed and challenged. Nearly seven years later, the result is this book: *The Story of Art without Men*.

This is not a definitive history – it would be an impossible task – but I am looking to break down the canon I have so often been confronted by in the culture in which I have grown up. The canon of art history is global, however, with the male Western narrative being so unjustly dominant at the expense of others, it is this that I unpack and challenge. The book takes its title from the so-called introductory 'bible' to art history, E. H. Gombrich's *The Story of Art*. It's a wonderful book but for one flaw: his first edition (1950) included zero women artists and even the sixteenth edition includes only one. I hope this book will create a new guide, to supplement what we already know.

Artists pinpoint moments of history through a uniquely expressive medium and allow us to make sense of a time. If we aren't seeing art by a wide range of people, we aren't really seeing society, history or culture as a whole, and so I hope more books will follow this one, expanding the canon even more.

Progress is happening. This is thanks to a collective effort by actively engaged artists, art historians, scholars and curators around the world, all of different ages and backgrounds. It is their work I am greatly indebted to, as without them it would have been impossible to write this book. I draw here on the extensive research by (and my discussions with) spearheading art historians and curators who are endeavouring to change our understanding of art and who makes it, and you can find their works listed in the Bibliography at the end of the book. Many of them have uncovered the detail of these artists' lives for the very first time. There is no denying that the increased attention to non-male artists enjoying blockbuster shows or appearing more frequently on museum walls is due to those who now hold

top-tier positions in museums. For the first time in history, women have taken the helm of the Tate, the Louvre, and The National Gallery of Art, D.C., to name but a few.

What does this demonstrate? That the inequalities in galleries and museums are reflective of a larger systemic issue, and so a lot of what we see needs to change. The same can be said for how we place monetary value on genders in society, considering that the highest price fetched at auction by a living woman artist (Jenny Saville's *Propped*, 1992) was just 12 per cent of the highest price achieved by a male living artist (David Hockney's *Portrait of an Artist (Pool with Two Figures)*, 1972) which topped $90.3 million. I hope this book will show you that the difference in price is not due to inherent quality, but to the value we put on different creators of art.

In the past decade we have seen a huge number of art-historical 'corrections' take place. From the numerous survey exhibitions dedicated to women sculptors, painters, abstractionists, or surrealists, such as *Fantastic Women: Surreal Worlds from Meret Oppenheim to Frida Kahlo*, *We Wanted a Revolution: Black Radical Women 1965–1985*, or *Radical Women: Latin American Art, 1960–1985*, to the first major solo exhibitions of Pauline Boty (p. 268), Carmen Herrera (p. 290) and Hilma af Klint (p. 100), among others. I hope we will see more – and that my next art fair offers me a different experience to the one back in 2015.

So here is my take on the 'story of art' (without men). Because while the statistics remain so shocking, it feels important to remove the clamour of men in order to listen carefully to the significance of other artists to our cultural histories. Beginning in the 1500s and ending with those defining the 2020s, I have divided this book into five parts which each focus on significant shifts or moments in mostly Western art history. To avoid artists only being seen as the wife of, the muse of, the model of, or the acquaintance of, I have situated them within their social and political context, in the time in which they lived.

While I have grouped artists within established movements (for the purpose of clarity), I am keenly aware that artists are not the products of categories, but rather individuals with varied lives and

careers who spearheaded key changes in styles. In the history of art, however, such moments have nearly always been attributed to men, and women's pioneering work has been overlooked. So, although I have merely skimmed the surface of many of these artists' multi-layered (and for some, still evolving) oeuvres – which can encompass more mediums, cultures, styles or time spans than those works and movements discussed here, I hope this book will give you an insight into at least a fraction of the work of non-male artists who have contributed to the 'story of art'.

PART ONE

PAVING THE WAY

c.1500—c.1900

TRIUMPHANT WOMEN

Being an artist and a woman has never been easy. In the sixteenth and seventeenth centuries, leading male artists – tackling five-metre-high marble sculptures and covering entire chapels with frescoes – were often termed 'virtuosi', while women, simply by virtue of their gender, received neither the acclaim nor the opportunities. As time progressed, attitudes did not: it took until the end of the nineteenth century for women to be allowed to study the nude from life. Linda Nochlin has described this deprivation 'as though a medical student were denied the opportunity to dissect or even examine the naked human body'. Even today, the contribution of women artists tends to be missing from history books and museum collections. It wasn't until 1976, when feminist art historians Nochlin and Ann Sutherland Harris's touring exhibition, *Women Artists: 1550–1950*, opened at the Los Angeles County Museum of Art, that women were even acknowledged as having contributed to 400 years of art. This show kick-started the scholarship, still scant, that we have on these pre-twentieth-century artists.

Until that point, the role of women in the history of art had been at best a curiosity. During the Victorian age, women, with their 'smaller', less 'creative' brains, were considered incapable of becoming professional artists and were often restricted to 'craft' or 'design' (genres not considered 'fine art' by the establishment). This perception made it very difficult not only for women to be taken seriously as artists, but for their (and their female predecessors') work to be sold. In order to get around this, nineteenth-century art dealers were known to scratch out a female artist's signature and replace it with that of a male contemporary, which explains why many works by women have only just come to light. (No wonder some of them hid self-portraits among their still lifes.)

Let's right this wrong. Because despite their many educational, personal and professional setbacks, and the lack of historians championing their work (bar some excellent feminist scholars, including

Griselda Pollock and Whitney Chadwick), women artists were also driving the changes of their time. They broke boundaries, taught the next generations, and – often rejecting gender conventions and tackling radical subjects – paved the way for the artists of today. To even begin to understand these trailblazers, we must examine the context in which they were working. This will enable us to realise their triumphs as artists, given their lack of social and financial freedoms, resources and training – all while living in cultures which valued them as less than men.

To be taken seriously as an artist in Renaissance Europe, a liberal arts education was required: the study of literature, mathematics, perspective and, significantly, human anatomy – drawing from art and live models, including nudes. Also key was access to cultural centres, such as Rome, Florence or Venice, to study and experience the splendour of Renaissance art and architecture, or ancient Classical ruins. All of this was, however, off-limits for women.

This lack of access to knowledge exacerbated existing class divisions which were already particularly acute for women. Whereas boys from lower social classes could be apprenticed in order to learn, most female artists were either the daughters of artists or daughters of wealthy and encouraging noblemen. Alternatively, and only if they were educated, they could join a nunnery, where basic activities included copying texts and adorning manuscripts.

Essentially, women artists had to have a powerful man (which might include God) looking after their interests. And while having a supportive artist father (or husband) might mean access to a studio, where a female could copy the work of male peers, she was still extremely restricted in her experience. Things didn't get any easier for hundreds of years.

Women were still banned from full inclusion at artist academies in the nineteenth century. It was not until the late 1800s that they were able to access a state-funded artistic education and allowed to wander unchaperoned in the streets or visit churches – the latter being another block to the imagination when it came to producing the most popular images of the day: grand, multi-figured historical or biblical scenes, with particular attention paid to the human anatomy.

So how did women get around this? In the sixteenth and seventeenth centuries they worked mainly in still life and portraiture, genres which were accessible and socially respectable. They painted themselves, sisters and teachers; domestic scenes; and objects. It was not long, of course, before these subjects were stereotyped as lowly and unintellectual. But let us not dwell on the hierarchies of subject imposed in the past; let us instead celebrate the greatness of such works since women did come to perfect these genres, monopolising their markets, and even subverting them with proto-feminist twists.

Starting with the Renaissance and going on to Neoclassicism, spanning Europe, Asia and America, in mediums ranging from painting and pottery to the beginnings of photography, this part will uncover the triumphant women working across four centuries, ending with those establishing unique methods that were so inventive that they inadvertently influenced what would become known as 'modern' art.

Chapter One

PAINTING HERSELF INTO THE CANON

(c.1500—c.1700)

THE RENAISSANCE

Before we meet the radical Italian women in the later sixteenth and seventeenth centuries, I would like to single out two artists working prior to this: Caterina de' Vigri (1413–63), a writer, musician, nun (later known as Saint Catherine of Bologna) and accomplished painter of manuscripts; and Properzia de' Rossi (1490–1530), a sculptor known for her rebellious pursuits. De' Rossi was acclaimed for her meticulous and minute carvings in wood, marble and cherry stones (see *Grassi Family Crest*, 1510–30). She received commissions for the kind of work no woman had done before, for instance her lively marble relief sculpture *Joseph and Potiphar's Wife*, c.1525–6, which she designed for the façade of Bologna's then most famous church, the Basilica di San Petronio. Both of these women were able to live as practising artists because they were fortunate enough to be born in Bologna, a place renowned for its progressive attitudes towards women.

At the time, Bologna was unique in championing the professions of women. The home of Europe's oldest university, which had supported female students since the thirteenth century, the city considered women artists as integral to its development. Praised by scholars, written about by biographers and adored by the locals, they were also supported by patrons of all social classes (from bankers to barbers), creating a varied culture of artistic patronage. (By contrast, in Florence and Naples, commissioning was reserved for select noble families.) Women were also encouraged to sign their work, as well as to paint self-portraits for the purposes of being known and, most importantly, remembered. No wonder scholars have recorded a staggering sixty-eight women artists working in the city between the fifteenth and eighteenth centuries.

These notable exceptions remind us that women have always been perfectly capable of being artists. But while there could have been an abundance of women working at this time, in reality female

artists were an absolute rarity, seen as 'tokens' rather than 'pioneers'. (After de' Rossi's death, no female sculptor is mentioned in the city's records for 200 years.) And little knowledge remains of those working during the Renaissance period. Most of what we know has been passed down by male scholars and through legal documents, rarely from the women themselves.

The Renaissance is considered to have begun in the mid-1300s, a good century or two before any detailed record of women artists emerges. Yet we begin this chapter in 1550s Italy – at a time when, as most history books will tell you, the splendours of the High Renaissance were almost over. The year 1550 was when Florentine art historian Giorgio Vasari published *The Lives of the Artists*, the

Properzia de' Rossi, *Grassi Family Crest*, 1510–30

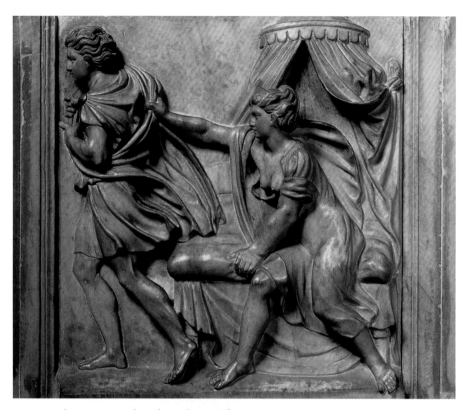

Properzia de' Rossi, *Joseph and Potiphar's Wife*, 1525–6

first text of its kind to explore artist biographies (featuring some, but very few, women). It is also when the term 'renaissance' is coined. Translating as 'rebirth' and 'revival', the Renaissance came about at a time of great economic prosperity and defined a new era of rapid learning and interest in the natural world. In central and northern Italy, artists and scholars rediscovered the ancient past and turned to the study of Classical antiquity and literature. With many of the Italian states physically built upon ancient ruins, artists and architects looked to them for theoretical and artistic influence. These included linear perspective, a technique utilising mathematical principles to create an illusion of depth and space to three-dimensional effect; naturalism, to emphasise anatomical accuracy; and secular themes, encouraging humanism and the focus on the individual artists, scholars and subjects.

Situated on the silk and the spice trade routes, and acting as gateways to the consumerist West, the Italian states had amassed enormous riches, which were often spent on artist patronage. The artistic capitals were Rome, home to the Catholic Church, the most powerful and wealthy patron, which commissioned works as a means of spreading the divine message of God; and Florence, whose leading banking dynasties commissioned art as a means of demonstrating erudition, opulence and their ties to the Church. However, as noble families from each Italian state increased their riches, competition broke out among patrons, who fought to employ the most acclaimed artists of the day. Greater art on a grander scale fuelled technical advancements, and soon each city was attracting a plethora of international travellers. By the end of the fifteenth century, the Northern Renaissance was born: a cultural revolution outside Italy which saw Renaissance theory diffused across Europe, and spurred an abundance of artistic commissions in the Netherlands, England, France and Spain. All this meant that artists were in great demand – but they were almost always men.

However, unfazed by critics who said that the painter's brush was 'manly' or by those who referred to them as the 'passive sex', women fought back. They developed innovative painting techniques and taught younger generations of female artists to eschew the men who would try to stifle their creativity. One such woman was Plautilla Nelli (1524–88), a Dominican nun who set up an all-female workshop at her convent. The first-known Florentine female Renaissance artist, she was one of only four women among hundreds of men praised by Vasari in *The Lives of the Artists*.

Entering a nunnery at the age of fourteen, Nelli became a self-taught miniaturist painter and then quickly worked her way up to tackling large-scale altarpieces, very rare for a woman of her day. She is now best known for *The Last Supper*, *c.*1560, a recently restored jewel of a painting on canvas and the first-known depiction of the biblical tale by a woman. Since 2019, it has hung in the refectory of the Santa Maria Novella in Florence (its first public outing in 450 years). As a woman, Nelli wasn't supposed to take on the challenge of large-scale religious paintings, but she did it anyway. Her richly

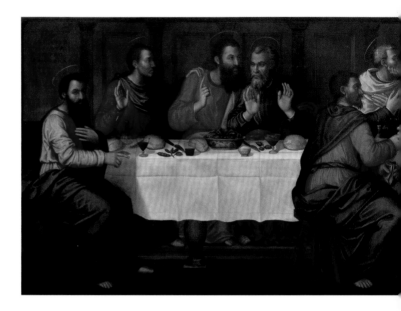

Plautilla Nelli,
The Last Supper,
c.1560

coloured seven-by-two-metre portrayal of Jesus and his twelve
Apostles is full of anatomical accuracy and keen behavioural obser-
vations, seen for instance in the strained tendons in the Apostles'
necks and the tenderness of gesture between Jesus and Saint John.
Clearly invested in capturing naturalism, Nelli portrays Saint John
as a distinctly feminine figure (with soft features and blush-coloured
cheeks), a common way of depicting him, but perhaps also indicating
the lack of male models she might have had access to. It is likely Nelli
had assistance from her fellow nuns in their all-women workshop.

How did Nelli come by the knowledge and skills that enabled her
to undertake this work? We know that she rigorously studied and
copied drawings by the Renaissance artist Fra Bartolomeo, with
Vasari noting that 'she would have done marvellous things if, as men
do, she had been able to study and learn to draw and work after liv-
ing models'.

An artist who did manage to secure an artistic education was
northern Italian painter Sofonisba Anguissola (1532–1625), the
daughter of a high-ranking Cremonese nobleman who was finan-
cially compromised. Determined that his daughters should be well

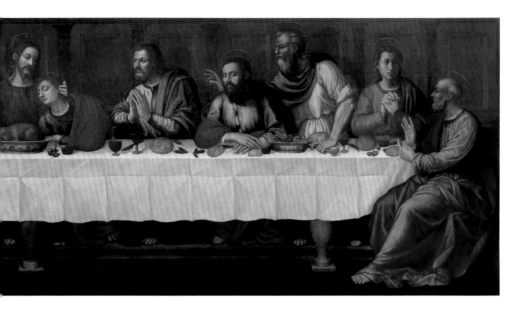

educated, Anguissola's father made the unusual choice to send his two eldest to apprentice with a local painter (perhaps due to the fact he didn't have a son until his seventh child). In this way, Anguissola was able to bypass social norms, earning enormous success and recognition during her lifetime. Holding the most prestigious position of painter at the Spanish Court, she was admired by Michelangelo and praised by Vasari (the latter remarking that her portraits are 'so lifelike that they lack only speech').

Anguissola's quiet and intimate self-portraits display her poised manner and gleaming eyes. Often depicting herself playing music or working at the easel with her paints all laid out and her brush at the ready, Anguissola epitomised what a mid-sixteenth-century woman with an education could be. Her success was so impactful that she inspired noble families from across Europe to instil in their daughters similar professional ambitions. Capturing women engaged in intellectual pursuits, she famously portrayed her sisters in the midst of a conversational and characterful game of chess.

Although mostly confined to portraiture, Anguissola showed great skill in the sophisticated composition of her paintings, from the

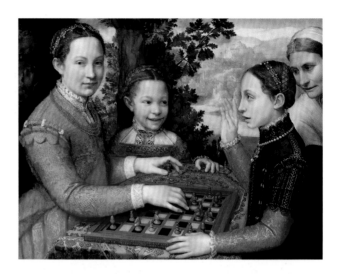

Sofonisba Anguissola,
The Chess Game, 1555

mountainous verdant landscapes behind the animated figures in *The Chess Game*, 1555, to the intricate religious Madonna and Child scene in *Self-Portrait at an Easel*, *c.*1556. For me, her best portrait is *Self-Portrait with Bernardino Campi*, 1550. Clever and witty, this work is also groundbreaking in eschewing gender conventions. At first glance we see Campi (an early teacher of Anguissola) looking over his shoulder to meet our gaze while controlling the young artist's image. But upon closer inspection we realise that it is not he who is dictating her appearance – but rather she is dictating his! Not only is she taking up nearly twice as much space as her teacher, and has him painting the embellishment of her jacket (a task often assigned to an apprentice), but as pentimento temporarily uncovered in 1996, she originally painted her wrist meeting his – as if guiding *his* hand across the canvas.

Anguissola was capable of great things and in her old age was clearly just as sharp. When she was in her early nineties, she was painted by the much younger artist Anthony van Dyck. Captivated by her intellect, in 1624 Van Dyck portrayed her as both astute and austere, qualities still evident in her piercingly resolute eyes, despite her near-blindness. He recalled that she was still very alert, and had advised him to 'not raise the light too high, so that the shadows would not accentuate the wrinkles of old age'. Although we will

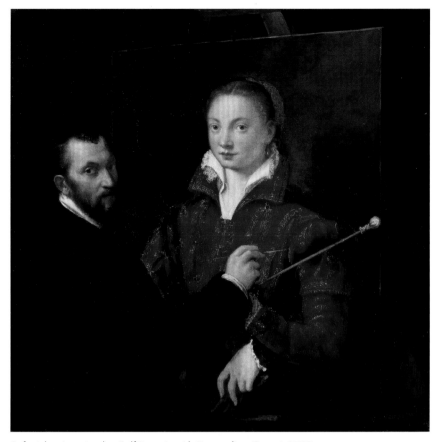

Sofonisba Anguissola, *Self-Portrait with Bernardino Campi*, 1550
(showing a second left hand revealed by conservators in 1996)

never know what she might have produced given the opportunities of her male counterparts, her paintings show a hunger for experimentation, and highlight the canny ways she found to subvert the limits put on her talents.

Unlike Anguissola, the slightly younger Bolognese-born Lavinia Fontana (1552–1614) did not restrict her production to portraiture. She painted religious and mythological scenes – some on the scale of magnificent altarpieces. Often thought to be the first professional woman painter to run her own studio, Fontana was the daughter of a well-known Bolognese painter and learned the tricks of the trade in his studio, developing her practice by copying his paintings. She

adopted a wide-ranging sophisticated style, with some of her works emulating the characteristics of Mannerism: elongated limbs, swirling drapery and dramatic curvilinear poses.

Admired for her portraits, Fontana was especially popular with the Bolognese elite for her exceptional attention to detail and ability to capture sparkling jewels and exuberant patterns. (My favourite remains *Portrait of Bianca degli Utili Maselli with six of her children*, 1605, with each figure kitted out in matching outfits and gleaming lace ruffs.) Full of ambition and determined to be remembered this way, Fontana immortalised herself as an educated artist in an array of self-portraits. In *Self-Portrait in a Studio*, 1579, we meet her at her desk about to draw antique bronzes and plaster casts – her sumptuous garments telling of her high-ranking clientele. In another, *Self-Portrait at the Virginal with a Servant*, 1577, she plays the spinet with her easel illuminated in the background. But the love knot resting on the instrument reveals a little more – the work is intended as a gift for her future father-in-law, no doubt as a way to show him her talents. Further demonstrating her scholarly knowledge, a Latin inscription reads: 'Lavinia, the unmarried daughter of Prospero Fontana, took this, her image, from the mirror, 1577'.

Aged twenty-five, she married a former pupil of her father, who not only allowed her to keep her maiden name but raised their eleven children. Running a successful studio (completing a staggering

Lavinia Fontana: (left) *Portrait of Bianca degli Utili Maselli with six of her children*, 1605; (right) *Self-Portrait at the Virginal with a Servant*, 1577

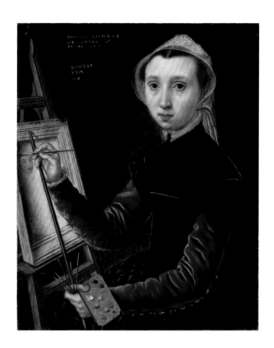

Caterina van Hemessen,
Self-Portrait, 1548

twenty-four public commissions), she quickly advanced to larger narrative paintings and her fame spread. By 1604 she had relocated to Rome, then the greatest place for artistic opportunity, where she became a member of the prestigious Accademia di San Luca and her work was admired by the Pope. Fontana is thought to be one of the first women in Western art to paint female nudes, as seen in her glittering and seductive *Venus and Mars*, 1595.

Across Europe, in Flanders, women were also thriving as artists, although far less is known about them compared to their Italian counterparts. Working slightly earlier than Fontana, Caterina van Hemessen (1528–c.1587) also began painting in her father's studio and was active during the 1540s and 50s, prolifically producing small portraits, often displaying dark backgrounds, plain clothing and solemn expressions. Van Hemessen is credited as the first artist (male or female) to paint a self-portrait at an easel. An inscription on her *Self-Portrait*, 1548, reads: 'I Caterina van Hemessen have painted myself / 1548 / Here aged 20'. Like her Italian contemporaries, she intended to be remembered as a woman who worked.

STILL LIFE IN THE SEVENTEENTH CENTURY

With the rise of a new middle class and the spread of the Protestant Reformation in northern Europe, patrons began to move away from sponsoring religious scenes and towards secular subjects. Still life became increasingly popular, as one of the most direct ways patrons could show off their wealth: depicting rarities imported from across the globe (spices, tobacco, vases, rugs, ceramics) and esoteric culinary items (exotic fruits and shellfish), items accessible only to a select few.

Still-life painting was also considered a suitable genre for upper-class women: it didn't pose a threat to male artists, who no doubt liked to guard 'great' and 'intellectual' subjects (mythological, religious), nor did it require a knowledge of human anatomy; moreover the objects were easily accessible from the home. Paintings of flowers and edible goods – dainties that once lived – had moral meanings. They represented *vanitas*, a word derived from the Bible, to remind the viewer of their own mortality; the fragility and temporality of life; the worthlessness of material goods in the eyes of God.

With its origins in antiquity, still life was popular in the Renaissance, and at the turn of the seventeenth century was deemed a respectable artform. Here, again, we find women artists pushing at the staid limits of the genre, demonstrating their high level of skill and looking to assert their identity as artists. This is particularly evident in their hidden self-portraits in still lifes – perhaps in part to avoid the attribution of their work to men.

An early adopter of still life was the Flemish-born Clara Peeters (1594–*c*.1657), who in 2016 was the first woman to be honoured with a major solo exhibition at Madrid's Museo Nacional del Prado. Peeters mastered a distinct style of still life, often painting delectable-looking wines, fruits, vegetables and fish spread out

invitingly on a platter, with glowing metal utensils and flowers leaping from their stems. But look closer and something is revealed in the goblets. Bouncing off the curved edges, small and shiny reflections suddenly catch the viewer's eye, unveiling minuscule self-portraits of the artist herself. My personal favourite is *Still Life with a Vase of Flowers, Goblets and Shells*, 1612, displaying two highly intricate gilded goblets, a stone vase, shells, a single tulip and a porcelain bowl filled with chains against a dark, dusky backdrop. The viewer's eye does not focus on the central goblet, but rather follows the elegant diagonal line that leads us to the one glimmering on the far right – where it reveals, worked into the goblet itself, the most extraordinary collection of self-portraits, around ten in total!

Peeters wasn't the only artist excelling at still lifes and miniature reflections in her work. In Milan, Fede Galizia (1578–1630), thought to have learned her craft from her miniaturist painter father, began (in childhood) her painstakingly detailed still lifes of cherries, apples, peaches and pears, with her trademark subdued, dark backdrops. Although Galizia never dated her work, her earliest still life, which scholars have described as the 'first dated still life by an Italian artist', is thought to be from 1602. An incredibly accomplished painter – she was internationally renowned by her teens – Galizia, like Peeters,

Clara Peeters: (left) *Still Life with a Vase of Flowers, Goblets and Shells,* 1612; (right) goblet detail

Fede Galizia: (left) *Portrait of Paolo Morigia*, 1592–5; (right) left hand detail

was keen on hidden details. Look closely at the expressive *Portrait of Paolo Morigia*, 1592–5, to find a finely worked window reflection sparkling in the pair of glasses lens in the sitter's left hand.

The Italian Baroque artist Giovanna Garzoni (1600–1670) painted still lifes full of acute naturalism and vitality: delicately rendered artichokes with crumpled leaves; plump cherries good enough to eat; leathery lemon skins; detailed observations of wasps. Simple in composition, often with a ceramic bowl at the centre (sometimes with tiny lapdogs), her work draws on objects and fruits from across the globe and blends still life with the precision of scientific drawing. Small, refined and highly collectable, Garzoni's paintings were so successful that, according to scholars, she sold them for 'whatever price she wished'.

Born into a cultured family in the Marche region of Italy, from an early age Garzoni learnt music, painting, letter writing and calligraphy. Unlike many female artists of her day, she travelled extensively around Italy, receiving her education in Venice and Rome, and later residing in Florence, where records show she met with Artemisia Gentileschi (p. 35).

Giovanna Garzoni: (above) *Dog with a Biscuit and a Chinese Cup*, 1640s;
(below) *Still Life with Bowl of Citrons*, late 1640s

Giovanna Garzoni: (left) *Prince Zaga Christ*, 1635; (right) inscription in Amharic of artist's name

Unconstrained by one medium or genre, Garzoni's output ranges from a calligraphy book featuring a series of capital letters adorned with fruits, poetic writings and letters executed in her exquisite handwriting, to glittering portrait miniatures. One of her best is that of the Ethiopian royal Prince Zaga Christ. Completed in 1635, this relic-like work, full of meticulous precision and just under six centimetres high, is thought to be the earliest depiction of a Black sitter in a Western European miniature portrait. The prince, shown wearing European court dress to highlight his royal status, had fled to Europe after the murder of his father, the King of Ethiopia (while in Rome, he was thought to have had an affair with a Franciscan nun!). A favourite aspect of this gem of a piece is its back, illustrating the likely friendship between the prince and Garzoni, where the artist's name is embossed in Amharic script.

THE BAROQUE

The Baroque, a period during which the motifs of painting were often violent and passionate, marked a shift both in the way subjects were executed and in technique. Whereas artists previously favoured the strict representation of form, the Baroque embraced the elaborate and the excessive: pictures were full of theatrical dynamism and vivid contrasts of light. Beginning at the start of the seventeenth century, the Baroque's capital was Rome and its greatest patron the Catholic Church. It demanded bold, emotional religious scenes to encourage the reading of biblical narratives and help steer people away from Protestantism.

Women artists were still rare, although they were less of a curiosity (in part due to the success of their predecessors), and they continued to be held back by societal restrictions and a lack of resources, often resorting to using themselves as models. But while the women of the Renaissance depicted themselves as desirable and educated, I find those associated with the Baroque to be more 'present' in their work, often portraying themselves as biblical heroines, and it's this presence which seems to make them more relatable today.

Dark backgrounds infused with stunning light effects; blood-ridden biblical and mythological subject matter; vigorous realism; triumphant women; striking psychological and emotive expression – these are just some elements found in the extraordinary work of Roman native Artemisia Gentileschi (1593–c.1653), who in her lifetime became an international celebrity. The first woman to be accepted into Florence's prestigious Accademia delle Arti del Disegno, she worked all around Italy (and beyond) and counted Charles I and the Medici family as patrons. But although she achieved glittering success, her beginnings were nothing short of difficult.

The eldest daughter in an artistic family, who raised her three brothers following her mother's death when she was twelve, Gentileschi grew up grinding pigments in her father Orazio's

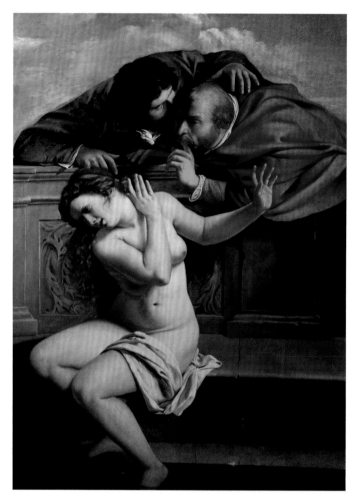

Artemisia Gentileschi, *Susanna and the Elders,* 1610

studio. As a woman, she was banned from wandering freely around the city's monumental buildings and churches or attending the life class, so she rigorously studied and copied the biblical subjects found in her father's grand paintings – subjects she later brilliantly tackled herself.

Encouraged by her father, who had given her the distinctively Classical name 'Artemisia', Gentileschi signed and dated her first large-scale painting when she was just seventeen. *Susanna and the Elders*, 1610, is a towering work consumed with drama, which

demonstrates both her exceptional technical painting skills and her talent for storytelling. Gentileschi recalls the tale of a virtuous young woman, Susanna, who is bathing in her garden when two lecherous men try to seduce her. Filling her viewers with discomfort and anguish, the artist captures the tense moment when Susanna shields her body away from the intruders. Attempting to encroach on her space, the two men almost snatch at her hair while leaning over the panel that should keep them firmly at a distance. This was a common subject in Baroque art (partly for the semi-nude Susanna), but Gentileschi treats it from the viewpoint of the young woman rather than the men. Although I am speculating, this work could also suggest what life might have been like for a woman living in seventeenth-century Italy.

In 1611, when working in her father's studio, Gentileschi was raped by Agostino Tassi, an artist friend of her father. Orazio took Tassi to court nearly a year later, primarily because the act had brought dishonour to his family. The traumatic seven-month trial that followed has left as its legacy a 300-page document, now over 400 years old. In it, we can hear the courageous, eloquent and affirming voice of Artemisia herself: 'He then threw me on to the edge of the bed, pushing me with a hand on my breast, and he put a knee between my thighs to prevent me from closing them. Lifting my clothes, he placed a hand with a handkerchief on my mouth to keep me from screaming.'

Gentileschi was tortured throughout the trial with a 'sibille' (ropes tied around her fingers and tightened, an equivalent to a modern-day lie detector – the most abhorrent persecution for an artist); she was also forced to prove her innocence – uttering the famous words '*è vero, è vero, è vero*' ('it's true, it's true, it's true'). Despite a guilty verdict, after being protected by the Pope, Tassi avoided punishment, an act that sadly still feels unsurprising today.

After the trial ended in 1612, Gentileschi was married off and moved to Florence, where she achieved meteoric recognition (patrons wanted portraits by her and *of* her – including portraits of her hand). It was in this period that she produced what is probably her best work. Focusing on large-scale full-figure compositions

imbued with psychological intensity, Gentileschi's paintings amplified the roles of heroic female subjects. From Judith to Susanna, Lucretia to Diana, she tackled biblical and mythological stories in ways male painters had never dared. She even altered original narratives as if to enhance the strength of the determined women, as seen in *Judith Slaying Holofernes*, 1612. Painted when she was nineteen, the work recounts the Old Testament tale of Holofernes's assassination by Judith and her maidservant. Yet if we make a comparison with Caravaggio's *c.*1600 version, one can't help but notice that in his painting Judith appears passive, and Holofernes, mighty. By stark contrast in Gentileschi's, Judith and her maidservant (who in the original story was keeping watch) take centre stage. The two work together to viciously saw a blade through Holofernes's neck, as if they were butchering a piece of meat. Remaining calm, the muscular women gleam in a single light source, lit from below as they pin down his head, tug at his hair (as seen through Judith's knuckles), and constrain his torso. Blood drips over the ivory sheets, and Holofernes, whose eyes and mouth are just about open, catches his last few breaths of life.

This work confirmed Gentileschi to be among the greatest artists of her day. Not only did it act as a showpiece for potential Florentine clients, such as the Medici (the women of the court were fans), but it proved that women were capable of tackling such subjects.

Powerful and triumphant, Gentileschi went on to immortalise herself in *Self-Portrait as Saint Catherine of Alexandria*, 1615–17, in the guise of the fourth-century saint who was tortured with a wheel of metal spikes and liberated by divinity. Exuding strength, her left hand is actively clenched to the wheel, while her right holds a martyr's palm. Gentileschi's stern gaze locks onto ours, commanding in its power.

Much of Gentileschi's work deals with women seeking to avenge themselves, yet there is not an instance where they appear as the victim. Although it's tempting to read her own life in these works, we must recognise them as extraordinary paintings in themselves.

Gentileschi has become a feminist idol in part due to her exceptionally strong sense of self-worth. We know from her letters that

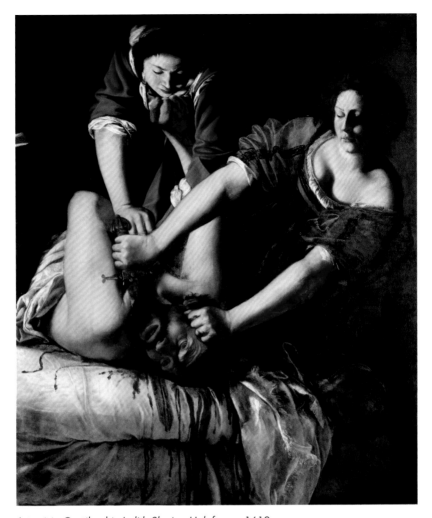

Artemisia Gentileschi, *Judith Slaying Holofernes*, 1612

she was a firm believer in treating and paying women fairly. A frugal businesswoman, in one letter she demands higher fees for multi-figure compositions, and, in another, she asserts to a Sicilian collector, Don Antonio Ruffo: 'You will find the spirit of Caesar in the soul of a woman.'

But it is only in the past four decades that appreciation for Gentileschi has resurfaced. When the Baroque age fell out of fashion in the mid-eighteenth century, her work was quietly forgotten. This

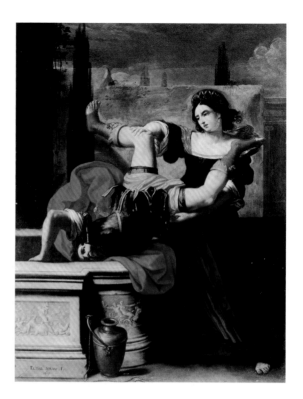

Elisabetta Sirani,
*Timoclea Kills the
Captain of Alexander
the Great,* 1659

was until feminist scholars, such as Nochlin and Sutherland Harris, in their influential exhibition *Women Artists: 1550–1950*, and Mary Garrard, with her groundbreaking monograph on the artist, brought her back to mainstream attention in the 1970s and 80s. Gentileschi is now the subject of books, scholarship, plays, movies and more, and in 2020 her fame was further reignited with a major exhibition at London's National Gallery, among their fastest-ever selling shows (despite the Covid-19 pandemic that raged at the time).

Gentileschi wasn't the only woman tackling large-scale works during the Baroque period. Her contemporary the Bolognese Elisabetta Sirani (1638–65), although now lesser known, was a remarkable painter, draftswoman and printmaker. Like Gentileschi, she centred her work on heroic female figures. But with her softer brushstrokes and more muted colours, Sirani's scenes appear less overtly dramatic – an exception being *Timoclea Kills the Captain of Alexander the*

Great, 1659, which features a lively – yet brutal – killing. Like many female artists of the time, Sirani grew up in an artistic family and learned her practice at her father's studio. Unlike others, the latter was known to oppose her artistic pursuits. But when he was incapacitated with gout, she had to take over, and by her late teens she was the sole family earner, supporting her parents and three siblings.

Sirani was prolific and produced more public pictures and altarpieces than her predecessors. She excelled at painting historical scenes, as we can see in her foremost work *Portia Wounding Her Thigh*, 1664. In Sirani's retelling of the story, Portia, wife of Brutus, is seen stabbing her thigh with a 'stiletto' (a tool used in embroidery), yet she is pictured in a calm and virtuous pose, as if to present a woman's strength and power to overcome. By depicting her historical protagonist in contemporary seventeenth-century dress, Sirani seems not just to draw a likeness to herself but to foreground the determination and poise of her female Bolognese peers.

Known to work in an open studio surrounded by admiring onlookers, perhaps to assert her talent as a female painter, Sirani went on to earn herself hundreds of commissions and was the subject of an extensive biography by the contemporary Bolognese scholar

Elisabetta Sirani, *Portia Wounding Her Thigh*, 1664

Carlo Cesare Malvasia. He commended her as 'the prodigy of art, the glory of the female sex, the gem of Italy, and the sun of Europe'.

But at the age of twenty-seven, she dropped dead – perhaps poisoned, as scholars once believed. Bologna was in shock. An extravagant funeral was held in her honour at the Basilica of San Domenico, an event complete with a 'Temple of Honour', a life-size sculpture of the artist, and an army of mourners. Her legacy, as both a painter and an example for women, is still remembered in the city today, with scholars crediting her for the abundance of women who became professional artists in the years after her death.

THE DUTCH GOLDEN AGE AND BOTANICAL ART

In the seventeenth century, the Dutch Republic became one of the richest nations in the world. Its thriving economy – supported by colonial exploitation – combined with rapid scientific and artistic developments following independence from Spain in 1581 led to the emergence of a wealthy merchant class, who aspired to become patrons of art. The new Protestant ruling class of the Dutch Republic differed in their tastes from Catholic Italian patrons. And with the development of an independent art market, the demand for commissions meant there were more artistic and educational opportunities.

During one of the more liberal periods in art history, the Seven United Provinces of the Dutch Republic were not only relatively tolerant of different religious practices but also more progressive in their attitudes to women, encouraging their education and allowing them to work in skilled production and trades. This period saw more than 150 female artists (compared to some 3,200 male artists) working with a variety of mediums.

Developing psychological intensity and striking light effects similar to those of Italian artists, seventeenth-century Dutch paint-ers rejected the extravagant and reverent splendour of previous Italian movements, favouring smaller-scale secular conversational scenes (landscapes and townscapes, flower painting and domestic

scenes), with some executed in rough, loose brushstrokes, full of dynamism.

The city of Haarlem was one of the artistic centres of the age, and was also where one of its most prominent painters, Judith Leyster (1609–60), resided. The eighth child of a brewer, as a teenager Leyster briefly lived in Vreeland, near Utrecht. At the time, it was home to followers of Caravaggio, the Utrecht Caravaggisti, who used chiaroscuro for dramatic effect, a technique Leyster utilised in her innovative scenes.

Dubbed 'the true Leading star in art' by a Haarlem historian in 1648 (her work could be distinctively identified through her star-motif signature – Leyster means 'lode star' or 'polestar' in Dutch), by the mid-1620s, she was already a painting sensation. At the age of twenty-four she became the youngest member of the Haarlem Painters Guild (one of only two women) and mixed with the most prominent artists of the era. (According to legal documents that can still be read today, she once found herself engaged in a dispute with Frans Hals, after he stole one of her assistants.)

Often set against dusky, neutral backdrops, Leyster's subjects are brought to life as characters full of effervescent energy. Depicted in casual poses and eccentric dress, their lips parted, they look as if they

Judith Leyster: (left) *The Merry Drinker*, 1629; (right) *The Serenade*, 1629

are about to burst into song. To me, the best aspect of her work is her ability to crystallise the exact essence and aura of the rooms in which they are set. Whether it be a warm, jolly, drunken man basking in afternoon light (*The Merry Drinker*, 1629); or a musician, in more intimate proximity, playing his instrument quietly in the night, his face – with its long shadows – lit by a single flame (*The Serenade*, 1629).

Similarly, Leyster's *Self-Portrait*, 1630, brims with ease and merriment. Casually and confidently sitting at an easel, one arm resting on a chair and a fine paintbrush in hand, she clasps used brushes and a palette of fresh paint in her other hand, as if we have interrupted her mid-stroke. Elaborately dressed with a matching lace collar and cuffs, Leyster delights not only in showing herself in action, but also in demonstrating her ability to paint a range of genres and styles, illustrated in the smaller, full-body study on the easel.

In spite of her early successes (she was running a studio, complete with apprentices and three male pupils, by the age of thirty), her career declined following her marriage to another artist in 1636. She was raising five children and managing her husband's studio – and her few collaborations with him were hardly ever credited.

Due to misattribution, it took centuries, and a scandal, in fact, for her talent to be rediscovered. In 1893, following a court case, it was

Judith Leyster, *Self-Portrait*, 1630

revealed that *Carousing Couple*, 1630, ascribed to Frans Hals (and bought by the Louvre as such), was in fact signed with the initials JL, accompanied by a star. Since then, many more paintings have come to light, more proof of Leyster's leading-star status.

As scientific interest in botany and horticulture grew, Dutch flower paintings achieved popular status, notably in Holland and Flanders, and later, in France. With the ruling classes acquiring goods from across the world, exotic plants were deemed collectable items, as another way of displaying one's wealth and connections to trade.

Women excelled at flower paintings. A number of Dutch women revolutionised the genre with lifelike – almost breathable! – paintings that captured the spirit of the 'tulip mania' era (a term used to describe the inflation of tulip prices) in the seventeenth century. Horticulture was already an immensely popular pastime in the Netherlands, as their numerous botanical gardens demonstrate, and the region made flower painting its special subject.

Rachel Ruysch (1664–1750), born in The Hague, stunned art lovers with her highly sophisticated depictions of flora and fauna. Painting until she was well into her eighties, Ruysch achieved international fame and financial success on a par with male painters of the day, selling her work for up to 750 guilders (nearly twice as much as Rembrandt during his lifetime). Her paintings are still preserved in major museums across the globe. However, she has often been left out of art history books.

Impressing her patrons by mixing flowers from different seasons – from peonies and poppies to apple blossom and lilies – Ruysch had an advantage due to her physician and botanist father. He was a great collector of natural specimens: exotic plants, skulls, minerals, insects, and even went so far as to embalm body parts and whole foetuses. These enabled Ruysch to bring together plants from all around the world in her work, having examined them at close quarters – and to paint the most idealised (you could say almost divine) bouquets of all time.

Often in mid- or full bloom, Ruysch's bouquets burst from their hidden vases, while simultaneously straggling into an abyss.

Rachel Ruysch, *Still Life with Flowers on a Marble Tabletop*, 1716

Illuminating them from a single light source, Ruysch not only revealed the depths of the flowers' carpels but painted every angle of the two- or three-tone twisting stems and leaves to expose each vein, wrinkle and droplet. She even included minuscule insects resting atop plants and scurrying in the petals, as seen in *Still Life with Flowers on a Marble Tabletop*, 1716. Obsessed with accuracy and anatomical precision, her technique included pressing butterfly wings into the wet paint to achieve extraordinarily lifelike appearances. Never before had people witnessed such exuberant profusion and pure intricacy of painted flowers as displayed in her works.

The mother of ten children and a member of the Confrerie Pictura artist society in The Hague (its first female member), Ruysch was also a court painter in Düsseldorf.

Painting at the height of still lifes' popularity, some women were also celebrated for their key contributions to scientific advancement – most notably, Maria Sibylla Merian (1647–1717), an entomologist, botanist and naturalist known in both artistic and horticultural circles, whose study of insects is still used by scientists today.

Born in Germany and, in 1691, settling in Amsterdam, Merian was an insect fanatic. She is now considered one of the founders of modern-day zoology, in recognition for her significant contribution to the science, with the publication of her volumes of natural illustrations which record the process of metamorphosis of nearly 200 insect species. Merian's break came in 1699, when she, along with her daughter, travelled to the most north-easterly point of South America where she recorded the existence of native plants and insects previously unknown in Europe. This was one of the first European voyages intended exclusively for the purpose of scientific fieldwork, and the outcome was her dazzling masterpiece, *Metamorphosis insectorum Surinamensium*. Published in Latin and Dutch in 1705, it included sixty meticulous illustrations by Merian, accompanied by detailed scientific descriptions.

Europeans at the time were so impressed by her research that she received a great deal of praise, with the likes of Goethe consulting her work. But after her death, her contributions went unacknowledged until the nineteenth century. Merian was only properly recognised in British and German publications in the 1970s and 80s, and, thanks to a republishing of *Metamorphosis insectorum*

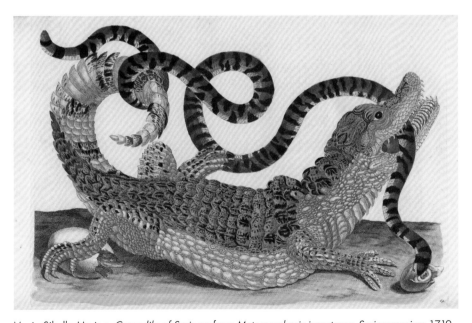

Maria Sibylla Merian, *Crocodile of Surinam* from *Metamorphosis insectorum Surinamensium*, 1719

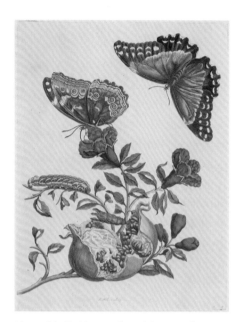
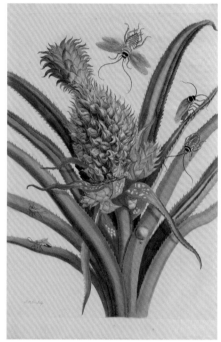

Maria Sibylla Merian, from *Metamorphosis insectorum Surinamensium*, 1719:
(left) *A pomegranate tree showing both its flowers and fruit, a caterpillar, its chrysalis, and two butterflies*; (right) *Pineapple with Australian and German Cockroaches*

Surinamensium in 2017 on the 300th anniversary of her death, her name has now come back to the fore.

Both Merian and Ruysch excelled in their field, mastering floral painting to an exceptional scientific and artistic level. But women across the Seven Provinces (and beyond) were not limiting themselves to the realm of botanical painting, or even the realm of painting itself.

One artist who demonstrated her exceptional ability to translate intricate natural scenes in alternative media was Joanna Koerten (1650–1715). Amsterdam-based and self-taught, Koerten specialised in silhouette paper cutting: intricately carving the outline of images from a single piece of paper set against a contrasting backdrop, which required the same – if not more – meticulous precision as oil painting. Sometimes working on a miniature scale, she produced the most delicate narrative scenes, of which a favourite is *Virgin and Child*

with St John, c.1703. Almost seven centimetres high, it rewards close scrutiny by revealing the most miraculous and mesmeric details: individual sprawling branches that shoot out like fireworks, ribbons of typescript wrapping around a *trompe l'œil* ('trick of the eye') frame, divine halos that crown the Madonna and Child, animals that scurry among the trees and leaves.

Throughout the eighteenth century, paper collage – like paper cutting – was a popular medium, especially in Britain among upper-class women. Pioneering this technique was Mary Delany (1700–1788). Born to an aristocratic English family, where she was taught music, art, languages and embroidery, Delany went on to produce nearly 1,000 extraordinarily detailed floral paper collages. But here's the thing: she only started making her 'paper mosaicks' (as she called them) at the age of seventy-two, after being utterly enraptured by the affinities shared between a loose geranium petal and a red piece of paper. Immediately inclined to start splicing, Delany worked ferociously on her decade-long project, *Flora Delanica*, until her eyesight weakened towards the end of her life.

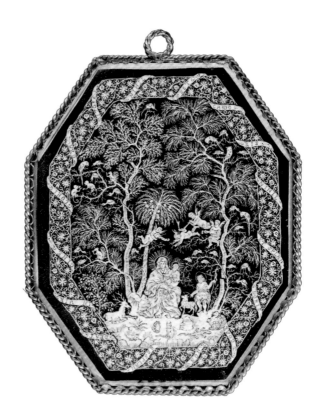

Joanna Koerten,
*Virgin and Child
with St John,* c.1703

Mary Delany, *Sea daffodil (Pancratium maritimum)*, 1778

Delany's inventive 'collage' process was nothing short of groundbreaking, and is thought to have been one of the first examples of collage in the history of Western art. Her radical technique involved her amassing different colour, weights and types of paper, which she spontaneously cut into (with no preparatory studies). She then pasted these cuttings onto a dark opaque background, to create a stark contrast to the luminous floral colours and accentuate the flower's dazzling details – as seen in *Sea daffodil*, 1778, with its stringy petals and specks of pollen that twirl and dance in the midst of stillness.

Praised for their scientific precision (painter Joseph Reynolds described them as 'perfection'), Delany's *Flora Delanica* are so life-like it's as though they are billowing freely in the night sky. Just like her contemporaries who advanced the still life, or trailblazed new techniques, Delany pioneered a new representation of botany. In 1772, she wrote, 'I have invented a new way of imitating flowers.'

Chapter Two

LOOKING TO
A HEROIC PAST

(c.1700—c.1800)

THE EIGHTEENTH CENTURY

The eighteenth century was full of advancements, artistically and stylistically, but also for the position of women. Records show that nearly 300 women artists worked professionally in Europe (as miniaturists, engravers, portraitists), with some reaching new heights of fame. Dominating specific markets, earning substantial salaries and commissions from royalty, a few women of this era broke ground with their complex history paintings and sophisticated portraits. They were fast-tracked to some of the most prestigious artist academies of the day, in part thanks to their close ties with high-ranking patrons. And yet it was the emergence of the very same artist academies (notably the Académie Royale de Peinture et de Sculpture in Paris, established in 1648, and the Royal Academy of Arts in London, in 1768) that resulted in major setbacks for the recognition of female artists.

Although academies had existed since the Renaissance, these two were founded with the purpose of providing artists with essential training, a theoretical education, exhibition opportunities (access to patrons for financial gain), preservation of the artist's work and legacy, and – let's not forget – prestige. Unsurprisingly, they were not welcoming to women.

Not only did these academies insist on making a distinction between 'high art', which was promoted exclusively, and 'craftsmanship', considered 'low', they also established a hierarchy *within* painting genres. Large-scale multi-figured history paintings were at the top; portraiture and still life were at the bottom. Predictably, this worked to the advantage of men, as despite women achieving elite positions at academies, they were still denied access to 'proper' training (for which the study of the nude from life was fundamental). This put women at a disadvantage before they could even attempt to undertake ambitious work and 'higher' genres.

Things didn't get any better with the academies. Having accepted

only a few women since its inception, in 1770 the Académie Royale capped the number of female artists admitted to just four at any one time. Even more outrageous, following the deaths of two of its female founders in the early 1800s, the London Royal Academy failed to admit any more women for over a century.

In the late eighteenth century, the popularity of philosopher Jean-Jacques Rousseau, who argued that a woman's place was in the home, also worked against the advancement of female artists, although some of them used this to their advantage, and chose to focus on the theme of 'mother and child' to comment on social issues. Nonetheless, a small number of female artists found other ways round all of these obstacles, and in an era of drastic social and political change, proved to be essential contributors to new styles and traditions. But first, let's go back to the beginning of the century, an era of exuberance, with one Venetian leading the way.

ROCOCO AND NEOCLACISSISM

Following the death in 1715 of Louis XIV, the long-ruling king who favoured a glorified Baroque style, the French court – now under the rule of the new boy, King Louis XV – migrated from the grand palaces of Versailles to the city of Paris. This change prompted a demand for an art style that could serve the new urban aristocracy: the 'Rococo'. Going against the splendorous and majestic formality of before, the style later known as the 'Rococo' was famed for its ornate opulence, asymmetrical curvilinear lines and scroll-like forms. Spanning architecture to the decorative arts, the painters of this style sought to capture charming, everyday subject matter, with a focus on the individual. They depicted playful scenes, often set against ethereal clouds or verdant backgrounds, and all swept up in a radiant, pale, pastel-like palette. ('Rococo' comes from the French word *rocaille*, referencing the grottoes encrusted with shells found in Versailles.)

But prior to the 1730s, the height of this style's popularity, a young Venetian artist, Rosalba Carriera (1673–1757), was already

working in a manner that anticipated the Rococo's elegance and lightness. Carriera was acclaimed for her shimmering pastel works that not only contributed to the shift in aesthetic, following her influential visit to Paris in 1720, but were instrumental in pioneering the 'pastel portrait'. Collected by royalty and dubbed the 'queen of pastel', during her lifetime she was known as the most successful female artist in Europe.

One of the first women artists whom we know to have been born into a middle-class family – her mother was a lacemaker and her father a civil servant – Carriera was raised in Venice, the eldest of three sisters. Having spent her youth drawing and designing lace, by

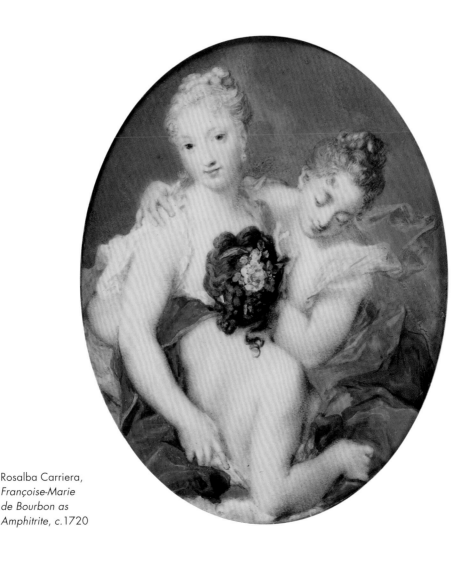

Rosalba Carriera,
*Françoise-Marie
de Bourbon as
Amphitrite, c.*1720

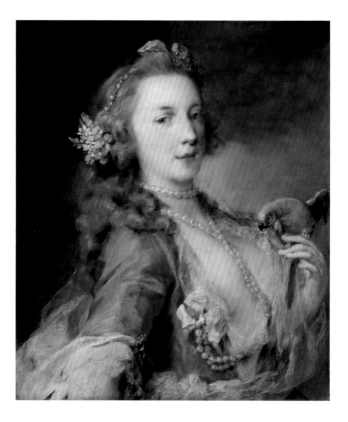

Rosalba Carriera,
*A Young Lady with
a Parrot,* c.1730

the early 1700s she was earning a living painting portrait miniatures on to ivory for the insides of snuffboxes. With her fast-growing, international clientele, Carriera began to experiment with pastel crayons for her portraits. This was an unusual medium at the time, as pastels were generally reserved for sketching or copying, but her work revolutionised it and pushed it into the realm of 'high art'.

As she mostly portrayed high-ranking aristocracy and wealthy merchants (often sporting silvery locks and translucent ruffs), Carriera's painterly use of pastel was perfect for the Rococo style. A dry medium (not dissimilar from eighteenth-century make-up), pastel allowed her to achieve a luminous surface, bright colouring and variations of textures, and was ideal to render the powdery hair favoured by early-1700s nobility, or the meticulous detail required for lace. Its dryness (in contrast with wet oil paint) enabled Carriera to finish vast amounts of portraits quickly (her sister Giovanna assisted by

filling in the backgrounds), and the fact that she was working on paper meant the portraits were easily transportable.

After being persuaded by an influential art collector to visit Paris, in 1720 Carriera arrived in the city and was met with nothing but praise (the revered French Rococo painter Jean-Antoine Watteau became a fan). Commissioned to portray the then ten-year-old Louis XV, Carriera made a lasting impression on the ruling classes, who appreciated her distinctive artistic style (her smaller portraits celebrating individuality chiming perfectly with the Rococo). Granted an honorary membership to the Académie Royale in Paris, Carriera went on to be elected at the Accademia Santa Clementina in Bologna, and to travel extensively across Europe.

Returning to Venice in 1721, Carriera continued to excel in the technical brilliance of pastel, which is showcased in *A Young Lady with a Parrot*, c.1730. A stunning, light-infused portrait executed with loose and lucid strokes, the painting captures the vivacious subject's elegance and charm, the cold, shiny hardness of her pearls, and the naturalistic feathers on the convincingly warm-bodied parrot. No wonder eighteenth-century art dealer Pierre-Jean Mariette claimed Carriera's images 'came from heaven'.

In Venice, Carriera spent her final years in the grip of depression, triggered by the death of her sister Giovanna, and her progressively fading eyesight. Although celebrated during her lifetime, fashions in the Rococo and pastel soon faded, eclipsed by the rise of Neoclassicism, and the subsequent negative gendered associations the Rococo had with 'femininity'. By the time of the 1789 French Revolution, the style had run its course. For centuries, Carriera was forgotten.

Angular lines, naturalistic palettes, compositional harmony, heroic narratives. The second half of the eighteenth century marked the rise of Neoclassicism, an International Western style and cultural movement born in Europe, which abhorred all things Rococo and looked towards a glorified ancient past. With seismic shifts in French politics and a rediscovery of Roman ruins, artists turned the focus of their work to striking and triumphant historical, biblical and mythological subject matter.

A child prodigy who spoke five languages and excelled at music, Angelica Kauffman (1741–1807) was celebrated for her stunningly executed portraits and history paintings. An artist full of determination, she pushed at (and broke) gender boundaries as a member of prestigious artist academies (in Rome, Bologna, Florence) who earned respect (and infatuation) from her male peers; by the end of the 1700s, Kauffman was considered one of Europe's leading painters. Just as a contemporary engraver of hers once remarked, 'The whole world is Angelica-mad.'

Born in Switzerland, Kauffman received artistic training from her painter father. Spending her youth travelling across Europe, tracking down patrons and admiring (and copying) Renaissance works, by the age of twelve or thirteen her painting skills were exemplary, as seen in the technically dazzling, rosy-cheeked *Self-Portrait with a Sheet of Music*, 1753, displaying both her artistic and musical talents. Assisting her father with large-scale commissions, during 1759–60 she travelled to Rome, Naples and Florence, where her Neoclassical artistic vocabulary began to take shape.

Arriving in London in 1766 (another artistic capital of Neoclassicism, due to the taste of reigning King George III), the financially savvy Kauffman set up a studio on Golden Square, where she was known to charge the same price as her male contemporaries. Quickly rising up the ranks, within just two years she became one of two

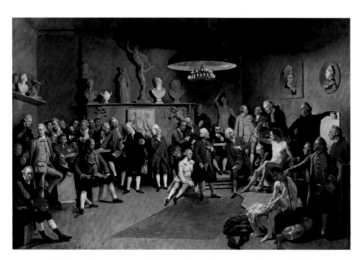

Johann Zoffany, *The Academicians of the Royal Academy*, 1772

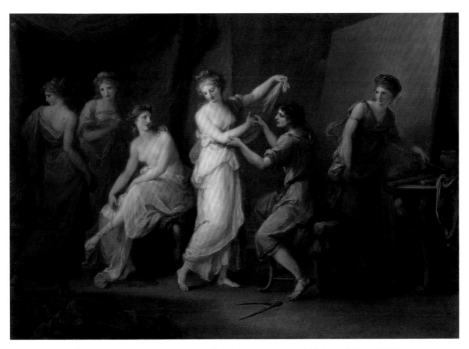

Angelica Kauffman, *Zeuxis Selecting Models for His Painting of Helen of Troy*, 1778

female founder members of the Royal Academy of Arts (the other being English botanist painter Mary Moser). But despite holding such prestigious titles, both Moser and Kauffman were banned from proper training, access to the life room and important meetings. A particularly savage move by the male academicians was when the women were portrayed alongside the founding thirty-six members in an official portrait by Johann Zoffany, *The Academicians of the Royal Academy*, 1772. Instead of painting them as figures (like the string of confident men who gather around the nude model, engrossed in conversation), Moser and Kauffman were merely (and almost unrecognisably) immortalised as portrait busts – as visible in the top right-hand corner.

Despite this cruelty, Kauffman continued to produce ambitious multi-figured paintings. She favoured elegant, anatomically accurate characters billowing in almost translucent drapery and spotlighted in a hazy glow, her style epitomised in *Zeuxis Selecting Models for His Painting of Helen of Troy*, 1778. This popular mythological

subject featured the fifth-century Greek 'master' painter Zeuxis attempting to reconfigure Helen of Troy (his idea of 'perfection'), by borrowing attributes from five idealised women. But look closer at the figure on the far right who stands clutching her brushes in front of a large easel. Kauffman has inserted herself into the painting, reminding us that it is not Zeuxis directing the scene, but rather she who is in charge.

How was Kauffman able to paint such ambitious compositions? At the Royal Academy, she was commissioned to create four ceiling roundels honouring the four elements of art in the form of allegories – *Colour*, *Composition*, *Invention* and *Design*, 1778–80. In *Design*, she portrays a female artist studying from the Belvedere Torso, a muscular body cast (and her substitute for a male life model). In drawing attention to the ways Kauffman got round her exclusion from the life room, *Design* shows both the capabilities of women and the limits within which they had to abide.

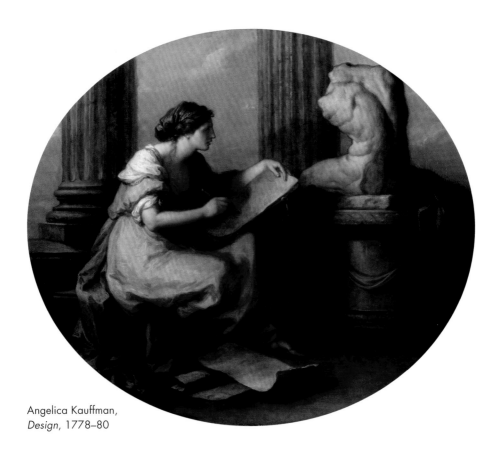

Angelica Kauffman,
Design, 1778–80

Although Moser's and Kauffman's senior positions appeared to show women entering new spaces, nothing changed for decades – a century even. It took until 1860 for the next female artist to be admitted to the Royal Academy (Laura Herford got in by submitting drawings using only her initials, L. H.); and until the 1890s for women to be allowed to study from the nude. The first official female Royal Academician was elected in 1936: Laura Knight; and, to date in 2022, only 9.35 per cent of Royal Academicians have been women. Like most such institutions, the Royal Academy still has a lot of work to do. But back to the eighteenth century – this time in France.

THE FRENCH REVOLUTION

Pre-Revolution France marked a time when some women achieved meteoric success. Taking up prime positions at the Paris salons, and admitted to the Académie Royale (despite the four-woman cap), their success was in part due to their glittering array of female royal clientele (who no doubt appreciated their ability to capture a handsome portrait). A favourite of the ruling Queen Marie Antoinette was Elisabeth Vigée Le Brun (1755–1842).

Born in Paris and trained briefly by her pastel portraitist father (he died when she was twelve), Vigée Le Brun was for the most part self-taught. Highly ambitious – by fifteen she was her family's sole earner – within a few years, she was married off to a high-society (albeit gambling) art dealer. Not only did he introduce her to the Parisian cultural elite, but his job meant she could access, copy and study the most important paintings of the day. Commended by patrons for her soft textures and desirable portraits, which made her sitters appear *slightly* more attractive than in reality, in 1778 Vigée Le Brun caught the attention of Marie Antoinette. Striking up a close friendship with her royal patron, Le Brun went on to immortalise her in around thirty portraits, with the pair remaining close until the Queen's arrest.

Straddling both the opulence of the Rococo and the order of Neoclassicism for her radiant paintings, Vigée Le Brun – a devout royalist who enjoyed the life of the elite and embraced the era of pre-Revolutionary France – was a master at grand hats and hairstyles (often featuring a fair few feathers). Brought in to 'soften' the infamous perception of the Queen at a politically tense time, Vigée Le Brun portrayed Marie Antoinette in a range of scenes, not all of which were always well received. This is evident in *Marie Antoinette in a Chemise Dress*, 1783, a portrait of the Queen wearing simply a casual (but glimmering) chemise dress held together with a yellow bow (designed by her dressmaker Marie Jeanne Bertin). When exhibited at the Paris Salon of the same year, the painting caused great commotion due to the dress's resemblance to an undergarment – highly inappropriate for the time. Although immediately removed by authorities, the painting sparked a new movement in fashion, with women all over Europe abandoning elaborate robes for casual dress.

Vigée Le Brun knew how to work to her own advantage. This was a time when Rousseau's views on women and motherhood were

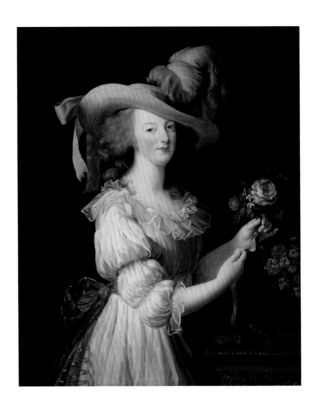

Elisabeth Vigée Le Brun,
*Marie Antoinette in
a Chemise Dress*, 1783

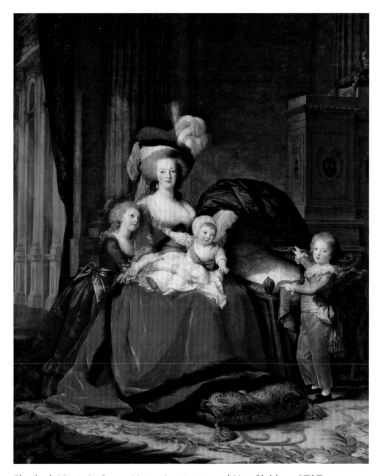

Elisabeth Vigée Le Brun, *Marie Antoinette and Her Children*, 1787

popular among all social classes. With the Revolution on the horizon, Vigée Le Brun was tasked with framing her patron as a doting mother, an example being *Marie Antoinette and Her Children*, 1787, a painting whose purpose was to portray the Queen as 'relatable' – albeit in an illustrious crimson velvet gown and accompanying extravagant hat.

Despite her being a supporter of the Revolution, another court favourite was Adélaïde Labille-Guiard (1749–1803). Labille-Guiard preferred a muted palette, and excelled at encapsulating an incredibly lifelike naturalism. Famed for her portraits of the French court,

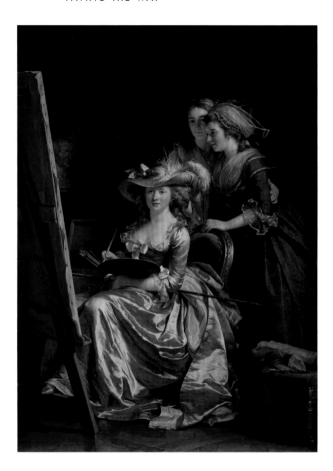

Adélaïde Labille-Guiard,
*Self-Portrait with Two Pupils,
Marie Gabrielle Capet and
Marie Marguerite Carreaux
de Rosemond*, 1785

Labille-Guiard is, however, best known as an advocate for women's artistic education (she was a teacher to many). This is illustrated in her *Self-Portrait with Two Pupils, Marie Gabrielle Capet and Marie Marguerite Carreaux de Rosemond*, 1785, depicting two students appearing in full admiration of their lavishly dressed teacher, who appears to be effortlessly tackling the giant canvas in front of her. This sumptuous painting is vital in documenting the influential status women artists had as teachers, with its monumental size and stunning execution alluding to the scale of women's achievements in the pre-Revolutionary period.

At the outbreak of the Revolution, Vigée Le Brun immediately fled France, living in exile for twelve years with her young daughter. Travelling across Europe, she earned favour with equally important

upper-class patrons, amassing a considerably high salary. But upon her return to France in 1801, she found a very different culture from the one she had left, recalling: 'Women reigned then. The revolution dethroned them.' Labille-Guiard stayed in France, but her career never again reached the heights of the 1780s.

Although the French Revolution saw the monarchy overthrown and political structures redefined, this era proved contradictory for women. In the 1790s the academies were dismantled (due to their associations with the aristocracy) and refounded, yet women artists still faced educational restrictions (banned from important societies and meetings, state-funded artistic education, the life room, and limited to genre, still-life and portrait painting). However, one aspect of these new 'refounded' academies was they allowed for non-academician artists to exhibit. This, in turn, saw an influx of middle-class female artists submitting to the Paris Salon.

One artist who earned acclaim in post-Revolution Paris was Marie-Guillemine Benoist (1768–1826). A former pupil of Vigée Le Brun, Benoist had some success in the 1790s with her genre paintings and pastels, but her fame soared after she exhibited *Portrait of Madeleine*, 1800, at the Paris Salon.

Wrapped in a dazzling white fabric tied with a red ribbon, Madeleine is depicted sitting with elegance and poise in a chair covered with a rich blue shawl – the colours evocative of the French Tricolour. Her portrait was painted six years after France abolished slavery in its territories (before it was reinstated by Napoleon in 1802), and scholars have suggested that it speaks of the new-found liberty in France for those previously enslaved. Interestingly, it has also been compared to Eugène Delacroix's *Liberty Leading the People*, 1830, made thirty years later, which also exposes the right breast of the protagonist, and has a red ribbon tied around Liberty's waist.

At the time the portrait was painted, Benoist failed to document the sitter's name, but after extensive research for a groundbreaking exhibition, *Posing Modernity: The Black Model from Manet to Matisse*, curated by Denise Murrell in 2019, the sitter was identified as Madeleine, a servant who had been brought to Paris from the

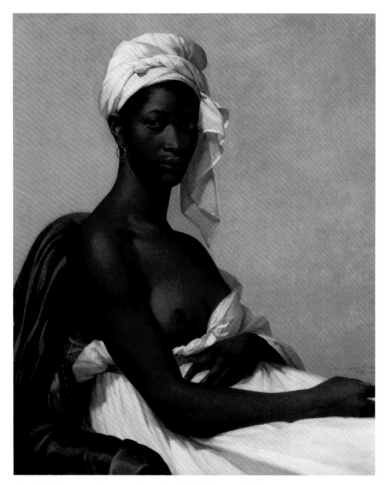

Marie-Guillemine Benoist, *Portrait of Madeleine*, 1800

Antilles by the artist's brother-in-law. Originally *Portrait d'une négresse*, the work was rightfully renamed *Portrait of Madeleine*. Prior to Murrell's research, others had criticised the lack of attention to the identity of the sitter, a contentious issue throughout much of art history, which has seen Black sitters' identities stripped. Murrell adds, 'Although the model is portrayed as emblematic of liberty, she can be assumed to have had little or no ability to influence the manner of her portrait'; confirming that Black people were regularly utilised as symbols rather than individuals, as Murrell notes, 'which would have been the case if they had been European'.

For those Linda Nochlin fans reading, have you ever wondered why a reproduction of *Marie Joséphine Charlotte du Val d'Ognes*, c.1801, graced the front cover of the 1971 *ARTnews* issue that published her essay *Why Have There Been No Great Women Artists?* Considered 'one of the great masterpieces of all time' by twentieth-century art historians, the work was acquired by the Metropolitan Museum of Art in 1917 for a staggering 200,000 dollars, when it was under the impression that it was in fact by Jacques-Louis David (the most prominent male artist of Neoclassicism). It was near universally praised by museumgoers, influential historians and writers who declared the work 'exemplary' and 'unforgettable'. In the 1930s the work was even made into prints to cater for its growing audience. *Marie Joséphine Charlotte du Val d'Ognes* has always been acclaimed for its celebration and embrace of the day's fashion. It employs simple perspective and foreshortening techniques that guide our eye

Marie Denise Villers,
*Marie Joséphine
Charlotte du Val
d'Ognes*, 1801

to the cracked glass, only to further reveal a romantic scene between two lovers in front of the Seine.

However, in 1947 a curator began to question its provenance, with conservators eventually confirming that it was in fact not by David, but by Constance Charpentier (1767–1849). According to one scholar, the response to this change of authorship was 'surprisingly calm' – although, in 1964, it comes as no surprise that a male critic commented that 'there are certain weaknesses of which a painter of David's calibre would not have been guilty.' In the 1970s, the work became an icon for the feminist movement. In 1996, the painting was once again reattributed, this time to an even lesser-known female artist, Marie Denise Villers (1774–1821). More proof of the brilliance and talents of women. Although, in truth it is difficult to imagine historians praising a work to the same degree (or museums paying a similar price tag) had they known the author was a woman from the start.

Although the post-Revolution years saw restrictions for women, Nochlin argues, women artists 'made progress, as a group and as individuals ... whether it was because of the less restricted access to the Salons or the greater emphasis on portraits and genre rather than history painting'. By 1835, 22.2 per cent of exhibitors at the Salon were women, a 7.6 per cent rise from 1801, and as we will discover in the next chapter, more women were achieving great critical and financial success.

Chapter Three

FROM REALISM TO SPIRITUALISM

(c.1800–c.1900)

SETTING UP FOR THE TWENTIETH CENTURY

The nineteenth century was revolutionary for women. Within 100 years, women in the West went from being barred from public education to having access to the most prestigious state-funded schools; by the 1890s, this included the life room. Materials and processes were also transformed (from printmaking to photography), as was subject matter (there was a move away from the heroism of Neoclassicism to scenes faithful to the natural world). Much of this was due to major changes in the political landscape: the 1848 French Revolution, the American Civil War, the abolition of slavery and the beginnings of the suffrage movement. This century also marked one of the first times women could succeed independently from men, and speak up publicly for their rights (aided by the establishment of networks such as the Union of Female Painters and Sculptors in Paris, and the Society of Women Artists in London). By the end of the century (with Symbolism, Spiritualism, and, as we discover in the following chapter, Impressionism, p. 111), artists were experimenting with styles so radical, so new, so revolutionary, that it would mark the dawn of what would come to be known as 'modern' art.

While I recognise this book has followed mostly European artists, here we explore some of those working outside the traditional Western canon and practising with alternative materials. From quilting to pottery, metalwork to printmaking: just as we should celebrate all artists, all artforms should be acknowledged, too.

Let us begin with the matriarchs who conquered size and scale and caused a sensation; those who rebelled against the perceived limitations of femininity, and those who achieved critical and financial success on a scale that no woman had before – earning international recognition and influencing future generations, all while staying true to the spirit of their subjects. This was a movement known as Realism.

'Why shouldn't I be proud to be a woman? My father [...] told me again and again that it was woman's mission to improve the human race [...] To his doctrines I owe my great and glorious ambition for the sex to which I proudly belong, whose independence I'll defend till my dying day. Besides, I'm convinced the future is ours' — Rosa Bonheur

Realism remains one of the most influential movements of the nineteenth century, and in a way, I think, still speaks to what artists make today. Capturing both the likeness of subject and the 'realities' of life – no matter how raw or unattractive – Realism looked to those who worked and occupied the land (farmers, soldiers, peasants, animals). It was with pathos and honesty, and at times, surprise, that artists caught the public by storm.

One great Realist artist born before women had access to the life room was Rosa Bonheur (1822–99). Bonheur was one of the most famous artists of the century (regardless of gender), receiving the highest of accolades, such as the French Legion of Honour. Not only did she advance painting in subject and scale, but she transformed the perceptions of the modern woman in her spirit, and style.

Born in Bordeaux and trained by her artist father, following the family's move to Paris in 1829 she spent her days sketching Dutch masters in the Louvre. Taking animals as her subject, Bonheur was so committed to her work that she observed cattle, dissected carcasses and even visited slaughterhouses to fastidiously study their anatomy. Recognised at the Paris Salon at nineteen, her first success was *Ploughing in the Nivernais*, 1849, featuring weighty farm animals trudging through a quagmire and glittering in the sunlight. Depicting what academies deemed lowly subject matter in a style generally reserved for glorified history paintings, Bonheur amplified the importance of the animals by executing the scene with triumphalism and on the scale of Neoclassicism.

But it is with *The Horse Fair*, 1852–5, that she really made her name. Five metres high and two metres wide, this was at the time the largest painting devoted to the subject of animals. It encompasses genres ranging from landscape, to portraiture and animal painting,

Rosa Bonheur, *The Horse Fair*, 1852–5

and demonstrates Bonheur's extraordinary skills at capturing light, shade, energy and movement, evident in the backdrop's imminent cloudburst juxtaposed with the luminescent white light that hits the group of horses rapidly charging in a circular motion. Bonheur situates the viewer in the midst of the action (as if we were at the foot of a stage at a theatrical performance): this is a painting so vivid, so lifelike, that when witnessed in the flesh, you can almost hear the hooves galloping across the earthy floor.

Considered one of the greatest works of its day by both critics and the general public, *The Horse Fair* was requested by Queen Victoria for a viewing at Buckingham Palace and, with the emergence of new technologies, widely reproduced in print.

Determined to achieve acute precision, Bonheur spent nearly two years preparing for this work: visiting horse fairs on a biweekly basis, sketching every detail and recording every hair. But for a woman attending a male-dominated event, this was not an easy task. Bonheur was granted a permit by French authorities to wear 'masculine' clothes, but this didn't bother her; in fact, she much preferred to wear trousers. She called them her 'great protectors', and was often portrayed proudly decked out in suits.

At a time when women were so constrained by societal norms, Bonheur was financially independent and internationally renowned. She was also open about her relationships with women, such as the

artist Anna Klumpke, with whom she lived in a château complete with wild and farm animals: lions, cows, sheep and stags – subjects which feature in Bonheur's later work.

Realist detail and acute observation can also be found in the paintings of British artist Lady Butler (1846–1933), whose documentations of the Crimean War and the Battle of Waterloo exude a visceral spirit. She, too, defied conventions, by working on a colossal scale and tackling subjects of war (usually the preserve of men). Unlike Bonheur's long-lasting fame, Butler's popularity was more short-lived. Haven't heard of her? Neither had I (until recently). But for a while, she was the most famous female painter in Britain.

Born Elizabeth Thompson, Butler's obsession with battles began early, and she was drawing figures firing pistols at the age of fourteen. Trained at the Female School of Art, in South Kensington in London, thanks to her parents' wealth Butler was able to take additional classes privately, including drawing from the nude. Although she attracted some attention for her battle paintings, it was in 1874 that her fame skyrocketed, after she submitted *Calling the Roll after an Engagement, Crimea* (also known as *The Roll Call*), 1874, to London's Royal Academy of Arts.

A vast painting depicting exhausted soldiers (fallen, leaning, resting, depleted) following a battle in the Crimean War, when it was publicly exhibited, *The Roll Call* caused one of the greatest

Lady Butler, *Calling the Roll after an Engagement, Crimea*, 1874

sensations the Royal Academy had ever experienced. Crowds gathered. Mile-long queues formed. Security was brought in to control the many punters who wanted to catch a glimpse of anything they could. Proving immensely popular, it went on tour. Even Queen Victoria bid for the work, and won. Like *The Horse Fair*, it was reproduced in prints. Critics couldn't believe that it was by a woman – indeed, leading critic John Ruskin considered it an exception to his barbaric statement that 'no woman could paint'.

So exactly why did this painting cause such a fuss? Not only were people shocked a woman could create such a work, but they were shaken by the psychological accuracy and intensity Butler had recorded so perfectly. Unlike previous momentous – and to an extent, idealised – battle paintings, *The Roll Call* depicted the soldiers' suffering, agony and sorrow, illustrating Butler's stated intent of 1922: 'I never paint for the glory of war, but to portray its pathos and heroism.'

Despite nearly becoming the first female Royal Academician in the nineteenth century (losing out by two votes), her fame soon faded. Within years she was virtually unknown. Married, raising children and regularly posted around the world due to her husband's military career, she was ignored by critics, who were dismissive (and no doubt suspicious) of work by a woman.

But while it is vital we marvel at these women's successes, we should also question why they in particular received such recognition: are women only able to achieve greatness when they emulate successful men in style and subject matter, showing that they, too, can tackle bloody scenes and triumphal scales? If we look at other female artists from this era, and examine their strengths and innovations, should we not consider their work equally worthy of praise and celebration?

So from here, let us turn to artists who are just as deserving of such recognition, though they were working on smaller scales, and some in alternative media, from the traditional establishment.

QUILTMAKING

Art historians have overlooked quilting as a key medium for far too long. No doubt in part as a hangover from the academies who dismissed embroidery as 'craft'. Quiltmaking is important, not only artistically, but as a political tool, and as a medium which women have historically dominated.

During the nineteenth century quilting was practised by many around the world, especially in America. It was an art women of all classes and backgrounds mastered. Whereas quilts from the early 1800s (that still exist today) have embroidered, intricate, hand-woven elements (look up those made in 1830s Baltimore), after the American Civil War and the rise of industrialism (with the abundance of mass-produced cloth and sewing machines), it was common for quilts to be pieced together and made by machine. This was known as appliqué: applying multiple pieces of cloth to create a richly textured surface.

Shown off at local and mainstream agricultural fairs (where quilters often won prizes), quilts were made for many purposes: practical, educational, political, decorative. For warmth, wedding gifts, to

Emma Civey Stahl,
*Woman's Rights
Quilt, c.1875*

raise money and awareness for abolitionist and feminist causes (as seen in Emma Civey Stahl's *Women's Rights Quilt*, c.1875, of which one square depicts a woman driving a horse and cart). Or, for education and astronomical readings, as seen in science teacher Ellen Harding Baker's mesmeric *Solar System Quilt*, 1876. Quilts were also made to recall stories, as seen in the two remaining quilts by Harriet Powers (1837–1910), the most renowned quiltmaker of the nineteenth century.

Born into slavery in Georgia, it is thought that Powers, like most quilters, learned sewing from her female family members. An accomplished African American woman who could read and write (and a mother to nine children), Powers received prizes for her narrative-driven quilts with complex, cut-out and appliquéd figures. Her surviving works are *Bible Quilt*, 1885–6, and *Pictorial Quilt*, 1895–8.

With its rich, vivid textures; its shapes of animals, angels, halos and ladders; its intricately sewn details and electric colouring (originally 'watermelon pink with green bars to frame each scene', as a previous owner was told), Powers's *Bible Quilt* consists of eleven appliqué squares illustrating stories from the Old and New Testament.

Honing her art on an even more ambitious scale, a few years later, Powers made her most impressive work, *Pictorial Quilt*, 1895–8. It comprises fifteen densely packed scenes, which recount a mix of

Ellen Harding Baker,
Solar System Quilt, 1876

Harriet Powers,
Pictorial Quilt,
1895–8

Bible stories and miraculous legends, each square featuring a range of meticulously cut-out shapes and symbols, and framed by dazzling strips of dotted fabric. Here, we see her recalling not only biblical tales, such as 'Jonah and the Whale' (see the giant fish far left in the middle row), but mystical tales of real-life events during and preceding her lifetime. In the central square, she notes: 'The falling of the stars on Nov. 13, 1833. The people were frightened and thought that the end had come. God's hand staid the stars. The varmints rushed out of their beds': most likely referring to the spectacular Leonid meteor storm (which saw between 50,000–150,000 meteors fall 'each hour'!); and far left in the bottom row: 'Cold Thursday, 10 of February, 1895. A woman frozen while at prayer. A woman frozen at a gateway … All blue birds killed. A man frozen at his jug of liquor': possibly referencing Florida's 'Great Freeze' as emphasised by the snow-like palette.

While we can only imagine why she chose to document these tales, we know her quilts were made for the purpose of being displayed, as opposed to practicality. Aware of the merits of her art, in 1910, Powers signed her autobiography: 'This I accomplish. Harriet A. Powers.' But despite her impressive quilting abilities, she remained largely unknown to the public until the 1970s, when her work was 'rediscovered' by feminists – who, as we will see in Chapter 11, used the art of thread as a form of protest.

WORKING IN THREE DIMENSIONS: POTTERY

Like quilting, pottery is practised in a variety of cultures. A global phenomenon, nearly all communities have developed distinctive, localised traditions as a result of the differences in availability of materials, the firing processes used and the techniques shared across generations. Perhaps the most well known of Native American potters is the Hopi-Tewa artist Nampeyo (1859–1942), who was and continues to be celebrated for her ingenuity as a potter and designer.

Born in the village of Hano, on First Mesa in northern Arizona, a Colorado Plateau community more than 1,000 years old, like many Pueblo potters Nampeyo learnt her craft from family members. She employed the 'coil and scrap' technique, which was achieved by hand, and sourced and used mineral clay and paints from the surrounding area. Executed in a range of shapes and styles, Nampeyo's pottery ranges from low, wide bowls, to large, everyday water vessels (known as 'ollas') and canteens, which she painted with intricate figurative, and at times geometric, curvilinear designs. Her inspirations for these designs came primarily from encounters with sherds of ancient pottery on old Hopi sites, including the First Mesa site Sikyátki, which led to her work being described as 'Sikyátki Revival'. Nampeyo also incorporated Katsinam imagery, which carries sym-

Nampeyo, *Polacca polychrome water jar,* c.1895–1900

bolic meanings, in her work (Katsinam were mediators between Pueblo people and the spirit world). Her *Polacca polychrome water jar*, c.1895–1900, for instance, has four different Katsinam symbols.

Suffering from vision problems for much of her life, in the end Nampeyo lost her sight entirely. Assisted by her three daughters who painted her pottery, she passed down her innovative, pioneering approaches to her descendants, who are today continuing her legacy. Housed in museums all over the world, Nampeyo's work has been appreciated by millions and has influenced numerous other artists who have appreciated her bold approach to design.

WORKING IN THREE DIMENSIONS: MARBLE

During this century, the impact of Neoclassicism – as discussed in the previous chapter – spread across the Atlantic to North America, spanning architecture and literature, music and sculpture. A group of American artists, in particular, excelled in the style with their spectacular marble creations.

So far, we haven't encountered any sculptors working in marble, in part because the medium often requires hard physical labour, prior anatomical training, and a high price point for materials, meaning it was mostly limited to men. But in the mid-nineteenth century, a group of female American sculptors who had travelled to and worked in Rome began to construct medallions, busts and life-size figures full of expression and charm. (In 1903, Henry James was to refer to them as the 'white marmorean flock'.) Harriet Goodhue Hosmer, Emma Stebbins, Margaret Foley, Anne Whitney and Edmonia Lewis each represented a unique Neoclassical aesthetic drawing on both contemporary and Classical subjects. While they all have advanced technical ability, a prominent member of the group was the great Edmonia Lewis (1844–1907), the first sculptor of African American heritage (of any gender) to achieve such fame and recognition. Her stunningly chiselled marble busts and figurative sculptures – with their elegantly coiled hair, elastic-like folds of drapery, idealised nudes with strong, robust builds – present exceptional realism and

Edmonia Lewis,
Forever Free, 1867

character. At a time of great societal change, they also showed vital political narratives.

Lewis was born to a Chippewa Indian mother (who nicknamed her 'Wildfire') and a father of African descent in Greenbush, New York. Orphaned at the age of nine, Lewis was encouraged to study by her older brother, Samuel, who funded her schooling at Oberlin College in the abolitionist town in Ohio. Enrolling in 1859, she studied Latin and Greek and experimented with drawing. Although popular among her peers, she faced racial discrimination, such as an instance when she was wrongly accused of stealing from her white roommates. Leaving Oberlin early in 1863, Lewis headed east for Boston, where she was to thrive as a sculptor.

Part of Boston's progressive abolitionist circle (an early mentor was Frederick Douglass), and witness to the city's monumental Neoclassical sculptures (which no doubt fuelled her artistic pursuits), Lewis was welcomed with open arms and briefly trained under a local sculptor. But it was her stone bust of a local abolitionist which earned her enough money to travel to Europe – a decision made in part to escape the racial prejudice of America. She later told *The New York Times* in 1878: 'The land of liberty had no room for a coloured sculptor.' Arriving by boat in 1865, Lewis soon made her

way to Rome. Here, inspired by the triumphant character of the Eternal City, she established a studio, experimented with marble, and developed her distinct Neoclassical style.

Most impressive among Lewis's early sculptures is *Forever Free*, 1867, referencing the Emancipation Proclamation of four years previously. Originally titled *The Morning of Liberty*, this smaller-than-life-size, yet weighty and mighty statuette immortalises an empowered, freed African American couple. Muscular and heroic, on the right we see a Herculean male figure breaking from his chains and raising a clenched fist. He is protecting the figure on the left, an elegant Freedwoman who kneels in prayer (protection being an important symbol of the Emancipation Proclamation). Her eyes are wide, her expression hopeful, as if she is looking towards a promising future.

Fusing African American narratives with the glorification of Neoclassicism, Lewis broke ground for a new type of subject matter and would go on to be a major influence for artists just decades later working in the Harlem Renaissance, in particular Meta Vaux Warrick Fuller (p. 196).

PICTURES OF THE FLOATING WORLD

Over in Japan, the Edo period (1603–1868) was booming: a flourishing consumer culture where beautiful images were in high demand, from large-scale scroll paintings to woodblock prints and illustrated books. A variety of genres were popular in the period, most notably *Kano-school* painting, (moralistic and didactic Chinese themes typically reserved for the ruling elite), *literati painting* (landscapes of the mind and nature painting), and *ukiyo-e*: 'images of the floating world'. Popular with the merchant classes, *ukiyo-e* could be anything from hand-painted works on silk or paper to printed books, showing everyday scenes, such as entertainment, landscapes or courtesans working in the brothel quarters.

In the nineteenth century, the great Katsushika Ōi (*c.*1800–*c.*1866) was earning a great deal of recognition. Brought up in her father's

workshop immersed in *ukiyo-e* paintings and print designs, Ōi displayed talents from an early age, and due to her circumstances she was able to fulfil her potential and pursue a prosperous, professional and independent career. Marrying and then divorcing (on the grounds, it was rumoured, that her husband's painting was not up to standard), Ōi returned to her father's studio, and no doubt got straight back to work.

In the style of East Asian painting, Ōi's calligraphic, intricate, sinuous lines are drawn with technical brilliance. She was a master at creating stark contrasts of light and dark shadows, and her use of glowing, saturated colour together with the exquisite shading in her folded robes is breathtaking. She was known to refer to a secret recipe for her innovative use of pigments, which saw her (as she recalled in a letter to a student) 'bury the material in the ground for around sixty days' in order to achieve dazzling hues. But her bold subject matter also reveals a great skill for storytelling and, in particular, women-led narratives shown through a distinctly female lens.

This skill is evident in the dramatic and highly atmospheric *Display Room in Yoshiwara at Night*, 1840s. Showing courtesans trapped behind barred windows in the glare of a huge light, the scene exudes melancholy. You could read into it Ōi's sympathy for the working women via the onlookers who, cloaked in the dark shadows of their lamps, eerily spy into the room.

Many of Ōi's images of women feel poignant and personal, in particular the exquisite *Girl Composing a Poem under the Cherry*

Katsushika Ōi,
*Display Room
in Yoshiwara
at Night*, 1840s

Katsushika Ōi,
*Girl Composing a Poem
under the Cherry Blossoms
in the Night, c.*1850

Blossoms in the Night, c.1850. Beneath a swirling, starry night sky, surrounded by a rich texture of cherry trees, and lit by the glow of a lantern, a woman is shown perhaps composing a poem, writing a letter, or drawing a picture. But the unusual (and no doubt uncomfortable) place for such an activity raises the question, could she be performing this in secret? – as she strides out into the shadows of the night sky where nobody will find her. Although we can only speculate, the work reminds me of the limitations faced by women writers and artists, not just in Japan, but also across the globe.

Following the death of her father, Ōi's life fell into obscurity – not even her death was recorded. Perhaps she was always dependent on him, but another, unsurprising reason might be that she was the daughter of the most important Japanese *ukiyo-e* artist in history, Hokusai, famed for his remarkable print design *Under the Wave off Kanagawa*, 1831, nicknamed 'The Great Wave': she was being viewed in his shadow. Ōi was Hokusai's foremost collaborator and assistant (he greatly admired her). Nevertheless, observing the masterful control of line and fineness of pigment that continued to characterise Hokusai's later paintings (which became enormously influential for European artists from 1870 onwards), scholars are now debating just how much help she did provide towards the end of his life.

BOTANICAL PHOTOGRAPHY AND SCIENTIFIC THOUGHT

In 1843, the British artist, floral illustrator and collector Anna Atkins (1799–1871) broke new ground. She was to self-publish the first ever book featuring photographic images. In *British Algae: Cyanotype Impressions*, 1843, Atkins used the photographic process known as 'Cyanotype' to produce her distinctively dark, blue-toned images: a technique achieved by fusing chemicals and applying them to photo-sensitive paper in a darkened room, placing an item on top of the paper, and exposing it to light. In doing so, she accomplished almost otherworldly, effervescent, detailed and to-scale representations of botanical ferns and seaweeds that dance off the page with their

Anna Atkins, *Dictyota dichotoma, in the young state and in fruit,*
from *Photographs of British Algae: Cyanotype Impressions (Part XI)*, c.1843–c.1853

lyrical and elegant stems. To me, they feel equally ancient and futuristic, and give an illusion of something growing deep underwater.

A trained botanist, raised by her father of the same profession, prior to her photographic book, Atkins had been a prolific illustrator and published over 250 drawings of shells. Despite her innovations – and the 6,000 or so Cyanotypes of flora and fauna she left behind – Atkins was largely ignored after her death, until 1985 when her name resurfaced thanks to a reissuing of *British Algae: Cyanotype Impressions*.

VICTORIAN BRITAIN: THE PRE-RAPHAELITES AND THE GLASGOW STYLE

'I have a talent and the constant impulse to employ it,
for the love of it and the longing to work … and no
man has a right to say that that is to be unheeded'
— Joanna Boyce Wells, 1857

In Britain, the second half of the nineteenth century was rife with artistic activity. The art market was expanding internationally, aided by the rise of technology and illustrated press prints, engravings and, later, photographic reproductions. The increase of independent art dealers and critics, too, began to shape tastes and movements. So emerged a whole range of schools with different social and political outlooks. But the greatest changes were the growing freedoms for women, who protested for their rightful access to art education and won.

This was challenging male and female roles, especially among the bourgeoisie, all the more since the most prominent art critic, John Ruskin, had proclaimed: 'The man's power is active, progressive, defensive. He is eminently the doer, creator, the discoverer. His intellect is for invention and speculation. But the woman's intellect is not for invention or creation.' Such an attitude made it difficult for British women to be taken seriously as professional artists. Taking matters into their own hands, they founded organisations, and at the

Emily Mary Osborn, *Nameless and Friendless*, 1857

dawn of the suffrage movement, slowly began to transform women's role in British society.

A great campaigner for women's suffrage, Emily Mary Osborn (1828–1925) used her paintings to critique the constant setbacks experienced by women, as evident in *Nameless and Friendless*, 1857. This is a painting centred on a Victorian woman who seems lost as she stands helplessly in an art dealer's shop. It is set up as a theatrical scene – rain pours beyond the back windows; the two men on the left gaze at her with a sinister look – and the woman appears unwelcomed by the dealer who patronisingly inspects her picture. His judgemental expression affirms her lowly status in a male-dominated society and any possibility of taking her seriously as a professional. For a twenty-first century audience, this provides an insight into life as a Victorian woman by speaking to the injustices of the time.

By the end of the century, much had changed. The establishment of the Slade Art School in the 1870s offered opportunities to female

students on an equal basis to men. And after a petition in 1859 demanding the admittance of women artists as students to the prestigious Royal Academy of Arts (with Laura Herford admitted in 1860), by 1893, women were finally welcome in the life room.

In mid-nineteenth-century Britain, a revolutionary group of artists emerged. Loosely referred to as Pre-Raphaelites, the group rebelled against the slick academic aesthetic and indulged in startling colours and romantic, jewel-like imagery. Mostly rejecting the increasingly conservative values of Victorian bourgeois society, they looked to alternative sources for inspiration: medieval art (pre-Raphael) and modern art, great literature (Petrarch, Dante) and the Romantic poets (Keats, Wordsworth). They aimed to take art back to a time when its concerns were classicism, literature, poetry and scripture.

Going against the era's conventions of female beauty, artists of different sexes favoured as their subjects ethereal women with strong, striking features and long willowy hair (symbolising 'free love', counteracting social morals). At the time, the images were criticised as 'grotesque' and 'confrontational', but looking back now, they couldn't appear more modern.

Although it is often referred to as the 'Pre-Raphaelite Brotherhood' (the group was initially founded by seven male poets in 1848), women played an active role within it. Not only did they sit for painters, influencing the male artists' imagery through their unique physical appearances, but they, too, were ambitious and professional artists. Aware of their oppression in society, and of the passivity of their poses in the work of men, they often chose strong heroines of the past as their subjects, and depicted women as symbols of strength, humility and intellect.

Elizabeth Siddal (1829–62) was an accomplished artist. Famed for modelling for John Everett Millais's *Ophelia*, 1851–2 (when she almost died posing in a tin bath of ice-cold water), and as *Beata Beatrix*, 1864–70, for her husband, Dante Gabriel Rossetti, who posthumously immortalised her in a haunting, transcendental glow, she was, in fact, full of determination. A world away from the victim-like, blank-faced passive person documented by her male peers.

Joanna Boyce Wells,
Elgiva, 1855

Born into a working-class family, Siddal, fascinated by poetry since her youth, accessed the group via modelling. Beginning her artistic pursuits in 1852, she was mostly self-taught bar some training from Rossetti, who instilled in her his love of Gothic forms and medieval subjects. Drawing influence from historic and contemporary poetry, Siddal's watercolours often featured dreamlike, romantic, chivalrous scenes. But, after suffering from depression, she died, aged thirty-two, from an overdose of laudanum. She had only exhibited twice. Although Rossetti buried her with a book of his poems, six years after her death he requested for it to be exhumed from her grave.

A friend and contemporary of Siddal, Joanna Boyce Wells (1831–61) was the most ambitious woman in the group. Born to a wealthy father, who financed and encouraged her training in Paris (her mother was less keen), unlike so many women, Boyce Wells was able to study anatomy, perspective and the nude from life, thanks to

private tutoring. Sometimes considered 'too good' by the group, Boyce Wells was a master at capturing her subjects' sculptural, three-dimensional physicality and inner psychological depth, as seen in *Elgiva*, 1855, a serene and sublime painting of the tragic Anglo-Saxon heroine. This was met with great praise when exhibited at London's Royal Academy of Arts, John Ruskin, no less, aptly describing Elgiva's expression as 'so subtle, so tenderly wrought'.

Although the Pre-Raphaelites are known for painting gaunt women with porcelain-like skin and long flowing hair, I want to spotlight Fanny Eaton (1835–1924), one of the most favoured and influential artist's models of the era (as depicted by Boyce Wells in a dignified portrait, *Study of Fanny Eaton*, 1861). Born a freewoman in Jamaica, one year after slavery was finally abolished in the British colonies, Eaton arrived in London in 1851. In 1860, she began her career as an artist's model, and was painted by numerous members

Joanna Boyce Wells,
*Study of Fanny
Eaton*, 1861

Julia Margaret Cameron,
Mnemosyne, 1868

of the group, who captured her composure and beautiful high cheekbones. Boyce Wells's study portrays her with humility, intimacy and psychological intensity. Like Elgiva, Eaton appears deep in thought. Turned to the side, she stands cloaked in a Grecian-style robe, wearing sparkling pearl earrings and a thin turquoise headband. This was intended as a study for a much larger unrealised painting, but it was to be Boyce Wells's last work, before her early death due to childbirth complications.

Working slightly later, the Anglo-Greek Marie Spartali Stillman (1844–1927) began her association with the Pre-Raphaelites as a model in the 1860s. The trailblazing photographer Julia Margaret Cameron (1815–79) captured her as a range of fictional subjects in a soft-focus lens, in line with the painterly aesthetics of her Pre-Raphaelite contemporaries, such as *Mnemosyne*, 1868. Set against

verdant backdrops, wearing floral headdresses, with long sweeping hair, Spartali Stillman was photographed in portraits which feel so fresh, so modern, they could have been taken today.

First working a camera at the age of forty-eight, Cameron became one of the medium's pioneers, and was instrumental in the development of portrait photography. (She brought to it a relaxed informality and intimacy, evidenced by her subjects' expressions or the visible lines on their faces, whereas before figures often appeared stiff due to the subjects having to stand still for long periods of time.) Recording the intellectual elite in her distinct sepia glow, Cameron photographed Alice Liddell (credited as the inspiration for Lewis Carroll's *Alice in Wonderland*) and Cameron's niece Julia Stephen (mother to Virginia Woolf and Vanessa Bell, p. 140).

Stillman herself enjoyed a prosperous career, travelling extensively, selling her art successfully and exhibiting internationally. Referencing medieval poetry and mythological subjects, she used watercolours to achieve her luminous surfaces and intricate details of robes and embroidery. Appearing to challenge the role of 'women-as-object', the female characters in Stillman's watercolours are actively engaged: writing, reading or playing instruments, perhaps to highlight the talents in which women excelled.

Due to their generally wealthy backgrounds, most women in this chapter received private tutoring. Let us now turn our attention to one of the first (and finest) examples of a woman who, working towards the end of the century, benefited from state-funded education.

On the eve of her seventeenth birthday, Evelyn de Morgan (1855–1919) wrote in her diary: 'seventeen years wasted in eating, dawdling and frittering time away ... Art is eternal, but life is short ... I will make up for it now, I have not a moment to lose.'

Rebelling against her parents' wishes and determined to be an artist, de Morgan enrolled at London's Slade School, one of their first ever female pupils. (Around this time, she also consciously swapped her first name, Mary, in favour of her more gender-ambiguous middle name, Evelyn.) To be admitted to the Slade on an equal footing with her male counterparts proved a revolutionary

Marie Spartali Stillman, *The Enchanted Garden of Messer Ansaldo*, 1899

opportunity. For the first time, women in England were given access to free and comprehensive art education, including, most significantly, access to the life room (albeit with a curfew of 5 p.m.!). Praised for her studies of the nude (for which she was awarded prizes ahead of many of her male classmates), de Morgan had an astonishing way of depicting muscularity. Full of rigour and anatomical accuracy, she portrays rippling drapery with such sumptuousness that it glides seamlessly over her figures in an almost breathable manner. To achieve this, she drew studies of the same life poses with and without drapery. An active pacifist, feminist and campaigner for women's rights, having put her name to the Declaration in Favour of Women's Suffrage of 1889, de Morgan imbued her work with deep political meaning.

Considered one of her most impressive paintings, *Night and Sleep*, 1878, is an exuberantly rich and colourful work full of hidden feminist symbolism. Closely referencing Zephyr and Cloris from

Evelyn de Morgan, *Night and Sleep*, 1878

Sandro Botticelli's *Birth of Venus*, 1485–6, her figures are surrounded by flowers (symbolic of 'birth' or 'regeneration'). However, in *Night and Sleep*, de Morgan includes poppies, a popular Victorian sleeping remedy. Floating through an evening's sky, the intertwined figures wrap a dusky cloak over themselves. Although the scene evokes the imminence of sleep, we could also interpret it as entering a new dawn, where the figure will awake to a world of equal gender rights, ready, like de Morgan, to make their mark.

As the century progressed, the Pre-Raphaelites continued to weave signs and symbols into their work (poppies, daisies, violets, canaries). Increasingly interested in the subconscious and the supernatural, artists began looking to different sets of ideas. So emerged Symbolism (moving away from the literal) and Aestheticism (celebrating beauty and art for art's sake). Whilst the Pre-Raphaelites pursued these ideas in paint, Symbolism also became popular in literature and the applied arts.

This further coincided with artists beginning to abandon the hierarchies between artforms (embroidery, painting, architecture, sculpture, design) and embracing their unity – and the concept of creating a *Gesamtkunstwerk* (a 'total work of art'). Although not as prominently recognised in art history as the Pre-Raphaelites, a group of Scottish artists associated with the Glasgow School of Art were just as pioneering, spearheading alternative ideas, which today seem more radical than ever. Foremost among them were sisters Margaret Macdonald Mackintosh (1864–1933) and Frances Macdonald (1873–1921). The Glasgow Style, as it was known, incorporated the values and utopian ideas of the Arts and Crafts Movement, and shared stylistic similarities with Art Nouveau and Symbolism, moving away from conventional representation and favouring bold, sinuous lines and elongated, distorted figures. Drawing their inspiration from natural forms, illuminated manuscripts, Japanese woodblock prints and Celtic pagan art, these artists worked in myriad media: painting, architecture, furniture, metalwork, woodwork and stained glass. Around seventy-five of them are associated with the Glasgow School (including Jessie M. King (1875–1949), who designed wallpaper, jewellery, bookplates and textiles), but it

was the 'The Glasgow Four' who accelerated the new style: the Macdonald sisters and their husbands.

Frances and Margaret were formidable pioneers. Upon moving to Glasgow in 1890, they were among the first women ever admitted to the Glasgow School of Art (a school prized for promoting experimentation and for encouraging women to develop their artistic education, exhibit and teach). Following their studies, the sisters established a studio on Hope Street, collaborating across all the arts (Margaret took the lead in gesso, and Frances was skilled in embroidery and metalwork).

Lauded by artists and architects all over Europe, The Four's reputation was cemented after they created the interior of the 'Scottish Rooms' for the Eighth Vienna Secession Exhibition in 1900. They were praised for their *Gesamtkunstwerk* approach, and Macdonald Mackintosh's giant gesso frieze, *The May Queen*, 1900, a panel of five exquisite female figures rendered from strikingly

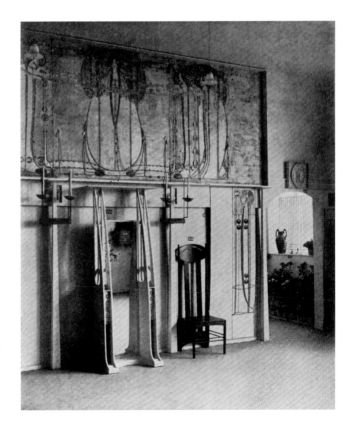

Margaret Macdonald Mackintosh, *The May Queen*, 1900 (the frieze in the top part of the wall); photograph of Secession Exhibition, Vienna, 1900

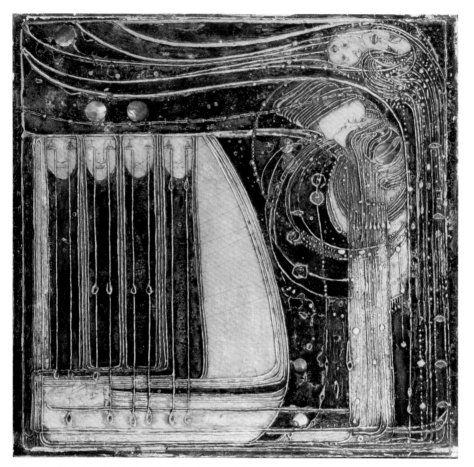

Margaret Macdonald Mackintosh, *The Opera of the Sea*, 1902

dynamic curvilinear lines, greatly impressed. Tapping into the zeitgeist of the Viennese *fin de siècle*, with subtle three-dimensional elements swept up in architectural form, it is thought artist Gustav Klimt was fascinated when he saw *The May Queen* (and the room at large), and that this influenced his *Beethoven Frieze* (exhibited at the Secession in 1902).

The clearest evidence of Macdonald Mackintosh's influence, however, was that she and her architect husband, Charles Rennie Mackintosh, were invited back for a further commission at Fritz Waerndorfer's Viennese villa in 1902. To adorn the piano in Waerndorfer's music room, she created a pair of shimmering inlaid gesso

panels, *The Opera of the Wind* and *The Opera of the* Sea, 1902. With
its glittering surfaces and elegant figures, *The Opera of the Sea* bears
striking similarities with Klimt's famous *The Kiss*, 1907, made five
years later. Klimt would have seen these works (Waerndorfer was a
prominent collector of his) – and yet . . . has Macdonald Mackin-
tosh's name ever been mentioned in reference to Klimt?

Recognition for their art didn't sustain The Four, however.
Despite successfully exhibiting internationally, within a couple of
years they stopped working as a group. Frances and her husband,
Herbert McNair, relocated to Liverpool in 1899, and although they
returned to Glasgow in 1908, the sisters drifted apart. Known for
her melancholic, mystical watercolours of women (which may or
may not have been rooted in autobiography), Frances continued
to exhibit widely, yet not much is known about her or her art after
1912. Up until then, her work had explored tensions in relation-
ships. Our lack of knowledge about her later years is due in part
to McNair, whose own artistic career faded, and who destroyed
much of Frances's work following her death (a suspected suicide)
in 1921.

Margaret's career continued to thrive in the early 1900s. Collab-
orating with her husband (who wrote to her, 'You are half if not
three-quarters in all my architectural work') and providing meticu-
lous gesso panels for his buildings (and no doubt a whole lot more),
she also carried on working in other media, such as watercolours.
But after 1909, suffering from poor health, she produced very little.

Despite the lack of attention the Glasgow School is afforded
in art museums and books today, Glasgow's impact on European
art was vast. Propelling a new creativity, a modern identity, and
merging artistic forms, the Macdonald sisters were central to the
development of the avant-garde. But in the wake of the First World
War, the rise of Post-Impressionism in Britain and of the Bauhaus
in Germany, the Glasgow Style declined in popularity, eventually
falling out of favour.

SPIRITUALISM

Running concurrently with all these artistic movements was Spiritualism, which, it is thought, foreshadowed modernism more than any other in Western art. Too often dismissed by the artistic establishment, Spiritualist artists sought alternative inspirations and developed a language that was unique. Undoubtedly, they were ahead of their time, and today they are proving to be more influential and popular than ever.

From the mid-1800s through to the early twentieth century, when established religions were being challenged and great advances were being made in science, artists became progressively captivated by Spiritualism. Emerging in the wake of the American Civil War, Spiritualism offered those coping with the emotional fallout incurred by the carnage an alternative set of religious ideas, promising them direct access to and communication with the dead. Led by the Fox sisters in 1848 in upstate New York, Spiritualism concerned a largely female community. Aligning themselves with the women's suffrage and the abolitionist movements (the sisters claimed these ideas had come from 'higher powers'), the women involved in this community were granted some of the few opportunities in Western history to speak out in public and take on authoritative roles.

In the 1850s, following visits from American 'mediums' (communicators between the living and the dead) who conducted 'séances' (the act of communicating with spirits), Spiritualism became enormously popular in Britain. Mediums performed both publicly and in the home, transmitting messages from their spirits by table rapping, knocking, or creating 'automatic' drawings. Influenced by the semi-unconscious state through which mediums were guided by spirits, artists started to use séances as a new method of creating art (they are often referred to as 'Mediumistic' artists). Famous among them were Georgiana Houghton (1814–84) and Hilma af Klint (1862–1944), who were guided by spirits as they drew perspective-free swathes and spirals of colour, often accom-

Georgiana Houghton, *Glory be to God, c.*1860/70

panied by text decoding their symbolism. Remarkably, this kind of
proto-abstract work now seems prescient of the developments
in early twentieth-century mainstream Western art, such as the
birth of abstraction (not to mention the Surrealists' interest in and
deep fascination with automatism).

One of the earliest artists to work under the influence of her spirit
guide in Victorian London, Georgiana Houghton produced ink and
watercolour drawings brimming with multilayered, scroll-like
shapes and symbols. Like other Mediumistic artists, Houghton came
to Spiritualism following the death of a close family member, her
youngest sister, Zilla Rosalia. Although she was traditionally trained,
Houghton began drawing through séances from the early 1860s,
using a 'planchette' (a round wooden board fitted with a pencil-
holder), to achieve her distinctively fluid lines.

Similarly to af Klint, working just decades later, Houghton
provided explanations to accompany her work. For *Flower of Zilla
Warren,* 1861, Houghton stated that blue signifies the 'love she had
for her family', and yellow 'represents her actions'. In earlier draw-

ings her shapes evoked naturalistic, plant-like forms, but as the 1860s progressed, she began to incorporate faces, and later migrated to extreme flurries of thin, dense swirls that vigorously and elegantly sped round the page.

In the summer of 1871, at the height of her production and working mostly in private, Houghton self-funded an ambitious exhibition, *Spirit Drawings in Water Colours*. Held at a gallery on Old Bond Street, London, it featured 155 of her A4-sized drawings (and was even attended by one of the Fox sisters). Determined to explain her method (these drawings would have been unlike anything seen in Victorian England – figuration was all the rage), Houghton produced a catalogue (plus a pink satin 'special edition' for Queen Victoria), and was always on-site to explain her work. Unfortunately (she was clearly too ahead of her time), the show was largely misunderstood. Although the *Era* newspaper referred to it as 'astonishing', the *Examiner* was scathing: 'We should not have called attention to this exhibition at all, did we not believe that it will disgust all sober people with the follies which it is intended to advance and promote.' Houghton was left nearly bankrupt, and never exhibited again during her lifetime. It took until 2016 for her next major solo exhibition to take place – to ecstatic reviews – at the Courtauld in London.

In 1879, after an English medium, William Eglinton, conducted a series of well-publicised lectures on the subject in Stockholm, interest in Spiritualism in Sweden surged. The year 1875 had marked the birth of the Theosophical Society, a strand of Spiritualism founded by Madame Blavatsky, who introduced Indian and Chinese philosophies, such as reincarnation, to the Western world. These philosophies had a profound effect on the then little-known Swedish artist Hilma af Klint.

Growing up in a scientific household, af Klint was known as a 'particularly perceptive' child. The Eglinton lectures on Spiritualism, which she had attended, inspired her to practise séances, but her interest in Spiritualism truly ignited following the death of her younger sister in 1880. However, it wasn't until the 1890s that she began incorporating Spiritualism into her art.

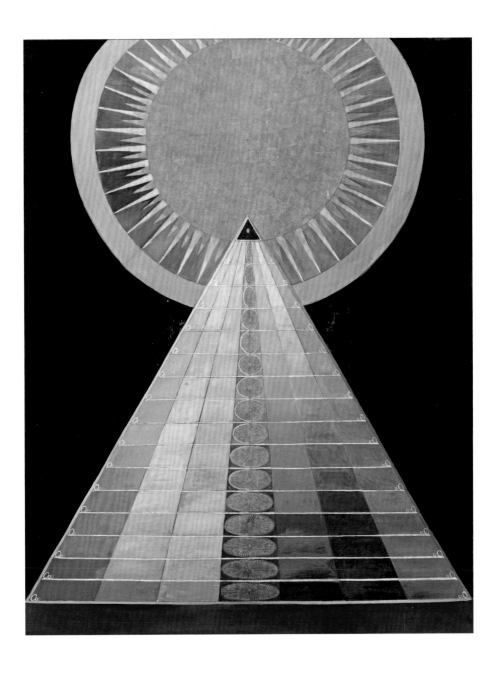

Hilma af Klint, *Group X, No. 1, Altarpiece*, from *Altarpieces*, 1915

Part of the second generation of women students admitted to the Royal Academy of Fine Arts in Stockholm during the 1880s (a traditional and male-dominated establishment), she studied drawing, and portrait and landscape painting. This was thought to be the only kind of art she made until her death decades later in 1944.

After meeting in secret with four other female artists, collectively known as 'The Five', it turned out that af Klint's work had undergone a transformation. Gathering in structured group séances from 1896, where they set up altar-like spaces, meditated and prayed, The Five recorded visions of spirits who guided their hands through flurries of automatic drawing and writing. But in 1906, af Klint was contacted by a spirit known as Amaliel for 'a great commission' to 'convey humanity the matters of the spiritual realm'. (Later, in the 1930s, she would be asked to assist in designing a 'spiral-like temple', a space uncannily similar to the Guggenheim building in New York, the site of af Klint's posthumous exhibition in 2018!) Warned off the project by The Five, who feared that too much 'close contact with such spirits could end up in madness', af Klint nevertheless took it on on her own, creating her monumental series *The Paintings for the Temple*, 1906–15.

Produced several years prior to the work of abstraction's 'founding fathers' Vassily Kandinsky and Kazimir Malevich, af Klint's paintings consist of interlocking, organic forms, circles, spirals and lettering, and are executed in luminous colouring. (Like Houghton, af Klint, too, imbued her colours with symbolism; blue representing the feminine, and yellow the masculine.) Between 1906 and 1908, she turned out an astonishing 111 paintings, with ten reaching over three-metres high (seen in the flesh, they evoke a sense of almost divine-like communication). She then took a four-year break from painting, resuming in 1912 to complete *The Paintings for the Temple* series (amounting to 193 paintings in total).

As she had never displayed her work in public (bar two known exhibitions, one in London at the Quaker Friends House and the other at the Theosophical Society in Stockholm), when af Klint died, the general consensus was that she was simply a landscape and portrait painter. In reality, she had completed over 1,300 works and left

behind 30,000 pages of notebooks. Respecting her instructions that they should not be seen for at least twenty years after her death, for fear that they would not be understood, the paintings remained in the hands of her family until 1986 when they were shown in a landmark exhibition, *The Spiritual in Art: Abstract Painting 1890–1985*, in Los Angeles. A show which reframed abstraction – challenging the modernist canon – and for the very first time, placed af Klint on the international artistic map.

The first major touring exhibition of her work, starting at the Moderna Museet in Stockholm, wasn't until 2013. It was soon followed by her first ever US solo exhibition, *Paintings for the Future*, at the Guggenheim (2018–19), which broke attendance records in the history of the museum. Not only did the exhibition explore ideas suggesting that we, in the twenty-first century, are very much the perfect viewers for af Klint's work, but it also celebrated her art as a precursor to – and pioneer of – modernism. Her emotive – almost diagrammatic – canvases, impregnated with geometric, biomorphic and cosmological shapes collapsing into each other, visually present to us the interconnectivity between humanity and the universe.

PART TWO

WHAT MADE
ART MODERN

c.1870–c.1950

THE PARTICIPATION OF WOMEN ARTISTS

'The woman artist is an ignored, little-understood force, delayed
in its rise! A social prejudice of sorts weighs upon her; and yet,
every year, the number of women who dedicate themselves to art
is swelling with fearsome speed' — Hélène Bertaux, 1881

Striding into modernity, Paris at the end of the nineteenth century
was a place of radical development. Transformed by architect
Haussmann's spectacular renovation (known as 'Haussmannisa-
tion'), streets were enlarged to become sprawling boulevards, and
cafés, parks and exhibition spaces sprang up all over the city. A new
artistic capital of the Western world had emerged. This followed a
time of extensive social change, brought about by the 1848 French
Revolution, the Franco-Prussian War and the emergence of the
Third Republic in 1870.

At the dawn of a new century – a new world – rapid advance-
ments in both industry and technology gave artists access to
innovative materials, train travel, non-Western art influences,
photography and the moving picture. Society was in a state of flux,
which inevitably called for a different type of art. We begin this
part with the Impressionists, a group working at the very end of the
nineteenth century – with (slightly more) forward-thinking attitudes
towards women – which ushered in a new artistic era and paved
the way for what was to be considered 'modern' art.

What does modern art mean, anyway? A break from the past, the
eradication of hierarchies, lines shattered on a canvas, scenes of
everyday subjects in modern society? Yes, you could say all those
things, but what makes modern art 'modern', as art historian Diane
Radycki argues, is the participation of women artists. No longer
always confined to working in a traditional social and artistic realm,
under the guard of or dependent upon men, they turned their gaze
onto themselves, claimed spaces of their own (and their earnings,

too), embraced sexual freedoms and, looking to the outside world, expressed how they saw this as they never had before.

Paris, as we will see, went on to play a huge role in the development of the avant-garde, providing an environment in which artists experimenting with new methods and media could flourish and give birth to modern artistic styles and movements. Despite not following an entirely linear trajectory, in this section we will cover the period up to the Second World War, a time that saw a shift from representation to full abstraction in and beyond Paris – across Europe, India and the Americas – and, with some artists, the embracement of all artforms as 'high art'. We will also explore the work of the artists who tried to make sense of the political events they witnessed, and those working beyond the confines of traditional mainstream establishments.

Chapter Four

WAR, IDENTITY AND THE PARIS AVANT-GARDE

c.1870—c.1940

IMPRESSIONISM

'I don't think there has ever been a man who treated a woman
as an equal and that's all I would have asked for – I know I am
worth as much as they' — Berthe Morisot, 1890

Departing from the traditions of the Salon and slick academic aesthetics, the artists who came to be known as the Impressionists emerged in Paris in 1874. They launched themselves with a radical exhibition that shook the art establishment to its core. Staging their shows independently and hosting them in alternative spaces to the Salons – the first was a former photography studio – the artists devised a style that was so revolutionary it is impossible to consider anything that came after without it.

With the advent of the railway and industrialisation evolving around them at speed, the Impressionists strived to capture an ephemeral 'impression' of something as opposed to a static, fixed image. They rejected the hierarchies of history painting, working on smaller scales and dealing with subjects from contemporary life. Favouring the bustling Parisian outdoor culture (often painting *en plein air*, in other words, 'outside' – aided by the recent invention of paint tubes, which no longer restricted artists to the studio), they broke the illusions of reality that had come before, using flickers and shards of light-filled colour to convey the pace of life in a new and exciting world.

Impressionism proved to be a movement that was both advantageous and limiting for women. In the 1870s, artistic education was still restricted to those who could afford private tutorage, and social custom continued to prevent bourgeois women from wandering the streets unaccompanied. Men, on the other hand, could frequent bars and cafés, travel afar and paint whatever and wherever they wished. These locations became some of their key subjects and places where formative meetings were held – Café Guerbois and

Café Nouvelle-Athènes in Montmartre were favourites. Female Impressionists were otherwise confined to drawing on their personal experiences and perspectives in private boudoirs and the domestic sphere. One artist who took full advantage of these settings was Berthe Morisot (1841–95).

Making use of her access to upper-class women, Morisot captured vividly and intimately their private worlds, lamenting their lack of independence but also celebrating their small freedoms. The only female participant in the first 1874 Impressionist exhibition, Morisot enjoyed a flourishing career and showed her work in all but one of their eight exhibitions between 1874 and 1886 (her only absence due to illness following the birth of her daughter). She was praised for her quick, feathery, at times rough, brushstrokes as well as for her subjects, which ranged from family life to the fashionable bourgeoisie. One of her finest examples of the latter is, I think, *Reclining Woman in Grey*, 1879, an unfinished-looking canvas with raw, bare edges acting to draw us into a sea of almost uncontrollable white and silvery splinter-like shapes. Although we meet this woman in an interior scene, the warmth and radiance of her lively expression hints at the increasing confidence and independence of a modern woman. The speed of Morisot's brushstrokes, too, replicate the pace of modernity – as if we were catching the subject in a fleeting world.

Born into an upper-middle-class Parisian family, Morisot, along with her sister Edma, showed great artistic skill from an early age, and they were encouraged by their parents, who hired the foremost tutors for them. One tutor, stunned (and shocked) by the sisters' talent, reported: 'Your daughters have such inclinations that my teaching will not give them merely the talent of pleasing; they will become painters. Do you know what this means? In your environment this will be a revolution if not a catastrophe.'

Desperate for further opportunities (and no doubt untroubled by the thought of an impending 'catastrophe'), the young women went on to be taught by some of the pre-eminent artists of the day (such as Camille Corot), and by 1864 had been accepted to exhibit at the prestigious Paris Salon. But despite her early successes, in 1869 Edma was forced to renounce her artistic pursuits for marriage. In

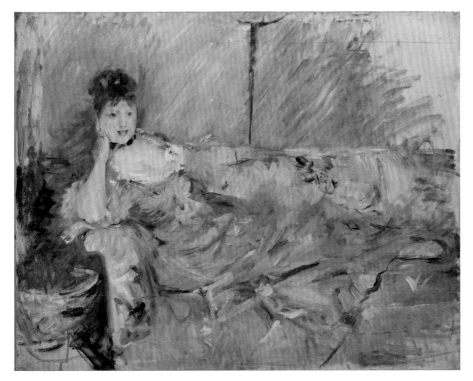

Berthe Morisot, *Reclining Woman in Grey*, 1879

The Artist's Sister at a Window, painted the same year, Morisot captures her sister's sadness at her predicament. Using an interior perspective, with figures conversing on balconies evident through the wide-open window, she not only draws attention to the societal boundaries that constrain her sister as a woman, but to her own role as an artist, too.

A few years later, Morisot launched her career at the inaugural Impressionist exhibition with another portrait of her sister, *The Cradle*, 1872. Critics dismissed the depiction of Edma and her newborn baby – calling it a 'sweet' painting of motherhood – but it is so much more than that. It is brimming with both tension and tenderness. Although Edma appears to be gazing lovingly at her child, her thoughtful stance – and the diagonal line that separates the two figures – seems to hint at the emotional complexities of being a mother (after all, she was forced to give up her art for this new life).

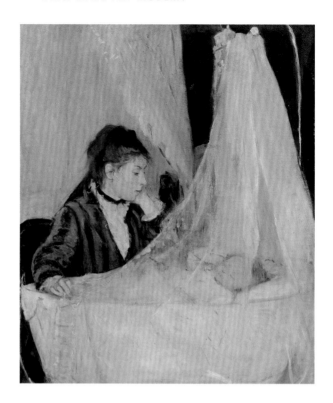

Berthe Morisot,
The Cradle, 1872

In contrast to stereotypical images of motherhood, Edma's fashionable choice of dress (a white ruffled shirt tucked into a striped blazer, and a black choker) suggests that she is still striving to live as a modern woman.

For the next decade, Morisot became fully immersed in Parisian life, selling her work through renowned dealer Paul Durand-Ruel, exhibiting with the Impressionists and pioneering a subject previously little explored: children portrayed by their mothers. She also continued to radicalise painting. During the 1880s, her brushwork loosened, as seen in *In the Garden at Maurecourt*, c.1884, revealing an oceanic way of painting with quick, colourful gestures that cave in on the scene (reminding me of Abstract Expressionist Joan Mitchell, p. 246). Constantly reinventing her style, Morisot veered towards Symbolism in the 1890s, before her life was cut short by pneumonia in 1895 – leaving us to wonder what she might have made had she lived to witness the first decades of the twentieth century.

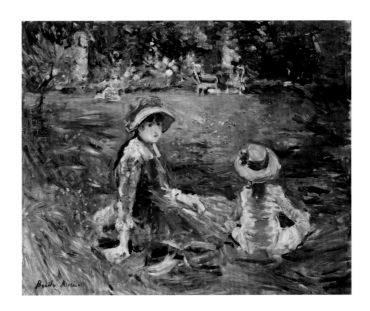

Berthe Morisot,
In the Garden at
Maurecourt, c.1884

The American-born artist Mary Cassatt (1844–1926) was the only non-European associated with the core Impressionists. Showing her work at four of the eight Impressionist exhibitions (the first in 1879), Cassatt was one of the group's leading figures. A Japanese print exhibition at the École des Beaux-Arts, which she attended in 1890, would prove a great influence on her art in its everyday subject matter, vibrant colours and flat-planed forms.

Fortunate in having a supportive mother who accompanied her on her trips to Europe and encouraged her to pursue an artistic career, Cassatt studied in Pennsylvania and arrived in Paris in 1866. Escaping to the French capital was popular among American women artists; the city offered them vast opportunities compared to the strictures of home. Out of the 1,000 or so American artists living there at that time, one-third were thought to be women.

Working in a distinctly loose, gestural style (one contemporary commentator noted her portraits were a 'symphony of colour'), Cassatt painted charming, intimate scenes featuring children and women of all ages caught in the moment: mothers teaching their daughters to read or sew; a pre-adolescent girl immersed in her book or gazing lovingly at her dog. Like Morisot, she gives us a

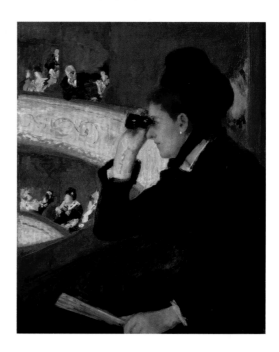

Mary Cassatt,
In the Loge, 1878

glimpse of the private worlds of women but, I find, in particular she emphasised women's intellect and learning.

She also challenged the idea of 'women-as-objects'. Her painting *In the Loge*, 1878, is set in the Paris Opera House, a venue which symbolised the height of society and one of the few places where it was acceptable for upper-class women to be seen out with friends and family. Cassatt switches up her version and turns her lens on the spectator. Illuminated by the glow of the central light, a Parisian woman dressed in smart black ruffles peers through a pair of binoculars. Although it may appear that she is in charge of the gaze, as she is facing away from us (the voyeurs), look again, and the top left-hand corner reveals another onlooker, also with binoculars. He leans across the balustrade with his sight firmly fixed on the woman in black. Ultimately, the message seems to be, woman is the spectacle: whichever way she looks, she is always controlled by a gaze.

Cassatt and Morisot were instrumental in the development of Impressionism, but their triumphs cannot be separated from the familial financial stability that allowed them the opportunity

to pursue such successful careers. Their contemporary Marie Bracquemond (1840–1916), on the other hand, was born into a working-class family, and would go on to depend on her engraver husband for income.

For the most part self-trained, Bracquemond nonetheless managed to exhibit at the Paris Salon when she was sixteen. From the late 1870s, she embraced styles and subjects synonymous with the Impressionists, often painting *en plein air*. A favourite painting of mine is *Trois femmes aux ombrelles* (*Three women with parasols*), 1880. Striding out into what seems like an early-spring day, in a scene saturated with shimmering colour, these three women feel liberated and untrammelled by societal restrictions, the outdoor setting reflecting their freedom. This is a work that celebrates the joy, independence and friendships of modern Parisian women, something Bracquemond no doubt would have longed for, constrained as she was by her domineering and demanding husband. He so detested her

Marie Braquemond,
*Trois femmes aux
ombrelles* (*Three women
with parasols*), 1880

Marie Bashkirtseff,
*Self-Portrait with
a Palette*, 1883

expressive style (despite her success at three Impressionist exhibitions) that he withdrew all emotional and financial support, resulting in Bracquemond, by 1890, giving up art entirely.

Towards the latter part of the century, the provision of art education for women was beginning to improve thanks to the unrelenting pressure applied by women artists. First, the alternative art schools (Académie Julian, est. 1868; Académie Colarossi, est. 1870) opened their previously male-only drawing sessions to women, and, by 1897, the renowned École des Beaux-Arts had, too. Despite this, access to the public realm still proved stifling to women, as is clear from the journal of Ukrainian-born painter Marie Bashkirtseff (1858–84):

> What I long for is the freedom of going about alone, of coming
> and going, of sitting on the seats in the Tuileries and especially
> in the Luxembourg, of stopping and looking at the artistic shops,
> of entering the churches and museums, of walking about the old
> streets at night; that's what I long for and that's the freedom
> without which one can't become a real artist.

Bashkirtseff's journal gives us an insight into the life of an ambitious woman at the end of the nineteenth century. Although she died

aged twenty-six, her *Self-Portrait with a Palette*, 1883, realised just one year earlier, shows us a young woman radiating determination. Bashkirtseff is gazing directly outwards – perhaps looking at us or at herself in a mirror, or at her canvas – and appears imbued with confidence, her palette covered in paint, as if she were about to conquer the work in front of her. She is forever immortalised as a serious and dedicated artist.

Change was afoot. Women now had access to the most prestigious schools of the day and, finally, the life room. The undeniable irony is that as soon as this happened, the most popular subjects depicted switched from momentous, grand historical scenes to images of daily life. Subjects that women had been painting for centuries.

In the years leading up to the twentieth century, sculpture also broke free of its Classical roots, pioneered by Camille Claudel (1864–1943). Sensual and erotic, with bodies dancing and entwined, Claudel's intensely passionate compositions pushed forth expression in sculpture.

Trained at the Académie Colarossi, Claudel went on to work as a studio assistant for Auguste Rodin, with whom she had a love affair. A remarkable work from this era is *The Waltz*, 1905. Full of desire, emotion, excitement and lust, it features a man and woman

Camille Claudel,
The Waltz, 1905

entangled in an all-encompassing dance. Tenderly embracing each other, they emerge from (or into) a sea or twisted flames, suggesting a love both uniting and fading, perhaps inspired by Claudel's muse – Rodin – and their tumultuous relationship.

Like so many women artists, Claudel has often been over-shadowed by her male lover. Despite her influence on Rodin, critics continued to position her as his follower. Her frustration at this injustice led to her distancing herself from him and taking her work in a new direction. However, following this departure, Rodin and his community cut her off, cementing her outcast status in a tight-knit art world. In 1913, she entered an asylum, where she remained until her death. Although her brother staged a posthumous exhibition of her work eight years after her death, it was derided and dismissed. Her work was not taken seriously again until after the feminist era of the 1970s.

A ROOM OF ONE'S OWN: SELF-PORTRAITURE

'Modern art attempts to represent the lives and reality
of those around us. If we were to observe carefully, we would
be able to see the beauty in ordinary things not typically
perceived as beautiful' — Georgette Chen, 1943

Before we get to the 'isms' of the avant-garde (Expressionism, Fauvism, Cubism, Orphism, Futurism, Constructivism), the so-called defining European styles of the early twentieth century, let us look at women artists working at a similar time who turned the gaze on to themselves and carved out careers independently of any male. What makes modernism modern is the participation of women artists, and the freedom with which they could paint. Travelling independently across America, Asia and Europe, often enlightened by the French Modernists, most claimed rooms of their own, and presented the self with new meaning.

A self-portrait can prove revelatory: it tells us how someone looks at themselves, what they want to project. Through this

Helene Schjerfbeck: (left) *Self-Portrait, Black Background*, 1915;
(right) *Self-Portrait with Red Spot*, 1944

genre, women artists showcased their newfound liberation. Unafraid to disclose truths, they conveyed with confidence their inward thoughts, desires, the ageing process, and some – for the first time in Western art history – painted themselves nude. It is no coincidence that these artists either lived in, were from, or travelled to, Paris. With the establishment embracing new artistic styles and granting more training and exhibition opportunities for women, the city attracted artists from all over the world and from a range of social classes. At the stroke of the new century, women in Paris could enjoy being able to sit in cafés and wander the streets unchaperoned, to attend life classes and exhibit their work to be seen by many. In anticipation of visiting the city, Paula Modersohn-Becker wrote: 'I hope to learn many things, particularly because there is a wonderful anatomy class dispensed free of charge at the school of fine arts, which will make up for my inadequate knowledge of anatomy . . . nowhere else are girls offered such a thing.'

This new breed of artists included the Finnish painter Helene Schjerfbeck (1862–1946). Schjerfbeck's artistic talents were evident from an early age. Following an accident in childhood that left her

with a limp, her father (her biggest champion) gave her a set of drawing pencils. She later said, 'When you give a child a pencil, you give her an entire world.' And she was right: by the age of eleven Schjerfbeck had enrolled in the Finnish Art Society, and by eighteen she had arrived in Paris, where she remained for six years. Setting up *en plein air*, painting landscapes, still lifes and portraits, she studied at the Académie Colarossi and travelled widely, including to Brittany, northwestern France, and St Ives, Cornwall.

Of particular interest are Schjerfbeck's self-portraits. The first created when she was just twenty-two and the last at the age of eighty-three, these enigmatic paintings reveal not only shifts in artistic fashions (the increasingly fragmented image), but also a woman battling with the looming notion of death. Whereas the earlier self-portraits have a fresh, youthful and hopeful quality, in those she painted later, executed with merely a few lines, she appears haunted, almost ghost-like.

Painted with a subdued palette and imbued with a serene tenderness, the self-portraits of Gwen John (1876–1939) are sometimes compared with Schjerfbeck's. The Welsh-born artist also ventured to Paris, following a stint at the Slade School of Art in London. Never conforming to a specific avant-garde style, John's paintings project an inward view of her reclusive, private world. Though they're small in scale and of single subjects or objects, there is a sense of power in them.

Earning her own money from her work as an artist and as an artist's model, John used interiors as a way of representing the self. In *A Corner of the Artist's Room in Paris*, c.1907–9, we see her cramped attic apartment and a few of her possessions: cut flowers, an umbrella and a shawl casually flung over a chair. It might not look like much, but the fact that they are hers is what matters. It signifies her freedom.

John's *Self-Portrait*, 1902, is just as affecting. Wearing a bright red shirt with a shawl that seems to have slipped from her relaxed, long shoulders, she gazes directly at us with a solemn expression, yet she is at ease with herself, surrounded by nothing but an auric haze of gold paint. Although she is dressed up, she is not an object,

Gwen John: (left) *A Corner of the Artist's Room in Paris*, c.1907–9; (right) *Self-Portrait*, 1902

and although she is watching us, we seem to be below her. She is silent, reclusive, introspective, firm. In the words of artist Celia Paul (p. 444): 'I have learned from John that you don't need to shout in order to make an impact.'

Paula Modersohn-Becker (1876–1907) also escaped to Paris and, like John, presented herself with a subtle defiance. Prior to her time in Paris, she had studied at traditional schools in London and Berlin, before settling in 1898 in Worpswede, an art colony in the north-German moors (where a group of German artists devoted themselves to painting lyrical naturalism). But on 1 January 1900, she made a seventeen-hour train journey to Paris. It was a trip – the first of four – that would change her life.

Enraptured by the works of the French Modernists – their dazzling colours and fragmented forms – as well as the paintings hanging in the Louvre, Modersohn-Becker thrived. Here, she was also able to study from the nude, in stark contrast to her rigid, academic background. Between visits to Paris, she returned to Worpswede to her older husband, Otto Modersohn (a founder of the art colony), but, stifled by rural life, she yearned for modernity. In 1906, she left Worpswede for the final time, writing in her journal:

Paula Modersohn-Becker,
*Self-Portrait, Sixth Wedding
Anniversary*, 1906

'I have left Otto Modersohn and stand poised between [sic] my new life. What will it be like? And what will I be like in my new life? Now it is all about to happen.'

In Paris, Modersohn-Becker produced dozens of expressive paintings, but her self-portraits in particular present a woman revelling in her independence. Just as she wrote in 1906: 'I am becoming something – I am living the most intensely happy time of my life.' With her canvases comprising thickly applied flat forms and rough scratchy textures, and executed in sun-drenched colours, she portrayed herself with an essence of intense possibility and emotional complexity, as seen in *Self-Portrait, Sixth Wedding Anniversary*, 1906. Wearing a beaded necklace and nude from the waist up (she is argued to be the first woman in Western art to paint herself in a semi-nude self-portrait), she stands clutching her bulbous round stomach.

She was not pregnant, but burgeoning with her new life. Assertive like her contemporaries, she appears free from all authority other than herself.

Unfortunately, with her limited finances, Modersohn-Becker was back in Worpswede by 1907. She gave birth the following November to a daughter, Mathilde, but due to complications she died just a few weeks later, aged thirty-one. She never achieved recognition in her lifetime – she had sold just a handful of paintings, yet left behind hundreds.

Her first solo exhibition was staged posthumously in 1919 in Berlin (by which time, postwar Germany had embraced modernism). In 1927 the Paula Modersohn-Becker Museum opened in Bremen, the first ever in Europe to be devoted to a female painter. Although she died on the cusp of its moment, scholars have since viewed Modersohn-Becker as an exponent of German Expressionism – a style, as we will discover in the following chapter, which favoured emotion over rigid narrative-led academicism (as Modersohn-Becker wrote, 'Personal feeling is the main thing').

The influence of French Modernism extended to America, where it is evident in the work of Jazz Age visionary Florine Stettheimer (1871–1944), who synthesised the styles she encountered during her extensive travels and studies in Europe with her bohemian eccentricity. Stettheimer painted glittering scenes of Manhattan life in blazing hues of reds, greens and oranges, sprinkled with shards of thick white paint. Her subjects ranged from spring sales at Bendel's to afternoon picnics (albeit with yellow grass), raucous theatre scenes and elegant nude self-portraits.

Never conforming to one style or fashion, Stettheimer was radical from the start. At forty-four years old, she confidently painted herself nude, as seen in *A Model (Nude Self-Portrait)*, 1915. A painting full of sparkling textures and luminescent colours, it is thought to be the first fully nude self-portrait by a woman. Measuring herself against Manet, Stettheimer appears with fiery red hair in a composition that closely resembles his famous *Olympia*, 1863. But whereas in Manet's painting Laure, modelling as the servant, is carrying the bouquet of flowers, Stettheimer holds her own (perhaps asserting

Florine Stettheimer, *A Model (Nude Self-Portrait)*, 1915

her independence). The amber beads resting on her thick white bedsheets recall those worn by Modersohn-Becker in her *Self-Portrait, Sixth Wedding Anniversary*, 1906.

Working slightly later, and exploring a range of painterly styles, was the remarkable Georgette Chen (1906–93). Born in Zhejiang, China, Chen spent her adolescent years in Paris and travelled extensively between China, France and the US. Trained in Shanghai by a Russian tutor, she studied in New York and later in Paris, an education that no doubt influenced her distinctive blending of styles. She later reflected, 'Although I belong to the modern school, I feel that I am not able to imitate any specific style. I paint what I see, whether it be a landscape or a figure.' This is evident in her *Self-Portrait*, *c.*1934, painted when she was in her twenties and already a successful artist in Paris, which feels like it could have been accomplished today. Reserved yet determined, Chen commands our attention with her stern, inquisitive gaze, as if to certify herself as a serious artist.

Subtle stoicism and strength are also present in the self-portraits of Pan Yuliang (1895–1977), who is now hailed as one of China's

most notable female painters. She left behind over 4,000 works and enjoyed a seven-decade career. But life wasn't always easy.

Orphaned as a child, Pan is thought to have been left in the hands of an uncle, who, when struck by poverty, sold her into a brothel. Marrying around 1912–13, Pan migrated to Shanghai where she learnt to paint. The 1911 Revolution had brought about major societal change and new ideas were reshaping the country – included in this was the embrace of Western-style painting. In 1920 she enrolled at the Shanghai Arts Academy in the Western Art Department, where she would later teach. After a brief stint in Lyon, Paris and Rome in the 1920s, she returned to Shanghai in 1928, earning great success with art critics, who praised her 'powerful brushstroke'.

But in 1937 Pan left for Paris and, caught in the upheaval of the Second World War, she was never to return to China again. In Paris she continued her practice, creating an array of strong portraits,

Georgette Chen,
Self-Portrait, c.1934

Pan Yuliang,
Self-Portrait in Red, c.1940

self-portraits and nudes (mostly modelled on herself), often inspired by the aesthetics of her Chinese heritage – using calligraphic lines or depicting subjects in traditional dress. Full of psychological intensity, Pan's self-portraits can carry deeper, melancholic messages, an example being *Self-Portrait in Red*, c.1940. Painted one year into the Second World War (and three years after her move to Paris), Pan portrays herself in Chinese dress and holding a sealed letter. As she looks straight out at us, drawing us in with her compelling and sincere gaze, she exudes both confidence and longing.

Presenting the self with assurance and defiance, the self-portraits created in the early decades of the twentieth century reveal what is at the heart of modernism: female artists enjoying their newfound liberty. Although we will go on to meet many other artists exploring self-portraiture, these artists give us a glimpse of the range of radicalism that women were expressing – immortalising themselves on their terms, and as they wished to be remembered.

FROM FAUVISM TO FUTURISM

The first decades of the twentieth century in Europe marked a time of revolutionary artistic change. Fuelled by the stylistic shifts initiated by the Impressionists and Post-Impressionists, artists sought to break from the past and hold up a mirror to the world around them. Their art reflected the exponential rise in new technologies (telephone, telegraph, high-speed motorboats, trains and cars); shifts in the physical landscape (the building of skyscrapers and monuments, such as the Eiffel Tower); new vistas (due, for instance, to air travel); and their inner, emotive, worlds (the rawness of everyday life, further intensified by the horrors of the First World War). Responding to changes in all areas of their lives, artists questioned traditions, rejected long-held perspectives and narratives, doing away with the hierarchies between artforms, and employing new palettes for the purpose of expressivity. As for women artists, they fearlessly took on subjects dominated by men, such as bathers, which they reworked from a distinct female viewpoint.

A significant factor that spawned these departures from traditions of the past was the availability of new source materials – notably, non-Western art objects. From West African tribal masks to Oceanic art, these artworks proved to be instrumental influences for modern artists and their new aesthetic, which favoured pictorial flatness, angular lines, expressive intensity and, as Denise Murrell writes, a 'spiritual aspect of the composition'. It is vital when analysing the output of artists working at this time that we recognise the importance of such influences, as well as the problematic complexities of European artists' reworking and appropriating these objects. Widely available in Europe as a consequence of colonial rule, they were seen as 'artefacts' rather than 'artworks', although artists were interested in them for their aesthetics rather than their anthropological value.

While I have grouped each of the following artists within an 'ism' category, they are by no means restricted to it. Using categories is an

artificial way of providing some clarity to artistic movements that were by their very nature fluid. We will start at the cusp of the century with Expressionism in Germany (Kollwitz, Münter), moving on to avant-garde Paris (Valadon, Marval, Laurencin), then on to the artists who broke boundaries and formed their own artistic styles and movements (Sher-Gil, Bell), those who pushed forth abstractions (Delaunay, Goncharova, Popova), and finally those who embraced the technological era (Cappa Marinetti).

Expressionism emerged in Germany around 1905. Artists (along with writers, poets, musicians and playwrights) abandoned all sense of realism and tradition. They turned to introspection and emotions, and were led by their internal worlds for inspiration. If Modersohn-Becker (p. 123) was the precursor to German Expressionism, then Käthe Kollwitz (1867–1945) was its pioneer. Working since the 1890s, Kollwitz produced some of the most extraordinary art of the entire century.

Primarily a printmaker, Kollwitz took psychological intensity to new heights with her often stark portrayals of the grief-stricken and oppressed. Depicting mothers and children wrenched apart by death; individuals filled with anguish and in mourning; poverty, love, hatred and war – Kollwitz's compassionate images reveal the grim rawness of reality observed through a deeply sensitive lens. Socially conscious and created with acute feeling (she once wrote, 'I agree with my art serving a purpose'), her work still speaks truth to the world we live in today.

Born in Eastern Prussia, Kollwitz, having witnessed the physical and emotional effects of industrialisation, used printmaking to record the bleakness and inequalities of life. Immediate, accessible and at times cheap, printmaking enables an artist to produce both intricately detailed images and bold graphic forms.

Kollwitz was deemed radical because of her subject matter. Documenting the working classes and the unemployed, she was a master at capturing the emotive intensity of her subjects' vulnerabilities and their experience of hardship. This is most brutally portrayed in *Need*, 1893–7, a lithograph of a dark, cramped room, featuring

Käthe Kollwitz: (left) *Need*, 1893–7; (right) *Woman with Dead Child*, 1903

what appears to be a mother in despair. Watched intently by others, she grasps her head in her hands while looking over at her sleeping baby, her agony almost palpable. A few years later, Kollwitz made what is, to me, one of the most jarring, and perhaps shocking, images in the history of art, the etching *Woman with Dead Child*, 1903. The grief of the mother clinging tightly to her dead infant, her head buried in the child's body, is so powerfully conveyed. Her emotions are so strong, so raw, so intense, that you can almost hear her cries and feel her tears sink into the skeletal, sculptural corpse.

Responding to the, in her words, 'unspeakably difficult years' of the First World War, between 1918 and 1923 Kollwitz worked on *Krieg* (*War*), a series no doubt shaped by autobiographical experiences. (She lost her youngest son in battle in 1914.) Employing a woodblock technique, Kollwitz adapted her classical style to produce opaque and exaggerated forms. *The Widow II*, 1922, depicts a mother catching her last breaths of life, a child, executed with barely a few lines, flung across her dying body.

Facing up fearlessly to the harsh environment around her, Kollwitz provides us with first-hand accounts of suffering during a politically tense and destructive moment. Born out of emotional honesty and sensitivity, the lack of individuality on the figures' faces also allows us as viewers to see her work more as the expression of a collective emotion: a world in mourning, as opposed to a specific narrative.

Käthe Kollwitz, *The Widow II*, 1922

As Expressionism progressed in Germany in the early 1900s, artists also began capturing the intensity of a subject by distorting conventional colouring (which they believed to have spiritual, symbolic meanings), as well as looking to the natural world. These artists were often associated with the group Der Blaue Reiter (The Blue Rider), formed in Munich in 1911, one of whose leading figures was Gabriele Münter (1877–1962). Münter first started these experimentations with colour after a visit to the alpine market town of Murnau, in rural Bavaria, in 1908. Inspired by her surroundings, her painting suddenly shifted from subdued landscapes to hallucinogenic realms.

Diffused into simplified fragments of gleaming colours, Münter's mountainous landscapes and hilltop villages are imbued with the power of her emotions and spiritual intuitions. Often produced in just one sitting, her kaleidoscopic images evoke a world composed of fiery abstract forms and reveal the speed and spontaneity with which she made them.

She used the same colouring technique in her figurative work, namely the 1909 portrait of her fellow German Expressionist artist and friend Marianne von Werefkin, whose dress, shawl and flamboyant hat are made up of blocks of bright pinks and greens. Applied with a palette knife to produce rough textures, the colours of her

prismatic and fluorescent palette vividly bring to life the vivacious character of her subject.

Back in Paris, artists were also using intense colours, breaking down naturalistic forms and incorporating stylised depictions of the figure. As with the artists we encountered on pp. 124-5, who took charge of their image, this era also saw women embracing the 'New Woman'.

The perfect embodiment of this new style was Suzanne Valadon (1865–1938). Nothing about her was conventional. Creating taboo-breaking paintings, portraying herself nude (sometimes beside her younger lover, as seen in *Adam and Eve*, 1909), Valadon became enormously successful in her lifetime. Her pioneering style encompassed Post-Impressionism with the wildness of Fauvism, and used a distinct language that chimed with the avant-garde (vibrant colours, rich textural patterns bound together by thick outlines). Her subjects, too, exude a fierce independence.

Her route into art was unlike any other female artist of the time. Born out of wedlock and raised in the bohemian heart of Montmartre in Paris, Valadon began her career as a circus performer, but her acrobatic dreams were cut short after an accident at the age of fifteen. A woman with strikingly prominent features, she turned to artist

Gabriele Münter,
Marianne von Werefkin, 1909

Suzanne Valadon, *The Blue Room*, 1923

modelling, posing for, among others, Henri de Toulouse-Lautrec, Pierre-Auguste Renoir and Berthe Morisot.

Determined to be an artist, despite her lack of finances, Valadon trained by carefully studying her employers at work as she sat for them. As a result, she developed one of the most extraordinary back-door insights into art education, and by 1909 she was painting professionally. In 1911, at the age of forty-six, she had her first solo exhibition, and thereafter was often championed by the renowned (and only female) art dealer of the age, Berthe Weill.

Her 1923 self-portrait *The Blue Room* for me captures the excitement and experimentalism of the avant-garde, while affirming Valadon as both artist and model. Wearing green-striped trousers and a loose-strapped pale pink top, she lies at leisure on her bed, framed by a sea of rich blue floral fabrics. A cigarette hangs out of her mouth and she has pushed a collection of books to the back of her bed. Exuding self-assurance and confidence in her

Jacqueline Marval, *Cheetah Odalisque,* 1900

intellect, Valadon is in control of her brush, her image and her life, epitomising the modern Parisian woman who could do whatever she wanted, whenever she pleased.

Valadon's self-taught contemporary Jacqueline Marval (1866–1932) also indulged in sensual scenes that fused the intensity of Expressionism and the saturated colours of Fauvism. Born Marie-Joséphine Vallet, she arrived in Paris in 1895, aged twenty-nine, having swapped her life as a wife for the pursuit of art. Settling in Montparnasse, Marval immediately got to work. At times, she was so short of money that she used her bedsheets as canvases.

Initially rejected from the 1900 Salon des Indépendants, in 1901 she submitted her work under the name of Jacqueline Marval (combining the first three letters of Mar(ie) and Val(let)) and exhibited a dozen paintings. One of these was her commanding *Cheetah Odalisque,* 1900, which references the composition of Ingres's famous *Grande Odalisque,* 1814. Whereas his figure is inviting, and made primarily for, a sexualised (male) gaze, hers is assertive, as though she is reclaiming his. But Marval's break came in 1903, when she exhibited *Les Odalisques,* 1902–3, at the Salon des Indépendants, a monumental brothel scene (a subject typically guarded by men) featuring four defiant female semi-nude and nude figures, and a dressed servant, all based on herself. The esteemed writer Guillaume

Jacqueline Marval, *Les Odalisques*, 1902–3

Apollinaire described it as 'an important work for modern painting'. Her prized painting, it was shown in 1916 alongside her friend Picasso's (strikingly similar in composition) *Les Demoiselles d'Avignon*, 1907, at the Salon d'Antin (the first time *Les Demoiselles* was ever exhibited).

As time went on, Marval's style loosened, with subjects ranging from sprawling bouquets to women bathing in dappled sunlit scenes. Internationally renowned, exhibiting in London, Prague and Tokyo, she also took part in 1913 in the groundbreaking Armory Show in New York City, the first exhibition to propel European Modernism to the other side of the Atlantic, and in 1919 exhibited at the Metropolitan Museum of Art.

A great admirer of Marval (as recalled in an interview of 1924), who exhibited alongside her at the Armory Show, was Marie Laurencin (1883–1956). A key figure in the Paris avant-garde community, Laurencin, frequenting Cubist circles, counted Gertrude Stein among her collectors, and was known to be in regular attend-

ance at the salons of American playwright Natalie Clifford Barney. Starting out in porcelain painting, then shifting to pictorially flat figures, from the 1910s she began working in a Cubist-like aesthetic: a new style that rejected all forms of perspective and traditional representation. Unlike her male counterparts (representing what some called the 'arrogant masculinity of Cubism'), Laurencin evolved her own distinct language.

Fusing geometric shards with heavily contrasted colours, Laurencin populated her paintings with stylised figures often basking in an all-female utopian environment. Sometimes painting from a queer perspective (Laurencin had both male and female lovers), she enriched the Cubist vocabulary with a new tradition of sexual desire, as seen in *Les Jeunes Filles* (*The Young Girls*), 1910. The elongated, ethereal women depicted as simplistic curvilinear figures, are set against angular green and grey trees, bound together by music and dance, rhythm and form, suggesting a world full of freedom.

Like Valadon and Marval, Laurencin reached extraordinary heights of fame during the interwar years. But a common theme with women artists of this era, especially those who achieved success in the 1920s and 30s, was that they were largely forgotten after

Marie Laurencin, *Les Jeunes Filles* (*The Young Girls*), 1910

their deaths. It would take until 1983 for Laurencin's name to resurface, in Japan, with the opening of the Laurencin Museum in Nagano-Ken, where her animated 1920s paintings of elegant, coy women have since remained popular. The first retrospective of Valadon's paintings at a major museum in the US was staged in 2021, and new scholarship on Marval is only just coming to light.

'I can only paint in India. Europe belongs to Picasso, Matisse and many others, India belongs only to me' – Amrita Sher-Gil, 1934

Before we get to the artists who left behind representation altogether, let us consider those who turned away from the Paris avant-garde, and synthesised traits of French Modernism with their own cultures. Modern art isn't just about embracing the new; it engages with internality and the rawness of life – and promotes, as we will see with Vanessa Bell, the breaking down of hierarchies between artforms.

Amrita Sher-Gil (1913–41) was India's foremost artist in the early twentieth century. Her paintings give prominence to real people at

Amrita Sher-Gil,
South Indian Villagers
Going to Market, 1937

real moments, and exude pathos and strength. Born in Budapest and raised in Shimla, northern India, between 1929 and 1932 Sher-Gil attended the École des Beaux-Arts in Paris, as the first Indian student to do so, where she was able to study from nude models. Acclaimed for her Expressionistic figurative painting, she exhibited at the Paris Salon. Soon enough, she was drawn back to India: 'I began to be haunted by an intense longing to return to India, feeling in some strange inexplicable way that there lay my destiny as a painter.'

Abandoning her European style, Sher-Gil's figurative work transformed into studies of saturated colour with fluorescent fabrics and glittering textures. Influenced by seventh- and eighth-century cave paintings and classical Indian art (as seen on her travels), her vivid artistic language not only extended the viewer's perception of modern art but also spoke sensitively to local villagers and market-goers.

The subject of solo exhibitions, and a recipient of multiple prizes, Sher-Gil showed her work in Delhi and Bombay. But soon after settling in Lahore with her new husband, she was overcome with illness and died at the age of twenty-eight. Her acute sensibility is evident in her paintings, which capture not just the electricity of colour, and the merging of global styles, but also the world of her sitters, no matter what their status.

Over in England, a group of radical writers, artists and cultural thinkers were gathering at 46 Gordon Square, London, the home of

Vanessa Bell's former studio at Charleston farmhouse, East Sussex

painter Vanessa Bell (1879–1961) and her sister, Virginia Woolf. Staging exhibitions, writing significant books and, for Bell in particular, evolving a language that would rescue British Modernism from its academic past, they were known collectively as the Bloomsbury Group.

Influenced (or in her words, 'liberated') by the French Modernists, Bell was drawn to everyday domestic scenes and to the English landscape. Her paintings, often composed of simple mosaic shapes and executed in loose brushstrokes which gave them a scratchy texture, vividly convey a sense of intimacy to her subject. Never restricted to one medium, Bell painted on canvas, textiles, ceramics and furniture. She designed covers for her sister's dust jackets and, along with other members of the Bloomsbury Group, painted every wall, lampshade, bookcase and wardrobe in Charleston, her farmhouse in East Sussex – perhaps the group's greatest *Gesamtkunstwerk*.

The Famous Women Dinner Service, 1932–4 (a collaboration with Duncan Grant), is one of my favourite pieces by Bell, and perhaps the most forward-looking. It is composed of fifty plates emblazoned with portraits of mythological and historical women (among others, Sappho and Cleopatra, George Eliot and Jane Austen, tenth-century Japanese poet Murasaki and Pre-Raphaelite Elizabeth Siddal). Not only does this showcase the versatility of her artistic range, but, seen from a twenty-first-century perspective, it seems extraordinarily

Vanessa Bell and Duncan Grant, *The Famous Women Dinner Service*, 1932–4

Sonia Delaunay, *Prismes électriques* (*Electric Prisms*), 1914

progressive – even more so considering it pre-dated Judy Chicago's *The Dinner Party* (p. 353) by nearly half a century.

Just as Bell had worked across a range of media and verged on abstraction in paint, artists in Russia and France also experimented with these distinct elements of modernism.

As the pace of life grew ever frenzied and the First World War loomed, artists ventured further towards abstraction with styles evoking the dynamism (and destruction) of the modern world. In 1911, the Ukrainian-born, Saint Petersburg-raised artist Sonia Delaunay (1885–1979), now living in Paris, pioneered a new strand of Cubism known as 'Orphism'. She was inspired by, in her words,

Natalia Goncharova, *Cyclist*, 1913

the 'Cubist conceptions' involved in the process of piecing together a blanket for her newborn son. Free of narrative, perspective and representation, the kaleidoscopic and interlocking swirls of Orphism reflect the pace and vibrancy of modern life. You can almost sense the bright electric lights adorning sprawling boulevards, with the cars careening through. Borrowing its name from Orpheus, Greek god of music and poetry, the style presented colours as visual harmonies, like musical notes chiming in concentric forms. Taking it further into the modern realm, Delaunay translated her designs to fabrics, interiors, ceramics – and even cars!

In Russia, Natalia Goncharova (1881–1962) was becoming the most successful artist of the era, having been in 1913 the first avant-garde artist (of any gender) to achieve a major exhibition at a Moscow museum (showing over 800 works).

Previously, she had embraced a style melding modernist aesthetics with Russian folk art, but in the 1910s she switched to pioneering

(left) Valentina Kulagina, *International Women Worker's Day* poster, 1930;
(right) Liubov Popova, *Painterly Architectonic*, 1918

a style known as Cubo-Futurism. Integrating the shattered shapes of Cubism with the speed and dynamism of Italian Futurism, Goncharova's paintings consisted of dizzying forms, distorted perspectives and flickers and flashes of bright white paint (she coined a style known as 'Rayonism'). Embracing the spirit of the new, she featured recently invented objects in her work – for example, the bicycle in *Cyclist*, 1913 – as if to condense into two-dimensional form the rapid momentum of the machine-fuelled modern age, which would soon be at war.

Running parallel to the anarchic artistic movements emerging out of the First World War, and following the 1917 collapse of the Russian empire, Russian art was also heading in a new direction, abandoning the figurative style and reflecting the values of the Soviet regime. Based on Constructivist aesthetics (formulaic, mechanical lines and bold geometric forms), the new style evoked the rise of

Benedetta Cappa Marinetti, *Speeding Motor Boat*, 1923–4

both industrialism and Communist thought in the Soviet Union. According to the Constructivist mindset, artists were engineers, they were communicators to the masses working with a specific purpose, and men and women were considered on an equal footing – for the first time in Western art history.

The Constructivists' utilitarian aim found its expression in paintings, books, set designs and propaganda posters, as exemplified in the posters of Valentina Kulagina (1902–87), promoting women's ability to operate heavy machinery. Yet one of the most radical artists, despite a very short-lived career, was Liubov Popova (1889–1924). A leader in defining Constructivism, she epitomised its style in her suite of non-objective forms known as *Painterly Architectonics*, which featured interlocking block-coloured shapes for a three-dimensional effect. Popova embraced Soviet aesthetics in painting, graphics, architecture and textile design, but her art never stopped being an exploration of the possibilities of line and movement, as seen in *Painterly Architectonic*, 1918.

Movement was also central to Futurism, a style born out of the rapid pace of industrialism. Although Italian Futurism emerged at the start of the century (with its expeditiously dynamic forms and glorification of war), during the 1920s the style, inspired by technological advances and the new perspectives afforded by plane travel, expanded to become Aerofuturism (*Aeropittura* in Italian). A significant contributor was Benedetta Cappa Marinetti (1897–1977), the only woman among eight men who penned her name to the *Aeropittura* manifesto, which stated: 'The changing perspectives of flight constitute an absolutely new reality that has nothing in common with the reality traditionally constituted by a terrestrial perspective.'

Cappa Marinetti produced dazzlingly angular landscapes evoking the technology of speed using elegant linear forms from a distorted perspective. One of her most successful paintings, I find, is *Speeding Motor Boat*, 1923–4: a glistening seascape broken up by ripples of blue and yellow diamonds, emanating from the trail of a tiny motorboat gliding into the distance. The painting fractures into geometric abstraction, its lyrical wave-like (or even bird-like) shapes crashing into the studded hard-edged waters.

QUEER IDENTITIES

'Masculine? Feminine? It depends on the situation. Neuter is
the only gender that suits me' — Claude Cahun, 1930

In the early decades of the twentieth century, ideas around gender types became the subject of much fascination. Representations of queerness and same-sex desire flourished, with artists using their own image to assert nuanced identities that didn't fit into society's rigid binary gender categories.

Shaving their heads and wearing trouser suits, some women artists would also go on to change their names to masculine or gender-nonconforming ones, signalling the identity they had chosen for themselves. Poets Edith Cooper and Katherine Bradley took the single name of Michael Field; Marjorie Moss became Marlow Moss; Hannah Gluckstein became Gluck; Lucy Schwob became Claude Cahun.

Self-fashioning was integral to queer artists' identities, as an abundance of carefully constructed photographs, self-portraits and portraits shows us. Although known for painting androgynous self-portraits, Gluck also commissioned photographers to take images of them dressed in a sharp tailored suit, radiating confidence. Similarly, the American Paris-based painter Romaine Brooks challenged traditional depictions of women through her commanding, grey-toned portraits, which recall historical heroic representations of men. Clothes were an important way of drawing attention to one's sexual identity, but this particular style was soon adopted as the high fashion of the day.

Although there are many examples of queer artists throughout this book (Rosa Bonheur, Marie Laurencin, Hannah Höch, to name a few), here I want to spotlight artists working at the height of the European avant-garde who explicitly used their work to make bold statements about same-sex desire: declarations mostly suppressed or

ignored in art history. It's not that I believe their work should be viewed exclusively through a queer lens, for they were, of course, simply great artists. I use the word 'queer' for its inclusive connotations, and, in line with recent discourse, I have also referred to some artists as 'them/they'.

Before we explore these representations, let us look at where these artists were working, because, during the 1920s, London and Paris were polarised places.

Male homosexuality had historically been the subject of much debate and legal scrutiny in Britain: until 1861 sodomy was punishable by death, and afterwards male homosexuality, even when acts were carried out in private, was a criminal offence. Female homosexuality, by contrast, was hardly ever mentioned. In 1921, when a Conservative MP suggested in Parliament that all 'acts of gross indecency by females' should be made illegal, the idea was swiftly dismissed for fear the very mention of such acts should lead women astray. Female homosexuality was not unlawful, but it was rather invisible.

Yet queer women living in Britain certainly didn't have it easy. Either, like the painter Dora Carrington (1893–1932), they were married and had lesbian affairs in private, or, if they were open about their sexuality, they were discriminated against. A case in point occurred in 1928, when lesbianism became a public topic of discussion after the publication of Radclyffe Hall's *The Well of Loneliness* and Virginia Woolf's *Orlando* within three months of each other. But it was the former title that elicited the more extreme reaction. British papers called it 'a book that must be suppressed'; *The Well of Loneliness* was banned until 1959.

To make explicitly queer art in these circumstances was radical. One of the foremost artists of the time, Gluck (1895–1978) grew up in a wealthy conservative Jewish family who disapproved of their child's artistic ambitions and androgynous look (at the age of twenty-three Gluck insisted that their name be reproduced with no 'prefix, suffix, or quotes'). Gluck studied art in London before escaping to the small coastal village of Lamorna, in Cornwall, where the Newlyn School artist colony was based. Unlike London, where

Gluck: (left) photographed by Howard Coster, c.1932; (right) *Ernest Thesiger*, 1925/6

social expectations had been stifling, Lamorna gave Gluck the freedom to dress and be as they chose, and to live openly with their then-partner, known as Craig.

Gluck often painted friends and lovers as well as themselves, memorialising queer men and women and hinting at their vulnerability. Particularly moving, I think, is the portrait of Ernest Thesiger, 1925/6, a married, homosexual man, known to perform in drag, which shows him spotlighted on a stage, with a thin shadow reflecting his tense body, accentuating his isolation. Gluck portrayed Ernest as he would have been accepted by society, in the same suit outfit that would have also emotionally suffocated him.

Living openly with women, Gluck was commercially successful and even developed their distinctive three-tiered 'Gluck Frame' to house their pictures. In the 1930s they produced paintings of meticulous floral arrangements, prepared by former lover and expert gardener Constance Spry. However, Gluck soon became involved with the married, wealthy American socialite Nesta Obermer,

Gluck, *Medallion (YouWe)*, 1936

represented in the double portrait *Medallion (YouWe)*, 1936. One of the first visibly Sapphic statements in Western art, this revolutionary double portrait (supposedly inspired by a night at the opera) presents Gluck and Nesta side by side in profile, bound together by their love, with Nesta's golden hair framing Gluck's like a halo. Although they are united, there is a remoteness to them. Gluck, who is closer to us, appears tense. Nesta, looking upwards and into the distance, is bathed in a celestial light, as if untouchable, with Gluck attempting to hold on to her.

Despite their bond, the relationship deteriorated in the early 1940s. In the self-portrait *Gluck*, 1942, the artist is staring down, defiant and in command, yet there is also sadness in their expression. Lines of tension are visible on their face, their lips are pursed, and their collar turned upwards as if it were a shield against pain. One

could also read this pain as British society's rejection of who Gluck wanted to be – free from gender, liberated from society, unclaimed by anyone.

Whereas London was dismissive of queer communities, in Paris it was a different story. For one, *The Well of Loneliness* continued to be published, in contrast with the British ban. Known as a haven for queer artists, writers and thinkers in particular, Paris was the setting for a queer community of mostly upper-class women, including art patron Gertrude Stein and writer Natalie Clifford Barney. Barney, famed for her weekly salons, would enter into a fifty-year relationship with American painter Romaine Brooks (1874–1970).

Like Gluck, Romaine Brooks (born Beatrice Romaine Goddard) explored gender-neutral portrayals. Having lived on the island of Capri at the turn of the 1900s (a place where many homosexuals

Romaine Brooks,
Self-Portrait, 1923

Tamara de Lempicka, *Group of Four Nudes*, 1925

migrated), Brooks moved to Paris in 1905. Here, she captured friends and lovers in compelling portraits, ignoring the modernist aesthetics of the day, but presenting her subjects as serious and mighty.

Using clothes to show off their identity and personality – sharp, tailored suits and cravats, worn with cropped hair and the occasional monocle (as seen in *Una, Lady Troubridge*, 1924, picturing the lover of Radclyffe Hall) – Brooks also presented herself as an independent and unobjectified woman. In *Self-Portrait*, 1923, she is staring directly at us from the shadow of her top hat, a subtle hint of red paint for her lips and cheeks, emblematic of the androgynous New Woman.

Having escaped the Russian Revolution in 1917, Tamara de Lempicka (1898–1980) found herself at the centre of a lively Parisian life, and constructed some of the most radical, liberal and avant-garde images of same-sex desire. Melding meticulous painting techniques found in Renaissance painting with cold and shiny art-deco aesthetics, de Lempicka's paintings feel almost metallic in style as they ooze the momentous spirit of the fast-paced age. Referencing popular art-historical compositions, her highly erotic *Group of Four Nudes*, 1925, fuses elements of the Baroque (its high drama and stunning light effects as it thrusts into our space) with a hard-edged industrialism (the robust semi-Cubist figures, their angular cheekbones and silvery eyes). Nicknamed the 'baroness with the brush', and known for being able to work for nine hours straight (breaking only for 'baths and champagne'), de Lempicka epitomised the modern woman, and painted her lifestyle and the exuberance of the Jazz Age. Sexually free, twice married and openly bisexual, for her self-portrait de Lempicka depicted herself, fittingly, holding the wheel of a Bugatti (*Self-Portrait (Tamara in a Green Bugatti)*, 1929), cloaked in a marble- like scarf.

Although known as a writer in 1920s Surrealist Paris, Claude Cahun (1894–1954) explored gender and identity through photographs and self-portraits taken in private with Marcel Moore (the artist's stepsister, and later lover and collaborator). Presenting themself as an angel, an aviator, or as fictional and fairy-tale characters, Cahun used performance to allude to their many selves and alter egos, and refused to conform to society's gender binaries. In their

words: 'Under this mask, another mask. I will never finish removing all these faces.'

Born to a wealthy, intellectual Jewish family, Cahun began experimenting with the camera in the early 1910s. In subsequent years, they shaved their head and dressed androgynously, tantalisingly documenting their transformation through photography. For decades, Cahun employed photographic techniques (such as superimposing images) and mirrors (see *Self-Portrait Reflected in a Mirror*, 1928), as if to present two versions of themself.

Witnessing the rise of anti-Semitism and fascism in Europe, in 1937 Cahun and Moore made their escape by hopping across the Channel to Jersey (a place they had visited as children). Known by the locals as 'les mesdames', they walked their cats on leads and made striking, performative images: dressing in costume, playing with backdrops, incorporating found objects. Seeing these works, which are minute in scale, is like stumbling into the private life of a couple who embraced theatricality.

But these images came to an end when German forces occupied the island. Instead of leaving, the pair used their performance skills

Marcel Moore, *Untitled* (Claude Cahun in *Le Mystère d'Adam*), 1929

Claude Cahun, *Self-Portrait Reflected in a Mirror*, 1928

to 'become' German soldiers, infiltrating marches, or to dress as elderly women in order to deliver counter-propagandistic messages to Nazis. However, after four years, the pair were found out, imprisoned and sentenced to death. Although they were liberated at the end of the war, they never recovered mentally.

Born into a society that would not accept them, the artists exploring queer identities feel contemporary, relevant and ahead of their time. Going against stylistic fashions of the day, and certainly not conforming to society's traditional paths for women, they wrote queerness into art history. Without them (and if the British press and government had got their way), we would not know these thriving communities had ever existed. It makes me wonder how many other experimental, unknown (as of yet) artists there were out there, breaking down gender barriers and writing their story into an art history that is only now itself being written.

Chapter Five

THE AFTERMATH OF THE FIRST WORLD WAR

(c.1920—c.1940)

DADA, THE READYMADE
AND THE WEIMAR ERA

In the aftermath of the First World War, Europe was scarred by political chaos and the horrors that had been witnessed by so many. Millions had been killed, even more wounded, and artists turned to the imagination and the absurd for relief. So 'Dada' was born, an art that refused to define itself (and in the words of its founder, Tristan Tzara, meant 'nothing'). It was more of a philosophy than an actual style, and the artists associated with it were ardently political. Protesting the establishment, they injected their work with dark humour and satire, no doubt as a way of dealing with the madness of the time.

Originating in 1916 in Zurich, where Sophie Taeuber-Arp and Emmy Hennings were known for their expressive performances at the Cabaret Voltaire, Dada was international in its influence, reaching Berlin, Munich, Paris and New York. Responding to the era's catastrophic events, the women of Dada were fearless, unafraid to poke fun at political leaders and caricature their male contemporaries. Experimental and egalitarian, they viewed art as integral to everyday life. Working across collage, painting, poetry, performance, they also sought out a new type of art known as the 'readymade'. This was a radically disruptive medium, which saw artists place manufactured objects as artworks in museums, questioning the value of artistic skill and the very essence of what art could be.

Hannah Höch (1889–1978), in my opinion, was the most important Berlin Dada artist. She adopted a distinct feminist and queer stance in her art, and reacted to the time through satirical photomontages. She engaged with contemporary social and political issues and shone a light on the oppression of women. Her inventive (and brilliantly punchy) visual language spliced together images and text

from journals, newspapers and fashion magazines, and gave a voice to those so often dismissed.

Trained in painting, glasswork, embroidery and patterning, Höch initially produced a series of disturbing yet playful 'Dada Dolls' in pairs of same-sex couples. By 1918 she had joined forces with the Berlin Dada group, and, taking photomontage as her medium, one year later she started on her most ambitious and explosively political work, *Cut with the Dada Kitchen Knife through the Last Weimar Beer-Belly Cultural Epoch in Germany*, 1919.

In *Cut with a Kitchen Knife* she collates fractured images to depict the disjointed reality of the era's political chaos (the 'kitchen' in the title references women's stereotypical roles). Swept up in the form of a macho (and almost disintegrating) machine, the different elements are presented as cogs attempting to turn the wheel of a lost and broken world.

A collage of the faces and bodies of politicians, artists and other notable figures from recent journals (as if to root the work in the contemporary moment), the piece is split into four. The densely packed top-right corner is emblazoned with the words 'Die anti-dada' (symbolising those 'against Dada'), set against an array of spoofed images of right-wing politicians, such as the slashed face of Kaiser Wilhelm, a significant contributor to the disaster of the First World War.

The top left is filled with propagandistic references, punctuated with the face of Einstein; the bottom left gives prominence to the German Communist leader Karl Liebknecht, and features the text 'join dada!'; in the bottom right are members of the Dada group as well as a map of Europe highlighting countries yet to allow women the vote. To bring the whole picture together – as if she were the key cog in the machine – Höch places the head of artist Käthe Kollwitz (p. 130) at its centre, atop a dancing body, perhaps to highlight the strength of women.

Capturing the rebellious spirit of the time, Höch sought to fight gender injustice, raising awareness about women's suffrage and reproductive rights. She always tempered her work with humour, and in 1920 she penned 'The Painter', a short story about a tormented

Hannah Höch, *Cut with the Dada Kitchen Knife through the Last Weimar Beer-Belly Cultural Epoch in Germany*, 1919

painter whose wife 'thwarted the boundless flights of his genius' by forcing to him to wash the dishes four times in four years. He is quoted as saying: 'The first time, actually, there had been a pressing reason. She was giving birth to the baby.'

Höch struck up a close friendship with another acclaimed artist, Sophie Taeuber-Arp (1889–1943). Famed for her poetry performances, Taeuber-Arp also worked with puppetry, painting, dance and interiors, and was one of the foremost artists working with geometric abstraction. Her *Dada Heads*, painted wooden sculptures with sharp angles and fragments of mechanical, manufactured objects as hair or facial features, speak to the era's interest in the 'readymade', and reflect the optimism and the anxieties brought about by industrial modernity.

Although their male contemporary Marcel Duchamp is often credited with inventing the 'readymade' (after all, he coined the art-historical term), there are those who claim that he was in fact predated by a woman: Baroness Elsa von Freytag-Loringhoven (1874–1927), who experimented with found objects and assemblages. According to her friend Jane Heap, editor of the *Little Review*, she was 'the only one living anywhere who dresses Dada, loves Dada, lives Dada'.

Born fifteen years prior to Höch and Taeuber-Arp, by the turn of the century the Baroness had already endured a most eventful life. Raised in a tumultuous household in Prussia, from which she ran away to join the European avant-garde, she helped her husband fake his death and arrived in America in 1910. Making her way to New York City – which was soon to become the artistic centre of the Western world – she married her third (and final) husband, a cash-stricken Baron (hence her title), and, to make ends meet, modelled for Man Ray. She attended salons and befriended Duchamp, who was enraptured by her poetry recitals, fractured lines assembled from slogans, known as 'ready-made poems'. He once said of her: '[The Baroness] is not a Futurist. She is the future.'

Often seeking to shock and provoke, Freytag-Loringhoven wandered the streets wearing little but a blanket, tinned tomato cans tied together with string around her chest, hats adorned with gilded carrots and other vegetables (or sometimes spoons), and stamps on her cheeks. She saw these items (often junk on the street) as 'wearable art'. With a shaved head and penchant for cross-dressing, she defied gender conventions and refused to conform to societal expectations.

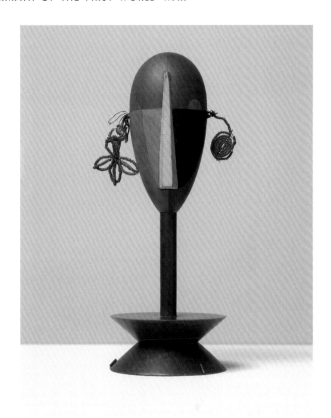

Sophie Taeuber-Arp,
Dada Head, 1920

There is no doubt that her experimental work was in the van-
guard of movements that defined the end of the twentieth century,
such as Body and Performance Art, as her biographer Irene Gammel
argues. Indeed, her found objects, assemblages and 'junk sculptures'
of the 1910s changed the course of art history. She produced her first
piece, titled *Enduring Ornament*, in 1913, an old metal ring which she
chose to declare as an artwork, a year before Duchamp's *Bottle Rack*.
(An everyday bottle rack that is seen as encapsulating one of the
defining moments in modernism.) In 1917, in collaboration with art-
ist Morton Livingston Schamberg, she created *God*, a sole metal
plumbing trap, which was previously (wrongfully) attributed to the
male artist alone. But her biggest snub was yet to come.

Ever heard of Duchamp's *Fountain*, from 1917, one of the most
famous works of art (some might say an icon of twentieth century

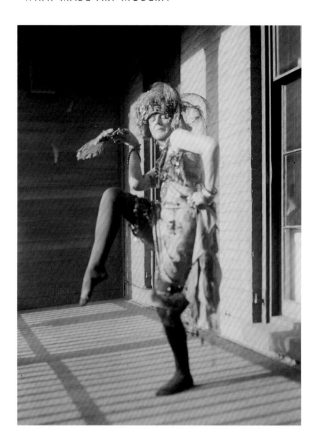

Baroness Elsa von Freytag-Loringhoven, c.1920–25

art), which helped kick-start modern art? After the 'readymade' (signed under the pseudonym 'R. Mutt') had been scandalously rejected by the Society of Independent Artists (an organisation which prized itself on progressiveness), Duchamp penned a rather telling letter to his sister Suzanne, writing: 'One of my female friends, under a masculine pseudonym Richard Mutt (or R. Mutt), sent in a porcelain urinal as a sculpture.'

Despite its rejection, the object was photographed by Alfred Stieglitz, who also claimed that the author of the radical piece was a woman. A clue perhaps suggesting that it may have been submitted by the Baroness is that Duchamp's details on procuring his urinal are hazy; he claimed the urinal was from 'JL Mott Iron Works', when it turns out they have no record of the product. I'll leave it up to you to decide, but the Baroness's exclusion from art history strikes me as

utterly unjust (considering she was making 'junk sculptures' before Duchamp). No wonder she called him 'Marcel Dushit'.

But the tragic fact is that she never received any recognition during her lifetime. By 1922, she was penniless and broken, and loathed America. Returning to an even more turbulent Berlin, the Baroness suffered from depression and lived on the streets. She went to Paris in 1926, where she died, some say by her own hand, just one year later.

'I have always wanted to be just a pair of eyes,
walking through the world unseen,
only to see others' — Jeanne Mammen, 1975

Like the turbulent Berlin the Baroness returned to, Germany in the interwar period was a time of extreme paradoxes. While the First World War and the collapse of the German empire had left the country shattered, society under the new democratic Weimar Republic led to a new era of social liberalism. German cities were rife with cultural optimism, and artists captured the vibrancy and turmoil of an exciting, restructuring new nation.

Opportunities had never been greater for women. Entering the workforce while men were at battle, some had had their first taste of independence, and thrived. Since 1919, women could vote, and legislation around birth control had loosened. It was now finally acceptable for them to roam the German streets unchaperoned. The New Woman was born. She was provocative and androgynous, dancing in nightclubs or performing in cabarets, and defying gender conventions. Although short-lived due to the rise of Nazism, this period redefined what had been German artistic identity, energising the art world and producing some of the greatest, most forward-thinking works of the early twentieth century.

With her cropped hair and trouser suits, Jeanne Mammen (1890–1976) epitomised the modern woman, embracing same-sex desire in her vibrant Berlin nightclub scenes. Successful, radical and a cunning observer of the day (regularly publishing her satirical drawings in magazines), she depicted women who were bold,

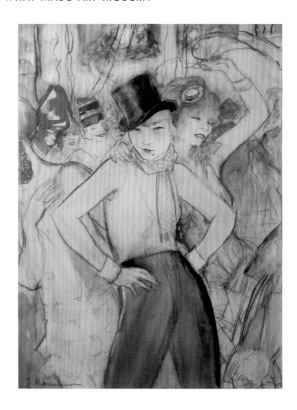

Jeanne Mammen,
*She Represents, c.*1928

glamorous, sensual and free, and her images erupt with colour, rhythm and movement: you can almost sense the pounding music in her jazz-fuelled scenes.

Returning from Paris to Berlin in 1921, where she captured the glitz, glamour and raucousness of the avant-garde, Mammen documented all-female dancing crowds, sharp-eyed and stylish in their top hats and waistcoats. In the watercolour *She Represents, c.*1928, queer women are pictured oozing with confidence and effervescent playfulness, although at the time German laws disallowed same-sex relationships. Transporting us to hectic, lively nights, Mammen nevertheless also conveys the gritty reality of Weimar life in her paintings of prostitutes getting ready for work under an electrically lit midnight sky.

Mammen's contemporary Lotte Laserstein (1898–1993) also poignantly explored gender and identity through paint. Although her style feels romantic and traditional, her subject matter is far

ahead of her time. At the height of the Weimar era, she was bound for an incredible career.

Laserstein began her artistic endeavours in Berlin, where she established a studio in 1927, painting weighty, breathable, meticulously rendered bodies. Her work was soon met with acclaim, and she exhibited both in Germany and more widely in Europe. Breaking down gender stereotypes, she adopted an androgynous look with her cropped hair and mannish shirt, as seen in her self-analytical and, I like to think, vulnerable *Self-Portrait with a Cat*, 1928. She often used her friend Traute Rose as a model, producing intimate and complex nudes that were full of sensuality and eroticism. In *At the Mirror*, 1930, a boyish-looking naked female figure, its muscular back turned to us, is gazing intensely at its reflection, bathed in dappled sunlight. Set to the right we see the artist – perhaps Laserstein herself – immersed in the moment, dancing between canvas and mirror, hurriedly squeezing paint onto her palette to conquer the canvas in front of her (it is applied so thickly that when you see it in person it is as though the canvas has become Laserstein's palette).

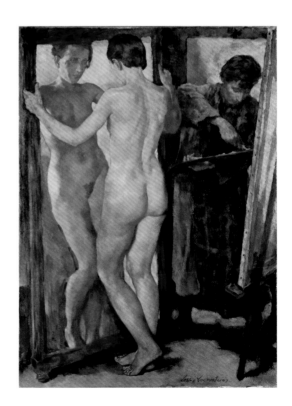

Lotte Laserstein,
At the Mirror, 1930

This is a painting full of tension – between artist and model, model and model, and artist and viewer.

Like her peers, Laserstein symbolised the New Woman. But just when her career was taking off, everything stopped. In 1934, after being declared a 'three-quarter Jew', she was banned from exhibiting in public. With the rise of Nazi power, her work, like that of many other defiant artists, was forced into obscurity. In 1937, she emigrated to Sweden, where she remained for the rest of her life, her career never reaching the same heights after the war.

Labelled 'degenerate' by Hitler for not conforming to his German nationalistic ideology and instead embracing expression and modernity, modernist art was banned and sometimes even destroyed. The Nazis seized more than 15,000 works and, in 1937, staged two 'Degenerate Art' exhibitions in Munich, featuring the likes of Mammen, Laserstein, Modersohn-Becker and Höch. Although the exhibitions were staged to explicitly mock these artists, what they did in fact was to put on public view some of the most revolutionary works in history. Works that spoke truth to both the freedom and tumult and of the age, and captured women in their modern and triumphant glory: accepted, liberated and encapsulating freedom.

BAUHAUS

'I find art is something that gives you something that you need
for your life. Just as religion is something that you need even
if you constantly find it denied today'— Anni Albers, 1968

One of the most influential and radical art and design schools to emerge during the Weimar era was the Bauhaus ('building house' in English). Bauhaus stripped out expressive artistry, enforcing function over form.

Inaugurated in 1919, in Weimar (until 1925), then Dessau (1925–32) and Berlin (1933), the Bauhaus offered a utopian direction in artistic education. Emphasising regeneration and renewal, and

Bauhaus Students of the Weaving Workshop in a Loom, 1928

promoting machine work, the school taught painting, sculpture, architecture, textiles and, in their words, 'above all, a modern philosophy of design'. It was open to students of any gender, age or class, and initially focused on the basics of each discipline. This was known as the 'Preliminary Course', as outlined by its founder, Walter Gropius – and it is still the standard 'foundation' course taught in art schools today. Funded by the Weimar government, the school ran for fourteen years.

But although it prided itself on offering a wide-ranging education and eliminating hierarchies across subjects and media, the school was far from equal. While men were free to experiment, women were mostly shut away in the weaving and bookbinding workshops. Gropius even proclaimed that women thought in 'two dimensions' whereas men thought in three. So women responded by mono-polising and dominating weaving and bookbinding, and innovating new techniques. Their influence on the weaving industry is felt to this day.

For the twenty-two-year-old Gunta Stölzl (1897–1983), who enrolled in the school the year it was founded, Bauhaus was the path

to another world. 'A new life begins,' she recorded in her journal. One of the most successful weavers to come out of the school (and one of the few women to hold a managerial position there), Stölzl free-weaved textile seats, curtains, carpets and wall-hangings, and was an influential teacher to Anni Albers, who praised her experimentalism.

Anni Albers (1899–1994) was a loom trailblazer. Becoming a student at the Bauhaus in 1922, after what she described as an 'unsatisfactory' experience at an applied arts school in Germany, she was initially reluctant to join the weaving workshop due to its lack of prestige. However, she soon became enraptured by the material, later recalling these 'amazing objects, striking in their newness of conception in regard to use of colour and compositional elements'.

Using threads to experiment for both functional and artistic purposes, Albers designed pieces that were not just useful and

Anni Albers, *Wall-Hanging*, 1926

Gertrud Arndt,
Maskenfoto, Dessau, 1930

innovative but also, with their geometric, rhythmic patterning and electric colouring, visually arresting, as seen in *Wall-Hanging*, 1926. One of her breakthrough pieces was the sound-absorbing, light-reflecting, wall-covering fabric she designed for the auditorium of Hannes Meyer (Gropius's successor). For this, she developed techniques to use the newly invented material cellophane, for which she received, in 1930, a Bauhaus diploma.

Unlike Albers and Stölzl, Gertrud Arndt (1903–2000) first joined the Bauhaus to study architecture. However, the hostility of her male peers made this unsustainable, so she reluctantly enrolled for the weaving course, in which she excelled. She went on to marry a fellow Bauhaus student and took up photography 'out of boredom' (according to her daughter) – but clearly with the experimental and productive Bauhaus spirit. Not exhibited until long after the Second World War, Arndt's extraordinary photographs reveal a woman intrigued by disguise. Dressing up as different characters in a flamboyant array of costumes and hats, she performed for the camera as

Marianne Brandt, *Teapot, c.*1924

a way to explore female identity. In an interview in the 1990s, she recalled, 'You just need to open your eyes and already you are someone else ...'

There were so many other female artists at that time: Marianne Brandt, who photographed herself in mirror balls, distorting her body and her surroundings, in addition to designing low-level, stylish metal teapots and desk lamps (her *No. 15 Kandem Table Lamp*, 1928, was the most commercial object to emerge from the entire Bauhaus); photographer Lucia Moholy, and weavers Otti Berger and Benita Otte. But by 1933, the Bauhaus had been shut down by the Nazis. The work carried out there had been revolutionary. Although women faced constant misogyny, they rose above it and excelled. Some of them, those lucky enough not to fall into the clutches of the Nazi regime, went on to achieve greatness. Albers headed up the weaving workshop at Black Mountain College (p. 253) and Stöltz fled to Switzerland and founded a successful hand-weaving business. Like the revolutionary artists working alongside them in Dada or Weimar Germany, not all survived, but their legacy does. The 1930 publication *Die Woche* (*The Week*) described the 'Bauhaus-girl type' as a woman who was ambitious, talented, creative and free – not unlike the New Woman, in fact. A type that became popular all over the world, inspired the next generation and continues to have currency today.

WORLDS BEYOND OUR REALM: SURREALISM

'Of course the women were important, but it was because they were our muses. They weren't artists' – so claimed Roland Penrose, husband of Lee Miller, to legendary feminist Whitney Chadwick, during her visit to his home in the 1980s. When Chadwick later asked artist Leonora Carrington for her thoughts on the Surrealist muse, she replied, 'I thought it was bullshit. I didn't have time to be anyone's muse … I was too busy rebelling against my family and learning to be an artist.'

Building on the anti-establishment notions of Dada, in the wake of the political crises and traumas of the First World War, the Spanish Civil War, and the fear of encroaching fascism across Europe, the artists, writers and thinkers of the Surrealist movement rejected ideas of conventionality and were drawn to the subconscious. They placed emphasis on the power of dreams and the dislocated imagery found in their fantasies or nightmares, engaging in the brutality of the body, in part influenced by the return of missing-limbed veterans from the front lines. Using new methods of working, from Automatism (creating 'without conscious thought'), which derived from Spiritualism, to collage and photomontage, the Surrealists combined pictures of the real world with those in the depths of our minds.

Founded by poet André Breton in Paris in 1924, Surrealism was initially appealing to women due to its projected ethos of equality and radical and progressive thought. However, this was not entirely borne out in practice, and many women eventually rejected Breton due to his profound misogyny. For him, as he wrote in his 1929 manifesto, 'The problem of woman' was 'the most marvellous and disturbing problem in all the world'. Given his views of women as muses, wonders, enigmas, objects and 'femmes enfants' (the child

woman was young, beautiful and obedient), it is not surprising that the female Surrealists had to carve out their own independent path, both through their art and the ways in which they dressed.

For male artists, Surrealist ideas were built around the sexuality of the female image, with the likes of Max Ernst and Salvador Dalí filling their canvases with violent and brutal images of fragmented or idealised bodies. However, as Carrington's punchy 'bullshit' statement informs us, being seen as a muse was not something these strong-willed women intended to settle for, despite the gatekeepers of art history so often writing it that way.

Women's role in Surrealism is a powerful, inventive and fascinating one. They switched up the eroticised portrayal of their own bodies by turning their gaze back onto themselves. They looked to represent liberation and oppression, imagination and transformation, as well as magical and sensual qualities in their work. In their depictions of dreamscapes, landscapes and frequently claustrophobic architectural interiors, they showed women as strong, dominating and free.

Unlike their male counterparts, who largely wore 'three-piece tweed suits', female Surrealists used dress as a means of expression, as if to become walking embodiments of Surrealist ideas, featuring themselves as animals, sphinxes and other mythological creatures (Leonor Fini would even dress up in lion-like headscarves!).

Centred mostly in Paris during the avant-garde, by 1930 the movement had attracted artists internationally – from runaway English debutantes (Carrington) to small-town American photographers (Miller). But although we hear so often about the male contribution to the movement, it was the women, working across collage, painting, photography, photomontage and sculpture, who also advanced Surrealist thinking and pushed forward techniques in the most radical of ways.

One of the leading Surrealist figures working in photography and photomontage was Dora Maar (1907–1997). Born Henriette Théodora Markovitch to a bourgeois family, Maar was raised between Buenos Aires and Paris. Here she turned to photography after

Dora Maar, *The Years*
*Lie in Wait for You, c.*1935

studying the decorative arts and painting, and captured the spirit of the movement through her gothic-inspired images.

Working both on commissions and on a commercial basis, Maar was one of the first women photographers to co-run a studio in Paris, and thrived in both her artistic and advertisement work. With the 1920s and 30s marking an exciting moment for commercial photography, thanks to the boom of advertising, magazine editors and contemporary brands favoured commissioning inventive photographs over hand-drawn illustrations. And it was Maar's distinctive eye and knowledge of Surrealist techniques that earned her work from a myriad of health and beauty projects designed to promote the 'New Woman'. These included *Femme aux cheveaux avec savon* (*Woman's Hair with Soap*), 1934, a shampoo promotion which depicted a highly imaginative and uncanny still of a woman washing her sculpture-like hair, and *The Years Lie in Wait for You, c.*1935, a photomontage of her friend, the poet Nusch Éluard, with a spider's

web superimposed over her face, created as marketing for an anti-ageing cream.

However, despite Maar's eagerness to project the idea of a 'modern woman' – and many of the other women Surrealists' intentions to do this – France between the two world wars was a 'contradictory' environment for women's rights, with the state demanding women return to the home (and it wasn't until 1944 that they were finally granted the right to vote). But like so many of her Surrealist contemporaries, she remained unmoved by the establishment. Motivated by her strong leftist beliefs, she ventured to the outskirts of Paris, London and Barcelona with a hand-held camera (very rare for a woman at that time) and captured subjects ranging from pearly queens to butchers and blind street peddlers in images now considered some of the earliest examples of 'street photography'. Maar always saw the extraordinary in the mundane, even though she often infused it with a slightly strange, slightly gothic, uncanny atmosphere.

Maar's friend and contemporary Lee Miller (1907–77) also worked on a range of subjects with varied photographic styles. Whether commercial, fashion or war photography, Miller always

Lee Miller, *Tanja Ramm under a Bell Jar,* Paris, France, 1930

Lee Miller, *Portrait of Space, Al Bulwayeb, near Siwa, Egypt*, 1937

caught an image with an otherworldly atmosphere, and contributed to inventing techniques such as solarisation (exposing undeveloped images to the light to create a mystical, silvery effect) that would not only push forward the movement of Surrealism, but develop the practice of photography itself.

Born Elizabeth Miller in Poughkeepsie, New York, the young, fearless and highly intelligent Miller grew up being treated as an equal to her two brothers, with whom she was known to be fiercely competitive. However, when her mother became unwell and left her in the care of family friends at the age of seven, she was raped and contracted gonorrhoea. She was told never to speak of the incident. Miller moved to New York in her teens where she became a successful model, gracing the cover of *Vogue* after allegedly meeting Condé Nast himself at a road crossing.

Ambitious and determined, Miller soon abandoned modelling to go behind the camera, travelling to Europe, where she assisted and collaborated with Man Ray. She was adept at finding Surrealist shapes within the body and rejected the male objectification of women entirely. Having been the muse and object for much of Man Ray's work (in 1933, the year after she'd left for New York, he remade his work *Object to Be Destroyed*, 1923, by attaching an image of her eye to a metronome), it was through photography that Miller documented the suffocating reality of what it was like to be a woman in the 1930s, as seen in the image of her friend Tanja Ramm's head suspended in a bell jar, silent and trophy-like.

A successful commercial photographer, Miller returned to New York in 1932, at the height of the Great Depression, and opened up a photographic studio under the androgynous name of 'Lee'. Life then took her to Egypt, where, with her Surrealist lens, she photographed expansive, empty desert scenes, glimpsed through a ripped mesh sheath, as seen in *Portrait of Space*, 1937. But it was in England that she settled, on the outbreak of global conflict, becoming a war correspondent for *Vogue*. Her photographs are records of women's contributions to the war effort, but also of the grief-stricken mothers affected by loss. Reporting from Dachau and Buchenwald concentration camps, Miller famously captured the horrors experienced by so many (see p. 212 for more).

Influenced by the Dada artists, the Surrealists favoured working with found objects, which they transformed from the ordinary to the extraordinary. Using simple materials, or even just placing two found objects together in an act of assemblage (similar to the way that photographers and collagists would merge multiple images, or painters did with multiple subjects), those working with objects believed in the power of reshaping the mundane in unexpected and exciting ways.

Designed to trigger the senses, the fur-lined teacup created by Meret Oppenheim (1913–85) is one of the most absurd, jarring and quintessential objects of the Surrealist movement. Titled *Object*, 1936, when exhibited at the Surrealist Exhibition in New York in

Meret Oppenheim, *Object*, 1936

the same year, it caused an uproar among viewers. It continues to divide opinion even today.

One of the foremost British artists working in a Surrealist style, Eileen Agar (1899–1991) was hailed for her vibrant sculptures made up of objects found in or beside the sea. She was interested in the magic created when two individual objects are placed beside each other, and their juxtaposed histories. Playing with the familiarity of objects, she fused them as one, as if piecing together a collage.

Born in Buenos Aires, Agar moved to the UK at the age of six. She grew up in an extravagant yet conservative household with a mother – known to be a lover of great hats – whose only wish was for her daughter to marry respectably. With altogether different thoughts in mind, Agar ran away to the Slade School of Art in the early 1920s, destroyed all her work prior to 1926, and soon after, fled to Paris, where she thrived. Here she mixed with the Cubists, who taught her about form, and the Surrealists, who introduced her to the idea of tapping into her subconscious mind. Returning to London in 1930, she painted *Three Symbols* (previously titled *The Flying*

Eileen Agar,
Angel of Anarchy,
1936–40

Pillar), combining subjects ranging from, in her words, 'Greek culture' to industrial modernity to reflect the rapidly developing world around her, and to evoke the idea of being a woman between the patriarchal 'pillars'.

Agar used assemblage to devise new purpose and personalities within an object and challenge gender conventions. Upon seeing a plain marble bust of her partner, Joseph Bard, Agar declared it caught nothing whatsoever of his character, and became determined to create a piece that did. The glittering (and – when witnessed in the flesh – stocky and heavy) *Angel of Anarchy*, 1936–40, is festooned with fabric, silk, seashells, feathers and diamanté stones, evoking both Bard's character and his significance in Agar's life as lover and muse. In acknowledgement of the great political and social upheaval taking place in Britain, Agar, who like Bard was

an anti-fascist and a pacifist, blindfolded the head in silk fabric, as if to symbolise her apprehensions about the future.

Surrealism continued to thrive in Britain. Leading the way were Edith Rimmington, Marion Adnams, Emmy Bridgwater, Kay Sage and Stella Snead, who each incorporated themes of nature and the significance of the landscape, perhaps to offer an imagined existence, away from suppressing patriarchal constructs.

In their paintings, the Surrealist women are intrigued by the slippage between different gender roles and the act of transformation. They painted themselves and each other in myriad guises, as well as using the medium to open up their psyches and inner worlds. With the outbreak of war in 1939, many of the women artists based in Paris went on to exhibit their work worldwide, and continued their practice in Europe, Mexico and the Americas.

Populating her paintings with commanding figures of women in the form of sphinxes, eroticised self-portraits with billowing hair, and emasculated males reminiscent of Velázquez's *The Rokeby Venus*, 1647–51, Leonor Fini (1907–96) incorporated the most fantastical, otherworldly realities in her tightly rendered surfaces. Born in Buenos Aires but raised in Trieste, in northern Italy (after her young mother escaped her domineering Catholic father), Fini, a self-taught artist, adopted a painting style reminiscent of the Renaissance works she had witnessed in her youth. Her childhood had been full of trauma, as she and her mother were often on the run from her father, who refused to grant his wife a divorce and was determined to take his daughter back to Argentina. To foil her father's kidnapping attempts, Fini dressed as a boy for many years. And during her adolescence, Fini suffered from rheumatic conjunctivitis that required her to have both eyes bandaged for months – which, allegedly, allowed her to look deep into her imagination.

Arriving in Paris in the early 1930s, Fini was adored by many. Chadwick has described her as: 'tall and striking, with jet-black hair and piercing eyes, she possessed a strange combination of feline grace and Amazonian power'. Rejecting Breton's manifesto and his misogynistic views, it was through paint that she depicted herself and her friends, Meret Oppenheim and Leonora Carrington,

Leonor Fini: (left) photographed at Arcachon, 1940; (right) *Self-Portrait with Scorpion*, 1938

as commanding women in charge of their own lives. Although at first glance her *Self-Portrait with Scorpion*, 1938, feels traditional, look closer and it exudes sexuality, seductiveness and dominance. Portraying herself in a proto-Punk, proto-feminist ripped dress, she holds a silver glove (a typical erotic symbol) hiding a scorpion (alluding to sexual passion or power) within. She turns three-quarters towards us, head-on, with self-assurance and determination. Influenced by the onset of the Spanish Civil War and the likelihood of another world war, Fini also turned to representations of the sphinx, as a warrior symbol of knowledge and beauty, with the power to overcome this distressing time.

The exploration of gender roles was a hugely important theme in Fini's work, as it was for the Surrealists as a whole. As if we were stumbling on a private scene, her *Self-Portrait with Nico Papatakis (L'Alcove)*, 1941, made at a time when she had fled Paris for Rome, presents a woman governing a highly idealised, eroticised effeminate male body with his hands coquettishly removing the bed sheets. Continuing to paint until her death in 1996 (she created the costumes for Federico Fellini's *8½*, 1963), and made ball gowns for the likes of

Leonor Fini, *Self-Portrait with Nico Papatakis (L'Alcove)*, 1941

Brigitte Bardot in the 1950s, she applied her Surrealist philosophy in every artform she tackled.

Similarly interested in magic, alchemy and experimenting with gender roles, Leonora Carrington (1917–2011) fled her debutante lifestyle in Lancashire to join the Surrealists in Paris. Like so many of the women of the movement who were from families steeped in tradition, Carrington was attracted to Surrealism for its anti-establishment values. However, after entering into a relationship with the much older artist Max Ernst, it was through painting that she portrayed her emotional and artistic oppression. In *Portrait of Max Ernst*, 1939, she presents him as almost feline, dressed in a billowing crimson fur coat and looming ominously in an icy land-scape. A white horse (representing Carrington) appears twice. One stands behind him, frozen in the distance, whereas another (in a similar style to Lee Miller's photograph of *Tanja Ramm under a Bell Jar*, p.174) is trapped in a green glass lantern, as if symbolising his inescapable, dominating control.

When the war broke out, and with no family to turn to, Carring-ton fled to Mexico City, a place that was appealing to Surrealist

artists because of its Aztec and Mayan history. It was here that she developed further as an artist and remained for the rest of her life, with close friends and fellow artists Remedios Varo (1908–1963), a Spanish painter known for her meticulously rendered alchemic and scientific paintings; photographer Kati Horna (1912–2000), who would capture Surrealist black-and-white images of Carrington; and poet and painter Alice Rahon (1904–87), who referenced Mexican culture, myths and landscape in her mystical paintings. Working well into the 2000s, Carrington often harked back to the constraints of her British childhood, through works such as *Green Tea*, 1942, which showed a mummified figure in a luscious verdant English landscape, and *Grandma Moorhead's Aromatic Kitchen*, 1975, which fused Mexican food with the memory of her grandmother's English stove.

The Mexican Surrealist art scene was already well established thanks to the legendary painter Frida Kahlo (1907–54) and the artists

Leonora Carrington,
Portrait of Max Ernst, 1939

Frida Kahlo, *Henry Ford Hospital*, 1932

participating in the cultural renaissance of post-revolution Mexico City. Another notable artist of the period was the self-taught María Izquierdo (1902–55), who produced vivid, icon-like portraits of women in traditional Mexican dress.

A 'child of the revolution' (she would lie about being born in 1910 as opposed to 1907, to coincide with Mexico's revolution), Frida Kahlo was passionately political and initially dreamed of becoming a doctor. However, following an early life full of trauma – she contracted polio at the age of six, which left her with a withered leg, and at seventeen suffered horrific injuries when she was involved in a bus crash – her dreams started to change. She was encouraged to paint when she was recovering from the accident and bedbound. She painted what she had access to – her friends, family, sisters, and also (her greatest subject) herself. Kahlo embraced and scrutinised her own image in a way that had never been done before.

Her output remains one of the most fascinating explorations of the self in art history.

Vulnerable, crippled, heartbroken, strong, assertive, full of life and in love, Kahlo portrayed herself going through every emotion and in every guise. She was intrigued by the body's ability to transform itself (a subject that also came up in the work of Carrington) and used painting to explore her struggles with pregnancy and miscarriage in images that are brutal yet truthful. In *Henry Ford Hospital*, 1932, we witness a harrowing Surrealist self-portrait of her experience of abortion, and of being separated from her foetus. Lying on an oversized hospital bed, her belly swollen and her spindled backside in a pool of blood, tears pour from her eyes, as she clutches a string-like umbilical cord that links her to the foetus, as well as to a snail, a pelvic bone, a machine, a flower and a cast — in this work, she presents the disturbing reality of what it was like to be a woman, affirming the vulnerability of the self in ways that remain radical today.

Not only was North America free of the misogynistic demands of the male Surrealists, but it was a place that was home to an inherently expansive surrealistic landscape (flat prairies and desert planes), motifs that would appear in the paintings of Dorothea Tanning (1910–2012) and Chicago-based Gertrude Abercrombie (1909–77).

Captivated by what she described as Surrealism's 'limitless expanse of possibility', the Illinois-born Tanning spent her childhood (where, she said, 'nothing happens but the wallpaper') escaping into the worlds of gothic novels and other literature. She first encountered Surrealism at the *Fantastic Art, Dada, Surrealism* exhibition in 1936 at the Museum of Modern Art (MoMA, formerly known as 'The Modern'), in New York, and three years later travelled to Paris in an attempt to meet the artists whose work she had seen. On getting there she discovered that many had fled the city at the outbreak of war. She would soon do the same and return home. In time, numerous European artists crossed the Atlantic, mainly settling in New York City, which became home to a haven of cultural refugees.

Dorothea Tanning,
Birthday, 1942

Determined to formulate her own Surrealist imagery and style, Tanning marked her 'birth' into the movement with a self-portrait. In *Birthday*, 1942, she stands bare-breasted, wearing a fantastical costume – a glittering mauve-and-silver, Elizabethan-like blouse, and a skirt filled with tiny formless bodies – in front of a suite of open doors that extend as far back as we can see. Perhaps a route to our most secret desires, the symbolism of the doors remains unknown. Famously evasive about her intentions, Tanning once said: 'Don't ask me to explain my paintings.'

Drawn to mystery and the power of dreams, upon moving to Sedona, Arizona (in her words, the 'landscape of wild fantasy'), Tanning painted *Eine Kleine Nachtmusik* in 1943. A disturbing

Gertrude Abercrombie, *Countess Nerona #3*, 1951

Surrealist nightmare picturing what looks like two young girls ominously standing in an empty hotel corridor, their hair erupting like flames as they are chased by (or are chasing) a giant sunflower. Experimenting further, Tanning later transformed elements from her paintings into soft sculptures in her installation *Hotel du Pavot, Chambre 202*, 1970–73, featuring stuffed, awkwardly shaped figures climbing on walls. As viewers of her work, we are unsure as to what constitutes life or reality, and through her art Tanning makes us see the world differently.

Working independently from the Surrealist 'group', Gertrude Abercrombie (1909–77) spent most of her life immersed in the Chicago jazz scene. With a penchant for cats, crescent and full moons, sinister desert-like landscapes that feature as paintings in bleak, cold interiors (as seen in *Countess Nerona #3*, 1951), stairs that lead to nowhere or a series of rhythmically coloured doors (as

Gertrude Abercrombie, *Doors, 4 (5 ½)*, 1957

seen in *Doors, 4 (5 1/2)*, 1957), Abercrombie forged a unique style, and presented her sometimes postage-stamp-sized paintings in flamboyant frames.

Through images of transformation, oppression and liberation, Surrealism as a movement and as a philosophy (which is still in development today) allowed women artists the possibility of challenging the establishment and fashioning their ideas, artworks and objects into something entirely new. Whereas some of these women are now more famous than others, in recent years exhibitions on Surrealism that feature only women artists have toured the world, in addition to major retrospectives by Tanning, Maar, Agar and Miller.

Chapter Six

MODERNISM
IN THE AMERICAS

(c.1920—c.1950)

NEW NATIONAL IDENTITIES
IN BRAZIL AND MEXICO

'I want to be the painter of my country'
— Tarsila do Amaral, 1923

In the early twentieth century there was a shift in focus from European-led narratives to the emergence of artistic centres elsewhere, in part fostered by the socio-political changes that were sweeping the globe. In this section, I begin by focusing on two particular countries experiencing rapid developments: Brazil, which gained independence from Portugal in 1822, abolished slavery in 1888 and eventually became a Republic in 1889; and Mexico, which faced total social upheaval following the revolution of 1910. These landmark moments in their histories spawned a hunger to shape new national artistic identities. One that could be free from the conservative past of colonial power and expressed in a vocabulary that was better representative of the Brazilian and Mexican people.

The early 1900s saw Brazil alive with optimism and opportunity, which called for a new type of art. Two driving forces in propelling this change of direction were Anita Malfatti (1889–1964) and Tarsila do Amaral (1886–1973). Both were part of the Grupo dos Cinco (Group of Five) – a group of painters, poets and writers who were central to the 1922 Semana de Arte Moderna in São Paulo: a cultural festival marking the birth of a new movement, which was held a century after the country achieved independence. Although do Amaral was not present at the event, her work, together with that of the Grupo dos Cinco, changed the face of Brazilian art.

Travelling around the globe as young women (at a time when it was rare to do so), Malfatti and do Amaral synthesised styles from the Americas to Europe in their bold paintings. Malfatti is

Tarsila do Amaral, *Carnival in Madureira (Carnaval Em Madureira)*, 1924

credited as the first Brazilian artist to bring European Modernism to São Paolo; do Amaral, conversely, is hailed for forging a specifically 'Brazilian' language that spoke to the country's population and landscape.

Raised in a bourgeois family whose wealth stemmed from managing a coffee plantation (the biggest export in São Paulo at the time), the young do Amaral was fortunate to have the chance to travel abroad, arriving in Paris in 1920. Travelling between France and Brazil, by the mid-1920s she had established her artistic vocabulary: exaggerated forms, distorted body features, simplistic shapes and bold colours (fiery oranges, blue skies, lemon-like suns). Taking influence from the Cubists, Brazilian folk art and her travels to the Minas Gerais region, do Amaral shifted her country's nationalistic identity by working with subjects that referenced the mythological creatures from Guaraní folklore, the cannibal, the *favelas*, and the industrial areas of a developing Brazil, an example being the energetic and bustling *Carnival in Madureira (Carnaval Em Madureira)*, 1924. But it is important to note that, as a white, privileged Brazilian,

Tarsila do Amaral,
Abaporu, 1928

sometimes her work from this time was racially problematic. This includes *A Negra*, 1923, which depicts a formerly enslaved Black Brazilian woman who lived on her family plantation, as well as presenting essentialised images of the Black female body as maternal and enshrined in nature.

Do Amaral is best known for her contribution to the Anthropophagic movement with her *Antropofagia* series, which she began in 1928, and in particular her painting *Abaporu*, 1928, which inspired her then-husband, José Oswald de Andrade, to publish the Anthropophagic Manifesto. *Antropofagia*, translating to 'cultural cannibalism', was the core idea of the manifesto, which spoke to notions that Brazilian artists must 'digest' or 'internalise' foreign (European) influences, to carve out a language reflective of their Brazilian heritage.

But after 1929, everything changed. The financial crash – which cost her family their fortune – and the subsequent rise of Getúlio Vargas's military dictatorship meant do Amaral was unable to sustain her bourgeois lifestyle and her subjects shifted dramatically.

Tarsila do Amaral, *Composição (Figura só)*, 1930

Some, such as *Figura só* (*Lonely Figure*), 1930, picture an isolated figure, her back turned towards us as if looking out into an abyss, with remnants of the vegetal motifs that once appeared in her paintings; others depicted socially conscious and sensitive portrayals of the people around her. (She also joined the Communist Party and visited the Soviet Union, for which she was detained for nearly a month.) Today, she remains Brazil's most famous artist (she goes by 'Tarsila', she's so well-known), and a recent exhibition at MoMA helped catapult her into worldwide recognition.

At a similar time, Mexico went through a radical cultural shift known as the Mexican Renaissance: a movement of great artistic production, which aimed to revive the spirit of the country's heritage, speak to people of all classes and instil socially conscious values. Artists associated with the movement included Frida Kahlo (p. 182) and, more broadly, the Mexican Muralists, which was a government-funded project of politically conscious art on public buildings. In a male-dominated field, Aurora Reyes Flores (1908–85) is thought to be the first female Muralist.

Photographers also documented the spirit of the era, my favourite being Tina Modotti (1896–1942), who not only spent her

seven-year photographic career in Mexico, capturing raw images of the people and landscapes, but used her camera to directly engage with political and social issues.

Modotti's own life was never far from drama. Raised in Italy, in 1913 she migrated to the US to join her father. Adored for her striking looks, she soon began work as a model, then an actor, starring in a string of Hollywood silent films. Taking up photography, in 1923 she moved to Mexico City to join the cultural avant-garde and experimented with intimate, hazy studies of close-up wilted flowers and light-filled architectural environments – some of the earliest examples of abstraction in photography.

As the 1920s progressed, and her involvement in the Communist movement deepened (officially joining the party in 1927), Modotti turned her lens towards social documentary, photographing empathetic, yet I think triumphant, portraits of locals and labourers. From the powerful and courageous *Woman with Flag*, 1928, who determinedly walks forward clutching an oversized standard, to

Tina Modotti,
Woman with Flag, 1928

Tina Modotti, *Diego Rivera and Frida Kahlo in the May Day Parade, Mexico City, 1st May, 1929*, 1929

the cropped, dusty portrait of *Worker's Hands*, 1927, Modotti also took her camera to anti-fascist, leftist rallies (with friends Frida Kahlo and Diego Rivera).

However, following the assassination of her then-lover, the Cubist revolutionary Julio Antonio Mella, she was forced to leave Mexico and abandon photography entirely. Fleeing Mexico for Weimar Berlin, Soviet Russia and then Spain, in 1939 she returned to Mexico City, but died three years later in the back of a taxi. Some still question the cause of her death, viewing it with suspicion due to her ardently leftist politics.

Modotti's parting gift to photography was handing her camera down to the equally inquisitive Lola Álvarez Bravo (1903–93). Inspired by Modotti's modernist aesthetic of architectural lines and intimate socially conscious images, Bravo also used street photography and Surrealist-style photomontages to document her country's changing political landscape. But my favourite works by Álvarez Bravo are of her friend Frida Kahlo. Capturing her as reflective and thoughtful, with a deep, introspective humanity, Bravo's images of Kahlo show a woman privately exploring her

identity, the emotional and physical pain she endured, and life as a woman in an ever-evolving world. Also a teacher and gallery owner, in 1954, Bravo staged Kahlo's only ever solo exhibition in Mexico during her lifetime. A show she had to arrive at via ambulance and be carried into on a hospital stretcher. Kahlo died one year later, but Bravo continued to take photographs until her death in 1993.

THE HARLEM RENAISSANCE

'We do not ask any special favours as artists because of our race.
We only want to present to you our works and ask you to
judge them on their merits' — Augusta Savage, 1939

Harlem in the 1920s and 30s was the epicentre of Black cultural creativity, and home to the birth of a cultural movement that became known as the Harlem Renaissance. With no unifying artistic style other than the desire to give expression to the Black experience, work produced in the Harlem Renaissance ranged from literature, dance and music to visual art. A time of intense cultural rebirth similar to the Italian Renaissance, the movement had such a radical impact that its influence stretched far beyond the confines of Harlem to Philadelphia, Boston, Chicago and further afield.

The 1910s had been a time of extensive transformation for African American communities. The abolition of slavery in 1865, followed by strict segregation laws enforced by white supremacists, meant that six million African Americans participated in The Great Migration of the 1910s: relocating from the rural South to Northern American cities to seek better economic opportunities. This event instilled a feeling of optimism. Cities formed within cities, and artistic communities – previously denied the freedom of expression due to the constraints of segregation – flourished. A prime example was the Upper Manhattan neighbourhood of Harlem, which by the 1920s had drawn in nearly 200,000 African Americans and was known by locals as the 'Black Capital'. With the negative imagery from white supremacists continuing to circulate, African American

artists actively associated their work with Black pride and advocated this message for the next generations.

Several such female artists played pivotal roles in this development, despite their limited opportunities in the visual arts, and earned international recognition during their lifetimes. This was in part thanks to their predecessor Edmonia Lewis, who set a precedent for great Black female sculptors (p. 79). Using painting, printmaking, sculpture and illustration, the artists took as their subject social issues and Black identities, which up until then (in Western art history) had been seen through a predominantly white, male lens. As activists and educators, the women countered racial stereotypes through their art. Working alongside the Paris avant-garde, painters such as Loïs Mailou Jones reclaimed the stylised visual language of Cubism, a European aesthetic influenced by African sculpture.

Even though opportunities were forged through exhibitions, community-run schools or freelance illustration commissions in magazines (*Opportunity* and *The Crisis* published the work of Laura Wheeler Waring and Jones), Black women faced constant racist and sexist discrimination. Many, like Jones, left for Paris, where they experienced a more tolerant environment and further artistic opportunity.

Regarded by some as the 'foremother' of the Harlem Renaissance, Meta Vaux Warrick Fuller (1877–1968) used her sculptures as a means to break away from traditional European-focused narratives and celebrate Black experience and history. Arriving in Paris from the US in 1899, where she came under the mentorship of Auguste Rodin and influential African American painter Henry Ossawa Tanner, Fuller initially sculpted recognisable biblical and mythological subjects. But being in Paris encouraged her to move beyond realism and focus her attention on expression. After meeting key Harlem Renaissance thinker W. E. B. Du Bois, Fuller was further motivated to centre her subjects on African Americans in order to promote the positive visibility of her community.

On her return to the US in 1903, Fuller pursued imagery which told the narratives of Black people in her own way. Producing poignant, striking, and empathetic sculptures, one of her finest

examples, I think, is *Ethiopia*, *c.*1921: a tall, mummified female figure who stands in a noble stance, as if waking up, on the dawn of greatness. Speaking about *Ethiopia*, she recalled, 'Here was a group who had once made history and now after a long sleep was awaking, gradually unwinding the bandage of its mummied past and looking out on life again, expectant but unafraid and with at least a graceful gesture.'

More trailblazing sculptors followed. Augusta Savage (1892–1962), raised in a strict family in Florida with a father who opposed her artistic pursuits, arrived in New York with just $4.60, and in 1922 enrolled at the Cooper Union School of Art. Coming to the fore in the 1920s, Savage mastered emotionally tender and stoic life-size figures and plaster portrait busts (painted with shoe polish for a bronzed effect), and her subjects ranged from dignified everyday Black figures to influential Harlemites, including W. E. B. Du Bois. She was also an advocate for equality, in particular in education, having her-

Meta Vaux Warrick Fuller,
Ethiopia, c.1921

self been denied a scholarship to study in France because of her race. By 1929, though, she had been awarded a Julius Rosenwald Fellowship (one of the few grants offered to artists of colour), permitting her to study and work in Paris.

Returning to Harlem in the early 1930s, Savage became the first African American woman in the US to open her own private art gallery (solely exhibiting and selling work by Black artists, including the likes of Gwendolyn Knight and Elba Lightfoot). In 1937, she was appointed the first director of the Harlem Community Art Center (HCAC), America's largest Works Progress Administration-funded school, which helped many artists, including painter Jacob Lawrence, start their careers. Lawrence later commented in 1992, 'Coming in contact with Augusta Savage was one of the highlights of my career.'

Savage's breakthrough came in 1937, when she was commissioned by the 1939 World's Fair to make a sculpture reflecting the contribution to music by African Americans. Originally titled *Lift Every Voice and Sing* (in reference to the hymn known as the 'Black national anthem') but renamed *The Harp* by the fair organisers, at sixteen foot high it portrayed an elegant harp-shaped choir of Black children whose bodies, making up the instrument's strings and

Augusta Savage, *The Harp*, 1939

wearing floor-length robes, stand in what appears to be the palm of God's hand. Centrally positioned, *The Harp* earned Savage national press coverage. Although photographs of the work still survive, the sculpture itself was destroyed after the fair, due to lack of funding to pay its storage costs. It is a tragic event that makes us think about the impact this piece could have had in the twentieth century and beyond. However, Savage's legacy lives on in the work of the students she taught, and the impact that their art had, and still has, on future generations.

A contemporary of Savage, who also worked at the HCAC, Selma Burke (1900–95) made busts of well-known figures and expressive wooden sculptures. Having initially studied for a career in nursing, it was after arriving in New York City in 1935 that she took sculpture classes at night, which she financed through her job as an artist model. Soon absorbed in the creative energy of the Harlem Renaissance, Burke (like Savage) was awarded a Rosenwald Fellowship that took her to Europe. A great believer in education, in 1946 she established the Selma Burke Art School in New York, and later the Selma Burke Art Center in Pittsburgh, which was open from 1968 to 1981.

For those reading this in North America, Burke might mean more to you than you realise – you could even be carrying one of her portraits around with you now. In 1943, she won a commission to sculpt a bronze relief sculpture of then-President Franklin D. Roosevelt, but he didn't survive to see the final version. As a result of his death, another engraving – this time by John Sinnock – was commissioned for the 1946 US dime, a version that was strikingly (some might say uncoincidentally) like Burke's. Outraged at the similarity, she demanded the FBI investigate this case. Unsurprisingly, they did not, and Sinnock never credited her. I strongly agree with those who say Burke should be celebrated for this artwork, and his 'JS' initials should be replaced by her 'SB'. The debate continues today.

Another educator, who taught for a staggering forty-seven years at the renowned Howard University in Washington, D.C. – the epicentre of Black intellectualism – Loïs Mailou Jones (1905–98) enjoyed an extensive career that stretched from the height of the

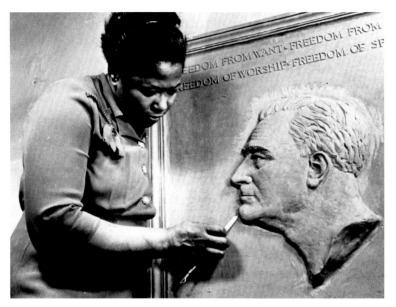

Selma Burke with her bas-relief portrait of President Franklin D. Roosevelt, c.1940s

Harlem Renaissance through to the late twentieth century. Born to accomplished, professional parents, Jones spent her early years in Boston and on Martha's Vineyard, surrounded by the cultural elite – including Meta Vaux Warrick Fuller, an early mentor to the young Jones.

Between 1923 and 1927, Jones was continuously awarded scholarships to the School of the Museum of Fine Arts, which was associated with the prestigious Museum of Fine Arts, Boston, where the highly determined artist originally specialised in textiles. However, her change in direction to fine arts was sparked by her finding out that designers' names weren't 'recognised' in the same way as painters'.

Spending summers immersed in the community of 1920s and 30s Harlem, exhibiting and attending key cultural events, in 1937 Jones ventured to Paris on sabbatical until 1938. Here she adopted a Post-Impressionist style and painted *en plein air*. Like so many of her contemporaries, Jones felt welcome as an artist in the French capital, recalling it offered her 'Freedom. To be shackle-free.' Incorporating African themes in her work – such as *Les Fétiches*, 1938, a small paint-

Loïs Mailou Jones, *Les Fétiches*, 1938

ing of multiple African masks infused with electric colouring – it was on her return to the US that philosopher Alain Locke prompted her to embrace everyday subjects of African American people. Constantly renewing and regenerating her artistic styles, Jones was inspired by trips to Haiti, France and the African continent, and in the 1940s she created some of her most tender, powerful portraits.

Although the Harlem Renaissance movement does not have an exact end date, I want to conclude this section with an artist who, working slightly later, was part of the generation that benefited from the movement's advancements and dedication to social justice and education.

Elizabeth Catlett (1915–2012) was a teenager during the height of the Harlem Renaissance. A student of Jones at Howard University in the 1930s, Catlett went on to study for her Master of Fine Arts at the mainly white University of Iowa, where, subjected to racial prejudice, she was disallowed from living on campus (she ended up living off-site with the future acclaimed novelist and poet Margaret Walker). Learning under the American modernist Grant Wood, who told her to 'take as your subject what you know best', from then on Catlett used art to reflect her own experiences. In the early years of her career, she sculpted expressive portrayals of mothers and children with identifiably Black anatomical features, reworking a traditional and common theme in the history of Western art that until then had almost always been exclusively focused on white subjects.

Instilling a sense of commitment to teaching the next generations, in 1942 Catlett moved to Harlem, where she became fully engaged in the community. She taught night classes at the George Washington Carver school, which had been established for Black professionals but was later shut down by the authorities due to the looming suspicions of Communist leanings that were being hunted out during the Cold War. Turning to printmaking for its democratic nature, Catlett's primary artistic purpose was to express social and political messaging (despite her art being incredibly beautiful and powerful,

Elizabeth Catlett,
Sharecropper, 1952

as well as imbued with intense and emotional forms, an example being *Sharecropper*, 1952). In 1946 she travelled to Mexico City, where she met and joined the Taller de Gráfica Popular, a radical printmaking collective, and remained there for the rest of her life.

The influence of the women of the Harlem Renaissance – both artistic and educational – is still felt in the neighbourhood (and beyond) today. Producing works of empathy, joy and poignancy, these women helped to revolutionise perceptions of the Black community through visual art, and thanks to major recent scholarship published on Lewis, Fuller, Jones, Savage and Catlett, they have been catapulted into the spotlight more than ever. With this renewed interest in these pioneering artists, we can perhaps hope to see more exhibitions of their work held worldwide to invite in new global audiences and pay homage to their huge significance in the story of art.

A NEW VISION OF LANDSCAPE

'Men put me down as the best woman painter.
I think I'm one of the best painters' — Georgia O'Keeffe

It is difficult, and perhaps futile, to always categorise artists into movements. Artists aren't the product of movements, but rather movements are the products of artists and their visionary innovations. One artist I find especially resistant to categorisation is the modernist giant Georgia O'Keeffe (1887–1986). O'Keeffe was a painter who I believe forged a more original artistic language for landscape than that of anyone else in America at the time. She was always fascinated by the natural world, and the subjects of her paintings in the early years were of natural forms (flowers, trees, shells) and cityscapes filled with electrically lit skyscrapers. In 1929, when she began to spend summers in the high desert of Northern New Mexico, O'Keeffe turned to adobe churches, animal skulls and the vastness of the American Southwest – opening a new vocabulary for American art.

Working at a similar time were Spiritualist artist Agnes Pelton and Canadian painter Emily Carr. To me, these two trailblazing artists, despite their immense differences, shared a vision akin to O'Keeffe in carving out a unique style of painting for the wild landscapes of North America, set apart from mainstream, Eurocentric influences.

Spending her childhood in wide-open countryside on a Wisconsin farm, and later in Virginia, O'Keeffe was one of the first women in America to receive an artistic education, studying at the Art Institute of Chicago School of Art, then the more progressive Art Students League in New York City. Her family was unable to fund more than a year at the Art Students League and O'Keeffe took teaching positions in art to pay her own way. Enrolling in summer courses at the University of Virginia – a male college that accepted female students in the summer – she was introduced to the principles of influential educator and painter Arthur Wesley Dow: to disseminate the natural world into lines and shapes – in other words, to explore abstract forms.

Employing Dow's revolutionary principles, O'Keeffe produced a group of charcoal drawings of semi-abstract shapes and sent them to her former classmate Anita Pollitzer, who brought them to Alfred Stieglitz, the photographer who ran the New York gallery 291. Immediately enthralled, Stieglitz exhibited them and invited the young artist to live under his patronage in the city (the pair would later marry and collaborate, with O'Keeffe often modelling for his photographic work).

Painting intensely dazzling, microscopic visions of flowers (which were generally interpreted by Stieglitz and male art critics as alluding to sexualised forms of the body) and equally luminescent cityscapes of imposing structures emblematic of modernity, it was in the late 1910s that O'Keeffe honed her style: blazons of colour in reduced biomorphic forms. But after frequenting New Mexico (her permanent home from the late 1940s), she shifted to making its arid landscape the subject of her work, featuring its lunar skies, red cliffs, golden plateaus and dry, dusty planes, as seen in *Black Mesa Landscape, New Mexico/Out Back of Marie's II*, 1930, with its beastly

Georgia O'Keeffe, *Black Mesa Landscape, New Mexico/Out Back of Marie's II*, 1930

and vascular umber mountains that heavily contrast with the soft icy peaks. Incorporating motifs of skulls and bones, she once set a cow's skull against red, white and blue stripes to evoke the American flag (see *Cow's Skull: Red, White, and Blue*, 1931). O'Keeffe also looked at the minutiae of bones. It is these glowing, semi-abstract compositions – as seen in *Pelvis II*, 1944 – that have the power to distort our vision, forcing us to recentre our perspective on such a familiar motif.

Like O'Keeffe, Agnes Pelton (1881–1961) was captivated by the desert. Her career began in the early 1900s, but she lived most of her life in solitude, residing near Palm Springs. She, too, studied the principles of Arthur Wesley Dow and adopted a mystical, ethereal style. Pulsating with celestial forms, biomorphic shapes and recurring natural motifs (stars, clouds and water), Pelton's glittering landscapes look as though they belong in a cosmic, other-worldly realm. Like Hilma af Klint (p. 100), Pelton was inspired by spiritual philosophies such as Theosophy, the teaching of the world through mystical insight, which she reflected in her paintings,

Agnes Pelton,
Star Gazer, 1929

portraying images from her dreams and visions and offering a glimpse of her inner world. For me, *Star Gazer*, 1929, especially emulates a divine-like vision, its focus being on a gleaming orb that levitates above the silent, night-filled desert.

Moving away from the cosmic, and situating the spiritual in a vegetative, verdant landscape, I want to end this trio with Emily Carr (1871–1945). Travelling widely, Carr spent her earlier career engaged with Canada's First Nation cultures and Indigenous vil-

Emily Carr, *Sombreness
Sunlit*, c.1938–40

lages. Like Pelton and O'Keeffe, she documented the natural world, in particular the Pacific Northwest Coast of British Columbia. These later hallucinogenic paintings of forestscapes are, I find, injected with a supernatural mood. You can almost sense the wind howling through the trees, emanating regeneration, energy and the soul of nature.

While I see O'Keeffe and Pelton engaged in a mystical realm, Carr's paintings feel more earthy, as though she is evoking the power of the soil and being immersed in nature. Carr and O'Keeffe are some of the most celebrated artists of their respected countries, but Pelton has come to the foreground only recently thanks to a major touring exhibition in the US. Despite all of these women working separately, they each reimagine the North American landscape in their own way – capturing the vast, spiritual power of this wide, expansive environment.

Chapter Seven

WAR AND THE RISE OF NEW METHODS AND MEDIA

(c. 1930–c. 1960)

DOCUMENTARY PHOTOGRAPHY
AND SOCIAL REALISM

'The camera is an instrument that teaches people
how to see without a camera' — Dorothea Lange, 1978

How do you record a historical event and at the same time capture the pathos, empathy or terror of those who experienced it? How can a single image define an era, give us a glimpse into history, or help us understand the truth of what happened?

The early decades of the twentieth century, in the wake of the Second World War, were full of political crises – the rise of Nazi Germany and fascism in Spain, and an increasingly desolate America struggling through the Great Depression. Looking at how people made art in response to these events, or how they were documented through photojournalism and street photography, helps us to understand the harsh realities of these dark times in history.

With the technical advancements of the hand-held camera developing at rapid speed, photography was becoming an increasingly available tool. Since 1888, the hand-held camera had enabled photographers to take to the street and record, through their distinct and personal lens, pivotal historical and political events, as well as everyday scenes. As a new and less-developed artform, photography was inherently more democratic than painting: women could participate without needing to push back against hundreds of years of male-dominated art-making, meaning they had more freedom to carve out their own space. When the world was in the grip of a crisis, women used photography to capture the devastation intimately, starkly, triumphantly and honestly.

In October 1929, the Wall Street Crash resulted in the largest worldwide economic downturn in history, known as the Great Depression. The combination of a poor agricultural policy, the system of tenant farmers and share croppers and a climate that eroded

the soil resulting in the devastation of the Dust Bowl, poverty in the US intensified, forcing 300,000 people to abandon their homes and seek work elsewhere. At the time, photographer Dorothea Lange (1895–1965) was working in her downtown San Francisco studio, but in 1933 she ventured out into the streets to photograph the jobless. Employed by Roosevelt's Resettlement Administration (RA), an agency created as part of his New Deal in 1935, she took her camera – her weapon – as a force for change and headed to the Mid-west to document the dispossessed.

Derelict shacks, makeshift tents, expansive landscapes and devastated families – Lange communicated the sweeping narrative of the time through intimate photographs of real people. In 1936, she took her most famed image, *Migrant Mother*, of Florence Owens Thompson, who looks beyond Lange's camera into a bleak, forlorn nation while shielding two children and cradling a sleeping baby. Her tense gaze and furrowed brow are evident of an uncertain future; her fraying sleeves evocative of the abysmal conditions. Soon picked up by

Dorothea Lange,
Migrant Mother, 1936

Dorothea Lange, *Turlock, California, May 2, 1942*, 1942

newspapers, the image subsequently prompted the government to send thousands of supplies to her camp, although Owens Thompson had already moved on by then. *Migrant Mother* affirmed Lange as one of America's most significant photographers of all time.

In response to the Japanese attack on the US naval base at Pearl Harbor in 1941, the American government forcibly rounded up more than 100,000 Americans of Japanese descent who were living in the US and sent them to internment camps (one of whom was the young artist Ruth Asawa, p. 256). Lange was hired by the government to photograph the camps, this time by the US War Department. Rebelling against the institutions that employed her, Lange's empathetic images sympathise with the persecuted Japanese Americans (although as a government employee she was supposed to remain neutral) and capture some of the most emotionally arresting images of the communities she found there. She documented young people, old people, people in their camps, homes, or in front of the American flag; for me, the most affecting images are of child evacuees swamped by giant suitcases bigger than their tiny bodies, as seen in *Turlock, California, May 2, 1942*. It is difficult to look at these images without

feeling their subjects' pain and humiliation. As if to amplify the injustices, many of Lange's images were censored and not released until long after the war had ended (the government owned the rights to them). It took until 1988 for the US government to issue a formal apology for the way they treated Japanese American citizens in their own country. Through her photographs Lange brought attention to the people living in dire circumstances, in ways that transcended cultures and now, generations later, transcend time.

Across the ocean in Europe, the 1930s signified the start of one of the most politically tumultuous times in history. At the invitation of the Confédération Générale du Travail union, in 1937 Kati Horna (1912–2000) travelled from Paris to Spain to photograph (in her distinct Surrealist style) individuals in small villages and large cities affected by the Spanish Civil War. At a similar time, Lee Miller (p. 174) was becoming one of the most renowned correspondents of the Second World War.

Already achieving success with her Surrealist and commercial work across Europe and America, by 1939 Miller had settled in England, where she started photographing fashion shoots for British *Vogue*. Some shots were taken against the rubble of the Blitz, while others saw women donning fantastically surreal fire masks in front

Lee Miller, *Fire Masks,*
21 Downshire Hill,
London, England, 1941

Lee Miller with David E. Scherman, *Lee Miller in Hitler's bathtub, Hitler's apartment, 16 Prinzregentenplatz, Munich, Germany*, 1945

of an air-raid shelter in her own Hampstead garden, as seen in *Fire Masks*, 1941. From 1941, though, Miller ventured around the country to document women's contributions to the war – from pilots to nurses and Auxiliary Territorial Service officers. In 1944, she arrived in northern France, where, just one month later, she would be the only photojournalist to witness – and capture on film – the Siege of Saint-Malo.

Women were banned from working as photographers on the front line, so many of Miller's images record painful, psychologically intense expressions of those subjected to shame and suffering on the

home front. But for me, her most upsetting and frightening images, which retain their power even today, are those from her travels to the death camps of Buchenwald and Dachau. Here she witnessed the inhumane atrocities of the Holocaust. When covering the liberation of Dachau, Miller wrote 'I implore you to believe this is true' in a note to British *Vogue*, accompanying one of her most significant articles, titled 'Believe It', featuring a devastating image of deceased, fragmented, skeletal and starved bodies piled up on one another, their bare bones made visible by her night-time flash.

Never afraid to enter into terrifying places, on the same day she left Dachau, Miller – along with her friend the Jewish photojournalist David E. Scherman – broke into Hitler's Munich apartment. It was here that they famously photographed Miller sitting in Hitler's bath, his muddied bathmat evidently stained by her military boots. Going further, Miller also photographed Scherman in the bath, looking painfully tense, with the shower visible, in reference to the atrocities of the death camps.

Miller eventually moved back to England in 1946, settling at Farley's Farm in Sussex – which was no doubt an abrupt shift from her active, dramatic life. She attempted to adjust to normality, but struggled. Suffering from post-traumatic stress disorder, Miller channelled her great energy into becoming a chef, the only profession her son, Antony (born 1947), thought his mother had had. It was not until a year after Miller's death in 1977, when Antony's wife found '20,000 original photographs and 60,000 negatives' in the family attic, that the truth of her life was revealed. Antony, and his daughter, Ami, have since dedicated themselves to uncovering the life and art of this exceptional photographer.

As the century progressed, women continued to pioneer photography. Margaret Bourke-White (1904–1971), the first woman photographer hired by *LIFE*, established her name documenting working life in the Soviet Union, whereas others, such as Helen Levitt (1913–2009) and Vivian Maier (1926–2009), using the streets as their stage, reflected everyday American culture through their quietly theatrical, uncanny, black-and-white street imagery.

THE SECOND WORLD WAR
AND THE HOLOCAUST

Art has always been an attempt to find expression in the face of the inexpressible. Experiencing fascist Italy, the rise of Nazi Germany and the brutality of war, Hannah Ryggen in Norway and Charlotte Salomon in Germany used their art to communicate their political beliefs and circumstances. At the same time they conveyed extremely personal stories, blurring the boundaries between art and reality.

Swedish-born Hannah Ryggen (1894–1970) was a passionate activist, pacifist and advocate of equality, who expressed her deep fury at the rise of fascism in colourful textiles. Living mostly in isolation in a remote farm on a peninsula in the Trondheim Fjord, she spun wool shorn from her sheep and taught herself to weave on a custom loom.

Having spent a decade mastering the technicalities of weaving, in 1933, as political turmoil was brewing all over Europe, Ryggen began work on her monumental tapestries. Infused with luminous dyed colourings (extracted from leaves and fruits), Ryggen's tapestries were direct responses to the political events and injustices of the day, using the artform to attack contemporary global enemy leaders, such as Mussolini, Hitler and Franco. Her first large-scale tapestry, *Fishing in the Sea of Debt* (*Fiske ved gjeldens hav*), 1933, made in the wake of the Great Depression, centres on a greedy debt collector fishing for money with myriad tragedies unfolding around him.

So began Ryggen's series of fearless anti-capitalist and anti-fascist tapestries devoted entirely to those who suffered in the turbulent war years, which she was known to leave out for Nazi passers-by to see. Clearly emotionally invested in the victims of the war, and no doubt using art to try to comprehend the true horrors as events in real life, Ryggen once wrote to a friend, 'What is dream and what is reality?'

In 1935, Ryggen produced *Ethiopia*, 1935, a complex, intricately woven tapestry through which she portrayed Italy's brutal attack on the country. More subdued in colour than her other works, *Ethiopia* depicts a square-faced Mussolini with a spear through his head. First exhibited at the Norwegian Pavilion at the 1937 Paris World Fair – where it was positioned near Picasso's *Guernica*, 1937 – the work was deemed so offensive the Italian authorities insisted the Mussolini section of the tapestry be hidden from sight.

Never shying away from her strongly held views, her tapestry *6 October 1942*, 1943, which refers to the state of the Nazi occupation of Norway two years in, also cited the execution date of ten local Trondheim residents killed by SS officers, one of which included her friend, a theatre director, whose brutal death she restages. On their right stands a firm Winston Churchill in a brick fortress, and further along are the Ryggen family on a small boat, guarded by roses from the violent waters with the monstrous mask-like faces of Hitler, Goebbels and Göring looming above them.

Working at a similar time was the German Jewish artist Charlotte Salomon (1917–43), who between 1941 and 1943, while on the run from the Nazis and living with her grandparents in the South of France, produced one of the most extraordinary, profound and ambitious works I have ever seen. Made up of 784 individual gouaches, *Life? Or Theatre?* is a dramatised autobiography written in the style of a three-part opera (Prelude, Main Part and Epilogue) with rich, vivid imagery and accompanying text. Complete with a score and

Hannah Ryggen, *6 October 1942*, 1943

Charlotte Salomon, from the
series *Life? Or Theatre?*, 1941–2

characters based on Salomon's life, *Life? Or Theatre?* is at times constructed as a detailed comic-strip-like storyboard, while in others the scenes appear hurried, as though she were swept up in its intensity.

Painting up to three gouaches a day (some with erratic energy, as if painting was the only thing she could hold on to), *Life? Or Theatre?* is produced with emotional vigour, full of glaring colours and brushstrokes ranging from intricate to rapid flurries. She records her realities of living in the rise of Nazism as a young Jewish girl in Berlin, the events of Kristallnacht, her escape from Germany to Nice, alongside her coming of age – going to school and then falling in love – albeit in unspeakable circumstances. But we also witness her personal trauma of coming to terms with her family's long history of suicide and mental illness. Beginning with when her aunt, also named Charlotte, jumps to her death on a gloomy Berlin night, Salomon goes on to re-examine her mother's death, also by suicide (although at the time the eight-year-old Salomon was told the cause was flu). As if to use the redemptive power of art to both process and escape personal tragedies, towards the end of this piece she turns to the death of her grandmother. She wrote: 'My life began ... when I found out that I myself am the only one surviving. I felt as though the whole world opened up before me in all its depths and horror.'

Never before has such a vast work dealt with so much immediate and traumatic imagery, which physically collapses as she tries to tell her stories: bodies falling vertically and horizontally, monstrous figures towering in tight hallways, the young Charlotte gazing up longingly to the angels in heaven expecting to receive a letter from her deceased mother. Exactly as titled, the barriers between life and theatre are indistinct, and despite the imagery of death throughout, there are scenes evoking the joy of life, with glimpses of beauty in luscious gardens, declarations of love, music, painting by lakes, with Salomon exclaiming at the end, 'I will live for them all.'

The most confronting, intimate and powerful visual record of a life ever told, Salomon's *Life? Or Theatre?* reveals a woman who used art to deal with her feelings of terror, love, passion, rage and survival. In 1943, Salomon's life was cut short. Along with her new husband, she was rounded up in France and deported to the extermination camp at Auschwitz, where she died aged twenty-six, five months pregnant.

The works of Salomon and Ryggen are important expositions of history, through which we witness first-hand accounts of individuals dealing with the horrors of the time. Both women are remarkable as individuals who used the tool of art, for all its redemptive qualities, to try to make sense of inexplicable tragedies.

Charlotte Salomon, from the series *Life? Or Theatre?*, 1941–2

ST IVES AND BRITISH ABSTRACTION

'I can't be unpolitically minded. I'm very involved, just as I was
in the Thirties during the Spanish war. I was involved in industry
in my home town. I was involved in the distress and the strikes.
I wasn't marching but I was involved through my work'
— Barbara Hepworth, 1973

At the start of the Second World War, artists based in European cultural centres travelled to join artistic communities across the globe, from New York to Mexico City. But there was also one small fishing village on the edge of west Cornwall that re-emerged as an international artistic hub – some might say it became the centre that defined Modern British Art for decades following the war: St Ives.

Hailed for its glowing light, mild summer climate and rocky terrain surrounded by seas, St Ives had been attracting artists since the end of the nineteenth century. Artists came from across the globe, from Finnish painter Helene Schjerfbeck (p. 121) and Canadian painter Emily Carr (p. 206), to the New Zealand native Frances Hodgkins. Students of the nearby Newlyn School and the neighbouring village Lamorna – an artist colony known for its strong queer community, which was home to Marlow Moss, Gluck, Ithell Colquhoun and Laura Knight – also had a significant creative impact.

But when the already established modernist sculptor Barbara Hepworth (1903–75) arrived in 1939, the town's reputation further elevated. With its wild beauty, subdued colours and a coastal landscape that became synonymous with British abstraction, St Ives offered artists a place of refuge, far away from the bombing and air-raid sirens of cities and the reminders of the ongoing conflict.

Hepworth, to me, is the giant of twentieth-century sculpture, and arguably the most influential artist to have ever resided in St Ives. Enormously successful and fiercely ambitious during her lifetime (she exhibited internationally and was the first woman to represent

Barbara Hepworth, *Sculpture with Colour and Strings,* 1939/61

Britain at the Venice Biennale), Hepworth is acclaimed for her small-to-colossal sculptures, which she hand-carved in wood and stone (and, from the 1950s, cast in bronze and other metals). Materials and techniques were fundamental to her artistic interplay between surface, space and form. Her sculptures fluctuate between hard and soft, light and dark, round and straight, solid and hollow, and are sometimes embedded with strings and suffused with colour.

Born in Wakefield, in the north of England, a region known for its dramatic, rolling-hilled landscape (silhouettes she was to always carry with her), Hepworth was just seventeen when she began studying at Leeds School of Art, then the following year transferred to London's Royal College of Art. Spending her early adult life visiting Italy, picking up direct carving techniques, frequenting Paris (where she briefly joined the movement Abstraction-Création – a group of predominantly politically focused abstract artists), and living among an artistic community in Hampstead, it was also around this time that she distilled her style to a simplified abstract language. (This is especially evident after 1934, when Hepworth gave birth to triplets, which also fuelled her use of tripartite structures.) But it was the move to St Ives in 1939 that enabled her practice to thrive.

Like many artists during the Second World War, Hepworth worked in any materials she could find (famously making drawings on hardboard) due to the scarce availability of traditional sculptural materials, such as bronze or marble. Carving holes and hollow spaces into small pieces of plaster, wood and stone, she used organic forms to emulate the shapes of her environment: curved edges, ocean-like swirls, rocky surfaces and weathered lines. After moving into the spacious Trewyn Studio in 1949, where she lived and worked until her death in 1975 (dying in a fire rumoured to be caused by her falling asleep with her lit cigarette), Hepworth's postwar practice was able to flourish. Working with larger, towering forms, Hepworth accessed exotic woods and durable bronze, which met her public-sculpture demands, as she was now shipping her work across the world.

Always maintaining her hollow shapes, in Hepworth's sculptures we can see multiple perspectives of the world around us. Sometimes seeming as though they have existed in the ground forever, changing with the seasons (as rain pours into them, or the blistering heat creates a dry, shiny surface), her sculptures have the power to accentuate the natural environment or enhance the modern architecture around them. (An example of the latter can be seen in her *Winged Figure*, 1961–2, a large sculpture that adorns the John Lewis department store on London's Oxford Street.)

Intent on showing the rough and smooth textures of her organic surfaces, Hepworth continued to hand-carve her structures right until the end of her life, as if to deliberately display an imperfectly

Barbara Hepworth: (left) photographed by Val Wilmer, 1963; (right) *Winged Figure*, 1961–2

human quality. Inviting touch, tenderness, emotion and a sense of where they were made in St Ives, she said of her medium in 1968:

> 'I think every sculpture must be touched, it's part of the way you make it and it's really our first sensibility, it is the sense of feeling, it is the first one we have when we're born. I think every person looking at a sculpture should use his own body. You can't look at a sculpture if you are going to stand stiff as a ramrod and stare at it, with a sculpture you must walk around it, bend toward it, touch it and walk away from it.'

Many artists working in St Ives also used painting to express their experience of the ever-changing landscape. Wilhelmina Barns-Graham (1912–2004) arrived in the coastal town from Edinburgh in 1940. Inspired by St Ives's dense layers of buildings, a diverse array of rock formations, as well as the intense and shimmering summer light, Barns-Graham's paintings encapsulate both ancient and modern histories of the Cornish town as well as its seasonal change. This, I find, is most present in the heat-filled *View of St Ives*, 1940, with its dazzling warm hues of pinks and blues, a stark contrast to *Island Sheds St Ives II*, 1940, which conveys the eerie, bleak wartime winter mood. Barnes-Graham remained in St Ives for the rest of her life and would go on to be a pioneer of postwar abstraction.

But she wasn't the only modernist painter working in the region. Born in London, the queer, Constructivist (a starker form of abstraction) artist Marlow Moss (1889–1958) worked mostly in parallel with the St Ives group.

Wilhelmina Barns-Graham: (left) *Island Sheds St Ives II*, 1940; (right) *View of St Ives*, 1940

Marlow Moss, *Untitled (White, Black, Blue and Yellow)*, c.1954

(Note: Although Moss's partner Netty Nijhoff referred to the art-
ist as 'she' when Moss was alive and after Moss's death, I refer to
Moss as 'them/they' in line with recent scholarship. I think it's
important to acknowledge Moss's queer identity when thinking
about why they worked in a Constructivist language: a style devoid
of external reference, which feels universal, and not necessarily tied
to the binaries of gender. However, I also acknowledge that other
artists, such as Mondrian, considered vertical and horizontal lines to
stand in for masculine and feminine binaries.)

Dropping out of the Slade Art School in 1919 (recalling, 'I
destroyed my own personality and created a new one'), Moss went

to Paris in 1927 to study, where they were brought to the attention of Piet Mondrian (who they are now recognised to have influenced). Taken by the recent technological advances of the early twentieth century, Moss developed their 'Constructivist' language in dialogue with Mondrian, inventing the 'double-line' (two thin black lines running in parallel with each other), often with block primary colours.

Swapping Paris for Lamorna at the outbreak of war, Moss remained and worked productively in Cornwall until their death (much of Moss's earlier work was destroyed in the bombing of their Normandy studio during the war). Moss was known for dressing androgynously: their go-to attire was a hunting jacket, silk cravat and short-crop haircut. Despite being ignored by Hepworth and her then-husband, Ben Nicholson (who they had shown alongside in Paris), Moss continued to develop their Constructivist style, moving into mechanical steel sculptures that chimed with their painting and drawing.

In 1949, the establishment of the Penwith Society of Arts in Cornwall (one of very few organisations to champion abstract art at the time) was instrumental in establishing St Ives as a centre of abstract art after the war. Hepworth's participation at the Venice Biennale in 1950 was also key in positioning this Cornish artists' community on the world stage. But British abstraction was also advanced by women working outside of the St Ives group, such as Paule Vézelay (1892–1984), a friend of Moss, who was known for her automatic, abstract paintings with a Surrealist, rhythmic feel. Prunella Clough (1919–99) was another prominent artist, whose visual language reflected the impact of industrialism and the degeneration of the urban landscape – she looked to paving stones and wire fences as if to accentuate the mundane marks in our everyday lives.

Perhaps to consider the horrors endured, following the war British abstraction held spaces for both existential reflection and public regeneration. Not only was this due to the radical art being made in St Ives, but also to wider trends that filtered through; significantly from New York City, but also from São Paulo and beyond as the art world reconnected across the globe.

ART BEYOND THE MAINSTREAM

Before we reach the next phase of this 'story' (as we shift to what I like to think of as the next phase of art history, with Abstract Expressionism), I want to end this section with artists who cannot so easily be collated into a 'school' or 'movement'; artists who are united by the fact that they were self-taught, worked outside of traditional art establishments, or were guided by extraordinary – at times, miraculous – experiences.

Often referred to as Art Brut ('raw art') – a term coined in 1945 by French artist Jean Dubuffet, who famously championed many of these artists, or 'Outsider Art', an English translation made in 1972 – I have chosen to group these artists under the moniker 'art beyond the mainstream'. This is due to the exclusionary and derogatory implications the word 'outsider' has had over time, the limitations it offers, and the great museum recognition that many of these artists have since achieved. While I could discuss so many who were working in this way (in the earlier 1900s, Emma Kunz and Laure Pigeon; in the mid- to late twentieth century, Minnie Evans and Anna Zemanková, and, more contemporarily, Pearl Alcock and Guo Fengyi), I want to highlight four artists who channelled their visionary experiences into playful and obsessive practices.

A choir of female faces cloaked in dark hoods and with piercing eyes; repetitive dreamlike realms, intense colouring and laborious pen work; Madge Gill (1882–1961) began her hypnotic drawings and embroideries after experiencing astonishing visions. As haunting as they are mesmerising (she felt her work was guided by her spirit, 'Myrninerest'), each work leaves me captivated, musing over who this figure (or figures) is, how it came to be, and what visions Gill experienced to feel such compulsion to create it.

Born illegitimately in Walthamstow, London, Gill was raised in an orphanage and later forcibly sent to Canada to work as a labourer. On her return to the UK, she took work as a nurse at Whipps Cross

Madge Gill,
Untitled, 1951

Hospital but continued to face hardships. Suffering from life-threatening illnesses, the loss of an eye and a whole set of teeth, Gill gave birth to a stillborn child, then lost a son to the Spanish flu epidemic.

In March 1920, though, her life suddenly changed. Controlled by higher powers, in a 'trance-like state', Gill began embroidering and producing ink drawings at aggressive speed. Later admitted to hospital, where she was put under the care of Dr Helen Boyle, a progressive doctor who encouraged her automatic drawings and writings, Gill's artistic practice thrived and was championed by her son, Laurie. She exhibited at London's Whitechapel Art Gallery and a Spiritualist convention in Belgium attended by Sir Arthur Conan Doyle – although she refrained from selling anything out of fear of disobeying Myrninerest.

While the figures in her work remain unresolved, scholars have suggested they might be self-portraits, or images of her Myrninerest,

her dead children or the family she never knew. All we know is that in a letter to a friend, Gill once wrote, 'My pictures take my mind off the worries.'

Equally theatrical, with their large blue pupil-less eyes and pink heart-shaped lips, Aloïse Corbaz's (1886–1964) dizzyingly passionately and sexualised drawings fill every millimetre of her pages. Born in Switzerland and raised with ambitions of becoming a professional singer, Corbaz worked as a governess, which brought her into contact with the German Emperor Wilhelm II, who is thought to be the male figure in her drawings. Forced home following the outbreak of the First World War, Corbaz was soon diagnosed with schizophrenia and, in 1918, admitted to a psychiatric ward. She would remain in

Aloïse Corbaz,
Carrousel
fait tourner
*la tête, c.*1951

Aloïse Corbaz, *Général Guisan sous le bouquet final,* (left) recto and (right) verso, *c.*1951–60

hospital care for over forty years. Much like Gill, she was supported by her doctor, Jacqueline Porret-Forel, who motivated Corbaz to channel her thoughts into art.

Initially drawing in private, from 1941 Corbaz began to work publicly, covering any surface she could find (from both sides of envelopes to fourteen-metre-long sheets of paper, supplied by Porret-Forel) with ever-expanding pictures bursting with repetitive imagery – often of herself and Emperor Wilhelm II enrobed in royal dress. In these works, you can almost feel her obsessive speed and pining love for him (although she penned him letters, it is thought her love was unrequited). Stemming from her deepest desires, such as the opera dream of her youth, Corbaz's playful scenes allow her to construct an imagined reality far from the world in which she lived (Porret-Forel referred to them as 'supernatural worlds, theatre of the universe').

After being introduced to Jean Dubuffet in 1948, Corbaz's art was launched on to the world's stage. The Collection de l'Art Brut in Lausanne (founded by Dubuffet to house his incredible collection)

is now filled with her colourful creations; creations that to me show the power of encouraging art-making by the neurodiverse, and the intense joy and freedom it can give as a form of communication.

Similarly fuelled by desire, religion and a need to convey fantastical, spiritual realities, or just memories of daily life, two self-taught artists working in America's Deep South were honing their highly stylised and inventive vernaculars.

In the 1930s, the legendary preacher Sister Gertrude Morgan (1900–80) received a message from God. She was to leave her husband, flee Columbus, in Georgia, and go and preach in New Orleans (in her words, the 'headquarters of sin'). Arriving in 1939, Morgan took to the streets and began singing sermons, playing her tambourine, and got to work healing souls in an orphanage. Then, in 1956, she had another revelation from God: this time, it was a call to paint. Fuelled by divine powers (rather than artistic intentions), she created dazzling, spiritual, biographical and biblical scenes. Erupting with the sounds of her singing angels, animated high-rise buildings (thought to be 'New Orleans as New Jerusalem') and often featuring Morgan kitted out in a billowing white dress as 'God's

Sister Gertrude Morgan, *Jesus is my Air Plane*, c.1970

Clementine Hunter, *Going to Church*, c.1963

wife', her joyous paintings ooze excitement and show a compulsion for inventiveness (executed on tambourines, paper fans, lampshades and bits of old wood).

In 1970, she gained nationwide success after publishing *God's Greatest Hits*: a book of Bible quotations accompanied by her illustrations, which sold over 300,000 copies.

Like Morgan, Clementine Hunter (1887–1988) worked on materials ranging from lampshades to cardboard. Her paintings recorded (from memory) idyllic scenes of everyday life. An African American woman born a generation after the abolition of slavery, Hunter – a mother of seven – spent her early life picking cotton and later worked as a housekeeper on a plantation. It wasn't until she was in her fifties that her prolific career took off. Gathering old paints left behind by a former artist-in-residence on her plantation, Hunter worked through the night and developed her iconic style: thick, block-like brushstrokes in bright, bold colours.

Revelling in everyday scenes of friends cooking, washing, feeding birds and attending church, Hunter's paintings give life to

quotidian activities. Populated with her close community, they exude universality and celebrate the simpler tasks that often go unnoticed. Clearly others agreed, because after hanging up paintings in her home, she was given a major solo exhibition at the New Orleans Museum of Art in 1955, despite this being a time of intense segregation. (As an African American woman, Hunter wasn't officially allowed into the museum, but a friend smuggled her in nonetheless.) Painting until her old age, by the time of her death aged 102 she had created over 5,000 works.

Although still often excluded from the traditional canon, these artists have since gone on to be exhibited all over the world, to influence globally renowned artists, and have even had popular children's books written about their life (such as *Art From Her Heart: Folk Artist Clementine Hunter*). When Sister Gertrude Morgan took the New York art scene by storm, it was Andy Warhol who stepped up as her great admirer. Aloïse Corbaz is now considered by scholars as the most important female Art Brut artist, and in 2018, Madge Gill had a giant mural erected in her honour, in her birth town of Walthamstow. Whether it is the symphonic flurries of faces or blazes of colour that charge through their work, it is, front and foremost, the playful and wonderous visions reflected in visual form that unite these artists. Working beyond the mainstream, they channelled their innermost thoughts into their art and, in turn, produced work that feels timeless, fresh, exciting – and that still merits its place today.

PART THREE

POSTWAR WOMEN

c. 1945–c. 1970

POLITICS, POP AND
THE BIRTH OF THE NEW

'… you have to think about Europe too and the Second World
War … Here we had gone through this holocaust and for what?
What is there left? What was left was a private conscience, an
individual searching his or her feelings, and making a move into an
unknown. One could only move as honestly and closely toward
oneself as possible. For the painters the unknown was a blank area or
space. That was all there was. There was no structure, nothing
interwoven. A lot of the music, dance, and poetry also had this as an
underlying philosophy. Then what happened was we reacted against
Europe. We had a very strong sense of being American, of being
pioneers again, creative pioneers' — Grace Hartigan, 1976

After the devastation of the Second World War, the question
becomes: what is the role of art, of the artist, and how could the
visual form be used to make sense of this time? How could art help
process the horrors endured during the Holocaust, the bombing of
Hiroshima, and the actions of fascist leaders who ran countries into
the ground, killing tens of millions and wounding even more? If
the postwar years were about rebuilding, the arts were in dire need
of rethinking, too.

Faced with the incomprehensible, artists boldly dismantled rep-
resentation and turned to abstract forms. Filling their canvases with
swathes of movement stemming from their innermost emotions, or
restricting strokes to the bare minimum, they revolutionised not just
what art could look like, but their (and our) interaction with it, too.
From inviting our physical presence to step into their colossal can-
vases, to the slow looking that is demanded by repetitive marks or
process-based sculptures, artists filled what painter Grace Hartigan
called the 'blank space' with materials and forms so new that they
expanded the horizons of what it was thought art could be. Taking

the canvas off the easel, relinquishing perspective, searching for the unknown, or deconstructing bodies through sculpture, this era also saw artists sometimes abandon the art object entirely. No longer required to be something physical that hung on a wall, art might now be an ephemeral 'performance', a form of protest, a new way to express ideas and emotions. This period revealed experimentalism at its greatest, when everything we thought we knew about art was radically reinvented from within.

From changes in social norms and the rise of Cold War politics, to capitalist mass consumerism and the assassinations of leaders, artists often responded by using their work to inflict change. With an abundance of refugees having fled Europe for the US during the Second World War, the cultural capital of the Western world shifted from Paris to New York City. And this is where we begin, with the 'Abstract Expressionists' who tore apart every tradition in painting and created the first great homegrown, avant-garde movement on American soil.

Chapter Eight

THE GREAT ERA OF EXPERIMENTALISM

(c.1950–c.1970)

ABSTRACT EXPRESSIONISM

'Painting is not separate from life. It is one.
It is *like* asking – *do I want to live?* My answer is yes –
and I paint' — Lee Krasner, 1960

Ambitious, bold, energetic; full of action, scale, intensity, drama, Abstract Expressionism – a term loosely applied to artists working in New York in the 1940s and reaching their zenith in the 1950s – marked the entry point to America's abstract avant-garde: a movement that paved the way for radical art-making in the latter half of the twentieth century. With some artists making sweeping, gestural marks, and others extravagantly applying paint to create strokes that glide across the canvas or are poured, sculpted or slashed, the artists associated with the movement carved out an entirely new abstract language.

Before we explore the careers of some of these pioneering women, it is important to note the context in which they worked. Prior to the development of Abstract Expressionism, there was barely any New York art market to speak of. When unemployment soared during the Great Depression that began in 1929, as part of his New Deal in 1935, President Franklin D. Roosevelt initiated government-funded art projects, such as the Works Progress Administration (WPA), to provide artists with gainful employment, such as making murals for public buildings. The WPA enabled women such as Lee Krasner to be on an equal footing with their male peers. However, when prominent European artists fleeing the war began to emigrate to the US (remember the male Surrealists' views on women?), attitudes towards gender changed. The market for Abstract Expressionism began to pick up in the mid-1950s, and at this point the women's work was valued (in every sense of the word) far less than that of male artists.

Despite the lack of institutional support and critical recognition (many women artists were subjected to sexism and criticised for not

being 'serious' enough), a few groundbreaking women became, in my opinion, some of the greatest artists of the twentieth century. With their strong personalities and fearless ambitions, many would deplore the thought of me categorising them as a 'woman artist' at all (a term deemed derogatory then, but which I like to think is now an embodiment of power). But for the purpose of collectively showing their sheer influence (on both their male contemporaries and future generations), I feel it vital to single them out and appreciate their importance as artists. After all, fewer than 20 per cent of the artists included in the Royal Academy's 2016 *Abstract Expressionism* exhibition were women, and only in the last few years have they achieved such mainstream and international recognition.

Artists from one school of the abstractionists (sometimes called the action painters) were bound up in dynamic, gestural painting. Their style pointed towards the excitement of a new world, but also reflected the realities and their personal experiences of the Great Depression, the Second World War and the atomic threat that felt ever closer in the Cold War era. Turning to new tools and materials – from household enamel paints to the recently invented acrylic paints – they used decorators' brushes and palette knives to create striking, jagged textures.

Many of these artists working in New York, male and female alike, studied, exhibited and socialised together – from drinking at the Downtown Cedar Tavern (where, in the words of artist Lee Krasner, 'the women were treated like cattle') to showing in the famous 1951 *Ninth Street Show* (the defining exhibition which brought together the different generations of Abstract Expressionists). But there was also a little-known artist, Janet Sobel (1893–1968), working slightly separately from the group, who, despite having only fleetingly been in the spotlight in the mid-1940s, has since come to be recognised as one of the movement's pioneers. Although she is rarely discussed in the histories of Abstract Expressionism, I decided to position her here (as opposed to in 'Art Beyond the Mainstream') because of the impact her work had on this movement and on scholars who are now writing her into its story.

Emigrating to the US in 1908 from Ukraine, after her father was murdered during a period of intense anti-Semitic violence, Sobel was a self-taught artist who took up painting in 1938, aged forty-five. Her artworks were inspired by her emotions, but also music (at times looking to Russian composer Dmitri Shostakovich's *Seventh Symphony*, which musically evokes the torments of the Siege of Leningrad), and the strength and power of her Jewish bloodline (in her words, 'I am a surrealist, I paint what I feel within me'). These influences were a catalyst for Sobel, who worked in an automatic manner to create paintings of exploding, gestural lines, methods the New York art world praised her for. Fusing enamel paint with sand, which she tipped and poured, she was, according to prominent art critic Clement Greenberg, one of the first artists in the context of Abstract Expressionism to demonstrate the 'all-over' painting technique (whereby paint covers the entire surface equally, a key stylistic feature).

Janet Sobel,
Milky Way, 1945

Encouraged by her son Sol, Sobel soon caught the attention of gallerists. Within five years, she had been offered a show at the Puma Gallery, an exhibition visited by none other than Jackson Pollock, who, according to his painter friend Peter Busa, was 'enthralled'.

Success followed. Alongside Leonora Carrington (p. 181) and fellow Jewish immigrant working in abstraction, Romanian-born Hedda Sterne, Sobel was featured in *The Women*, an exhibition held at Peggy Guggenheim's The Art of This Century gallery in 1945. The following year, Guggenheim gave Sobel a solo exhibition, which included *Milky Way*, 1945 – a jewel-like painting comprising swirling and web-like drip-painted enamel lines. According to Gail Levin, Lee Krasner's biographer, 'Pollock, too, employed astronomical themes in titles of the immediately succeeding years.' His breakthrough 'drip-paintings' were introduced to the world in 1947. Surely, with the information we have, Sobel should be rightly credited as an influence on Pollock. Yet where is her name when his is so ubiquitous?

Sadly, after moving to New Jersey in 1947, Sobel faded from the spotlight. It took until the late 1960s for her name to resurface, with MoMA's acquisition of *Milky Way*.

The overlooking of women artists wasn't anything out of the ordinary; after all, this was a time when Pollock asserted, 'I am nature'; Barnett Newman claimed, 'The first man was an artist'; and first-generation artists (whose careers began in the 1940s) Lee Krasner (1908–84) and Elaine de Kooning had to figure it all out for themselves. Determined, risk-taking and innovative in both their art and life, as Krasner said to art historian Cindy Nemser: 'we broke the ground'.

It wasn't until much later on that Krasner, who worked in a multitude of styles, received the global recognition she so rightly deserves. Raised in a working-class Orthodox Jewish household in Brooklyn by Russian-immigrant parents who spoke Russian, Hebrew and Yiddish, Krasner was formidably independent and outspoken. Aware of her artistic ambitions, in her words, since 'elementary school', Krasner commuted one hour each way from Brooklyn to Manhattan for her art education, which began at Wash-

Lee Krasner: (left) at the Hans Hofmann school, c.1940; (right) *Shellflower*, 1947

ington Irving (the only high school in New York where girls could do a course in art), and later Cooper Union and the Art Students League. Studying exclusively with male tutors (whom she often challenged), she soon swapped her birthname 'Lena' for the more androgynous 'Lee'.

Like several of her contemporaries, a significant moment for Krasner was when she attended the opening of MoMA in February 1929. Beginning with just a few rooms, MoMA staged exhibitions that offered American artists (who hadn't yet travelled abroad) the experience of witnessing in person the dynamism of the French Modernists, as opposed to small reproductions in journals like the *Cahiers d'Art*. The impact was vast.

Awarded a scholarship to study at the School of Fine Arts with Hans Hofmann, the notorious German tutor who introduced Analytical Cubism to the US, Krasner began to make work in a fully abstract vein, infused with rhythmic movement. Hofmann famously said her 'work is so good, you would never have known it was done by a woman'.

An accomplished artist before she met Pollock in 1941 (they married in 1945, but she never legally took his name), Krasner was responsible for introducing him to the small, burgeoning New York art world and, after his death, for preserving his Estate and securing

Lee Krasner, *The Eye is the First Circle*, 1960

his legacy. The pair moved to Springs, Long Island, in 1945, and it was here that Krasner (limited to using the bedroom as her studio while Pollock took over their gigantic barn to use as his) experimented with painting shards of luminous colour. These were known as her *Little Images*, an example being *Shellflower*, 1947. Critic Clement Greenberg praised them by stating, 'that's hot. It's cooking!', and in 1951 she received her first significant exhibition at the Betty Parsons Gallery. But in 1956, the year she left the US for the first time (to track down works by her beloved French Modernists), and the year that Pollock was killed in a car crash, her work, again, took a drastic turn.

Moving into Pollock's enormous studio, Krasner made work that was momentous, vast, her whole body visibly present in the outburst of somersaulting shapes that roll around the canvas. Her emotions can be felt through the pressure of the brush, and her urgent desire to paint through her raw, fleshy palette. Suffering from insomnia, she worked during the night for her *Umber* paintings. Forced to work under artificial light, she used quick, feathery strokes to make paintings up to five metres wide. Never beginning with preparatory studies, Krasner confronted the canvas head on.

Afraid of what she called the 'fixed image', Krasner's painterly language constantly evolved, and if she felt she was stagnating, she'd 'break' and move in a new direction, such as collage. In 1965, she had her first retrospective at London's Whitechapel Art Gallery, and in 1984 she was honoured with a major exhibition at MoMA, but died six months before the opening. Leaving an incredible legacy and a formidable energy, Krasner, in my view, embodied the liberal woman: 'I was a woman, Jewish, a widow, a damn good painter, thank you, and a little too independent …'

Working at the same time, Elaine de Kooning (1918–89) was another key contributor to the movement. De Kooning reinvented the portrait by using action-like gestures when depicting likenesses of sport stars, friends and presidents (popularised in Pop Art in the 1960s), including John F. Kennedy. Having fastidiously studied the former president from life, the television and hundreds of newspaper cuttings, in *John F. Kennedy #21*, 1964, she portrays him emerging

Elaine de Kooning in her studio at work on her *JFK* series, 1964, photographed by Alfred Eisenstadt

out of a pool of harsh, dry, flame-like strokes. Striving as she did, in her words, 'for a composite image', you can almost feel his multiple presences: the untouchable celebrity, the determined politician and the dynamic movement of their real-life interactions. Additionally, de Kooning was one of the earliest critics to write about Abstract Expressionism. Able to discuss art with the sensitivity and perspective of someone who was a maker, she translated through words her analyses of paintings and reviewed shows for *ARTnews*, one of the leading publications of the day.

De Kooning was also a founding member of The Club, a (notably male-dominated) group of artists, mostly working Downtown, who regularly met for debates, discussions and lectures at 39 East 8th Street. The Club famously organised the *Ninth Street Show*. Attended by art-world elite, including MoMA's founding director, Alfred Barr

Jr., the show refocused New York City as the artistic capital of the world. Out of the seventy-two artists exhibiting, eleven were women, and only five of these would be widely recognised today: de Kooning, Krasner, Grace Hartigan (1922–2008) – the first woman of the movement who had her work acquired by MoMA, hers being *The Persian Jacket*, 1952 – Joan Mitchell and Helen Frankenthaler.

Making her New York debut at the *Ninth Street Show*, Joan Mitchell (1925–92) stood out as one of the leading artists of the day, with her tough, fleshy, gestural painting. A frequenter of the hard-drinking Cedar Tavern, an avid smoker and famed for her feisty personality (in 2002 *The New Yorker* described how 'a wry set to her mouth would portend the utterance of something startlingly smart and, as often as not, scathing'), Mitchell was a genius at transforming paint into gusts of light, energy and movement. Applying her oils with strokes that varied from feathery and translucent to thick and aggressive, she would squeeze out entire tubes or vigorously throw paint onto the canvas. Unlike her contemporaries, Mitchell looked to the French Impressionists for influence, creating a vernacular that expanded on late-nineteenth-century painting. (Remember Berthe Morisot's *In the Garden at Maurecourt* on p. 115?)

Born in Chicago to a wealthy family, Mitchell's youth was spent amid the city's cultural elite; her mother was a poet and her father a doctor. Her childhood wasn't straightforward, though, as she had a complex and abusive relationship with her father, who wished she had been born a boy. Competing (and succeeding) in figure-skating, horseback-riding and diving competitions in childhood, by her early teens, Mitchell had already decided she wanted to be an artist. Financially supported by her family, she studied in Chicago, spent summers painting in Mexico and then a year in France, before settling in New York in 1949. Quickly immersing herself in the art scene, Mitchell was also close to many of the era's great poets – from Frank O'Hara to James Schuyler – and exhibited at the famous Stable Gallery. Within nine years of her arrival, her work *Hemlock*, 1956, would be acquired by the Whitney Museum of American Art.

Mitchell's compositions made in the first half of the 1950s feel, to me, intensely compact and claustrophobic, then as the decades

Joan Mitchell,
*12 Hawks at
3 O'Clock, c.*1962

progressed (following her regular travels to France from 1955 and permanent move there in 1959), they transform into looser, freer works. A spectacular example of this is *12 Hawks at 3 O'Clock, c.*1962. Smacking and smearing layers of paint onto the surface, it is as though she is conjuring (or tearing apart) centuries' worth of painting in her tough, gritty, yet dazzling-toned canvases. Like Krasner's *Night Journeys* series, you can almost imagine her fighting the work with industrial, heavyweight brushes, the vigour of her gesture exuding her determined character.

Drawing from the colours of nature, and often referencing the aesthetic of Monet's *Water Lilies*, Mitchell's later works verge on the

Joan Mitchell, *Edrita Fried*, 1981

sublime. This is especially evident in her four-panelled *Edrita Fried*, 1981, which at nearly eight metres long radiates a fiery energy and a dancing luminosity through the rough tides of scrubbed indigo that attempt to overcome the flame-like ochres.

While Mitchell was one of the great gesture painters, her contemporary Helen Frankenthaler (1928–2011) pioneered a 'soak-stain' technique that formed the basis of what became known as 'Colour Field' painting. Merging tradition with a new style of abstract painting, her work proved both instrumental and disruptive to the movement. Frankenthaler broke ground by removing her canvas from the easel and placing it on the floor, which, in her words, was

an act of 'dishonouring everything that painting had been about, assuming that you knew everything it was about'.

Born into a privileged home on New York City's Upper East Side, Frankenthaler's childhood was tainted by the death of her father when she was eleven years old. Attending Dalton School, where she was taught by Mexican muralist Rufino Tamayo, Frankenthaler later enrolled at Bennington College, where, a year after graduating, in 1950, when tasked with organising an exhibition of alumni, she invited the influential critic Clement Greenberg to visit – which he did (after she promised him 'martinis and Manhattans'!). At twenty-two, she became the youngest artist to show work

Helen Frankenthaler, *Mountains and Sea*, 1952

in the *Ninth Street Show*. But it was the following year that proved foundational when she invented the soak-stain technique, which was later adopted by male artists Kenneth Noland and Morris Louis.

Thinning down oil paint to a liquid consistency that she poured and brushed onto raw, unprimed, unstretched canvas, her soak-stain technique resulted in mesmeric pieces where surfaces are flooded with spontaneous, multilayered, colourful gestures. Her landmark painting *Mountains and Sea*, 1952, was the first to use this technique, and presents swathes of greens, blues, reds, golds and greys, evocative of the rocks, hills, pools of water and rich, deep seas that seem to be collapsing into one. Speaking about the painting in 1965, she recalled, 'the landscapes were in my arms as I did it'.

For me, her most impactful artworks are from the 1960s, such as *Flood*, 1967. Bringing to mind the sensation of a volcanic eruption, or perhaps the fluid and irregular contour lines of a map, *Flood* does away with all sense of perspective. Consuming our physicality with its overwhelming size and presence, when witness to it you can almost envision Frankenthaler's body entering into the canvas dur-

Helen Frankenthaler, *Flood*, 1967

ing the process of manipulating buckets of paint across its surface (as proven by the visible footprints!).

One of four artists representing America at the 1966 Venice Biennale, and the subject of retrospectives at New York's Jewish Museum (1960), the Whitney Museum of American Art (1969) and MoMA (1989), Frankenthaler continued to experiment with the subtle merging of colours and forms, as well as printmaking, until close to her death.

Although any sense of community within the Abstract Expressionists had mostly disintegrated by 1959, due to the emergence of Pop Art (p. 263), the women of the movement continued to evolve and expand ideas of paint. Working in parallel was Louise Nevelson (1899–1988), whose work, despite being sculpture, alludes

Louise Nevelson,
Sky Cathedral, 1958

to the same emotive power and overwhelming sensation (and scale) as her contemporaries working in two dimensions. Just as painters challenged centuries of representation, Nevelson pushed sculpture in directions that reflected the city's urban growth and development.

Nevelson's monochromatic and architectural wall sculptures are amassed from found, recycled and discarded objects sourced from her surrounding environment (from bedposts to bannisters), which she coated in opaque paint and stacked tall to form all-engulfing units. Nevelson, like Krasner, studied with Hans Hofmann (you can almost feel the fragmented lines that form through her innovations), and was also influenced by the ancient ruins of Mexico and Guatemala. This inspiration is evident in her work *Sky Cathedral*, 1958, which questioned new types of religious experiences and spaces.

Emulating the increasingly industrialised New York City around her, like the Abstract Expressionists' reflecting on the past while looking to the future, Nevelson, too, by experimentation, took something old and transformed it into something new.

BLACK MOUNTAIN COLLEGE

'Art will make people better, more highly
skilled in thinking and improving whatever business
one goes into, or whatever occupation. It makes
a person broader' — Ruth Asawa, 1976

Running concurrently with the birth of the American avant-garde in New York City was perhaps the most progressive and experimental liberal arts school to exist in Western history: Black Mountain College. Born out of the principles of the (then recently closed) Bauhaus (p. 166) and American philosopher John Dewey's progressive writings about education, Black Mountain College revolutionised artistic and academic schooling. Active between 1933 and 1957, and set up in rural North Carolina, the school's ethos included eliminating all hierarchies between students and teachers, genders and races. It boasted classes in pottery, painting, dance, music, weaving, carving, architecture, as well as maths, economics, literature, philosophy – disciplines they believed should be viewed and taught without any distinction.

Although Black Mountain College was founded by academic John Andrew Rice, former Bauhaus weaver Anni Albers and her husband, Josef, were powerful presences at the school. They encouraged their students to 'learn through doing', implementing educational methods that prioritised imagination, invention and the use of all available materials (part of the school was built from scratch, and the food served was prepared using ingredients farmed from the local area). Students were also advised to strip away any prior knowledge and leave their egos behind. In the words of Anni Albers: 'I tried to put my students at the point of zero. I tried to have them imagine that they are in a desert in Peru, no clothing, no nothing, no pottery … and to imagine themselves at the beach with nothing. And what do you do?' Not only did this provide a unique training

Anni Albers and
Alexander Reed,
Necklace, c.1940

for artists of any type, it was also vital for shaping the core values of
the individual students.

Black Mountain College, although remote, attracted a glittering
array of tutors, who brought with them philosophical ideas, as well as
constructs of modernism and abstraction. During the 1930s and 40s,
many institutions in the US were offering European refugees teaching
posts – especially those of Jewish heritage – to free them from the rise
of fascism in their home countries, to help them rebuild their lives.
Board members included Walter Gropius and Albert Einstein; other
visiting artists included key Harlem Renaissance painter Gwendolyn
Knight and Abstract Expressionist Elaine de Kooning, arriving with
their husbands, who had been invited to teach.

Black Mountain College was also one of the first schools to admit
non-white students and teachers as equal members of the commu-
nity; no matter what their role, everyone ate together during the day
and were known to party together at night. In an environment where
furniture-making was taught by Mary Gregory, poetry by Hilda
Morley, and Johanna Jalowetz oversaw bookbinding, and students

included Dorothea Rockburne, Mary Parks Washington, Susan Weil and Pat Passlof, the school embraced all practices and intellectual freedom. As confirmed by former student Ruth Asawa: 'I spent three years there and encountered great teachers who gave me enough stimulation to last me for the rest of my life.'

Although its influence has perhaps been overlooked across the globe, the school produced some of the most exciting artists and creative thinking of the twentieth century. While there were many women who benefited from the teaching, I want to focus on two artists in particular, for their pioneering approach to art-making and education; two disciplines they saw as inextricably linked and imperative to life.

Arguably the most influential woman to teach at Black Mountain College was Anni Albers (1899–1994). Having already established a career in Weimar Germany, the mid-twentieth-century decades saw Albers excel and pass on her experimental and playful approaches to her students (with whom she made necklaces out of sink plugs and weaved functional objects, napkins and placemats). After visiting the Mayan ruins in Mexico in the winter of 1935 into 1936, Albers

Anni Albers, *Intersecting*, 1962

continued to visit and be inspired by Central and South America, in particular Pre-Columbian Peruvian textiles, and incorporated this influence into Western traditions.

Previously creating textiles for functionality alone, in 1947 Albers began making hand-woven weaves for no other reason than 'to be looked at' and for self-expression. She called them 'pictorial weavings'. Orange, red, blue, white; webbed, braided and folded; Albers presented her textiles with a seamlessness that echoes how paintbrushes glide across canvas – one great example is *Intersecting*, 1962, with its sinuous lines and flickers of white throughout.

Departing Black Mountain College in 1949 to join her husband, Josef, at Yale University (where they would be great influencers on Sheila Hicks and the Fibre Arts Movement, p. 315), in the same year, she became the first female textile artist to receive a solo exhibition at New York's MoMA. In 1965, she published her monumental and influential book, *On Weaving*, which is still celebrated today.

Expanding form, defying structure, playing with traditions and blurring definitions between hard and soft, tall and small, strong and fragile, Ruth Asawa (1926–2013), created biomorphic sculptures that were also inspired by a trip to Mexico, taken during a summer break from Black Mountain College.

Asawa was brought up on a farm in California by immigrant Japanese parents. Curious and eager, she spent her childhood helping on the farm before and after school, and attending Japanese calligraphy classes on Saturdays. But it was the 1930s, and racial prejudice against the Japanese was worsening. Following the attack on Pearl Harbor in December 1941, more than 100,000 Japanese Americans were placed in internment camps across the US, including a teenage Asawa.

Held against their will and in abominable conditions, what she endured one can't imagine. But despite the horrific circumstances, communities in the camps came together, to bolster morale and provide education for the younger generations. Professional artists including Tom Okamoto, an animator for Walt Disney, spent time teaching Asawa. Motivated by her teachers to look to the future, upon her release Asawa set out to earn a teaching degree from

Ruth Asawa, *Untitled (S.310,*
Hanging Five-Lobed Continuous
Form Within a Form with
Spheres in the 2nd, 3rd,
and Bottom Lobes), c.1954

Milwaukee State Teachers College. However, despite training for three years, she was denied a job due to racial discrimination.

Encouraged by friends, she enrolled at Black Mountain College in 1946, where she flourished. She took classes with Josef Albers (her personal mentor) and Buckminster Fuller (whose hair she cut as a volunteer barber!) and after a trip to Mexico in 1947, began her repetitive, looped wiring technique.

Taking the Black Mountain College approach to art and life, Asawa moved to San Francisco in 1949 and set up her practice in her home. Hanging from the ceiling, her larger cell and cocoon-like wire sculptures simultaneously emanate strength and fragility, as seen in *Untitled*, c.1954. Made up of continuous and interlocking wires, some of Asawa's sculptures evoke bodily, weighty, womb-like forms, but also appear serene, vulnerable and weightless. From every angle,

they have the ability to take on a different, unexpected dimension, further enhanced when they are lit and creating shadows.

Implementing the school's ethos further, as an avid believer in the power of art and education to change lives, Asawa co-founded the Alvarado School Arts Workshop in 1968 with the goal of enabling children of all backgrounds to make art from cheap materials. Aiming to instil agency in children, she went on to found the first public arts high school, the School of the Arts in 1982 – renamed Ruth Asawa School of the Arts in her honour in 2010.

GUTAI

'As a group, however, we impose no rules. Ours is a free
site of creation wherein we have actively pursued diverse
experimentations, ranging from art to be appreciated
with the whole body' – Gutai Manifesto, 1956

Clearly the 1940s and 50s were a haven for experimentation, because in Japan a radical postwar group was emerging: Gutai (Gutai Bijutsu Kyokai). Abandoning all artistic convention – using their bodies to rip through paper, smashing bottles filled with paint, cycling over canvases or covering themselves with lights – those associated with Gutai reinvented how artists interacted with materials. Striving for pure originality in their work, their aim was to 'create what has never been done before'. Active between 1954 and 1972, Gutai, for me, represents the very start of Performance Art.

Founded by Jirō Yoshihara in the city of Ashiya, after the 1952 American occupation and at a time when Japan was rapidly rebuilding, the birth of Gutai coincided with the progression of women's rights (the right to vote was won in 1946) and the acceptance of women into Japan's most prestigious art schools.

Part of Gutai's first generation, Atsuko Tanaka (1932–2005) was still in her early twenties when she created one of the most imaginative and innovative works ever to emerge from the group, *Electric Dress*, 1956. Comprising 200 hand-painted incandescent light bulbs,

Atsuko Tanaka wearing her *"Electric Dress"*, suspended from the temporary beam at the Second Gutai Art Exhibition in Ohara Hall, Tokyo, 1956

blinking in fluorescent green, red, yellow and blue, and weighing over fifty kilograms, *Electric Dress* covered Tanaka from head to toe and was held up by a cord. Deemed disruptive for the interactivity between electricity, technology and the body, Tanaka debuted the work at the *Second Gutai Art Exhibition* in Tokyo. Not only did the sculpture open up new possibilities of what this artform could mean, be and look like, it also accelerated ideas about how artists might use the body to reflect on the technological advancements booming around them.

Opening up a new type of modernism to the Western world, the Gutai group strengthened Japan's artistic alliances with America and Europe by sending out published journals outlining their avant-garde practices. Going on to exhibit in New York, the group's approaches to body and art influenced the Abstract Expressionists, and later anticipated the birth of Fluxus and Happenings.

POSTWAR PHOTOGRAPHY

While experimentations had never been greater in painting, performance and sculpture, I want to end this section by highlighting the prosperity of photography in the postwar period. Using new technologies from the smaller hand-held camera to the thriving print market; and from the invention of colour photography to the development of the motion picture (as advanced by Agnès Varda and Maya Deren), women were also documenting monumental political changes. These included Ghana's independence from the United Kingdom in 1957, for which Felicia Ansah Abban (born 1935) was employed as an official photographer for the country's first president, Kwame Nkrumah. She would go on to photograph fashionable women draped in 1960s fashion at her Accra-based studio.

But postwar photographers also seemed to move away from exact representations of reality and instead focus on finding hidden meaning or evocation in a world that was rebuilding itself. In Japan, reflecting on growing up in the 1950s and 60s, Ishiuchi Miyako's (born 1947) series *Yokosuka Story*, 1976–7, saw her return to her home town of Yokosuka, once the location of one of the largest American naval bases in the Pacific area, where she photographed abandoned streets, brothels and buildings. Grainy, eerie, filmic, quiet, subfused with long shadows and taken from a lens evocative of diving into someone's memory, Ishiuchi's photographs capture traces of time, as if she were reconnecting to her history and confronting her memories of her youth, as seen in *Yokosuka Story #98*, 1976–7.

In America, Diane Arbus (1923–71) was doing something entirely different. Using the streets as her stage, from Manhattan to Coney Island, and in parks, bars, cafés or underground dressing rooms, Arbus chronicled the lives of postwar America with a strangeness and familiarity, a beauty and honesty. Seeking out those typically seen to be on the 'fringes' of society – drag queens, circus perform-

ers, strippers, sex workers – Arbus's output provides one of the most empathetic collective portraits of communities of which we would otherwise know little.

Recording intimate moments between herself and her subjects, I see Arbus using the camera as a tool to converse and connect with the people who lived through these devastations. Although aware of her presence – mostly looking straight at her – her subjects seem unposed. You can tell she's been talking with them, perhaps asking how they wish to be seen, although, as she said, 'there's a point between what you want people to know about you, and what you can't help people knowing about you'.

Controversial in their day, Arbus's images document an unfiltered depiction of a world so often dismissed from art history and sidelined by society. Her prints are minuscule in the flesh – all the better for that intimate, sensitive impact.

Just as Grace Hartigan said, this time was about an 'individual searching his or her feelings, and making a move into an unknown'. It was this unknown that all these artists entertained; from changing the traditions of painting, sculpture, performance, photography and education, and bringing new forms of inclusivity to their subjects or in their teaching.

Ishiuchi Miyako, *Yokosuka Story #98*, 1976–7

Chapter Nine

POLITICAL CHANGE AND NEW ABSTRACTIONS

(c.1950–c.1970)

POP ART

'A revolution is on the way, and it's partly because we
no longer take our standards from the tweedy top. All over
the country young girls are starting, shouting and shaking,
and if they terrify you, they mean to and they are beginning
to impress the world' – Pauline Boty, 1963

If the 1950s was a decade of experimentation, reflection and rebuilding after the Second World War, the 1960s burst forth as a time of change, consumerism and commercialisation. Surfacing during the decline of Abstract Expressionism in America, and an old-fashioned realist style in Britain known as the Euston Road School, Pop Art marked a return to figuration and replaced emotional expression with slick, sharp surfaces. Holding up a mirror to the hyper commercial, image-proliferated world that took shape in the Western postwar era, artists abandoned painterly and sculptural traditions in favour of new materials and ideas.

Colour television and CinemaScope; brands, billboards and repetitive, logo-like imagery; Elvis, Marilyn, the sexual revolution and the Space Race; the growth in the US economy, with American goods being exported across the globe – 'Americanisation' propelled capitalist thought and introduced new ways of interacting with media. Full of innovation and optimism, excitement and possibility, newness and technology, artists reacted to the everyday by reflecting the dynamism (and destruction) of this fast-paced decade.

Running alongside the rise of mass culture, the role of women in society became increasingly complex: many were forced to renounce their wartime working roles in favour of the men returning from military service, and once more live a life of domesticity. As a result, advertising began to centre even further around the sexualised image of woman, the glorified family home and the passive (yet smiling) housewife. By society's standards, a woman's role was once again

263

firmly a domestic one. She was certainly not meant to be an artist engaging in the politics of her time.

Yet, because Pop Art reflected the everyday, male artists also adopted this mainstream view of a woman's place, and so the movement is often seen as a 'masculine' one. (One only has to look up Allen Jones's hypersexualised female mannequins supporting the legs of tables to get an idea of this mindset ...) In fact, it was not until very recently that history acknowledged women's participation in Pop, proven by the Royal Academy's landmark 1991 exhibition *The Pop Art Show* – out of the 202 works on view, only one was by a woman. If Pop was about fast cars, pin-ups and hard, cold, shiny surfaces, how did women establish their own influence within it?

The bold women of Pop fought back, enriching the movement by subverting and claiming ownership of its sexist imagery. They made fun of it and revealed the misogynistic visual lexicons charted by men in works that I think go far deeper than those of their male counterparts: Marisol with her phallus-shaped sculptures; Martha Rosler with her spliced collages; Beatriz González with her recreations of tabloid stories reflecting conflicts caused by La Violencia in Columbia; Pauline Boty with her sex-filled, politicised paintings; and nun-turned-artist Sister Corita Kent with her text-based works promoting social justice. All of these artists demonstrate that women were not solely interested in engaging with celebrity fandom or the commercialised world, but worked to comment on the decade's capitalist downsides – wars, protests, inequality – from a distinctly female perspective. They were articulating, using both manufactured and traditional processes, the effects of mass culture across the decades – from the Cold War and the ongoing Vietnam War, to the US Civil Rights Movement.

I've always loved the satirical sculptures of Venezuelan-American artist Maria Sol Escobar – who went by the moniker 'Marisol'(1930–2016) – with their deadpan expressions and awkward, playful stances. Marisol merged her hand-carved wooden figures with real-life objects (forks, hats, boots, bags) to mock right-wing America, comment on female identity and challenge Western ideals.

Raised between Paris, Caracas and Los Angeles, Marisol arrived

in New York City in 1950, where she briefly took up Abstract Expressionist-style painting. Soon abandoning it for sculpture, Marisol quickly became a central part of the development of 'Pop', referencing political subjects and celebrity figures (think John F. Kennedy and the British Royal Family). She attracted enormous attention in the early 1960s (when she was more famous than her friend Andy Warhol). Thousands queued up for her 1966 exhibition at the Sidney Janis Gallery, and in 1967, *The New York Times* described her as 'clever as the very devil and catty as can be'.

Blank-faced, boxed-in, comical and disturbing, Marisol's hand-carved sculptures reflect the silenced and sexualised women idealised by 1960s media. One of my favourite works, *Dinner Date*, 1963, is a life-size wooden sculpture of two women dining, who stare blankly

Marisol,
Dinner Date,
1963

Marisol, *Love*, 1962

ahead, devoid of personality, connection or interest, but draped in the high fashions of the day: sporting headbands, minidresses and heeled leather boots. Working at a time when male Pop artists favoured the 'factory-like' approach to working (with their entourage of assistants and engagement with hard-edged, industrial materials), Marisol hit back and formed her own version of Pop. Influenced by Pre-Colombian and folk art, she hand-carved each sculpture alone, perhaps to emphasise the only 'human' aspect of the figures who had otherwise been stripped of their identities, personas – and brains – all for the purpose of pleasing others (men) or fitting into society. They are a stark reminder of the trappings of femininity, which are still very much alive today.

Like many of her Pop contemporaries, Marisol worked with identifiable American logos that are symbolic of capitalism, but instead of glorifying them, she critiqued their ubiquity. For her 1962 sculpture *Love*, she forced a nearly full, phallic coke bottle down into a cast of a woman's mouth. A deeply unsettling sight, it is impossible to look at this work without feeling suffocated. I read *Love* (the antithesis of its title) as alluding to the silencing of women,

to the brutal sexual imagery of the era, and the violence that went unpunished (marital rape wouldn't be criminalised in the US until 1993). But the shoving of a quintessential American item into the mouth could also be a symbol for the nation's imperialism, and the unavoidability of its global hegemony.

Another fiercely political artist, Martha Rosler used the power of collage to splice together photographs from a range of contemporary magazines, using a combination of images to create uncomfortable yet vital dialogues that reveal the horrors and absurd realities of the time. In an era when reports about the Vietnam War were blaring out on colour television screens, interrupted only by regular commercial breaks promoting sexist consumerist goods, Rosler interrogated the inextricable links between the war and capitalism by bringing together their contrasting imagery in her work. She saw each as capitalist destruction motivated by financial gain.

Rosler's collage *Cleaning the Drapes*, from the series *House Beautiful: Bringing the War Home*, c.1967–72, merged imagery of glorified and capitalist American symbols (the vacuum and 'perfect' home, complete with the smiling, idealised housewife) sourced

Martha Rosler, *Cleaning the Drapes* from *House Beautiful: Bringing the War Home*, c.1967–72

from *House Beautiful* magazine, with those of war, taken from *LIFE*. Her collages, for me, embody the contradictory moment in history, and Rosler would go on to mass-produce these images, handing them out as flyers at demonstrations. Still continuing the series today, Rosler returned to this theme in the early 2000s during the wars in Iraq and Afghanistan.

Over in Britain, Pop Art was booming from the mid-1950s, first emerging with the discussions and exhibitions organised by the 'IG' (Independent Group). Made up of artists, writers and historians, the IG kick-started a new direction and aesthetic in British Art, and their reputation was cemented in the 1956 exhibition *This Is Tomorrow* at the Whitechapel Art Gallery, in London.

Thrumming with the excitement of the Swinging Sixties, Beatle-mania, Rock'n'Roll, and the currents of Americanisation, British Pop artists employed bright, bold text and imagery to exude the rhythm of youth and greater sexual freedoms. Making shrine-like paintings that glorified the music and movie icons of the day, artists also collaborated with musicians. The Beatles commissioned Hollywood native Jann Haworth (born 1942), known for her soft, sewn sculptures, and her then-partner, Peter Blake, for the cover of their 1967 album, *Sgt. Pepper's Lonely Hearts Club Band*. It is an iconic artwork that is very rarely credited to Haworth too.

For me, the most important artist of any gender to shape the face of British (Pop) Art was Pauline Boty (1938–66). Boty embodied the possibilities of the modern Pop woman – an actress, TV star and radio commentator who read Proust – and was clearly ahead of her time (she would recite overtly feminist monologues on the BBC radio show *The Public Ear*). Her paintings fused the glamour and vivacity of 1960s life with staunch political commentary (from the Cuban Missile Crisis to the Profumo Affair). At times, she turned the desiring gaze onto men, as seen in her painting of Jean-Paul Belmondo.

Born in Croydon to a housewife mother (who had always aspired to attend art school herself), and a conservative accountant father, Boty grew up in a strict Catholic household and was wildly ambitious. Holding strong feminist views, she studied at Wimbledon

School of Art on a scholarship (where she was dubbed the 'Wimbledon Bardot'). Later, she joined the school of stained glass at the Royal College of Art (women were rarely accepted on the painting course, and there weren't even female loos when the new wing of the school was built!). She thrived, going on to star in the hit 1962 BBC documentary *Pop Goes the Easel,* on which she stole the show with her witty, sharp-tongued intellect and impressive political and pop-culture knowledge that totally outweighed that of the men.

Boty translated the energy, spirit and dynamism of contemporary life onto her canvases, exuding warmth, mischief and fun. She explored her new technique of painting a 'collage' – a constellation of images on a flat surface (as if to mirror the proliferation of images coming at us from the media). Often incorporating images of film stars and music icons, she must have been entranced by their glamour, recalling, 'It's almost like painting mythology, a present-day mythology – film stars, etc ... the twentieth-century gods and goddesses. People need them, and the myths that surround them, because their own lives are enriched by them. Pop art colours those myths.'

Inspired by the energy and youth-driven imagery of Pop Art, Boty twice captured the decade's leading star, Marilyn Monroe. But unlike her American counterparts' hypersexualised and highly commodified depictions, Boty presented the film icon as relaxed and at ease (and still incredibly revered) for *Colour Her Gone,* 1962. Slotted between two rectangular, wallpaper-like planes and surrounded by red roses (a recurring symbol that evoked female desire), Boty's Marilyn appears saint-like, but with character and humanity. For the title, she referenced the final line of Ebb and Kander's (Dusty Springfield-covered) song, 'My Colouring Book', but in a proto-feminist twist, she changed 'him' to 'her'.

Of all the Marilyns depicted by artists, I find the most emotional to be Boty's *The Only Blonde in the World,* 1963. Painted in the months after the star's death, Boty immortalised her in her full glory: beaming, relic-like, glistening in her shimmering silver 1960s outfit and boxed between two panes, suggestive of the closing curtains after a movie or the crack of a door. She appears untouchable – just as the public, and no doubt Boty, saw and admired her.

Pauline Boty, *The Only Blonde in the World*, 1963

A critique of the place of women in mass culture runs parallel with her heartfelt celebration of the experiences to be found within it. Later work became more overtly critical, with titles like *It's a Man's World #I* and *II*. The first features Kennedy's assassination, The Beatles, Lenin and Einstein, the composition emulating the style of a teenage bedroom bulletin board. Her red rose is also present, caught in the middle of painted collage images. The second piece is a visceral critique of the objectification of the female nude in soft porn, and in this the rose has disappeared.

Boty embodied the promise that the 1960s seemed to offer, a place for energetic, multifaceted women. But in the summer of 1966, she died of cancer aged just twenty-eight, having refused treatment because of her pregnancy. She died five months after giving birth. Boty's finished works mostly disappeared after her death, only to be found in a shed in the 1990s. I will never understand why it took so long to honour her incredible portfolio of work; perhaps it was

Pauline Boty,
It's a Man's World #I,
1964

because it was held in private collections by owners who didn't understand her worth, or because she painted in such an immediate, contemporary way, using a collage of the images that swarm us daily. Or perhaps it was because she was a woman, who didn't 'fit in' to the realm of Pop Art. Whatever the reason, thanks to feminist scholars, Boty's (and other women's) formative contribution to Pop has finally, in the past decade, come into the light.

Evelyne Axell (1935–72) is another artist who was equally as charismatic, politically aware and sensitively attuned to pop culture as Boty. An acclaimed theatre and film actor, the Belgian-born, Paris-based Axell turned to painting in 1964 after visiting London, where she was exposed to the British Pop Art scene (we even have records of her meeting with Boty). Going by the gender-neutral name 'Axell' after her work was heavily criticised by men, she used car enamel paint and mass-produced objects in her canvases, filling the space with playful, provocative images of female pleasure.

Highly political, in her work Axell addresses the inequalities facing women, because although the 1960s marked the exciting, opportunistic era of the Space Race, it was also still constraining for aspiring career women like her. I think this is most powerfully

Evelyne Axell, *Valentine*, 1966

demonstrated through *Valentine*, 1966, a painting that pays homage to female Soviet engineer and cosmonaut Valentina Tereshkova. Set back on a glittering gold surface, Axell places a pin-up-style silhouette (perhaps reclaiming the motif often used by men, or showing that women can be both sexual and intellectual) beside her son's toy space helmet. On the one hand, this displays the subject's achievements (Tereshkova was the first and remains the only woman to have undertaken a solo space mission), but by using a toy version, she might be indicating the lack of seriousness with which women were viewed at the time.

Expanding and critiquing what constitutes as 'Pop', these women didn't hold back from engaging in subjects so often conquered by men. Taking ownership and subverting their imagery, and looking at the growing world so acutely, this work feels as relevant as ever as we fight for equality, but also as a counterpoint to the proliferation of images of celebrity or branded advertisements that swarm our society.

THE CIVIL RIGHTS ERA

'Every time I think about colour it's a political
statement … It would be a luxury to be white and never
have to think about it …' – Emma Amos, 1991

The turmoil of the US Civil Rights Movement in the 1960s and
70s forever changed the making of and discourse around Black Art
in America. Known as the Black Arts Movement, the artists associ-
ated with it worked in a range of media and styles to advance ideas
around Black empowerment and Black beauty, which were created
in opposition to white-dominated aesthetic standards. From using
collage to photography, assemblage to painting, sculpture to
drawing, artists responded to the political events of the time both
indirectly and directly. Their works reflected on the March on
Washington for Jobs and Freedom, the assassination of prominent
Black civil rights leaders, activist Stokely Carmichael's 1966 call
for 'Black Power', as well as their own personal experiences of racial
and gender injustices.

Expanding the fabric of what constituted 'American Art', many
radical and progressive women, although overshadowed by their
male contemporaries associated with the Black Arts Movement, used
their work to expose and resist racism and create social change. As I
will also explore in this chapter, these women were responsible for
setting up Black-owned galleries and Black art-focused journals, as
well as forming artist collectives for discussion.

Emerging in the aftermath of the 1963 March on Washington, one
of the first artist collectives to kick-start the Black Arts Movement
was Spiral, a New York-based group of fifteen radical artists that was
established to discuss the role of art and culture at the time of the
Civil Rights Movement. While predominately male, bar Emma
Amos (1937–2020), who at twenty-seven was also the youngest
member, the group staged exhibitions, increased the visibility of
their communities, pushed forth alternative ways of showing their

work and prompted artists in cities elsewhere to do the same. However, as the only woman, Amos realised that gender boundaries also needed to be dismantled in the fight for equality, a subject she went on to explore in her work.

A feminist activist (later a member of the Guerrilla Girls, p. 357, and whose radical, defiant paintings of the 1980s saw her appropriate works by male artists), in the 1960s and 70s Amos worked with bold, Pop-like figurative paintings filled with warm colours and scenes of daily life. It was in these paintings that she tackled head-on myriad political issues and personal experiences, such as her role as a working mother (as seen in *Eva the Babysitter*, 1973), while also seeking to record Black middle-class life. My favourite of Amos's paintings is *Sandy and her Husband*, 1973, a hazy, intimate and atmospheric 1970s-style living room (complete with a zebra-patterned rug and bright, bold walls) in which the focus is on an interracial couple bound together by love. But set back from their union in the upper-left corner is a window-like painting (an echo of Amos's earlier self-portrait *Flower Sniffer*, 1966), which, displaying a tense gaze, disrupts this romantic scene – perhaps alluding to society's voyeuristic judgement of their love.

Also interrogating issues of motherhood and Black domestic life, Betye Saar (born 1926), made prints, political collages and assemblages of found materials (choosing her medium in part due to the practicalities of being an artist while raising three young children). Growing up in the 1930s and 40s in Los Angeles, Saar took inspiration from the building of artist Simon Rodia's Watts Towers, 1921–54. An enormous site made from scrap materials, it also sparked her interest in transforming discarded (and often oppressive) objects into sculptures of meaning. Originally creating prints and assemblage, Saar's work turned political following the events of 1968 and the killing of Martin Luther King Jr., and it was around this time that she began sourcing her materials from flea markets; in particular, collectibles of African American stereotypes which Saar reworked into figures of political protest.

Saar's first directly political artwork was *The Liberation of Aunt Jemima*, 1972. In the assemblage Saar transformed the ubiquitous

Emma Amos, *Sandy and her Husband*, 1973

'mammy' stereotype of a rotund African-descended woman wearing a headscarf frequently charged with caring for white children from an offensive symbol to one of power. Adding a shotgun and a fist of Black Power on the front of the trade card (evocative of the Black Panther symbol), this revolutionary work hit back and took control of the racial stereotypes of the day. According to acclaimed and radical political activist Angela Davis, it is the critical piece that sparked the Black women's movement.

Images of Black Power and political leaders and activists were also constructed through prints and sculpture. Most notable of these were by Elizabeth Catlett (1915–2012), who we met in the Harlem Renaissance chapter (p. 195). This pioneering artist spent the second half of the twentieth century working in Mexico City with the leftist

Elizabeth Catlett, *Black Unity* (front and back view), 1968

printmaking group Taller de Gráfica Popular, until 1966. Politically united with the artists in America who were fighting for change from her position in Mexico (she was banned from the US due to her Communist leanings and only later allowed entry for her Studio Museum in Harlem show in 1971), Catlett said of her work, 'I have always wanted my art to service Black people – to reflect us, to relate to us, to stimulate us, to make us aware of our potential.'

Filled with strength and beauty, Catlett's mahogany-carved *Black Unity*, 1968, is one of the most powerful works of the era. Conceived to be viewed from both angles, on one side she presents a giant clenched fist, and on the other, two united Black faces, protected by the defending hand. Using sculpture to uplift and service Black communities or pay her respects to those who lost their lives in the course of their activist work, Catlett's work has stood the test of time. Her pieces remain vital and relevant symbols in our polarised twenty-first-century society, with a new generation of activists committed to carrying on the struggle.

In response to the constant injustices against Black people that she witnessed first-hand in Harlem, Faith Ringgold (born 1930) began her *American People Series* in 1963. It was the height of the Civil Rights Movement, when many artists in New York City were failing to address the political tumult around them. At first, the series was wrongly and foolishly overlooked by the white-dominated art

world, but today it is recognised as one of the formative works of the twentieth century, hanging prominently in MoMA.

A native Harlemite, who grew up during the thriving Renaissance, Ringgold's intention for this series of twenty paintings was, in her words, to 'tell my story as a Black woman in America'. The works are large-scale and mural-like, imbued with bright, Pop-like, repetitive symbols and figures. From innocent interracial children (with no racial preconceptions) hiding behind foliage, to using the symbol of the American flag to highlight injustices (with blood dripping from it), the series drew on Ringgold's personal experiences.

Responding directly to the pivotal moment when civil rights activist Stokely Carmichael said 'Black Power' on television, and looking to expose the segregational structure of American society, for *#19 US Postage Stamp Commemorating the Advent of Black Power*, 1967, executed in the format of a postage stamp, Ringgold depicted 100 faces. Ten of these are Black, on a diagonal line in the form of an X with the words BLACK POWER. However, insidiously woven into the piece are the words WHITE POWER, as if to tell the underlying truth of American society.

When the media began to fail to document the violent truth, such as the race riots, Ringgold ended her *American People Series* with, I think, her most profound and confrontational work, *#20: Die*. Using grey slabs of pavement as her backdrop, *#20: Die* portrays blood-spattered, interracial, mixed-gendered and multiple-aged figures, from grown men in suits never-endingly fighting and robbing each other of their lives, to scared children clinging to each other for safety. It is a powerful reminder of the reality of the politically tumultuous time, and its effect on innocent people.

The 1960s and 70s also saw the formation of a range of artist collectives intent on forging a unique Black aesthetic across the US. The Chicago-based *AfriCOBRA* (African Commune of Bad Relevant Artists) broke away from traditional American and European aesthetics to create distinct, vivid messaging based on, as outlined in their manifesto of 1970, notions of 'rhythm' and 'shine'. Barbara Jones-Hogu (1938–2017) fused text and image for *UNITE*, a kaleidoscopically coloured print with an electric purple, orange

Faith Ringgold, *American People Series #20: Die*, 1967

Barbara Jones-Hogu, *Unite*, 1971

and blue sky embellished with the word UNITE merged with the Black Power fists held up by the crowd. Carolyn Lawrence (born 1940) depicted figures dancing, drumming and playing in her paintings, which are infused with uplifting messages of hope.

On the West Coast, artist and gallery owner Suzanne Jackson and artist and educator Samella Lewis pushed (and are still pushing) for visibility and recognition for Black women artists (Lewis first published her extensive book *Black Artists on Art* in 1969). In 1970, Jackson's prominent Gallery 32 brought together Saar, Jackson, Gloria Bohanon, Sue Irons (later Senga Nengudi, p. 338), Yvonne Cole Meo and Eileen Abdulrashid for one of the most important Black, all-female shows of the era, the *Sapphire Show*.

In New York City in 1972, photographer Ming Smith joined the Kamoinge Workshop (meaning 'a group of people acting together' in Gikuyu, a language spoken in Kenya) as its first female member. This was a group of Black photographers who regularly met at

Ming Smith, *Grace Jones at Studio 54*, 1978

each other's homes and studios to socialise and discuss their work. Showcasing the richness of Black culture and creativity, Smith shot intimate scenes of women and children, men playing pool in late-night smoky bars, the glittering images of Grace Jones mid-dance at Studio 54, and Tina Turner waiting on a dock under the Brooklyn Bridge.

But despite the wealth and breadth of Black talent erupting across America, white-owned museums and galleries failed to recognise their contribution to American art. Things particularly soured when the Metropolitan Museum of Art staged *Harlem on My Mind: The Cultural Capital of Black America, 1900–1968* in 1969. Instead of exhibiting work by Black artists and involving Black curators, the exhibition merely displayed archival photographs of Harlem. Sparking a major backlash, artists came together and formed the Black Emergency Cultural Coalition (BECC), a group who protested against the lack of visibility of Black artists. In response to the

BECC's demands that institutions re-evaluate their programming, in 1971 the Whitney Museum of American Art staged *Contemporary Black Artists in America* (failing, however, to bring on board a curator of colour).

Taking matters into their own hands, commercial galleries devoted to promoting the work of African American artists were formed, including artist and gallerist Linda Goode Bryant's Just Above Midtown in 1974. In 1976, artist and scholar David Driskell guest-curated the touring *Two Centuries of Black American Art*, now considered a historic landmark exhibition. After three years of intensive planning, in 1968 the Studio Museum in Harlem opened its doors, which is today one of the most influential spaces worldwide, for their significant exhibitions and the legacy it has created through its artist-in-residence programme.

Trailblazing through their artistic works, community-focused projects, exhibition programming and scholarship, the work of these women is still very much at the forefront of art. Not only did a hugely successful, major exhibition titled *Soul of a Nation: Art in the Age of Black Power* – which highlighted their work and that of Black artists and collectives – tour around the US between 2017 and 2020, but in 2019, Betye Saar was honoured with a long-overdue exhibition at MoMA. In 2022 MoMA will chart the twelve-year evolution of Just Above Midtown with a major exhibition dedicated to the gallery. More proof, if it is needed, of these women artists' great and enduring influence.

MINIMALIST IDEAS
AND OTHER ABSTRACTIONS

Born out of the 1950s and early 60s, Minimalism upended the heroic individualism and intense theatricality of the Abstract Expressionists in favour of ideas of order and simplicity. Traditionally, it is a style devoid of personalisation and expression: repetitive, rectangular precision and streamlined shapes centred on the grid (we'll return to this idea: the 'grid' is often seen as an emblem of modernism). By definition, 'Minimalist' artists favoured hard edges, rigid monochromatic lines and industrial materials. It was also seen as an incredibly 'masculinist', male-dominated movement, formidably excluding of artists such as Anne Truitt and Carmen Herrera. Other female artists (Judy Chicago, Lynda Benglis) poked fun at the macho-ness of it and constructed a minimalist language of their own with organic, yonic forms.

But I have called this section 'Minimalist Ideas and Other Abstractions' because, although the artists I discuss here work with lines, grids, repetition and precision, to my mind, they go beyond the constraints of pure Minimalism and traditional abstraction. They make us look further. Feel deeper. They permit us, through their dizzying or serene forms, to physically experience their work: whether it is imbued with political meaning or personal memory, or able to transport us to new dimensions.

If there's one artist who teaches us how to look at a painting slowly, it's Agnes Martin (1912–2004). Faintly drawn grid- or line-based canvases of reduced and repetitive forms – seeing a painting by Martin in the flesh is a meditative and transcendental experience. Featuring light pencil marks, pastel colouring and, at times, glistening gold hues, for me, Martin's paintings are about the act of looking and attempting to tune into the mindset of an artist who lived a monk-like existence. Allow every mark in one of her works to slowly

disintegrate in front of us, and we are transported to the same joyous, calm sensation of looking out onto the slow ripples of an ocean, or eternal prairies – evocative of a Midwestern landscape.

Raised on a rural, isolated farm in Canada with a knack for competitive sports (having nearly become an Olympic swimmer), Martin came to art in her thirties, after studying at Columbia University, where she also became attuned with Zen Buddhism. Although initially drawn to European Cubist and Surrealist influences, Martin's career matured at the decline of Abstract Expressionism and beginning of Minimalism. She adopted emotive, large-scale canvases from the former, and rigid, repetitive lines from the latter.

In 1947, she migrated to the artistic town of Taos, New Mexico, but a decade later was persuaded back to New York City by acclaimed dealer Betty Parsons who, in 1958, staged Martin's first ever solo exhibition when Martin was forty-six years old. Settling in Coenties Slip on the waterfront in Lower Manhattan, a community of predominantly gay artists, Martin was in her late forties by the time she really honed her style: restrained and abstract, mesh-like grids.

Ten years later, for reasons unknown, Martin abandoned the city for a monastic way of life in the New Mexican desert, giving up painting for a number of years. As if reborn as an artist, she titled her first print series made at the end of the hiatus *On a Clear Day*, 1973. Working up until her death, Martin, for her later paintings, applied wide bands of diluted colour that seem to never-endingly stretch across the canvas. It is these that I feel are the most freeing.

Martin continues to be globally recognised for her work, which reinvented the way we look at painting. Get up close and you see the artist's hand: her faint marks, her rubbings-out. But step back and the lines dissolve before you, as seen in *Friendship*, 1963, which gradually takes on the form of a glimmering golden landscape. The same is true of the late 1950s and early 1960s work of pioneering Japanese multidisciplinary artist Yayoi Kusama (born 1929), whose *Infinity Net* series gives an illusion of looking down at silent, slow-moving waves from an airplane – the same feeling Kusama had when travelling halfway across the world from Japan to America in the 1950s. Her work, like Martin's, when seen up close, displays repetitive

Agnes Martin,
Friendship, 1963

variations of minute, tactile brush marks sweeping from edge to edge, but unlike Martin, hers visibly lick, fold and scoop off the surface, creating microscopic shadows with three-dimensional effects.

Born to parents who managed a plant factory, Kusama began drawing at an early age, in spite of her mother's wishes (she would take away her paints). Kusama has described how, from childhood, she had hypnotic hallucinations, with polka dots, nets and flowers enveloping her. To this day, she channels her obsessive visions into her sculptures, paintings and immersive environmental installations, her artworks drawing in millions of visitors every year.

Established in the Japanese art scene from her early twenties, it was after a brief letter correspondence with Georgia O'Keeffe (p. 203) in 1955 that Kusama felt encouraged to pursue her dream of being an artist in America. Leaving Japan, she arrived in New York City in 1957 with a suitcase of drawings and one aspiration: 'to grab everything that went on in the city and become a star'.

Formidably ambitious and with, in her words, 'mountains of creative energy stored inside myself', she succeeded. Settling among the Downtown cultural avant-garde, Kusama immediately got to

Yayoi Kusama,
Infinity Nets (1), 1958

work on her paintings, which were semi-evocative of the 'Minimal-ist' style (the *Infinity Net* series is characteristic). Applying her repetitive gestures across multiple media, she created myriad soft sculptures in which phallic protrusions covered household objects, a strategy she employed to process her childhood traumas and visions. (Placing the sculptures in boats, she photographed them and blew them up as sequentially printed wallpaper, two years before Warhol created his strikingly, and suspiciously similar, *Cow Wallpaper*.) Taking the repetitive motifs further, in the 1960s she constructed her early mirror rooms: infinite immersive environments where her viewers experience flurries of repeated forms in a real-life, all-encompassing mirrored installation. Upon entering the room (filled with twinkling lights or infinite streams of bright yellow pumpkins), you are catapulted from reality into Kusama's dazzling multidimensional world. A celestial, hypnotic experience incomp-arable to any other.

While achieving great feats in painting, Kusama was simultane-ously pushing the boundaries of Performance Art (with anti-war,

Yayoi Kusama, *Kusama's Peep Show or Endless Love Show*, 1966

political messaging), as well as film and fashion (she had her own clothing line). In 1973 she moved back to Japan. In 1989 she returned to the spotlight, exhibiting at the Center for International Contemporary Arts in New York, and four years later she represented Japan at the Venice Biennale. Finding stardom in the Western art world once more, Kusama is an artist with no limits, who has remained at the forefront of the avant-garde for the past seven decades and counting.

In Britain, Bridget Riley (born 1931), whose career took off in the 1960s, developed a painterly language known as Op ('optical') Art, which plays on abstractions and dizzying forms. Using beguiling and energetic images that stretch the limits of visual perception to give its viewer optical illusions, similar to Kusama and Martin, when witnessed in real life, her canvases become interactive experiences.

Full of rhythmic forms reminiscent of the energy of the Swinging Sixties (she studied at the Royal College of Art in the 1950s), Riley's early paintings experiment exclusively with monochromatic colours in rigid, repetitive forms evoking motion. Her work is heavily

influenced by the optical effects of Post-Impressionist painter Georges Seurat, as well as the Abstract Expressionists whose work she would have seen at the Whitechapel Art Gallery in the 1950s. Like them, Riley was interested in emulating nature through her simple shapes and disorientating abstractions. Harking back to her childhood on the Cornish coast, Riley often cited land- and sea-scapes as inspiration for her abstract works, writing in 1984: 'On a fine day … all was spattered with the glitter of bright sunlight and its tiny pinpoints of virtually black shadow – it was as though one was swimming through a diamond.'

I find a similar effect of using abstract forms to emulate nature in the paintings of Alma Thomas (1891–1978). Full of shards of colour in the form of small, geometric but distinctly gestural marks (often called 'Alma stripes'), Thomas's paintings pulsate with strokes that sing, dance and bounce off the canvas. You can tell she loved colour through the many ways she interpreted it – monochromatically or rainbow-like; as swirls or in strips – just as she said in 1972: 'A world without colour would seem dead. Colour, for me, is life.'

Translating the environment that surrounded her into paint: from flowers in her garden to the visions of Earth seen from space via the newly invented colour television, Thomas's canvases reflect the urban and natural world, from a macro and micro perspective.

A constant pioneer, Thomas initially enrolled at Howard University as a home economics major, and later switched to Fine Art. Her professors included Loïs Mailou Jones (p. 199) and she became Howard's first graduate in the subject. Although active in the Washington art scene (in 1943 she established the first gallery in the district to exhibit interracial artists), between 1924 and 1960 Thomas worked as a junior high school teacher. It wasn't until post-retirement in 1960, aged sixty-nine, that she re-enrolled to study art before pursuing, for the rest of her life, a vastly successful career.

Working professionally throughout the politically tense 1960s and 70s, Thomas indirectly conveyed through her paintings the contradictions of progress. Although referencing technological advancements and the excitement of seeing the first moon landing

Alma Thomas, *Blast Off*, 1970

in 1969 – as seen in *Blast Off*, 1970, with a vertical, rocket-like form – this painting has also been interpreted by scholars as pointing to the inescapable political tumult taking place on Earth, with the murder of prominent progressive leaders throughout the era.

Using the same palette for nature and for spaceships, Thomas's abstractions, I think, create an atmosphere full of sound and stillness. Her artworks can elicit the sounds of jazz or classical music, the eruption of a rocket blast, or even a layer of snow silently covering the coat of colour underneath (as seen in the all-pink *Cherry Blossom Symphony*, 1972). When standing in front of them, whichever way you look, colour seems to constantly interlock and pulsate, or sit frozen in time, still on the surface.

In 1972, aged eighty-one, Thomas became the first African American woman to achieve a solo exhibition at The Whitney, and in 2015 she was the first woman of colour to enter the White House Art Collection, thanks to former First Lady Michelle Obama.

Recognition also came later in life to Cuban-born artist Carmen Herrera (1915–2022), when she was honoured in 2016 with her first

Alma Thomas,
*Cherry Blossom
Symphony*, 1972

(left) Carmen Herrera, *Black and White*, 1952; (right) Gego, *Columna (Reticulárea cuadrada)*, 1972

major museum exhibition at The Whitney at age 101. Having started out studying architecture, Herrera pioneered geometric abstraction with her paintings, which starkly contrast simplistic lines and shapes from ovals to semi-circles, in a multitude of colours. Exploring 'Minimalist' aesthetics even before the terminology had been coined, her style was often misunderstood by critics in the mid-twentieth century. Herrera's paintings such as *Black and White*, 1952, maintain a mechanical sharpness, with tensions or even optical illusions generated between her crisp, angular lines.

Abstraction took different forms – from paint and sculpture, to squares and circles, to hexagonal shards of glistening glass. All have different emphases and accentuations, which reflect the artistic context in which they were created. Minimalist structures by the Venezuelan artist, Gego (Gertrud Goldschmidt, 1912–94) have an all-encompassing, mesmeric effect. The web-like hanging wires of *Columna (Reticulárea cuadrada)*, 1972, almost disintegrate in front of your eyes.

Whereas Gego's fragile structures allow us to see the world through them, Lebanese poet and artist Etel Adnan's (1925–2021) paintings use singular blocks of solid colour to present an abstracted

version of the natural world. Beginning her career in the 1960s, Adnan's references range from the memories of her childhood in Beirut, her later life spent in California, near Mount Tamalpais, to contemporary political events. Taking the form of mountainous landscapes, seascape horizons, or however we wish to view them, much like her poetry they have the power to shift our perspective of our surrounding environment.

Other artists have drawn directly from Islamic Art. Particularly striking are the 1950s paintings of Fahrelnissa Zeid (1901–91), a former Turkish princess, whose abstractions are full of sinuous calligraphic lines snaking in and out of thick black contours. Her works erupt with emotion (apparently, she created them in trance-like

Etel Adnan,
Untitled, 2014

Monir Shahroudy Farmanfarmaian, *Sunset*, 2015 (detail)

states) and look to evoke splinters of mosaics imbued with complex interlocking forms. Taking the repetition of American Minimalism, Islamic traditions and craft techniques further, Monir Shahroudy Farmanfarmaian (1924–2019), who was based between Iran and New York City, made her two- and three-dimensional compositions from jewel-like mirrors, a much later example being *Sunset*, 2015, which glitters in cosmological structures, evoking the exuberant mosques in Shiraz.

POSTWAR BRAZIL

Artists were riffing off Minimalist and abstract concepts in Brazil, where a revolutionary cultural shift was taking place. As with Tarsila do Amaral and the Antropofagia movement (p. 189), which came about at a culturally prosperous time in the 1920s (but was corrupted by the rise of Getúlio Vargas's right-wing dictatorship), the postwar era in Brazil also marked a moment of rapid change.

Following the dissolution of the Vargas regime, the late 1940s and early 1950s (under the presidency of Juscelino Kubitschek, 1956–61) saw artistic and economic developments flourish in Brazil. Museums were built, cultural centres erected, and Brasília, purpose-built in the geographic centre of the country, was now the capital city. And thanks to the establishment of the São Paulo Biennial in 1951 (the first art biennial outside Venice), Brazil's cultural legacy and practices were brought to the global stage. It's also important to note that at around this time the Communist Party became legal in Brazil, and as we learned with the Russian Revolution (p. 142), artists similarly began to focus on Constructivist aesthetics. Known as the 'Concrete' movement, a new artistic identity replaced the figurative modernism with harsh and stark geometric lines and forms.

One of the leading architectural visionaries building the new Brazil was Lina Bo Bardi (1914–92), an Italian-born architect who, already acclaimed for her buildings (such as the Glass House, designed 1951), in 1957 began work on the Museum of Art São Paulo (MASP). A monumental seventy-metre concrete block suspended above the ground that incorporated both a museum and a communal gathering space underneath, it was an exceptional feat for a woman architect to be commissioned to undertake something on this vast scale. Reinventing centuries' worth of institutional exhibition spaces, Bo Bardi's brutalist-tinged (heavy and industrial) design centred around a fully open-plan space and revolutionised artwork displays by hanging each painting on its own glass panel. Giving the illusion

Lina Bo Bardi, MASP, designed 1957. (Modern interior view with art installation)

of the paintings floating in space, her design also forces us to have a new interaction with the art: being able to see both front and back, and having other viewers in our eyeline as we take in each piece. The artworks form new relationships and comparisons, fuelling a rereading of traditions and dialogues in art history.

Bo Bardi's Brazilian contemporaries Lygia Clark and Lygia Pape were also looking to dismantle existing traditions of painting and sculpture. Like Bo Bardi with her public gathering space built into MASP, they also actively encouraged a physical connection between the viewer and the work.

Training in Rio de Janeiro and Paris in the 1940s, Lygia Clark (1920–88) spent the 1950s experimenting with geometric abstraction in painting. At the time she was part of a Rio-based Concrete Art community (known as the Grupo Frente), but in 1959 she contributed to the formation of the 'Neo-Concrete' movement. She put her name to a manifesto that questioned Concrete Art's mathematical dogmatism and instead embraced human interaction and sensorial expression.

From 1959, Clark started work on her *bichos* (translating from Portuguese as 'bug'), which she referred to as 'living organisms'.

Lygia Pape, *Book of Creation*, 1959–60

They are intimate, small, freestanding metal constructions connected by hinges, which when handled by the viewer can form an infinite number of arrangements. Physically destroying formal structures of traditional sculpture, Clark's *bichos* have the power to beautifully and sensitively fold into myriad animalistic-like forms.

Lygia Pape (1927–2004), too, embraced the art object as a living experience, and, like Clark, invites the viewer to manipulate objects and forms, tailoring them to their own interpretations. Having spent the mid-1950s creating her *Weavings* (*Tecelares*), textural and geometric woodblock prints, at the time of the Neo-Concrete Manifesto Pape produced a series of books that disrupted tradition. Getting rid of standard 'pages', Pape instead filled her *Book of Creation*, 1959–60, with a variety of primary-coloured squares which, when handled by the viewer, fold out (or pop up) into two- and three-dimensional paper shapes. For me, this seems such a poetic way of interacting with a book: an artform filled with stories that we each interpret as our own. At a time of such optimism in Brazil, to be able to carve out your own story and sculptural forms (and decide for yourself which ones you want to hide behind – or reveal) sparks a wider conversation about freedom and possibility.

The Neo-Concrete movement came to an end in 1961, coinciding with the end of liberal democracy and the rise of another right-wing dictatorship that was to last until 1985. Despite the change in direction of the country, the group created the framework for Brazilian art today.

The mid-twentieth century was rife with artists experimenting with abstraction. Whether through sculpture, painting, installation or architecture, women pioneered the genre. Teaching us how to look slowly at painting or leading us through alternative ways of engaging with sculpture, they revolutionised our experience with art, while also imbuing it with personal and political meaning.

Chapter Ten

THE BODY

(c.1960–c.1970)

THE BODY IN SCULPTURE

'Sculpture allows me to re-experience the past, to see the
past in its objective, realistic proportion … Since the fears
of the past were connected with the functions of the body,
they reappear through the body. For me, sculpture is the body.
My body is my sculpture' — Louise Bourgeois, 1992

How does it feel to be inside a body, and how can you translate that
visually? How, through the power of art, can you make people feel the
visceral sensation of a body that has been hurt or scrutinised, ideal-
ised, or wrought with scars of barely comprehensible histories? When
confronted with the sculptural work of Eva Hesse, Alina Szapocznikow,
Niki de Saint Phalle and Louise Bourgeois, sometimes I don't know
how to feel. The bodies they present to us are complex, troubling,
sexual, sometimes funny and explicit. They challenge us to think
about who these women were, what they might have experienced, as
well as their intentions, obsessions or confessions. Hailing from di-
verse traditions and times, I nonetheless wanted to unite them for
their explorations of the body – and because they were working prior
to the 1970s, when scholars had yet to put into words what constituted
'feminist art'.

These artists radicalised the image of the body in art. Before
them, bodies in sculpture had so often appeared as whole, solid,
unfragmented and 'together' – certainly not flayed and fleshy, or raw
and decomposed. Drawing on the fetishisation of consumerism, as
well as the political and social tumult of the twentieth century so
far, it was through new ways of making that these artists rid them-
selves of tradition, while also working in dialogue with their artistic
contemporaries. Borrowing from a range of styles – emulating the
eroticism and humour of Surrealism, the action-like, time-based
process of Abstract Expressionism, the commercialism and hyper-

sexualisation in Pop, they also looked to the Minimalists, who were using fabricators (external parties with whom they cast work) and bought materials (liquid latex, fibreglass, rubber, felt and more) to upend their artform's rigidity through their use of biomorphic shapes and malleable media.

What is it like to be confronted with a sculptural work by Eva Hesse (1936–70)? It's difficult to describe, but it shifts senses right through your body. In my experience, Hesse allows you to see the body without giving you a body at all, and her visceral, fleshy latex and rubber materials, and chaotic and awkward compositions, leave me questioning – is it decaying, or is it living?

Working in New York in the 1960s and early 70s, despite her brief, only decade-long career, Hesse was a profound experimenter. Always searching for a new material or form, fusing incompatible substances found laying about on her studio floor, or deconstructing the Minimalist 'grid', through her process-based work we see an artist bursting to create. Writing in her diary in 1959 she revealed, 'I have so much stored inside me recently, I need to paint … but I am overflowing also with an energy of the kind needed in investigating ideas, and things to think about.'

Born into a Jewish family in Germany, Hesse was two years old when she was sent to Holland on the Kindertransport. Her family survived, and in 1939 they settled in New York, where they tried to rebuild their lives. Her father retrained as a lawyer, and her mother, never recovering from the horrors, committed suicide when Eva was ten. Although Hesse died aged thirty-four from a brain tumour, we should not read her work through the prism of these events, but rather through her incredible zest for life and hunger for invention.

Trained at Yale by Josef Albers, on her return to New York, Hesse, struck by the improvisational nature of Abstract Expression-ism, produced fluid, scribbly paintings. But it wasn't until she returned to Germany in 1964 that she began to formulate her distinct language. Occupying an abandoned factory, full of bits of fibre and textiles, Hesse made playful, sexually suggestive, relief-like sculp-tures, such as *Ringaround Arosie*, 1965. With its protruding, cell-like shapes, she described the work as both 'breast and penis'. Innova-

Eva Hesse,
Ringaround Arosie, 1965

tively mixing cord, plaster and machine parts (materials which at the time sparked debate about what sculpture could be), these break-through works not only subverted the angular nature of Minimalism but, coming from someone who often cited Simone de Beauvoir in her diary, were no doubt made as a way to push through the perceived limitations of her gender.

Returning to the US in 1965, Hesse set about sourcing industrial materials from Canal Street and collaborating with fabricators, which brought her to experiment with liquid latex. Decaying over time, changing colour (slowly becoming opaque) and perishing in its flaying form, these latex sculptures, although now stabilised, are a reminder of the fragility, destruction and also the beauty of life. In particular, *Right After*, 1969, which, when lit, transforms into an almost celestial, iridescent, webbed entanglement.

Eva Hesse, *Right After*, 1969

Working in Paris in the 1960s, Alina Szapocznikow (1926–73) portrayed the body not as abstractions, but rather as loose fragments, which to me appear darker, more deteriorated and erotic than the interpretations of her contemporaries. With their closed, muted lips, discoloured, loose breasts and machine-like limbs, Szapocznikow's abject, absurd sculptures, which she often referred to as 'awkward objects', disrupt traditions of Western classical sculpture (an idealised whole nude), and invite the viewer to question their context.

Born in Poland to an intellectual Jewish family, Szapocznikow grew up in the opportunistic wake of the country's independence (her mother was a trained doctor). But with the growing anti-Semitism of the 1930s, she and her mother were sent to various concentration camps, where they lived in unspeakable conditions. Although they later became separated, they both survived the internment.

After her liberation in 1945, Szapocznikow pursued sculpture. Settling in Prague, where she joined a stonemasonry, then Paris, she returned to Poland after contracting tuberculosis – a life-threatening

Alina Szapocznikow: (left) *Lampe-bouche* (*Illuminated Lips*), 1966; (right) *Deser IV* (*Dessert IV*), 1971

illness that left her infertile. While she earned state commissions and success (she represented Poland at the 1962 Venice Biennale), in the mid-1950s she began to abstract the body. Pulling it apart and singling out features, her bodies were no longer 'whole' but rather distorted. In 1962, she cast her own leg as a loose limb, as if a precursor for what she would go on to make.

Returning to Paris in 1963, Szapocznikow fused body parts with industrial materials. From car parts and electric lamps to lips and breasts sitting like ice-cream scoops ready to be eaten, I like to read these as her challenging society's idealisations of female forms. While her lamps appear sexualised, with their fleshy yellows and pinks, by tearing the body apart Szapocznikow might also be pointing towards the dying body, reflective of the horrific pain she endured.

Szapocznikow's final works were scattered, bulbous forms, with red lips or haunting images of the Holocaust hidden under layers of resin. While we will never know why she chose to depict the body

like this, she once said she hoped her work might convey, 'the fleeting moments of life, its paradoxes and absurdity'. To me, they are some of the most brutal, raw depictions in art history.

Szapocznikow's contemporary the French-American self-taught artist Niki de Saint Phalle (1930–2002) also attacked versions of the body, as seen in her early 1960s *Shooting Paintings*. Violently shooting at canvases with bags of coloured paint that exploded and dripped onto a plaster surface, Saint Phalle used her 'shooting events' to fight against political corruption and the patriarchy. Employing large-scale canvases and machoistic gestures to emulate (and poke fun at) her male contemporaries (such as the violent, splattered marks on Pollock's colossal canvases), it was also through chance encounters and group efforts (inviting painters such as Robert Rauschenberg to join in) that Saint Phalle pioneered early concepts of Performance Art.

By the mid-1960s, Saint Phalle had taken a different direction, abandoning her *Shooting Paintings* for her *Nana* sculptures: voluptuous and bulbous figures that reclaim the female form and celebrate the 'everywoman'. Speaking about them in 1972, she said: 'Why the nanas? Well, first because I am one myself. Because my work is very personal and I try to express what I feel. It is the theme that touches me most closely. Since women are oppressed in today's society I have tried, in my own personal way, to contribute to the Women's Liberation Movement.'

Dancing, playing or standing on plinths (as though they were always meant to inhabit that space), Saint Phalle wrapped her goddess-like *Nanas* in kaleidoscopic colours and distinct bold patterning. I find it impossible to look at a *Nana* without feeling full of the joy communicated by their free-spirited stances. Ranging from small to gigantic, one of Saint Phalle's greatest works was completed in the summer of 1966 with her temporary installation of an eighty-two-by-thirty-foot reclining *Nana* in Stockholm's Moderna Museet. Titled *Hon – en katedral* (*She – A Cathedral*) and referred to by Saint Phalle as a 'grand fertility goddess', she made her visitors enter through the *Nana*'s vagina (perhaps to remind them where they came from). Once inside, they could enjoy a bar,

Niki de Saint Phalle, *Hon – en katedral* (*She – A Cathedral*), 1966 (a collaborative work between Niki de Saint Phalle, Jean Tinguely and Per Olof Ultvedt)

an aquarium, a cinema playing a Greta Garbo movie and more, presenting myriad activities as if to expound the capabilities of women, including the miracle of life.

Setting her artistic ambitions even higher, and fulfilling her 'lifelong desire to live inside a sculpture', Saint Phalle devoted the later decades of her life to building a live-in sculpture park in Tuscany, with mammoth-sized *Nanas* erected in the form of Tarots, their mirrored and vibrant mosaic cladding glistening in the sunlight. (Pictured on the next page is *The Empress*, whose breasts each hold a bedroom and fully functioning kitchen!) To me, her

Niki de Saint Phalle, *The Empress*, Giardino dei Tarocchi, Garaviccio, Italy; completed 1998

sculptural bodies refuse to conform to the power of the patriarchy. Physically taking up space and blocking your sight with their huge rounded features, Saint Phalle's *Nanas* provide a joyous monument of sorts, and set our bodies free.

Like Saint Phalle, Louise Bourgeois (1911–2010) worked in a spectrum of scales, using multiple materials, shapes and subjects. Her radical and highly influential seven-decade career spanned from the late 1930s to the late 2000s and saw her constantly challenge the role of the body: how we feel inside it, and how we respond to it.

Born in Paris into a family of tapestry restorers, Bourgeois often recalled how her childhood was scarred by her complicated relationship with her father (especially his destructive affair with her English tutor), and the effects of her mother's chronic illness and eventual death when Bourgeois was twenty. First studying mathematics before turning to art, she came of age in the Surrealist era, and in 1938 moved to New York with her American art-historian husband. The works she made during this period, while also raising three young boys, seem to scream of a prison-like existence – the

story of a woman forced to limit herself to her domestic role. In her painting series *Femme Maison*, 1946–7, tall, uneasy bodies, slotted into and confined by thin, long frames, their faces blinded and suffocated by four-walled buildings, conveyed the sensations she would employ across her sculptures, drawings and prints.

Working on her rooftop, which doubled up as a studio, Bourgeois drew influence from the looming, phallic skyscrapers that surrounded her for her 1940s *Personages* series: clusters of long, thin and faceless sculptural figures, evoking the friends and family she left behind (and missed) in France. To me, they appear both alien-like and protective (much like her later giant spider sculptures or her eerily haunting *Cell* installations). But in the 1960s she began to work with new materials, aligning herself with avant-garde art, using latex, rubber and plaster for her absurd bodily forms. Challenging the male-dominated history of sculpture, Bourgeois also worked in marble and bronze, turning the classical form on its head with her phallic and discomforting figures. I find one of her most perverse works to be *Janus Fleuri*, 1968; a combination of male and female organs evocative of a pre-birth state, and which hints at her ongoing interest in psychoanalysis.

Louise Bourgeois: (left) *Femme Maison*, 1946–7; (right) *Personages*, 1946–50

Louise Bourgeois,
Janus Fleuri, 1968

Even after her death, Bourgeois continues to draw in viewers and teach us new ways of thinking about our bodies and psyches, with her profound ability to unlock our deepest desires and fears, whether it be through her trapping *Cells* or protective but equally monstrous spiders. Bourgeois's extensive oeuvre, like Hesse's, Szapocznikow's and Saint Phalle's, has opened up a feminist discourse that I believe has shaped art history forever.

THE BEGINNINGS OF PERFORMANCE ART

While some artists were reinventing the body in sculpture, others were using it to pioneer a new art: Performance Art, a genre defined by risk-taking, and which links to today's Conceptual Art. Often employing the self as their primary medium (sometimes as a politicised tool to address gender, identity and an oppressive society), artists blurred the distinctions between life and art with live acts, audiences and multidimensional processes that yield different outcomes depending on participants. Created through actions, these works are full of physical and psychological tension, and use unsettling environments that test the endurance of both artist and viewer.

Through Performance Art, artists take on a range of identities, raising explicit and direct questions about the body – and society – in ways that they thought more immediate, and more authentic, than creating a single object to be placed staidly on a gallery wall. Despite these performances existing only in scripts, instructions or images today (unless or until they are re-performed), I find their strength and vulnerability still resonates today.

A pioneer in this field, Yoko Ono (born 1933) set the precedent for disruptive performance pieces that simultaneously challenge and enforce a dialogue between artist and viewer. Raised in Japan, by 1953 she had settled in New York, and it was here that she became involved in the city's avant-garde Fluxus group: a predominantly political group of artists, poets and musicians who were invested in chance encounters and the unpredictability of performance.

Ono's radical work *Cut Piece*, 1964/1965, took the world by storm. First performed in Kyoto and then New York, *Cut Piece* questioned the power of trust and was one of the earliest works to invite audience participation. It saw Ono kneel, still and silent, on a vast stage, initially dressed in a black suit, with a pair of scissors laid out in front of her. After inviting the viewer to contribute to the work – by giving them the licence to cut up her clothes (and keep them, as they wished) – Ono soon became more and more exposed. An act (or symbol) of violence, *Cut Piece* amplified and confronted

Yoko Ono,
Cut Piece,
1964/1965

the sexual aggression directed towards women, while also alluding to their constant vulnerability in an oppressive society.

Also addressing these urgent and (still) timely subjects, the Belgrade native Marina Abramović (born 1946) took the genre in a different direction. Through her extreme performances, she tests the physical pain and demands of the body and, like Ono, she acts as both object and subject, challenging her audience, and pushing the psychological limits of the artist's mind. I find this evident in her early solo, time-based performance, *Rhythm 10*, 1973. Based on a Russian drinking game, *Rhythm 10* involved Abramović using a white piece of paper, a tape recorder, and twenty different-sized knives, which she stabbed repeatedly between her fingers, switching her tool every time she cut herself. Borrowing from the electric spirit emitted by the audience who allowed her not to 'feel pain', it was, she reflected in 2010, the 'first time I realised what energy means in the audience, and the energy I could take and transmit to my own and give it back'.

A year later, she returned with her six-hour performance, *Rhythm 0*, 1974. Having laid out seventy-two objects on a table in front of her – perfume, roses, scissors, a loaded gun – she also instructed the audience to 'use [the objects] on me as desired', declaring herself as the 'object', and taking 'full responsibility'. At first the assembled onlookers were passive, but after a few hours they began to violently abuse their power. In 2010 she stated, 'it became

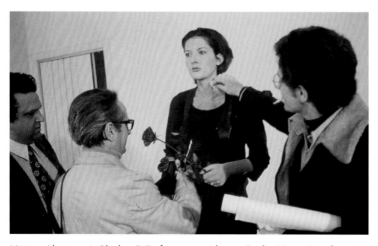

Marina Abramović, *Rhythm 0*, Performance, 6 hours, Studio Morra, Naples, 1974

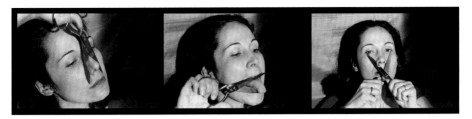

Anna Maria Maiolino, *É o que sobra* (*What is Left Over*), from *Fotopoemação* (*Photopoemaction*) series, 1974

more and more aggressive … They would cut my clothes … cut me with a knife, close to my neck …' Pushing the resilience of the artist's body and mind – as well as trust in the participating audience – I see this work evoking the power structures of society, as well as the effects of control in authoritarian (and misogynistic) cultures.

Political motive and misogyny were similarly articulated in the work of Brazilian artist Anna Maria Maiolino (born 1942), who in the 1970s used performance and the body as a form of protest.

Maiolino's formative teenage years coincided with a period of great progress in 1950s Brazil, as explored in the previous chapter with Pape and Clark (p. 295). Having moved to the US in 1968, she returned three years later to a country torn apart by the military regime. With scarce materials available, she took to using her body as her primary tool. At a time when censorship was rife, this practice not only left no trace or evidence, as a material art object would do, but it raised questions about the silencing of women under the repressed regime. In *É o que sobra* (*What is Left Over*), 1974, she holds sharp blades over her tongue and nose, as if to obliterate the very basic constructions of the body: to eat, taste, smell and speak.

Although many of these artists went on to play active roles in the 1970s Feminist movement (p. 326) – with some works achieving landmark status, such as Ono's *Cut Piece* – most were working at a time when a feminist discourse was yet to be written. It fascinates me that 'Body Art' or 'Performance Art' is a genre dominated – and pioneered – by women. The female form has been commodified in art for centuries, so it seems apt that women would upend the very same tool and use it as a symbol of protest.

Chapter Eleven

WEAVING NEW TRADITIONS

(c.1950—c.2000)

FIBRE ARTS

'If I were unable to speak, I could make something,
and show it to you, and you would get the idea without
my having to verbalize it' — Sheila Hicks, 2018

Artists have been working with textiles for hundreds, if not thousands, of years: for function (clothes, blankets and even soundproofing devices); as political tools (such as the banners made by the Suffragettes); for the purposes of storytelling and communication; or as a medium for self-expression. Using natural and synthetic fibres, ancient techniques and modern ones – stitching, quilting and weaving, bundling together old clothing or using found objects – artists have configured wall-hangings, three-dimensional sculptures, and giant, immersive installations.

Despite the innovative and progressive ways through which the medium has been handled, particularly in the twentieth century, textiles and embroidery have historically been derogated as 'decorative arts' due to their association with women. In feminist art-historian Rozsika Parker's book *The Subversive Stitch*, published 1984, she writes about how embroidery was 'characterised as mindless, decorative, and delicate'. But what the medium actually reveals is a deep political subtext, one that charts the history of oppression of women throughout the last 500 years.

First relegated from the high arts in the Renaissance, the lowly status of textiles was cemented by artistic academies in the eighteenth century (the Royal Academy of Arts in London banned embroidery within eighteen months of its opening). This meant that women had to actively reject the medium if they wanted to be taken seriously. Even in the twentieth century, schools such as the Bauhaus, which sought to diminish hierarchies between artforms, revealed its gender and form hierarchy by sending women off to the weaving workshop. And if you need any more convincing that it was Western patriarchal

ideals that forced these associations slowly into existence, it might come as no surprise that Le Corbusier was once quoted as saying: 'There is a hierarchy in the arts: decorative art at the bottom, and human forms at the top. Because we are men.' No wonder artists in the 1970s feminist movement used the needle as a form of protest (see Judy Chicago's *The Dinner Party*, 1974–9, p. 352).

Alongside feminist art, things changed. When artists expanded the supposed limits of weaving in an advanced and improvisatory way, adopting both ancient techniques and working 'off-loom', institutions began to take note of the emergence of 'Fibre Art'. Landmark moments included *Wall Hangings* at MoMA in 1969, outlined by the museum as the first group exhibition in America 'devoted to the contemporary artistic weaver'.

Looking at new ways of approaching the medium in the realm of fine art, the show featured Lenore Tawney (1907–2007), a former New Bauhaus student, and her highly inventive 'woven forms' inspired by Peruvian techniques. Also included was Polish artist Magdalena Abakanowicz (1930–2017), who used woven fibre for her vast-in-scale, malleable bodily forms (which she called *Abakans*). Responding to European tapestry traditions, Abakanowicz pushed forward new ways of thinking about textiles as installations and encouraged 360-degree looking. Exhibited alongside these artists was work by a young Sheila Hicks, who was fresh out of Yale having been taught by Josef Albers (and briefly, informally, by Anni Albers).

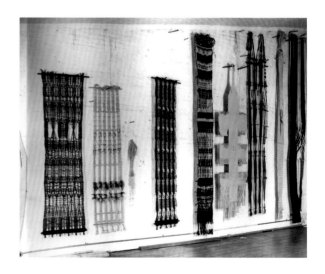

Lenore Tawney's studio at 27 South Street studio, New York, 1962

While artists working in textiles feature throughout this book –
Harriet Powers, Sonia Delaunay, Hannah Ryggen, Louise Bourgeois,
to name a few – I want to use this chapter to draw a distinction
between them and those just mentioned who exclusively used textiles
as their medium. I have chosen to do this here to highlight the range
of experimentation, and before we discuss the Women's Liberation
Movement. This is also the only chapter that spans numerous dec-
ades, as fibre is an artform that is steeped in history.

We begin with Hicks, who emerged in the 1960s with the Fibre
Arts Movement, and end with quiltmakers, who continue to practise
century-long traditions today. Although some of the artists I will
discuss were working at the same time as the feminist movement,
which saw women embrace the domestic forms of textiles, their
art has a less overtly political agenda and stems from different tradi-
tions. From sculptors, weavers and quiltmakers, to the self-taught
and neurodiverse, for me, these artists broke ground with their rad-
ical works in fibre, despite so often being dismissed by establishment.

Oozing with bright colours, glittering surfaces, rich textures and
organic, at times cosmic, forms, looking at work by Sheila Hicks
(born 1934) tends to immediately provoke intrigue and astonish-

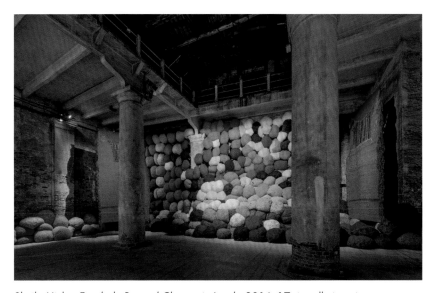

Sheila Hicks, *Escalade Beyond Chromatic Lands*, 2016–17, installation view
at the Venice Biennale, 2017

Cecilia Vicuña, *Quipus Visceral*, 2017

ment. Whether it is her smaller weavings inspired by pre-Columbian textiles learned in her youth while travelling in Latin America (which she calls 'minimes') or her colossal architectural environments that pour out of ceilings or swarm entire rooms – a more recent example being *Escalade Beyond Chromatic Lands*, 2016–17, Hicks's fibre creations break down all tensions between art object and viewer. By encouraging us to sit down, reflect, and physically feel and touch her artworks, she creates environments where we can be at one with her work. For her, tactility is key. The same can be said for Chilean-born poet and artist Cecilia Vicuña (born 1948), who, like Hicks, has been active since the 1960s and works on an all-encompassing scale that disrupts all perspective and engulfs us as viewers. Cascading from the ceiling in a formation of forest-like abundance, Vicuña's fibre works incorporate the Indigenous traditions of *quipis* – a system of communication relying solely on hand-tied knots used by the Quechua people. One can get completely lost in her immersive

Mrinalini Mukherjee
with her work, *PRITHVI*
(*Woman on a Swing*), 1989

installations, which invite us to participate as performers as well as engage in a wider language that doesn't necessarily need to involve speech.

Working quite apart from the Western art world, the Indian artist Mrinalini Mukherjee (1924–2015) configured the most extraordinary sculptures from dyed rope (either hung from the ceiling or standing by themselves). Working purely intuitively, without sketches or preparatory work, and drawing from folk art, nature and mythology, Mukherjee employed a hand-knotting technique (known as 'macramé') for her towering, regal figures. Full of expression and animation, when witnessed in real life they come alive and command power, and when exhibited together they appear like ancient deities who once ruled the world. Looming over us (at times nearly double

Judith Scott, *Untitled*, 2004

our height), in forest greens, burnt oranges and rich, deep purples, Mukherjee's figures feel both human and otherworldly, protective and monstrous, as they oscillate between abstraction and figuration in their labour-intensive, elegant, thick and thin folds.

In America, the self-taught Judith Scott (1943–2005) was using fibre in a completely different way. Her fluid and complex sculptures merge wheels, trolleys, locks and chairs with bundles of threads – some of these pieces she would work on for six hours straight, or months at a time. While Scott has often been positioned alongside those in 'Art Beyond the Mainstream', I believe she deserves to be placed among the greatest innovators of fibre. Her inventive methods and obsessively spun sculptures cocoon found objects and function as a form of communication – which is particularly extraordinary for someone who couldn't hear or speak verbally.

Born with Down's syndrome and an undiagnosed deafness, from the age of seven Scott's family placed her in a series of mental institutions. She endured horrific conditions for more than thirty-five years, until 1985, when her twin sister, Joyce, born without disabilities, became her legal guardian and brought her to California. Here, Joyce enrolled Scott at the Creative Growth Art Centre in Oakland, one of the first places to provide artistic freedom for people with psychological or physical disabilities. She made nothing for the first two years of her time there, but after participating in a fibre art workshop Scott became obsessed with threads. She spent the next seventeen years of her life (until her death, aged sixty-one) fastidiously wrapping, bundling and spinning fibres around objects, transforming them into her extraordinary creations, such as in *Untitled*, 2004, which buries a chair, a bike wheel, a basket and more, under layers of an assortment of kaleidoscopically coloured fibres.

Like those working with fibre, quilters have also mainly been left out of art-historical scholarship, even though the medium has been a staple of textile art for centuries (as seen in the work of Harriet Powers, p. 76). Through quilts, artists have expressed political and cultural viewpoints, recited stories or just continued age-old traditions through a long line of female family members.

Faith Ringgold, *Tar Beach 2*, 1990, from the *Woman on a Bridge* series

Although Faith Ringgold (born 1930) appears in chapter 9, I wanted to include her again here to emphasise her commitment to the advancement of the medium. Taught the art of quilting by her fashion-designer mother, Willi Posey, Ringgold's narrative patchwork quilts comprise rich, colourful imagery and text. Honouring cultural figures from Martin Luther King Jr. (with his 'I Have A Dream' speech inscribed onto one), to James Baldwin, Audre Lorde and Harriet Tubman, Ringgold also used the medium to reference childhood memories in Harlem – from hot summer nights eating on rooftops with her family, playing cards with friends, to looking up to

Rosie Lee Tompkins, *Untitled*, 1996

the stars. My favourite series is *Woman on a Bridge*, begun in 1988, which follows the story of a young girl, Cassie Lightfoot, who flew above the sparkling New York skies with the hopeful message that 'anyone can fly, all you gotta do is try'.

Like Ringgold, the nurse-turned-artist Rosie Lee Tompkins (1936–2006) populated her patchwork quilts with cultural reference points, but she executed hers in a Pop Art, collage-like form. Bursting with colour in patches of velvet, faux-fur, T-shirts and tapestries, Tompkins's quilts at times brilliantly commented on the current state of America. In *Untitled*, 1996, we see a shattered American flag spread across a whole range of images: from the political to the spiritual to the just plain humorous (at the bottom left of the quilt she places an image of Christ beside two poodles!), for me, Tompkins's eccentric mix of culture and politics sums up the eclectic highs and lows of American culture.

Tompkins also made quilts so magical that the colours bounce off the surface, glistening in vibrant hues of pinks, purples or dark blues with hints of yellows emulating a starry night's sky, or looking down on the electric lights of Earth. Luminous colours, jazzy patterns and

Sue Willie Seltzer and Gee's Bend Quiltmakers, *Housetop–Nine-Block*
'Half-Log Cabin' Variation, c.1955

dizzying multilayered forms are also key motifs of the art group
I want to end this chapter with. The Gee's Bend Quiltmakers, the
all-female, African American community (mostly descended from
those formerly enslaved), who since the early twentieth century have
been quilting in the rural Alabama-based town of Boykin (formerly
known as Gee's Bend).

Bound together, in their words, 'by the spirit of the cloth', the
Gee's Bend Quiltmakers now encompass up to four or five gener-
ations of women (and counting). They make quilts not always for

the purpose of 'art', but primarily for practicality, such as, in their words, 'warmth in the winter, and when it's hot, to keep mosquitoes out'. Recognised by the American museums in the early 2000s (with a touring exhibition that travelled to twelve cities including the Whitney Museum of American Art), their quilts, which include some of the current quilters' childhood bedroom quilts, now hang on the walls of museums, from The Met to LACMA (often much to the surprise of the Gee's Bend women).

Sourcing materials from bits of old clothes, one of the current Gee's Bend members, Loretta Pettway Bennett (born 1960), has created a jean-themed quilt using up her husband's and son's trousers, reflecting the ideology of the group, who have described their work as 'to make something shine from something that has been thrown away'. Using experimental and improvisational techniques passed down from generations, their versatile quilts can be geometric or asymmetrical, irregular or freeform as seen in Sue Willie Seltzer's *Housetop–Nine-Block 'Half-Log Cabin' Variation*, c.1955. Executed in a variety of textures and colours, filled with beauty and with love, each quilt, I find, comes with its own lively personality, but also a deep personal history: 'You can see the struggle, you can see the joy, you can see sadness, happiness, all those different emotion in those quilts,' says Pettway Bennett.

Sculptors, weavers, quiltmakers, tapestry-makers: the sheer breadth of work created by artists working across fibres is astounding. From the all-engulfing environments created by Hicks, the knotted, coded languages by Vicuña, the colossal rope sculptures by Mukherjee, the intricate patchwork quilts by Ringgold to the bundles of fibre that submerge found objects by Scott. Each artist comes from a different tradition and uses different processes, and through their work they tell personal and political stories, all while working in a medium that reveals a deep political history and connects them to a long lineage of (named and unnamed) women.

PART FOUR

TAKING OWNERSHIP

OWNERSHIP

1970—2000

WOMEN'S LIBERATION IN THE CONTEMPORARY SPHERE

'November 1970, a time when there were no women's studies,
no feminist theory, no African American studies, no queer theory,
no postcolonial studies. What there was ... was a seamless
web of great art, often called "The Pyramids to Picasso"...
extolling great (male, of course) artistic achievement
since the very dawn of history' — Linda Nochlin reflecting
on the women's liberation movement, 2006

Fuelled by the activism of the previous decade, the 1970s marked a revolutionary era for women, although, as far as institutions were concerned, women remained less visible than men. Protesting their outrageous treatment at the hands of the establishment, women responded by campaigning for their rights and actuating change. Forming feminist-focused educational programmes and staging all-women exhibitions, women artists expanded ideas around Conceptualism and Performance Art, while simultaneously dismantling traditional art spaces. The monumental progress they made left a lasting impact that not only propelled them into mainstream recognition but forced the white-male establishment to sit up and listen.

Across the thirty years that this section covers, the world changed drastically, and in synthesis with this growth, so, too, did art. Mostly the children of postwar societies, who were raised amid Cold War politics and who grew up watching television, artists in this period didn't just forsake and rework traditional artforms, but, as Nochlin's quote reminds us, they also fought for institutional recognition for those historically excluded. Paving the way for art in the millennium and defining what we consider to be 'contemporary art' today, it is also thanks to their efforts that by the end of the century people of colour, queer people and women were gradually integrated and accepted by mainstream institutions.

Chapter Twelve

THE ERA OF FEMINISM

THE FIGHT FOR CHANGE

'I became a feminist because I wanted to help my daughters,
other women and myself aspire to something more than
a place behind a good man' — Faith Ringgold, 2005

The 1970s was an explosive decade for women, marking a time of
fundamental change and activism ignited by women all over the
world. Following the legalisation of abortion in the UK in 1968
(America, France, Spain and Italy soon followed), and in the US
the push for gay rights with the 1969 Stonewall uprising in the after-
math of the Civil Rights Movement, as well as the passing of the
Equal Rights Act (1972), women came together in groups to beat
their overarching enemy: the patriarchy. This global movement
saw feminists protest for equal rights in the workplace and for the
criminalisation of violence against women, among other things. And
considering the dearth of visibility by women across galleries
and museums, it comes as no surprise that women artists, too, felt
compelled to force radical change.

In New York, the Ad Hoc Committee of Women Artists was
established in 1970 (members included Faith Ringgold, Poppy John-
son and critic Lucy Lippard), which campaigned for the Whitney
Museum of American Art to feature in their Whitney Annual exhib-
ition 50 per cent women artists, and for 50 per cent of that number to
be Black. (In the end only 20 per cent of women were included, and
although numbers had increased from the previous year's 5 per cent,
only two of those women were Black.)

On the West Coast, when the Los Angeles Council of Women
Artists protested against the lack of visibility of women at the Los
Angeles County Museum of Art (LACMA) in 1970 (after just 1 per
cent of artists included in their display were women), a ground-
breaking exhibition was installed six years later: *Women Artists:
1550–1950*. Curated by art historians at the forefront of the feminist

Faith Ringgold,
*Woman Freedom
Now*, 1971

movement, Ann Sutherland Harris and Linda Nochlin, the exhibition demonstrated the legitimate long history of women artists, and introduced to a wider audience artists such as Artemisia Gentileschi (p. 35) and Sofonisba Anguissola (p. 24).

While women were demanding change, museums, commercial galleries and university institutions continued largely to ignore them – or at least the idea of women-led university courses – so they created their own. 'Very few women were being shown in the galleries,' artist Howardena Pindell told me. 'The lucky few had to be white, the child of, lover of, spouse of a famous white male artist.' Taking matters into their own hands, the A.I.R. Gallery (with founding members including Agnes Denes, Harmony Hammond,

Sylvia Sleigh, *A.I.R Group Portrait*, 1977–8

Pindell, Nancy Spero, among others, who Sylvia Sleigh painted in *A.I.R Group Portrait*, 1977–8) opened in New York City in 1972 to glowing reviews as the first commercial gallery space dedicated to women. Soon after, in 1974, Linda Goode Bryant opened the Just Above Midtown gallery (JAM), dedicated to showing exclusively Black artists.

On the East Coast, a critical moment occurred when Linda Nochlin penned the historic essay *Why Have There Been No Great Women Artists?* for *ARTnews*'s January 1971 issue, kick-starting the debate on gender disparity in art (as well as the feminist art movement in general). An essay so influential, Judy Chicago said it 'changed the world'. This was published the year after Nochlin began her Women

and Art course at Vassar College in 1970, the same year the West Coast-based artists Chicago and Miriam Schapiro instigated the first feminist art programme at Fresno State College. In 1971, Chicago, Schapiro, Luchita Hurtado, Vija Celmins and others formed the Los Angeles Council of Women Artists. Meeting on a weekly basis, the group penned a report highlighting statistics on the lack of female representation in exhibitions, and encouraged each other to produce and exhibit artwork. Luchita Hurtado recently reflected, 'It wasn't until I had joined this women's consciousness movement that I started to show people my work and not turn my paintings towards the wall.' In 1973, Chicago, Sheila Levrant de Bretteville and art historian Arlene Raven opened the Woman's Building in Los Angeles, the first physical space dedicated to feminist art and education and, most importantly, discussion (and where Hurtado would have her first solo exhibition in 1974). Accommodating of all arts, with the likes of novelist Margaret Atwood and poet/theorist Audre Lorde passing through, it is no wonder Lucy Lippard described it as the 'capital of cultural feminism'.

In the UK, the first Women's Liberation group formed in 1970, spearheaded by artists Mary Kelly and Margaret Harrison, who experimented with living in communes to promote equal parenting. Rome was an important centre for early European feminism, thanks to advocate art historian and critic Carla Lonzi and artist Carla Accardi, who founded the radical feminist art collective Rivolta Femminile. Additionally, in Austria, influential artist VALIE EXPORT used provocative performances (such as wearing crotchless trousers) to take on the male-dominated art scene epitomised by the members of Performance Art group Viennese Actionism.

Queer visibility was essential to the movement, as championed by artist Harmony Hammond, who curated *A Lesbian Show* in SoHo, New York, in 1978. This was the first all-lesbian art show in the US and featured work by eighteen artists, including Kate Millet, Dona Nelson, Louise Fishman and Amy Sillman. Hammond also created vital feminist discourse as the co-founder of the quarterly publication *Heresies: A Feminist Publication on Art and Politics*, which dedicated issues to female gay culture.

Although the Women's Liberation Movement was radical, it had its faults. Most notably, in some communities white women were (consciously or unconsciously) exclusionary of Black women – Pindell has since referred to it as the 'white women's movement'. Having witnessed the impact of the Civil Rights Movement in the 1960s – where, despite playing essential and authoritative roles, women of colour were marginalised by male-dominant groups – Black women united to form their own collectives. In 1971 artists Kay Brown, Dindga McCannon and Faith Ringgold assembled a group of Black women artists, known as 'Where We At' Black Women Artists. Turning their discussions into action, that summer they staged *Where We At: Black Women Artists: 1971* at Acts of Art Gallery, the first all-Black, all-female exhibition in New York City. Committed to engaging with other marginalised communities, *Where We At* exhibited and held workshops in hospitals, prisons, community centres and schools. Not only did they support, nurture and encourage their fellow artists' professional lives, but – at a time when they were doubly excluded by the art world – they helped each other with domestic duties, too. McCannon told me: 'Different artists babysat other members' children. We sort of took turns using whoever was available. It was a win–win situation as the kids kept one another company, which allowed me to work … I can remember *Where We At* loaning me money to pay overdue rent, a constant problem even though then rents were often $50–100 a month!'

Perhaps the most significant method of igniting change was through the nature of art-making itself. Whereas some artists employed more traditional media, such as painting, sculpture and textiles, to push forward the vocabulary of feminist art, others sought new methods of working altogether. Addressing (often in protest) subjects of motherhood, violence, migration and race, artists alluded to a woman's experience and told their version of living in an oppressive society. Sharing concerns and sensibilities, and raising questions about what it meant to be a woman at this time, it was in this decade that women artists began to imagine and formulate what 'feminist art' could be.

'I took hold of my own identity, and I said henceforth,
I should determine who I am. I reject the definitions
which society has given me' – Judy Chicago, 1971

Although there was no singular aesthetic for feminist art, many chose to work with the body, or with other corporeal symbols. In the 1960s, Judy Chicago, previously Judy Gerowitz (she renounced her first husband's surname, adopting the name of her birth city instead), gained recognition for her block-like Minimalist sculptures. Her work *Rainbow Pickett*, 1965, was featured in the landmark 1966 Jewish Museum exhibition, *Primary Structures*, as one of only three women (out of fifty-one artists) included. Due to the increasingly male-dominated discourse around Minimalism, though, Chicago switched up her aesthetic to reflect vulva-like forms, as if to poke fun at her male artist contemporaries. Taking classes at a car auto-body school (the only woman among 250 students), Chicago learned to use spray guns to paint vaginal forms on car hoods. Then, as if to forge a feminist take on the rigidity of Minimalism, she spray-painted on canvas angular, phallic forms in bright pinks, blues and purples. My favourite example of this is the aptly titled *Heaven is for White Men Only*, 1973.

Judy Chicago, *Heaven is for White Men Only*, 1973

Heralded then and now for her pioneering feminist art, Chicago spearheaded a different approach towards art education too. Instructing her students to, in her words, 'build their art-making on the basis of their experiences as women', she banned them from reading male authors and taught them to fight for their rights. Chicago's course inspired a generation of performance artists, one of whom was the great Suzanne Lacy (born 1945).

At a time when the definition of rape did not cover marital intercourse (regardless of consent), Lacy used the power of performance to break taboos and raise awareness. Making the personal political, for three weeks in May 1977 she gathered rape reports from a Los Angeles police department, marking them across a 25-foot-long map in red painted stamps prominently displayed in City Hall. Named *Three Weeks in May*, the work prompted a media storm and received even further attention after the Hillside Strangler raped and murdered ten women the following December. In honour of the victims, Lacy, artist Leslie Labowitz and others dressed in black and led a procession from the Woman's Building to City Hall in Los Angeles. On arrival, in front of a sign reading 'In Memory of Our Sisters, Women Fight Back', these women took to the microphone and read

Suzanne Lacy and Leslie Labowitz, *In Mourning and in Rage*, 1977

aloud a statement about violence against women specific to Los Angeles. Titled *In Mourning and in Rage*, it is a work that still feels uncomfortably relevant today.

Issues of violence and rape were also explored through brutal and raw performances. While completing her MA at the University of Iowa, the radically pioneering and experimental Cuban-born artist Ana Mendieta (1948–85) used the body to address the injustices faced by women. This included *Untitled (Rape Scene)*, 1973, Mendieta's re-enactment of the aftermath of the murder and rape of a student at her university. Mendieta stood naked, bent down, exposed and drenched in blood, inviting her fellow students to watch: a harsh, direct and painful reminder of the stark realities of exploitation and abuse still endured by women.

Mendieta's use of the body as her primary medium was as much a political choice as an artistic one. Born in pre-revolution Havana, Mendieta's life changed when Fidel Castro came to power and her father (initially supportive of the Castro movement, but later blacklisted after declining to join the Communist Party) was imprisoned. Exiled from Cuba and sent to America (settling in Iowa, aged twelve), Mendieta remained separated from her parents – and birth country – for years.

Interrogating themes of memory, history, displacement and rebirth, Mendieta described using 'the earth as a canvas and my soul as my tools', when creating more than 200 performative and ephemeral 'sculptures', which she called *siluetas* (silhouettes). Through methods of burning, carving, planting and more, Mendieta sought to 'become one with the earth', moulding the outlines of her body onto the soil of Iowa, Mexico and, from 1980, Cuba. These *siluetas* spoke to notions of healing – both in respect of the rift between her home country and America, as well as the powers of nature. They also bring to light the redundancy of borders, given Mendieta's upbringing between countries and cultures, and ultimately, in a feminist realm, show the freed woman leaving her imprint on the soil – a canvas free from patriarchy.

Throughout the 1970s, women used unconventional environments for performance, not least because of their struggle to enter

Ana Mendieta,
Untitled: Silueta Series,
Iowa, 1977

the sanctified sites of art, whether museums or private galleries. Devoid of patriarchal barriers and 'gendered' architectural spaces, the outdoors and public realms allowed women more freedom to express themselves on their terms, using these locations for political statements. In 1973, Mierle Laderman Ukeles (born 1939), created her performance series *Washing/Tracks/Maintenance: Outside*, in which she documented herself in black-and-white photographs vigorously scrubbing the outdoor steps of the Wadsworth Atheneum Museum of Art, in Hartford, Connecticut (as if mirroring the action-like gestures of the male Abstract Expressionists). Addressing issues associated with the patriarchal and hierarchical structure of museums, Ukeles gave precedent to those so often marginalised and unseen by visitors, by performing tasks usually done by maintenance workers. Placing herself at the centre of the 'domestic' act, she also questioned the role of a mother as both worker and caretaker, and in her 1969 manifesto coined the term 'Maintenance Art' to challenge society's perception of those trying to do both.

Mierle Laderman Ukeles,
Washing/Tracks/Maintenance:
Outside, 1973

Over in the UK, women critiqued their highly gendered roles around domestic labour. To obfuscate her roles as both mother and artist, between 1973 and 1979, Mary Kelly (born 1941) created the *Post-Partum Document,* a six-part record of her son's early years. Expressing her raw subconscious thoughts alongside data and artefacts from her son (from nappy liners to his baby clothes), Kelly's aim was to communicate a mother's psychological experience to the viewer – a subject matter previously unheard of in male-dominated Conceptual Art. Not only did she challenge representations of motherhood in art history, but she also deepened our contemporary understanding of a mother's role and inner life. But when exhibited at London's Institute of Contemporary Arts (ICA) in 1976, the *Post-Partum Document* was met with some controversy; a few critics were outraged at the inclusion of stained nappy liners inside a pristine, white-walled gallery. Yet today it is embraced as a landmark moment in feminist and Conceptual Art, lauded for its candid exploration of motherhood and for its unconventional,

non-figurative visualisation of a 'mother and child', one of the oldest and most traditional subjects in Western art history.

If *Post-Partum Document* presented one of the earliest conceptual representations of the 'mother and child', then, for me, Senga Nengudi (born 1943) introduced a new dimension. Her work *R.S.V.P.*, 1977, was among the most powerful series of the 1970s. Performed at the acclaimed JAM gallery in 1977, *R.S.V.P.* looked at alternative ways of visualising the physical and psychological effects of motherhood. Nengudi, who had recently given birth, attached her stretched and knotted nylon stockings to the wall, with some areas filled with sand to create bulbous, cell-like, organic sacks and others left empty and malleable. Extending the fragile material to its limit, on the one hand *R.S.V.P.* feels unnervingly tense, perhaps signalling a mother's anxious psyche; on the other it shows the incredible capacity of the body and mind to expand and contract, yield and gift beyond what could be imagined. By utilising clothing often worn by

Mary Kelly,
Study for Post-Partum Document: Introduction (Prototype II), 1973

Senga Nengudi, *Performance Piece*, 1978 (part of the *R.S.V.P* series)

women, she charges the fibre-based material with strength and resilience – as confirmed by the artist who recently spoke of the stockings as being, symbolically, a 'holder of power'.

With a background in modern dance and influenced by the highly experimental Gutai group (p. 258), through *R.S.V.P.* Nengudi explored new ways of fusing sculpture, installation and performance, using her work as a site for activation – for both the artist and dancers and, to an extent, her viewers. The title may also allude to an invitation to bring to the artwork our own experiences of feeling tensions within the body.

Taking Performance Art in a different direction while also examining subjects of birth, womanhood and the suppression women faced in society, for *Interior Scroll*, 1975, Carolee Schneemann (1939–2019) climbed up onto a table, stark-naked. Covering her body with mud, she then extracted a scroll-like, folded-up text from her vagina. Describing her overlapping notions of the vagina as 'the source of sacred knowledge, ecstasy, birth passage, transformation', in *Interior*

Carolee Schneeman,
Interior Scroll, 1975

Hannah Wilke,
*S.O.S. Starification Object
Series*, 1974

Scroll she further subverts expectations when it transpires the text is
a series of criticisms of her film work by a (male) filmmaker, which
she proceeded to read aloud.

Hannah Wilke (1940–93), who like Schneemann had already
been developing a radical feminist practice since the 1960s, worked
with non-traditional materials (lint, terracotta, latex and gum) and
her own body to reflect the oppressive politics and positioning of
women in America. This was most poignantly explored in her *S.O.S.
Starification Object Series*, 1974–82; a sequence of black-and-white
images in which she confronts the viewer by posing semi-seductively
with the top half of her body exposed. Of covering herself in tiny
labial sculptures made from chewing gum (for me, a symbol of
Americanisation), she said in 1980: 'I chose gum because it's the
perfect metaphor for the American woman – chew her up, get what
you want out of her, throw her out and pop in a new piece.'

Questioning, in my view, the American public's preconceived
ideas around gender, race and class, in her series *Catalysis*, 1970,

conceptual artist and philosopher Adrian Piper (born 1948) used everyday spaces to examine and expose the public's treatment of each other based on first-glance interactions. With the title playing on notions of 'catalysing' or prompting a reaction in her audience, Piper took to the streets, bookshops, department stores, museums and subways of New York and dressed and behaved in ways that would provoke a response from passers-by. She wore clothes drenched in cod liver oil, milk, vinegar and egg for a week; stuffed her mouth with a bath towel while riding the bus, and chewed and popped bubble gum onto her face when visiting the Metropolitan Museum of Art. At times documenting these performances through images, as seen in *Catalysis IV*, 1970, Piper presented people ignoring and turning away from her in discomfort – stark reminders of the injustices and prejudices in America, and beyond.

Among the most pioneering artists of the decade (and still today), Howardena Pindell (born 1943) not only advanced ideas across painting, collage and film, but was also instrumental in standing up for Black rights in America.

Having completed her Bachelor of Fine Arts at Boston University (at a time when the art school had a quota of one Black student

Adrian Piper,
Catalysis IV, 1970

Howardena Pindell,
Untitled #69, 1974

a year) and a Masters at Yale, following graduation in 1967 Pindell took a day job as a curator at MoMA and worked on her studio practice during the night. Painting without any natural light, she responded by turning to abstraction. Engaging with Minimalism by playing with and disrupting the 'grid' (the iconic framework of the movement), Pindell's canvases consist of hole-punched dots, ovals and circles. Influenced in part by the feminist movement, she began using unorthodox materials such as glitter and talcum powder: 'I thought not so much that [my artworks] were Minimalist, but thought of them as transcending the mundane circle, clustered dots, sprayed in something of beauty that lifted one out of the daily hum drum of life.'

In 1979 Pindell's work turned autobiographical, following a severe car crash that left her with memory loss. Earlier that year she

had also left the museum after protesting (a form of expression that MoMA saw as 'censorship') the disgraceful behaviour by a white male artist, Donald Newman, who titled an exhibition of abstract drawings with a racial slur. Fuelled by frustration with the white-dominated women's movement, in the summer of 1980 Pindell made one of her most groundbreaking works, *Free, White and 21* – a video detailing her personal encounters with racism in America. Performing two parts – as herself and as an odd-looking white woman (wearing stage make-up and using props) – Pindell recites racist accounts endured by both herself and her mother, to which the white woman, also played by Pindell, responds 'you must be really paranoid'. The film was first shown at *Dialectics of Isolation*, an exhibition featuring artists of colour at the A.I.R. Gallery in 1980, curated by her friend Ana Mendieta. Although when first screened it was met with hostility, *Free, White and 21* is now considered one of the most significant films of the later twentieth century. Shown frequently across the globe, in 2020 it was even blown up and projected outside the Brooklyn Museum.

Putting women and activism at the centre of her work, Faith Ringgold (born 1930) used myriad materials and bold messages to challenge the art world, from posters emblazoned with the sign *'WOMAN FREEDOM NOW'* (comprising the colours of the Black Liberation flag), to paintings, quilts and murals. In her art, Ringgold depicts the reality of oppression, as well as women's contributions to society, and in 1971 she worked with the female inmates at the Correctional Institution for Women, on Rikers Island, for a public commission, *For the Women's House*. Divided into eight triangles,

Howardena Pindell, two stills from the video *Free, White and 21*, 1980

Faith Ringgold, *For the Women's House*, 1971

with each quadrant filled with bright, bold imagery, *For the Women's House* displays scenes of interracial women playing sports and music, and in professional roles (bus drivers, policewomen, construction workers). Having prepared for the work by interviewing many of the women, it proposes a vision of a better and more equal future, and no doubt was a guiding light for those who witnessed societal injustices daily.

A colleague of Ringgold, with whom she formed *Where We At*, Dindga McCannon (born 1947) began her career working with the Weusi Art Collective, founded in 1965, which was made up of artists who adopted African subjects and symbols in their work. Working across a multidisciplinary practice, McCannon's most impactful

piece, to my mind, is *Revolutionary Sister*, 1971. Fusing a headpiece reminiscent of the Statue of Liberty with the colours of the Black Liberation flag, McCannon makes clear in this work the discriminations against non-whites in America. Writing about its symbolism, she stated:

> In the 60s and 70s we didn't have many women warriors (that we were aware of), so I created my own … The shape was inspired by my thoughts on the Statue of Liberty; she represents freedom for so many but what about us (African Americans)? … The bullet belt validates her warrior status. She doesn't need a gun; the power of change exists within her …

Dindga McCannon,
Revolutionary Sister, 1971

Alice Neel: (left) *Margaret Evans Pregnant*, 1978; (right) *Benjamin*, 1976

I now wish to turn your attention to artists who took charge, up-ended and visually reinvented a medium so deeply ingrained with patriarchy: figurative painting. For centuries, figurative painting had been almost entirely dominated by men, with their images of objecti-fied, idealised female nudes – 'men look, and women appear', as the art historian John Berger summarised in 1972. But now women had formed a new style when painting themselves, their bodies and the male and female nude.

Alice Neel (1900–84) remains, I believe, among the most innova-tive figurative painters of the twentieth century. Her raw, honest and at times tough paintings of people exude a pulsating energy. They manifest the artist's confidence in catching her subjects mid-expression or mid-thought, crystallising their essence and imbuing it with a familiarity akin to glancing at your friends or neighbours through their windows. You feel as though you know them. Spindly women with protruding – almost bursting – pregnant bellies (*Margaret Evans Pregnant*, 1978); sexualised coy male nudes

Alice Neel: (left) *Andy Warhol*, 1970; (right) *Self-Portrait*, 1980

(*John Perreault*, 1972); nervous, excited boys on the cusp of adolescence (*Benjamin*, 1976); a playwright in contemplation at her window (*Alice Childress*, 1950), Neel's paintings expose her family and friends (some renowned) as their true, unguarded selves. Painted from life at her live-in studio apartment, Neel's subjects appear intimate and fragile, their expressions suffused with memories, conversation and curiosity. But above all, they are hers.

Neel's life and artistic career ran almost the length of the twentieth century. Dropping out of art school after running away with a Cuban man, Neel suffered a great deal at the start of her adulthood. Her first child died of diphtheria in infancy, her second (who she only met a handful of times and who she painted in the most stark and distant way) was taken from her and deposited with her paternal grandparents in Cuba. By the end of the 1920s, Neel had suffered a breakdown. After spending time in a mental health facility, she headed to New York City to work as an artist for the WPA (Works Progress Administration). Settling in Greenwich Village, by the

mid-1940s Neel had swapped Downtown bohemia for life up in Spanish Harlem. It was here that she painted her community; people of all different races and from all walks of life: Black, white, gay, straight, young, old, in drag, in suits and in the nude.

Describing herself as a 'collector of souls', Neel painted every sitter in her distinctively thick, dry, blue outlines – lines that, to me, enhance expression. Capturing the conversation or encounter she had with her sitters beyond the surfaces they projected, Neel challenges how both men and women had previously been idealised in painting. She reveals their tensions and imperfections, but mostly their vulnerability. For me, her most striking portrait is the eponymously titled *Andy Warhol*, 1970. Painted one year after his attempted assassination, she depicted him as gaunt, faded and fragile. It's as if he is sinking into the canvas towards death, with his closed eyes, exposed scars, yellow flesh and bony hands; his context reduced to a muddy amber line making up his seat, worlds away from the glamorous superficiality of his own paintings and prints.

With her rambunctious personality, Neel was unafraid of exposing her subjects. 'If she did a portrait of you, you wouldn't recognise yourself, what she would do with you. She would almost disembowel you,' remarked her painter friend Joseph Solman. Depending on how she saw people, Neel also painted them full of life and full of colour – as exemplified in the portrait of her great friend Linda Nochlin and her wide-eyed daughter Daisy, the latter radiating hope and possibility, perhaps for the next generation of women (p. 8). In her monumental (and, I think, rightly self-assertive) nude *Self-Portrait*, 1980, painted when she was eighty, she is full of conviction and warmth in her old age, with splashes of reds on her cheeks and a direct, unflinching gaze that demands our attention.

Only gaining mainstream recognition towards the end of her life, Neel had to wait until 1974 before she received her first major museum exhibition at the Whitney Museum of American Art. Despite the relevance and contemporary nature of her work today – cemented by numerous critically and publicly exalted international touring retrospectives – Neel died aged eighty-four with her apartment stacked full of unsold paintings.

Sylvia Sleigh, *Imperial Nude: Paul Rosano*, 1977

Neel's contemporary Sylvia Sleigh (1916–2010) painted her community and the culturally significant in her vibrant, Neo-Realist paintings. Unlike Neel, Sleigh is, in my view, under-recognised today. Males and females, whether clothed or unclothed, and often with meticulously rendered details of patterned fabrics, body hair and tan lines, are portrayed by her from an acutely feminist view-point. Her paintings repossess the male-dominated art history by presenting men in idealised and provocative Venus-like poses, directly citing works by French nineteenth-century painters, such as Jean-Auguste-Dominique Ingres for *The Turkish Bath*, 1973.

Born in Wales, Sleigh arrived in New York in 1961 and within years became an active participant in the feminist art scene. A found-ing member of the A.I.R. Gallery, who she documented in a famous group portrait (p. 330), Sleigh strived for her paintings to envision equality between genders. In 2007, she reflected: 'To me, women were often portrayed as sex objects in humiliating poses. I wanted to give my perspective. I liked to portray both man and woman as intelligent and thoughtful people with dignity and humanism that

emphasised love and joy.' Painting real people in real situations – most notably her friend Paul Rosano, who frequently appears as seductive and effeminate in his fully nude portraits – Sleigh also actively celebrated queer communities in her erotic group portraits of male nudes. Likening them to mythological female figures, her painting of an angelic Rosano in *Imperial Nude: Paul Rosano*, 1977, recalls the reclining woman in Manet's *Olympia*, 1863, but in typical Sleigh style is full of personality, poise, empathy and humour.

As if to switch the lens back onto women and retrieve the myriad pornographic images swarming 1960s and 70s media (in addition to the sexually objectified woman in art history), this decade saw Joan Semmel (born 1932) use her body as the source for a radical series, *Self Images*, 1974–9. Erotic, empowered and at times engaged in sexual acts, the figures in Semmel's cropped paintings are viewed from the perspective of a woman looking down at her own ageing body. Featuring visibly fleshy bodies, these paintings still feel unusual, countering the plethora of idealised young bodies that we are so often exposed to today.

Semmel's friend and long-time fan Maria Lassnig (1919–2014) made some of the most shocking and confronting self-portraits in this era. Born in rural Austria, Lassnig's early years were spent in the care of an illiterate grandmother, and she hardly spoke until she was six years old. As a child, she was often criticised for staring at people

Joan Semmel, *Intimacy-Autonomy*, 1974

Maria Lassnig: (left) *Transparentes Selbstportrait* (*Transparent Self-Portrait*), 1987;
(right) *Du oder Ich* (*You or Me*), 2005

strangely, saying 'I caught them' – a glare that seems to echo
throughout her later paintings, such as *Du oder Ich* (*You or Me*), 2005.
After moving to Vienna to study, she settled in Paris in the 1960s,
and it was here that she first experimented with her innovative 'Body
Awareness' paintings: a process of translating her internal bodily
sensations onto canvas, as observed in her distorted facial features
or use of unconventional, bruise-like colouring. Exhausted by the
constant misogyny typified in 'praise' such as 'you paint like a man',
in 1968 Lassnig moved to New York City.

Re-establishing her career, despite working in figuration when
Conceptual Art dominated, Lassnig continued to paint her expres-
sive and sensorially arresting self-portraits, among other subjects,
challenging the viewer with their uneasiness and tensions. Unafraid
of exposing her innermost desires, ageing, embarrassment, gro-
tesqueness or obsession with technologies, as seen in a glaringly
technicoloured painting from the following decade, *Transparentes
Selbstportrait* (*Transparent Self-Portrait*), 1987, Lassnig's paintings
recalibrate perceptions of women in art history.

Huguette Caland, *Bribes de corps (Body Parts)*, 1973

Deconstructing bodies to sensual abstractions, Lebanese artist Huguette Caland's (1931–2019) luminous paintings celebrate the female form in an electric palette. A mother of three, in 1970 Caland swapped her dutiful life for one as a full-time artist in Paris. Leading up to her departure, her paintings were composed of squashed and fragmented body parts. Following her move, her style shifted drastically to one that elicited a newfound freedom, with curvaceous lines that commemorate both her own body and those of all women. This is particularly played out in *Bribes de corps* (*Body Parts*), 1973, oozing in reds and oranges, with its ambiguous, erotic, cellular-like arcs and forms.

I wanted to end this section with what I like to think of as the 'icon' of the decade: *The Dinner Party* by Judy Chicago: a monumental installation honouring thirty-nine Western historical and mytho-

logical women in the form of place settings. Collectively worked on by more than 100 women between 1974 and 1979, *The Dinner Party* stretches across a colossal, purposefully non-hierarchical, 'Minimalist' triangle, as if to finally award women a 'seat at the table'. Each place incorporates a yonic-shaped ceramic plate and hand-embroidered cloth (materials traditionally dismissed as 'feminine' and 'decorative') emblazoned with the name of a notable woman: from artists Artemisia Gentileschi and Georgia O'Keeffe, writer Virginia Woolf and poet Emily Dickinson, women's suffrage activist Susan B. Anthony and abolitionist Sojourner Truth. Housed in the centre on shiny, porcelain tiles are the names of a further 999 notable women. Theatrical and vast, visiting *The Dinner Party* is like embarking on a pilgrimage, complete with medievalesque flags drenched in rich, regal colours. Although undoubtedly significant, in recent times this work has been criticised for its severe non-white

Judy Chicago, *The Dinner Party*, 1974–9

representation: only one woman of colour has been 'invited'. Critically responding to the work in 2019, artist and activist Patricia Kaersenhout constructed *Guess Who's Coming to Dinner Too?* to lionise women of colour, such as activist and drag queen Marsha P. Johnson and Haitian revolutionary Sanité Bélair.

Back in 1979, touring across the US, crowds of more than 100,000 attended *The Dinner Party*'s inaugural stop at the San Francisco Museum of Modern Art, igniting a spark in the celebration of overlooked women. But like so many of the artists mentioned in this chapter whose recognition has been delayed until recently, it took until 2007 – three decades after its production – for this work to find its permanent home at the Brooklyn Museum.

Just as *The Dinner Party* unites many women, the 1970s was a time when women actively worked in groups and communities to foster real change. Whether through their experimental art-making or campaigning for their rights, their legacies live on due to their bravery and vision, as well as their impact on artist-activists in the following decades.

Chapter Thirteen

THE 1980S

TEXT, IMAGE AND PHOTOGRAPHIC PERFORMANCES

Mass consumerism, blaring advertisements, the birth of MTV, video games and personal computers, the right-wing administration of Ronald Reagan in America and Margaret Thatcher in Britain; the 1980s marked a decade of free markets (the booming art market), new media and protest (the threat of a nuclear war, censorship, an unfolding AIDS epidemic and a looming climate crisis). As a corollary, we see the creation of some of the most explicitly political art yet. With signage projected onto buildings and posters pasted in the streets (Jenny Holzer), radical performances influenced by those in the preceding decade (the Guerrilla Girls), emotive photographic imagery (Cindy Sherman, Carrie Mae Weems) and bold, loud, text-based works (Barbara Kruger), artists rightly tackled the key issues of the era.

The first generation to have televisions in their homes, these artists placed the image, moving image and commercial image as central to their art-making. Playing with the media (and art history's) stereotypes of women, they took back control of the gaze and turned it upon themselves – a topic much discussed in the work of noted feminist film theorist Laura Mulvey, who in her widely read essay *Visual Pleasure and Narrative Cinema*, (written 1973, published 1975) first coined the term 'male gaze'. Using photography, some women transformed their identities, both literally and theatrically, whereas others documented the frustrations and complexities of the everyday. Recording personal experiences that addressed race, sexuality, discrimination and authorship, artists also shifted the perception of what constituted subject matter in 'fine art' photography.

But before I get on to those trailblazers (and note, some works fall slightly outside of the 1980s but are included here for the purpose of their subject and innovation), I want first to introduce you to those

who dealt head on with the era's lingering inequalities. Despite the previous decade of progress, there was (and still is) so much to be done. White male artists ruled the white male art market. The top auction results of the decade were all by men: Jasper Johns, Willem de Kooning and Salvador Dalí. The equally misogynistic and ego-tistical Neo-Expressionists took up mountains of space with their colossal and oh-so-tormented paintings. The decade's superstar, Georg Baselitz, stated as recently as 2013: 'women don't paint very well ... it's a fact'. (He's only in his eighties, shall we send him a copy of this book?) If you think the situation is bad now, back then it was worse. With museums and galleries still excluding women, something had to be done.

In 1985, after MoMA included just seventeen women and eight artists of colour (out of 169 artists) in their *International Survey of Recent Painting and Sculpture* (how 'international'), the Guerrilla Girls (1985–present) formed. The all-female-identifying, activist artist collective took to the streets (anonymously and throughout the night) to protest for the recognition and support for women artists and artists of colour. Claiming the streets (as they told me, 'because they were free'), the group, kitted out in gorilla masks, pasted posters emblazoned with bold, disruptive text and statistics on walls near museums to shock (and preach truth to) the public. Exposing the reality of New York institutions, by using humorous graphics and tag lines (*When Racism & Sexism Are No Longer Fash-ionable, What Will Your Art Collection Be Worth?*), the Guerrilla Girls brought public attention to the inequalities and systematic

Guerrilla Girls, *Do Women Have to be Naked to get into the Met. Museum?*, 1989

**HOW MANY WOMEN HAD
ONE-PERSON EXHIBITIONS AT
NYC MUSEUMS LAST YEAR?**

Guggenheim	0
Metropolitan	0
Modern	1
Whitney	0

SOURCE: ART IN AMERICA ANNUAL 1985-86 A PUBLIC SERVICE MESSAGE FROM **GUERRILLA GIRLS**
CONSCIENCE OF THE ART WORLD

Guerrilla Girls, *How Many Women Artists Had One-Person Exhibitions In NYC Art Museums Last Year?*, 1985

discriminations in the art world, and ultimately asked just how did museums get away with celebrating the history of patriarchy instead of the history of art?

Disruptive from the get-go, telling me, 'Women artists were excited and empowered, and everyone else was really pissed off!', the group targeted both individuals and institutions. And they were right to, considering the statistics in their 1985 poster *How Many Women Artists Had One-Person Exhibitions In NYC Art Museums Last Year?* states the Guggenheim had zero, the Met had zero, the Whitney had zero and The Modern (now MoMA) had one. That same year they asked, *What Do These Artists Have In Common?* Listing the names of forty-two male artists, the Guerrilla Girls added: 'They allow their work to be shown in galleries that show no more than 10 per cent women artists or none at all.' The facts were real, and the Guerrilla Girls continued to make noise.

Making fun of the lack of support and opportunity given to women artists, in 1988 they created a poster aptly titled, *The Advantages of Being a Woman Artist* – revealing the disadvantages of

THE ADVANTAGES OF BEING A WOMAN ARTIST:

Working without the pressure of success
Not having to be in shows with men
Having an escape from the art world in your 4 free-lance jobs
Knowing your career might pick up after you're eighty
Being reassured that whatever kind of art you make it will be labeled feminine
Not being stuck in a tenured teaching position
Seeing your ideas live on in the work of others
Having the opportunity to choose between career and motherhood
Not having to choke on those big cigars or paint in Italian suits
Having more time to work when your mate dumps you for someone younger
Being included in revised versions of art history
Not having to undergo the embarrassment of being called a genius
Getting your picture in the art magazines wearing a gorilla suit

A PUBLIC SERVICE MESSAGE FROM **GUERRILLA GIRLS** CONSCIENCE OF THE ART WORLD

Guerrilla Girls, *The Advantages of Being a Woman Artist*, 1988

being a woman artist – and in 1989 began questioning the abundance of nude female bodies versus the women artists on view at the Met. The results? 'Less than 5% of the artists in the Modern Art sections are women, but 85% of the nudes are female.' Revisiting the statistics in 2012, they found that little had improved: 'Less than 4% of the artists in the Modern Art sections are women, but 76 % of the nudes are female.' Let's just say they're still fighting inequalities to this day.

Individual artists also used poster-style text and images to bring attention to urgent political concerns. Using the skills learned at her job as an editorial designer at Condé Nast in the mid-1960s, Barbara Kruger (born 1945) developed a distinct and direct artistic vernacular in the style of advertising that brought meaning to (often meaningless) signage.

Bold and readily legible, with black-and-white imagery and bright red text, Kruger's iconic and tabloid-esque works powerfully confront everyday issues and continue to resonate in the world today. Seeking to, in her words, 'bring the world into my art', one of

Barbara Kruger, *Untitled (Your body is a battleground)*, 1989

her most remarkable images, I think, is to be *Untitled (Your body is a battleground)*, 1989. Originally made for a 1989 pro-choice demonstration in Washington, D.C., which protested the government's debate over anti-abortion laws challenged in the Roe vs. Wade court case, this image and slogan still brings uncomfortable yet vital issues to light. The piece starkly represents the violation experienced by people of all genders when they are refused control of their own bodies, or denied safety, acceptance and equality due to someone else's assessment of it. Visually empowering and arresting, for its sharp and punchy approach, this work strikes me as one that will speak to, and continue to teach, generations to come.

Also using art as a form of activism and commentary on the everyday, Jenny Holzer (born 1950) takes art outside the gallery

and into our lives by exhibiting text on billboards and benches, posters and T-shirts, LED screens and projections onto buildings. Like Kruger, she, too, cleverly incorporates methods of advertising and marketing to display politically ambiguous messaging. Holzer started out by pasting what she calls *Truisms* (essays and sentences shown out of context) onto the streets of New York in the late 1970s. Her sets of words provoke, question and challenge, eliciting a whole range of responses from the viewing public. Some examples read, *'Abuse of Power Comes as No Surprise'*, *'Society is responsible for his fate'*, *'Protect me from what I want'* and *'All things are delicately interconnected'*. These phrases show me the potency of decontextualisation, forcing one's own associations to the surface. Blowing them up to

Jenny Holzer,
from *Truisms*, 1982

emulate technological advertisements and displayed to amplify their accessibility in the manner of public signage, like so many artists of her generation, Holzer leaves the viewer full of ambivalence about what is art and what is not.

Ambivalence is key to the work of photography-based and, to an extent, performance artist Cindy Sherman (born 1954). Sherman was part of a group of artists emerging in the late 1970s and early 1980s known as the 'Pictures Generation' (along with Louise Lawler and Sherrie Levine) who used photography to scrutinise representation, authorship and originality.

Once saying 'through a photograph you can make people believe anything' in her work Sherman transforms herself into unsettlingly convincing identities evocative of Hitchcock films, horror movies, clowns, the Renaissance, society women, housewives, supermodels and Valley girls. Through photography, Sherman brings to life the stereotypical, passive roles assigned to women in both grotesque and glamorous ways.

Channelling her own frustrations with societal expectations of women, Sherman used her body to play on society's obsession

Cindy Sherman, *Untitled Film Still*, 1979

Cindy Sherman,
Untitled Film Still, 1977

with youth, artifice and the so-often silent, objectified female character presented in movies, and in 1977 began her *Untitled Films Stills*, 1977–80.

Made up of seventy small black-and-white images of unnervingly familiar (and disturbing) filmic characters, as if trapped under a dominant gaze of a male director, Sherman plays the blonde pin-up, the perfect housewife and the secretarial graduate about to take on the big city. At other times she is stranded alone on a wide-open road, or bruised, beaten, emotionally tense and in tears. Although we know Sherman's works are imaginary constructs, I find they present us with versions of the truth. She makes us question both the reality for women, but also the context in which this character exists: is she trapped? Can she escape? Why is she alone? What has a patriarchal society done to make her become so vulnerable, vain, empty or silenced? Caught in a millisecond just before or after a dramatic event, as the title suggests, it is up to us to envisage how the scene might play out.

Having cemented her name and earned much acclaim in the New York art world, Sherman, as the 1980s progressed, continued

Cindy Sherman, *Untitled*, 2008

to disrupt and reinvent the wheel. Going against society and the art market's idea of beauty (and perhaps reacting against the crowd-pleasing, collector-friendly Neo-Expressionists), she switched her lens to one of abjection, repulsion and horror for *Fairy Tales and Disasters*, 1985–9, a series she remarked to be 'a challenge for somebody to want to hang above their sofa'. Yet, my favourite to date remains her *Society Portraits*, 2008, with Sherman playing uncomfortably lifelike, wealthy socialites, blown up to a scale as if hung in the subject's grandiose hallway – complete with gilded frames. Their faces are filled with prosthetics, their bodies fashioned from fake nails, wigs, warped tights and dolly-like shoes, the closer you look, the clearer it becomes that they are visibly and intentionally complete living façades.

Probing ideas of theatricality, contradiction (power v. vulnerability, truth v. fiction, history v. the contemporary, presence v. absence), and the use of self as both model and photographer, Francesca Woodman (1958–81) created in her short life over 800 photographs. Raised between Denver and Tuscany in an artistic family (her mother was the famed ceramicist Betty Woodman), Woodman first picked up a camera aged thirteen. Although that's nothing these days, her *Self-Portrait at 13*, 1972, feels so sophisticated and technically advanced, while also evocative of her later style: a visibly shielded face, bodies dissolving and evolving in and out of focus, and employing what became her signature small-scale, square, black-and-white format.

Studying at the Rhode Island School of Design, with a highly influential year abroad in Italy, Woodman used everything from scientific laboratories to derelict-looking interiors (with exposed floorboards and peeling wallpapers) as sets for her atmospheric photographs. Distorting her semi-nude or nude body using a long shutter speed for movement, and shards of shattered glass or mirrors for harsh lines and light, Woodman pushed the limits of photography and built a space, much like her contemporaries, between the real and surreal.

When Woodman moved to New York in 1979, though, she struggled to find work and exhibited very little. Many records remain of

Francesca Woodman: (left) *Self-Portrait at 13*, Antella, Italy, 1972; (right) from *Space²*, Providence, Rhode Island, 1976

her brilliant, but unsuccessful, grant applications. We don't know why, but in January 1981, aged just twenty-two, Woodman committed suicide. Never living to see the impact of her work, five years after her death a touring major exhibition was mounted in her honour. The show took the public by storm and catapulted her art into the mainstream.

Photography in this decade was not just pioneered by those who explored fictional realms; the medium was also used to record humanity, tell emotive stories of our daily lives, and to enhance the visibility of under-represented communities. Carrie Mae Weems (born 1953) picked up a camera for the first time in 1973 and set out to capture the beauty of the everyday. Challenging the stories of a white-dominated art world, she started out making documentary-style images. An early series, *Family Pictures and Stories*, 1981–2, memorialises her multigenerational family loving and supporting each other, in large groups or candid shots, brimming with energy or in moments of quiet.

Turning the lens upon herself in 1989, Weems began her landmark *Kitchen Table Series*. 'Landmark', as for the first time in art history it elevated and gave precedence to the everyday moments in the lives of Black women – images that the art world, and the world at large, would and still do so often dismiss. Centred around the

Carrie Mae Weems,
*Untitled (Woman
and daughter with
makeup)* from *Kitchen
Table Series*, 1990

same kitchen table with an illuminating drop-down light, the *Kitchen Table Series* reveals the many relationship dynamics, interactions and stories within the home, at all times of day, any day of the week. Alone, with friends, or with family members young and old; playing cards, consoling one another, eating, reading or – my favourite – a mother and daughter applying their make-up together, the series catches tensions and intimacies that feel relevant and universal today. Reflecting on the series in 2016, Weems said:

> There's still sort of a dearth, a lack of representational images of women. And not, you know, like strong, powerful, and capable, that kind of bullshit, but rather just images of Black women in the world, in the domain of popular culture. I think it's one of the reasons that *Kitchen Table* still proves to be so valuable, or invaluable, to so many women, and not just Black women, but white women and Asian women; and not just women, but men as well, have really come to me about the importance of this work in their lives.

Nan Goldin, *Nan and Brian in Bed, New York City*, 1983

Passionately and avidly recording intricate moments of life in its raw and real state – incorporating drug addiction, hard-partying, domestic violence, drag queens, the AIDS crisis, and sexual connections between lovers – Nan Goldin (born 1953) saw the camera 'like an extension of my hand'.

Born into a Jewish family, and the youngest of four children, Goldin's life changed at age eleven after the suicide of her older sister, Barbara (to whom she has dedicated much of her work, writing, 'I don't ever want to lose the real memory of anyone again'). Leaving home, living in foster homes, the 'shy' Goldin picked up the camera, which, she acknowledged, became her 'first way of talking'. Not so much engaged in the technicalities but rather the content, in the glittering era of disco she photographed nights out and the glamour of Boston's drag queens. In the late 1970s Goldin moved to New York City and took her camera everywhere.

Working when museum curators were yet to catch up with 'life-style' photography as a fine-art form, Goldin struggled to get her work shown until 1985, when she compiled 700 narrative-driven

Nan Goldin, *Misty and Jimmy Paulette in a Taxi*, 1991

photographs (with a soundtrack) for her monumental series *The Ballad of Sexual Dependency*, 1979–95. Erupting with energy, colour, beauty, excitement, youth, but also life's harsh realities, *The Ballad* captured Goldin's chosen family in real time over nearly twenty years. Photographing from a non-judgemental lens (as she puts it, 'without glamorisation, without glorification'), *The Ballad* features the haziness of an ex-boyfriend smoking at the end of a bed (*Nan and Brian in Bed, New York City*, 1983), a bruised Goldin (beaten by the same ex-boyfriend) and friends kissing, partying and sitting in the backs of cars (*Misty and Jimmy Paulette in a Taxi*, 1991). Celebrating gay and transgender communities, some photographs were taken during the AIDS crisis and rendered visible those who had been hit hard by the epidemic and so viciously silenced by the government and media.

I also find this emotive quality in *La Manzana de Adan* (*Adam's Apple*), 1982–7. This series by former schoolteacher and self-taught Chilean photographer Paz Errázuriz (born 1944) captures moments of tenderness in the transgender and cross-dressing prostitute

Paz Errázuriz,
Evelyn,
La Palmera,
Santiago,
Chile, 1981

communities during Augusto Pinochet's brutal dictatorship
(1973–90). Under Pinochet's regime, gender nonconformity and
homosexuality were condemned, and if uncovered, were to be pun-
ished with prosecution or torture.

Errázuriz created *La Manzana de Adan* when she was living
alongside these communities, recalling in an interview, 'I found a
family that I wish had always been my own'. Through her inten-
tionally activist, visual documentation, Errázuriz gave a voice to
their otherwise silenced reality. Centred on two siblings, Pilar and
Evelyn, and their mother, Mercedes, for me, the images recognise
the subjects' individual beauty and humanity while exposing their
vulnerability and defiance. Intentionally political, Errázuriz recalled,
'Photography let me participate in my own way in the resistance. It
was our means of showing that we were there and fighting back.'
The images, published in the final year of the dictatorship, marked a
major moment in the fight for freedom.

Hungarian-Jewish, Brazilian photographer Claudia Andujar
(born 1931) has spent decades using the camera for social change, in
particular in capturing the world of the Yanomami, an Indigenous
people living in the Amazon rainforest. Andujar first encountered
the Yanomami in 1971 and began photographing their daily life.
Reflecting their spiritual and Shamanic beliefs, Andujar's experimen-

370

tal approach involved using infrared film to saturate her prints in vivid hues of blues, pinks and yellows and rubbing Vaseline on her lens to achieve a blurred effect. Mystical and ethereal, Andujar's images harness the spiritual energy of the Yanomami while also reflecting her own relationship with them – she has lived alongside them for extensive periods of time. After witnessing the effects of the environmental damage inflicted upon the land from the mid-1970s onwards as a result of extractive industries, from gold mining to logging, she focused her efforts on activist activities. Working with the Yanomami, Andujar has spent the last four decades raising awareness of their culture and lack of medical resources and aiding the campaign against the destruction of their people and lands.

Ecological issues were pivotal for the artists driving the Land Art Movement: large-scale, immersive and environmentally motivated works. Abandoning the museum and stepping into the realm of public space, Agnes Denes (born 1931), a pioneer of the Ecological Art Movement, responded to the ever-evolving climate crisis and ongoing damage and mismanagement of land inflicted by capitalist societies. The result was *Wheatfield: A Confrontation*, 1982, a four-month-long project in which she planted and harvested an incredibly ambitious two-acre wheat farm in the Battery Park landfill (then

Claudia Andujar, *The young Susi Korihana thëri swimming, Catrimani, Roraima*, 1972–4

situated between the World Trade Center and the Statue of Liberty). A project that today feels more relevant than ever. Writing about her philosophy for the environmental piece in 1982, she stated:

> My decision to plant a wheat field in Manhattan instead of designing just another public sculpture, grew out of the longstanding concern and need to call attention to our misplaced priorities and deteriorating human values. Placing it at the foot of the World Trade Center, a block from Wall Street, facing the Statue of Liberty, also had symbolic import ... It represented food, energy, commerce, world trade, economics. It referred to mismanagement, waste, world hunger and ecological concerns.

The artists of the 1980s were radical. They responded to the social and political issues of the era by giving voice to their own personal histories, the climate crisis and under-represented communities, by attacking misogynistic institutions and making visible society's treatment of women. Seeking new ways of using graphic media (the camera, video, projections, advertisements), they changed how museums thought about fine art subjects and ultimately paved the way for the 1990s, when institutions finally gave recognition to activism and art.

Agnes Denes, *Wheatfield – A Confrontation: Battery Park Landfill, Downtown Manhattan – With New York Financial Center*, 1982

Lorraine O'Grady: (left) *Art Is ... (Girlfriends Times Two)*, 1983/2009;
(right) *Art Is ... (Troupe with Mlle Bourgeoise Noire)*, 1983/2009

To end this formative decade, I bring you Lorraine O'Grady's (born 1934) photographic series *Art Is ...*, 1983/2009. A series that brought art into the public realm, expanded the fabric of photography and performance, and addressed criticisms around the relevance of high culture to society. This is the essence of what this entire book is about, exploring great art by great artists who fuel and expand our understanding of what art can mean and do for society. Art can be a performance, a reflection, a provocation, a question, and a call to action. For O'Grady, art is 'A joyful performance in Harlem's African American Day Parade'.

Responding to a casually racist comment by her 'non-artist acquaintance' that 'avant-garde art doesn't have anything to do with Black people', and to prove that it did, in September 1983 O'Grady took her camera to Harlem's vivacious parade celebrating African American culture. On a gold-fabric-covered float with a giant gilded frame, fifteen performers (all dressed in white) reached out to the excitable and adoring crowd to hold up gold frames to their faces, declaring their worth of belonging 'inside the frame'. Intervening, O'Grady photographed people of all ages and myriad personalities in her exceedingly joyous, sun-lit images. From young, energetic groups of girls and laughing teens, to those caught in the background reflecting on the parade, *Art Is ...* ultimately celebrates people for being people. Just as we've learned in this chapter, art is for everyone, and everyone is worthy of being a suitable subject for 'art'.

Chapter Fourteen

THE 1990S

THE ACCEPTANCE OF
POLITICAL ART

The 1990s are often viewed to be flanked by two major political events: the fall of the Berlin Wall in 1989, and the September 11 attacks on New York City in 2001. Within that space of time the world felt the effects of globalisation, with increased travel, mass communication and new economic structures, but also experienced political, cultural and economic shifts that transmuted art. Politically, it saw the rise of New Labour in Britain, the election of Bill Clinton as President of America, and the end of apartheid in South Africa. The battle against the AIDS epidemic persisted, continued racial injustice triggered the LA riots, and the growth of the internet saw the acceleration of the technological revolution, and the rise of celebrity culture.

Artists continued to abandon traditional media, instead favouring more experimental multimedia and digital processes, building all-encompassing installations and involving participatory audiences. But it was also a decade that saw them constantly (and unapologetically) pose questions about inequality, identity, migration and multiculturalism – subjects that artists are still actively dealing with today.

We know that artists have been making 'politicised' work for decades (if not centuries). However, it was in the 1990s that art institutions and biennials (finally) started to pay more sustained attention to artists who were non-white, queer, and women. A landmark moment was the 1993 Whitney Biennial, which caused huge uproar among the mostly white, male art world. Michael Kimmelman of *The New York Times* wrote 'I hate the show', and deemed it a 'scam', perhaps due to many of the exhibited artists' engagement with identity politics. Yet it was one of the first mainstream exhibitions to offer visibility to those usually sidelined from institutional conversations.

Coco Fusco, *Couple in the Cage: Two Undiscovered Amerindians Visit the West*, 1992–4

Thought to have laid the groundwork for American art in the following decade, the show (curated by Thelma Golden, John G. Hanhardt, Lisa Phillips and Elisabeth Sussman) also propelled recognition for a younger generation of artists, such as Renée Green, Lorna Simpson, Janine Antoni and Coco Fusco, among others.

The first day of the biennial featured Fusco's (born 1960) touring performance *Couple in the Cage: Two Undiscovered Amerindians Visit the West*, 1992–4. A collaboration with Guillermo Gómez-Peña, the pair presented themselves in a gilded cage as Indigenous people from a fictional, uncolonised island in the Gulf of Mexico. In Fusco's words, the aim was 'to make a satirical commentary on the history of the ethnographic display of Indigenous people', a tradition initiated by Christopher Columbus.

That same year, the Venice Biennale also saw drastic progression. French-American artist Louise Bourgeois (p. 306), who had been steadily gaining worldwide recognition since her MoMA retrospective in 1982–3, was the second woman ever to represent the US, following Jenny Holzer in 1990 (p. 360); Yayoi Kusama represented Japan (p. 284); Lorna Simpson (p. 381) became the first African American woman *ever* to show at the historic exhibition at all; Cuban artist Belkis Ayón exhibited her spiritual, otherworldly prints, aged just twenty-six; and a whole section of the biennale, *Aperto 93*, was dedicated to spotlighting emerging artists, including Kiki Smith, Pipilotti Rist (p. 384) and Doris Salcedo (p. 416).

In 1994, legendary curator Thelma Golden curated 'Black Male: Representations of Masculinity in Contemporary American Art' at the Whitney, a show that engaged with Black stereotypes in art and featured Adrian Piper (p. 341), Alison Saar and Lorna Simpson. Other emerging artists included Kara Walker (p. 418) and Ellen Gallagher (p. 426), who directed their work at dismantling racist imagery and later went on to acclaimed careers in the 2000s. Biennials in Havana and Johannesburg also gained worldwide attention for their support of non-mainstream artists and subjects relating to identity and migration.

Contemporary Australian Indigenous artists came to the fore towards the end of the 1980s and into the early 1990s. In 1997 Emily Kame Kngwarreye (1910–96) posthumously represented Australia at the Venice Biennale and would go on to receive such global recognition that she later broke attendance records in museums

Emily Kame Kngwarreye,
Anwerlarr angerr
(Big yam), 1996

across the world. Taking up painting in her late seventies, Kame Kngwarreye produced over 3,000 works over her eight-year career (the equivalent of one per day). A ceremonial leader belonging to the Anmatyerre people, Kame Kngwarreye's acrylic paintings took inspiration from the iconography created in the Awelye ceremony (during which women paint each other's bodies with traditional designs), with arcs and contours that mirror the natural Australian landscape. Transfixing and dreamlike, her repetitive calligraphic lines, veiled in vivid colouring, snake across her mesmeric surfaces.

Unlike artists in many of the eras in history we have already discussed, those working in this decade had no united style, or singular aesthetic, nor did they align themselves with any particular movement. Instead, much of their work was generated by their engagement with the everyday and with the changing landscape. Fuelled by political crises and society's rigid views on those marginalised, women artists actively challenged these issues by pioneering new artforms and reinventing more conventional ones. They began to work with conceptual photography and film, shifted the traditions of portraiture and created a new language for contemporary figurative painting – all while demanding visibility and legislating for actual change.

One of the most significant events that dominated at this time (and in the twentieth century) was the raging AIDS epidemic, an issue that was catastrophically silenced by then-President Reagan, who failed to publicly acknowledge the tragedy until 1985. By then, over 12,000 Americans had already died and the gay community was in turmoil as a result of a disease that took the lives of so many, and stigmatised many more.

The AIDS epidemic also had an impact on the visual arts, which were facing their own crisis at the end of the 1980s after Republican Senator Jesse Helms decried Robert Mapplethorpe's explicit homosexual photographs and in response defunded the National Endowment for the Arts. Sparking debate and culture wars, this discriminatory act fuelled the formation of art collectives ACT UP (AIDS Coalition to Unleash Power) and Queer Nation, which encouraged members to use their art for political protest.

Using simple, accessible aesthetics, ACT UP adopted the iconic *Silence = Death* poster in 1987, and art collective Gran Fury drew attention to the false claim that the disease could be transmitted through kissing in their billboard-style work *Kissing Doesn't Kill, Greed and Indifference Do*, 1989–90. Erected in subway stations across San Francisco and New York, the work featured interracial and mixed-sexed couples kissing.

At the height of the AIDS epidemic and ahead of the 1992 US presidential election, activist, artist and member of ACT UP, Zoe Leonard (born 1961) made one of the most moving works of the era, *I want a president*, 1992. Typed up as a statement originally intended for a queer magazine, and inspired by the great poet Eileen Myles,

I want a dyke for president. I want a person with aids for president and I want a fag for vice president and I want someone with no health insurance and I want someone who grew up in a place where the earth is so saturated with toxic waste that they didn't have a choice about getting leukemia. I want a president that had an abortion at sixteen and I want a candidate who isn't the lesser of two evils and I want a president who lost their last lover to aids, who still sees that in their eyes every time they lay down torest, who held their lover in their arms and knew they were dying. I want a president with no airconditioning, a president who has stood on line at the clinic, at the dmv, at the welfare office and has been unemployed and layed off and sexually harrassed and gaybashed and deported. I want someone who has spent the night in the tombs and had a cross burned on their lawn and survived rape. I want someone who has been in love and been hurt, who respects sex, who has made mistakes and learned from them. I want a Black woman for president. I want someone with bad teeth and an attitude, someone who has eaten that nasty hospital food, someone who crossdresses and has done drugs and been in therapy. I want someone who has committed civil disobedience. And I want to know why this isn't possible. I want to know why we started learning somewhere down the line that a president is always a clown: always a john and never a hooker. Always a boss and never a worker, always a liar, always a thief and never caught.

Zoe Leonard, *I want a president*, 1992

who had mounted their own presidential bid, *I want a president* combines progressive, empathetic sentences about Leonard's hope for a new leader. Questioning the corruption of authorities, and leaders' lack of humanity and openness to gender, race and class, today the work remains just as effective and, sadly, relevant (having been blown up on New York's The High Line in the lead-up to Trump's win in the 2016 US presidential election).

Paying tribute to her friend artist David Wojnarowicz, who died from AIDS in 1992, in the five years following his death Leonard created *Strange Fruit*, 1992–7. A poignant installation of 295 scattered, decaying fruit skins, hand-sewn back together, and evocative of mortality and the transient nature of life (as well as its title referencing Billie Holiday's song of the same name), it is a compelling reminder of the many who suffered death and/or discrimination in the early years of the epidemic.

The wider repercussions of how AIDS affected individuals within the queer community were also sensitively recorded by Catherine Opie (born 1961), who came to prominence with her photographic series *Portraits*, 1993–7. Set up in the style of Renaissance portraits, with traditional, dignified poses and richly coloured backgrounds, *Portraits* captures intimate images of the artist's gay leather S/M communites. At a time when society dismissed or 'othered' them, as well as judged them for their appearances (Opie has since recalled

Zoe Leonard,
Strange Fruit,
1992–7

Catherine Opie,
Self-Portrait/Cutting, 1993

how the leather community were perceived as 'predatory' or 'perverted'), *Portraits* powerfully gave recognition to her subjects' beauty and humanity.

Addressing her own personal longings, *Self-Portrait/Cutting*, 1993, for me, is particularly striking. Taken in her studio against an elaborate deep green backdrop, Opie turns her bare back towards us, revealing it to be marked with a blood-carved, childlike drawing of two women holding hands in front of a family house. A potent statement considering the era's fear of blood (the primary channel for HIV transmission), *Self-Portrait/Cutting* also evokes the family values integral to us all, regardless of our appearance or sexual orientation.

Lorna Simpson (born 1960), who established her career in the mid-1980s with conceptual photographs that explore subjects of race, representation, gender and history, like Opie, challenged traditions of portraiture. Presenting Black women in multiple panels, with their faces turned away from us or obscured by ambivalent text

Lorna Simpson, *Five Day Forecast*, 1988

(single words, sentences or poems), Simpson provokes thought by concealing parts of her subjects' identities. When confronted with them, I ask myself, why are they choosing to look away from us? Can they not see us? What do these words symbolise? Are we supposed to believe them? For me, Simpson's work speaks so mightily of the visibility that women (especially Black women) lack in society, in a world where they are often told what to do, what to think, what to be, what to say and what not to say by a patriarchal culture. Similar to Holzer's *Truisms*, Simpson's work probes the strength of decontextualised language and its diversity of meaning.

Providing us with cropped figures, dressed in generic white gowns in a clinical environment with arms firmly folded, Simpson also invites discussion about the shaming, misconceptions or societal expectations surrounding women and their bodies. I find this typified in a slightly earlier work, *Five Day Forecast*, 1988, with the days Monday to Friday written on plaques above the images, and words beginning with 'mis' installed below (misidentify, misfunction, misinformation, among others).

Simpson's contemporary Shirin Neshat (born 1957) also uses photography to fight stereotypical portrayals of women (especially those from the Middle East), as seen in her commanding, complex series *Women of Allah*, 1993–7.

Raised in a progressive, intellectual family in Iran, as the foundations for the Islamic Revolution were being laid, Neshat, after being sent to America to complete her education aged seventeen, remained in exile in the US due to the revolution, and was unable to return to her birth country for eleven years. When she finally did in 1990, she came back to a country transformed. After hearing the stories of those who had lived through the revolution, she processed her emotional and psychological reactions to these recollections by creating *Women of Allah*. This photographic series reflects the defiance and resilience of the Iranian women, as well as Neshat's own sense of displacement as a migrant and experience living in exile.

Using herself as both artist and model, in some images Neshat looks right at us, wears the chador, is armed with weapons and has hand-drawn Farsi lettering on her face (which reproduce poetry by female Iranian writers). Referencing subjects of martyrdom and power, *Women of Allah* amplifies the voice of Iranian women and provides a framework through which viewers can pose questions as

Shirin Neshat,
Rebellious Silence,
1994, from *Women
of Allah*, 1993–7

Pipilotti Rist, *Ever is Over All*, 1997

well as engage their experience. As a consequence, Neshat's work facilitates our understanding of the societal perceptions and expectations of women (in Neshat's case, Muslim women in Western and non-Western countries), their strength and the realities of (particularly marginalised people's) lives beneath the surface.

Towards the end of the decade, Neshat shifted into working with the moving picture. Using the effect of double screens to emphasise contrasting narratives (such as the roles of men and women in society), Neshat, like many women in this era – Dara Birnbaum, Tacita Dean, Susan Hiller, Joan Jonas, Pipilotti Rist – pushed forward the potential of filmmaking.

It is Rist (born 1962) who I think really opened up a new language for film in the 1990s that reflected the experimental age, with her hypnotic, technicoloured and immersive multiscreen videos. Projected onto various multimedia surfaces (lights, screens, sheets, sculptures – sometimes even chandeliers made from underwear!) and set against blasting euphoric soundtracks (often with Rist singing or humming), her enveloping installations transport her viewer to glittering subaqueous worlds, with slow-moving screens and sounds that warp in and out of focus.

In a similar way to her photographic contemporaries, Rist's films also challenge and reject stereotypes of femininity, as seen in her brilliantly anarchic *Ever is Over All*, 1997. Set up on two screens, on the

left we see a woman decked out in a Dorothy-like costume (blue dress and red shoes) walking freely down the street holding a giant (phallic) flower called a 'red hot poker', which mirrors the flowers slowly swaying on the right-hand screen. It is with this tool (her poker!) that she smashes the car windows parked on the street. Cackling as she does it, she walks on as if utterly oblivious to what has just happened. Rebelling against the advancement of technology with her blurry, grainy, lo-fi videos (perhaps in a reaction to the male dominance of tech), this is a film of her, as I like to think of it, smashing up the system.

But as much as artists were engaging with new media, they also returned to more 'traditional' media with the resurgence of figurative painting. Capturing the zeitgeist of the age through a reworking of historical art traditions, artists immortalised in paint many contemporary figures and cultural events. Sourcing imagery from politics and pop culture, they formed a new language for figuration in the disruptive spirit of the 1990s, which, in my opinion, is partly responsible for the continued rise of figurative painting today.

How do you capture a fleeting moment on a canvas so accurately, so emotionally, that the stillness of a single image can evoke it so fully? I want to start with the American artist Elizabeth Peyton (born

Marlene Dumas,
Naomi, 1995

Marlene Dumas,
The Image as Burden,
1992–3

1965), who shot to fame with her icon-like incarnations of rock stars and historical figures. Canonising the music gods that defined the era – Kurt Cobain, Jarvis Cocker, Liam Gallagher – from images found in magazines, it's as if Peyton resurrects her (and our) coy, teenage self who once gazed adoringly at these stars. She transports us to the memory of hearing their voice through song or romanticising their thoughts, and her jewel-like paintings evoke the excitement of the burgeoning new age.

Marlene Dumas (born 1953) also paints from second-hand images, a method that perhaps stems from her growing up in South Africa during apartheid, where she was only able to acquire knowledge

Shahzia Sikander, *The Scroll*, 1989–90

surreptitiously through illicit books and journals. Memorialising the famous and infamous (Naomi Campbell, Phil Spector, Osama bin Laden), anonymous faces and political events, Dumas draws her subjects from films, postcards and magazines, once saying, 'I don't paint people, I paint images.' But unlike Peyton's sentimentalised paintings, Dumas's figures are ghoulish, washy, swollen and mortal. Full of emotion and psychological heaviness, the subjects feel bruised as they sink deep into her fluid and stained lines.

Confronting art history, Shahzia Sikander (born 1969), who had originally trained in Indian and Persian miniature painting, upended its conventions by creating works steeped in feminist imagery. A response in part to her strict upbringing in Pakistan, when women were very much second-class citizens, for her monumental work *The Scroll*, 1989–90, Sikander used the framework of Indian and Persian miniature painting, but overturned the traditional subjects by centring it on women claiming freedom in a domestic space – marking, in her words, 'a new beginning'.

Lisa Yuskavage (born 1962), contrastingly, looks to traditional painterly techniques. Emerging from an acid-like haze of saturated greens, reds and yellows, Yuskavage's portrayals of doll-like, pre-pubescent, semi-naked women are as much about investigating light and colour as they are about the female figure. Commanding and provocative, inviting yet repelling, with starkly striking gazes; although considered 'outrageous' in the 1990s, dividing opinion

Lisa Yuskavage, *Big Blonde with Hairdo*, 1994

among critics and feminists, Yuskavage's women take hold of the explicit soft-porn, female figure as so often violently depicted by the 1990s media. With her vulnerability exposed, she is presented free from shame, belonging to no one but herself.

Based in New York City from the early 1990s, after abandoning the more 'conceptual' young art scene in London (recalling, 'in my generation people weren't interested in doing painterly paintings'), Cecily Brown (born 1969) melded the grand themes, scale and sheer epic-ness of the European Old Masters with the action-like gestures of Abstract Expressionism. Taking the fleshiness and fluidness of oil paint to new heights in her part-abstract, part-figurative canvases, Brown's sensorially overwhelming paintings come alive with eroticism and electric energy. As if to emulate the excitement of New York, where, as she told me, the city was 'filled with street art, graffiti and flyers ... like a collage', Brown utilises

Cecily Brown, *The Tender Trap II*, 1998

every millimetre of her surfaces, as seen in the monstrous and feverish *The Tender Trap II*, 1998.

It seems fitting to end this section with the great Paula Rego (born 1935). Although Rego's career began in the 1950s, it was only in the mid-1980s that she finally achieved recognition. She is one artist whose work is impossible to categorise. Yet, because in this chapter we have looked at artists whose work gives visibility to the under-represented, fights political injustices and re-evaluates painterly traditions, to me, she is best mentioned here. Rego's powerful, unsettling, narrative-driven pictures not only defy all convention in painting (in subject, scale and style), but they have also directly contributed to legislated social change.

Born in fascist Portugal, three years into Salazar's dictatorship, Rego grew up in a time of extreme oppression for women. Painting since childhood, as a teenager Rego could already capture emotional

Paula Rego, *Dog Woman*, 1994

truths, as seen in a poignant portrait of her father's depression. Enrolling in London's Slade School of Art in the 1950s, on her return to Portugal in the 1960s, she painted the bloody reality of life.

Challenging traditions of the family portrait and exposing the tensions that lie within them; impugning the fairy tales we learned in childhood (but question as adults); expressing her inner demons and secrets, Rego's paintings present women in fear, pain and isolation. But they also emanate a brutal honesty: the woman silently screaming in animalistic-like form, unable to escape the confines of her frame (*Dog Woman*, 1994), or those undergoing unsafe abortions (the *Untitled* series, 1998–9). The latter, a series documenting women's weighty bodies with psychological and physical anguish, was created in the wake of Portugal's failed 1998 referendum to legalise abortion, raising awareness for these dangerous procedures. These images were used as propaganda during the successful campaign in 2007 to allow women access to safe abortions, and were credited by the then-president as having contributed to the successful outcome.

Paula Rego, *Untitled #2*, 1998

While I have discussed the works in this section in the context of the issues of the time, they can each be interpreted and read by viewers in numerous ways, which is right, because the power of great art is its ability to transcend time. Interrogating and giving voice to issues ranging from inequality to multiculturalism, the artists of this era – like those in Britain that I discuss in the following chapter – dealt with such urgent and contemporary subjects that they laid the foundations of what would be accepted in the twenty-first century.

Chapter Fifteen

RADICAL CHANGE IN BRITAIN

(c.1980—c.2000)

THE BRITISH BLACK ARTS MOVEMENT

'We were using art to change things'
— Lubaina Himid, 2020

With rising unemployment rates, the destruction of the unions, the premiership of Margaret Thatcher and a growing right-wing conservatism, a group of young, defiant artists exploded onto the British art scene who would collectively come to be known as the Black Arts Movement. Born out of the active political energy of the radical West Midlands-based Blk Art Group (spearheaded by Claudette Johnson and Marlene Smith) who united in 1979, their mandate was to disrupt, discuss and debate what was deemed 'British Art'. Claiming a Black British identity with their bold, powerful and explicitly political work, the artists worked in a variety of materials, styles and subjects to fight the discrimination of the British art world. (Note: it wasn't until 1987 that a work by a Black British female artist, Sonia Boyce, even entered the Tate's collection.)

Forming discussions around what it meant to be a young Black British artist, the group put their words into action and made their presence felt by staging formative exhibitions. A major driving force was Lubaina Himid (born 1954), who, in the early 1980s, sent notes to art schools across the country pleading that those, in her words, 'interested in identifying as a Black artist' send her slides. This resulted in three groundbreaking all-female exhibitions in London: *Five Black Women* at the Africa Centre (1983, featuring Himid, Houria Niati, Sonia Boyce, Veronica Ryan, Claudette Johnson), *Black Women Time Now* at the Battersea Arts Centre (1983) and *The Thin Black Line* at the ICA (1985). Interpolating poetry with theatre, painting with collage, these exhibitions signified the advent of a group who championed the presence and preservation of Black artists. Fighting injustices and addressing urgent, anti-racist issues through their work – subjects so visibly present in today's art – they

Lubaina Himid, *A Fashionable Marriage*, 1986

are, in my opinion, the reason for the relevance of British art today. As proven by Lubaina Himid's triumphant 2017 Turner Prize win (as the first woman of colour), and Boyce's representation for Britain at the 2022 Venice Biennale.

Born in Zanzibar and raised in London by her textile-designer mother, Himid spent her weekends alternating between visiting department stores and museums. These trips enabled the young Himid to realise the potential of what art could do, from dizzying our eyesight (she was a fan of Bridget Riley, p. 287) to its purpose of political protest. Training as a theatre designer in the 1970s – drawn to the medium for its power to make, in her words, 'revolutionary statements' and 'multilayered performances' – she also uses the medium to physically disrupt white-walled gallery spaces. From the very start, Himid's art has sparked conversations around identity, hidden histories and critiquing the establishment. Using non-traditional art materials, employing found or domestic objects (bed-sheets, drawers, plates, boats), Himid encourages us as viewers to

consider the deep political subtexts behind materials, which, when put in dialogue with one another, can reveal historical truths.

Some of Himid's best-known works are her communities of free-standing painted, collaged, life-size 'cut-outs'. Taking a swipe at the bigoted politicians of Thatcher's government, Himid constructed *A Fashionable Marriage*, 1986. A brilliant satire of the leaders of the day, directly influenced by William Hogarth and his caricatural portrayals of eighteenth-century aristocracy, she portrays the apartheid-supporting, welfare-state-destroying Thatcher as the reprehensible Countess. More recently, she used the same medium to draw attention to the individual lives of those formerly enslaved, whose identities were stripped from them upon their arrival in Europe. *Naming the Money*, 2004, features a set of 100 cut-out figures, draped in colourful, patterned garments, who (via a sound-track) state their original name, life-story and professional roles (drummers, dancers, musicians). When exhibited as individuals in museums, each figure confronts the uncomfortable colonial truths of (especially British) institutions and surrounding objects. But when shown together, *Naming the Money* is a compelling image of collective hope.

One of my favourite works from this era is her theatrical, larger-than-life, mixed-media, bedsheet-based installation *Freedom and Change*, 1984 (what she likes to call 'Running Women'). Based on the semi-nude female figures from Picasso's *Two Women Running on the*

Lubaina Himid, *Naming the Money*, 2004

Beach (The Race), 1922, Himid, interested in taking back Picasso's 'stealing of African imagery', centralises her work on two Black women. Holding hands, pulled along by a pack of four dogs and kicking sand into the eyes of the bald men behind them (perhaps evoking the patriarchy, or the white male artists who have ruled for too long!), this image symbolises, to me, breaking free from the constraints of society, as seen in the sheer delight of the women who set sail into the freedom-filled future.

Working alongside Himid, Sonia Boyce (born 1962) made paintings that uplifted and spotlighted the everyday lives of Black women. Aware of their invisibility in magazines, the media and on gallery walls, Boyce worked in figuration to bring imagery centred on the Black female experience into museums. But her works also challenge the museum's – and Britain's – fraught history. This, I find, is most potent in her aptly titled *Lay back, keep quiet and think of what made Britain so great*, 1986, a large-scale, four-panelled work charged with beauty and political symbolism. Although at first we might see a self-portrait of the artist set among an intricately designed, decorative and luscious wallpaper, on closer inspection the three crosses reveal the names of British colonies. Caught between sharp thorns and surrounded by black roses, Boyce subtly exposes Britain's hidden, bloody history.

Also working in figuration, Claudette Johnson (born 1959) paints her friends in larger-than-life canvases with expressions imbued with

Sonia Boyce, *Lay back, keep quiet and think of what made Britain so great*, 1986

Claudette Johnson, *Trilogy*, 1982–6

confidence and psychological intensity. With their bodies pushing beyond the confines of the frame, filling almost every inch of the surface, in her words, 'to look at how women occupy space', it is Johnson's three-part painting *Trilogy*, 1982–6, (first exhibited at Himid's *Thin Black Line* exhibition) which I find particularly powerful. It is her ability to capture not just the surface of these women, but to seek out their stories, and give them a platform to recount them too.

Figuration in photography was also key to the movement, and Scottish artist Maud Sulter (1960–2008) led the way. In her studio-style portrait series *Hysteria*, 1991, Sulter and collaborator Himid dressed up in the multiple guises of a nineteenth-century Black artist. Loosely based on Edmonia Lewis (p. 79), as part of Lewis's journey from America to Rome, Sulter's portraits give precedence to the presence of historical Black women artists. And as if to tackle the exclusion of Black women in mythology, her series *Zabat*, 1989 (a word coined by her) gathered a group of Black women artists to pose as goddesses and muses – from the muse of dance and lyric poetry, to Clio, the muse of history.

Working together, feeding off the energy and disruptive fervour of the era, the artists continued to mount important exhibitions spot-lighting their Black British contemporaries. At the end of the decade,

Maud Sulter, *Hysteria*, 1991

as if uniting this generation with their overlooked predecessors, artist Rasheed Araeen curated in 1989 *The Other Story* at the Hayward Gallery. It was a mammoth, monumental survey collating multiple generations of artists of Asian, Caribbean and African descent (including Himid, Boyce, Mona Hatoum and others), rightfully acknowledging their contribution to British art. Although the exhibition set out to be disruptive and game-changing – and proves now to have been fundamental not just for spotlighting overlooked artists but for expanding the discourse of British art, too – it was, at the time, mostly dismissed by the white art critics.

So, while British art was fêted internationally in the 1990s, the artists associated with the Black Arts Movement began to be overlooked. Although it's often thought that the artists of the 1990s kick-started contemporary art in Britain, for me, it is those mentioned above that I believe considerably paved the way with their vital addressing of outwardly political and anti-racist subjects, which today remain more prevalent than ever among the next generation of artists.

COOL BRITANNIA

'In the 1990s British art was making such a huge
impression on people' — Tracey Emin, 2015

Full of energy, anarchy, provocation and determination, a rebellious
group of young artists burst onto the scene at the end of the 1980s.
With no shared common aesthetic (other than that they were young,
ambitious and made art on their own terms), the artists shelved
all tradition and advanced new ideas in sculpture, painting and
installation that were so loud, and so shocking, their work often
made headlines.

Set against a backdrop of a rapidly shifting Britain (the decline of
Thatcherism, the 1991 recession, the rise of Labour Prime Minister
Tony Blair and the beginnings of the contemporary art market),
through their experimental and epic work, these artists captured the
zeitgeist of the rocketing era. Fearless and full of conviction (most
came from working-class backgrounds), they took influence from
the world around them, engaged with real people and real issues,
transformed everyday objects, had their work seen by the masses
and opened themselves up for critical discussion. Spurred on by the
British tabloids, who reported on their radical, explicit and confes-
sional creations, these artists were catapulted to mainstream fame
and propelled public debate on issues ranging from art to the state of
society.

First launched with *Freeze,* the 1988 exhibition held in a Dock-
lands warehouse, the artists I discuss here went on to be astonishingly
successful. Many women were awarded or nominated for the Turner
Prize (an event so popular the award was broadcast on television). By
the end of the decade, their legacies had been cemented by the con-
troversial landmark exhibition *Sensation,* 1997–2000, at the Royal
Academy in London, which attracted tens of thousands across the
world and toured museums in Berlin and New York.

Rachel Whiteread,
House, 1993

Marking a new era for British Art, and London as a new capital for contemporary art, many of the artists of the 1990s were influenced by the revival of Louise Bourgeois; Helen Chadwick (the first woman nominated for the Turner Prize), famed for her radical decaying, time-based work (sometimes of vegetables rotting); and Susan Hiller, who experimented with large-scale, technological audio and multi-screen video installations.

To me, this group of artists perpetuated some of the most significant developments in terms of redefining what we now recognise as 'contemporary art'. They took art outside the confines of the gallery walls and into the public realm and coined a new type of subject matter accepted by British art institutions, which in turn piqued stratospheric interest in the minds of the public and media.

An artist epitomising this ethos is the formidable Rachel Whiteread (born 1963), who created perhaps the most contentious work of the era: *House*, 1993, a monumental, to-scale concrete cast of the inside of a three-storey townhouse. Erected on the site of the

house's former location in Bow, East London, Whiteread's familiar yet ghostlike sculpture once provided, in tangible form, the preservation of all the memories of the lives lived in the home. Although *House* feels recognisable, her harsh use of concrete prevents one from accessing the house both literally and psychologically, removing all intimacy a home is meant to provide. Discussing how her work gives, in her words, 'authority to forgotten things', *House* gave commentary on the rapidly gentrifying London, the state of change in 1990s Britain, as well as imparting a sense of impermanence and loss. As if to heighten the transient nature of the work, *House* – having sparked public outrage, a media storm and even dividing opinion in parliament – was torn down after just eleven weeks, and now only exists in images and memory.

Savvy, determined and brilliantly entrepreneurial, artists also actively sought out spaces for commercial and financial gain. Notably Tracey Emin (born 1963) and Sarah Lucas's (born 1962) *The Shop*, located in the East End's Brick Lane. Painted, according to Emin, a shade of 'magnolia' to contrast the increasingly popular white walls of galleries, *The Shop* ran for seven months between January and July 1993, and ended with a party on Emin's thirtieth birthday.

Sarah Lucas and Tracey Emin, *The Shop*, 1993

Selling artworks and merchandise (prices ranged from 50p to £500), slogan T-shirts (a popular one was 'she's kebab'), safety-pinned labels and ashtrays emblazoned with the face of Damien Hirst ('you put your cigarette out on him', Emin later recalled), the artists even kept four fish called Ken (after former London Mayor, and at the time MP, Ken Livingstone) and a chicken-wire altarpiece honouring David Hockney, named *Our David*.

At the cusp of her success, Lucas in the early 1990s was radical. She captured the female form as never before, presenting it through twisted, soft, stuffed sculptures and everyday objects (chairs, cigarettes, fruits, tights). A graduate of Goldsmiths College and among those featured in *Freeze*, she used wit and banality to critique expectations of how society wanted women to behave. Stripping the female body down to its bare minimum, she mocked gender stereotypes by incorporating humorous objects in her work, as seen in *Two Fried Eggs and a Kebab*, 1992.

Engaging directly with the misogyny of the tabloid newspapers (a staple of British 1990s culture), she also blew up offensive spreads to spotlight their scathing headlines and cruelty towards women. But for me, it's her grungy photographic self-portraits that exude control and command attention, in particular her *Self-Portrait with Fried Eggs*, 1996. With her legs splayed, pissed-off gaze, ripped jeans and eggs placed on her chest, Lucas takes ownership of her image and womanhood, however she wished to define it.

Tracey Emin (although perhaps now best known for her painting, p. 447, telling me, 'I hate it, I love it, I scream at it'), launched her career with artwork so poignant, so personal, so expressive and confessional, that it sent shockwaves around the world – and still does today. Raised in Margate, where she was seduced by the town's neon lights, Emin, in her words, had an 'unhappy childhood in a happy place', and channelled these emotional and traumatic experiences (her abortions, her rape at thirteen) into her raw, personal and political work.

Enrolling at Maidstone College of Art in the early 1980s, Emin's education there was formative, and I think fascinating. Although the 'feminist' elders were known to tear down her semi-nude

Sarah Lucas, *Self-Portrait with Fried Eggs*, 1996

self-portraits (deeming them 'too offensive'), Maidstone, according to Emin, was a 'hotbed of political activism'. Students would interact with the protestors from Greenham Common Women's Peace Camp as well as local miners to discuss how making art can relate to real-life issues. No doubt drawing strength from their experiences, Emin went on to earn an MA from the Royal College of Art, then spent the 1990s making work dealing not only with the immediacy of her emotional state, but the truth of what was happening to women, saying, 'If people are shocked by that, then maybe they should look at their own lives.'

Making the political personal, and the personal public, in 1995 Emin opened *The Tracey Emin Museum* on Waterloo Road (running until 1998), where she performed monologues, sold souvenirs from her childhood and exhibited her art, including her embroidered tent,

Tracey Emin, *My Bed*, 1998

Everyone I Have Ever Slept With, 1963–95. Followed shortly was *My Bed*, 1998: a visual record of a four-day breakdown. A diaristic story of an intensely personal time, *My Bed* provided in conceptual form the essence of Emin's psychological, emotional and physical condition. Exhibited at Tate Britain as part of the Turner Prize in 1998, not only was this a critical piece that caught the public attention and launched her reputation beyond the art world, but it marked the arrival of a new type of subject matter in an established institution. Consisting of an unmade bed, empty vodka bottles, old cigarette butts, torn bits of newspaper, and a Polaroid of Emin, the work spoke the language of the everyday urban person and revolutionised the concept and potentials of art. To me, *My Bed* feels like a modern-day Baroque sculpture, with its dramatic theatrical elements (the sheet's marble-like folds, depicting the crux of the narrative), which shock and provoke the viewer in their many layers.

I find theatricality is also present in Jenny Saville's (born 1970) colossal and effervescent paintings. She approaches the body in a more traditional style than her Conceptual Art contemporaries. Harking back to the vigour and grandeur of the Old Masters (grand themes, epic scale, emphatic strokes and honest subjects), Saville reinvents how the (particularly female) body is portrayed through oil paint. Her corpulent bodies are uneasy, tense, squashed, stretched, exposed, raw, as well as physically and psychologically confronting.

One of her most monumental paintings from this era, *Juncture*, 1994, depicts a giant backside full of wet, oily, impasto strokes. The work is so vast, the thickness of the paint so visible – so close to you – it almost feels like the body is about to fall from the canvas. On the one hand I find it beautiful, capturing the naked body in swathes of texture, and on the other, it's grotesque, full of abjection, pain and anguish. Like so many of her contemporaries, Saville pushes her medium to its limits.

Jenny Saville, *Juncture*, 1994

Cornelia Parker, *Cold Dark Matter*, 1991

Beginning her career slightly before some of those mentioned above, this decade saw Cornelia Parker (born 1956) expand the idea of what sculpture and installation could be, looking to found, every-day, in her words, 'clichéd objects', which she fragmented, squashed, exploded and destroyed. Full of suspense, violence and action, for *Cold Dark Matter*, 1991, Parker worked with the British Army to blow up the contents of a garden shed, which she resurrected by suspending it in fragmented form (using invisible string). Lit with a single light bulb, floating motionless in space, with dramatic and contrasted shadows (in themselves creating new identities), *Cold Dark Matter* feels like a microcosm of the world slowly disintegrat-ing. Familiar yet banal, it's as if she has put a memory into visual form, a reminder, perhaps, of the fragility of life.

Disturbing and hostile, uncanny yet familiar, Mona Hatoum's (born 1952) all-encompassing installations also catch their viewers off-guard. I find them more sinister, confined and unsettling than

Mona Hatoum, *Light Sentence*, 1992

Parker's. Palestinian in heritage but born in Beirut, Hatoum settled in London in 1975 following the outbreak of the Lebanese civil war and has continued to make overtly political work addressing subjects of displacement and exile. Beginning her experimental performative and political work in the 1980s, for *Roadworks*, 1985, she took to the streets, walking barefoot for one hour through Brixton with Doc Martens boots tied to her ankles – a response to the constant imposition of police surveillance and recent introduction of stop and search procedures. Swapping performance for intrusive installations, Hatoum scrutinised ideas of surveillance and imprisonment for *Light Sentence*, 1992: a cage-like environment lit by a suspended, single (and constantly moving) light, resulting in an uncomfortable, captive atmosphere through the long and towering shadows.

As if to turn art back onto the audience, following the 1991 recession, Gillian Wearing (born 1963) made the photographic series *Signs that say what you want them to say and not Signs that say what*

Gillian Wearing, *Signs that say what you want them to say and not Signs that say what someone else wants you to say*, 1992–3: (this page) *I'M DESPERATE*; (opposite page, right) *EVERYTHING IS CONNECTED IN LIFE THE POINT IS TO KNOW IT AND TO UNDERSTAND IT*; (opposite page, far right) *BEST FRIENDS FOR LIFE! LONG LIVE THE TWO OF US*

someone else wants you to say, 1992–3. Taking to the streets of London, she asked nameless passers-by (men in suits, best friends, couples, homeless people) to write their innermost thoughts on a piece of paper, which they would hold up for Wearing to photograph. Profound, emotional, uplifting and shocking, the photographs have the ability to transcend their individual subjects and become universal. I think they remain some of the most impactful ever taken. Some are more surprising than others, such as the white, suited man who simply wrote, 'I'm desperate', or the policeman who said 'HELP'. Full of love and aspiration, there are also the best friends who hope to remain close forever, the guy who confidently poses with 'Queer and Happy', and the man contemplating the essence of life with the words 'Everything is connected in life. The point is to know it, and to understand it.'

Distorting the veil between how we think in private and how society tells us to behave in public, Wearing's highly emotive work, like Parker's, makes us see afresh what is already in front of us; like Hatoum's art, it deals directly with the public; like Emin's, it engages with the personal; like Lucas's, it provides a commentary on British culture; and like Whiteread's and Saville's, it allows us to see something that appears so strong on the outside reveal itself to be so fragile underneath.

Here were a group of radical artists who, with their complex, timeless and universal takes on the world, helped to push forth contemporary art in Britain. The spirit of their experimentalism no doubt triggered a subsequent fearlessness in British artists (and curators) to push art to its extreme confines – from the large-scale public commissions to the sheer range of daring work we will see in the 2000s. But it was also thanks to them that London was repositioned as a capital of contemporary art, which saw museums, such as Tate Modern, erected at the dawn of the twenty-first century and which serve to incubate modern and contemporary art today.

PART FIVE

STILL WRITING

WRITING

2000—present

THE STORY OF ART IN THE NEW MILLENNIUM

Art since the millennium is explosive. How can one even attempt to encapsulate the last two decades in a few chapters? It's impossible. We are still living and breathing it, figuring out what artists are asking, answering or analysing, as we experience ongoing drastic social and political changes in these formative years. But it's also impossible because the art world is now recognising an abundance of non-male artists.

Benefitting from the foundations built by those who came (and fought) before, never have artists from so many different backgrounds, working across a multitude of media, had such opportunities to stand up and claim their rightful space. It has only been since the 2000s – perhaps even more recently – that institutions and galleries have catapulted those overlooked artists to the centre of the world's stage. With all-women group exhibitions: *WACK! Art and the Feminist Revolution* (2007), *Women of Abstract Expressionism* (2016), *We Wanted a Revolution: Black Radical Women, 1965–85* (2017), or *Radical Women: Latin American Art 1960–1985* (2018), this side of the millennium has also seen major overdue solo retrospectives by Lee Krasner, Faith Ringgold, Howardena Pindell, Lubaina Himid and pioneering British sculptor Phyllida Barlow. Nonetheless, there is still so much work to be done.

While all the artists mentioned here have played a pivotal role in defining art today, they are but a fraction of those contributing to our new and ongoing story of art. What does art look like today? Well, it's never looked more varied or, to me, more powerful. Artists of the new millennium are tackling complex themes cleverly, explicitly and on such grand scales. They are rewriting lost pasts and exposing historical truths, decolonising art history, challenging and reinventing what we think of as 'monuments', and employing utopian and

dystopian themes or returning to figurative painting to make sense of our time. Women and people of colour have achieved senior institutional roles. Technology has shifted the way we consume, educate and physically view and experience art, and there's no denying that the rise in equality within this creative sphere has been aided by democratic internet-based platforms. Political events have also been a driving force for artistic change: the September 11 attacks and the war on Iraq, the Obama administration and the dark years of Trump in the US, the refugee crisis, the looming climate crisis, and the rise of the #MeToo and Black Lives Matter movements around the world. It is through a vast range of visual forms that artists reflect our ever-developing, contradictory world.

Chapter Sixteen

DECOLONISING NARRATIVES AND REWORKING TRADITIONS

(c.2000—present)

PUBLIC ART AND MODERN MONUMENTS

I want to start with what I see as some of the most vital subjects and artforms tackled this side of the millennium: the challenging of colonial narratives, the impact and meaning of monuments, and the rise in public art.

Since the 1990s, interest in contemporary art has continued to grow on an ambitious scale, as reflected in skyrocketing art-market prices, public art commissions and the upsurge in museums and exhibition spaces. A pivotal moment was the opening of London's Tate Modern in 2000, a colossal gallery in a former power station built for the purpose of showing modern and contemporary art. Home to the Turbine Hall, at twenty-six metres high the cathedral-like gallery has, in my opinion, contributed to the change in how some art is made, exhibited and viewed today.

Inaugurated with Louise Bourgeois's *I Do, I Undo, I Redo* (a show still fresh in my mind from when I visited it as a six-year-old, awestruck by the sheer vastness and openness of the room), which featured three giant walk-up towers and a huge steel spider (her monumental sculpture *Maman*), the Turbine Hall has been host to a plethora of ambitious installations (including by Rachel Whiteread, Dominique Gonzalez-Foerster), large-scale films (Tacita Dean) and radical performance works. One impactful example of this is Cuban artist Tania Bruguera's (born 1968) *Tatlin's Whisper #5*, which in 2008 saw her employ two policemen on horseback to control the Tate's crowd, a statement that was intended to bring attention to the strict control of Cuban authorities. Other similar spaces followed: Paris's Palais de Tokyo in 2002, which is dedicated to large-scale, disruptive art-making, and public parks have also increasingly become sites displaying art. In 2005, Jeanne-Claude (1935–2009) and her collaborator husband, Christo, temporarily installed over 7,000 saffron-coloured fabric sheets in New York's Central Park for their work *The Gates*.

415

Doris Salcedo,
Untitled, 2003

The explosion of international biennials has also propelled the exhibiting of large-scale public art across the globe. In my opinion, one of the most powerful works remains Colombian artist Doris Salcedo's (born 1958) epically scaled *Untitled*, for the 2003 Istanbul Biennial, a temporary installation comprising around 1,500 wooden chairs, precariously stacked and shoved on top of each other, and slotted in an empty space between two buildings.

The strength of *Untitled* lies in its ability to facilitate so much interpretation, speaking of loss, vacancy, mourning and destruction. I can read it as addressing the brutality of the civil war in Colombia (as witnessed by the artist, who grew up during the Colombian Armed Conflict), but it can equally evoke the losses of the cruel

wars of the early 2000s, the mishandling by governments of its people, or, more recently, the loss of life during the Covid-19 pandemic. It's a masterclass in transforming everyday objects into symbols full of meaning.

Four years later, Salcedo presented *Shibboleth*, 2007, a 160-metre-long crack in the floor of Tate Modern's Turbine Hall. Splitting the vast room in two, her dividing line (varying in depth and width) could be viewed both from platforms up high or on the floor, up close. Like *Untitled*, it can elicit multiple analyses, but, as the artist has said, 'I am a Third World artist ... from the perspective of the victim ... the defeated people, it's where I'm looking at the world.' With this simple yet charged image she gets us to question borders and danger, violence and immigration, the silenced and the powerful, the excluded and the included. As an artwork, *Shibboleth* points to the futile and socially constructed lines that keep societies apart, and by permanently scarring the floor (it's still visible today if you

Doris Salcedo,
Shibboleth, 2007

Kara Walker: (left) *A Subtlety, or the Marvelous Sugar Baby, an Homage to the unpaid and overworked Artisans who have refined our Sweet tastes from the cane fields to the Kitchens of the New World on the Occasion of the demolition of the Domino Sugar Refining Plant*, 2014; (right) *Fons Americanus*, 2019

look closely), it acts as an enduring reminder of the deep, cruelly racist and colonial histories of the Western world.

Explicitly addressing the violent histories of the past, in 2014 Kara Walker (born 1969) erected on the site of the soon-to-be-pulled-down factory building in Williamsburg, Brooklyn, *A Subtlety*, or the *Marvelous Sugar Baby, an Homage to the unpaid and overworked Artisans who have refined our Sweet tastes from the cane fields to the Kitchens of the New World on the Occasion of the demolition of the Domino Sugar Refining Plant*. Looming at the back of the huge warehouse – still reeking of sweetness – Walker's giant, sugar-coated, sphinx-like woman confronted the brutal history of the building (once the entry point for sugar arriving from the Caribbean, where it was produced by slave labour), holding the viewer in its powerful gaze, regal stance and spectacular monumentality. Preceded by a series of boy statues coated in sugar and molasses that

attendees were forced to pass in order to view her, the *Sugar Baby* sparked discussion around race, oppression, violence and sexuality, as well as the power dynamics of a capitalist and imperialist world.

In 2019, at Tate Modern's Turbine Hall, Walker returned with a vast Neoclassical-style fountain, *Fons Americanus*. Similar to *A Subtlety*, it was placed at the far end of the industrial-scale room and was preceded by the figure of a child, this time a weeping boy encased in a scalloped shell. Based on the Victoria Memorial outside Buckingham Palace (a fountain honouring the triumphs of the British Empire), Walker instead populated her 'anti-monument' with caricatures of communities affected by the transatlantic slave trade. *Fons Americanus* makes us realise that in fact what we are so often surrounded by is imperialist propaganda. The monument is all the more poignant as it took up space in a gallery named after an individual whose family's wealth was 'constructed on the foundations of slavery'.

Symbols of water and decolonial thinking are also at the core of one of Brazil's most celebrated artists today, Adriana Varejão (born

Adriana Varejão, *Green Tilework in Live Flesh*, 2000

1964). Varejão has spent the last thirty years interrogating her country's violent past in paintings that are equally intended to attract and repel, fusing gruesome and fleshy, gut-like imagery with pristinely washed tiles. The gory features expose the violence hidden behind the beauty of the tiles, which themselves reference the Baroque, European, blue-and-white-ceramic *azulejos* – a motif loaded with colonial meaning and found in abundance in Portugal and its former colonies.

I find the power of Varejão's paintings is in their ability to speak to historical truths that must remain known and must be acknowledged. Like Salcedo, she opens up a way to talk about death and absence. And like Walker, she addresses the meaning of supposedly often immaculate symbols, buildings and monuments, which conceal or glorify deeply embedded traumas.

UPENDING ALL CONVENTION

'The information can be so layered and
disintegrated that it becomes a dust-like atmosphere'
— Julie Mehretu, 2008

How does one encapsulate our globalised world in art? For me, it is through the works of Julie Mehretu, Sarah Sze and Katharina Grosse. Not only do they redefine all conventions of painting and sculpture, but in visual form the artists allow us to begin to comprehend the complexity and fragility of the world, and the drastic changes of the last twenty years. Certainly, in two-dimensional form, the closest reflection of our changing planet I've found is in the multilayered paintings by Julie Mehretu (born 1970). The Ethiopian-born American artist's dynamic paintings erupt with layers of architectural renderings, map-like forms and clusters of symbols, shapes, gestures and lines. Monumental and theatrical, they're still intimate and filled with political references. Somehow, Mehretu's paintings emulate the motion of the world: on the verge of collapse, or the brink of transition.

Julie Mehretu, *Stadia II*, 2004

Studying in the 1990s and rising to acclaim at the start of the new millennium, an era of energy and optimism, Mehretu's early work investigates 'the map', in part to present a transitory world. But as if to show how, in her words, all 'came to an abrupt end after the Twin Towers fell' and to translate the contradictory and complex years of the early 2000s onto a flat surface, she produced her monumental three-part series, *Stadia*, 2004. Made at the time of the Iraq War and the Olympic Games in Athens, *Stadia* echoes the structures of amphitheatres or today's vast arenas. But instead of glorifying them, she interrogates the meaning of these historically charged sites: of spectacle, propaganda, entertainment, imprisonment, or as places of collective fervour, competition or nationalist identity (as demonstrated in the rectangular shapes evocative of flags).

I like to think of these works, with their sweeping lines and shapes that disrupt and interweave within the space, as fracturing the once-ordered world system, and equally speaking to the over-

load of information consuming today's society. Presenting, as they do, both a macro and micro view of the world, when I experience her paintings, such as *Stadia II*, up close, smaller pockets of information reveal themselves, but when I step back, a panoramic, dynamic view of the world unfolds.

I get a similar feeling when I see the part-architectural, part-digital sculptural installations by Sarah Sze (born 1969). They take the form of a planetarium, a colosseum, a work-in-progress laboratory. Held up by precarious stick-like structures and formed around everyday objects (and, more recently, moving images), her works behave as the greatest visual microcosm for the excess of information and images inundating today's internet-dominated society. (In her book of essays *Feel Free*, Zadie Smith recalled visiting Sze's *Centrifuge*, 2017, with her children, who compared the structures to 'a sort of exploded iPhone'.) Making use of everyday materials – such as wire, congealed paint, tape measures, scissors, newspapers – as well as images and films taken on her iPhone, by giving prominence to mundane, mass-produced objects

Sarah Sze, *Centrifuge*, 2017

Katharina Grosse, *The Horse Trotted Another Couple of Metres, Then it Stopped*, 2018. Installation at Carriageworks, Sydney, 2018

evocative of our world, she enters an art-historical dialogue with her 'readymade'-inventing predecessors and disrupts all barriers between our lives and the art.

Without traditional framing devices, vantage points or a clear indication of where a work begins and where it ends, as we circum-navigate Sze's installations, whether up close or from afar, our per-spective constantly fluctuates and different elements of the work are revealed. This is also apparent in the all-engulfing work of German artist Katharina Grosse (born 1961), in which sculpture and painting combine in breathtaking constellations. Using an industrialised space as her canvas (or even at times desolate, outdoor landscapes), she packs it full of giant, sprawling swathes of fabric soaked in elec-trically luminous, spray-painted colours, seeking to, in her words, 'reset the idea of what a painting can be'. By giving us access to the inside of the space (as viewers we can physically walk in and out of her spray-painted constructions), Grosse encourages us to sense, touch and experience painting and sculpture from within.

Cao Fei,
Whose Utopia?,
2006

Coalescing the real and artificial, fantastical and virtual, artists in the past two decades have engaged with digital media and new technologies – not just as the medium of their art, but as the subject of it, too. From building worlds on social media platforms and employing immersive filmmaking, to using artificial intelligence, virtual and augmented reality, two multimedia artists spearheading this art-tech revolution – while simultaneously analysing the state of contemporary society – are Cao Fei and Hito Steyerl.

Raised in Guangzhou, China, at a time of drastic urbanisation, Cao Fei (born 1978) has been instrumental in recording the vast changes in landscape and industry in modern-day, post-Cultural Revolution China. Addressing the utopian and dystopian state of the world, she transports her viewers to imagined and familiar sci-fi-like places. Yet while they might appear otherworldly, they also uphold the essence of human values. I find *Whose Utopia?*, 2006, to be one of her most poignant films. It documents labourers working in a light-bulb factory, following them as they assemble machines, and then as the film unfolds we see Cao's protagonists realise their dreams – a young ballerina on pointe, a man dancing in the aisles of the factory.

For her four-year-long project, *RMB City: A Second Life City Planning*, 2007–11, Cao built a fictionalised virtual Chinese city

Cao Fei, *RMB City: A Second Life City Planning*, 2007–11

(complete with real-life buildings and parks) on the social platform Second Life. She constructed an alter ego (with her same morals) and encouraged her audience to do the same (the only way to enter *RMB City* was to build your own avatar). Reflecting the technologically driven world of today, *RMB City* feels akin to the all-consuming world of gaming, but the built landscape also points me towards art history. Having compared her virtual kingdom to a 'traditional Chinese brush painting', it's as though Cao is doing what painters have always done: manufacturing semi-fictionalised scenes and settings with the same emotional impact, just using a more modernised medium.

German artist Hito Steyerl (born 1966) also engages with the latest technologies in the digital sphere. She works with computer-generated imagery and blends real-life scenarios with fantastical

Hito Steyerl, *How Not to Be Seen: A Fucking Didactic Educational .MOV File*, 2013

narratives, addressing issues bedevilling contemporary society. Steyerl's film *How Not to Be Seen. A Fucking Didactic Educational .MOV File*, 2013, examines practical, imaginative and downright unrealistic ways of hiding from the surveillance in society which tracks us today. Set up as a video manual, the film suggests strategies ranging from 'being a superhero' to 'being a female over fifty', to comment on the absurd realities of the world we inhabit.

Steryerl and Cao have also influenced a generation of artists who incorporate technology into their work as subject and/or medium, such as text messaging or iPhone videos (Martine Syms), or large-projections of magical realist-style films (Wu Tsang).

UTOPIAN DREAMS

'My warrior sculptures manifest themselves
through the female figure, but the potential of the
woman is infinite …' — Bharti Kher, 2021

Using painting, collage and sculpture to create an alternative reality in which male-led, Eurocentric narratives do not dominate, some of the most prominent artists of this period reimagine histories and reinvent the future while working with magical realism and Afrofuturism. Movements that draw on mythology and concepts of transformation.

Afrofuturism – a cultural movement led by Black diasporic artists, writers and musicians who employ ancient, mythical and futuristic subjects and the latest technologies to conjure new worlds – has been embraced by a new generation of artists in the early 2000s. One of the foremost visual artists engaging in Afrofuturist themes is Ellen Gallagher (born 1965), with her multimedia series *Watery Ecstatic*, begun in the early 2000s. Populated by biomorphic, marine-like beings who appear to be trapped in another realm or enjoying the freedom of living deep underwater, Gallagher's ongoing series references the fictional myth *Drexciya*, which was named after the anonymous electronic music duo who created it. In the *Watery*

Ellen Gallagher, *Ecstatic Draught of Fishes*, 2019

Ecstatic series, Gallagher translates into visual form *Drexciya*'s proposed submarine kingdom of reincarnated formerly enslaved, pregnant West African women and their unborn children who died or were thrown overboard during the transatlantic slave trade. This gives a poignant narrative to the artist's highly textural, glittering paintings of mythical figures and cell-like forms, elegantly living, breathing and building the ecosystems of a submarine world.

Also engaging with Afrofuturist aesthetics is Wangechi Mutu (born 1972). The Kenyan-born artist's oeuvre encompasses painting,

Wangechi Mutu, *a dragon kiss always ends in ashes*, 2007

performance, sculpture and film, always on a plain that is both terrestrial and celestial, human and animalistic, violent and seductive, ancient and modern. Drawing from Kenyan folklore and proposing imagined sea mythologies, she suffuses her work with hybridised figures who take the form of underwater creatures and sci-fi-tinged cyborgs. They are powerful, regal, visible.

Emerging to acclaim in the early 2000s for her kaleidoscopic collages spliced from magazines, Mutu's ambiguous part-human, part-animal, part-plant figures – a great example of which is *a dragon kiss always ends in ashes*, 2007 – are often caught in active, erotic poses. Appearing as beautiful as they are monstrous, her collages also spark discussions about the violence and sexualisation of the body. Speaking about them, she has said: 'It was a lot of taking these posed, very fictional females and extracting meaning out of them and squeezing a new discussion into them.'

Since opening her second studio in Kenya in 2016 (she previously worked primarily in New York for two decades), Mutu has favoured materials sourced directly from the land (sand, clay, rocks, minerals) as well as more traditional media, such as bronze for her large-scale sculptures. Sculptures which, in my opinion, exude nobility in commanding poses. Challenging Eurocentric busts and monuments,

Wangechi Mutu, *Mama Ray*, 2020. Installation view at the Legion of Honor Museum, San Francisco, 2021

they demand a redress of authority and highlight the need to decolonise institutions, as is evident in her tall, bronze, part-human, part-sea-creature figure *Mama Ray*, 2020. When exhibited in front of the Neoclassical façade of the Legion of Honor in San Francisco in 2021, it stood facing Auguste Rodin's *The Thinker*, 1904, defiantly confronting the epitome of traditional European sculpture. Instilling hope for the future, and addressing the contemporary moment, she aptly titled the exhibition in which it was shown *I Am Speaking, Are You Listening?*

Claiming space and putting Black women centre stage, Simone Leigh's (born 1967) sculptures are equally powerful. Whether they are assertive and striking sixteen-foot-high busts on New York's High Line Plinth (as seen in *Brick House*, 2019) or smaller, head-shaped, relic-like vessels, Leigh's sculptures are full of strength and self-preservation. With their eyes shut or wearing long braids

Simone Leigh, *Brick House*, 2019

with cowry shells, Leigh's works, like Mutu's, are the icons that we require today.

Part of a generation of ceramicists, including Magdalene Odundo (born 1950), who are expanding clay-based traditions, Leigh is a strong influence on younger artists disrupting the medium. One of them is the Ugandan-born Leilah Babirye (born 1985), whose towering and purposefully genderless figures – constructed from items once deemed 'throwaway' – unite in the form of imagined queer clans.

Hybridity is also central to the work of Bharti Kher (born 1969). Although known for her bindi-based abstract paintings which take the form of maps, cells or organically shaped contour lines (glistening like slow, rippling water seen from above), it is Kher's sculptures of goddess-like women I find most compelling. Working from body casts taken of friends to, as she told me, 'get an idea of truth from the body, not just physically but psychologically', Kher fuses the real with elements drawn from mythology, ecology and spiritualism. One example is *Warrior with Cloak and Shield*, 2008, in which the

Bharti Kher, *Warrior with Cloak and Shield*, 2008

subject's body is veiled with a banana leaf (symbolic of fragility and protection) and the skull is punctured with sprawling antlers (to 'carry with her the energy of masculinity', or in reference to the half-man, half-woman Hindu god, Shiva).

Transforming her figures through hybrid forms and symbolism, like her contemporaries, Kher demonstrates the complexity of a woman's psyche and the potential of her multifaceted character. Similar to the imaginary worlds proposed by Gallagher, the defiant alternative rulers by Mutu, or the composed busts by Leigh, Kher's sculptures challenge the dominance of Eurocentric, male-led art. By using the female body as a framework, she gives women, in her words, 'the potential to go anywhere, to move things, to transform themselves, to become shamans and have magical possibilities …'

Chapter Seventeen

FIGURATION IN THE TWENTY-FIRST CENTURY

(c.2010–present)

RETHINKING REPRESENTATION

'… figuration is still important today because people want to see
themselves in art. They want to see their children and their mothers
and their selves. In the same way that those people who made cave
paintings of handprints wanted to say, "Here I am" … I do not think
that much has changed. Here I am, here's my hand, my body, myself.
Human beings' sense of the brevity of life makes it even more
important to leave a record of their own. To tell their story to
the future' — Chantal Joffe, 2021

In times of crisis, artists have often turned to the figure. Realism in
nineteenth-century France emerged in the wake of the French Revo-
lution; in the decades following the Mexican Revolution the Mural-
ists presented socially conscious portrayals of people; artists in the
Weimar era documented street life and nightlife; at the height of the
Depression, American artists turned to the figure; and, just as Joffe
said, the cave painters began with themselves. In today's world of
new technologies, dystopian politics, global pandemics, ecological
destruction and right-wing capitalism, I'm interested that we are
finding ourselves in a renaissance of figurative painting. Are we
craving humanity, real people, real moments? Are we trying to right
the wrongs of the past by honouring those so often shunned from art
– queer people, the working class, people of colour, women – in
works created from a specifically non-objectifying (non-male) gaze?

Although figurative painters have been discussed throughout
this book, it is only in the last two decades that sustained interest in
these artists has occurred. (Alice Neel, p. 346, Emma Amos, p. 273,
Sylvia Sleigh, p. 349 and Maria Lassnig, p. 350, are examples of a
fraction of the artists working in the twentieth century whose figur-
ative work has been recently commemorated.) I find myself asking,
why do these artists, finally celebrated in blockbuster shows and
influencing the youth of today, speak so much to the now? Is it their

distinctly personal take on figuration, as opposed to grand themes or immortalising high-status individuals? For me, these artists give us raw imperfections and real conversations (Neel), daily life and relationship dynamics (Amos), familiarities and humour (Sleigh), truth and fearlessness (Lassnig), and, as Joffe expands, 'a recognition of the self that can feel brand new'. Representation matters, and figuration has the weight to create change: it can challenge mainstream, past or negative imagery for future generations, provide a record of now, and the many individuals who lived and shaped it.

Starting with those who reclaim historic paintings and rethink representation, I want to show you the latest artists holding up a mirror to this complex world. They paint from life and from their imaginations; tell stories; uplift others; preserve legacies of under-represented communities; and through their collages, paintings and photographs, pose political questions about our past and present.

'Portraits are very powerful. They have a great representation and dominance in the world... of trying to capture the essence of someone' — Mickalene Thomas, 2013

Mickalene Thomas (born 1971) understands the power of representation. Beginning her career training in law, it wasn't until she saw Carrie Mae Weems's *Kitchen Table Series*, 1990 (p. 366) that she was inspired to pursue art. (Speaking in a recent interview, she recalled the 'transformative' experience, 'not only to me as a young Black girl from Camden, New Jersey, standing in a museum in Portland, Oregon, but as a queer woman, as a young artist ... they changed my life.') Enrolling in art school, receiving her MFA from Yale, Thomas has since worked on a large (at times immersive) scale to elevate the presence of Black women in art. Putting her subjects in prime position in her photographs, collages, paintings and installations, she aggrandises friends, family members and lovers, melding glittering rhinestone crystals with rich and colourful patterning. Reminiscent of royal portraits, the poses are authoritative and forthright, as if demanding to be seen.

Mickalene Thomas, *La Leçon d'amour*, 2008

Drawing from pop culture and history, and striving to encapsulate the beauty and glamour she witnessed in *Jet* magazine when growing up, Thomas also restages and reclaims art-historical compositions – for *La Leçon d'amour*, 2008, she reworked Balthus's notorious painting *The Guitar Lesson*, 1934, as if correcting male-dominated art history. Set in 1970s-style interiors, full of houseplants and clashing fabrics (reminiscent of her childhood in her grandmother's home), her paintings elevate and almost mythologise everyday spaces.

Interior settings are also central to the work of Njideka Akunyili Crosby (born 1983), whose paintings portray family gatherings, conversations with friends, traditional Igbo wedding rituals and moments of quiet. Raised in Nigeria, she's been living in America since she was sixteen, and her work reflects the union and disparities between her two worlds.

Njideka Akunyili Crosby,
When the Going is Smooth
and Good, 2017

Overlaid with image transfers of photographs recalling 1980s Independence-era Lagos (Grace Jones on the television; Holy Communions in childhood) and commemorative portrait fabrics, Akunyili Crosby's meticulous surfaces amalgamate personal histories and cultural references, and are starkly contrasted with blocks of bright colour. Akunyili Crosby employs the traditional approaches of European painting (portrait, interior, still life), claiming as her own a genre rooted in colonial history. Often revolving around a single point of focus, with figures or furniture set against modernist interiors, Akunyili Crosby's paintings draw you in with their many layers and stories. Stare at them for minutes (or hours) and the abundance of imagery hidden in the multilayered floor, clothes, framed photographs or figures becomes apparent.

When the Going is Smooth and Good, 2017, is, for me, her most tender image. Centred on an interracial couple, lovingly dancing and lost in the moment, the pair are surrounded by friends or family dancing, no doubt feeling the beat blasting from the retro-style

speaker, on a glittering dance floor embellished with pop icons. Seemingly unrooted in any specific time or geographic location, Akunyili Crosby's ambiguous, atmospheric setting is suggestive of either summer in Los Angeles or Christmas in Lagos. (The giveaway is the two dancers on the left, who have been lifted from celebrated Malian photographer Malick Sidibé's *Christmas Eve, Happy Club*, 1963.)

South African-born Lisa Brice (born 1968), with her commanding depictions of unruly women, is also reinventing figuration for

Lisa Brice,
After Ophelia, 2018

Lynette Yiadom-Boakye, *Harp-Strum* (diptych), 2016

the twenty-first century. Physically reincarnating female characters from historic paintings (such as Elizabeth Siddal (p. 88) posing as Millais's *Ophelia*, 1851–2), Brice frees them from the passivity they are so often considered to be expressing. Minding their own business with a bottle of beer, cigarette in mouth or paintbrush in hand (as if they're writing themselves into history – this time, on their terms), she charges her women with power in their glaring gazes and gives-no-fucks stances.

Drenched in a specific tone of cobalt blue, as if to reclaim Yves Klein's trademarked blue (into which he dipped female bodies to use as paintbrushes) or Pablo Picasso's famous Blue Period, or in reference to the Blue Devil character in traditional Trinidadian carnival, Brice's women exist in hot, hazy, liminal spaces, traversing the

thresholds between reality and surreality. Rooted in what Brice refers to as the 'gloaming hour' (when day becomes night), she presents them with an air of authority, as if it's their time to rule.

Freedom and sensuality is also at the heart of paintings by Lynette Yiadom-Boakye (born 1977). The British-born painter is a master at presenting lyrical, poetic scenes derived solely from her imagination. She features single or multiple figures of all different ages and genders. At times thinking, socialising, dancing, reading or laughing, they stare out at us, at each other or introspectively on themselves. Familiar yet otherworldly, I find looking at one or multiple of her paintings is like watching a play unfold. Full of personality, possibility and psychological depth, the vitality of her figures bounces off the canvas through her quick, brash brushstrokes.

Toyin Ojih Odutola, *Representatives of State*, 2016–17

While some artists today use figuration to create alternative realms, others use storytelling to pose questions about the state of reality. Toyin Ojih Odutola (born 1985) works from her imagination yet sees the pen as a 'writing tool first'. Often beginning a series by inventing a narrative (taking influence from sci-fi author Octavia E. Butler), Ojih Odutola questions the history of the 'myth' and who has control of these stories. She tells me, 'I think narrative helps people see better, because when there's a story involved, you're less

inclined to say, I already know what this is …' And in doing so, she alerts the viewer to the potentials of using this device.

Although Ojih Odutola's meticulously rendered figures might at first appear familiar, a closer inspection reveals unsettling ambiguities: off-centred shadows and perspectives; acts still unlawful in specific countries. Not only does this force us to query what we see on a surface level, but to go deeper and probe the power dynamics of a cruel, corrupt history. This is apparent in *To Wander Determined*, 2017, a series of portraits she presented as the 'private art collections' of two fictionalised Nigerian dynasties, connected by the marriage of their two sons. Proposing a history free from colonialism, her wealthy, dignified characters pose in front of elaborate backdrops and wear sumptuous clothes. Yet the slightly unbalanced perspective and angles remind us of the fact that what we see can never be real. This is due to the ongoing prohibition of homosexuality in Nigeria and the destructive impact the legacies of colonialism and the British Empire continue to have worldwide.

Colombian-born, New York-based María Berrío's (born 1982) collaged paintings, crafted from fragments of hand-dyed textured paper, too, pose questions around a corrupt world. Recalling stories of mostly women and girls who appear as courageous and resilient – whether fighting on the front lines or feeding their children – Berrío's exquisite works allude to political realities through poignant symbolism.

When addressing notions of migration and displacement, Berrío said, 'the imagined people in my paintings are displaced, and are seen in preparation for their travels, in moments of transition, and in states of uncertainty'. *Oda a la Esperanza (Ode to Hope)*, 2019, is an example of this. Made in response to the Trump administration's family separation policy, Berrío depicts eight young girls as captives in an institution-like environment. Similarly, *Wildflowers*, 2017, centres on an abandoned train carriage evocative of La Bestia – the banned network of freight trains used by Mexican migrants to cross the US border. Despite these undertones, her paintings are full of hope and regeneration, evident in her joyous depictions of the natural world – the encroaching vines and the abundance of plants and animals swept up in a utopian glory.

María Berrío, *Wildflowers*, 2017

Chantal Joffe, *Esme on the Blue Sofa*, 2018

While those already mentioned use figuration to present fantastical imaginary scenes, artists working now also use it to record real-life interactions. What does it mean to paint from life today? To catch and record an intimate moment, or a relationship filled with tensions, unease, love or loneliness? To be in the same room as a sitter, and have a physical documentation of that sacred time?

Chantal Joffe (born 1969) records psychological intensity in the actual second. Looking at (or possibly 'within') her subjects, it's as though her every stroke is charged with conviction. In *Esme on the Blue Sofa*, 2018, you can tell a conversation has played out: there's a dialogue in the unflinching yet familiar gaze of her warm-blooded sitter – her daughter – whose body is worked in wet, loose brushstrokes. Painting quickly but effectively, Joffe does something that very few can do: she gets under the skin of her subjects as if to preserve that truth, thought, expression, desire. She tells me, 'Sometimes when I start a painting I'm moving the paint around and feeling like I've never painted before and, what's the point? Then suddenly I make a mark and it's sort of the face of how the person looks or the way their eye feels, and I've fallen through to something else. A kind of magic.'

British painter Celia Paul's (born 1959) paintings are equally as personal. 'I am not a portrait painter. If I'm anything, I have always

Celia Paul, *Painter and Model*, 2012

been an autobiographer and chronicler of my life and family,' she reflected in 2019. Painting sensitive portrayals of her sisters, mother, friends and past lovers, whom she cloaks in a hazy glow at her sparse studio-slash-apartment, Paul's paintings uphold the sacredness of the moment and the relationship she shares with her sitters. But it is her stoic, statuesque self-portrait, *Painter and Model*, 2012, that I find the most compelling. Quietly intense and subtly monumental, she presents herself draped in her floor-length overall. Glistening with impasto paint splatters in colours so distinctly hers, it's as if Paul softens the lines between where her palette ends and her painting begins.

Although of a different generation, quiet intensities are equally present in the work of Jennifer Packer (born 1984), who paints private, politically charged portraits of those close to her in the Black

Jennifer Packer: (left) *Tia*, 2017; (right) *Say Her Name*, 2017

community. Like Paul, she captures the emotional and physical encounter; like Joffe, she reveals truths in her subjects' expressions. Often emerging from a pool of luminous pigment, the weightiness of her sitters is communicated through the heavy fabric and the chairs they sink into, their active minds palpable through their psychologically intense gaze. They feel real, seemingly breathing, as though we are in the same room as them. But Packer also paints lives lost in the form of sprawling, blooming funerary bouquets. Equally bursting with life and dissolving with decay, *Say Her Name*, 2017, was painted to commemorate the life of civil rights activist Sandra Bland whose life was allegedly lost to police brutality.

Distorting all visibility of facial features with lines that bruise into the canvas and outline the shape of a human body, Tracey Emin's paintings of recent years are full of vigour. You can feel her body move across the canvas, her innermost feelings press against the surface. Layered with strokes that seep into and drip down the canvas, it's as though she is culminating decades' worth of love, pain, death and desire into one canvas, something I find particularly

Tracey Emin, *You Kept it Coming*, 2019

present in *You Kept it Coming*, 2019. Although it is not visibly Emin, we can feel her presence in the distinctly washy, charcoal-coloured lines in the body set against the avalanche of paint that falls behind her. Speaking about this work, she told me, 'When I am so much in love and trapped, it feels like I am crawling through blood.'

The portraits and self-portraits by Zanele Muholi (born 1972) exemplify the impact of figuration in photography. A self-proclaimed 'visual activist', who identifies as non-binary, Muholi's practice memorialises the importance of Black queer lives mostly in their native South Africa, where LGBTQIA+ communities are still subject to assault. Growing up during apartheid, and a young adult

Zanele Muholi, *Qiniso,*
The Sails, Durban, 2019

when the brutal system officially ended in 1994, Muholi took up photography, describing it as a medium 'through which I could speak about whatever was inside – the feelings, the pain, the personal experiences I had gone through. I discovered that photography was a means of articulation.'

For *Only Half the Picture*, 2002–6, Muholi took their camera into townships across South Africa, capturing with sensitivity those subjected to violence. Using photography to promote their community's visibility and humanity – by weaving their stories into art history and assertively placing them on museum walls – Muholi gives this awareness, in their words, 'so that future generations will note that we were here'. In 2012, Muholi began their bold, commanding series of self-portraits, wearing everyday materials (hair combs, electric cables) in the form of crowns and armour. The title, *Somnyama Ngonyama*, 2012–ongoing, is translated from the artist's first language of isiZulu, meaning *Hail the Dark Lioness*.

Khadija Saye, *Peitaw*, 2017,
from the series *Dwelling:
in this space we breathe*

A photographer of some of the most profound images in recent
years was Khadija Saye (1992–2017). This young artist, who tragic-
ally died in the 2017 Grenfell Tower fire in London, described
her art as investigating 'the deep-rooted urge to find solace in a
higher power'. Saye put self-portraiture and explorations of identity
at the centre of her work. Born to Gambian parents (a Christian
mother and a Muslim father), she utilised photography to engage
with her mixed religious heritage, Gambian spiritualist rituals
and as an act of self-healing. She said, 'I wanted to investigate
how a portrait could function as a way of announcing one's piety,
virtue, soul, and prosperity'. Saye exhibited six out of nine tintypes
from her series *Dwelling: in this space we breathe* at the Diaspora
Pavilion at the 2017 Venice Biennale when she was just twenty-four.
Using this nineteenth-century photographic technique, her striking
black-and-white images of herself interacting with objects (prayer
beads, amulets, incense pots) exude a divine-like essence and

timelessness and have since been shown at some of the world's most prestigious museums.

The artists I have mentioned so far are but a fraction of those redefining figuration today. There are also those transforming the body through paint – Dana Schutz (born 1976) with her all-engulfing, thick-impasto distorted figures; Nicole Eisenman (born 1965) with their exuberantly textured, contemplative figures that reflect so perfectly the anxieties of modern life; or Loie Hollowell (born 1983), whose part-abstract luminescent, geometric paintings reinvent how we look at the pre-birth and post-birth state.

Challenging conventions of portraiture, Harlem-based Jordan Casteel (born 1989) and Mexican-born Aliza Nisenbaum (born 1977) use the genre for social change by honouring professionals and people from under-represented communities in their deeply expressive, psychologically intense paintings. Amy Sherald (born 1973), too, is re-evaluating the 'American portrait', with her dazzlingly block-coloured canvases – at times on the scale of Old Masters – which immortalise images of everyday Black people who exist in a

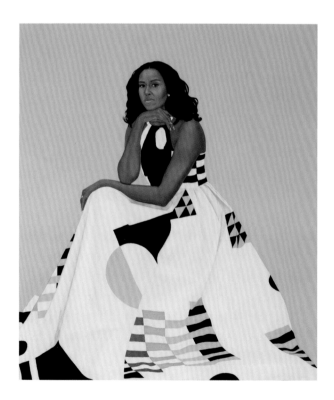

Amy Sherald,
Michelle LaVaughn
Robinson Obama, 2018

Deborah Roberts,
Baldwin's Promise, 2017

space, as the artist has said, 'between fantasy and reality'. In 2017, Sherald was commissioned as the official portraitist of former First Lady Michelle Obama. Depicted as both triumphant and approachable (with the pattern on her billowing dress referencing the Gee's Bend Quiltmakers, p. 322), Obama's gaze is full of wisdom and optimism. This I find is also key to the work of Deborah Roberts (born 1962). Comprising spliced features from contemporary cultural and historical figures (from James Baldwin to Rihanna), Roberts's collages of confident adolescent figures, with oversized features and excitable expressions, engage in discussions about contemporary and historical African American politics.

Claiming space on gallery walls across the globe, these artists and their works instil hope in future generations and tell the stories of those shaping the world today.

Chapter Eighteen

THE 2020S

THE NEW MASTERS

'I feel like I see paint as a living thing in itself.
And I envy it because it just holds so
much character' — Jadé Fadojutimi, 2020

Let's close with three young painters who are looking to the future as much as they are looking back at history. All British, all born in the 1990s, they are who I like to think of as the 'New Masters': artists whose influence, I believe, will be some of the most impactful on the next generation and the future of art history.

Jadé Fadojutimi's (born 1993) paintings are full of ecstatic, vivid (almost spiritual) colouring. Although two-dimensional, when witnessed in the flesh they seem three-dimensional, with layers of colours that swarm out of the canvas, consuming the viewer. Erupting with drama and theatricality, it's almost as though you can see something moving under the top layers of paint, as so much pigment lies on the surface. Fadojutimi often works through the night, blaring movie or anime soundtracks as she applies paint and oil stick to canvas, from which she creates myriad textures using forks or the sharp end of a paintbrush.

Reminding me of the vigour of Joan Mitchell (p. 246), the expressiveness of Lee Krasner (p. 240) and the luminosity of Helen Frankenthaler (p. 248), I see Fadojutimi's paintings as neither abstract nor figurative. They're not rooted in any one place or fixed into any strict category. To me, they are utopian: worlds where only harmony, joy and pure colour exist. All are given lyrical and poignant titles, but of all her works I find *There exists a glorious world. Its name? The Land of Sustainable Burdens*, 2020, one of her most mesmeric. It is a glowing, gleaming painting, which appears to present a planet within a planet. Is this day becoming night, or night becoming day? Are we on water, on land, or looking at a micro or macro view of the universe? Fadojutimi's paintings offer me a language for a new time,

Jadé Fadojutimi, *There exists a glorious world. Its name? The Land of Sustainable Burdens*, 2020

just as the artist has observed herself, 'My paintings seem to be aware of the present while colliding with the past.'

Equally visceral, Fadojutimi's contemporary, Flora Yukhnovich (born 1990), employs oil paint that morphs in and out of figuration and abstraction. Splattering, stretching and lathering paint onto her colossal canvases, she creates scenes fluctuating between movement and stillness, 'innocence and experience', then and now. Steeped in the rococo (in particular, the fêtes galantes: outdoor parkland scenes popular in the eighteenth century), Yukhnovich's paintings loosely reconfigure scenes by celebrated historical male artists. She draws from R'n'B music videos, contemporary capitalist consumption, the warped history of sweetness and sugar, the media (and art history's) hypersexual view of women. Bridging the frivolous, erotic nature of pre-Revolution France with the contemporary, she tells me: 'painting is a way of making sense of all the images that bombard us minute by minute. In a painting, the different aesthetics, whether old, or new, can coexist, uncovering the similarities that echo across art history. I think all image-making involves a dialogue between

Flora Yukhnovich, *Warm, Wet N' Wild*, 2020

old and new, but with painting, it can happen in a very explicit and revealing way.' The result is a poignant commentary of the over-consumed and hyperdigitised world we live in today.

Working with splinter-like strokes that are simultaneously car-toonish and violent, playful and rigorous, with fleshy, food-like, painterly textures (buttery yellows, cream-like pinks, sugar-coated blues), Yukhnovich is a master at constructing gusts of light, air and watery aesthetics out of paint. This is seen in *Warm, Wet N' Wild*, 2020, a popular historic subject – bathers – reincarnated. She also

Flora Yukhnovich,
*Out of the Strong Came
Forth Sweetness, 2019*

plays with *trompe l'eoil* ('trick of the eye') – as evident in the infinite heavenly sky in *Out of the Strong Came Forth Sweetness*, 2019.

Finally, Somaya Critchlow (born 1993) is creating a new history where Black female nudes possess an equal nobility to figures found in Old Masters. Creating small-scale, even pocket-sized paintings of bold and triumphant women, her work has some of the commanding spirit as that of seventeenth- and eighteenth-century painters. Referencing their muted palette, exquisite painterly style, mighty gazes and strong stances, her women remind me of the powerful, dominating presence of figures as seen in the work of Leonor Fini (p. 179). Like her contemporaries, Critchlow marries art history with perceptions of women in the media today, drawing influence from television shows (*Love & Hip Hop* or the eery, cult-like aesthetic of

David Lynch). Although her works play with power structures and she incorporates Victoriana objects (such as clocks, chairs, teacups, shoes), Critchlow's compositions are not situated in any specific time or place. Instead, they confront past histories to make sense of the stories once left out. In turn, she interacts with and changes traditions of miniature oil painting, and demands a new identity for British art today.

These artists are by no means the only ones working today who are paving a new way of painting – you can look to the timeline on p. 467 to discover many more. However, these three, to me, most directly address the art history that I described to you at the very start of this book. In their work they are reinvigorating the traditional medium of oil painting, bringing it into the modern day. And despite this being a time of myriad new artforms, Fadojutimi, Yukhnovich and Critchlow, through paint, directly confront contemporary issues and draw from our technology-filled world.

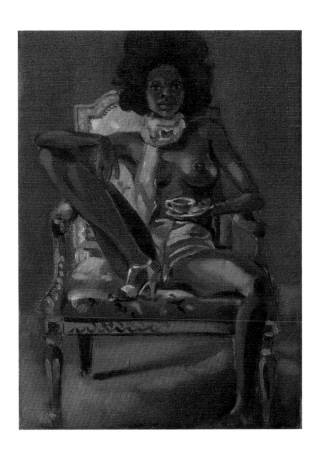

Somaya Critchlow,
*Figure Holding a Little
Teacup*, 2019

WHERE ARE WE NOW?

Although this book is rooted in historical context and 'isms', it is impossible to define what age we are in or will be in. And perhaps it is no longer so relevant. More than ever, art is being practised across a broad range of spectrums and the 'establishment' is finally acknowledging this. One thing is certain: we are living in a more inclusive (and therefore exciting) art moment than ever before. This is an age where our institutions are being questioned and changed, from within and without. Not only have we seen an influx of major retrospectives and touring group shows by overlooked women and people of colour, but permanent shifts are happening, too – for example, in 2020, the Baltimore Museum of Art acquired only work by women for their permanent collection.

Today, the world seems to be moving faster than it is turning: consumed by social media, with news stories released and forgotten at an unsettlingly rapid pace; more economically, politically and socially divided than in the lifetimes of previous generations; a deafeningly threatening climate crisis; major cuts to the arts; and an awareness that we will be dealing with the effects of the Covid-19 pandemic and Putin's warmongering for decades to come. Where does the world stand in the 2020s, and what is the role of art, and the artist? In previous historical crises art changed drastically: following the Second World War artists turned to abstraction and performance – perhaps to make sense of the events witnessed – and at other times, such as the AIDS epidemic, artists came together to campaign for the visibility of neglected and disregarded communities.

So, despite the urgency of all of these matters, perhaps we can expect people – including artists – to come together again. Artists in the West are living in the era of protest: Black Lives Matter, #MeToo, Extinction Rebellion, change, progression. They are awake to fight issues of inclusivity and justice, hungry to learn and unlearn what they have been taught, examining and reinventing the

representations of monuments, statues or artworks, ready to break down Eurocentric, white, male-focused curriculums and dominating patriarchal systems. No longer interested in one linear, single-minded view of the world, the future of art is in opening up a world without hierarchy.

Right now, these issues are more present than ever in the work of contemporary artists. But I cannot express enough that just because they are being discussed right now, this does not mean that they should be seen as a 'trend'. Overlooked artists are not a trend. Women artists are not a trend. Queer artists are not a trend. Artists of colour are not a trend. Art historians, and those engaged in creating the canons of art, must sustain their stories, and in order to do that – so future generations can see equality as normality and representation as priority – we must create useful, deeply engaging, thoughtful, accessible resources and institutions that reflect the new world. We must make sure those who prioritise these matters are given positions of power; single out under-represented artists through specific prizes or residencies; provide mentorships and put pressure on governments to realise the power of artistic education.

As the world resets, so must art history. There's no doubt the rise in new voices emerging across a global demographic is also thanks to more democratic platforms like the internet. Not only is the pool of material for artists greater than ever, but so is the range of people telling this story.

Despite my efforts to create a linear narrative for the purpose of clarity, the 'story of art' is not straightforward and narrow, and certainly not limited. And this is just a fraction of non-male artists who have contributed to this story. History is constantly being, and will continue to be, rewritten day by day.

GLOSSARY

ABSTRACT EXPRESSIONISM
A term loosely applied to artists working in New York in the 1940s and 50s working in an abstract manner with gestural brushstrokes.

ACTION PAINTING
A type of painting defined by artists working with 'action-like' vigorous and visible brushstrokes; most commonly applied to artists working in the manner of Abstract Expressionism; 1940s and 50s.

AESTHETICISM
A nineteenth-century European movement that saw artists advocate for beauty or 'art for art's sake' over narrative-based compositions.

AFROFUTURISM
A cultural movement adopted by Black diasporic artists, writers to musicians who employ futuristic technologies and African myths to imagine possible realms of our past, present and future.

ALL-OVER TECHNIQUE
A technique common in Abstract Expressionism in which artists cover the entirety of the canvas but do not prioritise any particular area.

APPLIQUÉ
Applying multiple pieces of cloth to create a richly textured surface.

ART BRUT
'Raw art'; refers to artists working outside of the establishment and beyond the mainstream; coined by Jean Dubuffet in 1945.

ART DECO
A style characterised by simple, elegant, geometrical shapes, spanning furniture and the decorative arts; 1920s and 30s.

ASSEMBLAGE
Art compiled of everyday found objects.

AVANT-GARDE
Translating to 'vanguard' in English; refers to experimental and new ideas in art.

BAROQUE
A European style full of dynamism and theatricality; c.1600–1750

BAUHAUS
A German school active between 1919 and 1933. Translates to '*building house*', the Bauhaus stripped out expressive artistry enforcing function over form.

BLACK MOUNTAIN COLLEGE
A progressive and experimental liberal arts schools based in North Carolina; active 1933–1957.

BLOOMSBURY GROUP
A group of avant-garde British artists who lived in the Bloomsbury district of London; early twentieth century.

BODY ART
A wide-ranging art centred on using the body as a primary medium; from the 1960s.

CHIAROSCURO
Paintings featuring sharp contrasts between light and dark. Popular in the Baroque; 1600–1750.

COLOUR FIELD PAINTING
A type of abstract painting pioneered by artists associated with Abstract Expressionism who emphasised large areas of colour over 'action-like' strokes.

CONCEPTUAL ART
A wide-ranging term used to describe an artform in which the most important aspect is the concept.

CONSTRUCTIVISM
An austere and abstract art born in Russia to reflect the modern world; c.1915.

CUBISM
An artform that revolutionised representation through distorted perspectives, shattered shapes and fragmented forms; emerged 1907–8.

CUBO-FUTURISM
A fusion of Cubism and Futurism. Emerged in Russia; 1910s.

CYANOTYPES
A photographic process resulting in dark, blue-toned images: made by fusing chemicals and photosensitive paper in a darkened room, placing the flower on top and exposing them to light.

DADA
An art movement comprised of artists making anarchic and satirical artwork in reaction to the horrors of the First World War; emerged c.1916.

DUTCH GOLDEN AGE
An era of great wealth and artistic patronage in the Dutch Republic; seventeenth century.

EUSTON ROAD SCHOOL
British artists who reacted against Modern Art's avant-garde styles; mid-twentieth century.

EXPRESSIONISM
An avant-garde art popular in Europe that favoured emotion over lifelike depictions. Characteristics include distorted perspectives, saturated colouring, bold black outlines; late nineteenth century and early twentieth century.

FAUVISM
A French word for 'the wild beasts'. An avant-garde style popular in Europe that saw artists employ vivid, strong, unlifelike colouring; 1905–10.

FEMINIST ART
Artists associated with the second-wave Feminist Movement who used their artwork to actively challenge the patriarchy; 1970s.

FLUXUS
A group of artists who prioritised the process or performance in their art; 1960s.

FUTURISM
A style that rejected the past and looked towards the glorification of speed, technology, war, and the modern industrialised world. Aerofuturism (*Aeropittura* in Italian): a strain of Futurism triggered by newfound perspectives from airplanes; emerged early twentieth century.

GERMAN EXPRESSIONISM (DIE BRÜKE/DER BLAUE REITER)
German-based art movement in which artists distorted shapes and colours to focus on the intensity of emotion. Two main groups dominated Expressionism in Germany. The artists associated with Die Brüke (translating to 'The Bridge') emerged in Dresden in 1905, and employed sharp, distorted and flattened forms inspired by African and Oceanic sculpture. The Munich-based Der Blaue Reiter ('The Blue Rider') formed in 1911, founded by Wassily Kandinsky, lasted until the start of the First World War.

GESAMTKUNSTWERK
A total work of art.

GLASGOW SCHOOL/STYLE
A group of artists and designers based in Glasgow, Scotland. Characteristics include striking curvilinear and elegant lines; late nineteenth century.

GUTAI
'Gu' (tool) 'tai' (body). A group of radical postwar Japanese artists who revolutionised artists' interaction with materials; established 1954.

HARLEM RENAISSANCE

A time of intense cultural rebirth akin to the Italian Renaissance of the fourteenth and fifteenth centuries that saw artists give precedent to the Black experience; Harlem, Upper Manhattan and Northern US cities; 1920s and 30s.

HIGH RENAISSANCE

The pinnacle of Renaissance period, such as when the most 'exceptional' work was thought to be made; early 1500s.

HISTORY PAINTING

Painting with a 'historical' subject matter, such as mythology or Biblical.

IMPRESSIONISM

Refers to a group of artists based in Paris who rebelled against the slick aesthetic of academic painting and aimed to capture a fleeting moment of bustling life through their bright colours and shard-like, light-filled brushstrokes; late nineteenth century.

LAND ART

Art created within the landscape, often with ecological motives; from the 1960s.

MANNERISM

A European style featuring elongated limbs, swirling drapery and dramatic curvilinear poses; emerged, c.1520.

MEXICAN RENAISSANCE

A period of great artistic flourishment following the Mexican Revolution; emerged in 1910s.

NEOCLASSICAL

International Western style and cultural movement, born in Europe, which looked towards a glorified ancient past. Characteristics included angular lines, naturalistic palettes and compositional harmony; eighteenth century.

NORTHERN RENAISSANCE

Artists working in the manner of the Renaissance across the Northern territories of Europe (The Netherlands, Belgium, Germany, France, England); late fifteenth century.

NOUVEAU RÉALISME

European-based movement often seen as a counterpart to Pop Art; 1960s.

ORPHISM

A style born in Paris reflecting speed and vivacity of modern life, free of narrative, perspective and representation with kaleidoscopic colouring and interlocking swirls; 1910s.

PERFORMANCE ART

A genre defined by risk-taking and chance encounters created through 'actions'. Performance Art sees artists often employ the self as their primary medium; from 1960s.

PHOTOMONTAGE

An amalgamation of photographs to make up a collage.

PICTURES GENERATION

A group of American artists who rose to prominence for their critique on media culture; 1970s.

PLEIN AIR

Used to describe artists who paint 'outside'.

POP ART

A movement that drew from references stemming from politics, popular culture and commercialisation; 1950s and 60s.

PROCESS-BASED WORK

Artwork in which a key and visible element of the work is the process itself; popular from the mid-twentieth century.

READYMADE

A radically disruptive medium that saw artists place manufactured objects as artworks in museums. The 'readymade' questioned all values of artistic skill and the very essence of what art could be; 1910s.

REALISM

Artistic movement characterised by capturing the likeness and naturalism of a subject; nineteenth century.

RELIEF SCULPTURES

A two-dimensional sculpture with three-dimensional elements raised from the base.

RENAISSANCE

Translates to 'rebirth'; most applied to a period of cultural and political flourishment following the Middle Ages spanning fourteenth to seventeenth centuries.

ROCOCO

A European style famed for its florid and frivolous opulence, asymmetrical curvilinear lines, and scroll-like forms; emerged early 1700s.

SILHOUETTE PAPER CUTTING

Intricately carving the outline of images from a single piece of paper set against a contrasting backdrop.

ST IVES SCHOOL

Refers to a group of artists working in the coastal town in West Cornwall; mid-twentieth century.

SURREALISM

An art embracing an automatic way of working in which artists look to dreams and the unconscious; emerged early twentieth century.

SYMBOLISM

A European movement favouring expression over a realistic depiction; nineteenth century.

UKIYO-E

Translating to 'images of the floating world', *ukiyo-e* was popular with the merchant classes and could be anything from hand-painted works on silk or paper to printed books. These images showed everyday scenes, ranging from entertainment and landscapes to courtesans working in the brothel quarters. Popular in the Edo Period; 1603–1868.

VANITAS

Objects symbolic of mortality in still life paintings.

VIENNESE ACTIONISTS

Vienna-based group of performance artists who often used shocking and violent actions; emerged 1960s.

WASHINGTON COLOUR SCHOOL

An abstract art movement based in Washington, DC; associated members included Alma Thomas; emerged 1950s.

TIMELINE

Maria Sibylla Merian

BOTANICAL WORKS

Joanna Koerten Rachel Ruysch

Hildegard of Bingen

Maria van Oosterwijck

DUTCH GOLDEN AGE

Judith Leyster

Mary Delany

Angelica Kauffman

NEOCLASSICISM

Plautilla Nelli Sofonisba Anguissola Mary Moser
Caterina de' Vigri Lavinia Fontana

Fede Galizia

RENAISSANCE

Clara Peeters

Properzia de' Rossi Barbara Longhi
Levina Teerlinc Marietta Robusti

Marguerite Gérard

ROCOCO

Rosalba Carriera

Giovanna Garzoni Elisabetta Sirani

BAROQUE

Artemisia Gentileschi

Elisabeth Vigée Le Brun

PRE-REVOLUTION FRANCE

Adélaïde Labille-Guiard

Anastasia

Twelfth century *Fifteenth century* *Eighteenth century* *Nineteenth century*

Elizabeth Siddal Marie Spartali Stillman

PRE-RAPHAELITES

Joanna Boyce Wells Evelyn de Morgan

Julia Margaret Cameron

Tamara de Lempicka

EARLY PHOTOGRAPHIC/
BOTANICAL PROCESSES

Harriet Powers

Gluck ## QUEER PIONEERS

QUILTMAKING

Anna Atkins

Ellen Harding Baker

Romaine Brooks Claude Cahun

Emma Civey Stahl

Suzanne Valadon Marie Laurencin

EDO PERIOD

EXPRESSIONISM/FAUVISM

Katsushika Ōi

Jacqueline Marval Émilie Charmy

Käthe Kollwitz Marianne von Werefkin

VICTORIAN BRITAIN

GERMAN EXPRESSIONISM Gabriele Münter

Emily Mary Osborn

Paula Modersohn-Becker

Helene Schjerfbeck Pan Yuliang 潘玉良

PARIS 1900/SELF PORTRAIT Florine Stettheimer

Gwen John Georgette Chen

Marie Braquemond Lilla Cabot Perry

Berthe Morisot

IMPRESSIONISM Camille Claudel

Eva Gonzalès Cecilia Beaux

Mary Cassatt

Marie Bashkirtseff

ORPHISM

Sonia Delaunay

Margaret Foley Anne Seymour Damer

NEOCLASSICAL SCULPTURE Anne Whitney

Emma Stebbins Liubov Popova Valentina Kulagina

Harriet Goodhue Hosmer

Edmonia Lewis ## RUSSIAN REVOLUTION

Jessie M. King Varvara Stepanova

GLASGOW SCHOOL/STYLE

Rosa Bonheur

REALISM Margaret Macdonald Mackintosh ## AEROFUTURISM/FUTURISM

Lady Butler Frances Macdonald Benedetta Cappa Marinetti

Nampeyo

Marie Denise Villers

NATIVE AMERICAN POTTERY ## CUBO-FUTURISM

Natalia Goncharova

POST-REVOLUTION FRANCE Maria Martinez

Constance Charpentier

Hilma af Klint

arie-Guillemine Benoist Vanessa Bell Nina Hamnett

SPIRITUALISM

BLOOMSBURY GROUP

Georgiana Houghton Emma Kunz

Dora Carrington

Twentieth century

TIMELINE

Charlotte Salomon

**THOSE LIVING THROUGH
THE SECOND WORLD WAR**

Frances Hodgkins

Emmy Hennings

Laura Knight Barbara Hepworth

Hannah Ryggen

Sophie Taeuber-Arp

DADA Hannah Höch

ST IVES SCHOOL + MODERN BRITISH ART

Baroness Elsa von
Freytag-Loringhoven

Marlow Moss Wilhelmina Barns-Graham

Anita Malfatti

BRAZIL 1920S/ANTHROPOPHAGIA

Tarsila do Amaral

Aloïse Corbaz

Jeanne Mammen

Madge Gill Sister Gertrude Morgan

Anita Berber **WEIMAR ERA** Lotte Laserstein

Pearl Alcock

Anita Rée Valeska Gert

ART BEYOND THE MAINSTREAM

Guo Fengyi

Minnie Evans Laure Pigeon

Georgia O'Keeffe

Clementine Hunter Anna Zemánková

NEW AMERICAN LANDSCAPE

Agnes Pelton Emily Carr

Gunta Stölzl

Otti Berger Marianne Brandt

Loïs Mailou Jones Laura Wheeler Waring

Anni Albers

BAUHAUS Gertrud Arndt **HARLEM RENAISSANCE** Selma Burke

Lucia Moholy

Benita Koch-Otte Augusta Savage Elizabeth Catlett

Meta Vaux Warrick Fuller

Alice Rahon

Kati Horna

Marion Adnams Gertrude Abercrombie

Kay Sage Dora Maar Lee Miller **PHOTOJOURNALISM**

Emmy Bridgwater Dorothea Tanning Dorothea Lange

SURREALISM Kati Horna

Stella Snead Eileen Agar

Meret Oppenheim

Ithell Colquhoun Remedios Varo

Leonor Fini Edith Rimmington Vivian Maier Helen Levitt

Leonora Carrington **MID-CENTURY PHOTOGRAPHY**

Frida Kahlo

Margaret Bourke-White

María Izquierdo Lola Álvarez Bravo

MEXICO RENAISSANCE Tina Modotti

Aurora Reyes Flores

*Interwar Years
(1920s–1930s)*

*Postwar 1940s/50s
onwards*

Janet Sobel Hedda Sterne

Betty Parsons Lee Krasner

ABSTRACT EXPRESSIONISM Joan Mitchell

Elaine de Kooning Louise Nevelson

Helen Frankenthaler

Barbara Jones-Hogu Emma Amos

Suzanne Jackson Carolyn Lawrence

Samella Lewis

BLACK ARTS MOVEMENT 1960S/70S Ming Smith

Betye Saar Elizabeth Catlett

Linda Goode Bryant

Faith Ringgold

Lenore Tawney The Gee's Bend Quiltmakers

Felicia Ansah Abban Mrinalini Mukherjee ## FIBRE ART PIONEERS Sheila Hicks

Ishiuchi Miyako Agnès Varda Judith Scott Loretta Pettway Bennett

POSTWAR PHOTOGRAPHY AND FILM Cecilia Vicuña Magdalena Abakanowicz

Diane Arbus Maya Deren Rosie Lee Tompkins

Anni Albers Dorothea Rockburne ## ARCHITECTS

Lina Bo Bardi Eva Hesse

BLACK MOUNTAIN COLLEGE Alina Szapocznikow

Ruth Asawa

Mary Parks Washington ## ABSTRACT/BODY SCULPTURE

Niki de Saint Phalle

Louise Bourgeois

GUTAI Alma Thomas Etel Adnan

Atsuko Tanaka Gego (Gertrud Goldschmidt)'s Monir Shahroudy
Farmanfarmaian

Anne Truitt ## ABSTRACTION

Bernice Bing Carmen Herrera . Fahrelnissa Zeid

BEAT GENERATION Lynda Benglis Agnes Martin

Jay DeFeo Bridget Riley

Yayoi Kusama

Yoko Ono Marina Abramović

PERFORMANCE ART

Senga Nengudi Yayoi Kusama

Anna Maria Maiolino

Marisol Martha Rosler

POP ART Evelyne Axell Lygia Clark

Jann Haworth Pauline Boty ## NEO-CONCRETE MOVEMENT

Lygia Pape

*More 1960s
onwards*

TIMELINE

Louise Lawler

PICTURES GENERATION

CONTEMPORARY INDIGENOUS AUSTRALIAN ART

Emily Kame Kngwarreye

Sherrie Levine

Cindy Sherman

Jenny Holzer

Guerrilla Girls

Nan Goldin

PHOTOGRAPHY/PERFORMANCE

Barbara Kruger Claudia Andujar Paz Errázuriz

Huguette Caland

Lorraine O'Grady Carrie Mae Weems

Maria Lassnig

Margaret Harrison

Francesca Woodman

Joan Semmel

Adrian Piper VALIE EXPORT

Lorna Simpson

Miriam Schapiro

Hannah Wilke Mary Kelly

1990S PHOTOGRAPHY

Howardena Pindell

Alice Neel ## THE ERA OF FEMINISM

Ana Mendieta

Catherine Opie

Shirin Neshat

Suzanne Lacy Harmony Hammond

Vija Celmins

Senga Nengudi Faith Ringgold

Carolee Schneemann Luchita Hurtado

Kay Brown

Agnes Denes

Mierle Laderman Ukeles Dindga McCannon

LAND ART

Judy Chicago Carla Accardi

Nancy Holt

Chila Kumari Burman

Belkis Ayón

Veronica Ryan Ingrid Pollard

Sonia Boyce

BRITISH BLACK ARTS MOVEMENT

Kiki Smith

Claudette Johnson

Maud Sulter

Lubaina Himid

Marlene Smith

Coco Fusco

NEW TECHNOLOGIES

TEXTILE ARTISTS

ACTIVIST ARTISTS

Cao Fei Hito Steyerl

Billie Zangewa

Zoe Leonard

Shirin Neshat

Jeanne-Claude (and Christo) Phyllida Barlow

Joan Jonas Susan Hiller

Sarah Sze

MODERN MONUMENTS/PUBLIC ART/
NEW PAINTING AND SCULPTURE

VIDEO ART

Kara Walker

Pipilotti Rist Tacita Dean

Adriana Varejão Katharina Grosse Doris Salcedo

Dara Birnbaum

Dominique Gonzalez-Foerster Julie Mehretu

Rachel Whiteread

Flora Yukhnovich

Sarah Lucas

Somaya Critchlow Jadé Fadojutimi

Cornelia Parker Tracey Emin

Chloe Wise

BRITISH CONTEMPORARY ART Jenny Saville **PAINTERS** Issy Wood

Kudzanai-Violet Hwami

Gillian Wearing Mona Hatoum

Antonia Showering Louise Giovanelli

Shannon Cartier Lucy Rachel Jones

Mickalene Thomas Victoria Cantons

Toyin Ojih Odutola María Berrío

ACT UP

Njideka Akunyili Crosby Lisa Brice

COLLECTIVES

Chantal Joffe **FIGURATION** Celia Paul

Gran Fury

Jennifer Packer Dana Schutz

Zanele Muholi

Nicole Eisenman Deborah Roberts

PHOTOGRAPHERS

Amy Sherald Aliza Nisenbaum

Khadija Saye

Jordan Casteel

Cecily Brown

Juno Calypso

Ellen Gallagher

Elizabeth Peyton

Marlene Dumas **AFROFUTURISM**

FIGURATION Shahzia Sikander Wangechi Mutu Magdalene Odundo

Paula Rego Lisa Yuskavage **CERAMICS** Leilah Babirye

Simone Leigh Betty Woodman

2000s onwards

NOTES AND BIBLIOGRAPHY

EPIGRAPH

'I'll show you what a woman can do', Artemisia Gentileschi, 1649. Original quote: 'I will show Your Most Illustrious Lordship what a woman can do', letter from Artemisia Gentileschi to Don Antonio Ruffo, 7 August 1649, cited from *Artemisia* exhibition, National Gallery, 3 October 2020–24 January 2021 (www.nationalgallery.org.uk/exhibitions/past/artemisia)

INTRODUCTION

NOTES

p. 9 '*Why Have There Been No Great Women Artists?*', Nochlin, Linda, 'Why Have There Been No Great Women Artists?', *ARTnews*, January 1971 (www.artnews.com/art-news/retrospective/why-have-there-been-no-great-women-artists-4201/)

p. 10 'A study published in 2019 found that in the collections of eighteen major US art museums, 87 per cent of artworks were by men, and 85 per cent by white artists', cited from Topaz, Chaz, 'Museums in US still failing with artist diversity, study finds', *Guardian*, 20 March 2019 (www.theguardian.com/artanddesign/2019/mar/20/museums-in-us-still-failing-with-artist-diversity-study-finds)

p. 10 'Currently, women artists make up just 1 per cent of London's National Gallery collection', McMillan, Kate, 'Representation of Female Artists in Britain During 2019', Freelands Foundation, p. 42 (https://freelandsfoundation.imgix.net/documents/Representation-of-female-artists-2019-Clickable.pdf)

p. 10 'And 2023 will mark the first time the Royal Academy of Arts in London has ever hosted a solo exhibition by a woman in their main space'; this is in reference to Marina Abramović at the Royal Academy of Arts, 2023 (www.royalacademy.org.uk/exhibition/marina-abramovic)

p. 10 YouGov survey: 'results showed that 30% could name no more than three (83% of 18–24-year-olds could name not even three)', Sanderson, David, 'Name three female artists? Most of us need to brush up', *The Times*, 8 March 2022 (https://www.thetimes.co.uk/article/name-three-female-artists-most-of-us-need-to-brush-up-7kph873nz)

p. 11 'I draw here on the extensive research by (and my discussions with) spearheading art historians and curators…', in reference to Griselda Pollock, Rozsika Parker, Mary D. Garrard, Sheila Barker, Sue Tate, Thelma Golden, Denise Murrell, Iris Müller-Westermann, Linda Nochlin, Ann Sutherland-Harris, and many more

p. 12 'The highest price fetched at auction by a living woman artist (Jenny Saville's *Propped*, 1992) was just 12 per cent of the highest price achieved by a male living artist (David Hockney's *Portrait of an Artist (Pool with Two Figures)*, 1972) which topped $90.3 million', Kazakina, Katya, 'Jenny Saville Painting Sets Auction Record for a Living Female Artist', *Bloomberg*, 6 October 2018 (https://www.bloomberg.com/news/articles/2018-10-05/saville-painting-sets-auction-record-for-a-living-female-artist – accessed September 2021); Freeman, Nate, 'David Hockney Is Now the World's Most Expensive Living Artist', *Artsy*, 16 November 2016 (www.artsy.net/article/artsy-editorial-david-hockney-worlds-expensive-living-artist – accessed September 2021)

EXHIBITIONS

Fantastic Women: Surreal Worlds from Meret Oppenheim to Frida Kahlo, Schirn Kunsthalle Frankfurt, 13 February–5 July 2020; Louisiana Museum of Modern Art, 25 July–8 November 2020

Radical Women: Latin American Art, 1960–1985, curated by Cecilia Fajardo-Hill and Andrea Giunta, Hammer Museum, 15 September–31 December 2017; Brooklyn Museum, 13 April–22 July 2018; Pinacoteca de São Paulo, 18 August–19 November 2018

We Wanted a Revolution: Black Radical Women 1965–85, curated by Catherine Morris and Rujeko Hockley, Brooklyn Museum, 21 April–17 September 2017; The California African American Museum, 13 October 2017–14 January 2018; Albright-Knox, 17 February 2017–27 May 2018

PART ONE: PAVING THE WAY (C. 1500–C. 1900)

TRIUMPHANT WOMEN

BOOKS

Borzello, Frances, *Seeing Ourselves: Women's Self-Portraits* (Thames and Hudson, 2018)

Chadwick, Whitney, *Women, Art and Society* (Thames and Hudson, 1990)

Heller, Nancy, *Women Artists: An Illustrated History* (Abbeville Press, 2020)

Higgie, Jennifer, *The Mirror and the Palette* (Weidenfeld and Nicolson, 2021)

Nochlin, Linda and Sutherland Harris, Ann, *Women Artists 1550–1950* (Los Angeles County Museum of Art, 1976)

Parker, Rozsika and Pollock, Griselda, *Old Mistresses: Women, Art, and Ideology* (I.B Taurus & Co, 2013)

EXHIBITIONS

Women Artists: 1550–1950, curated by Linda Nochlin and Ann Sutherland Harris, Los Angeles County Museum of Art, 21 December 1976–March 1977; University Art Museum Austin; Carnegie Museum of Art; Brooklyn Museum

CHAPTER ONE: PAINTING HERSELF INTO THE CANON

NOTES

p. 16 'five-metre-high marble…', in reference to Michelangelo's *David*, 1501–4

p. 16 'entire chapels…', in reference to Masaccio's Brancacci Chapel, Florence, 1425–7

p. 16 'as though a medical student were denied the opportunity…', cited from Nochlin, Linda, 'Why Have There Been No Great Women Artists?', *ARTnews*, 1971 (www.artnews.com/art-news/retrospective/why-have-there-been-no-great-women-artists-4201/)

p. 16 'During the Victorian age, women, with their "smaller", less "creative" brains…', cited from Gladwell, Malcolm, 'Malcolm Gladwell discusses tokens, pariahs, and pioneers', *The New Yorker* Festival, 2013 (www.newyorker.com/video/watch/talk-malcolm-gladwell-full)

p. 16 'scratch out…', conversation with Nina Cahill, Curator, National Gallery, London

p. 17 'liberal arts education…', Nochlin and Harris, *Women Artists 1550–1950*, p. 21

p. 17 'allowed to wander unchaperoned in the streets or visit churches – the latter being another block to the imagination when it came to producing the most popular images of the day…', conversation with Letizia Treves, Curator, National Gallery, London

BOOKS

Parker and Pollock, *Old Mistresses: Women, Art, and Ideology*, p. 9

THE RENAISSANCE

NOTES

p. 20 'designed for the façade…', in reference to de' Rossi's *Joseph and Potiphar's Wife*, cited from Parker and Pollock, *Old Mistresses: Women, Art, and Ideology*, p. 17

p. 20 'scholars have recorded a staggering…', cited from Bohn, Babette, *Women Artists, Their Patrons, and Their Publics in Early Modern Bologna* (Penn State University Press, 2021), p. 3

p. 21 '"tokens" rather than "pioneers"', cited from Gladwell, Malcolm, 'Malcolm Gladwell discusses tokens, pariahs, and pioneers', *The New Yorker* Festival, 2013 (www.newyorker.com/video/watch/talk-malcolm-gladwell-full)

p. 21 'The Renaissance is considered to have begun…', cited from Gombrich, E.H, *The Story of Art* (Phaidon, 1909–2001), p. 223

p. 21 'The year 1550 was when Florentine art historian Giorgio Vasari published *The Lives of the Artists*', in reference to ed. and trans., Conaway Bondanella, Julia and Bondanella, Peter, *Vasari, Giorgio, Lives of the Most Eminent Painters, Sculptors & Architects, (1550)* (Oxford University Press, 2008)

p. 23 'The artistic capitals…', conversation with Chloe Stead, Director, Colnaghi Gallery, London

p. 23 'the painter's brush was "manly"', Marco Boschini defending Venetian painting against charges by Michelangelo and Vasari that his native school was somehow effeminate, cited from Sohm, Philip, 'Gendered Style in Italian Art Criticism from Michelangelo to Malvasia', *Renaissance Quarterly*, 1995, p. 778 (www.jstor.org/stable/pdf/2863424.pdf?refreqid=excelsior%3Ad4ce-717d6051854a723b2e37a9615556)

p. 23 'passive sex', cited from Wiseman, Mary, '*Titian's Women* by Rona Goffen', *The Journal of Aesthetics and Art Criticism*, 2000, p. 421 (www.jstor.org/stable/pdf/432191.pdf?refreqid=excelsior%3A8a2ad41f079b70743ae362a00b8cfa85)

BOOKS

Bohn, Babette, eds., Anselmi, Gian Mario; De Benedictis, Angela; and Terpstra, Nicholas, 'Patronizing Pittrici', *Bologna. Cultural Crossroads from the Medieval to the Baroque: Recent Anglo-American Scholarship* (Bologna University Press, 2013) (www.academia.edu/26095345/Patronizing_pittrici)

ARTICLES

Bohn, Babette, 'Female self-portraiture in early modern Bologna', *Renaissance Studies*, 2004 (www.jstor.org/stable/pdf/24413408.pdf?refreqid=excelsior%3Afa9881d9237c23062b-12ce54e293d00a)

Bohn, Babette, 'Women Artists, Their Patrons, and Their Publics in Early Modern Bologna', National Gallery of Art, 2018 (www.nga.gov/research/casva/research-projects/research-reports-archive/bohn-2017-2018.html)

Chernick, Karen, 'How Women Artists Flourished in Northern Italy During the Renaissance', *Hyperallergic*, 21 October 2019 (https://hyperallergic.com/522392/women-artists-bologna-lavinia-fontana/)

Tiella, Marco, 'The Violeta of S. Caterina De' Vigri', *The Galpin Society Journal*, 1975, pp. 60–70 (www.jstor.org/stable/pdf/841571.

pdf?refreqid=excelsior%3A487f73e1b25a7f6b-f50e0aadf72d7c66)

In conversation with Katy Hessel: Chloe Stead; Letizia Treves.

PLAUTILLA NELLI

NOTES

p. 23 'praised by Vasari…', Vasari, *The Lives of Artists*, cited from Nochlin and Harris, *Women Artists 1550–1950*, p. 21

p. 24 'she would have done marvellous things', a different version occurs here: 'she would have done marvellous things had she had the opportunity, as men do, to study and devote herself to drawing and portraying living and natural things', Nochlin and Harris, *Women Artists 1550–1950*, p. 21

ARTICLES

Garrard, Mary D., 'Repositioning Plautilla Nelli's Lamentation', *MAVCOR Journal*, 2013 (https://mavcor.yale.edu/conversations/essays/repositioning-plautilla-nelli-s-lamentation)

McGivern, Hannah, 'Renaissance woman Plautilla Nelli's Last Supper unveiled after restoration in Florence', *The Art Newspaper*, 21 October 2019 (https://www.theartnewspaper.com/2019/10/21/renaissance-woman-plautilla-nellis-last-supper-unveiled-after-restoration-in-florence)

Moorhead, Joanna, 'Restored to glory: How a 16th-century nun regained her place in art history', *Observer*, 19 October 2019 (www.theguardian.com/artanddesign/2019/oct/19/renaissance-nun-regains-place-in-art-history-the-last-supper)

Nelson, Jonathan K., 'Sister act – Plautilla Nelli and the painter nuns of 16th-century Florence', *Apollo Magazine*, 21 November 2019 (www.apollo-magazine.com/plautilla-nelli-last-supper-santa-caterina/)

Quin, Sally, 'Plautilla Nelli's Role in Giorgio Vasari's Lives of the Painters (1568) and Serafino Razzi's History of Illustrious Men (1596)', ed. Nelson, Jonathan K., *Plautilla Nelli (1524–1588): The Painter-Prioress of Renaissance Florence* (Syracuse University in Florence, 2008) p. 49 (https://suabroad.syr.edu/florence/wp-content/uploads/sites/3/2016/04/Plautilla_Nelli.pdf)

In conversation with Katy Hessel: Joanna Moorhead

SOFONISBA ANGUISSOLA

NOTES

p. 25 'praised by Vasari …', Vasari, *The Lives of the Artists*, cited from Nochlin and Harris, *Women Artists 1550–1950*, p. 31

p. 25 '"so lifelike that they lack only speech"';
p. 26 '"not raise the light too high, so that the shadows would not accentuate the wrinkles of old age"'; cited from Campbell, Caroline, 'Virtuosa', *London Review of Books*, 10 September 2020 (www.lrb.co.uk/the-paper/v42/n17/caroline-campbell/virtuosa)

p. 25 'Anguissola epitomised what a mid-sixteenth-century woman…', cited from Nochlin and Harris, *Women Artists 1550–1950*, p. 108

BOOKS

Cole, Michael W., *Sofonisba's Lesson: A Renaissance Artist and Her Work* (Princeton University Press, 2020)

Ruiz, Leticia, *A Tale of Two Women Painters: Sofonisba Anguissola and Lavinia Fontana* (Museo Nacional del Prado, 2020)

ARTICLES

Loh, Maria H., 'In the Sixteenth Century, Two Women Painters Challenged Gender Roles', *Art in America*, 25 February 2020 (www.artnews.com/art-in-america/features/sofonisba-anguissola-lavinia-fontana-italian-renaissance-women-painters-1202678831/)

In conversation with Katy Hessel: Dr Maria H. Loh

LAVINIA FONTANA

BOOKS

Bohn, eds. Anselmi; De Benedictis; and Terpstra 'Patronizing Pattrici' in *Bologna. Cultural Crossroads from the Medieval to the Baroque: Recent Anglo-American Scholarship*

ARTICLES

'Lavinia, the unmarried daughter of Prospero Fontana, took this, her image, from the mirror, 1577' cited in Bohn, Babette, 'Female self-portraiture in early modern Bologna', *Renaissance Studies*, 2004 (www.jstor.org/stable/pdf/24413408.pdf?refreqid=excelsior%3A-fa9881d9237c23062b12ce54e293d00a)

Cheney, Liana De Girolami, 'Lavinia Fontana: a woman collector of antiquity', *Aurora*, 2001

Loh, Maria H., 'In the Sixteenth Century, Two Women Painters Challenged Gender Roles', *Art in America*, 25 February 2020 (www.artnews.com/art-in-america/features/sofonisba-anguissola-lavinia-fontana-italian-renaissance-women-painters-1202678831/)

McIver, Katherine A., 'Lavinia Fontana's "Self-Portrait Making Music"' *Woman's Art Journal*, 1998 (www.jstor.org/stable/1358647?seq=1#metadata_info_tab_contents)

The Uffizi Gallery, 'Lavinia Fontana' (www.virtualuffizi.com/lavinia-fontana.html)

MEDIA

Colnaghi Foundation, 'Podcast with Babette Bohn', 13 November 2020

STILL LIFE IN THE SEVENTEENTH CENTURY

CLARA PEETERS

NOTES

p. 31 'which scholars have described as the "first dated still life…"', cited from Nicholson, Elizabeth S. G., *Women Artists from Renaissance to Baroque* (Skira, 2007), p. 180

BOOKS

'*Still Life with a Vase of Flowers, Goblets and Shells*, 1612'; cited from Nochlin and Harris, *Women Artists 1550–1950*, pp. 131–3, pp. 33–4

Vergara, Alejandro, *The Art of Clara Peeters* (Museo Nacional del Prado, 2016)

ARTICLES

The Met Museum, '*A Bouquet of Flowers* (ca.1612) by Clara Peeters' (www.metmuseum.org/art/collection/search/827660)

EXHIBITIONS

The Art of Clara Peeters, curated by Alejandro Vergara, Museo Nacional del Prado, 25 October 2016–19 February 2017 (www.museodelprado.es/en/whats-on/exhibition/the-art-of-clara-peeters/e4628dea-9ffd-4632-85c9-449367e86959)

In conversation with Katy Hessel: Chloe Stead

FEDE GALIZIA

'scholars have described as the "first dated still life by an Italian artist"'; citing *Italian women artists from Renaissance to Baroque* (Exhibition), curated by Carole Collier Frick; Elizabeth S. G. Nicholson, National Museum of Women in the Arts, 2007

GIOVANNA GARZONI

NOTES

p. 32 'Italian Baroque artist…', cited from The Getty Center, 'Giovanna Garzoni' (www.getty.edu/art/collection/artists/14049/eorgian-garzoni-italian-1600-1670/)

p. 32 '"whatever price she wished."', cited from *ibid* (www.getty.edu/art/collection/artists/14049/eorgian-garzoni-italian-1600-1670/)

p. 34 'Prince Zaga Christ – he was a "self-proclaimed" prince', cited from Barker, Sheila, '"The Immensity of the Universe" in the art of Giovanna Garzoni' (Gallerie degli Uffizi, 2020) p. 128 (www.sillabe.it/en/exhibition-catalogues/926-the-immensity-of-the-universe-in-the-art-of-giovanna-garzoni.html)

BOOKS

Nicholson, *Italian Women Artists from Renaissance to Baroque*

ARTICLES

Philip Mould & Co., 'Zaga Christ Portrait Returns "Home"' (https://philipmould.com/news/65-zaga-christ-portrait-returns-home-portrait-by-giovanna-garzoni-to-be-included-in/)

EXHIBITIONS

'The Greatness of the Universe' in the Art of Giovanna Garzoni, curated by Sheila Barker, Pitti Palace, 28 May 2020–28 June 2020 (www.uffizi.it/en/events/the-greatness-of-the-universe-in-the-art-of-giovanna-garzoni)

@georgian_diaspora, Instagram, 22 June 2020 (https://www.instagram.com/p/CBt7se3gNRV/)

THE BAROQUE

ARTEMISIA GENTILESCHI

NOTES

p. 37 '"He then threw me on to the edge of the bed…"', cited from Jones, 'More savage than Caravaggio: the woman who took revenge in oil', *Guardian*, 5 October 2016 (www.theguardian.com/artanddesign/2016/oct/05/artemisia-gentileshi-painter-beyond-caravaggio)

p. 37 '"it's true, it's true, it's true"', cited from Stevens, Ellice, 'Artemisia's rape trial', The National Gallery, September 2020 (www.nationalgallery.org.uk/exhibitions/past/artemisia/artemisias-rape-trial)

p. 38 'if we make a comparison with Caravaggio's c. 1600 version', cited from Nicholson, *Italian Women Artists from Renaissance to Baroque*, p. 206; Jones, Jonathan, 'More savage than Caravaggio: the woman who took revenge in oil', *Guardian*, 5 October 2016 (www.theguardian.com/artanddesign/2016/oct/05/artemisia-gentileshi-painter-beyond-caravaggio?page=with%3Aimg-3)

p. 38 'Gentileschi has become a feminist idol…', cited from The Brooklyn Museum, 'Artemisia Gentileschi' (www.brooklynmuseum.org/eascfa/dinner_party/place_settings/artemisia_gentileschi)

p. 39 'in one letter she demands higher fees for multi-figure compositions', cited from Nochlin

and Harris, *Women Artists 1550–1950*, p. 119. Original quote: 'defending her prices once more, she says that pictures with many female nudes are expensive to do and produce "un gran rompimento di capo" (a big headache)'

p. 39 '"You will find the spirit of Caesar in the soul of a woman"', Letter from Artemisia Gentileschi to Don Antonio Ruffo, 13 November 1649

BOOKS

Garrard, Mary D., *Artemisia Gentileschi and Feminism in Early Modern Europe* (Reaktion, 2020)

Garrard, Mary D., *Artemisia Gentileschi: The Image of the Female Hero in Italian Baroque Art* (Princeton UP, 1991)

Siciliano, Gina, *I Know What I Am: The Life and Times of Artemisia Gentileschi* (Fantagraphics, 2019)

Treves, Letizia, *Artemisia* (Yale University Press, 2020)

EXHIBITIONS

Artemisia, curated by Letizia Treves, National Gallery, London, 3 October 2020–24 January 2021 (www.nationalgallery.org.uk/exhibitions/past/artemisia)

MEDIA

Much of the information has been extracted from Hessel, Katy, *The Great Women Artists Podcast*, 'Letizia Treves on Artemisia Gentileschi', 11 November 2020, including specific facts: 'Much of Gentileschi's work deals with women seeking to avenge themselves, yet there is not an instance where they appear as the victim'; (patrons wanted portraits by her and of her – including portraits of her hand)

Hessel, Katy, *Inside Museums*, 'Artemisia Gentileschi', BBC 4, 2020

Higgie, Jennifer, *Bow Down: Women in Art* podcast, 'Helen Cammock on Artemisia Gentileschi', 22 October 2019 (www.frieze.com/article/bow-down-podcast-women-art-history)

In conversation with Katy Hessel: Letizia Treves

ELISABETTA SIRANI

NOTES

p. 42 '"the prodigy of art, the glory of the female sex, the gem of Italy, the sun of Europe"', quoting Carlo Cesare Malvasia, cited from Reynolds, Anna; Peter, Lucy; and Clayton, Martin, *Portrait of the Artist*, Royal Collection Trust, 2016 (www.rct.uk/collection/906360/a-self-portraitn)

BOOKS

Nicholson, *Italian Women Artists from Renaissance to Baroque*

Nochlin and Harris, *Women Artists 1550–1950*, pp. 147–50

Parker and Pollock, *Old Mistresses: Women, Art, and Ideology*, p. 27

ARTICLES

Bohn, Babette, 'Female self-portraiture in early modern Bologna', *Renaissance Studies*, 2004 (www.jstor.org/stable/pdf/24413408.pdf?refreqid=excelsior%3Afa9881d9237c23062b-12ce54e293d00a)

Bohn, Babette, 'The antique heroines of Elisabetta Sirani', *Renaissance Studies*, 2002 (www.jstor.org/stable/24413226)

Bohn, Babette, 'Women Artists, Their Patrons, and Their Publics in Early Modern Bologna', National Gallery of Art, 2018 (www.nga.gov/

research/casva/research-projects/research-reports-archive/bohn-2017-2018.html)

Chernick, Karen, 'How Women Artists Flourished in Northern Italy During the Renaissance', *Hyperallergic*, 21 October 2019 (https://hyperallergic.com/522392/women-artists-bologna-lavinia-fontana/)

EXHIBITIONS

Portrait of the Artist, Queen's Gallery, London, 4 November 2016–17 April 2017 (www.rct.uk/collection/themes/exhibitions/portrait-of-the-artist/the-queens-gallery-buckingham-palace)

Thank you to Sheila Barker, Babette Bohn and Dr Maria Loh who read and checked this chapter.

THE DUTCH GOLDEN AGE AND BOTANICAL ART

JUDITH LEYSTER

NOTES

p. 42 'Its thriving economy…', cited from The National Gallery of Art, Washington, 'Painting in the Dutch Golden Age', p. 14 (www.nga.gov/learn/teachers/teaching-packets/dutch.html)

p. 42 '150 female artists (compared to some 3,200 male artists)' cited from Honig, Elizabeth Alice, 'The Art of Being "Artistic": Dutch Women's Creative Practices in the 17th Century', *Woman's Art Journal*, 2001, p. 31. She writes: '…to date 125 women artists active in Holland and born before 1725 have been documented, and most likely there were many more.' She based this on Els Kloek's database on women artists, which has been further developed into the Digital Women's Lexicon of the Netherlands (Digitaal Vrouwenlexicon van Nederland) (http://resources.huygens.knaw.nl/vrouwenlexicon)

p. 43 '"the true Leading star in art"', a quote by Dutch writer and poet Theodore Schrevelius, cited from The National Gallery of Art, Washington, 'Painting in the Dutch Golden Age', p. 14 (www.nga.gov/learn/teachers/teaching-packets/dutch.html)

ARTICLES

Smith, Dominic, 'Daughters of the Guild,' *The Paris Review*, 4 April 2016 (www.theparisreview.org/blog/2016/04/04/daughters-of-the-guild/)

Schjeldahl, Peter, 'A Woman's Work: The brief career of Judith Leyster', *The New Yorker*, 29 June 2009 (www.newyorker.com/magazine/2009/06/29/a-womans-work-2)

The National Gallery of Art, 'Self Portrait (1630) by Judith Leyster' (www.nga.gov/collection/highlights/leyster-self-portrait.html)

In conversation with Katy Hessel: Nina Cahill

RACHEL RUYSCH

BOOKS

Nochlin and Harris, *Women Artists 1550–1950*, pp. 137–140

MEDIA

National Gallery, *#Paintingherstory*, 'Rachel Ruysch: Painter of the court and mother of 10', 8 March 2019 (https://www.youtube.com/watch?v=GqToJVkIxU4)

Conversations and discussions with: Nina Cahill

MARIA SIBYLLA MERIAN

NOTES

p. 47 'one of the founders of modern-day zoology…', cited from Valiant, Sharon, 'Maria Sibylla

Merian: Recovering an Eighteenth-Century Legend,' *Eighteenth-Century Studies*, 1993 (www.jstor.org/stable/pdf/2739414.pdf?refreqid=excelsior%3Ab50455a0d6875d3ecdafd541c4020fca)

BOOKS

Nochlin and Harris, *Women Artists 1550–1950*, pp. 153–5

van Delft, Marieke and Mulder, Hans, *Maria Sibylla Merian: Metamorphosis insectorum Surinamensium* (Lannoo, 2016)

ARTICLES

Klein, Joanna, 'A Pioneering Woman of Science Re-Emerges After 300 Years,' *The New York Times*, 23 January 2017 (www.nytimes.com/2017/01/23/science/maria-sibylla-merian-metamorphosis-insectorum-surinamensium.html)

MEDIA

BBC 2, *The Story of Women and Art*, 2014

JOANNA KOERTEN

ARTICLES

The V&A, '*Virgin and Child with St. John* (c.1703) by Joanna Koerten' (https://collections.vam.ac.uk/item/O1109610/virgin-and-child-with-st-miniature-koerten-joanna/)

MARY DELANY

NOTES

p. 51 'Joseph Reynolds described them as "perfection"', cited from Miller, Lydia, 'The Two Marys of St James's Church, Piccadilly', Philip Mould & Co. (https://philipmould.com/news/131-the-two-marys-of-st-jamess-church-piccadilly-essay-by-lydia-miller/)

p. 51 '"I have invented a new way of imitating flowers"', cited from *The British Museum Blog*, 'Late bloomer: the exquisite craft of Mary Delany', 20 March 2019 (https://blog.britishmuseum.org/late-bloomer-the-exquisite-craft-of-mary-delany/)

ARTICLES

The British Museum, 'Mary Delany' (www.britishmuseum.org/about-us/british-museum-story/people-behind-collection/mary-delany)

The British Museum Blog, 'Late bloomer: the exquisite craft of Mary Delany', 20 March 2019 (https://blog.britishmuseum.org/late-bloomer-the-exquisite-craft-of-mary-delany/)

Maginnis, Hayden B. J., 'Giotto's World through Vasari's Eyes', *Zeitschrift für Kunstgeschichte*, 1993 (www.jstor.org/stable/pdf/1482649.pdf?refreqid=excelsior%3Aa6bbd46147e9e4678b8db-678bf1b63cf)

Rosenberg, Karen, 'A Shower of Tiny Petals in a Marriage of Art and Botany', *The New York Times*, 22 October 2009 (www.nytimes.com/2009/10/23/arts/design/23delany.html)

BOOKS

Fleming, John and Honour, Hugh, *A World History of Art*, 7th ed. (Laurence King, 2005)

Frigeri, Flavia, *Women Artists* (Thames and Hudson, 2019)

Laird, Mark and Weisberg-Roberts, Alicia, *Mrs. Delany and Her Circle* (Yale University Press, 2009)

Thank you to Nina Cahill who read and checked this chapter.

CHAPTER TWO: LOOKING TO A HEROIC PAST

NOTES

p. 53 'Records show that nearly 300 women artists worked…', cited from Nochlin and Harris, *Women Artists 1550–1950*, p. 41

p. 53 'fast-tracked to some of the most prestigious artist academies of the day…', I write this in relation to Elisabeth Vigée Le Brun

p. 53 'Although academies had existed since the Renaissance, these two were founded with the purpose of providing artists with essential training, a theoretical education, exhibition opportunities…', cited from Parker and Pollock, *Old Mistresses: Women, Art, and Ideology*, pp. 27–8 and p. 87

p. 54 'capped the number of female artists…', cited from Chadwick, *Women, Art and Society*, p. 165 and p. 144

p. 54 'following the deaths of two of its female founders…', Mary Moser died in 1819, and the first official female Royal Academician was elected in 1936: Dame Laura Knight

BOOKS

Chapman, Caroline, *Eighteenth-Century Women Artists: Their Trials, Tribulations and Triumphs* (Unicorn, 2017)

Higgie, *The Mirror and the Palette*

ARTICLES

Butchard, Amber, 'The Artificial Divide Between Fine Art and Textiles is a Gendered Issue', *Frieze*, 14 November 2018 (www.frieze.com/article/artificial-divide-between-fine-art-and-textiles-gendered-issue)

Evans, Howard V. and Evans, Charlotte B., 'Women Artists in Eighteenth-Century France', *Man and Nature*, 1982 (www.erudit.org/en/journals/man/1982-v1-man0227/1011803ar.pdf)

MEDIA

BBC 2, *The Story of Women and Art*, 2014

ROSALBA CARRIERA

NOTES

p. 57 '…art dealer Pierre-Jean Mariette claimed Carriera's images "came from heaven"', cited from Lack, Jessica, 'Rosalba Carriera: the pastellist whose "images came from heaven"', Christie's (https://www.christies.com/features/the-life-and-art-of-venetian-artist-rosalba-carriera-10796-1.aspx)

BOOKS

Heller, *Women Artists: An Illustrated History*, pp. 35–6

Oberer, Angela, *The Life and Work of Rosalba Carriera (1673–1757): The Queen of Pastel* (Amsterdam University Press, 2020) (also where '"queen of pastel"', p. 55, cites)

Parker and Pollock, *Old Mistresses: Women, Art, and Ideology*, p. 28

EXHIBITIONS

Color into Line: Pastels from the Renaissance to the Present, curated by Furio Rinaldi, Legion of Honor, San Francisco, 9 October 2021–13 February 2022; co-published with Fine Arts Museums of San Francisco, 2021

MEDIA

Hinckley, Miranda, *The National Gallery Podcast*, 'Episode 94', August 2014 (www.nationalgallery.org.uk/podcast/podcasts/the-national-gallery-podcast-episode-94)

In conversation with Katy Hessel: Dr Yuriko Jackall

Thank you to Dr Yuriko Jackall for reading and checking this section.

ANGELICA KAUFFMAN

NOTES

p. 57 'The second half of the eighteenth century marked the rise of Neoclassicism, an International Western style…', cited from *Art in Time: A World History of Styles and Movements* (Phaidon, 2014)

p. 58 '"The whole world is Angelica-mad."' cited from Uglow, Jenny, 'The meteoric rise of Angelica Kauffman RA', *RA Magazine*, 2 July 2020 (www.royalacademy.org.uk/article/ra-magazine-jenny-uglow-angelica-kauffman-ra)

p. 58 '…financially savvy Kauffman set up a studio on Golden Square, where she was known to charge the same price as her male contemporaries', cited from Baumgärtel, Bettina, *Angelica Kauffman* (Hirmer, 2020)

p. 60 'Greek "master" painter Zeuxis attempting to reconfigure Helen of Troy (his idea of "perfection")', cited from Borzello, *Seeing Ourselves: Women's Self-Portraits*

p. 61 'only 9.35 per cent of women have been Royal Academicians…', this statistic has been worked out via the Royal Academy website, Jan 2022 (https://www.royalacademy.org.uk/royal-academicians)

BOOKS

Baumgärtel, Bettina, *Angelica Kauffman* (The University of Chicago Press, April 2020)

Borzello, *Seeing Ourselves: Women's Self-Portraits*

Häusle, Magdalena, *Angelica Kauffman: A Woman of Immense Talent* (Distributed Art Pub Incorporated, 2007)

ARTICLES

Loske, Alexandra, 'Angelica Kauffman: An eighteenth century "Wunderkind"', Brighton Museum & Art Gallery, 19 February 2015 (https://brightonmuseums.org.uk/discover/2015/02/19/angelica-kauffman-an-eighteenth-century-wunderkind/)

EXHIBITIONS

Angelica Kauffman, at The Royal Academy in London, (Exhibition cancelled in 2020 due to Covid-19) (www.royalacademy.org.uk/exhibition/angelica-kauffman)

ON THE ZOFFANY PORTRAIT

BOOKS

Parker and Pollock, *Old Mistresses: Women, Art, and Ideology*, pp. 87–90

ARTICLES

The Royal Collection Trust, 'The Academicians of the Royal Academy (1771–72) by Johan Zoffany' (www.rct.uk/collection/400747/the-academicians-of-the-royal-academy)

Myrone, Martin, 'Lives of the Artists: Angelica Kauffman', *Tate etc.*, 2018 (https://www.tate.org.uk/tate-etc/issue-43-summer-2018/lives-of-the-artists-angelica-kauffman-martin-myrone)

VIGÉE LE BRUN

GENERAL

BBC 2, *The Story of Women and Art*, 2014

Borzello, *Seeing Ourselves: Women's Self-Portraits*, pp. 92–3

Heller, *Women Artists: An Illustrated History*, p. 60

Higgie, *The Mirror and the Palette*

NOTES

p. 62 'a devout royalist…', cited from Parker and Pollock, *Old Mistresses: Women, Art, and Ideology*, p. 32

p. 62 'a time when Rousseau's views on women and motherhood were popular…', cited from *ibid*, pp. 98–9

p. 64 'she earned favour with equally important upper-class patrons…', cited from Heller, *Women Artists: An Illustrated History*

p. 65 '"Women reigned then. The revolution dethroned them"', cited from Parker and Pollock, *Old Mistresses: Women, Art, and Ideology*, pp. 97–8

ADÉLAÏDE LABILLE-GUIARD

NOTES

p. 63 Despite her being a supporter of the Revolution, another court favourite was Adélaïde Labille-Guiard…', cited from Parker and Pollock, *Old Mistresses: Women, Art, and Ideology*, p. 32

p. 64 'best known as an advocate for women's artistic education…', cited from *ibid*, p. 33

p. 64 On 'Self Portrait with Two Pupils' 1785: 'This sumptuous painting is vital in documenting the influential status…', cited from *ibid*, p. 28

p. 65 'But upon her return to France in 1801…', cited from *ibid*, p. 33

In conversation with Katy Hessel: Francesca Whitlum-Cooper; Lisa Small

POST-REVOLUTION FRANCE

GENERAL

Nochlin, Linda, ed. Reilly, Maura, 'Women Artists After the French Revolution', *Women Artists: The Linda Nochlin Reader* (Thames and Hudson, 2020), pp. 93–107

NOTES

p. 65 'scholars have suggested that it speaks of the new-found liberty in France for those previously enslaved.', cited from Nochlin and Harris, *Women Artists 1550–1950*, p. 49

p. 68 '"made progress, as a group and as individuals…"'. Statistics show that more women than ever were exhibiting in the Salon in the early nineteenth century (by 1835, 22.2% of exhibitors were women, a nearly 8% rise from 1801). Cited from Nochlin, ed. Reilly, *Women Artists: The Linda Nochlin Reader*, pp. 94–95; statistics also cited from Chadwick, *Women, Art and Society*, p. 179

MARIE-GUILLEMINE BENOIST

NOTES

p. 66 '"Although the model is portrayed as emblematic of liberty …"', cited from Murrell, Denise, *Posing Modernity: The Black Model from Manet and Matisse to Today* (Yale University Press, 2018), p. 40

p. 66 '"which would have been the case if they had been European"', quote by Murrell, cited from 'French museum renames masterpieces after black subjects', *Expatica.com/fr*, 25 March 2019 (www.expatica.com/fr/uncategorized/french-museum-renames-masterpieces-after-black-subjects-151860/)

p. 68 '"made progress, as a group and as individuals…"'. By 1835, 22.2% of exhibitors at

the Salon were women, a 7.6% rise from 1801, and as we will discover in the next chapter, more women were achieving great critical and financial success. Nochlin, ed. Reilly, 'Women artists after the French Revolution', *Women Artists: The Linda Nochlin Reader*, pp. 93–107

BOOKS
Murrell, *Posing Modernity: The Black Model from Manet and Matisse to Today*

EXHIBITIONS
Posing Modernity: The Black Model from Manet and Matisse to Today, curated by Denise Murrell, Wallach Art Gallery, 24 October 2018–10 February 2019; Musée du Orsay, 26 March–14 July 2019 (https://wallach.columbia.edu/exhibitions/posing-modernity-black-model-manet-and-matisse-today-le-modèle-noir-de-géricault-à)

MARIE DENISE VILLERS

Nochlin, ed. Reilly, *Women Artists: The Linda Nochlin Reader*, p. 100

NOTES
p. 67 '"exemplary"', cited from Higonnet, Anne, *Detective Stories about Met Treasures*, 'A Single Painting—Marie Denise Villers's *Charlotte du Val d'Ognes*', 2 April 2014 (https://www.metmuseum.org/metmedia/video/lectures/detective-stories-charlotte-du-val-dognes)

p. 67 '"unforgettable"', cited from Greer, Germaine, *The Obstacle Race: The Fortunes of Women Painters and Their Work*, (Bloomsbury, 2001) p. 42

p. 68 'According to one scholar, the response to this change of authorship was "surprisingly calm"', cited from an email conversation with Anne Higonnet

p. 68 'a male critic commented that "there are certain weaknesses of which a painter of David's calibre would not have been guilty."', James Laver quoted in Pollock and Parker, *Old Mistresses*, p. 106. (Original quote: *The Saturday Book*, 1964, p. 19)

MEDIA
General information and analysis, e.g. 'foreshortening techniques…' cited from Higonnet, Anne, *Detective Stories about Met Treasures*, 'A Single Painting—Marie Denise Villers's *Charlotte du Val d'Ognes*' (www.metmuseum.org/metmedia/video/lectures/detective-stories-charlotte-du-val-dognes)

Thank you to Yuriko Jackall, Lisa Small and Dr Richard Taws for reading and checking this chapter.

CHAPTER THREE: FROM REALISM TO SPIRITUALISM

NOTES
Nochlin, ed. Reilly, *Women Artists: The Linda Nochlin Reader*, pp. 102–13

ROSA BONHEUR

BOOKS/NOTES
Chadwick, *Women, Art and Society*, pp. 195–9

Klumpke, Anna, *Rosa Bonheur: the artist's (auto) biography, 1856–1942*. c.1997

Madeline, Laurence, *Women Artists in Paris: 1850–1900* (Yale University Press, 2017), pp. 35–7

p. 71 '"Why shouldn't I be proud to be a woman?…"', Rosa Bonheur, cited from Klumpke, *Rosa Bonheur: the artist's (auto) biography, 1856–1942*, p. 206

p. 72 '"great protectors"', *ibid*. (p. 205)

ARTICLES
Blume, Mary, 'The Rise and Fall of Rosa Bonheur', *The New York Times*, 4 October 1997 (www.nytimes.com/1997/10/04/style/IHT-the-rise-and-fall-of-rosa-bonheur.html)

Patterson, Alex, 'The life of Rosa Bonheur', National Museums Liverpool (www.liverpoolmuseums.org.uk/stories/life-of-rosa-bonheur)

The Met Museum, 'The Horse Fair (1852–55)' (www.metmuseum.org/art/collection/search/435702)

MEDIA
Robbins, Anne, #Paintingherstory, 'Rosa Bonheur: "As far as males go, I only like the bulls I paint"', The National Gallery, 8 March 2019 (https://www.youtube.com/watch?v=zEg-3w2DCE14)

LADY BUTLER

NOTES
Chadwick, *Women, Art and Society*, pp. 201–2

Heller, *Women Artists: An Illustrated History*, pp. 91–2

Nochlin, ed. Reilly, *Women Artists: The Linda Nochlin Reader*, p. 106

p. 73 '…she was drawing figures firing pistols at the age of fourteen.', cited from BBC 2, *The Story of Women and Art*, 2014

p. 74 'John Ruskin considered it an exception …', cited from Marsh, Jan, referencing John Ruskin in *"Resolve to be a Great Paintress": Women Artists in Relation to John Ruskin as Critic and Patron*. *Nineteenth Century Contexts, An Interdisciplinary Journal*, 1994, Vol. 18, pp. 177–85. In his 1875 Academy Notes, Ruskin wrote: 'I never approached a picture with more iniquitous prejudice against it than I did Miss Thompson's; partly because I have always said that no woman could paint; and, secondly, because I thought that what the public made such a fuss about must be good for nothing. But it is Amazon's work this; no doubt of it, and the first fine Pre-Raphaelite picture of battle we have had; profoundly interesting, and showing all manner of illustrative and realistic faculty. Of course, all that need be said of it, on this side, must have been said twenty times over in the journals; and it remains only for me to make my tardy genuflexion, on the trampled corn, before this Pallas of Pall Mall', cited from Brownell, Robert, *John Ruskin: Patron or Patriarch*, in Morris, William and Ruskin, John: *A New Road on Which the World Should Travel* (University of Exeter Press, 2019), p. 30.

p. 74 '"I never painted for the glory of war, but to portray its pathos and heroism"', Elizabeth Butler, cited from Butler, Elizabeth, *Autobiography* (Fisher Press, 1922) p. 253

ARTICLES
Royal Collection Trust, 'The Roll Call (1874) by Elizabeth Thompson' (www.rct.uk/collection/405915/the-roll-call)

MEDIA
Gladwell, Malcolm, 'Malcolm Gladwell discusses tokens, pariahs, and pioneers', *The New Yorker Festival*, 2013 (www.newyorker.com/video/watch/talk-malcolm-gladwell-full)

Gladwell, Malcolm, *Revisionist History* podcast, 'The Lady Vanishes', 16 June 2016 (www.pushkin.fm/episode/the-lady-vanishes/)

QUILTMAKING

BOOKS/NOTES
Chadwick, *Women, Art and Society*, p. 213

Payne, Elizabeth Anne, *Writing Women's History: A Tribute to Anne Firor Scott* (University Press of Mississippi, 2011)

Thatcher Ulrich, Laurel, '"A Quilt unlike Any Other": Rediscovering the Work of Harriet Powers', in *ibid*

Whitley, Lauren; Parmal, Pamela; and Swope, Jennifer, *Fabric of a Nation: American Quilt Stories* (Museum of Fine Arts Boston, 2021)

p. 77 '…mystical tales of real-life events during and preceding her lifetime.', all of these quotes are cited from Museum of Fine Arts Boston (https://collections.mfa.org/objects/116166)

In conversation with Katy Hessel: Jennifer Swope; thank you to Jennifer Swope for reading this passage.

NAMPEYO

BOOKS
Gaylord, Torrence, *Art of Native America: The Charles and Valerie Diker Collection* (Met Publications, 2018), pp. 22, 34, 35

ARTICLES
Arizona State Museum, 'Nampeyo Showcase', The University of Arizona (https://statemuseum.arizona.edu/online-exhibit/nampeyo-showcase)

In conversation with Katy Hessel: Hillary Olcott; Diane Dittemore; thank you to Hillary Olcott and Diane Dittemore for reading this passage.

EDMONIA LEWIS

BOOKS
Dabakis, Melissa, *A Sisterhood of Sculptors: American Artists in Nineteenth-Century Rome* (Penn State University Press, 2014)

Lewis, Samella, *African American Art and Artists* (University of California Press, 2003)

ARTICLES
Powers, Hermenia, 'Who was Edmonia "Wildfire" Lewis?', *ArtUK*, 28 October 2020 (https://artuk.org/discover/stories/who-was-edmonia-wildfire-lewis)

MEDIA
Lev, Elizabeth, 'Forever Free: A Presentation on the Life and Legacy of Sculptor Edmonia Lewis', *Sheen Talks*, 16 February 2021

In conversation with Katy Hessel: Elizabeth Lev; thank you to Elizabeth Lev for reading and checking this passage.

PICTURES OF THE FLOATING WORLD

NOTES
p. 82 '…"bury the material in the ground for around sixty days"…' cited from Keyes, Roger, ed. Clark, Timothy, *Hokusai: Beyond the Great Wave* (Thames and Hudson, 2017), p. 301

ARTICLES
Nelson Davis, Julie, 'Hokusai and Ōi: art runs in the family', *The British Museum Blog*, 18 June 2017 (https://blog.britishmuseum.org/hokusai-and-oi-keeping-it-in-the-family/)

MEDIA
Govier, Katherine and Buckland, Rosina, 'Katsushika Oei: A Woman Artist in a Floating World', The Japan Foundation, Toronto, 18 December 2020

In conversation with Katy Hessel: Rosina Buckland; thank you to Rosina Buckland for reading this passage.

BOTANICAL PHOTOGRAPHY AND SCIENTIFIC THOUGHT

ANNA ATKINS

ARTICLES

History of Science Museum, Oxford, 'Daughters, Wives, Sisters… and Scientists' (https://oumnh.ox.ac.uk/daughters-wives-sisters-and-scientists)

Lotzof, Kerry, 'Anna Atkins's cyanotypes: the first book of photographs', Natural History Museum (https://www.nhm.ac.uk/discover/anna-atkins-cyanotypes-the-first-book-of-photographs.html)

Moorhead, Joanna, 'Blooming marvellous: the world's first female photographer – and her botanical beauties', *Guardian*, 23 June 2017 (www.theguardian.com/artanddesign/2017/jun/23/blooming-marvellous-the-worlds-first-female-photographer-and-her-botanical-beauties)

MEDIA

Batchen, Geoffrey and Fritsch, Lena, 'Anna Atkins: Botanical Illustration and Photographic Innovation', TORCH: The Oxford Research Centre in the Humanities, 10 November 2020 (www.youtube.com/watch?v=-z_7hCq-lNM)

VICTORIAN BRITAIN: THE PRE-RAPHAELITES AND THE GLASGOW STYLE

NOTES

Nochlin, ed. Reilly, *Women Artists: The Linda Nochlin Reader*, pp. 102–13

p. 86 '"The man's power is active, progressive, defensive…"', cited from Ruskin, John, *Works of John Ruskin*, Library Edition, vol. XVIII (1905), p. 122

Parker and Pollock, *Old Mistresses: Women, Art, and Ideology*, p. 9

EMILY MARY OSBORN

NOTES

p. 86 '"I have a talent and the constant impulse to employ it, for the love of it and the longing to work… and no man has a right to say that that is to be unheeded"', quotation by Joanna Boyce Wells, 1857. *Pre-Raphaelite Sisters*, wall text, the National Portrait Gallery, London, 17 October 2019–26 January 2020 (www.npg.org.uk/whatson/pre-raphaelite-sisters/exhibition/)

BOOKS

Cherry, Deborah, *Beyond the Frame: Feminism and Visual Culture, Britain, 1850–1900* (Routledge, 2000)

Marsh, Jan; Funnell, Peter; Gere, Charlotte; Gerrish Nunn, Pamela; Smith, Alison, *Pre-Raphaelite Sisters* (National Portrait Gallery, 2019)

ARTICLES

Smith, Alison, 'Nameless and Friendless. "The rich man's wealth is his strong city, etc.", Proverbs, x, 15', Tate, October 2015 (www.tate.org.uk/art/artworks/osborn-nameless-and-friendless-the-rich-mans-wealth-is-his-strong-city-etc-proverbs-x-15-t12936)

In conversation with Katy Hessel: Alison Smith

MEDIA

Woman's Hour, 'Elizabeth Siddal and Pre-Raphaelite women', BBC Radio 4, 14 October 2019 (https://www.bbc.co.uk/programmes/m00099ys)

ELIZABETH SIDDAL

BOOKS

Hawksley, Lucinda, *Lizzie Siddal: The Tragedy of a Pre-Raphaelite Supermodel* (Andre Deutsch Ltd., 2008)

JOANNA BOYCE WELLS

NOTES

p. 90 'Sometimes considered "too good" by the group', cited from *Woman's Hour*, 'Elizabeth Siddal and Pre-Raphaelite women'

p. 90 '"so subtle, so tenderly wrought"', cited from Ings-Chambers, Caroline, *Louisa Waterford and John Ruskin: 'For you have Not Falsely Praised'* (Taylor & Francis, 2017), p. 56

BOOKS

Marsh; Funnell; Gere; Nunn; Smith, *Pre-Raphaelite Sisters*

FANNY EATON

ARTICLES

Figes, Lydia, 'Fanny Eaton: Jamaican Pre-Raphaelite Muse', *ArtUK*, 23 October 2019 (https://artuk.org/discover/stories/fanny-eaton-jamaican-pre-raphaelite-muse)

JULIA MARGARET CAMERON

ARTICLES

Higgins, Charlotte, 'Julia Margaret Cameron: soft-focus photographer with an iron will', *Guardian*, 22 September 2015 (www.theguardian.com/artanddesign/2015/sep/22/julia-margaret-cameron-victorian-portrait-photographer-exhibitions)

V&A, 'The real Alice in Wonderland', 2021 (https://www.vam.ac.uk/articles/the-real-alice-in-wonderland)

V&A, 'Julia Margaret Cameron's working methods' (https://www.vam.ac.uk/articles/julia-margaret-camerons-working-methods)

EXHIBITIONS

Alice Curiouser and Curiouser, V&A, 22 May 2021–31 December 2021

EVELYN DE MORGAN

NOTES

p. 92 '"seventeen years wasted in eating, dawdling and frittering time away…"', cited from the De Morgan Foundation (www.demorgan.org.uk/discover/the-de-morgans/evelyn-de-morgan/)

BOOKS

de Morgan, Catherine, *Evelyn de Morgan: Oil Paintings* (De Morgan Foundation, 1996)

In conversation with Katy Hessel: Sarah Hardy; thank you to Sarah Hardy for reading this passage.

GLASGOW STYLE

BOOKS

Helland, Janice, *The Studios of Frances and Margaret Macdonald* (Manchester University Press, 1996)

Neat, Timothy, *Part Seen, Part Imagined: Meaning and Symbolism in the Work of Charles Rennie Mackintosh and Margaret MacDonald* (Canongate Books, 1994)

ARTICLES

Green, Cynthia, 'The Scottish Sisters Who Pioneered Art Nouveau', *JSTOR Daily*, 19 December 2017 (https://daily.jstor.org/the-scottish-sisters-who-pioneered-art-nouveau/)

Helland, Janice, 'Frances Macdonald: The Self as Fin-de-Siècle Woman', *Woman's Art Journal*, 1993 (www.jstor.org/stable/pdf/1358425.pdf?refreqid=excelsior%3A0e410b6debeec-354a96d24c9d75472e4)

National Galleries Scotland, 'Margaret Macdonald Mackintosh' (www.nationalgalleries.org/art-and-artists/artists/margaret-macdonald-mackintosh)

The Glasgow Style (www.theglasgowstyle.co.uk/)

The Glasgow Style, 'Margaret Macdonald' (www.theglasgowstyle.co.uk/copy-of-margaret-gilmour-4)

The Glasgow Style, 'Frances Macdonald' (www.theglasgowstyle.co.uk/copy-of-margaret-gilmour)

EXHIBITIONS

Gustav Klimt: Painting, Design and Modern Life in Vienna 1900, Room Guide, Fritz and Lili Waerndorfer, Tate Liverpool, 30 May 2008–31 August 2008

MEDIA

National Galleries Scotland, *Scotland's Art*, 'The Glasgow Girls', 22 January 2021 (www.youtube.com/watch?v=ke0nV-xa1mc&t=10s&ab_channel=nationalgalleries)

In conversation with Katy Hessel: Sarah Hardy (Evelyn de Morgan Foundation), Dr Alison Smith (Tate/National Portrait Gallery), Dr Carol Jacobi (Tate), Jan Marsh (via email), Lachlan Goudie (artist), Freya Spoor (Scottish National Galleries)

Thank you to Sarah Hardy, Carol Jacobi and Freya Spoor for reading this chapter.

SPIRITUALISM

NOTES

p. 101 '…"love she had for her family"… "represents her actions"', Georgiana Houghton's notes describing *Flower of Zilla Warren, 31st August 1861*, transcribed by Henry Lenny, cited from Grant, Simon; Bang Larsen, Lars; Pasi, Marco; eds. Vegelin van Claerbergen Ernst, and Wright, Barnaby, *Georgiana Houghton: Spirit Drawings* (The Courtauld Gallery, 2016), p. 40

p. 102 '"astonishing"', cited from Brown, Mark, 'Spiritualist artist Georgiana Houghton gets UK exhibition', *Guardian*, 5 May 2016 (www.theguardian.com/artanddesign/2016/may/05/spiritualist-artist-georgiana-houghton-uk-exhibition-courtauld)

p. 102 '"We should not have called attention to this exhibition at all…"', *Examiner*, 27 May 1871, cited from Grant; Bang Larsen; and Pasi, eds. Vegelin van Claerbergen and Wright, *Georgiana Houghton: Spirit Drawings*, p. 19

BOOKS

Grant; Bang Larsen; and Pasi, eds. Vegelin van Claerbergen and Wright *Georgiana Houghton: Spirit Drawings*

EXHIBITIONS

Georgiana Houghton: Spirit Drawings, curated by Simon Grant; Lars Bang Larsen; and Marco Pasi, The Courtauld Gallery, 16 June 2016–11 September 2016

HILMA AF KLINT

NOTES

p. 102 '"particularly perceptive"; p. 104 '"a great commission" to "convey humanity the matters of the spiritual realm"'; '"spiral-like temple"'; '"close contact with such spirits could end up in

madness"'; quotes by Tracey Bashkoff in Hessel, Katy, *The Great Women Artists Podcast*, 'Tracey Bashkoff on Hilma af Klint', 22 September 2020 (https://soundcloud.com/thegreatwomenartists/tracey-bashkoff-on-hilma-af-klint)

Karmel, Pepe, *Abstract Art: A Global History* (Thames and Hudson, 2020), pp. 26–30, pp. 174–6

Much of the factual information here has been extracted from Hessel, Katy, *The Great Women Artists Podcast*, 'Tracey Bashkoff on Hilma af Klint', 22 September 2020 (https://soundcloud.com/thegreatwomenartists/tracey-bashkoff-on-hilma-af-klint)

BOOKS
Bashkoff, Tracey, *Hilma af Klint: Paintings for the Future* (Guggenheim Museum Publications, 2018)

Müller-Westermann, Iris, *Hilma Af Klint: A Pioneer of Abstraction* (Hatje Cantz, 2013)

Voss, Julia, *Hilma af Klint: Die Menschheit in Erstaunen versetzen: Biographie* (Fischer, 2020)

EXHIBITIONS
A New Age, The Spiritual in Art, curated by Ruth Direktor, The Tel Aviv Museum of Art, 6 August 2019–1 February 2020 (www.tamuseum.org.il/en/exhibition/new-age-spiritual-art/)

Hilma af Klint: Paintings for the Future, curated by Tracey Bashkoff, The Solomon R. Guggenheim Museum, 12 October 2018–23 April 2019 (www.guggenheim.org/exhibition/hilma-af-klint)

MEDIA
Dover, Caitlin, 'Who Was Hilma af Klint?: At the Guggenheim, Paintings by an Artist Ahead of Her Time', *Guggenheim Blog* (https://www.guggenheim.org/blogs/checklist/who-was-hilma-af-klint-at-the-guggenheim-paintings-by-an-artist-ahead-of-her-time)

Jeffries, Stuart, '"They called her a crazy witch": did medium Hilma af Klint invent abstract art?', *Guardian*, 6 October 2020 (https://www.theguardian.com/artanddesign/2020/oct/06/hilma-af-klint-abstract-art-beyond-the-visible-film-documentary)

Kellaway, Kate, 'Hilma af Klint: a painter possessed', *Guardian*, 21 February 2016 (https://www.theguardian.com/artanddesign/2016/feb/21/hilma-af-klint-occult-spiritualism-abstract-serpentine-gallery)

FILM
Dir. Dyrschka, Halina, 'Beyond the Visible: Hilma af Klint', Modern Films, 2019

Thank you to Simon Grant and Julia Voss for reading this passage.

PART TWO: WHAT MADE ART MODERN (C.1870–C.1950)

NOTES
p. 108 '"The woman artist is an ignored, little-understood force…"', Hélène Bertaux, founder of Paris's Union des Femmes Peintres et Sculpteurs, 1881, cited from Madeline, *Women Artists in Paris: 1850–1900*, p. 2

p. 108 'what makes modern art "modern"…', cited from Hessel, Katy, *The Great Women Artists Podcast*, 'Diane Radycki on Paula Modersohn Becker', 30 March 2021 (https://soundcloud.com/thegreatwomenartists/diane-radycki-on-paula-modersohn-becker)

Chadwick, *Women, Art and Society*, pp. 238–52

CHAPTER FOUR: WAR, IDENTITY AND THE PARIS AVANT-GARDE

IMPRESSIONISM

BOOKS
ed. Britt, David, *Modern Art: Impressionism to Post-Modernism* (Thames and Hudson, 2007)

Higgie, *The Mirror and The Palette*

Hughes, Robert, *The Shock of the New: Art and the Century of Change* (Thames and Hudson, 1991)

Madeline, *Women Artists in Paris: 1850–1900*

BERTHE MORISOT

Patry, Sylvie, *Berthe Morisot, Woman Impressionist* (Rizzoli, 2018)

NOTES
p. 111 '"I don't think there has ever been a man…"', Berthe Morisot, cited from Dube, Ilene, 'Why Berthe Morisot was an Essential Figure in the Impressionist Movement', *Hyperallergic*, 31 October 2018 (https://hyperallergic.com/468570/why-berthe-morisot-was-an-essential-figure-in-the-impressionist-movement/)

p. 112 '"Your daughters have such inclinations…"', cited from Mongan, Elizabeth, *Berthe Morisot* (Shorewood Publishing Co, 1960), p. 12

Parker and Pollock, *Old Mistresses: Women, Art, and Ideology*, pp. 41–4

p. 113 '*The Cradle*…', cited from Harris, Beth and Zucker, Steven, 'Morisot, the Cradle', Khan Academy (https://www.khanacademy.org/humanities/becoming-modern/avant-garde-france/impressionism/v/morisot-the-cradle-1872)

BOOKS
Madeline, *Women Artists in Paris: 1850–1900*

Museyon Guides, *Art + Paris: Impressionists & Post-Impressionists: The Ultimate Guide to Artists, Paintings and Places in Paris and Normandy* (Museyon Guides, 2011)

ARTICLES
Marlowe, Lara, 'Berthe Morisot: "I have sinned, I have suffered, I have atoned"', *Irish Times*, 12 January 2019 (www.irishtimes.com/culture/art-and-design/visual-art/berthe-morisot-i-have-sinned-i-have-suffered-i-have-atoned-1.3746820)

Schjeldahl, Peter, 'Berthe Morisot, "Woman Impressionist," Emerges from the Margins', *The New Yorker*, 22 October 2018 (www.newyorker.com/magazine/2018/10/29/berthe-morisot-woman-impressionist-emerges-from-the-margins)

EXHIBITIONS
Berthe Morisot: Woman Impressionist, Barnes Foundation, 21 October 2018–14 January 2019; Patry, Sylvie, *Berthe Morisot, Woman Impressionist* (Rizzoli, 2018)

MEDIA
Hessel, Katy, *The Great Women Artists Podcast*, 'Cindy Kang on Berthe Morisot', 27 April 2021 (p. 113 'calling it a "sweet" painting of motherhood…'; '*The Artist's Sister at a Window*…'; '…*The Cradle*'; are cited from this discussion with Cindy Kang) (https://soundcloud.com/thegreatwomenartists/cindy-kang-on-berthe-morisot)

MARY CASSATT

NOTES
p. 116 'her painting *In the Loge, c. 1880*…' This was a subject often tackled by Cassatt's female contemporaries, such as Eva Gonzalès

Nochlin, ed. Reilly, *Women Artists: The Linda Nochlin Reader*, pp. 200–19

BOOKS
Madeline, *Women Artists in Paris: 1850–1900*

MARIE BRACQUEMOND

NOTES
p. 117 'Marie Bracquemond (1840–1916), on the other hand, was born into a working-class family…', cited from Chadwick, *Women, Art and Society*, p. 242

BOOKS
Madeleine, *Women Artists in Paris: 1850–1900*

MARIE BASHKIRTSEFF

NOTES
p. 118 '"What I long for is the freedom of going about alone…"', cited from Myers, Nicole, 'Women Artists in Nineteenth-Century France', The Met Museum, September 2008 (www.metmuseum.org/toah/hd/19wa/hd_19wa.htm)

Borzello, *Seeing Ourselves: Women's Self-Portraits*, pp. 126–8

BOOKS
Madeline, *Women Artists in Paris: 1850–1900*

CAMILLE CLAUDEL

ARTICLES
Cain, Abigail, 'Camille Claudel, the Sculptor Who Inspired Rodin's Most Sensual Work', *Artsy*, 1 May 2017 (www.artsy.net/article/artsy-editorial-bold-female-sculptor-inspired-rodins-sensual-work)

Chadwick, *Women, Art and Society*, pp. 305–6

Cook, William, 'How Camille Claudel Stepped out of Rodin's Shadow', BBC Arts, 27 March 2017 (www.bbc.co.uk/programmes/articles/2KQwKKyPGcJCJ5JGWpVJLHB/how-camille-claudel-stepped-out-of-rodins-shadow)

Musée Camille Claudel, '1909–1943: Period of Confinement' (www.museecamilleclaudel.fr/en/collections/camille-claudel-biography/1909-1943-period-confinement)

In conversation with Katy Hessel: Alice Strang, Lisa Small, Diane Radycki

Thank you to Cindy Kang, Lisa Small, Diane Radycki, Freya Spoor for reading this chapter.

A ROOM OF ONE'S OWN: SELF-PORTRAITURE

NOTES
p. 120 '"Modern art attempts to represent the lives and reality of those around us…"', Georgette Chen, 1943. Quoted from an article, 'Yi Shu De Dian Di' ("Some Thoughts on Art")', cited in National Gallery Singapore Exhibition Catalogue, p. 184

p. 120 '…participation of women artists…' cited from Hessel, Katy, *The Great Women Artists Podcast*, 'Diane Radycki on Paula Modersohn-Becker', 30 March 2021 (https://soundcloud.com/thegreatwomenartists/diane-radycki-on-paula-modersohn-becker)

p. 121 '"I hope to learn many things…"', Paula Modersohn-Becker, cited from Madeline, *Women Artists in Paris: 1850–1900*, p. 17

HELENE SCHJERFBECK

NOTES
p. 122 '"When you give a child a pencil, you give her an entire world."', cited from Kellway, Kate, '"Finland's Munch": the unnerving art of Helene Schjerfbeck', *Guardian*, 6 July 2019

(www.theguardian.com/artanddesign/2019/jul/06/helene-schjerfbeck-finnish-painter-royal-academy)

Higgie, *The Mirror and the Palette*, pp. 136–43

BOOKS
von Bonsdorff, Anna-Maria; Bray, Rebecca; Lewison, Jeremy; de Chair, Désirée, *Helene Schjerfbeck* (Royal Academy of Arts, 2019)

EXHIBITIONS
Helen Schjerfbeck, Royal Academy, 20 July 2019–27 October 2019 (https://www.royalacademy.org.uk/exhibition/helene-schjerfbeck)

MEDIA
Royal Academy of Arts, 'Katy Hessel meets Helene Schjerfbeck', September 2019 (https://www.youtube.com/watch?v=_yWm3M-d3zA)

GWEN JOHN

NOTES
Borzello, *Seeing Ourselves: Women's Self-Portraits*, pp. 141–3

Higgie, *The Mirror and the Palette*, pp. 158–62

p. 123 '"I have learned from John that you don't need to shout in order to make an impact"', cited from Paul, Celia, 'Celia Paul on the Restraint and Freedom in Gwen John's Self-Portrait', *Frieze*, 30 August 2018 (www.frieze.com/article/celia-paul-restraint-and-freedom-gwen-johns-self-portrait)

BOOKS
Foster, Alicia, *British Artists: Gwen John* (Tate, 2015)

Taubman, Mary, *Gwen John* (Scolar Press, 1985)

PAULA MODERSOHN-BECKER

NOTES
p. 125 'burgeoning with her new life…' cited from Franco, Bernadine, *Beyond the Paint with Bernadine* podcast, 'Paula Modersohn-Becker: Revolutionary Nude', 25 August 2019 (https://beyondthepaint.net/episode-88-paula-modersohn-becker-revolutionary-nude/)

p. 125 '… "Personal feeling is the main thing"', referencing her letters; cited from Joffe, Chantal, *Chantal Joffe: Personal Feeling is the Main Thing* (Laurence King Publishing, 2018)

Nochlin and Harris, *Women Artists 1550–1950*, pp. 273–80

BOOKS
Radycki, Diane, *Paula Modersohn-Becker: Self-Portrait, One on One Series* (MoMA Publications, 2018)

EXHIBITIONS
Chantal Joffe: Personal Feeling is the Main Thing, The Lowry, 19 May 2018–2 September 2018 (www.victoria-miro.com/news/908)

MEDIA
Hessel, Katy, *The Great Women Artists Podcast*, 'Diane Radycki on Paula Modersohn-Becker', 30 March 2021(https://soundcloud.com/thegreatwomenartists/diane-radycki-on-paula-modersohn-becker)

In conversation with Katy Hessel: Diane Radycki

FLORINE STETTHEIMER

BOOKS
Bloemink, Barbara, *Florine Stettheimer: A Biography* (Hirmer, 2022)

Brown, Stephen and Uhlyarik, Georgiana, *Florine Stettheimer: Painting Poetry* (Yale University Press, 2017)

ARTICLES
Schjeldahl, Peter, 'Revisiting Florine Stettheimer's Place in Art History', *The New Yorker*, 15 May 2017 (www.newyorker.com/magazine/2017/05/15/revisiting-florine-stettheimers-place-in-art-history)

EXHIBITIONS
Florine Stettheimer: Painting Poetry, The Jewish Museum, New York, 5 May 2017–24 September 2017 (https://thejewishmuseum.org/index.php/exhibitions/florine-stettheimer-painting-poetry)

GEORGETTE CHEN

NOTES
p. 126 '"Although I belong to the modern school, I feel that I am not able to imitate any specific style. I paint what I see, whether it be a landscape or a figure."' Cited from '"Yi Shu Dian Di" ("Some Thoughts on Art")', National Gallery Singapore Exhibition Catalogue, 1943; image of article sent by Gwen Thiam to KH on 10 September 2021

Bailey, Stephanie, 'Georgette Chen: Pioneer of the Nanyang Style', *Ocula*, 25 November 2020 (https://ocula.com/magazine/features/georgette-chen-pioneer-of-the-nanyang-style/)

National Gallery Singapore on 'Georgette Chen' (www.nationalgallery.sg/georgettechen)

EXHIBITIONS
Georgette Chen: At Home In The World, National Gallery Singapore, 27 November 2020–26 September 2021

In conversation with Katy Hessel: Teo Hui Min, Curator, National Gallery Singapore; thank you to Teo Hui Min for reading this passage and for providing a notes document about Georgette Chen's life and work.

PAN YULIANG

BOOKS
Teo, Phyllis, *Rewriting Modernism: Three Women Artists in Twentieth-Century China (Pan Yuliang, Nie Ou and Yin Xiuzhen)* (Amsterdam University Press, 2015), p. 127 '"powerful brushstroke"', cited from here

Thank you to Horatio Hsieh, The Li Ching Cultural and Educational Foundation, for reading this passage.

FROM FAUVISM TO FUTURISM

GENERAL
Heller, *Women Artists: An Illustrated History*, pp. 118–19

Hughes, Robert, 'Shock of the New', BBC, 1980 (https://www.youtube.com/watch?v=J3ne7U-daetg&list=PLFtSvldL7Mh4ismj4BgH33p-BR9hbtBkxz)

NOTES
p. 129 '"…spiritual aspect of the composition"; '"artefacts" rather than "artworks…"', citing Murrell, Denise, 'African Influences in Modern Art', Metropolitan Museum of Art, April 2008 (https://www.metmuseum.org/toah/hd/aima/hd_aima.htm)

EXPRESSIONISM

NOTES
Phaidon, 'Expressionsim/Der Blaue Reiter', *Art in Time: A World History of Styles and Movements*, p. 177

Phaidon, 'Die Brücke', *Art in Time: A World History of Styles and Movements*, p. 179

p. 131 '"unspeakably difficult…"', 'Käthe

Kollwitz: *The Widow I (Die Witwe I)* from *War (Krieg)* 1921–22, published 1923', MoMA (https://www.moma.org/collection/works/69685)

BOOKS
Behr, Shulamith, *Expressionism Reassessed* (Manchester University Press, 1993)

ed. Britt, *Modern Art: Impressionism to Post-Modernism*

Hughes, *The Shock of the New: Art and the Century of Change*

KÄTHE KOLLWITZ

NOTES
Gombrich, *The Story of Art*, p. 566

BOOKS
Egremont, Max; Carey, Frances; ed., Watkins, Jonathan; *Portrait of the Artist: Käthe Kollwitz* (Ikon Gallery Ltd., 2017)

Perry, Gillian, *Women Artists and the Parisian Avant-Garde: Modernism and Feminine Art, 1900 to the Late 1920s* (Manchester University Press, 1995)

ARTICLES
Tenz, Courtney, 'Käthe Kollwitz's Art Was Compassionate, Subversive and Politically Outspoken', *Artsy*, 14 May 2020 (www.artsy.net/article/artsy-editorial-kathe-kollwitzs-art-compassionate-subversive-politically-outspoken)

MEDIA
MacGregor Neil, 'Kathe Kollwitz: Suffering Witness', BBC Radio 4, 29 October 2014

GABRIELE MÜNTER & MARIANNE VON WEREFKIN

ARTICLES
Budick, Ariella, 'Gabriele Münter: "I was only a side dish to Kandinsky"', *Financial Times*, 19 July 2018 (www.ft.com/content/46c43c44-84f1-11e8-9199-c2a4754b5a0e)

Gotthardt, Alexxa, 'The German Expressionists' Shockingly Raw Work Exploded Bourgeois Values and Reinvented Art', *Artsy*, 31 August 2018 (https://www.artsy.net/article/artsy-editorial-german-expressionists-shockingly-raw-work-exploded-bourgeois-values-reinvented-art)

EXHIBITIONS
Gabriele Münter, Lousiana Museum, 2018

In conversation with Katy Hessel: Dr Shulamith Behr, Dr Isabelle Jansen, Diane Radycki, Frances Carey; thank you to Dr Shulamith Behr, Diane Radycki, Frances Carey, Carmen Kühnert for reading this section.

SUZANNE VALADON

BOOKS
Borzello, *Seeing Ourselves: Women's Self-Portraits*, pp. 168–9

Higgie, *The Mirror and the Palette*, pp. 242–54

Perry, *Women Artists and the Parisian Avant-Garde*

EXHIBITIONS
Suzanne Valadon: Model, Painter, Rebel, curated by Nancy Ireson, Barnes Foundation, 26 September 2021–9 January 2022

MEDIA
Hessel, Katy, *The Great Women Artists Podcast*, 'Jennifer Higgie on Suzanne Valadon', 6 April 2021 (https://soundcloud.com/thegreatwomenartists/jennifer-higgie-on-suzanne-valadon)

In conversation with Katy Hessel: Nancy Ireson

JACQUELINE MARVAL

NOTES

p. 136 In an interview with Marie Laurencin, she mentions she admires Jacqueline Marval: 'I admire Segonzac and Marval, Derain and…', quote from Laurencin, Marie, 'Dialogues Avec des Peintres', *Le Gaulois*, 8 March 1924

Comité Jacqueline Marval, 'Biography' (www.jacqueline-marval.com/biography)

BOOKS

Perry, *Women Artists and the Parisian Avant-Garde*

In conversation with Katy Hessel: Camille Roux dit Buisson (Comité Jacqueline Marval); Beverly Held

MARIE LAURENCIN

NOTES

Chadwick, *Women, Art and Society*, pp. 305–7

Nochlin and Harris, *Women Artists 1550–1950*, pp. 295–6

Fondation du musée Marie Laurencin, 'About Marie Laurencin' (http://marielaurencin.jp/en/about/)

p. 137 '"arrogant masculinity of Cubism"', cited from McPherson, Heather, '*Marie Laurencin: Une Femme Inadaptée in Feminist Histories of Art* by Elizabeth Louise Kahn', *Woman's Art Journal*, 2005 (https://www.jstor.org/stable/3566535)

BOOKS

Kahn, Elizabeth Louise, *Marie Laurencin: Une Femme Inadaptée in Feminist Histories of Art* (Routledge, 2003)

ARTICLES

Figes, Lydia, 'Marie Laurencin: the avant-gardist who painted Coco Chanel', *Art UK*, 27 February 2020 (https://artuk.org/discover/stories/marie-laurencin-the-avant-gardist-who-painted-coco-chanel)

Gabbott, Miranda, 'Why Marie Laurencin, the Queen of Avant-Garde Paris, Was Misunderstood for Decades', *Artsy*, 15 June 2020 (www.artsy.net/article/artsy-editorial-marie-laurencin-queen-avant-garde-paris-misunderstood-decades)

Otto, Elizabeth, 'Memories of Bilitis: Marie Laurencin beyond the Cubist Context', *Genders 1998–2013*, 2002 (www.colorado.edu/gendersarchive1998-2013/2002/08/01/memories-bilitis-marie-laurencin-beyond-cubist-context)

EXHIBITIONS

Marie Laurencin, Nahmad Projects, 7 February 2020–9 April 2020

AMRITA SHER-GIL

NOTES

p. 138 '"I can only paint in India…"' Amrita Sher-Gil, letter to Karl Khandalavala, April 1938, cited from ed., Sundaram, Vivan, *Amrita Sher-Gil: A Self Portrait in Letters and Writings* (New Delhi, 2010), 2:491

p. 139 '"I began to be haunted by an intense longing to return to India"', cited from *Amrita Sher-Gil*, Tate Modern Exhibition Catalogue (www.tate.org.uk/whats-on/tate-modern/exhibition/amrita-sher-gil/amrita-sher-gil-room-2-return-india)

BOOKS

Higgie, *The Mirror and the Palette*, pp. 211–2

ARTICLES

Mathur, Saloni, 'A Retake of Sher-Gil's

Self-Portrait as Tahitian', *Critical Inquiry*, 2011 (www.jstor.org/stable/10.1086/659356?seq=1#metadata_info_tab_contents)

Mzezewa, Tariro, 'Overlooked No More: Amrita Sher-Gil, a Pioneer of Indian Art', *The New York Times*, 20 June 2018 (www.nytimes.com/2018/06/20/obituaries/amrita-sher-gil-dead.html)

Singh, N. Iqbal, 'Amrita Sher-Gil', *India International Centre Quarterly*, 1975 (www.jstor.org/stable/23001838?seq=1#metadata_info_tab_contents)

EXHIBITIONS

Amrita Sher-Gil, curated by Emma Dexter, Ann Coxon and Matthew Gale, Tate Modern, 28 February–22 April 2007

In conversation with Katy Hessel: Vivan Sundaram; thank you to Vivan for reading and checking this passage.

BLOOMSBURY GROUP/VANESSA BELL

NOTES

p. 140 '"liberated" by the French Modernists…', cited from an interview: Ian A.C. Dejardin and Sarah Milroy discussing the significance of Vanessa Bell, Dulwich Picture Gallery, 2017

Phaidon, 'Bloomsbury Group', *Art in Time: A World History of Styles and Movements*, pp. 172–3

BOOKS

Dejardin, Ian A.C.; Milroy, Sarah, *Vanessa Bell* (Philip Wilson Publishers, 2017)

EXHIBITIONS

From Omega to Charleston: The Art of Vanessa Bell and Duncan Grant (1910–1934), curated in partnership with Richard Shone, Piano Nobile, 16 February 2018–28 April 2018

Vanessa Bell (1879–1961), curated by Ian A.C. Dejardin and Sarah Milroy, Dulwich Picture Gallery, 8 February 2017–4 June 2017

NOTES

p. 142 '"Cubist conceptions"', full quote: 'About 1911 I had the idea of making for my son, who had just been born, a blanket composed of bits of fabric like those I had seen in the houses of Russian peasants. When it was finished, the arrangement of the pieces of material seemed to me to evoke cubist conceptions and we then tried to apply the same process to other objects and paintings.' Cited from room guide, *Sonia Delaunay*, Tate Modern, 15 April 2015–9 August 2015

Orphism definition, 'Borrowing its name from Orpheus, Greek god of music and poetry…' cited from Phaidon, 'Orphism', *Art in Time: A World History of Styles and Movements*, pp. 174–5

SONIA DELAUNAY

BOOKS

Montfort, Anne and Godefroy, Cécile, *Sonia Delaunay: exhibition book* (Tate Gallery Publishing, 2014)

EXHIBITIONS

Sonia Delaunay, of Tate Modern, 15 April 2015–9 August 2015

RUSSIAN AVANT-GARDE

BOOKS

eds. Bowlt, John E., and Drutt, Matthew, *Amazons of the Avant-Garde* (Guggenheim Museum, 2000)

NATALIA GONCHAROVA

NOTES

Tate, 'Introducing Natalia Goncharova' (https://

www.tate.org.uk/art/artists/natalia-goncharova-1186/introducing-natalia-goncharova)

BOOKS

Gale, Matthew, and Sidlina, Natalia, *Natalia Goncharova: exhibition book* (Tate Publishing, 2019)

EXHIBITIONS

Natalia Goncharova, Tate Modern, 6 June 2019–8 September 2019

MEDIA

Higgie, *Bow Down: Women in Art* podcast, 'Natalia Sidlina on Natalia Goncharova', 2 December 2019 (https://www.frieze.com/article/bow-down-natalia-sidlina-natalia-goncharova)

RUSSIAN REVOLUTION

NOTES

MoMA, 'Poster for International Women Workers' Day (1930) by Valentina Kulagina (www.moma.org/collection/works/217704)

BOOKS

eds. Bowlt, Drutt, *Amazons of the Avant-Garde*

ARTICLES

Wilson, Jacob Charles, 'Varvara Stepanova, the pioneer who brought constructivist design to proletarian life', *It's Nice That*, 26 October 2017 (https://www.itsnicethat.com/articles/varvara-stepanova-contructivist-design-port-magazine-fashion-261017)

LIUBOV POPOVA

ARTICLES

Lodder, Christina, 'Liubov Popova: From Painting to Textile Design', *Tate Papers*, 2010 (www.tate.org.uk/research/publications/tate-papers/14/liubov-popova-from-painting-to-textile-design)

EXHIBITIONS

Liubov Popova, MoMA, 14 February 1991–23 April 1991

BENEDETTA CAPPA MARINETTI

NOTES

Frigeri, *Women Artists*, pp. 66–7

ARTICLES

Lasker-Ferretti, Janaya S., 'Appropriating the Abstract: Benedetta's "Le forze umane" and Neoplasticism', *Annali d'Italianistica*, 2009 (www.jstor.org/stable/24016264?seq=1#metadata_info_tab_contents)

Palmieri, Jessica, 'Futurists on Speed', *Guggenheim Blog*, 2 May 2014 (www.guggenheim.org/blogs/checklist/futurists-speed)

QUEER IDENTITIES

NOTES

p. 147 '"Masculine? Feminine? It depends on the situation…"' Claude Cahun, *Aveux non avenus* ('*Disavowals'*), 1930

p. 148 'I use the word "queer" for its inclusive connotations…' This is in line with a text by Barlow, Claire, 'Queer British Art', Tate Britain. Full quote: 'Queer has a mixed history – from the 19th century onwards it has been used both as a term of abuse and as a term by LGBT people to refer to themselves. Our inspiration for using it came from Derek Jarman who said that it used to frighten him but now "for me to use the word queer is a liberation". More recently, of course, it has become reclaimed as a fluid term for people of different sexualities and gender identities. Historians of sexuality have also argued that it is preferable to other terms for sexualities in the past as these often don't map onto modern sexual

identities.' (https://www.tate.org.uk/whats-on/tate-britain/queer-british-art-1861-1967)

p. 148 'until 1861 sodomy was punishable by death, and afterwards male homosexuality…' citing Dryden, Steven, 'A short history of LGBT rights in the UK', British Library (www.bl.uk/lgbtq-histories/articles/a-short-history-of-lgbt-rights-in-the-uk)

p. 148 'lesbianism became a public topic of discussion…' citing Buzwell, Greg, 'The censorship of lesbian fiction: From *The Well of Loneliness* to *Tipping the Velvet*', British Library, 23 October 2020 (https://www.bl.uk/womens-rights/articles/the-censorship-of-lesbian-literature)

p. 148 'British papers called it "a book that must be suppressed"…' in reference to *Sunday Express* editor, James Douglas, who campaigned for the erasure of *The Well of Loneliness*. He called it the 'Book That Should Be Suppressed.' Cited from Staveley-Wadham, Rose, 'The Well of Loneliness – An LGBTQ Book on Trial', The British Newspaper Archive Blog, 15 June 2020 (https://blog.britishnewspaperarchive.co.uk/2020/06/15/the-well-of-loneliness/)

BOOKS
Barlow, Clare, *Queer British Art: 1867–1967* (Tate Publishing, 2017)

MEDIA
BBC 4, 'Gluck – Who did she think he was?', 27 August 2017 (www.youtube.com/watch?v=Q2e-6JcJK6LM&ab_channel=BobTee)

EXHIBITIONS
Constance Spry and the Fashion of Flowers, curated by Shane Connolly, Garden Museum, 17 May 2021–26 September 2021

Queer British Art: 1867–1967, curated by Clare Barlow, Tate Britain, 5 April 2017–1 October 2017

GLUCK

NOTES
p. 148 'at the age of twenty-three Gluck insisted that their name be reproduced with no "prefix, suffix, or quotes").', citing Terzi, Sara, *Women Artists: A Conversation* (The Fine Art Society, 2017), p. 3

Meyer, Sophie, 'The Hidden Histories of Cornwall's Queer Community', *Royal Cornwall Museum Blog*, 20 February 2019 (www.royalcornwallmuseum.org.uk/the-hidden-histories-of-cornwalls-queer-community)

BOOKS
Souhami, Diana, *Gluck: Her Biography* (Quercus, 2013)

ARTICLES
Broadley, Rosie, 'The Great British Art Tour: Gluck shapes herself with gender defiance', *Guardian*, 2 February 2021 (www.theguardian.com/artanddesign/2021/feb/02/the-great-british-art-tour-national-portrait-gallery-london-gluck)

Souhami, Diana, '"Now it is out": the 1930s painting that declared lesbian love', *RA Magazine*, 6 December 2017 (www.royalacademy.org.uk/article/magazine-gluck-brighton-museum-art-gallery-diana-souhami)

MEDIA
BBC 4, 'Gluck – Who did she think he was?', 27 August 2017 (www.youtube.com/watch?v=Q2e-6JcJK6LM&ab_channel=BobTee) (much of the information cites this article, including Sandi Toksvig's discussion around *Ernest Thesiger*, 1925–6)

In conversation with Katy Hessel: Patrick Duffy; thank you to Patrick Duffy and Diana Souhami for checking this passage.

ROMAINE BROOKS

NOTES
Chadwick, *Women, Art and Society*, pp. 308–12

BOOKS
Langer, Cassandra, *Romaine Brooks: A Life* (University of Wisconsin Press, 2015)

EXHIBITIONS
The Art of Romaine Brooks, curated by Virginia Mecklenburg and Joann Moser, Smithsonian American Art Museum, 16 June–1 October 2016 (https://americanart.si.edu/exhibitions/brooks)

MEDIA
Langer, Cassandra, 'Romaine Brooks, 20th-Century Woman – Art Discussion, SAAM', Smithsonian American Art Museum, 22 June 2016 (www.si.edu/es/object/yt_e2TmLbixqsc)

TAMARA DE LEMPICKA

BOOKS
Néret, Gilles, *de Lempicka (Basic Art Series)* (Taschen, 2000)

MEDIA
p. 153 '"baroness with the brush"'; '"baths and champagne"', 'Tamara de Lempicka, Hollywood's Deco Diva', BBC 4, October 2009 (www.youtube.com/watch?v=ki-WKU0oo2t0&ab_channel=ClaudeVarieras)

CLAUDE CAHUN

NOTES
p. 154 'Under this mask, another mask...' Claude Cahun, 1930, cited from Howgate, Sarah, *Gillian Wearing and Claude Cahun: Behind the mask, another mask* (National Portrait Gallery, 2017)

p. 154 '"les mesdames"', cited from The National Portrait Gallery, 'Who was Claude Cahun?' (https://www.npg.org.uk/whatson/wearing-cahun/explore/claude-cahun/)

BOOKS
Howgate, *Gillian Wearing and Claude Cahun: Behind the mask, another mask*

ARTICLES
Treaster, Joseph B., 'Overlooked No More: Claude Cahun, Whose Photographs Explored Gender and Sexuality', *The New York Times*, 19 June 2019 (www.nytimes.com/2019/06/19/obituaries/claude-cahun-overlooked.html)

EXHIBITIONS
Gillian Wearing and Claude Cahun: Behind the mask, another mask, The National Portrait Gallery, London, 9 March 2017–29 May 2017

MEDIA
Higgie, *Bow Down: Women in Art* podcast, 'Juliet Jacques on Claude Cahun', 1 August 2019 (www.frieze.com/article/bow-down-juliet-jacques-claude-cahun)

Thank you to Diana Souhami, Patrick Duffy and Martin Coomer for reading this chapter.

CHAPTER FIVE: THE AFTERMATH OF THE FIRST WORLD WAR

DADA, THE READYMADE AND THE WEIMAR ERA

NOTES
p. 157 '"…nothing"' Robert Hughes quoting Tristan Tzara, cited from MoMA Learning, 'Dada' (www.moma.org/learn/moma_learning/themes/dada/)

Hughes, *The Shock of the New: Art and the Century of Change*

HANNAH HÖCH

NOTES
Hirschl Orley, Heidi, 'Hannah Höch: German, 1889–1978', MoMA (www.moma.org/artists/2675)

p. 159 '… "she was giving birth to the baby"', cited from Hunt, Jeremy, 'Hannah Höch – Der Maler (1920) The Painter', *Art in Fiction*, 5 January 2017 (https://artinfiction.wordpress.com/tag/the-painter/)

BOOKS
Ades, Dawn; Butler, Emily; and Hermann, Daniel F., *Hannah Höch: Works on Paper* (Prestel, 2014)

ARTICLES
Barber, Karen, 'Hannah Höch, Cut with the Kitchen Knife Dada Through the Last Weimar Beer Belly Cultural Epoch of Germany', Khan Academy (www.khanacademy.org/humanities/art-1010/dada-and-surrealism/dada2/a/hannah-hoch-cut-with-the-kitchen-knife-dada-through-the-last-weimar-beer-belly-cultural-epoch-of-germany)

Cohen, Alina, 'The Radical Legacy of Hannah Höch, One of the Only Female Dadaists', *Artsy*, 11 March 2019 (https://www.artsy.net/article/artsy-editorial-radical-legacy-hannah-hoch-one-female-dadaists)

EXHIBITIONS
Hannah Höch, curated by Daniel F. Herrmann, Dawn Ades and Emily Butler, The Whitechapel Gallery, 15 January 2014–23 March 2014

SOPHIE TAEUBER-ARP

BOOKS
Kaufmann, Bettina; and Hoch, Medea, *Sophie Taeuber-Arp: exhibition book* (Tate Publishing, March 2021)

EXHIBITIONS
Sophie Taeuber-Arp, Tate Modern, 15 July 2021–17 October 2021

MEDIA
Higgie, Jennifer, Hauser & Wirth, 'Sophie Taeuber-Arp: Modern Master', 11 July 2020 (https://www.hauserwirth.com/ursula/35114-sophie-taeuber-arp-modern-master/)

BARONESS ELSA VON FREYTAG-LORINGHOVEN

NOTES
p. 160 '…there are those who claim that he was in fact predated by a woman: Baroness Elsa von Freytag-Loringhoven…' citing the Tate acknowledging Baroness Elsa Von Freytag-Loringhoven as a contributor to *Fountain*; Tate, ' Marcel Duchamp, *Fountain*, (1917, replica 1964)' (www.tate.org.uk/art/artworks/duchamp-fountain-t07573)

p. 160 '"the only one living anywhere who dresses Dada, loves Dada, lives Dada."', quotation from Heap, Jane, 'Dada', *The Little Review* (1919). Cited from Cotter, Holland, 'Dada's Women, Ahead of Their Time', *The New York Times*, 6 July 2006 (https://www.nytimes.com/2006/07/06/arts/design/06dada.html)

p. 160 '"ready-made poems"…'[The Baroness] is not a Futurist. She is the future."' Quotation by Marcel Duchamp cited from Oisteanu, Valery, 'The Dada Baroness', *Artnet*, 20 May 2002 (http://www.artnet.com/magazine/features/oisteanu/oisteanu5-20-02.asp)

p. 160 '"wearable art"', cited from Lappin, Linda, 'Dada Queen in the Bad Boys' Club: Baroness Elsa Von Freytag-Loringhoven', *Southwest Review*, 2004, p. 313 (https://www.jstor.org/stable/43472537)

p. 161 '"junk sculptures"' cited from *ibid*, p. 309

p. 161 '…in collaboration with artist Morton Livingston Schamberg, she created *God*, a sole metal plumbing trap, which was previously (wrongfully) attributed to the male artist alone', cited from Tate, 'Marcel Duchamp, *Fountain*, (1917, replica 1964)' (https://www.tate.org.uk/art/artworks/duchamp-fountain-t07573)

p. 162 '…letter to his sister Suzanne, writing: "One of my female friends, under a masculine pseudonym Richard Mutt (or R. Mutt), sent in a porcelain urinal as a sculpture."', letter cited from Thill, Vanessa, 'Elsa Von Freytag-Loringhoven, the Dada Baroness Who Invented the Readymade', *Artsy*, 18 September 2018 (www.artsy.net/article/artsy-editorial-elsa-von-freytag-loringhoven-dada-baroness-invented-readymade)

p. 162 '…he claimed the urinal was from "JL Mott Iron Works", when it turns out they have no record of the product…', cited from *ibid*

BOOKS
Gammel, Irene, *Baroness Elsa: Gender, Dada, and Everyday Modernity – A Cultural Biography* (MIT Press, 2003)

ARTICLES
Higgs, John, 'Was Marcel Duchamp's "Fountain" actually created by a long-forgotten pioneering feminist?', *Independent*, 8 September 2015 (www.independent.co.uk/arts-entertainment/art/features/was-marcel-duchamp-s-fountain-actually-created-long-forgotten-pioneering-feminist-10491953.html)

Hustvedt, Siri, 'A woman in the men's room: when will the art world recognise the real artist behind Duchamp's Fountain?', *Guardian*, 29 March 2019 (www.theguardian.com/books/2019/mar/29/marcel-duchamp-fountain-women-art-history)

Lappin, Linda, 'Dada Queen in the Bad Boys' Club: Baroness Elsa Von Freytag-Loringhoven', *Southwest Review*, 2004 (www.jstor.org/stable/pdf/43472537.pdf?refreqid=excelsior%3A0f0beb-81fa224854b3ebb2cf3cfceea1)

Thill, Vanessa, 'Elsa Von Freytag-Loringhoven, the Dada Baroness Who Invented the Readymade', *Artsy*, 18 September 2018 (www.artsy.net/article/artsy-editorial-elsa-von-freytag-loringhoven-dada-baroness-invented-readymade)

Thank you to Linda Lapplin, Dorothy Price, Irene Gammel for reading this chapter.

WEIMAR GENERAL

NOTES
p. 163 '"I have always wanted to be just a pair of eyes…"', cited from 'To Be Just A Pair of Eyes: The other side of Jeanne Mammen', *ArtMag Deutsche Bank* (https://db-artmag.com/en/78/feature/to-be-just-a-pair-of-eyes-the-other-side-of-jeanne-mammen/)

EXHIBITIONS
Magic Realism: Art in Weimar Germany (1919–33), Tate Modern, 30 July 2018–14 July 2019

Into the Night: Cabarets and Clubs in Modern Art, The Barbican Art Gallery, 4 October 2019–19 January 2020

ARTICLES
Jones, Jonathan, 'Magic Realism: Art in Weimar Germany 1919–33 review – sex, death and decadence', *Guardian*, 30 July 2018 (www.theguardian.com/artanddesign/2018/jul/30/magic-realism-art-weimar-germany-1919-33-review-tate-modern-otto-dix-george-grosz)

The Barbican Centre, 'New Women in the Weimar Republic' (https://sites.barbican.org.uk/intothenight-berlin/)

BOOKS
Schick, Karin, *Anita Rée: Retrospective* (Prestel, 2017)

JEANNE MAMMEN

BOOKS
ed. Lügtens, Annelie, *Jeanne Mammen. The Observer: Retrospective 1910–1975)* (Hirmer, 2018)

ARTICLES
McNay, Anna, 'Jeanne Mammen: The Observer. Retrospective (1910–75)', *Studio International*, 16 December 2017 (www.studiointernational.com/index.php/jeanne-mammen-the-observer-retrospective-1910-75-review-berlin)

LOTTE LASERSTEIN

NOTES
p. 166 '"three-quarter Jew"', cited from Stroud, Caroline, *Lotte Laserstein: paintings and drawings from Germany and Sweden (1920–1970)* (Thos. Agnews & Sons Ltd, 2017)

BOOKS
Stroud, *Lotte Laserstein: paintings and drawings from Germany and Sweden (1920–1970)*

ARTICLES
Berlinische Galerie, 'The Estate of Lotte Laserstein' (https://berlinischegalerie.de/en/collection/our-collection/estate-of-lotte-laserstein/)

Leicester's German Expressionism Collection, 'Lotte Laserstein' (www.germanexpressionism-leicester.org/leicesters-collection/artists-and-artworks/lotte-laserstein/)

EXHIBITIONS
Lotte Laserstein's Women, Agnews Gallery, 8 November 2017–15 December 2017

In conversation with Katy Hessel: Anthony Critchton-Stuart

Thank you to Dorothy Price for reading this chapter.

BAUHAUS

NOTES
p. 166 '"I find art is something that gives you something…"', cited from Fesci, Sevim, 'Oral History Interview with Anni Albers', *Smithsonian*, 5 July 1968 (www.aaa.si.edu/collections/interviews/oral-history-interview-anni-albers-12134#how-to-use-this-collection)

p. 166 '…"building house" in English', cited from *Britannica Academic Encyclopaedia*, 'Bauhaus'

p. 167 '"above all, a modern philosophy of design"', cited from inside cover of Bayer, Herbert, ed. Gropius, Walter, and Gropius, Ise, *Bauhaus 1919–1928* (Secker and Warburg, 1975)

(https://assets.moma.org/documents/moma_catalogue_2735_300190238.pdf?_ga=2.78384596.154917366.1627486158-625684553.1571092286)

p. 167 '…and it is still the standard "foundation" course taught in art schools today', cited from

Hessel, Katy, *The Great Women Artists Podcast* 'Emma Ridgway, on Ruth Asawa', 6 May 2021 (https://soundcloud.com/thegreatwomenartists/emma-ridgway-on-ruth-asawa)

p. 167 'Gropius even proclaimed that women thought in "two dimensions" whereas men thought in three', cited from Glancey, Jonathan, 'Haus proud: The women of Bauhaus', *Guardian*, 7 November 2009 (https://www.theguardian.com/artanddesign/2009/nov/07/the-women-of-bauhaus)

BOOKS
Bayer, ed. Gropius and Gropius, *Bauhaus 1919–1928*

Otto, Elizabeth and Rössler, Patrick, *Bauhaus Women: A Global Perspective* (Herbert Press, 2019)

GUNTA STÖLZL

NOTES
p. 168 '"A new life begins"', cited in Müller, Ulrike, *Bauhaus Women: Art. Handicraft. Design* (Flammarion, 2009)

ARTICLES
Gotthardt, Alexxa, 'The Women of the Bauhaus School', *Artsy*, 3 April 2017 (www.artsy.net/article/artsy-editorial-women-bauhaus-school)

ANNI ALBERS

NOTES
p. 168 'she described as an "unsatisfactory"…', cited from Fesci, Sevim, 'Oral History Interview with Anni Albers', *Smithsonian*, 5 July 1968 (www.aaa.si.edu/collections/interviews/oral-history-interview-anni-albers-12134#how-to-use-this-collection)

p. 168 '"amazing objects, striking in their newness of conception in regard to use of colour and compositional elements"', cited from Tate exhibition guide, 'Anni Albers' (https://www.tate.org.uk/whats-on/tate-modern/anni-albers/exhibition-guide)

p. 169 'she developed techniques to use the newly invented material cellophane', cited from Fer, Briony, 'Anni Albers Weaving Magic', *Tate Etc.*, 10 October 2018 (https://www.tate.org.uk/tate-etc/issue-44-autumn-2018/anni-albers-weaving-magic-briony-fer)

BOOKS
Coxon, Ann, *Anni Albers* (Tate Publishing, 2018)

ARTICLES
Fer, Briony, 'Anni Albers Weaving Magic', *Tate Etc.*, 10 October 2018 (https://www.tate.org.uk/tate-etc/issue-44-autumn-2018/anni-albers-weaving-magic-briony-fer)

Hicks, Sheila, 'My encounters with Anni Albers', *Tate Etc.*, 10 October 2018 (https://www.tate.org.uk/tate-etc/issue-44-autumn-2018/anni-albers-sheila-hicks)

EXHIBITIONS
Anni Albers, Tate Modern, 11 October 2018–27 January 2019

GERTRUD ARNDT

NOTES
p. 169 '"out of boredom"', cited from Bauhaus Kooperation, 'Mask Portrait No. 13, Dessau, Gertrud Arndt, 1930', 2015 (https://www.bauhauskooperation.com/knowledge/the-bauhaus/works/photography/mask-portrait-no-13-dessau/)

p. 170 '"You just need to open your eyes and

already you are someone else...", cited from Bauhaus Kooperation, 'Mask Portrait No. 13, Dessau', (1930) Gertrud Arndt', 2015 (www.bauhauskooperation.com/knowledge/the-bauhaus/works/photography/mask-portrait-no-13-dessau/); also cited from Müller, *Bauhaus Women: Art. Handicraft. Design*, pp. 57–61 (full quote: '*I am simply interested in the face, what does one make from a face? There you need only to open your eyes wide and you are already someone else*')

p. 170 'The 1930 publication *Die Woche* (*The Week*) described the "Bauhaus-girl type"', cited from Jansen, Charlotte, 'The trailblazing women of the Bauhaus', *Wallpaper*, 1 April 2019 (https://www.wallpaper.com/art/bauhaus-pioneering-women-artists-taschen-book)

ARTICLES
Abbaspour, Mitra, 'Gertrud Arndt', MoMA Object Photo Series (www.moma.org/interactives/objectphoto/artists/24581.html)

Guttenberger, Anja, 'Festive and Theatrical – The Mask Photos of Gertrud Arndt and Josef Albers as an Expression of Festival Culture', *Bauhaus Imaginista*, 11 March 2019 (www.bauhaus-imaginista.org/articles/4273/festive-and-theatrical?0bbf55ceffc3073699d40c945ada9faf=0e-1c670a111358bbf6310f6eb4e0f162)

MARIANNE BRANDT

BOOKS
Rössler, Patrick, *Bauhausmädels. A Tribute to Pioneering Women Artists* (Taschen, 2019)

ARTICLES
Bauhaus Kooperation, 'Marianne Brandt: 1923–1928 Bauhaus student / 1928–1929 Deputy Head of Metal' (https://www.bauhauskooperation.com/knowledge/the-bauhaus/people/biography/145/)

Thank you to Emma Ridgway and the team at Bauhaus-Archiv for reading this chapter.

SURREALISM

NOTES
p. 171 'Of course the women were important...", Roland Penrose, husband of Lee Miller, to legendary feminist Whitney Chadwick during her visit to his home in the 1980s. Cited from Chadwick, Whitney, *The Militant Muse: Love, War and the Women of Surrealism* (Thames and Hudson, 2017), p. 9

p. 171 'I thought it was bullshit...", Leonora Carrington on her thoughts on the surrealist muse, cited in *ibid*

p. 171 'Automatism', Tate: Art Terms (www.tate.org.uk/art/art-terms/a/automatism)

p. 171 'The problem of woman...", André Breton writing in his second surrealist manifesto from 1929, cited from Figes, Lydia, 'More than muses: the women at the centre of Surrealism', *Art UK*, 29 November 2019 (https://artuk.org/discover/stories/more-than-muses-the-women-at-the-centre-of-surrealism)

p. 171 'femmes enfants'", cited from *ibid*

p. 172 '...largely wore "three-piece tweed suits"', information cited from Hessel, Katy, *The Great Women Artists Podcast*, 'Alyce Mahon on Leonor Fini', 4 November 2020 (https://soundcloud.com/thegreatwomenartists/alyce-mahon-on-leonor-fini)

BOOKS
Chadwick, Whitney, *Women Artists and the Surrealist Movement* (Thames and Hudson, 1991)

Chadwick, *Women, Art and Society* (Thames and Hudson, 2020)

McAra, Catriona; Eburne, Jonathan P., *Leonora Carrington and the international avant-garde* (Manchester University Press, 2017)

In conversation with Katy Hessel: Laura Smith; Alyce Mahon; Ami Bouhassane; Emma Lewis.

DORA MAAR

BOOKS
Amao, Damarice; Maddox, Amanda; and Ziebinska-Lewandowska, Karolina; *Dora Maar: exhibition book* (Tate, 2019)

EXHIBITIONS
Dora Maar, Tate Modern, 20 November 2019–15 March 2020

MEDIA
Hessel, Katy, *The Great Women Artists Podcast*, 'Emma Lewis on Dora Maar', 14 January 2020, (much of the information has been extracted from this discussion including, p. 174 'Maar's eagerness to project the idea of a "modern woman"'; 'a "contradictory" environment between the world wars') (https://soundcloud.com/thegreatwomenartists/emma-lewis-on-dora-maar)

LEE MILLER

NOTES
p. 175 '...solarisation' – defined from Tate: Art Terms, 'Solarisation' (https://www.tate.org.uk/art/art-terms/s/solarisation)

Information about her upbringing cited from Hessel, Katy, *The Great Women Artists Podcast*, 'Ami Bouhassane on Lee Miller', 21 October 2019 (https://soundcloud.com/thegreatwomenartists/ami-bouhassane-on-lee-miller)

BOOKS
Alison, Jane and Malissard, Coralie, *Modern Couples: Art, Intimacy and the Avant-Garde* (Prestel, 2018)

Roberts, Hilary, *Lee Miller: A Woman's War* (Thames and Hudson, 2015)

MEDIA
Much of the factual information here has been extracted from Hessel, Katy, *The Great Women Artists Podcast*, 'Ami Bouhassane on Lee Miller', 21 October 2019 (https://soundcloud.com/thegreatwomenartists/ami-bouhassane-on-lee-miller)

MERET OPPENHEIM

NOTES
p. 178 'Greek culture'", cited from Agar, Eileen, *A Look at My Life* (London 1988), p. 93, via Tate (https://www.tate.org.uk/art/artworks/agar-three-symbols-t00707)

BOOKS
Dupêcher, Natalie; Umland, Anne; and Zimmer, Nina, *Meret Oppenheim: My Exhibition* (MoMA, 2021)

ARTICLES
MoMA Learning, 'Object (1936) by Meret Oppenheim' (www.moma.org/learn/moma_learning/meret-oppenheim-object-paris-1936/)

EILEEN AGAR

BOOKS
Smith, Laura, *Eileen Agar: Modern Women Artists* (Eiderdown Books, 2021)

EXHIBITIONS
Eileen Agar: Angel of Anarchy, The Whitechapel Gallery, 19 May 2021–29 August 2021

MEDIA
Much of the factual information here has been extracted from Hessel, Katy, *The Great Women Artists Podcast*, 'Laura Smith on Eileen Agar', 3 March 2020 (including, p. 178 '"pillars"'; discussion on *Angel of Anarchy*; biography of Eileen Agar) (https://soundcloud.com/thegreatwomenartists/laura-smith-on-eileen-agar)

LEONOR FINI

NOTES
p. 179 'tall and striking, with jet-black hair...", cited from Chadwick, *The Militant Muse: Love, War and the Women of Surrealism*, p. 62

ARTICLES
Lauter, Estella, 'Leonor Fini: Preparing to Meet the Strangers of the New World', *Woman's Art Journal*, 1980

MEDIA
Much of the factual information here has been extracted from Hessel, Katy, *The Great Women Artists Podcast*, 'Alyce Mahon on Leonor Fini', 4 November 2020, (including discussion on *Self-Portrait with Scorpion* and *Self-Portrait with Nico Papatakis*; biographical information; sphinx as a warrior symbol; proto-Punk, etc.)

Thank you to Richard Overstreet for reading this passage.

LEONORA CARRINGTON

MEDIA
Hessel, Katy, *The Great Women Artists Podcast*, 'Joanna Moorhead on Leonora Carrington', 29 October 2019 (https://soundcloud.com/thegreatwomenartists/joanna-moorheadonleonora-carrington)

FRIDA KAHLO

NOTES
Chadwick, *Women, Art and Society*, pp. 326–8

BOOKS
Lozano, Luis-Martín, *Frida Kahlo. The Complete Paintings* (Taschen, 2021)

MEDIA
Hessel, Katy, *The Great Women Artists Podcast*, 'Jessie Burton on Frida Kahlo', 21 January 2020 (https://soundcloud.com/thegreatwomenartists/jessie-burton-on-frida-kahlo)

In conversation with Katy Hessel: Luis-Martín Lozano

DOROTHEA TANNING

NOTES
p. 184 'limitless expanse of possibility'", cited from Tanning, Dorothea, *Between Lives: An Artist and Her World* (W.W. Norton, 2001), p. 49

p. 184 'nothing happens but the wallpaper'"; full quote: 'Galesburg, where nothing happens by the wallpaper', cited from 'Dorothea Her Lights and Shadows (A Scenario)', XXe Siècle, September 1976. Reprinted in *Dorothea Tanning: 10 Recent Paintings and a Biography*, exhibition catalogue (Gimpel-Weitzenhoffer Gallery, 1979), pp. 26–7.

p. 185 'birth'", cited from *Dorothea Tanning*, Tate Modern, 27 February–9 June 2019

p. 185 'Don't ask me to explain my paintings'"; full quote: 'I'll show you some new pictures. But please don't ask me to explain them. I don't think it's possible.' Cited from dir. Schamoni, Peter, 'Insomnia'; via Tate (https://www.youtube.com/watch?v=92LvYigLMLc)

p. 185 '"landscape of wild fantasy"', cited from Tanning, *Between Lives: An Artist and Her World*, p. 96

EXHIBITIONS
Dorothea Tanning, curated by Dr Alyce Mahon, Tate Modern, 27 February–9 June 2019

MEDIA
Tate, 'Dorothea Tanning – Pushing the Boundaries of Surrealism', TateShots, 5 April 2019 (https://www.youtube.com/watch?v=92LvYigLMLc)

Waldemar, Januszczak, 'Art of the Night: Dorothea Tanning', ZCZ Films, 21 February 2019 (https://www.youtube.com/watch?v=-ZwZOj7LqG1c)

Thank you to Pamela Johnson for reading this passage.

GERTRUDE ABERCROMBIE

BOOKS
Cozzolino, Robert; Storr, Robert; Weininger, Susan; Dinah Livingston, *Gertrude Abercrombie* (Karma, 2018)

EXHIBITIONS
Gertrude Abercrombie, Karma Gallery, 9 August 2018–23 September 2018

In conversation with Katy Hessel: Susan Weininger

Thank you to Laura Smith for reading this chapter.

CHAPTER SIX:
MODERNISM IN THE AMERICAS

NEW NATIONAL IDENTITIES IN BRAZIL AND MEXICO

NOTES
p. 189 '"I want to be the painter of my country…"', cited from Grimson, Karen, 'Tarsila do Amaral', MoMA (https://www.moma.org/artists/49158)

p. 191 '"cultural cannibalism"…Brazilian artists must "digest" or "internalise"…', referencing Tate: Art Terms, 'Anthropophagia' (https://www.tate.org.uk/art/art-terms/a/anthropophagia)

p. 191 information about *A Negra*, cited from Akinkugbe, Alayo, @ablackhistoryofart, Instagram, 9 December 2020 (https://www.instagram.com/p/CIjbIeqlumw/)

ARTICLES
Damian, Carol, 'Tarsila do Amaral: Art and Environmental Concerns of a Brazilian Modernist', *Woman's Art Journal*, 1999 (www.jstor.org/stable/pdf/1358838.pdf?refreqid=excelsior%3A0ab08ae3e80b202142366e0a0a0d0fb3)

De Andrade, Oswalde, 'Anthropophagite Manifesto' (1928). Originally published in *Revista de Antropofagia* (São Paulo, May 1928), trans., Pedrosa, Adriano, and Cordeiro, Veronica

Hawksley, Lucinda, '1922: The year that changed Brazilian art', *BBC Culture*, 10 October 2014 (https://www.bbc.com/culture/article/20140710-a-year-that-changed-brazilian-art)

TARSILA DO AMARAL

NOTES
p. 192 '*Figura só (Lonely Figure)*, 1930, picture an isolated figure, her back turned towards us as if looking out into an abyss, with remnants of the vegetal motifs…', cited from Belchior, Camila, 'Tarsila do Amaral, MASP', *Artforum*, September

2019 (https://www.artforum.com/print/reviews/201907/tarsila-do-amaral-80663)

BOOKS
Pedrosa, Adriano, and Fernando, Oliva, *Tarsila Do Amaral: Cannibalizing Modernism* (MASP, 2019)

ARTICLES
Ebony, David, 'Brazil's First Art Cannibal: Tarsila do Amaral', *Yale University Press Blogs*, 1 December 2017 (http://blog.yalebooks.com/2017/12/01/brazils-first-art-cannibal-tarsila-do-amaral/)

EXHIBITIONS
Tarsila do Amaral: Inventing Modern Art in Brazil, MoMA, 11 February 2018–3 June 2018

In conversation with Katy Hessel: Sofia Gotti; Victoria Nerey

MEXICO

EXHIBITIONS
Vida Americana: Mexican Muralists Remake American Art, 1925–1945, The Whitney Museum of American Art, 17 February 2020–31 January 2021 (https://whitney.org/exhibitions/vida-americana)

MEDIA
Much of the information about the Mexican Renaissance and Tina Modotti cites this talk: Albers, Patricia, 'Tina Modotti and the Mexican Renaissance', UC Berkley Events, 4 August 2010 (www.youtube.com/watch?v=6U2prC-7Q_84&ab_channel=UCBerkeleyEvents); Albers, Patricia, 'Art Focus Lectures | Tina Modotti & the Mexican Renaissance', The Cantor Arts Centre, 13 March 2019 (https://museum.stanford.edu/programs/art-focus-lectures-tina-modotti-mexican-renaissance)

TINA MODOTTI

NOTES
Frigeri, Flavia, *Women Artists*, pp. 64–5

Sidley, Kelly, 'Tina Modotti', MoMA (https://www.moma.org/artists/4039)

ARTICLES
Flores, Tatiana, 'Strategic Modernists: Women Artists in Post-Revolutionary Mexico', *Woman's Art Journal*, 2008 (www.jstor.org/stable/pdf/20358161.pdf?refreqid=excelsior%3Acf2018947927839eb91561a944ec82a)

Gonzalez, David, 'A Mexican Photographer, Overshadowed but Not Outdone', *New York Times Blogs: Lens*, 25 February 2015 (https://lens.blogs.nytimes.com/2013/02/25/a-mexican-photographer-overshadowed-but-not-outdone/)

Lambson, Ann, 'Women of Mexican Modernism', *Denver Art Museum Blog*, 1 December 2020

EXHIBITIONS
Frida Kahlo, Diego Rivera, and Mexican Modernism, The Denver Art Museum, 25 October 2020–17 January 2021

Thank you to Sofia Gotti and Leslie Ramos for reading this chapter.

THE HARLEM RENAISSANCE

NOTES
p. 195 '"We do not ask any special favours as artists because of our race…"' Augusta Savage, cited from O'Neal, Eugenia, *113 Black Voices: Speaking Truth to Power* (Independently published, 2019)

p. 195 '"Black Capital"', quotation from *Black Capital: Harlem in the 1920s* exhibition, The New

York State Museum (www.nysm.nysed.gov/exhibitions/ongoing/black-capital-harlem-1920s-0)

BOOKS
Kirschke, Amy Helene, *Women Artists of the Harlem Renaissance* (University Press of Mississippi, 2014)

Lewis, Samella, *African American Art and Artists*

Perry, Regenia A., *Free within Ourselves: African-American Artists in the Collection of the National Museum of American Art* (National Museum of American Art in Association with Pomegranate Art Books, 1992)

ARTICLES
Sayej, Nadja, 'Augusta Savage: the extraordinary story of the trailblazing artist', *Guardian*, 8 May 2019 (www.theguardian.com/artanddesign/2019/may/08/augusta-savage-black-artist-new-york)

In conversation with Katy Hessel: Melanie A. Herzog and Rebecca K. VanDiver

EDMONIA LEWIS

ARTICLES
Smithsonian American Art Museum, 'Edmonia Lewis' (https://americanart.si.edu/artist/edmonia-lewis-2914)

META VAUX WARRICK FULLER

NOTES
p. 197 '"Here was a group who had once made history…"', cited from The National Museum of African American History and Culture, 'Ethiopia (1921) by Meta Vaux Warrick Fuller' (https://nmaahc.si.edu/meta-vaux-warrick-fuller-ethiopia-1921)

ARTICLES
Ater, Renée, 'Making History: Meta Vaux Warrick Fuller's "Ethiopia"', *American Art*, 2003 (www.journals.uchicago.edu/doi/abs/10.1086/444622?journalCode=amart&)

Beach, Caitlin, 'Meta Warrick Fuller's Mary Turner: and the Memory of Mob Violence', *Nka: Journal of Contemporary African Art*, 2015 (https://muse.jhu.edu/article/583920/pdf)

Britannica Academic, 'Laura Wheeler Waring'

Brundage, W. Fitzhugh, 'Meta Warrick's 1907 "Negro Tableaux" and (Re)Presenting African American Historical Memory', *The Journal of American History*, 2003 (www.jstor.org/stable/pdf/3092547.pdf?refreqid=excelsior%3A132ae8f-20da4bf71dd4bca82b627668f)

Perkins, Kathy A., 'The Genius of Meta Warrick Fuller', *Black American Literature Forum*, 1990 (www.jstor.org/stable/pdf/2904066.pdf?refreqid=excelsior%3Adfd9e099be65d303c-1fe7e891a0432ea)

Taylor, Jacqueline S., 'Waring, Laura Wheeler', *Oxford Art Online*, 2011

AUGUSTA SAVAGE

NOTES
p. 198 '"Coming in contact with Augusta Savage was one of the highlights of my career"', Jacob Lawrence, cited from Nicholas, Xavier, and Lawrence, Jacob, 'Interview with Jacob Lawrence', *Callaloo*, 2013 (www.jstor.org/stable/pdf/24264907.pdf?refreqid=excelsior%3Af-1522cbb6cb545b67a3c7c343508e21d)

BOOKS
Hayes, Jeffreen M., *Augusta Savage: Renaissance Woman* (D. Giles Ltd., 2018)

ARTICLES

de León, Concepción, 'The Black Woman Artist Who Crafted a Life She Was Told She Couldn't Have', *The New York Times*, 30 March 2021 (www.nytimes.com/2021/03/30/us/augusta-savage-black-woman-artist-harlem-renaissance.html)

Harlem Community Art Center, 'Mapping the African American Past', contributor: a Columbia University student enrolled in Art History W3897, African American Art in the 20th and 21st Centuries, taught by Professor Kellie Jones in 2008 (https://maap. columbia.edu/place/58. html)

Sayej, Nadja, 'Augusta Savage: the extraordinary story of the trailblazing artist', *Guardian*, 8 May 2019 (www.theguardian.com/artanddesign/2019/may/08/augusta-savage-black-artist-new-york)

EXHIBITIONS

Augusta Savage: Renaissance Women, curated by Jeffreen M. Hayes, The New York Historical Society, 3 May 2019–28 July 2019

SELMA BURKE

ARTICLES

Ayele Djossa, Christina, 'Who Really Designed the American Dime?', *Atlas Obscura*, 17 January 2018 (www.atlasobscura.com/articles/who-designed-american-dime-selma-burke-franklin-roosevelt)

Verderame, Lori, 'The Sculptural Legacy Of Selma Burke, 1900–1995' (http://static1. squarespace.com/static/533b9964e4b-098d084a9331e/t/544d2748e4b08f-142d9df764/1414342472498/Verderame_on_Burke.pdf)

In conversation with Katy Hessel: Jeffreen M Hayes, *The Great Women Artists Podcast*, January 2022

LOÏS MAILOU JONES

NOTES

p. 200 'designers' names weren't "recognised" in the same way as painters', cited from Hessel, Katy, *The Great Women Artists Podcast*, 'Rebecca VanDiver on Loïs Mailou Jones', 9 December 2020 (https://soundcloud.com/thegreatwomenartists/rebecca-vandiver-on-lois-mailou-jones)

p. 200 '"Freedom. To be shackle-free"', cited from Rowell, Charles H., 'Interview with Lois Mailou Jones', *Callaloo*, 1989, pp. 357–8 (https://www.jstor.org/stable/i347947)

BOOKS

VanDiver, Rebecca, *Designing a New Tradition: Loïs Mailou Jones and the Aesthetics of Blackness* (Pennsylvania State University Press, 2020)

MEDIA

Much of the factual information here has been extracted from the discussion on Hessel, Katy, *The Great Women Artists Podcast*, 'Rebecca K VanDiver on Loïs Mailou Jones', 9 December 2020 (https://soundcloud.com/thegreatwomenartists/rebecca-vandiver-on-lois-mailou-jones)

ELIZABETH CATLETT

NOTES

p. 202 '"take as your subject what you know best"', cited from Herzog, Melanie A., 'Elizabeth Catlett (1915–2012)', *American Art*, September 2012 (https://www.jstor.org/stable/10.1086/669226)

BOOKS

Herzog, Melanie A., *Elizabeth Catlett: An American Artist in Mexico* (University of Washington Press, 2005)

MEDIA

Much of the factual information here has been extracted from Hessel, Katy, *The Great Women Artists Podcast*, 'Melanie Herzog on Elizabeth Catlett', 1 September 2020 (https://soundcloud.com/thegreatwomenartists/melanie-herzog-on-elizabeth-catlett)

Thank you to Melanie A. Herzog and Rebecca K. VanDiver for reading this chapter.

A NEW VISION OF LANDSCAPE

GEORGIA O'KEEFFE

NOTES

p. 203 '"Men put me down as the best woman painter…"', Georgia O'Keeffe, cited from Chadwick, *Women, Art and Society*, p. 314

BOOKS

Barson, Tanya, *Georgia O'Keeffe* (Abrams, 2016)

Corn, Wanda M., *Georgia O'Keeffe: Living Modern* (Prestel, 2017)

EXHIBITIONS

Georgia O'Keeffe: Living Modern, curated by Wanda M. Corn, The Brooklyn Museum, 3 March 2017–23 July 2017

Georgia O'Keeffe, Tate Modern, 6 July 2016–30 October 2016

Georgia O'Keeffe, Centre Pompidou, 8 September–6 December 2021

MEDIA

Hessel, Katy, *The Great Women Artists Podcast*, 'Wanda M. Corn on Georgia O'Keeffe', 13 October 2020 (https://soundcloud.com/thegreatwomenartists/wanda-m-corn-on-georgia-okeeffe)

In conversation with Katy Hessel: Wanda M. Corn, Anna Hiddleston-Galloni.

AGNES PELTON

ARTICLES

Smith, Roberta, '"Agnes of the Desert" Joins Modernism's Pantheon', *The New York Times*, 12 March 2020 (www.nytimes.com/2020/03/12/arts/design/agnes-pelton-review-whitney-museum.html)

EXHIBITIONS

Agnes Pelton: Desert Transcendentalist, Whitney Museum of American Art, 13 March 2020–1 November 2020

MEDIA

Haskell, Barbara, and Humphreville, Sarah, 'Ask a Curator: Agnes Pelton: Desert Transcendentalist', Whitney Museum of American Art, 21 October 2020 (www.youtube.com/watch?v=uM-9MziL-6t8&t=1s&ab_channel=WhitneyMuseumofAmericanArt)

EMILY CARR

BOOKS

Milroy, Sarah; Dejardin, Ian A.C., *From the Forest to the Sea: Emily Carr in British Columbia* (Goose Lane Editions, 2017)

Thank you to Wanda M. Corn, India Rael Young and Rachel S. Zebro for reading and checking this chapter.

CHAPTER SEVEN: WAR AND THE RISE OF NEW METHODS AND MEDIA

DOROTHEA LANGE

NOTES

p. 209 '"The camera is an…."' Dorothea Lange, *Los Angeles Times*, 13 August 1978

BOOKS

Golbach, Jilke and Pardo, Alona, *Dorothea Lange: Politics of Seeing* (Prestel, 2018)

EXHIBITIONS

Dorothea Lange: Politics of Seeing, The Barbican Art Gallery, 22 June 2018–2 September 2018

Thank you to Alona Pardo for reading this passage.

KATI HORNA

ARTICLES

Naggar, Carole, 'Surrealist Photographs of the Spanish Civil War', *TIME Magazine*, 20 August 2014 (https://time.com/3811407/kati-horna-spanish-civil-war/)

EXHIBITIONS

Kati Horna, curated by Ángeles Alonso Espinosa and José Antonio Rodríguez, Jeu de Paume, 3 June 2014–21 September 2014

LEE MILLER

ARTICLES

Imperial War Museum, 'Lee Miller's Second World War' (www.iwm.org.uk/history/lee-millers-second-world-war)

MEDIA

Much of the factual information in this section and all quotations (including: p. 214 '"20,000 original photographs, and 60,000 negatives,"') are cited from Hessel, Katy, *The Great Women Artists Podcast*, 'Ami Bouhassane on Lee Miller', 21 October 2019 (https://soundcloud.com/thegreatwomenartists/ami-bouhassane-on-lee-miller)

THE SECOND WORLD WAR AND THE HOLOCAUST

HANNAH RYGGEN

NOTES

p. 215 'Ryggen once wrote to a friend, "What is dream and what is reality?"'. Hannah Ryggen wrote to her friend Helge Thiis in 1937, cited from Shirokawa, Nanase 'Weaving the Fabric of Resistance: The Tapestries of Hannah Ryggen and Cold War Anxiety', *Bowdoin Journal of Art*, 2018 (https://www.academia.edu/36437452/Weaving_the_Fabric_of_Resistance_The_Tapestries_of_Hannah_Ryggen_and_Cold_War_Anxiety)

BOOKS

Paasche, Marit, *Hannah Ryggen: Threads of Defiance* (Thames and Hudson, 2019)

ARTICLES

Attlee, James, 'Hannah Ryggen: Modern Art Oxford, UK', *Frieze*, 23 January 2018 (www.frieze.com/article/hannah-ryggen)

Sherwin, Skye, 'The woman who kept Hitler and Churchill in stitches: Hannah Ryggen Woven Histories review', *Guardian*, 14 November 2017 (https://www.theguardian.com/artanddesign/2017/nov/14/hannah-ryggen-woven-histories-review-modern-art-oxford)

EXHIBITIONS

Hannah Ryggen: Woven Histories, Modern Art Oxford, 11 November 2017–18 February 2018

Thank you to Stephanie Straine for reading this passage.

CHARLOTTE SALOMON

NOTES

p. 217 '"My life began… when I found out that I myself am the only one surviving. I felt as though the whole world opened up before me in all its depths and horror."'

'"I will live for them all."', cited from Bentley, Toni, 'The Obsessive Art and Great Confession of Charlotte Salomon', *The New Yorker*, 15 July 2017 (https://www.newyorker.com/culture/culture-desk/the-obsessive-art-and-great-confession-of-charlotte-salomon)

BOOKS

Belinfante, Judith and Benesch, Evelyn, *Charlotte Salomon: Life? or Theatre?* (Taschen, 2017)

Pollock, Griselda, *Charlotte Salomon and the Theatre of Memory* (Yale University Press, 2018)

EXHIBITIONS

Charlotte Salomon: Life? or Theatre?, Jewish Museum London, 8 November 2019–1 March 2020

MEDIA

Much of the factual information here, plus our discussion on the redemptive power of art, is cited from Hessel, Katy, *The Great Women Artists Podcast*, 'Chantal Joffe on Charlotte Salomon', 18 February 2021 (https://soundcloud.com/thegreatwomenartists/chantal-joffe-on-charlotte-salomon)

Thank you to Helen Atkinson for reading this passage.

ST IVES AND BRITISH ABSTRACTION

BARBARA HEPWORTH

NOTES

p. 219 '"I can't be unpolitically minded…"' Barbara Hepworth in an interview with Cindy Nemser, 1973. Cited from Bowness, Sophie, *Barbara Hepworth: Writings and Conversations* (Tate Publishing, 2015), p. 260

p. 222 '"I think every sculpture must be touched…"', Barbara Hepworth in a 1968 Westward Television documentary, cited from Tate, 'Who is Barbara Hepworth?' (www.tate.org.uk/art/artists/dame-barbara-hepworth-1274/who-is-barbara-hepworth)

BOOKS

Clayton, Eleanor, *Barbara Hepworth: Art & Life* (Thames and Hudson, 2021)

Stephens, Chris, *St Ives: The art and the artists* (Pavilion, 2018)

ARTICLES

Barbara Hepworth, 'Barbara Hepworth' (https://barbarahepworth.org.uk/)

Smith, Ali, 'Ali Smith: Looking at the world through the eyes of Barbara Hepworth', *The New Statesman*, 22 June 2015 (www.newstatesman.com/culture/2015/06/ali-smith-looking-world-through-eyes-barbara-hepworth)

Tate, 'Dame Barbara Hepworth 1903–1975' (https://www.tate.org.uk/art/artists/dame-barbara-hepworth-1274)

EXHIBITIONS

Barbara Hepworth: Art & Life, Hepworth Wakefield, 21 May 2021–27 February 2022

MEDIA

Baring, Jo, and Turner, Sarah, *Sculpting Lives* podcast, 'Sculpting Lives: Barbara Hepworth', 25 March 2020

Hessel, Katy, *The Great Women Artists Podcast*,

'Ali Smith on Barbara Hepworth, Pauline Boty, Tacita Dean, and Lorenza Mazzetti', 11 May 2021 (https://soundcloud.com/thegreatwomenartists/ali-smith-on-barbara-hepworth-pauline-boty-tacita-dean-and-lorenza-mazzetti)

In conversation with Katy Hessel: Sara Matson

Thank you to Sophie Bowness for reading this section.

WILHELMINA BARNS-GRAHAM

BOOKS

Gooding, Mel, *Wilhelmina Barns-Graham: Movement and Light Imag(in)ing Time* (Tate Publishing, 2004)

ARTICLES

Wall text: 'Island Sheds, St. Ives No. 1 (1940) by Barns-Graham', Tate St Ives (www.tate.org.uk/art/artworks/barns-graham-island-sheds-st-ives-no-1-t07546)

Wilhelmina Barns-Graham Trust (www.barns-grahamtrust.org.uk)

MARLOW MOSS

NOTES

p. 223 '"them/they"', referencing Tate, 'Queer Cornwall: Marlow Moss, Gluck and Ithell Colquhoun in Lamorna | Tate', 29 October 2021 (https://www.youtube.com/watch?v=uaOUp-C2Dzgw&t=3s)

BOOKS

Howarth, Lucy, *Marlow Moss: Modern Women Artists* (Eiderdown Books, 2019)

ARTICLES

Howarth, Lucy, 'Marlow Moss (1889–1958)', PhD dissertation, University of Plymouth, 2008 (https://pearl.plymouth.ac.uk/handle/10026.1/2528)

Howarth, Lucy, 'The lonely radical: Marlow Moss at Tate St Ives', *Tate etc.*, 25 June 2019 (www.tate.org.uk/tate-etc/issue-28-summer-2013/lonely-radical)

Thank you to Sara Matson, Lucy Howarth and Robert Airey for reading this chapter.

ART BEYOND THE MAINSTREAM

In conversation with Katy Hessel: Eleanor Nairne, Hannah Rieger and James Brett

BOOKS

Brugger, Ingried; Rieger, Hannah; Rudorfer, Veronika, *Flying High: Künstlerinnen der Art Brut* (Kehrer Verlag, 2019)

Fol, Carine, *From Art Brut to Art without Boundaries* (Skira Editore, 2015)

Nairne, *Jean Dubuffet: Brutal Beauty*

Peiry, Lucienne, trans., Frank, James, *Art Brut: The Origins of Outsider Art* (Flammarion, 2006)

Rhodes, Colin, *Outsider Art: Spontaneous Alternatives* (Thames and Hudson, 2000)

EXHIBITIONS

Jean Dubuffet: Brutal Beauty, curated by Eleanor Nairne, The Barbican Art Gallery, 17 May 2021–22 August 2021. Information on Corbaz; p. 225 '"raw art"' cited from *Jean Dubuffet: Brutal Beauty* (Prestel, 2021)

In conversation with Katy Hessel: James Brett, Hannah Rieger and Eleanor Nairne

MADGE GILL

NOTES

p. 226 '"trance-like state"', cited from Roberts, Vivienne, 'Star of Destiny: Madge Gill and

Spiritualism', in Dutton, Sophie, *Madge Gill by Myrninerest* (Rough Trade Books, 2019), p. 74

p. 227 '"My pictures take my mind off the worries"', Madge Gill in a letter to her friend Louise Morgan, cited from Dutton, Sophie, 'Introduction' in *ibid*, p. 11

BOOKS

Dutton, *Madge Gill by Myrninerest*

ARTICLES

Cardinal, Roger, 'Biography', Madge Gill (http://madgegill.com/biography)

ALOÏSE CORBAZ

NOTES

p. 228 '"supernatural worlds, theatre of the universe"', note by Aloïse Corbaz from her 1941 sketchbook, cited from Porret-Forel, Jacqueline, and Muzelle, Céline, *Aloïse: Le Ricochet Solaire* (5 Continents, 2012), p. 38

SISTER GERTRUDE MORGAN

NOTES

p. 229 '"headquarters of sin"', quotation by Morgan recounting her call from God, cited from DeCarlo, Tessa, 'Sister Gertrude, a Preacher Who Could Paint', *The New York Times*, 22 February 2004 (https://archive.nytimes.com/www.nytimes.com/ref/arts/design/22DECA.html)

p. 229 '"New Orleans as New Jerusalem"… '"God's wife"', cited from Clark, Emily Suzanne, 'New World, New Jerusalem, New Orleans: The Apocalyptic Art of Sister Gertrude Morgan', *Louisiana History: The Journal of the Louisiana Historical Association*, 2014. p. 454

BOOKS

Fagaly, William A., *Sister Gertrude Morgan: The Tools of her Ministry* (Rizzoli, 2004)

MEDIA

Whitley, Zoe; Brett, James; Fagaly; William, 'Sister Gertrude Morgan', The Museum of Everything, 14 December 2020 (www.facebook.com/watch/live/?v=142342494077700&ref=watch_permalink)

Zimmerman, Cara, '5 minutes with… *Aristoloches* by Aloïse Corbaz', Christie's, 3 January 2018 (https://www.christies.com/features/5-minutes-with-Aloise-Corbazs-Aristroloches-8817-1.aspx)

CLEMENTINE HUNTER

BOOKS

Lewis, *African American Art and Artists*

Whitehead, Kathy, and Evans, Shane W. (Illustrator), *Art From Her Heart: Folk Artist Clementine Hunter* (G.P. Putnam's Sons, 2008)

ARTICLES

Barice, Ashleigh, 'Clementine Hunter: dynamic depictions of America's rural south', *Art UK*, 9 March 2017 (https://artuk.org/discover/stories/clementine-hunter-dynamic-depictions-of-americas-rural-south)

Thank you to Eleanor Nairne, Hannah Rieger and James Brett for reading this chapter.

PART THREE: POSTWAR WOMEN (C. 1945–C. 1970)

NOTES

p. 234 '"… you have to think about Europe too and the Second World War…"', Grace Hartigan in conversation with Cindy Nemser, 1976, cited from Nemser, Cindy, *Art Talk: Conversations With 15 Women Artists* (Westview Press, 1996), p. 145

CHAPTER EIGHT: THE GREAT ERA OF EXPERIMENTALISM

ABSTRACT EXPRESSIONISM

NOTES

p. 237 '"Painting is not separate from life…."', Lee Krasner in 1960, cited from Rago, Louise E., 'We Interview Lee Krasner', *School Arts*, September 1960, p. 32

p. 237 information about WPA; art market sourced from Chadwick, 'Gender, Race, and Modernism after the Second World War', *Women, Art and Society*, pp. 331–70; Horejs, Jason, *RedDot Podcast*, 'Episode 022, An Interview With Ninth Street Women Author Mary Gabriel', 28 January 2021 (https://reddotblog.com/reddot-podcast-episode-022-an-interview-with-ninth-street-women-author-mary-gabriel-21/)

p. 237 'criticised for not being "serious" enough', cited from my conversation with Elizabeth Smith

p. 238 'many would deplore the thought of me categorising them as a "woman artist" at all…' For example: 'I can't talk anonymously about being a woman artist. All I can talk about is my own experience. To be truthful I didn't even think about being a woman. I thought about how difficult it was to paint.' Grace Hartigan in conversation with Cindy Nemser, 1976. Cited from Nemser, *Art Talk: Conversations With 15 Women Artists*, p. 128

p. 238 'fewer than 20 per cent of the artists included …' in reference to *Abstract Expressionism*, Royal Academy of Arts, 24 September 2016–2 January 2017

p. 238 '"the women were treated like cattle"', Lee Krasner, cited from Falconer, Morgan, 'New York nights: the Manhattan of the Abstract Expressionists', *RA Magazine*, 1 September 2016 (www.royalacademy.org.uk/article/new-york-nights-manhattan-of-abex)

p. 240 'It wasn't until much later on that Krasner… received the global recognition she so rightly deserves', I write this in reference to Gabriel, Mary *Ninth Street Women* (Little, Brown US, 2019); *Lee Krasner: Living Colour*, Barbican Centre, 30 May 2019–1 September 2019; *Joan Mitchell*, Baltimore Museum of Art, 6 March 2022–14 August 2022

BOOKS

Gabriel, *Ninth Street Women*

ed. Marter, Joan, *Women of Abstract Expressionism* (Yale University Press, 2016)

Nairne, Eleanor, *Lee Krasner: Living Colour* (Thames and Hudson, 2019)

Nemser, *Art Talk: Conversations With 15 Women Artists*

Rose, Barbara, *Lee Krasner: A Retrospective* (Museum of Modern Art, 1984), p. 9; *Lee Krasner: A Retrospective* exhibition catalogue, MoMA, 20 December 1984–12 February 1985

ARTICLES

Doss, Erika, 'Review: Not Just a Guy's Club Anymore', *American Quarterly*, 1998 (www.jstor.org/stable/pdf/30042171.pdf?refreqid=excelsior%3Aa34bca8f97d04332c8ec74f177fed0c4)

Falconer, Morgan, 'New York nights: the Manhattan of the Abstract Expressionists', *RA Magazine*, 1 September 2016 (www.royalacademy.org.uk/article/new-york-nights-manhattan-of-abex)

MEDIA

D'Augustine, Corey, 'Women Artists and Postwar Abstraction | HOW TO SEE the art movement with Corey D'Augustine', MoMA, 18 July 2017 (https://www.youtube.com/watch?v=n8yL-H4viZaM)

Dir. Martin, Fabia, 'An Introduction to Abstract Expressionism – Now Featuring Lee Krasner', Barbican Centre, 12 July 2019 (www.youtube.com/watch?v=0Ug3hBQIIt0&ab_channel=BarbicanCentre)

JANET SOBEL

NOTES

p. 239 'looking to Russian composer Dmitri Shostakovich's *Seventh Symphony*…', in reference to a quotation by Sobel: '*Music is my impression of the music of Shostakovich created in a world torn by war and bloodshed.*' Cited from Levin, Gail, 'Janet Sobel: Primitivist, Surrealist, and Abstract Expressionist', *Woman's Art Journal*, 2006, p. 8. She references Janis, Sidney, *Abstract & Surrealist Art in America* (Reynal & Hitchcock, 1944), pp. 87, 96–7

p. 239 '"I am a surrealist, I paint what I feel within me"'. Sobel in conversation with Bill Leonard 1946, cited from Zalman, Sandra, 'Janet Sobel: Primitive Modern and the Origins of Abstract Expressionism', *Woman's Art Journal*, 2015, p. 24

p. 239 'she was, according to prominent art critic Clement Greenberg …', cited from Greenberg, Clement, 'American-Type Painting Essay (1958 revised version)' in *Reading Abstract Expressionism* (Yale University Press, 2017); Greenberg's essay is inaccurate: Sobel did not show at Peggy Guggenheim's gallery in 1944, but 1945. Pollock saw Sobel's 1944 show at Puma Gallery. Although her influence on Pollock is the subject of much debate, Sobel started her 'all-over' paintings before Pollock. Cited from Levin, Gail, 'Janet Sobel: Primitivist, Surrealist, and Abstract Expressionist', *Woman's Art Journal*, 2005, p. 8. She notes: 'Rubin [MoMA curator] was interested in Sobel because her "all-over drip" painting… had influenced the abstract expressionist Jackson Pollock, a fact remarked in the late 1950s by no less an authority than the critic Clement Greenberg')

p. 240 'Jackson Pollock… was "enthralled"', Peter Busa to Melvin P. Lader, 26 May 1976; quoted in Kays, Judith S., *Mark Tobey and Jackson Pollock: Setting the Record Straight* (Museo Nacional Centro de Arte Reina Sofia, 1997), p. 102; cited from Levin, Gail, 'Primitivist, Surrealist, and Abstract Expressionist', p. 8

p. 240 '"Pollock, too employed astronomical themes…"', Levin, Gail, 'Janet Sobel: Primitivist, Surrealist, and Abstract Expressionist', *Woman's Art Journal*, 2005, p. 8

ARTICLES

Blackstone, Maya, 'Overlooked No More: Janet Sobel, Whose Art Influenced Jackson Pollock', *The New York Times*, 30 July 2021 (www.nytimes.com/2021/07/30/obituaries/janet-sobel-overlooked.html)

Levin, Gail, 'Janet Sobel: Primitivist, Surrealist, and Abstract Expressionist', *Woman's Art Journal*, 2005

Zalman, Sandra, 'Janet Sobel: Primitive Modern and the Origins of Abstract Expressionism', *Woman's Art Journal*, 2015

Thank you to Isabella St. Ivany for reading and checking this passage.

LEE KRASNER

NOTES

p. 240 '"I am nature"', Jackson Pollock quoted, 'Lee Krasner interview with Dorothy Seckler', Lee Krasner Papers (LKP), 14 December 1964

p. 240 '"The first man was an artist"', cited from ed., Chipp, Herschel B., 'Barnett Newman: The First Man was an Artist', *Theories of Modern Art* (London, 1968), pp. 551–2

p. 240 '"we broke the ground"', Lee Krasner in conversation with Cindy Nemser in 1976, cited from Nemser, *Art Talk: Conversations With 15 Women Artists*, p. 80

p. 240 '…"elementary school"'; full quotation: 'When I was ready to graduate from elementary school, I said I wanted to be an artist…', Lee Krasner in conversation with Cindy Nemser, 1976, cited from *ibid*, p. 70

p. 241 'Beginning with just a few rooms…', cited from Hessel, Katy, *The Great Women Artists Podcast*, 'Eleanor Nairne on Lee Krasner', 24 September 2019 (https://soundcloud.com/thegreatwomenartists/eleanor-nairne-on-lee-krasner)

p. 241 '…"work is so good, you would never have known it was done by a woman"', Lee Krasner in conversation with Barbara Rose, 1975, cited from Nairne, *Lee Krasner: Living Colour*, exhibition catalogue, The Barbican Art Gallery, 30 May 2019–1 September 2019

p. 244 '"that's hot. It's cooking!"', Lee Krasner quoting Clement Greenberg in conversation with Cindy Nemser, 'A Conversation', p. 44, cited from *ibid*.

p. 244 '"fixed image"…"break"', cited from Hessel, Katy, *The Great Women Artists Podcast*, 'Eleanor Nairne on Lee Krasner', 24 September 2019 (https://soundcloud.com/thegreatwomenartists/eleanor-nairne-on-lee-krasner)

p. 244 '"I was a woman, Jewish, a widow…"', Krasner in an interview with *Newsday* journalist, Amei Wallach, 1973, cited from Nairne, *Lee Krasner: Living Colour*

BOOKS

Levin, Gail, *Lee Krasner: A Biography* (Thames and Hudson, 2019)

Nairne, *Lee Krasner: Living Colour*, exhibition catalogue, The Barbican Art Gallery, 30 May 2019–1 September 2019

ARTICLES

Flint, Charlotte, 'Introducing: Lee Krasner', The Barbican Centre, 2019 (https://sites.barbican.org.uk/introducingleekrasner/)

Gilbert, Sophie, 'The Irrepressible Emotion of Lee Krasner', *The Atlantic*, 13 June 2019 (https://www.theatlantic.com/entertainment/archive/2019/06/lee-krasner-living-colour-barbican-retrospective-review/591499/)

EXHIBITIONS

Lee Krasner: Living Colour, The Barbican Art Gallery, 30 May 2019–1 September 2019

MEDIA

Hessel, Katy, *The Great Women Artists Podcast*, 'Eleanor Nairne on Lee Krasner', 24 September 2019 (https://soundcloud.com/thegreatwomenartists/eleanor-nairne-on-lee-krasner)

Gleason, Eric, and Hessel, Katy, 'Lee Krasner's Collage Paintings, Katy Hessel & Eric Gleason', Kasmin Gallery, 5 April 2021 (https://www.youtube.com/watch?v=tHs2TYJzIwY)

Molesworth, Helen, *Recording Artists by Getty* podcast, 'Lee Krasner: Deal with it', 12 November 2019 (https://www.getty.edu/recordingartists/season-1/krasner)

ELAINE DE KOONING

NOTES

p. 245 '"for a composite image"', Elaine de Kooning in 1964, cited from Brame Fortune, Brandon, *Elaine de Kooning: Portraits* (Prestel, 2015)

p. 245 'she translated through words her analyses of paintings and reviewed…' cited from Horejs, Jason, *RedDot Podcast*, 'Episode 022, An Interview with Ninth Street Women Author Mary Gabriel', 28 January 2021 (https://reddotblog.com/reddot-podcast-episode-022-an-interview-with-ninth-street-women-author-mary-gabriel-21/)

BOOKS

Gabriel, *Ninth Street Women*

ARTICLES

Moonan, Wendy, 'Why Elaine de Kooning Sacrificed Her Own Amazing Career for Her More-Famous Husband's', *Smithsonian Magazine*, 8 May 2015 (www.smithsonianmag.com/smithsonian-institution/why-elaine-de-kooning-sacrificed-her-own-amazing-career-her-more-famous-husbands-180955182/)

JOAN MITCHELL

NOTES

p. 246 'a wry set to her mouth…', cited from Schjeldahl, Peter, 'Tough Love: Resurrecting Joan Mitchell', *The New Yorker*, 7 July 2002 (www.newyorker.com/magazine/2002/07/15/tough-love-3)

p. 246 '(Remember Berthe Morisot's Garden at Marecourt …?)', Reference to Berthe Morisot, cited from Schjeldahl, Peter, 'Berthe Morisot, "Woman Impressionist," Emerges from the Margins', *The New Yorker*, 29 October 2018 (www.newyorker.com/magazine/2018/10/29/berthe-morisot-woman-impressionist-emerges-from-the-margins)

BOOKS

Roberts, Sarah, and Siegel, Katy, *Joan Mitchell* (Yale University Press, 2021)

ARTICLES

Sandler, Irving, 'Mitchell Paints a Picture', *ARTNews*, 1957 (www.joanmitchellfoundation.org/joan-mitchell/citations/mitchell-paints-a-picture)

EXHIBITIONS

Joan Mitchell, SFMoMA, 4 September 2021–17 January 2022

MEDIA

Hessel, Katy, *The Great Women Artists Podcast*, 'Eileen Myles on Joan Mitchell', 24 August 2021 (https://soundcloud.com/thegreatwomenartists/eileen-myles-on-joan-mitchell)

HELEN FRANKENTHALER

NOTES

p. 248 '"soak-stain"; p. 251 'footprints', cited from Hessel, Katy, *The Great Women Artists Podcast*, 'Elizabeth Smith on Helen Frankenthaler', 24 February 2021 (https://thegreatwomenartists/elizabeth-smith-on-helen-frankenthaler)

p. 249 '"dishonouring everything that painting had been about…"' cited from dir. Miller Adato, Perry, 'Frankenthaler: Toward A New Climate',

The Originals: Women in Art, WNET-Channel Thirteen, 1978

p. 249 '"martinis and Manhattans"', cited from Rose, Barbara, *Oral history interview with Helen Frankenthaler, 1968*, Smithsonian Archives of American Art (www.aaa.si.edu/download_pdf_transcript/ajax?record_id=edan-mdm-AAADCD_oh_212046)

p. 250 '"the landscapes were in my arms…"', Frankenthaler in 1965, cited from Geldzahler, Henry, 'An interview with Helen Frankenthaler', *Artforum*, October 1965 (www.artforum.com/print/196508/an-interview-with-helen-frankenthaler-36915)

BOOKS

Slifkin, Robert, Baro, Gene, Rudikoff, Sonia, and Geldzahler, Henry, *Imagining Landscapes: Paintings by Helen Frankenthaler, 1952–1976* (Rizzoli, 2021)

ARTICLES

Smith, Elizabeth, 'Colour Issues', *Public Journal*, 2015 (www.frankenthalerfoundation.org/images/PUBLIC_journal_COLOUR_ES_Article_Issue_51_web_horizontal.pdf)

EXHIBITIONS

Helen Frankenthaler: Radical Beauty, curated by Jane Findlay, Dulwich Picture Gallery, 15 September 2021–18 April 2022 (www.dulwichpicturegallery.org.uk/whats-on/exhibitions/2021/may/helen-frankenthaler-radical-beauty/)

Helen Frankenthaler, Tate Modern Collection Room, November 2019–December 2021

MEDIA

'Katy Hessel, Matthew Holman, and Eleanor Nairne on Helen Frankenthaler', *Gagosian*, 8 September 2021 (https://www.youtube.com/watch?v=82ubSF2ubnk)

Hessel, Katy, *The Great Women Artists Podcast*, 'Elizabeth Smith on Helen Frankenthaler', 24 February 2021 (https://soundcloud.com/thegreatwomenartists/elizabeth-smith-on-helen-frankenthaler)

Molesworth, Helen, *Recording Artists by Getty* podcast, 'Helen Frankenthaler: Let 'er Rip', 12 November 2019 (https://www.getty.edu/recordingartists/season-1/frankenthaler/)

LOUISE NEVELSON

BOOKS

Wilson, Laurie, *Louise Nevelson: Art is Life* (Thames and Hudson, 2016)

ed. Kamin Rapaport, Brooke, *The Sculpture of Louise Nevelson* (Yale University Press, 2007); *The Sculpture of Louise Nevelson*, exhibition catalogue, The Jewish Museum, New York, 5 May 2007–16 September 2007

Thank you to Eleanor Nairne, Elizabeth Smith and Laura Morris for reading this chapter.

BLACK MOUNTAIN COLLEGE

NOTES

p. 253 '"Art will make people better…"' Ruth Asawa, 1976. Cited from Nathan, Harriet, 'Oral history transcript / Ruth Asawa', Bancroft Library, 1974 & 1976, p. 110 (https://digicoll.lib.berkeley.edu/record/54622?ln=en)

p. 253 '"learn through doing"', cited from 'Helen Molesworth on Black Mountain College', Index Foundation Sweden, 18 November 2020 (http://indexfoundation.se/talks-and-events/talk-helen-molesworth-on-black-mountain-college)

p. 253 '"I tried to put my students at the point of zero…"', Anni Albers in conversation with Sevim Fesci in 1968, cited from Fesci, Sevim, 'Initiation: An Interview with Anni Albers', Archives of American Art, Smithsonian Institution, 5 July 1968 (https://black-mountain-research.com/2015/05/27/initiation-listening-and-reading-an-interview-by-anni-albers/)

p. 255 '"I spent three years there…"', Ruth Asawa, cited from Ruth Asawa Lanier Inc., 'Black Mountain College' (https://ruthasawa.com/life/black-mountain-college/)

p. 253–5 much of the information defining BMC is cited from 'Helen Molesworth on Black Mountain College', Index Foundation Sweden, 18 November 2020 (http://indexfoundation.se/talks-and-events/talk-helen-molesworth-on-black-mountain-college); Hessel, Katy, *The Great Women Artists Podcast*, 'Emma Ridgway on Ruth Asawa', 4 May 2021; *Question Everything!*, curated by Kate Averett and Alice Sebrell, Black Mountain College Museum + Art Center, 24 January 2020–20 March 2021 (www.blackmountaincollege.org/question-everything-the-women-of-black-mountain-college/; www.blackmountaincollege.org/womenofbmc/)

BOOKS

Molesworth, Helen, *Leap Before You Look: Black Mountain College, 1933–1957* (Yale University Press, 2015)

ARTICLES

Black Mountain College Museum + Art Center, 'Question Everything!: Women of Black Mountain College' (www.blackmountaincollege.org/womenofbmc/)

Black Mountain College Museum + Art Center, 'Women in Craft' (www.blackmountaincollege.org/women-in-craft/)

Fer, Briony, 'Anni Albers: Weaving Magic', *Tate Etc.*, 10 October 2018 (www.tate.org.uk/tate-etc/issue-44-autumn-2018/anni-albers-weaving-magic-briony-fer)

Yau, John, 'Ruth Asawa, a Pioneer of Necessity', *Hyperallergic*, 24 September 2017 (https://hyperallergic.com/401777/ruth-asawa-david-zwirner-2017/)

MEDIA

The Getty, *Art + Ideas* podcast, 'Helen Molesworth on Black Mountain College', 29 June 2016 (https://blogs.getty.edu/iris/audio-helen-molesworth-on-black-mountain-college/)

Bostic, Connie, 'Interview with Jacob Lawrence and Gwendolyn Knight Lawrence', Seattle, Washington, December 20, 1999 (https://www.blackmountaincollege.org/wp-content/uploads/Final_Edited-Bostic_Interview.pdf)

In conversation with Katy Hessel: Alice Sebrell

ANNI ALBERS

ARTICLES

Fer, Briony, 'Anni Albers: Weaving Magic', *Tate Etc.*, 10 October 2018 (www.tate.org.uk/tate-etc/issue-44-autumn-2018/anni-albers-weaving-magic-briony-fer)

Hicks, Sheila, 'My encounters with Anni Albers', *Tate Etc.*, 10 October 2018 (https://www.tate.org.uk/tate-etc/issue-44-autumn-2018/anni-albers-sheila-hicks)

BOOKS

Albers, Anni, *On Weaving* (Wesleyan University Press, 1965)

EXHIBITIONS

Anni Albers, curated by Briony Fer, Tate Modern, 11 October 2018–27 January 2019

RUTH ASAWA

NOTES

p. 256 'Curious and eager, she spent her childhood helping on the farm'; '…professional artists including Tom Okamoto…'; p. 257 'she took classes with Josef Albers (her personal mentor) and Buckminster Fuller (whose hair she cut as a volunteer barber!)', cited from Hessel, Katy, *The Great Women Artists Podcast*, 'Emma Ridgway on Ruth Asawa', 4 May 2021

ARTICLES

Katz, Vincent, Ruth Asawa (1926–2013), *Artforum*, 7 October 2013

La Force, Thessaly, 'The Japanese-American Sculptor Who, Despite Persecution, Made Her Mark', *The New York Times Style Magazine*, 20 July 2020 (www.nytimes.com/2020/07/20/t-magazine/ruth-asawa.html)

EXHIBITIONS

Ruth Asawa: Citizen of the Universe, curated by Emma Ridgway, Modern Art Oxford, 28 May 2022–21 August 2022 (www.modernartoxford.org.uk/event/citizen-of-the-universe/)

Revolution in the Making: Abstract Sculpture by Women, 1947–2016, Hauser & Wirth, Los Angeles, 13 March 2016–4 September 2016 (www.hauserwirth.com/hauser-wirth-exhibitions/5564-revolution-in-the-makingabstract-sculpture-by-women-1947-2016)

MEDIA

'Oral history interview with Ruth Asawa and Albert Lanier, 2002, June 21–July 5', Karlstrom, Paul, Archives of American Art (www.aaa.si.edu/download_pdf_transcript/ajax?record_id=edanmdm-AAADCD_oh_230409)

Much of the factual information here has been extracted from Hessel, Katy, *The Great Women Artists Podcast*, 'Emma Ridgway on Ruth Asawa', 4 May 2021 (https://soundcloud.com/thegreatwomenartists/emma-ridgway-on-ruth-asawa)

Thank you to Alice Sebrell and Emma Ridgway for reading this chapter.

GUTAI

NOTES

p. 258 '"As a group, however, we impose no rules…"', Jiro Yoshihara, *Gutai Art Manifesto*, 1956 (http://web.guggenheim.org/exhibitions/gutai/data/manifesto.html)

BOOKS

Tiampo, Ming and Munroe, Alexandra, *Gutai: Splendid Playground* (Guggenheim Museum Publications, 2013)

ARTICLES

Smith, Roberta, 'Japanese Gutai in the 1950s: Fast and Fearless', *The New York Times*, 14 June 2018 (www.nytimes.com/2018/06/14/arts/design/japanese-gutai-art-1950s.html)

Yoshimoto, Midori, 'Women Artists in the Japanese Postwar Avant-Garde: Celebrating a Multiplicity', *Woman's Art Journal*, 2006 (www.jstor.org/stable/pdf/20358068.pdf?refreqid=excelsior%3A7dcb13ef98563d30c90d0231ef4ff9e3)

EXHIBITIONS

Gutai Splendid Playground, The Guggenheim, 15 February 2013–8 May 2013 (www.guggenheim.org/exhibition/gutai-splendid-playground)

MEDIA

Munroe, Alexandra, 'The Guggenheim, Internationalism and Gutai', Guggenheim Museum, 5 December 2016 (https://www.guggenheim.org/video/the-guggenheim-internationalism-and-gutai)

Tiampo, Ming and Munroe, Alexandra, 'Gutai: Splendid Playground at the Guggenheim Museum', The Guggenheim, 29 April 2013 (www.youtube.com/watch?v=azEItP8X-vaA&t=70s&ab_channel=GuggenheimMuseum)

TANAKA ATSUKO

ARTICLES

Kunimoto, Namiko, 'Tanaka Atsuko's "Electric Dress" and the Circuits of Subjectivity', *The Art Bulletin*, 2013 (www.jstor.org/stable/pdf/43188842.pdf?refreqid=excelsior%3A5dc-3f11ad8039168c4a45f9b27656411)

Thank you to Ming Tiampo for reading this chapter.

POSTWAR PHOTOGRAPHY

FELICIA ANSAH ABBAN

ARTICLES

Das, Jareh, 'Felicia Ansah Abban', *Avril 27*, April 2019 (https://avril27.com/art-community/felicia-ansah-abban-text-jareh-das/)

ISHIUCHI MIYAKO

BOOKS

Maddox, Amanda, *Ishiuchi Miyako: Postwar Shadows* (Getty Publications and Yale University Press, 2015)

EXHIBITIONS

Ishiuchi Miyako: Frida, Michael Hoppen Gallery, 14 May 2015–10 July 2015 (www.michaelhoppengallery.com/exhibitions/23/overview/)

DIANE ARBUS

NOTES

p. 261 '"there's a point between…"', Diane Arbus, cited from Arbus, Doon, and Israel, Marvin, *Diane Arbus: An Aperture Monograph* (Aperture, 2012)

BOOKS

Lubow, Arthur, *Diane Arbus: Portrait of a Photographer* (Ecco Press, 2017)

ARTICLES

Als, Hilton, 'The Art of Difference', *The New York Review of Books*, 8 June 2017 (https://nybooks.com/articles/2017/06/08/diane-arbus-art-of-difference/)

Als, Hilton, 'Unmasked: A different kind of collection by Diane Arbus', *The New Yorker*, 19 November 1995 (https://www.newyorker.com/magazine/1995/11/27/unmasked-books-hilton-als)

Tate, 'Picture Essay: Three Images by Diane Arbus' (www.tate.org.uk/art/artists/diane-arbus-5271/three-images-diane-arbus)

CHAPTER NINE: POLITICAL CHANGE AND NEW ABSTRACTIONS

POP ART

NOTES

p. 263 '"A revolution is on the way…"' Pauline Boty to *The Public Ear*, 1963. Quoted in Tate, Sue, *Pauline Boty: Pop Artist and Woman* (Wolverhampton Art Gallery & Museums Publishing, 2013)

p. 264 '"masculine"… out of the 202 works on

view…' cited from Hessel, Katy, *The Great Women Artists Podcast*, 'Sue Tate on Pauline Boty', 10 March 2021 (https://soundcloud.com/thegreatwomenartists/gwap-sue-pauline-boty-final-with-ads-mixdown)

p. 268 information about 'Americanisation', cited from Hessel, Katy, *The Great Women Artists Podcast*, 'Griselda Pollock on Alina Szapocznikow', 25 November 2020 (https://soundcloud.com/thegreatwomenartists/griselda-pollock-on-alina-szapocznikow)

BOOKS

Morgan, Jessica, *The World Goes Pop* (Tate Publishing, 2015); *The World Goes Pop*, exhibition catalogue, Tate Modern, 17 September 2015–24 January 2016

Sachs, Sid and Kalliopi Minioudaki, *Seductive Subversion: Women Pop Artists 1958–1968* (Abbeville Press, 2010)

Stief, Angela, *Power Up: Female Pop Art* (DuMont Buchverlag, 2010)

Tate, *Pauline Boty: Pop Artist and Woman*

EXHIBITIONS

The World Goes Pop, Tate Modern, 17 September 2015–24 January 2016

MARISOL

NOTES

Chadwick, Whitney, *Women, Art and Society*, pp. 350–5

Parker and Pollock, *Old Mistresses: Women, Art, and Ideology*, pp. 151–2

p. 265 '"clever as the very devil and catty as can be"', John Canaday about Boty, *The New York Times*, 1967, cited from Grimes, William, 'Marisol, an Artist Known for Blithely Shattering Boundaries, Dies at 85', *The New York Times*, 2 May 2016 (www.nytimes.com/2016/05/03/arts/design/marisol-an-artist-known-for-blithely-shattering-boundaries-dies-at-85.html)

p. 267 information around 'quintessential American item…' cited from a discussion between KH and Flavia Frigeri, 2020

MEDIA

Hessel, Katy, *The Great Women Artists Podcast*, 'Flavia Frigeri on Marisol', October 2021 (https://soundcloud.com/thegreatwomenartists/flavia-frigeri-on-marisol)

In conversation with Katy Hessel: Flavia Frigeri

MARTHA ROSLER

ARTICLES

Hubber, Laura, 'The Living Room War: A Conversation with Artist Martha Rosler', *Getty Blogs*, 16 February 2017 (https://blogs.getty.edu/iris/the-living-room-war-a-conversation-with-artist-martha-rosler/)

Merjian, Ara H., 'Martha Rosler Still Brings the War Home', *Frieze*, 16 January 2019 (www.frieze.com/article/martha-rosler-still-brings-war-home)

MoMA, 'Martha Rosler: *House Beautiful: Bringing the War Home* (c. 1967–72)' (www.moma.org/collection/works/152791)

MEDIA

MoMA, 'House Beautiful (Bringing the War Home), 1967–72 SEEING THROUGH PHOTOGRAPHS', 13 February 2019 (www.moma.org/collection/works/152791)

MoMA, *Modern Art & Ideas*, 'How artists respond to political crises', 13 January 2017 (www.you-

tube.com/watch?v=whyXxfmCbTA&ab_chan-nel=TheMuseumofModernArt)

BRITISH POP ART/JANN HAWORTH/ PAULINE BOTY

NOTES

p. 269 '"Wimbledon Bardot"', cited from Watling, Sue, and Mellor, David Alan, *The Only Blonde in the World: Pauline Boty (1938–1966)*, (AM Publications, 1998); *The Only Blonde in the World: Pauline Boty (1938–1966)*, exhibition catalogue, Whitford Fine Art & The Mayor Gallery Ltd., 1998, p. 1

p. 269 '"It's almost like painting mythology…"', Pauline Boty, cited from Smith, Ali, 'Ali Smith on the prime of pop artist Pauline Boty', *Guardian*, 22 October 2016 (www.theguardian.com/ books/2016/oct/22/ali-smith-the-prime-of-pauline-boty)

BOOKS

Smith, Ali, *Autumn* (Penguin, 2017)

Tate, *Pauline Boty: Pop Artist and Woman*

ARTICLES

Laing, Olivia, 'Interview: Ali Smith: "It's a pivotal moment … a question of what happens culturally when something is built on a lie"', *Guardian*, 16 October 2016 (www.theguardian. com/books/2016/oct/16/ali-smith-autumn-interview-how-can-we-live-ina-world-and-not-put-a-hand-across-a-divide-brexit-profu)

Rosenberg, Karen, 'Overlooked No More: Pauline Boty, Rebellious Pop Artist', *The New York Times*, 20 November 2019 (www.nytimes. com/2019/11/20/obituaries/pauline-boty-over-looked.html)

EXHIBITIONS

Jann Haworth: Close Up, Pallant House Gallery, 2 November 2019–23 February 2020 (https://pal-lant.org.uk/whats-on/jann-haworth-close-up/)

MEDIA

Much of the factual information has been extracted from Hessel, Katy, *The Great Women Artists Podcast*, 'Sue Tate on Pauline Boty', 10 March 2021 (https://soundcloud.com/ thegreatwomenartists/gwap-sue-pauline-boty-final-with-ads-mixdown)

In conversation with Katy Hessel: Sue Tate

EVELYNE AXELL

ARTICLES

Coustou, Elsa, 'Evelyne Axell', Tate, September 2015 (www.tate.org.uk/whats-on/tate-modern/ exhibition/ey-exhibition-world-goes-pop/ artist-biography/evelyne-axell)

Gavin, Francesca, 'Evelyne Axell: pop art's forgotten star takes the limelight', *Financial Times*, 6 August 2020 (www.ft.com/con-tent/2734fc86-297b-429e-ba70-21b88acd748e)

EXHIBITIONS

Evelyne Axell: Body Double, curated by Anke Kempkes and Krzysztof Kościuczuk, Muzeum Susch, 1 August 2020–22 May 2021 (www. muzeumsusch.ch/en/1301/Evelyne-Ax-ell-Body-Double)

MEDIA

Morgan, Jessica, and Frigeri, Flavia, 'The World Goes Pop at Tate Modern', Philippe Axel (https://www.youtube.com/ watch?v=TuHnkLGxyV8&ab_channel=Philip-peAxell)

Thank you to Sue Tate and Flavia Frigeri for reading this chapter.

THE CIVIL RIGHTS ERA

BOOKS

Butler, Cornelia, and Mark, Lisa Gabrielle, *WACK!: Art and the Feminist Revolution* (MIT Press, 2007); *WACK!: Art and the Feminist Revolution*, exhibition catalogue, MOCA, 4 March 2007–16 July 2007

Much of the information for this section was learnt and drawn from this significant book: Godfrey, Mark, and Whitley, Zoé, *Soul of a Nation: Art in the Age of Black Power*, (Distributed Art Publishers, 2017). The essays 'American Skin: Artists on Black Figuration' (Whitley, Zoé) and 'Black Women Artists' (p. 110–111) are especially useful; *Soul of a Nation: Art in the Age of Black Power*, Tate Modern, 12 July 2017–22 October 2017.

Lewis, *African American Art and Artists*

ed. Morris, Catherine, and Hockley, Rujeko, *We Wanted a Revolution: Black Radical Women, 1965–85: New Perspectives* (Duke University Press, 2017); *We Wanted a Revolution: Black Radical Women, 1965–85: New Perspectives*, exhibition catalogue, The Brooklyn Museum, 21 April 2017–17 September 2017

ARTICLES

Smith, Valerie, 'Abundant Evidence: Black Women Artists of the 1960s and 70s', in Butler, and Mark, *WACK!: Art and the Feminist Revolution* (www.amherst.edu/system/files/ media/0115/Butler_Abundant_Evidence_Black_ Women_Art.PDF)

EXHIBITIONS

We Wanted a Revolution: Black Radical Women, 1965–85: New Perspectives, curated by Catherine Morris and Rujeko Hockley, The Brooklyn Museum, 21 April 2017–17 September 2017

We Wanted a Revolution: Black Radical Women, 1965–85: New Perspectives, exhibition catalogue, Albright-Knox Art Gallery, 17 February 2018–27 May 2018

MEDIA

Symposium: *We Wanted a Revolution*, 'Interview – Faith Ringgold and Dindga McCannon with Catherine Morris', Brooklyn Museum, 21 April 2017

Symposium: *We Wanted a Revolution*, 'Panel Discussion: Just Above Midtown, East and West: Performance, Gesture, and Space-Making by Black Women Artists: Uri McMillan with Linda Goode Bryant, Maren Hassinger, and Lorraine O'Grady', Brooklyn Museum, 21 April 2017

Symposium: *We Wanted a Revolution*, 'Panel Discussion: "Ain't Nothin' Goin' On But the Rent": 1980s New York: Rujeko Hockley with Kellie Jones, Lisa Jones, and Lorna Simpson', Brooklyn Museum, 21 April 2017

Gipson, Ferren, *Art Matters*, 'Soul of a Nation ft. Zoé Whitley – Episode 60', 16 June 2020 (https://podtail.com/de/podcast/art-matters/ soul-of-a-nation-ft-zoe-whitley-episode-60/)

EMMA AMOS

NOTES

p. 273 '"Every time I think about colour it's a political statement…"', Amos in conversation with Lucy Lippard in 1991, cited from Lippard, Lucy, 'Floating Falling Landing: An Interview with Emma Amos', *Art Papers*, 1991 (www.jour-nals.uchicago.edu/doi/full/10.1086/689715#fn3)

BOOKS

Godfrey and Whitley, *Soul of a Nation: Art in the*

Age of Black Power, exhibition catalogue, Tate Britain, 12 July 2017–22 October 2017, pp. 110–11

ARTICLES

Cotter, Holland, 'Emma Amos, Painter Who Challenged Racism and Sexism, Dies at 83', *The New York Times*, 29 May 2020 (www.nytimes. com/2020/05/29/arts/emma-amos-dead.html)

Cotter, Holland, 'To Be Black, Female and Fed Up With the Mainstream', *The New York Times*, 20 April 2017 (www.nytimes.com/2017/04/20/ arts/design/review-we-wanted-a-revolu-tion-black-radical-women-brooklyn-museum. html)

Frieze Editors, 'Brooklyn Museum Acquires 96 Pieces by Female Artists In Effort to Broaden "Historic Narratives"', *Frieze*, 6 June 2018 (www. frieze.com/article/brooklyn-museum-ac-quires-96-pieces-female-artists-effort-broad-en-historic-narratives)

Valentine, Victoria L., 'Cleveland Museum of Art Has Acquired a Significant Painting by Emma Amos', *Culture Type*, 20 June 2018 (www. culturetype.com/2018/06/20/cleveland-muse-um-of-art-has-acquired-a-significant-painting-by-emma-amos/)

EXHIBITIONS

Soul of a Nation: Art in the Age of Black Power, curated by Zoé Whitley and Mark Godfrey, Tate Modern, 12 July 2017–22 October 2017

MEDIA

Higgie, *Bow Down: Women in Art* podcast, 'Duro Olowu on Emma Amos', 10 September 2020 (https://www.frieze.com/article/bow-down-duro-olowu-emma-amos)

BETYE SAAR

NOTES

p. 274 Much of the factual information is cited from Hessel, Katy, *The Great Women Artists Pod-cast*, 'Zoé Whitley on Betye Saar', 17 December 2019 (including the discussion on transforming discarded (and often oppressive) objects into sculptures of meaning) (https://soundcloud. com/thegreatwomenartists/zoe-whitley-on-betye-saar)

p. 275 'According to acclaimed radical political activist, Angela Davis…', cited from Sayej, Nadja, 'Betye Saar: the artist who helped spark the black women's movement', *Guardian*, 30 October 2018 (www.theguardian.com/ artanddesign/2018/oct/30/betye-saar-art-exhibit-racism-new-york-historical-society)

ARTICLES

Cotter, Holland, '"It's About Time!" Betye Saar's Long Climb to the Summit', *The New York Times*, 4 September 2019 (www.nytimes. com/2019/09/04/arts/design/betye-saar.html)

Nittle, Nadra, 'Betye Saar: the brilliant artist who reversed and radicalised racist stereotypes', *Guardian*, 23 September 2021 (www.theguardian. com/society/2021/sep/23/betye-saar-the-brilliant-artist-who-reversed-and-radicalised-racist-stereotypes)

The Berkeley Revolution, '*The Liberation of Aunt Jemima* (1972) by Betye Saar' (http://revolution. berkeley.edu/liberation-aunt-jemima/)

ELIZABETH CATLETT

NOTES

p. 276 '"I have always wanted my art to service Black people…"' Elizabeth Catlett, cited from, Whitley, Zoé, 'American Skin: Artists on Black

Figuration' in Godfrey, and Whitley, *Soul of a Nation: Art in the Age of Black Power*, p. 207; Whitley cites Lewis, Samella, *Art: African American* (New York, 1978), p. 125

BOOKS

Jones, Kellie, 'Swimming with E. C.' in eds. Hockley, and Morris, *We Wanted A Revolution: Black Radical Women, 1965–1985: New Perspectives*

MEDIA

Much of the factual information cited from Hessel, Katy, *The Great Women Artists Podcast*, 'Melanie Herzog on Elizabeth Catlett', 1 September 2020 (https://soundcloud.com/thegreatwomenartists/melanie-herzog-on-elizabeth-catlett)

FAITH RINGGOLD

NOTES

p. 277 '"tell my story as a Black woman in America"', quotation by Faith Ringgold, cited from 'Faith Ringgold: In Conversation', *Tate Talks*, 5 July 2018 (https://www.youtube.com/watch?v=g5tbIjNwyrg)

p. 277 'AfriCOBRA' definition, Tate: Art Terms (www.tate.org.uk/art/art-terms/a/africobra); 'The Chicago-based *AfriCOBRA* (African Commune of Bad Relevant Artists) broke away from traditional American and European ...', cited from Morgan, Jo-Ann, *The Black Arts Movement and the Black Panther Party in American Visual Culture* (Taylor & Francis, 2018), which cites Donaldson, Jeff, *Black World*, July 1970, *AfriCOBRA at the Studio Museum in Harlem*, p. 89

Whitley, 'American Skin: Artists on Black Figuration' in Godfrey and Whitley, *Soul of a Nation: Art in the Age of Black Power*, pp. 204–11

EXHIBITIONS

Much of the factual information cited from *Faith Ringgold* (exhibition and guide), curated by M. Blanchflower and N. Grabowska, Serpentine Galleries, 6 June 2019–8 September 2019 (www.serpentinegalleries.org/whats-on/faith-ringgold/)

MEDIA

Hessel, Katy, *The Great Women Artists Podcast*, 'Hans Ulrich Obrist on Faith Ringgold and Luchita Hurtado', 28 January 2020 (https://soundcloud.com/thegreatwomenartists/hans-ulrich-obrist-on-faith-ringgold-and-luchita-hurtado)

MING SMITH

NOTES

p. 280 '"a group of people acting together"', *Working Together: The Photographers of the Kamoinge Workshop*, The Whitney Museum of American Art, 21 November 2020–28 March 2021 (https://whitney.org/exhibitions/kamoinge-workshop); definition also drawn from Godfrey, and Whitley, *Soul of a Nation: Art in the Age of Black Power*

BOOKS

Eckhardt, Sarah, *Working Together: Louis Draper and the Kamoinge Workshop* (Duke University Press Books, 2020)

Smith, Ming, Iduma, Emmanuel, Hill Talbert, Janet, Jayawardane, M. Neelika, Serpell, Namwali, Tate, Greg, Jafa, Arthur, Obrist, Hans Ulrich, and Murray, Yxta Maya, *Ming Smith: An Aperture Monograph* (Aperture, 2020)

CAROLYN MIMS LAWRENCE

ARTICLES

DeBerry, Linda, 'Soul of a Nation: An Interview with Carolyn Mims Lawrence', Crystal Bridges Museum of Modern Art, 12 February 2018 (https://crystalbridges.org/blog/soul-of-a-nation-an-interview-with-carolyn-mims-lawrence/)

SUZANNE JACKSON

NOTES

p. 281 'Black Emergency Cultural Coalition (BECC)...', Cooks, Bridget R., 'Black Artists and Activism: Harlem on My Mind (1969)', *American Studies*, 2007, pp. 5–39 (www.jstor.org/stable/pdf/40644000.pdf?refreqid=excelsior%3Ab-8e231c5df3e6a0ad330d56b06cd5aae); Godfrey, and Whitley, *Soul of a Nation: Art in the Age of Black Power*, p. 80–81

ARTICLES

Smith, Melissa, '"We Had to Do It For Ourselves": Legendary Gallerist and Artist Suzanne Jackson on Why the Art World Has Never Gotten Her Story Right', Artnet, 20 November 2019 (https://news.artnet.com/art-world/suzanne-jackson-interview-1709232)

Thank you to Melanie Herzog and Rebecca K. VanDiver for reading this chapter.

MINIMALIST IDEAS AND OTHER ABSTRACTIONS

AGNES MARTIN

BOOKS

Morris, Frances, Bell, Tiffany, *Agnes Martin: exhibition book*, (Tate Publishing, 2015)

Princenthal, Nancy, *Agnes Martin: Her Life and Art* (Thames and Hudson, 2018)

ARTICLES

Laing, Olivia, 'Agnes Martin: the artist mystic who disappeared into the desert', *Guardian*, 22 May 2015 (www.theguardian.com/artanddesign/2015/may/22/agnes-martin-the-artist-mystic-who-disappeared-into-the-desert)

EXHIBITIONS

Agnes Martin, curated by Frances Morris, Tate Modern, 3 June 2015–11 October 2015 (www.tate.org.uk/whats-on/tate-modern/exhibition/agnes-martin)

MEDIA

Much of the factual information cited from Hessel, Katy, *The Great Women Artists Podcast*, 'Frances Morris on Agnes Martin', 12 November 2019 (https://soundcloud.com/thegreatwomenartists/frances-morris-on-agnes-martin)

Higgie, *Bow Down: Women in Art* podcast, 'Olivia Laing on Agnes Martin', 1 August 2020 (https://www.frieze.com/article/bow-down-olivia-laing-agnes-martin)

YAYOI KUSAMA

NOTES

p. 285 '"to grab everything that went on in the city and become a star"', Yayoi Kusama in conversation with Akira Tatehata, cited from Tatehata, Akira; Hoptman, Laura; Kultermann, Udo; Taft, Catherine, *Yayoi Kusama: revised & expanded edition* (Phaidon, 2017), pp. 8–30

p. 285 '"mountains of creative energy stored inside myself"', Yayoi Kusama, cited from 'Yayoi Kusama – Obsessed with Polka Dots', Tate, 6 February 2012 (https://youtu.be/rRZB3nsiIeA)

p. 286 'Warhol...', references dir. Lenz, Heather, *Kusama – Infinity*, Dogwoof Studios, 2018

p. 287 'her own clothing line', cited from Hessel, Katy, *The Great Women Artists Podcast*, 'Stephanie Rosenthal on Yayoi Kusama', 20 April 2021 (https://soundcloud.com/thegreatwomenartists/stephanie-rosenthal-on-yayoi-kusama)

BOOKS

Manns, Erin, Stephenson, Kathy, Turner, Cat, Coomer, Martin, *Yayoi Kusama* (Victoria Miro Gallery, 2016)

Morris, Frances, *Yayoi Kusama* (Tate Publishing, 2011)

EXHIBITIONS

Yayoi Kusama: White Infinity Nets, Victoria Miro, 1 October 2013–16 November 2013

Yayoi Kusama, curated by Frances Morris, Tate Modern, 9 February 2012–5 June 2012

MEDIA

Morris, Frances '1989/Yayoi Kusama – Talk by Frances Morris, Tate', Modern Art Oxford, 23 March 2016

BRIDGET RILEY

NOTES

p. 288 '"On a fine day..."', quotation from Riley, Bridget, *The Pleasures of Sight*, 1984', cited from The Fitzwilliam Museum, Cambridge, '*Shadowplay* (2001) by Bridget Riley' (https://fitzmuseum.cam.ac.uk/objects-and-artworks/highlights/PD56-1996)

BOOKS

Kudielka, Robert, Tommasini, Alexandra, Naish, Natalia, *Bridget Riley: The Complete Paintings* (Thames and Hudson, 2018)

EXHIBITIONS

Bridget Riley, Hayward Gallery, 23 October 2019–26 January 2020

MEDIA

BBC 2, *The Culture Show*, 'Episode 15', 25 November 2010 (https://www.bbc.co.uk/programmes/b00wcmkc)

BBC 2, 'Bridget Riley – Painting the Line', 19 November 2021 (https://www.bbc.co.uk/programmes/m0011psx)

Lauson Cliff, 'Bridget Riley: The Art of Perception', *HENI Talks*, 22 December 2020 (https://henitalks.com/talks/bridget-riley/)

National Galleries of Scotland, 'Bridget Riley In Conversation with Sir John Leighton', 16 July 2019 (https://www.nationalgalleries.org/sites/default/files/transcriptions/Video%20Transcript%20Bridget%20Riley.pdf)

ALMA THOMAS

NOTES

p. 288 '"Alma stripes"', a term used by Nikki A. Greene, in Berry, Ian, and Haynes, Lauren, *Alma Thomas* (Prestel, 2016), p. 53

p. 288 '"A world without colour would seem dead. Colour, for me, is life."', cited from *ibid*, p. 204

p. 290 'interpreted by scholars as...', cited from Hessel, Katy, *The Great Women Artists Podcast*, 'Bridget R Cooks on Alma Thomas', 11 August 2020 (https://soundcloud.com/thegreatwomenartists/bridget-r-cooks-on-alma-thomas)

BOOKS

Berry, and Haynes, *Alma Thomas*, exhibition catalogue, The Studio Museum in Harlem, 14 July 2016–30 October 2016

MEDIA

Much of the factual information cited from

Hessel, Katy, *The Great Women Artists Podcast*, 'Bridget R Cooks on Alma Thomas', 11 August 2020 (https://soundcloud.com/thegreatwomenartists/bridget-r-cooks-on-alma-thomas)

In conversation with Katy Hessel: Bridget R Cooks

CARMEN HERRERA

ARTICLES

Hattenstone, Simon, 'Carmen Herrera: "Men controlled everything, not just art"', *Guardian*, 31 December 2016 (www.theguardian.com/artanddesign/2016/dec/31/carmen-herrera-men-controlled-everything-art)

BOOKS

Miller, Dana, *Carmen Herrera: Lines of Sight* (Yale University Press, 2016); *Carmen Herrera: Lines of Sight*, exhibition catalogue, The Whitney Museum of American Art, 16 September 2016–9 January 2017

EXHIBITIONS

Carmen Herrera: Lines of Sight, curated by Dana Miller, The Whitney Museum of American Art, 16 September 2016–9 January 2017 (https://whitney.org/exhibitions/carmen-herrera)

ETEL ADNAN

MEDIA

'Hans Ulrich Obrist visits Etel Adnan', *HENI Talks*, 24 February 2020 (https://henitalks.com/talks/hans-ulrich-obrist-visits-etel-adnan/)

FAHRELNISSA ZEID

EXHIBITIONS

Fahrelnissa Zeid, Tate Modern, 13 June 2017–8 October 2017

MEDIA

Tate, 'Fahrelnissa Zeid – 'She Was the East and the West' | Tate', 31 May 2017 (https://www.tate.org.uk/art/artists/fahrelnissa-zeid-22764/fahrelnissa-zeid-she-was-east-and-west)

MONIR SHAHROUDY FARMANFARMAIAN

EXHIBITIONS

Monir Shahroudy Farmanfarmaian: Infinite Possibility. Mirror Works and Drawings, 1974–2014, The Guggenheim, 13 March 2015–3 June 2015

POSTWAR BRAZIL

NOTES

In conversation with Katy Hessel: Dr Sofia Gotti

Galan, Daniela, Lecture Series, *Amalgama*, (www.artamalgama.com)

p. 294 '…Communist Party became legal in Brazil…' information cited from *Amalgama*

LINA BO BARDI

ARTICLES

Baratto, Romullo, 'Spotlight: Lina Bo Bardi', *ArchDaily*, 4 December 2019 (www.archdaily.com/575429/spotlight-lina-bo-bardi)

Camacho, Sol, 'Retrospective: Lina Bo Bardi', *The Architectural Review*, 13 January 2020 (www.architectural-review.com/essays/retrospective/retrospective-lina-bo-bardi)

EXHIBITIONS

Isaac Julien: Lina Bo Bardi – A Marvellous Entanglement, Victoria Miro, 7 June 2019–27 July 2019

LYGIA PAPE

MEDIA

Hauser & Wirth, 'In Conversation: Connie Butler & Julieta González on "Lygia Pape. Tupinambá"', 17 June 2017

LYGIA CLARK

EXHIBITIONS

Lygia Clark: Painting As An Experimental Field, 1948–1958, The Guggenheim Bilbao, 6 March 2020–25 October 2020

Lygia Clark: The Abandonment of Art, 1948–1988, MoMa, 10 May 2014–24 August 2014

Thank you to Sofia Gotti, Flavia Frigeri, Rachel Taylor and Leslie Ramos for reading this chapter.

CHAPTER TEN: THE BODY

NOTES

p. 299 '"Sculpture allows me to re-experience the past…"', Bourgeois, Louise, 'Self-Expression is Sacred and Fatal', in Meyer-Thoss, Christiane, *Louise Bourgeois: Designing for Free Fall* (Ammann Verlag, 1992), p. 195

BOOKS

Laing, Olivia, *Everybody* (Pan Macmillan, 2021)

Lippard, Lucy, 'Eccentric Abstraction', *Changing: Essays in Art Criticism* (Dutton Paperback, 1971)

This chapter draws from my discussions with Briony Fer and Griselda Pollock on *The Great Women Artists Podcast* (2019–present)

EXHIBITIONS

Louise Bourgeois: The Return of the Repressed, curated by Philip Larratt-Smith, Fundación Proa, 26 March 2011–June 26 2011

EVA HESSE

NOTES

p. 300 '"I have so much stored inside me recently…"', from the diaries of Eva Hesse, 1959, cited from ed. Rosen, Barry, and Bloomberg, Tamara, *Eva Hesse: Diaries* (Hauser & Wirth Publishers, 2020), p. 203

p. 300 '"breast and penis"', quotation by Eva Hesse in a letter to Sol LeWitt, 1965, cited from *Eva Hesse*, 'Eva Hesse: Exhibition Guide: Room 5', Tate Modern, 13 November 2002–9 March 2003

EXHIBITIONS

Eva Hesse, Tate Modern, 13 November 2002–9 March 2003

MEDIA

Dir. Begleiter, Marcie, 'Eva Hesse', Kino International, 2017

Much of the factual information cites Hessel, Katy, *The Great Women Artists Podcast*, 'Briony Fer on Eva Hesse', 23 June 2020, (including reference to Simone de Beauvoir) (https://soundcloud.com/thegreatwomenartists/briony-fer-on-eva-hesse)

ALINA SZAPOCZNIKOW

NOTES

p. 299 'Borrowing from a range of styles … malleable media', cited from Hessel, Katy, *The Great Women Artists Podcast*, 'Griselda Pollock on Alina Szapocznikow', 25 November 2020 (https://soundcloud.com/thegreatwomenartists/griselda-pollock-on-alina-szapocznikow)

p. 302 '"awkward objects"', Alina Szapocznikow has also referred to her works as 'the fleeting moments of life, its paradoxes and absurdity', quotations by Alina Szapocznikow in a 1972 statement, cited in Norton, Margot and Pyś, Pavel S., *To Exalt the Ephemeral: Alina Szapocznikow, 1962–1972* (Hauser & Wirth Publishing, 2019), p. 12

p. 304 '"the fleeting moments of life, its paradoxes and absurdity"', cited from *ibid*, p12

BOOKS

Norton and Pyś, *To Exalt the Ephemeral: Alina Szapocznikow, 1962–1972*; *To Exalt the Ephemeral: Alina Szapocznikow, 1962–1972*, exhibition catalogue, Hauser & Wirth, London, 7 February 2020–14 August 2020

ARTICLES

The Hepworth Wakefield, 'Alina Szapocznikow timeline' (https://hepworthwakefield.org/timeline/)

EXHIBITIONS

Alina Szapocznikow: Human Landscapes, The Hepworth Wakefield, 21 October 2017–28 January 2018

To Exalt the Ephemeral: Alina Szapocznikow, 1962–1972, Hauser & Wirth, London, 7 February 2020–14 August 2020

MEDIA

Hessel, Katy, *The Great Women Artists Podcast*, 'Griselda Pollock on Alina Szapocznikow', 25 November 2020 (https://soundcloud.com/thegreatwomenartists/griselda-pollock-on-alina-szapocznikow)

NIKI DE SAINT PHALLE

NOTES

p. 304 '"Why the nanas?"', Niki de Saint Phalle, *La Metropole*, 23 February 1972, cited from Niki Charitable Art Foundation, 'The Evolution of a Woman Artist' (http://nikidesaintphalle.org/evolution-woman-artist/)

p. 304 '"grand fertility goddess"', cited from Rudick, Nicole, *What Is Now Known Was Once Only Imagined: An (Auto)biography of Niki de Saint Phalle* (Siglio Press, 2022), p. 90

p. 305 '"lifelong desire to live inside a sculpture"', *ibid*, p. 185

Chadwick, *Women, Art and Society*, pp. 350–53

BOOKS

de Saint Phalle, Niki, *The Tarot Garden* (Benteli Verlag, 2003)

Groom, Simon, *Niki de Saint Phalle* (Tate Publishing, 2008)

ARTICLES

Hessel, Katy, 'Tucked in the Tuscan Countryside, Niki de Saint Phalle's Mystical Sculpture Park Celebrates Femininity', *Artsy*, 15 July 2017 (www.artsy.net/article/artsy-editorial-tucked-tuscan-countryside-artists-mystical-sculpture-park-celebrates-femininity)

Levy, Ariel, 'Beautiful Monsters: Art and obsession in Tuscany', *The New Yorker*, 11 April 2016 (www.newyorker.com/magazine/2016/04/18/niki-de-saint-phalles-tarot-garden)

Schjeldahl, Peter, 'The Pioneering Feminism of Niki de Saint Phalle', *The New Yorker*, 29 March 2021 (www.newyorker.com/magazine/2021/04/05/the-pioneering-feminism-of-niki-de-saint-phalle)

Tellgren, Anna, 'Remembering She – A Cathedral', Moderna Museet (www.modernamuseet.se/stockholm/en/exhibitions/remembering-she-a-cathedral/)

Tobin, Amy, 'Shooting Picture (1961) by Niki de Saint Phalle', Tate, June 2016 (www.tate.org.uk/art/artworks/saint-phalle-shooting-picture-t03824)

EXHIBITIONS

Niki de Saint Phalle, Tate Liverpool, 1 February 2008–5 May 2008

Thank you to The Niki de Saint Phalle Foundation for reading this passage.

LOUISE BOURGEOIS

BOOKS

Goodeve, Thyrza, *Louise Bourgeois (Phaidon Contemporary Artists)* (Phaidon, 2003)

Wye, Deborah, *Louise Bourgeois: An Unfolding Portrait: Prints, Books, and the Creative Process* (MoMA, 2017)

EXHIBITIONS

Louise Bourgeois, Tate Modern, 10 October 2007–20 January 2008

MEDIA

'Louise Bourgeois – Peels a Tangerine', ZCZ Films, 17 February 2017 (https://www.youtube.com/watch?v=M2mx1gZqh1E)

Much of the factual information cites Hessel, Katy, *The Great Women Artists Podcast*, 'Jo Applin on Louise Bourgeois', 28 April 2020 (https://soundcloud.com/thegreatwomenartists/jo-applin-on-louise-bourgeois)

Storr, Robert, 'Louise Bourgeois: 'A prisoner of my memories', *HENI Talks*, 11 May 2018 (https://henitalks.com/talks/louise-bourgeois/)

Tate 'Louise Bourgeois – "I Transform Hate Into Love"', *TateShots*, 9 June 2016 (https://www.youtube.com/watch?v=qy7xJhImnLw)

THE BEGINNINGS
OF PERFORMANCE ART

BOOKS

Wood, Catherine, *Performance in Contemporary Art* (Tate, 2018)

MEDIA

Tate, 'An Introduction to Performance Art', *TateShots*, 22 September 2017 (www.youtube.com/watch?v=6Z-YZ3A4mdk&ab_channel=Tate)

YOKO ONO

BOOKS

Ono, Yoko, *Yoko Ono: To the Light – Serpentine Gallery* (Buchhandlung Walther König, 2012)

ARTICLES

MoMA Learning, 'Cut Piece (1964) by Yoko Ono' (www.moma.org/learn/moma_learning/yoko-ono-cut-piece-1964/)

EXHIBITIONS

Yoko Ono: To the Light, Serpentine Gallery, 19 June 2012–9 September 2012 (www.serpentinegalleries.org/whats-on/yoko-ono-light/)

MEDIA

Fierce Women, 'Yoko', BBC Arts, 4 March 2020

The Art Assignment, 'The Case for Yoko Ono | The Art Assignment | PBS Digital Studios', 18 February 2016 (www.youtube.com/watch?v=K-oU0E_ab36Q&ab_channel=TheArtAssignment)

KH discussions with Alexandra Munroe

MARINA ABRAMOVIĆ

BOOKS

Biesenbach, Klaus, Iles, Chrissie, Stiles, Kristine, and Abramović, Marina, *Marina Abramović (Phaidon Contemporary Artists)* (Phaidon, 2008)

Biesenbach, Klaus, *Marina Abramović: The Artist Is Present* (MoMA, 2010)

EXHIBITIONS

Marina Abramović: The Artist is Present, MoMA, 14 March 2010–31 May 2010 (www.moma.org/calendar/exhibitions/964)

MEDIA

Dir. Akers, Matthew, and Dupre, Jeff, 'Marina Abramović: The Artist is Present', Dogwoof, 2012

RHYTHM 10

NOTES

p. 310 '"first time I realised what energy means in the audience…"', Marina Abramović, cited from Kim, Hannah, 'Listening to Marina Abramović: *Rhythm 10*', *Inside/Out*, 24 March 2010 (https://www.moma.org/explore/inside_out/2010/03/24/listening-to-marina-abramovic-rhythm-10/)

MEDIA

Abramović, Marina and Lowry, Glenn, 'Marina Abramović. Rhythm 10. 1973–74/2010', MoMA (www.moma.org/audio/playlist/243/3115)

RHYTHM 0

NOTES

p. 310 '"it became more and more aggressive…"', Marina Abramović in conversation with Glenn Lowry, 'Marina Abramović. Rhythm 0. 1974', MoMA (www.moma.org/audio/playlist/243/3118)

BOOKS

Abramović, Marina, *Walk Through Walls: A Memoir* (Crown Archetype, 2016)

ARTICLES

Spector, Nancy, 'Rhythm 0 (1975) by Marina Abramović', The Guggenheim: Collection Online (www.guggenheim.org/artwork/5177)

MEDIA

Abramović, Marina and Lowry, Glenn, 'Marina Abramović. Rhythm 0. 1974', MoMA (www.moma.org/audio/playlist/243/3118)

ANNA MARIA MAIOLINO

NOTES

p. 311 'evidence…', cited from Hessel, Katy, *The Great Women Artists Podcast*, 'Iwona Blazwick on Anna Maria Maiolino', 26 November 2019 (https://soundcloud.com/thegreatwomenartists/iwona-blazwick-on-anna-maria-maiolino)

BOOKS

Molesworth, Helen, *Anna Maria Maiolino* (Prestel, 2017)

EXHIBITIONS

Anna Maria Maiolino: Making Love Revolutionary, The Whitechapel Gallery, 25 September 2019–12 January 2020

MEDIA

Much of the factual information cited from Hessel, Katy, *The Great Women Artists Podcast*, 'Iwona Blazwick on Anna Maria Maiolino', 26 November 2019 (https://soundcloud.com/thegreatwomenartists/iwona-blazwick-on-anna-maria-maiolino)

Thank you to Flavia Frigeri, Jo Applin and Maggie Wright for reading this chapter.

CHAPTER ELEVEN:
WEAVING NEW TRADITIONS

THE RISE OF FIBRE ARTS

NOTES

p. 313 '"If I were unable to speak…"', Sheila Hicks in conversation with Sander Lak in 2018, cited from 'Sheila Hicks Says There Are No Limitations—And We Believe Her!', *Garage Magazine*, 4 September 2018 (https://garage.vice.com/en_us/article/d3eky7/sheila-hicks-sander-lak)

p. 314 '"There is a hierarchy in the arts: decorative art at the bottom, and human forms at the top. Because we are men."', Le Corbusier and Amédée Ozenfant, 'On Cubism', 1918, cited from The Brooklyn Museum, 'Women's Work' (www.brooklynmuseum.org/eascfa/dinner_party/womens_work)

BOOKS

Constantine, Mildred, and Lenor Larsen, Jack, *Wall Hangings* (MoMA, 1969); *Wall Hangings*, exhibition catalogue, MoMA, 25 February 1969–4 May 1969

Parker, Rozsika, *The Subversive Stitch: Embroidery and the Making of the Feminine* (I B Tauris & Co Ltd, 2006)

Phaidon Editors, *Vitamin T: Threads and Textiles in Contemporary Art* (Phaidon, 2019)

ARTICLES

Butchart, Amber, 'The Artificial Divide Between Fine Art and Textiles is a Gendered Issue', *Frieze*, 14 November 2018 (www.frieze.com/article/artificial-divide-between-fine-art-and-textiles-gendered-issue)

The Brooklyn Museum, 'Women's Work' (www.brooklynmuseum.org/eascfa/dinner_party/womens_work)

Judah, Hettie, 'Entangled: Threads and Making', *Frieze*, 27 February 2017 (www.frieze.com/article/entangled-threads-and-making)

EXHIBITIONS

Wall Hangings, MoMA, 25 May 1969–4 May 1969

SHEILA HICKS

BOOKS

Stritzler-Levin, Nina, *Sheila Hicks: Weaving as Metaphor* (Yale University Press, 2006)

ARTICLES

Camhi, Leslie, 'A Career Woven From Life', *The New York Times*, 31 March 2011 (www.nytimes.com/2011/04/03/arts/design/sheila-hicks-50-years-retrospective-in-philadelphia.html)

Cohen, Alina, 'At 84, Sheila Hicks Is Still Making Defiant, Honest Art', *Artsy*, 2 May 2019 (www.artsy.net/article/artsy-editorial-84-sheila-hicks-making-defiant-honest-art)

Roux, Caroline, 'Sheila Hicks: weaving the world into her work', *Financial Times*, 21 May 2021 (www.ft.com/content/f24e80e0-3c5f-4dff-9615-91f1f52448cd)

EXHIBITIONS

Sheila Hicks: Foray into Chromatic Zones, The Hayward Gallery, 23 February 2015–19 April 2015

MEDIA

Friedman Benda, *Design in Dialogue*, 'Sheila Hicks', 14 April 2021 (https://www.friedmanbenda.com/design-in-dialogue/design-in-dialogue-100-sheila-hicks/)

Green, Tyler, *The Modern Art Notes Podcast*, 'NO. 396: SHEILA HICKS', 6 June 2019 (https://manpodcast.com/portfolio/no-396-sheila-hicks/)

McNay, Anna, *Studio International*, 'Sheila Hicks, interview, Hayward Gallery, Project Space, London', 23 February 2015 (https://vimeo.com/121141218)

KH conversation: *The Great Women Artists Podcast*, 'Sheila Hicks', 22 March 2021

CECILIA VICUÑA

BOOKS
Vicuña, Cecilia, *About to Happen* (Siglio Press, 2017)

ARTICLES
Brostoff, Alex, 'The Dazzling and Dooming Art of Cecilia Vicuña', *Hyperallergic*, 26 September 2018 (https://hyperallergic.com/462470/the-dazzling-and-dooming-art-of-cecilia-vicuna/)

MEDIA
Avishai, Tamar, *The Lonely Palette* podcast, 'Cecilia Vicuñas Disappeared Quipu,', 14 December 2018 (http://www.thelonelypalette.com/episodes/2018/12/1/episode-35-cecilia-vicuas-disappeared-quipu-2018)

Guggenheim Museum, 'Cecilia Vicuña: Hugo Boss Prize 2020 Nominee', 5 October 2020

Brooklyn Museum, *BKM Studio Visits*, 'Cecilia Vicuña', 9 November 2018 (https://www.youtube.com/watch?v=9x2PFaBQQ30)

MRINALINI MUKHERJEE

BOOKS
Jhaveri, Shanay, *Mrinalini Mukherjee* (Shoestring Publishers, 2019)

ARTICLES
Kovel, Sophie, 'In Mrinalini Mukherjee's Garden of Earthly Delights', *Frieze*, 23 July 2019 (www.frieze.com/article/mrinalini-mukherjees-garden-earthly-delights)

EXHIBITIONS
Mrinalini Mukherjee, Tate Modern Collection Room, 2 July 2018–29 November 2020

Phenomenal Nature: Mrinalini Mukherjee, The Metropolitan Museum, 4 June 2019–29 September 2019

JUDITH SCOTT

BOOKS
Morris, Catherine, and Higgs, Matthew, *Judith Scott: Bound and Unbound* (Prestel, 2014); *Judith Scott: Bound and Unbound*, exhibition catalogue, The Brooklyn Museum, 24 October 2014–29 March 2015

ARTICLES
Cotter, Holland, 'Silence Wrapped in Eloquent Cocoons', *The New York Times*, 4 December 2014 (www.nytimes.com/2014/12/05/arts/design/judith-scotts-enigmatic-sculptures-at-the-brooklyn-museum.html)

EXHIBITIONS
Judith Scott: Bound and Unbound, The Brooklyn Museum, 24 October 2014–29 March 2015

MEDIA
The Culture Show, 'Judith Scott at The Museum of Everything', BBC 2, 2011

Creative Growth, 'Judith Scott (Alum)' (https://creativegrowth.org/judith-scott)

Dir. Barrera, Dolores, and Peñafiel, Iñaki, 'Que Tienes Debajo del Sombrero', 2006 (https://www.youtube.com/watch?v=3F_gqM2WDac)

FAITH RINGGOLD

NOTES
Spector, Nancy, 'Woman on Bridge #1 of 5: Tar Beach (1988) by Faith Ringgold', The Guggenheim: Collection Online (www.guggenheim.org/artwork/3719)

p. 321 '"anyone can fly, all you gotta do is try"', Faith Ringgold, cited from Hessel, Katy, *The*

Great Women Artists Podcast, 'Hans Ulrich Obrist on Faith Ringgold and Luchita Hurtado', 28 January 2020; Faith Ringgold in 2019, cited from Wallace, Michele, Ringgold, Faith, Ulrich Obrist, Hans, *Faith Ringgold*, (Serpentine Galleries, 2019)

ROSIE LEE TOMPKINS

ARTICLES
Smith, Roberta, 'The Radical Quilting of Rosie Lee Tompkins', *The New York Times*, 29 June 2020 (www.nytimes.com/interactive/2020/06/26/arts/design/rosie-lee-tompkins-quilts.html)

EXHIBITIONS
Rosie Lee Tompkins: A Retrospective, The Berkeley Art Museum and Pacific Film Archive, 19 February 2020–18 July 2021; virtual tour of the exhibition (www.youtube.com/watch?v=T8NL-3KAA8wQ&ab_channel=BAMPFA)

THE GEE'S BEND QUILTMAKERS

NOTES
p. 322 '"by the spirit of the cloth"', quoted in *World Service*, 'Stitching souls', BBC News, 16 August 2020

p. 323 'You can see the struggle, you can see the joy…' quoted in Hessel, Katy, *The Great Women Artists Podcast*, 'The Gee's Bend Quiltmakers!', 17 March 2021 (https://soundcloud.com/thegreatwomenartists/the-gees-bend-quiltmakers)

EXHIBITIONS
The Gee's Bend Quiltmakers, Alison Jacques, 2 December 2020–25 April 2021

MEDIA
Curran, Maris, 'How a Group of Women in This Small Alabama Town Perfected the Art of Quilting | Op-Docs', *The New York Times*, 19 November 2018 (https://www.youtube.com/watch?v=YHEqYVzSs7U)

Thank you to Ann Coxon and Leslie Ramos for reading this chapter.

PART FOUR: TAKING OWNERSHIP (1970–2000)

NOTES
p. 326 '"November 1970, a time when there were no women's studies…"', Linda Nochlin reflecting on the movement in 2006, cited in eds. Armstrong, Carol, and de Zegher, Catherine, *Women Artists at the Millennium* (MIT Press, 2006); referenced in Nochlin, Linda, 'Why Have There Been No Great Women Artists? Thirty Years After', *Why Have There Been No Great Women Artists?, 50th anniversary edition* (Thames and Hudson, 2021), p. 82

BOOKS
Butler, and Mark, *WACK!: Art and the Feminist Revolution*, exhibition catalogue, MOCA, 2007

Parker and Pollock, *Old Mistresses: Women, Art, and Ideology*

MEDIA
BBC 4, 'Rebel Women: The Great Art Fight Back', 18 June 2018 (https://www.bbc.co.uk/programmes/b0b6zgm0)

CHAPTER TWELVE: THE ERA OF FEMINISM

NOTES
p. 328 '"I became a feminist because I wanted to help my daughters…"', Faith Ringgold, 2005, excerpt from Ringgold, Faith, *We Flew Over the Bridge: The Memoirs of Faith Ringgold* (Duke University Press, 2005), pp. 175–80, via The

Brooklyn Museum (https://www.brooklynmuseum.org/eascfa/about/feminist_art_base/faith-ringgold)

p. 328 'the Ad Hoc Committee of Women Artists was established in 1970…' statistics in this paragraph sourced from Meller, Sarah, 'The Biennial and Women Artists: A Look Back at Feminist Protests at The Whitney', *The Whitney: Education Blog*, 3 May 2010 (https://whitney.org/education/education-blog/biennial-and-women-artists); also cited from Ringgold, *We Flew Over the Bridge: The Memoirs of Faith Ringgold*, pp. 175–80, via The Brooklyn Museum (https://www.brooklynmuseum.org/eascfa/about/feminist_art_base/faith-ringgold)

p. 328 'On the West Coast…', cited from Moravec, Michelle, 'Toward a History of Feminism, Art, and Social Movements in the United States', *Frontiers: A Journal of Women Studies*, 2012 (www.jstor.org/stable/pdf/10.5250/fronjwomestud.33.2.0022.pdf?refreqid=excelsior%3Af1b5edcea96ae6e414ad4ac79667612b)

p. 328 information about LACMA exhibition cited from BBC 4, 'Rebel Women: The Great Art Fight Back', 18 June 2018 (https://www.bbc.co.uk/programmes/b0b6zgm0)

p. 329 '"Very few… The lucky few had to be white, the child of, lover of…"', quotation by Howardena Pindell in 2021, cited from Hessel, Katy, *The Great Women Artists Podcast*, 'Howardena Pindell', 3 March 2021 (https://soundcloud.com/thegreatwomenartists/howardena-pindell)

p. 330 '"changed the world"', quotation by Judy Chicago about Nochlin's 1971 essay, cited from Nochlin, *Why Have There Been No Great Women Artists?, 50th anniversary edition*, p. i

p. 331 '"It wasn't until I had joined this women's consciousness…"', quotation by Luchita Hurtado in conversation with Hans Ulrich Obrist c.2020, cited from Obrist, Hans Ulrich, and Hurtado, Luchita, *Luchita Hurtado* (Walther Koenig/Hauser&Wirth, 2021), p. 227–8

p. 331 '"capital of cultural feminism"', cited from Lippard, Lucy, 'Foreword: Going Around in Circles', *From Site to Vision: The Woman's Building in Contemporary Culture* (Otis, 2011), p. 11

p. 331 'In the UK…' information cited from BBC 4, 'Rebel Women: The Great Art Fight Back', 18 June 2018

For more on Carla Lonzi and Carla Accardi, see Hessel, Katy, *Dior Talks* podcast, '[Feminist Art] Paola Ugolini on the increasing visibility of feminist art', 20 March 2020 (https://podcasts.dior.com/paola-ugolini)

For more on *A Lesbian Show*, 1978, see Haynes, Clarity, 'Going Beneath the Surface: For 50 Years, Harmony Hammond's Art and Activism Has Championed Queer Women', *ARTnews*, 27 June 2019 (www.artnews.com/art-news/artists/harmony-hammond-12855/)

p. 332 'Although the Women's Liberation…'; information is predominantly cited from Smith, Valerie, 'Abundant Evidence: Black Women Artists of the 1960s and 1970s', in Butler, and Mark, *WACK!: Art and the Feminist Revolution*; Morris, and Hockley, *We Wanted a Revolution: Black Radical Women, 1965–85: New Perspectives*; *We Wanted a Revolution: Black Radical Women, 1965–85: New Perspectives*, The Brooklyn Museum, 21 April–17 September 2017

p. 332 '"Different artists babysat other members' children…"' Dindga McCannon, from email correspondence with Katy Hessel, 2021

BOOKS
Butler, and Mark, *WACK!: Art and the Feminist Revolution*

ARTICLES
Darlington, Andra, 'Preserving the Legacy of the Los Angeles Woman's Building', *Getty Blogs*, 1 November 2018 (http://blogs.getty.edu/iris/preserving-the-legacy-of-the-los-angeles-womans-building/#_ftn1)

Nochlin, Linda, 'Why Have There Been No Great Women Artists?', *ARTnews*, 1971 (www.artnews.com/art-news/retrospective/why-have-there-been-no-great-women-artists-4201/)

Tan, Ken, 'The Fantastic Life of Faith Ringgold', *Hyperallergic*, 1 January 2019 (https://hyperallergic.com/477794/the-fantastic-life-of-faith-ringgold/)

Wallace, Caroline, 'Three Lessons from Artists' Protests of the Whitney Museum in the 1960s–70s', *Hyperallergic*, 27 April 2017 (https://hyperallergic.com/374428/three-lessons-from-artists-protests-of-the-whitney-museum-in-the-1960s-70s/)

JUDY CHICAGO

NOTES
p. 333 '"I took hold of my own identity…"' Judy Chicago in 1971, dir. Dancoff, Judith, 'Judy Chicago and the California Girls', California Girls Productions, 2008

p. 333 'Taking classes at a car autobody school…', cited from Alligood, Chad, 'Through Minimal to Feminist' in Chicago, Judy, Fisher Sterling, Susan, Thornton, Sarah, Ulrich Obrist, Hans, Alligood, Chad, Ammer, Manuela, Gioni, Massimiliano, Kaiser, Philipp, Katz, Jonathan D., Nussbaum, Martha C., Simmons, William J., *Judy Chicago: New Views* (Scala, 2019)

p. 334 '"build their art-making on the basis of their experiences as women"', Chicago speaking in an interview in BBC 4, 'Rebel Women: The Great Art Fight Back', 18 June 2018 (https://www.bbc.co.uk/programmes/b0b6zgm0)

BOOKS
Chicago, Fisher Sterling, Thornton, Obrist, Alligood, Ammer, Gioni, Kaiser, Katz, Nussbaum, Simmons, *Judy Chicago: New Views*

EXHIBITIONS
Judy Chicago, Baltic Centre for Contemporary Art, 16 November 2019–16 March 2020

MEDIA
Deitch, Jeffrey, 'Artist Talk: Judy Chicago', *Art Basel*, 7 January 2019 (www.youtube.com/watch?v=0wSfg4OICW4&ab_channel=ArtBasel)

Hessel, Katy, *Dior Talks*, '[Feminist Art] Judy Chicago on how working with Dior brought a long-planned feminist art project to fruition,' 8 March 2020 (https://podcasts.dior.com/judy-chicago)

SUZANNE LACY

ARTICLES
Labowitz-Starus, Leslie, and Lacy, Suzanne, '"In Mourning and in Rage…"', *Frontiers: A Journal of Women Studies*, 1978, pp. 52–5

The Getty Center, 'Art of Protest—Artist Suzanne Lacy discusses the connection between art and activism', *Pacific Standard Time*, 2011

(https://blogs.getty.edu/pacificstandardtime/explore-the-era/archives/v63/)

MEDIA
Interview with Suzanne Lacy in BBC 4, 'Rebel Women: The Great Art Fight Back', 18 June 2018 (https://www.bbc.co.uk/programmes/b0b6zgm0); (information about JC being her teacher was learnt here)

ANA MENDIETA

NOTES
p. 335 '"the earth as my canvas and my soul as my tools"', Ana Mendieta, original reference in Lukkas, Lynn, 'Forever Young: Five Lessons from the Creative Life of Ana Mendieta', cited from *Ana Mendieta's 'Experimental and Interactive Films'*, curated by Kim Levin, Galerie Lelong, 5 February 2015–26 March 2016

p. 335 '"become one with the earth"', quotation by Ana Mendieta, cited from Tate, 'Ana Mendieta: "Pain of Cuba / Body I Am"' (www.tate.org.uk/whats-on/tate-modern/film/ana-mendieta-pain-cuba-body-i-am)

BOOKS
Laing, *Everybody*

EXHIBITIONS
Ana Mendieta: Traces, The Hayward Gallery, 24 September 2013–15 December 2013

MEDIA
Hessel, Katy, *The Great Women Artists Podcast*, 'Raquel Cecilia Mendieta on Ana Mendieta', 7 September 2021 (https://soundcloud.com/thegreatwomenartists/raquel-cecilia-mendieta-on-ana-mendieta)

Hessel, Katy, *The Great Women Artists Podcast*, 'Olivia Laing on Chantal Joffe, Sarah Lucas and Ana Mendieta', 12 May 2020 (https://soundcloud.com/thegreatwomenartists/olivia-laing-on-chantal-joffe-sarah-lucas-and-ana-mendieta)

Thank you to Mycroft Zimmerman for reading this section.

MIERLE LADERMAN UKELES

EXHIBITIONS
Mierle Laderman Ukeles: MATRIX 137, accompanying text, The Wadsworth Atheneum, 20 September 1998–15 November 1998 (www.thewadsworth.org/wp-content/uploads/2011/06/Matrix-137.pdf)

MEDIA
Hickson, Patricia, 'Mierle Laderman Ukeles, *Washing/Tracks/Maintenance: Outside (July 23, 1973)*', *Smarthistory*, 22 December 2018 (https://smarthistory.org/ukeles-washing/)

University lectures (UCL, 2015): Dr Andres David Montenegro Rosero

MARY KELLY

NOTES
p. 337 'Over in the UK, women critiqued their highly gendered roles…' cited from BBC 4, 'Rebel Women: The Great Art Fight Back', 18 June 2018 (https://www.bbc.co.uk/programmes/b0b6zgm0)

p. 337 'Kelly's aim was to communicate a mother's psychological experience to the viewer' cited from British Library Learning, *Sisterhood and After*, 'Post-Partum Document (1973–79) by Mary Kelly' (www.bl.uk/learning/histcitizen/sisterhood/clips/culture-and-the-arts/visual-arts/143927.html)

BOOKS
Crimp, Douglas, Iversen, Margaret, and Bhabha, Homi K., *Mary Kelly* (Phaidon, 1997)

MEDIA
British Library Learning, *Sisterhood and After*, 'Post-Partum Document (1973–79) by Mary Kelly' (www.bl.uk/learning/histcitizen/sisterhood/clips/culture-and-the-arts/visual-arts/143927.html)

SENGA NENGUDI

NOTES
p. 338 '"mother and child"', cited from Whitley, 'American Skin: Artists on Black Figuration', *Soul of a Nation: Art in the Age of Black Power*, pp. 216–18

p. 339 '"holder of power"', Senga Nengudi in 2021, cited from Denver Art Museum, 'Identity Lesson: Interview with Artist Senga Nengudi', 18 February 2021 (www.youtube.com/watch?v=W-te72h0uTx8&ab_channel=YerbaBuenaCenterfortheArtsYerbaBuenaCenterfortheArts)

BOOKS
Weber, Stephanie and Muhling, Matthias, *Senga Nengudi: Topologies* (Hirmer, 2019)

ARTICLES
MoMA Learning, 'R.S.V.P. I (2003) by Senga Nengudi' (https://www.moma.org/learn/moma_learning/senga-nengudi-r-s-v-p-i-19772003/

MEDIA
MoMA, *UNIQLO ARTSPEAKS*, 'A sculpture prompts reflections on motherhood and loss, Senga Nengudi', 11 December 2019 (https://www.youtube.com/watch?v=hyEC9Pwh7uk)

CAROLEE SCHNEEMANN

NOTES
p. 339 '"the source of sacred knowledge, ecstasy, birth passage, transformation"', cited in *More Than Meat Joy*, pp. 234–5, via Tate. Full quote: 'I thought of the vagina in many ways – physically, conceptually: as a sculptural form, an architectural referent, the source of sacred knowledge, ecstasy, birth passage, transformation'; cited from an interview with Carolee Schneemann in BBC 4, 'Rebel Women: The Great Art Fight Back', 18 June 2018 (https://www.bbc.co.uk/programmes/b0b6zgm0)

Information cited from a discussion between KH and Griselda Pollock: *The Great Women Artists Podcast*, 'Griselda Pollock on Alina Szapocznikow', 25 November 2020 (https://soundcloud.com/thegreatwomenartists/griselda-pollock-on-alina-szapocznikow)

ARTICLES
Manchester, Elizabeth, 'Interior Scroll (1975) by Carolee Schneemann', Tate, November 2003 (www.tate.org.uk/art/artworks/schneemann-interior-scroll-p13282)

Williams, Hannah 'Hannah Wilke's Naked Crusade to Subvert the Patriarchy', 1 Jan 2019, *Artsy* (https://www.artsy.net/article/artsy-editorial-hannah-wilkes-naked-crusade-subvert-patriarchy)

HANNAH WILKE

NOTES
p. 340 '"I chose gum because it's the perfect metaphor for the American woman…"' Hannah Wilke in 1980; cited from Jones, Amelia, *Body Art/Performing the Subject* (University of Minnesota Press, 1998)

ADRIAN PIPER

BOOKS

Cherix, Christophe, Butler, Cornelia, Platzker, David, *Adrian Piper: A Synthesis of Intuitions, 1965–2016* (MoMA, 2018); *Adrian Piper: A Synthesis of Intuitions, 1965–2016*, exhibition catalogue, MoMA, 31 March 2018–22 July 2018

ARTICLES

Lippard, Lucy, and Piper, Adrian, 'Catalysis: An Interview with Adrian Piper', *The Drama Review*, 1972 (www.jstor.org/stable/pdf/1144734.pdf)

Ma, Nathan, 'Adrian Piper's Catalysis Taught Me How to Resist Everyday Racism', *Elephant Magazine*, 21 January 2020 (https://elephant.art/nathan-ma-on-adrian-pipers-catalysis/)

EXHIBITIONS

Adrian Piper: A Synthesis of Intuitions, 1965–2016, MoMA, 31 March 2018–22 July 2018

Thank you to the APRA Foundation for reading and checking this section.

HOWARDENA PINDELL

NOTES

p. 342 '"I thought not so much that [my artworks] were Minimalist…"' Howardena Pindell in 2021, cited from Hessel, Katy, *The Great Women Artists Podcast*, 'Howardena Pindell', 3 March 2021 (https://soundcloud.com/thegreatwomenartists/howardena-pindell)

p. 343 'a form of expression that MoMA saw as "censorship"', citing *ibid*. Full quotation: 'I would say that I was highly motivated to leave the Modern as the general mainstream attitude to the protest against … Drawings by Donald Newman, the artist, was seen as censorship. We did not shut down the show. It was not seen as censorship when people of color and women were closed out of the system'.

p. 343 '"you must be really paranoid"', from Pindell, Howardena 'Free, White and 2' (1980); much of the information is cited from Hessel, Katy, *The Great Women Artists Podcast*, 'Howardena Pindell', 3 March 2021 (https://soundcloud.com/thegreatwomenartists/howardena-pindell)

p. 343 'blown up and projected outside the Brooklyn Museum', information cited from *ibid*

p. 341–3 Information on 'Free, White and 21' cited from Smith, Valerie, 'Abundant Evidence: Black Women Artists of the 1960s and 70s', in Butler, and Mark, *WACK!: Art and the Feminist Revolution*

BOOKS

Beckwith, Naomi and Cassel Oliver, Valerie, *Howardena Pindell: What Remains to Be Seen* (Prestel, 2018); *Howardena Pindell: What Remains to Be Seen*, exhibition catalogue, MCA Chicago, 31 March 2018–22 July 2018

EXHIBITIONS

Howardena Pindell: What Remains To Be Seen, MCA Chicago, 24 February 2018–20 May 2018

MEDIA

The Courtauld, 'Howardena Pindell: In conversation with Jo Applin, Naomi Beckwith, Amy Tobin', 11 June 2019 (https://www.youtube.com/watch?v=Za6ymkt80Cg)

Thank you to Rachel Garbade for reading and checking this section.

FAITH RINGGOLD

NOTES

Morris, and Hockley, *We Wanted a Revolution:*

Black Radical Women, 1965–85: New Perspectives, exhibition catalogue, The Brooklyn Museum, 21 April 2017–17 September 2017

Smith, Valerie, 'Abundant Evidence: Black Women Artists of the 1960s and 1970s', in Butler, and Mark, *WACK!: Art and the Feminist Revolution*; Smith, Valerie, 'Abundant Evidence: Black Women Artists of the 1960s and 70s', also in Fields, Jill, *Entering the Picture* (Routledge, 2011)

DINDGA MCCANNON

NOTES

p. 345 '"In the 60s and 70s we didn't have many women warriors…"', cited from McCannon, Dindga, *Revolutionary Sister*, 1971, The Brooklyn Museum (www.brooklynmuseum.org/opencollection/objects/210707)

BOOKS

Morris, and Hockley, *We Wanted a Revolution: Black Radical Women, 1965–85: New Perspectives*, exhibition catalogue, The Brooklyn Museum, 21 April 2017–17 September 2017

ARTICLES

'Exhibition Spotlight: Dindga McCannon and "Where We At" Black Women Artists in We Wanted a Revolution: Black Radical Women, 1965–85', *Albright-Knox Blog*, 26 April 2018 (www.albrightknox.org/blog/exhibition-spotlight-dindga-mccannon-and-%E2%80%9Cwhere-we-%E2%80%9D-black-women-artists-we-wanted-revolution)

ALICE NEEL

NOTES

p. 346 '"men look, and women appear"', cited from Berger, John, *Ways of Seeing* (Penguin, 1972), p. 47

p. 348 '"collector of souls"', Alice Neel, cited from Hope, Henry R., 'Alice Neel: Portraits of an Era', *Art Journal*, 1979 (www.jstor.org/stable/pdf/776378.pdf?refreqid=excelsior%3Abad68f-66b05f2ed1f3744b6660d15590)

p. 348 '"If she did a portrait of you, you wouldn't recognise yourself…"', Joseph Solman, painter and friend of Alice Neel, once remarked about Neel, cited from Hoban, Phoebe, *Alice Neel: The Art of Not Sitting Pretty* (Saint Martin's Press, 2010), p. 108

p. 348 'cemented by numerous, critically and publicly exalted international touring retrospectives', including exhibitions at The Met Museum (2021); Guggenheim Bilbao (2021–22); Pompidou (2022); Barbican (2023)

BOOKS

Als, Hilton, *Alice Neel: Uptown* (David Zwirner Books and Victoria Miro, 2017)

Lewison, Jeremy, Walker, Barry, Storr, Robert, Garb, Tamar, *Alice Neel: Painted Truths* (Museum of Fine Arts Houston, 2010)

Neel, Alice, *Alice Neel: Freedom* (David Zwirner Books, 2019)

MEDIA

Hessel, Katy, *The Great Women Artists Podcast*, 'Helen Molesworth on Alice Neel', 28 April 2020 (https://soundcloud.com/thegreatwomenartists/helen-molesworth-on-alice-neel)

SYLVIA SLEIGH

NOTES

p. 349 '"To me, women were often portrayed as sex objects in humiliating poses…"', Sylvia Sleigh in 2007 responding to the question:

'How has feminism changed contemporary art practice?', cited from the University of Brighton, 'Sylvia Sleigh' (http://arts.brighton.ac.uk/faculty-of-arts-brighton?a=23625)

Nochlin, 'Sylvia Sleigh: Portraits of Women Artists and Writers, 1999', cited from Nochlin ed., *Women Artists: The Linda Nochlin Reader*, pp. 220–25

JOAN SEMMEL

BOOKS

ed. Throckmorton, Jodi, *Joan Semmel: Skin the Game* (Marquand Books, 2021)

EXHIBITIONS

Joan Semmel: A Necessary Elaboration, Alexander Gray Associates, 10 January 2019–16 February 2019

MARIA LASSNIG

NOTES

p. 351 '"I caught them"', Maria Lassnig, cited from Hessel, Katy, *The Great Women Artists Podcast*, 'Natalie Lettner on Maria Lassnig', 28 July 2020 (https://soundcloud.com/thegreatwomenartists/natalie-lettner-on-maria-lassnig)

p. 351 '"praise" such as "you paint like a man"', Maria Lassnig, cited from *ibid*

ARTICLES

Williams, Gilda, 'How Embarrassing!', *Tate Etc.*, 25 June 2016 (https://www.tate.org.uk/tate-etc/issue-37-summer-2016/how-embarrassing)

EXHIBITIONS

Maria Lassnig, Tate Liverpool, 18 May 2016–18 September 2016

MEDIA

Much of the factual information cited from Hessel, Katy, *The Great Women Artists Podcast*, 'Natalie Lettner on Maria Lassnig', 28 July 2020 (https://soundcloud.com/thegreatwomenartists/natalie-lettner-on-maria-lassnig)

HUGUETTE CALAND

BOOKS

Barlow, Anne, *Huguette Caland* (Tate Publishing, 2019); *Huguette Caland*, exhibition catalogue, Tate St Ives, 24 May 2019

EXHIBITIONS

Huguette Caland, Tate St Ives, 24 May 2019–1 September 2019

JUDY CHICAGO/THE DINNER PARTY

NOTES

Simmons, William J., 'To Tell of Touch, to Touch by Telling: The Erotics of *The Dinner Party*' in Chicago, Fisher Sterling, Thornton, Obrist, Alligood, Ammer, Gioni, Kaiser, Katz, Nussbaum, Simmons, *Judy Chicago: New Views*, pp. 67–104.

EXHIBITIONS

The Dinner Party by Judy Chicago 1974–9, Permanent display, Elizabeth A. Sackler Centre for Feminist Art at The Brooklyn Museum

Guess Who's Coming To Dinner Too?: Patricia Kaersenhout, De Appel, Amsterdam, 5 October 2019–1 December 2019 (https://deappel.nl/en/exhibitions/guess-whos-coming-to-dinner-too)

MEDIA

Hessel, Katy, *Dior Talks*, '[Feminist Art] Judy Chicago on how working with Dior brought a long-planned feminist art project to fruition', 8 March 2020 (https://podcasts.dior.com/judy-chicago)

Thank you to Alona Pardo, Jo Applin, Richard Saltoun, Niamh Coghlan, and Gilda Williams for reading this chapter.

CHAPTER THIRTEEN: THE 1980S

TEXT, IMAGE AND PHOTOGRAPHIC PERFORMANCES

NOTES

p. 356 '"fine art"' cited from various discussions on Nan Goldin

p. 357 '"women don't paint very well... it's a fact"', Baselitz in a 2013 interview with *Die Spiegel*, cited from Miller, M. H., 'Georg Baselitz Says "Women Don't Paint Very Well"', *Observer*, 29 January 2013 (https://observer.com/2013/01/georg-baselitz-says-women-dont-paint-very-well/)

ARTICLES

LeBourdais, George Phillip, 'The Most Iconic Artists of the 1980s', *Artsy*, 17 August 2015 (www.artsy.net/article/artsy-editorial-the-most-iconic-artists-of-the-1980s)

Mulvey, Laura, *Visual Pleasure and Narrative Cinema*, 1975 (https://www.amherst.edu/system/files/media/1021/Laura%2520Mulvey,%2520Visual%2520Pleasure.pdf)

EXHIBITIONS

This Will Have Been: Art, Love & Politics in the 1980s, curated by Helen Molesworth and Barbara Lee, MCA Chicago, 11 February 2012–3 June 2012

GUERRILLA GIRLS

NOTES

pp. 357–8, '"international"'; '"because they were free"'; '"Women artists were excited and empowered, and everyone else was really pissed off!"', all quotations from Hessel, Katy, *The Great Women Artists Podcast*, 'Guerrilla Girls', 28 October 2020 (https://podtail.com/en/podcast/the-great-women-artists-trailer/guerrilla-girls/)

BOOKS

Guerrilla Girls, *The Art of Behaving Badly* (Chronicle Books, 2020)

BARBARA KRUGER

NOTES

Chadwick, *Women, Art and Society*, pp. 397–400

p. 359 '"bring the world into my art"', Barbara Kruger in conversation with Melissa Ho in 2012, cited from 'Meet the Artist: Barbara Kruger', The Hirschhorn Museum, 13 December 2012 (https://hirshhorn.si.edu/explore/meet-the-artist-barbara-kruger/)

ARTICLES

Mitchell, W. J. T., and Kruger, Barbara, 'An Interview with Barbara Kruger', *Critical Inquiry*, 1991 (www.jstor.org/stable/pdf/1343844.pdf?refreqid=excelsior%3A8b4438ee9954b55ad-d2374755ead8d5b)

EXHIBITIONS

Barbara Kruger: Belief + Doubt, permanent display, The Hirschhorn Museum

JENNY HOLZER

NOTES

Chadwick, *Women, Art and Society*, pp. 397–400

BOOKS

Beckett, Samuel, Canetti, Elias, Holzer, Jenny, *Jenny Holzer* (Phaidon, 2001)

MEDIA

Culture Show, 'Andrew Graham Dixon interviews

Jenny Holzer', BBC, 2013 (www.youtube.com/watch?v=Y74WGcc084M&ab_channel=AGDofficial)

CINDY SHERMAN

NOTES

p. 362 '"through a photograph you can make people believe anything"'; p. 365 '"a challenge for somebody to want to hang above their sofa"', Cindy Sherman, cited in BBC 4, *Arena*, 'Cindy Sherman's First Interview in 10 Years', 28 July 2019 (https://www.bbc.co.uk/programmes/p07hyprk)

BOOKS

Art in Time: A World History of Styles and Movements (Phaidon, 2014); (information about the 'Pictures Generation')

Moorhouse, Paul, *Cindy Sherman: That's Me* (National Portrait Gallery, 2019)

EXHIBITIONS

Cindy Sherman, National Portrait Gallery, June–September 2019

MEDIA

Foster, Hal, 'Under the Gaze: The Art of Cindy Sherman,' *HENI Talks*, 16 May 2018 (https://henitalks.com/talks/under-the-gaze-the-art-of-cindy-sherman/)

FRANCESCA WOODMAN

BOOKS

Woodman, Francesca, ed. Tellgren, Anna, *Francesca Woodman: On Being an Angel* (Thames and Hudson, 2015); *Francesca Woodman: On Being an Angel*, exhibition catalogue, Moderna Museet, 5 September 2015–6 December 2015

MEDIA

Much of the factual information cited from Hessel, Katy, *The Great Women Artists Podcast*, 'Katarina Jerinic on Francesca Woodman', 24 March 2021 (https://soundcloud.com/thegreatwomenartists/katarina-jerinic-on-francesca-woodman)

Hessel, Katy, *The Great Women Artists Podcast*, 'Deborah Levy on Francesca Woodman, Lee Miller, Paula Rego, Leonora Carrington', December 2021 (https://soundcloud.com/thegreatwomenartists/deborah-levy-on-francesca-woodman-lee-miller-paula-rego-leonora-carrington)

CARRIE MAE WEEMS

NOTES

p. 367 '"There's still sort of a dearth..."', Carrie Mae Weems in 2016, cited from Eckardt, Stephanie, 'Carrie Mae Weems Reflects on Her Seminal, Enduring Kitchen Table Series', *W Magazine*, 4 July 2016 (www.wmagazine.com/story/carrie-mae-weems-kitchen-table-series-to-day-interview)

Edwards, Adrienne, 'Scenes of the Flesh: Thinking-Feeling Carrie Mae Weems's Kitchen Table Series Twenty-Five Years On,', Lewis, Sarah, and Edwards, Adrienne, *Carrie Mae Weems: Kitchen Table Series* (Damiani, 2016), pp. 10–11

BOOKS

Lewis, Sarah Elizabeth, *Carrie Mae Weems – October Files* (MIT Press, 2021)

ARTICLES

Eckardt, Stephanie, 'Carrie Mae Weems Reflects on Her Seminal, Enduring Kitchen Table Series', *W Magazine*, 4 July 2016 (www.wmagazine.com/story/carrie-mae-weems-kitchen-table-series-to-day-interview)

Lombardi, D. Dominick, 'Kathryn E. Delmez on Carrie Mae Weems at the Frist', *Huffpost Arts & Culture*, 7 September 2012

O'Grady, Megan, 'How Carrie Mae Weems Rewrote the Rules of Image-Making', *The New York Times: Style Magazine*, 15 October 2018 (www.nytimes.com/2018/10/15/t-magazine/carrie-mae-weems-interview.html)

NAN GOLDIN

NOTES

p. 368 '"like an extension of my hand"', Nan Goldin in 2017, cited from 'Nan Goldin speaking about "The Ballad of Sexual Dependency"', MOCA, 29 October 2017

p. 368 '"I don't ever want to lose the real memory of anyone again"', Nan Goldin, cited from Als, Hilton, 'The Third Set: Nan Goldin And Dominique Nabokov', *Artforum*, 1994 (www.artforum.com/print/199401/the-third-set-nan-goldin-and-dominique-nabokov-33467)

p. 368 the "shy" Goldin... took her camera everywhere', cited from BBC Radio 4, *Profile*, 'Nan Goldin', 9 March 2019 (https://www.bbc.co.uk/programmes/m00035hr)

p. 369 '"without glamorisation, without glorification"', Nan Goldin in 2017, cited from 'Nan Goldin speaking about "The Ballad of Sexual Dependency"', MOCA, 29 October 2017

ARTICLES

Als, Hilton, 'Nan Goldin's Life in Progress', *The New Yorker*, 27 June 2016 (www.newyorker.com/magazine/2016/07/04/nan-goldins-the-ballad-of-sexual-dependency)

PAZ ERRÁZURIZ

NOTES

p. 370 '"I found a family that I wish had always been my own"', Paz Errázuriz, cited from Tate Modern, 'Adam's Apple (1983) by Paz Errázuriz', December 2019 (www.tate.org.uk/art/artworks/errazuriz-adams-apple-p13169)

p. 370 '"Photography let me participate in my own way in the resistance..."', Paz Errázuriz in 2003, cited from Epps, Philomena, 'La Manzana de Adan by Paz Errázuriz', *Elephant Magazine*, 11 March 2018 (https://elephant.art/la-manzana-de-adan-by-paz-errazuriz/)

ARTICLES

Daniel, Alex, 'Another Kind of Life: Photography on the Margins', *Elephant Magazine*, 5 March 2018 (https://elephant.art/another-kind-of-life/)

Epps, Philomena, 'La Manzana de Adan by Paz Errázuriz', *Elephant Magazine*, 11 March 2018 (https://elephant.art/la-manzana-de-adan-by-paz-errazuriz/)

EXHIBITIONS

Another Kind of Life: Photography on the Margins, Barbican Art Gallery, 28 February 2018–27 May 2018

MEDIA

Barbican Centre, 'Barbican Meets: Paz Errázuriz', 13 April 2018 (https://www.barbican.org.uk/read-watch-listen/barbican-meets-paz-errazuriz)

CLAUDIA ANDUJAR

BOOKS

Andujar, Claudia, Nogueira, Thyago, Albert, Bruce, Rocha, Jan, Manjabosco, Ângelo, Tong, Valentina, *Claudia Andujar: The Yanomami Struggle* (Thames and Hudson, 2020)

EXHIBITIONS

Claudia Andujar: The Yanomami Struggle, The Curve in the Barbican Centre, 17 June 2021–29 August 2021 (www.barbican.org. uk/whats-on/2021/event/claudia-andu-jar-the-yanomami-struggles)

In conversation with Katy Hessel: Alona Pardo. Thank you to Alona Pardo for reading this passage.

AGNES DENES

NOTES

p. 372 '"My decision to plant a wheat field…"', Agnes Denes in 1993, cited from Denes, Agnes, quoted in 'Wheatfield – A Confrontation: The Philosophy' in 'Notes on Eco-Logic: Environmental Artwork, Visual Philosophy and Global Perspective', *Leonardo*, 1993, p. 389 (www.jstor. org/stable/pdf/1576033.pdf?refreqid=excel-sior%3A7e333a6cb9c577894dc584f73703a08a)

EXHIBITIONS

Agnes Denes: Absolutes and Intermediates, The Shed, 9 October 2019–12 March 2020 (https:// theshed.org/program/6-agnes-denes-abso-lutes-and-intermediates)

LORRAINE O'GRADY

NOTES

p. 373 '"non-artist acquaintance"… "avant-garde art doesn't have anything to do with Black people"', Lorraine O'Grady, cited from the summary of 'Art Is… by Lorraine O'Grady' (www.lorraineogrady.com/wp-content/uploads/2015/11/OGrady_ARTIS_summary.pdf)

Whitley, 'American Skin: Artists on Black Figuration', *Soul of a Nation: Art in the Age of Black Power*, pp. 219–25

Smith, 'Abundant Evidence: Black Women Artists of the 1960s and 1970s', in Butler, and Mark, *WACK!: Art and the Feminist Revolution*

EXHIBITIONS

Soul of a Nation: Art in the Age of Black Power, curated by Zoé Whitley and Mark Godfrey, Tate Modern, 12 July 2017–22 October 2017

MEDIA

'Thelma Golden on the Studio Museum & Post-Black Artists', *Crystal Bridges*, 29 May 2018 (www.youtube.com/watch?v=5l9tsR3lrw-c&ab_channel=CrystalBridges)

Thank you to Gilda Williams and William J Simmons for reading this chapter.

CHAPTER FOURTEEN: THE 1990S

THE ACCEPTANCE OF POLITICAL ART

NOTES

p. 375, 'often viewed to be flanked', information cited from Schwartz, Alexandra, *Come as You Are: Art of the 1990s* (University of California Press, 2014)

p. 375 '"I hate the show"…"scam"', cited from Kimmelman, Michael, 'At the Whitney, Sound, Fury and Little Else', *The New York Times*, 25 April 1993 (www.nytimes.com/1993/04/25/arts/art-view-at-the-whitney-sound-fury-and-little-else.html); also cited in Saltz, Jerry, and Corbett, Rachel, 'How Identity Politics Conquered the Art World: An Oral History', *Vulture: New York Magazine*, 26 April 2016 (www.vulture.com/2016/04/identity-politics-that-for-ever-changed-art.html)

p. 376 '"to make a satirical commentary on the history of the ethnographic display of Indigenous

people"', Coco Fusco in 1994, cited from Fusco, Coco, 'The Other History of Intercultural Performance', *The Drama Review*, 1994 (https:// www.jstor.org/stable/1146361)

p. 376 'Lorna Simpson became the first African-American woman *ever* to show at the historic exhibition…' information cited from Golden, Thelma, Beckwith, Naomi, Iles, Chrissie, and Jones, Kellie, *Lorna Simpson* (Phaidon, 2021); full text: … 'her breakthrough moment in 1993, when she became the first African-American woman ever to show in the Venice Biennale' (https://www.phaidon. com/agenda/art/articles/2021/june/17/all-you-need-to-know-about-lorna-simpson/)

BOOKS

Sandler, Irving, *Postmodern Era: From The Late 1960s To The Early 1990s* (Routledge, 1997)

Much of the factual information has been learnt and cited from Schwartz, *Come as You Are: Art of the 1990s*, exhibition catalogue, The Montclair Art Museum, 8 February 2015–17 May 2015

ARTICLES

Farago, Jason, 'The 90s: The Decade that Never Ended', *BBC Culture*, 5 February 2015 (https:// www.bbc.com/culture/article/20150205-the-1990s-never-ended)

Lax, Thomas J., 'Slant: Black Male (1994–95): Thelma Golden as told to Thomas J. Lax', *Artforum*, Summer 2016 (www.artforum.com/print/201606/black-male-1994-95-60084)

Saltz, Jerry, and Corbett, Rachel, 'How Identity Politics Conquered the Art World: An Oral History', *Vulture: New York Magazine*, 26 April 2016 (www.vulture.com/2016/04/identity-poli-tics-that-forever-changed-art.html)

Velimirović, Andreja, '90s Art and Its Bequest to Contemporary Art', *Widewalls*, 17 October 2016 (www.widewalls.ch/magazine/90s-art)

EXHIBITIONS

Come as You Are: Art of the 1990s, curated by Alexandra Schwartz, The Montclair Art Museum, 8 February 2015–17 May 2015

MEDIA

Yoland, K., and Garza, Evan, 'At the Blanton Museum of Art – Come as You Are: Art of the 1990s', *Art This Week*, 29 April 2019

In conversation with Katy Hessel: Alexandra Schwartz, May 2021

EMILY KAME KNGWARREYE

NOTES

Chadwick, *Women, Art and Society*, pp. 462–3

Phaidon, 'Contemporary Aboriginal Art', *Art in Time: A World History of Styles and Movements* (Phaidon, 2014), pp. 24–5

ARTICLES

Hong, Tamsin, 'Emily Kame Kngwarreye', *Tate Etc.*, 15 January 2021 (www.tate.org.uk/tate-etc/issue-51-spring-2021/emily-kame-kngwarreye)

ZOE LEONARD

BOOKS

Simpson, Bennett, *Zoe Leonard: Survey* (Prestel, 2018); *Zoe Leonard: Survey*, exhibition catalogue, The Whitney Museum of American Art, 2 March 2018–10 June 2018

EXHIBITIONS

Zoe Leonard: I want a president, The High Line, 11 October 2016–17 March 2017

Zoe Leonard: Survey, The Whitney Museum of American Art, 2 March 2018–10 June 2018

MEDIA

Molesworth, Helen, 'Zoe Leonard's I want a president', Hauser & Wirth, 2018 (www.hauserwirth. com/ursula/28233-zoe-leonards-want-president)

Leonard Zoe, and Nichols Goodeve, Thyrza, 'Philosopher of the Sequence Out of Sync', *The Brooklyn Rail*, June 2018 (https://brooklynrail. org/2018/06/art/ZOE-LEONARD-with-Thyrza-Nichols-Goodeve-)

CATHERINE OPIE

NOTES

p. 381 'the leather community were perceived as "predatory" or "perverted"', Catherine Opie, cited from Burns, Charlotte, *In Other Words* podcast, 'Investigating America with Artist Catherine Opie', 14 November 2019 (https:// www.sothebys.com/en/articles/70-investigat-ing-america-with-artist-catherine-opie)

The Museum of Contemporary Art, 'Klaus Biesenbach in conversation with Catherine Opie', *Virtual Studio Visits*, 16 May 2020 (https://www. youtube.com/watch?v=oXWzB40LnEk)

BOOKS

Als, Hilton, Fogle, Douglas, Molesworth, Helen, Smith, Elizabeth A. T., and Cotton, Charlotte, *Catherine Opie* (Phaidon, 2021)

LORNA SIMPSON

BOOKS

Golden, Jones, Parks, *Lorna Simpson* (Phaidon, 2002)

MEDIA

'Lorna Simpson, Artist Talk 10.8.15', Brown University, 8 October 2015 (https://www. youtube.com/watch?v=vDD7pCLwoxg)

'In Conversation: Lorna Simpson and Thelma Golden', Hauser & Wirth, 1 March 2018 (https:// www.youtube.com/watch?v=t0qOQYmaI2o)

SHIRIN NESHAT

NOTES

Bouveresse, Clara, *Women Photographers: Contemporaries 1970–today* (Thames and Hudson, 2020), p. 41

BOOKS

Schad, Ed, *Shirin Neshat: I Will Greet the Sun Again* (Prestel, 2019)

EXHIBITIONS

Shirin Neshat: I Will Greet the Sun Again, The Broad, 19 October 2020–16 February 2021

MEDIA

Much of the factual information cites Hessel, Katy, *The Great Women Artists Podcast*, 'Shirin Neshat', 25 February 2020 (https://soundcloud. com/thegreatwomenartists/shirin-neshat)

PIPILOTTI RIST

BOOKS

Gioni, Massimiliano, *Pipilotti Rist: Pixel Forest: Published in Association with the New Museum* (Phaidon, 2016). *Pipilotti Rist: Pixel Forest*, exhibition catalogue, The New Museum, 26 October 2016–15 January 2017

EXHIBITIONS

Pipilotti Rist: Eyeball Massage, Hayward Gallery, 28 September 2011–8 January 2012

Pipilotti Rist: Pixel Forest, The New Museum, 26 October 2016–15 January 2017

MEDIA

Lund, Christian, 'Pipilott Rist: Color is Dangerous', Louisiana Channel, 2012 (https://www.youtube.com/watch?v=NdLuwX2uRTM)

Lund, Christian, 'Pipilotti Rist Interview: Freeing the Wonderlight', Louisiana Channel, 20 April 2019 (https://www.youtube.com/watch?v=V-jmmAzS63H8)

ELIZABETH PEYTON

BOOKS

Bell, Kirsty, *Elizabeth Peyton: Dark Incandesence* (Rizzoli, 2017)

EXHIBITIONS

Elizabeth Peyton: Aire and Angels, National Portrait Gallery, London, 3 October 2019–5 January 2020

MARLENE DUMAS

NOTES

p. 387 '"I don't paint people, I paint images"', Dumas quoted from Spence, Rachel, 'Marlene Dumas show at the Stedelijk, Amsterdam', 3 October 2014 (www.ft.com/content/8749a296-48ae-11e4-9d04-00144feab7de)

BOOKS

Coelewij, Leontine, Sainsbury, Helen, Vischer, Theodora, *Marlene Dumas: The Image as Burden* (Tate Publishing, 2015); *Marlene Dumas: The Image as Burden*, exhibition catalogue, Tate Modern, 5 February 2015–10 May 2015

ARTICLES

Cooke, Rachel, 'Interview: The daring art of Marlene Dumas: duct-tape, pot bellies and Bin Laden', *Observer*, 11 January 2015 (www.theguardian.com/artanddesign/2015/jan/11/the-daring-art-of-marlene-dumas-duct-tape-pot-bellies-and-bin-laden)

EXHIBITIONS

Marlene Dumas: The Image as Burden, Tate Modern, 5 February 2015–10 May 2015

MEDIA

Dumas, Marlene, 'Marlene Dumas: Lecture', Fondation Beyeler, 14 August 2015

SHAHZIA SIKANDER

NOTES

p. 387 '"a new beginning"', Shahzia Sikander, cited from The Morgan Library & Museum, 'The Scroll (1989-90)'; a work featured in *Shahzia Sikander: Extraordinary Realities*, The Morgan Library & Museum, 18 June 2021–26 September 2021 (www.themorgan.org/exhibitions/online/shahzia-sikander/scroll)

BOOKS

Museum of Rhode Island School of Design, *Shahzia Sikander: Extraordinary Realities* (Hirmer, 2021)

LISA YUSKAVAGE

MEDIA

Hessel, Katy, *The Great Women Artists Podcast*, 'Lisa Yuskavage', 31 August 2021 (https://soundcloud.com/thegreatwomenartists/lisa-yuskavage)

CECILY BROWN

NOTES

p. 388 '"in my generation people weren't interested in doing painterly paintings"'; '"filled with street art, graffiti and flyers…like a collage"', from Hessel, Katy, *The Great Women Artists Podcast*, 'Cecily Brown', 20 October 2020 (https://soundcloud.com/thegreatwomenartists/cecily-brown)

BOOKS

Martin, Courtney J., Rosenfeld, Jason, Prose, Francine, *Cecily Brown* (Phaidon, 2020)

Tøjner, Poul Erik, Myers, Terry R., Als, Hilton, Kold, Anders, *Where, When, How Often and with Whom* (Louisiana Museum of Modern Art, 2019)

PAULA REGO

BOOKS

Crippa, Elena, *Paula Rego* (Tate Publishing, 2021); *Paula Rego*, exhibition catalogue, Tate Britain, 7 July 2021–24 October 2021

EXHIBITIONS

Paula Rego, curated by Elena Crippa, Tate Britain, 7 July 2021–24 October 2021

MEDIA

Hessel, Katy, *The Great Women Artists Podcast*, 'Nick Willing on Paula Rego', October 2021 (https://soundcloud.com/thegreatwomenartists/nick-willing-on-paula-rego)

Dir. Nick Willing, *Paula Rego: Secrets and Stories*, BBC 2, 25 March 2017 (https://www.bbc.co.uk/programmes/b08kz9qz)

'Paula Rego – A Portuguese childhood (1/51)', Web of Stories – Life Stories of Remarkable People, 19 September 2017 (https://www.youtube.com/watch?v=vsBPrqEQ7BA)

Thank you to Gilda Williams for reading this chapter.

CHAPTER FIFTEEN: RADICAL CHANGE IN BRITAIN

NOTES

p. 393 '"We were using art to change things"', Lubaina Himid, cited from Hessel, Katy, *The Great Women Artists Podcast*, 'Lubaina Himid', 15 July 2020 (https://soundcloud.com/thegreatwomenartists/lubaina-himid)

BOOKS

Walsh, Susan and Himid, Lubaina, *Thin Black Line(s)*, Tate Britain 2011/2012, Making Histories Visible Project, Centre For Contemporary Art, 2011

MEDIA

Much of the factual information has been learnt and cited from Emmanus, Brenda presents 'Whoever Heard of a Black Artist? Britain's Hidden Art History', BBC 4, 30 July 2018

Sinclair, Leah, 'The BLK Art Group: how the West Midlands collective inspired the art world', *ArtUK*, 12 August 2020 (https://artuk.org/discover/stories/the-blk-art-group-how-the-west-midlands-collective-inspired-the-art-world)

Tate: Art Terms, 'The Blk Art Group' (https://www.tate.org.uk/art/art-terms/blk-art-group)

Information on exhibitions via Making Histories Visible (https://makinghistoriesvisible.com/curations/thin-black-lines/)

LUBAINA HIMID

NOTES

p. 393 '"interested in identifying as a Black artist"', cited from Hessel, Katy, *The Great Women Artists Podcast*, 'Lubaina Himid', 15 July 2020 (https://soundcloud.com/thegreatwomenartists/lubaina-himid)

p. 394 'These trips enabled the young Himid to realise the potential of what art could do… "revolutionary statements" and "multi-layered performances"', Lubaina Himid, cited from *ibid*

Lubaina Himid, 'A Fashionable Marriage: Pentonville Gallery (1986), Tate Liverpool (2014)' (https://lubainahimid.uk/portfolio/a-fashionable-marriage/)

BOOKS

Wellen, Michael, *Lubaina Himid: exhibition book* (Tate Publishing, 2021)

ARTICLES

Castagnini, Laura '*Freedom and Change* (1984) by Lubaina Himid', Tate, April 2018 (https://www.tate.org.uk/art/artworks/himid-freedom-and-change-t15264)

EXHIBITIONS

Naming the Money, Spike Island, 20 January 2017–26 March 2017

SONIA BOYCE

BOOKS

Baucom, Ian, Boyce, Sonia, Wainwright, Leon, Bailey, David A., *Shades of Black: Assembling Black Arts in 1980s Britain* (Duke University Press Books, 2005)

ARTICLES

Higgie, Jennifer, 'Sonia Boyce: 30 Years of Art and Activism', *Frieze*, 29 May 2018 (www.frieze.com/article/sonia-boyce-30-years-art-and-activism)

Orlando, Sophie, trans., Pleasance, Simon, 'Sonia Boyce: Post-1989 Art Strategies', *Critique d'art*, 2014 (https://journals.openedition.org/critiquedart/15362?lang=en)

EXHIBITIONS

Sonia Boyce, Manchester Art Gallery, 23 March 2018–2 July 2018

MEDIA

Bloomberg Markets and Finance, 'Sonia Boyce, Pioneer and Trailblazer', Brilliant Ideas, 29 August 2017 (https://www.bloomberg.com/news/videos/2017-08-29/sonia-boyce-on-brilliant-ideas-video)

Tate, 'Sonia Boyce – Gathering a History of Black Women', *TateShots*, 27 July 2018 (https://www.youtube.com/watch?v=vRB6H06UpJ4)

CLAUDETTE JOHNSON

NOTES

p. 397 '"to look at how women occupy space"', Claudette Johnson, cited from Spence, Rachel, 'Claudette Johnson at Modern Art Oxford – figures that simmer with mystery', *Financial Times*, 8 July 2019 (www.ft.com/content/97f8e52c-9f2d-11e9-9c06-a4640c9feebb)

BOOKS

Johnson, Claudette, Martin, Courtney J., Mills, Ella S., Ridgway, Emma, Tawadros, Gilane, McQueen, Steve, *Claudette Johnson: I Came to Dance* (Modern Art Oxford, 2019)

ARTICLES

Güner, Fisun, 'Q&A with Claudette Johnson', *a-n*, 12 June 2019 (www.a-n.co.uk/news/a-qa-with-claudette-johnson-artist-exploring-black-identity-and-representation/)

Lea, Cabanca, 'Taking up Space: Reflections on Claudette Johnson's *I Came to Dance*', *Modern Art Oxford Blog*, 13 June 2019 (www.modernartoxford.org.uk/taking-up-space/)

EXHIBITIONS

Claudette Johnson: I Came to Dance, Modern Art Oxford, 1 June 2019–8 September 2019

MAUD SULTER

BOOKS

Murrell, *Posing Modernity: The Black Model from Manet and Matisse to Today*

ARTICLES

Sulter, Maud, 'Hysteria', letter relating to an exhibition, 1991, The Brewery Arts Centre (http://new.diaspora-artists.net/display_item. php?id=248&table=artefacts)

EXHIBITIONS

Maud Sulter: Passion, Impressions Gallery, Bradford, 1 April 2016–4 June 2016

The Other Story: Afro-Asian Artists in Post-War Britain (1989–1990) Hayward Gallery, 1989–90 (www.afterall.org/exhibition/the-other-story/)

Thank you to Dorothy Price for reading this chapter.

COOL BRITANNIA

NOTES

p. 399 '"In the 1990s British art was making such a huge impression on people"', Tracey Emin, 2015. Quoted from a transcript of a Tate video on *My Bed*, 1998, 2 April 2015. Full quote: 'I think in the 1990s British art was making such a huge impression on people and all the tabloids were actually genuinely interested in it, regardless of how they set it up, and so that made the public interested in it, and I think the bed captured people's imagination; it was a good thing for [the] zeitgeist of the time.'

RACHEL WHITEREAD

NOTES

p. 401 '"authority to forgotten things"', quoted in Tate, 'Rachel Whiteread', *TateShots*, 2017

BOOKS

Gallagher, Ann, *Rachel Whiteread* (Prestel Pub, 2018)

ARTICLES

Fawcett, Laughlin, Review: '*Rachel Whiteread: House* by James Lingwood', 1996, *Landscape Architecture Magazine*, 1996 (https://www. jstor.org/stable/44671789?refreqid=-excelsior%3A714030e5eafc0ae60f60e3b-74b131295&seq=1)

EXHIBITIONS

Rachel Whiteread, Tate Britain, 12 September 2017–24 January 2018

SARAH LUCAS

NOTES

pp. 401–2 '"magnolia"'…"she's kebab"…"you put your cigarette out on me"', cited from Abbot, Kate, 'Interviews: Tracey Emin and Sarah Lucas: How we made The Shop', *Guardian*, 12 August 2013 (www.theguardian.com/ artanddesign/2013/aug/12/tracey-emin-sarah-lucas-shop)

BOOKS

Gioni, Massimiliano and Norton, Margot, *Sarah Lucas: Au Naturel* (Phaidon, 2018)

EXHIBITIONS

The Shop, Brick Lane, 1993

MEDIA

Hessel, Katy, *The Great Women Artists Podcast*, 'Olivia Laing on Chantal Joffe, Sarah Lucas and Ana Mendieta', 12 May 2020 (https:// soundcloud.com/thegreatwomenartists/ olivia-laing-on-chantal-joffe-sarah-lucas-and-ana-mendieta/sets)

TRACEY EMIN

NOTES

pp. 402–3 '"I hate it, I love it, I scream at it"'; '"unhappy childhood in a happy place"'; '"hotbed of political activism"', Tracey Emin in 2020, cited from Hessel, Katy, *Dior Talks*, '[Feminist Art] Boundary-breaking artist Tracey Emin on her very personal return to painting', 27 March 2020 (https://podcasts.dior.com/tracey-emin)

p. 403 '"If people are shocked by that, then maybe they should look at their own lives"', quoted in 'Tracey Emin, 1990s Interview and Exhibition, YBA', Kinolibrary Archive Film Collections (www.youtube.com/watch?v=LPB99H-sAuFQ&ab_channel=thekinolibrary); *Tracey Emin: I Need Art Like I Need God*, South London Gallery, 16 April–18 May 1997

BOOKS

Brandtzæg, Kari J., Devaney, Edith, Fuchs, Rudi, *Tracey Emin / Edvard Munch: The Loneliness of the Soul* (MUNCH, 2020)

Emin, Tracey, *Strangeland: The memoirs of one of the most acclaimed artists of her generation* (Sceptre, 2006)

EXHIBITIONS

The Shop, Brick Lane, 1993

Tracey Emin / Edvard Munch: The Loneliness of the Soul, Royal Academy of Arts, 18 May–1 August 2021

MEDIA

Much of the information cites KH in conversation with TE – Hessel, Katy, *Dior Talks*, '[Feminist Art] Boundary-breaking artist Tracey Emin on her very personal return to painting', March 2020 (https://podcasts.dior.com/tracey-emin)

Tate, 'Tracey Emin on *My Bed*', *Tate Shots*, 2 April 2015

JENNY SAVILLE

BOOKS

Saville, Jenny, *Jenny Saville* (Rizzoli International Publications, 2018)

ARTICLES

Cooke, Rachel, 'Interview: Jenny Saville: "I want to be a painter of modern life, and modern bodies"', *Observer*, 9 June 2012 (https://www. theguardian.com/artanddesign/2012/jun/09/ jenny-saville-painter-modern-bodies)

MEDIA

Luke, Ben, *A Brush With…*, 'A brush with… Jenny Saville', 12 August 2020 (https://podtail. com/en/podcast/a-brush-with/a-brush-with-jenny-saville/)

CORNELIA PARKER

BOOKS

Blazwick, Iwona, *Cornelia Parker* (Thames and Hudson, 2014)

MEDIA

Hessel, Katy, *The Great Women Artists Podcast*, 'Cornelia Parker', 25 August 2020; '"clichéd objects"', p. 406 quoted in this episode (https:// soundcloud.com/thegreatwomenartists/ cornelia-parker)

MONA HATOUM

BOOKS

Spector, Nancy, Brett, Guy, Archer, Michael, *Mona Hatoum*, revised and expanded edition (Phaidon, 2016)

ARTICLES

Perrot, Capucine, Mona Hatoum, 'Performance Still (1985–95)', Tate (www.tate.org.uk/ research/publications/performance-at-tate/ perspectives/mona-hatoum)

EXHIBITIONS

Mona Hatoum, Tate Modern, 4 May–21 August 2016

GILLIAN WEARING

BOOKS

Ferguson, Russell, De Salvo, Donna, Slyce, John, *Gillian Wearing* (Phaidon, 1999)

EXHIBITIONS

Gillian Wearing, Whitechapel Gallery, 28 March–17 June 2012

KH note: I have not referred to the artists as 'YBAs' due to an artist's request

In conversation with Katy Hessel: Waldemar Januszczak

Thank you to Gilda Williams, Harry Weller/ Tracey Emin and the studio of Sarah Lucas/ Sadie Coles HQ for reading this chapter.

PART FIVE: STILL WRITING (*2000–PRESENT*)

THE STORY OF ART IN THE NEW MILLENNIUM

BOOKS

Armstrong, and De Zegher, *Women Artists at the Millennium*

Chadwick, *Women, Art and Society*, pp. 534–41

Golden, Thelma and Storr, Robert, *Art 21: Art in the 21st Century* (H.N. Abrams, 2001)

Heartney, Eleanor, Posner, Helaine, Princenthal, Nancy, Scott, Sue, *The Reckoning: Women Artists of the New Millennium* (Prestel, 2013)

ARTICLES

Jansen, Charlotte, 'The Art Movements of the 2010s', *Artsy*, 18 December 2019 (www.artsy.net/ article/artsy-editorial-art-movements-2010s)

'The Exhibitions That Defined The 2000s', *Art in America*, 8 December 2020 (www.artnews.com/ list/art-in-america/features/the-exhibitions-that-defined-the-2000s-1234578321/)

'The 10 Most Important Artists of the 2010s', *Artsy*, 17 December 2019 (www.artsy.net/article/ artsy-editorial-10-artists-2010s)

'The 25 Works of Art That Define the Contemporary Age', *The New York Times Style Magazine*, 15 July 2019 (www.nytimes. com/2019/07/15/t-magazine/most-impor-tant-contemporary-art.html)

MEDIA

Numerous films produced by Art21 (https:// art21.org/)

In conversation with Katy Hessel: Julia Peyton-Jones

CHAPTER SIXTEEN: DECOLONISING NAR-RATIVES AND REWORKING TRADITIONS

TANIA BRUGUERA

ARTICLES

Westerman, Jonah, 'Tania Bruguera, Tatlin's Whisper #5, 2008', *Performance at Tate: Into the Space of Art* (Tate Research Publication, 2016)

EXHIBITIONS

Hyundai Commission: Tania Bruguera: 10,148,451, Tate Modern, 2 October 2018–24 February 2019

MEDIA

BBC Radio 4, 'Imagining the New Truth', 5 January 2017 (https://www.bbc.co.uk/programmes/b087lwt5)

DORIS SALCEDO

NOTES

p. 417 '"I am a Third World artist…"', Doris Salcedo in 2009, cited from Sollins, Susan, and Dowling, Susan, '"Compassion": Art in the Twenty-First Century, Season 5,' *Art21*, 7 October 2009 (https://art21.org/watch/art-in-the-twenty-first-century/s5/compassion/)

ARTICLES

Dover, Caitlin, 'How Artist Doris Salcedo's Practice Quietly Challenges Injustice', *Guggenheim Museum Blog*, 29 June 2015 (www.guggenheim.org/blogs/checklist/how-artist-doris-salcedos-practice-quietly-challenges-injustice)

White, Celia, 'Doris Salcedo: Shibboleth I (2007)', Tate, December 2014 (www.tate.org.uk/art/artworks/salcedo-shibboleth-i-p20334)

EXHIBITIONS

The Unilever Series: Doris Salcedo: Shibboleth, Tate Modern, 9 October 2007–6 April 2008

MEDIA

Luke, Ben, *A Brush With…*, 'A brush with… Doris Salcedo', 7 April 2020 (https://www.theartnewspaper.com/2021/04/07/a-brush-with-doris-salcedo)

MCA Chicago, 'Doris Salcedo's Public Works, 2015', 2015 (https://mcachicago.org/Publications/Video/2015/Doris-Salcedos-Public-Works)

Street, Ben, 'Material Visions: Wood | Untitled, Doris Salcedo, 2003, Istanbul', *Masterpiece London*, 3 March 2021

Tate, 'Doris Salcedo – Shibboleth', *Tate Shots*, 12 August 2008 (https://www.youtube.com/watch?v=NIJDn2MAn9I)

The Museum of Contemporary Art, 'Klaus Biesenbach in Conversation with Doris Salcedo', *Virtual Studio Visits*, 27 March 2021 (https://www.moca.org/program/virtual-studio-visits-doris-salcedo)

KARA WALKER

NOTES

p. 419 '…"constructed on the foundations of slavery"', cited from Centre for the Study of the Legacies of British Slave-ownership, University College London, Tate (https://www.tate.org.uk/about-us/history-tate/tate-galleries-and-slavery)

ARTICLES

Smith, Roberta, 'Sugar? Sure, but Salted With Meaning', *The New York Times*, 11 May 2014 (www.nytimes.com/2014/05/12/arts/design/a-subtlety-or-the-marvelous-sugar-baby-at-the-domino-plant.html)

EXHIBITIONS

A Subtlety, curated by Creative Time, Domino Sugar Factory, 10 May–6 July 2014

Fons Americanus, Tate Modern, 2 October 2019–7 February 2021 (https://www.tate.org.uk/art/artists/kara-walker-2674/kara-walkers-fons-americanus)

MEDIA

Forster, Ian, 'Kara Walker: "A Subtlety, or the Marvelous Sugar Baby"', *Art21*, 23 May 2014 (https://www.youtube.com/watch?v=sRk-P5rcXtys)

Walker, Kara, 'Creative Time Presents Kara Walker's "A Subtlety"', *Creative Time*, 20 March 2017 (https://creativetime.org/projects/karawalker/)

ADRIANA VAREJÃO

BOOKS

Crosby, Njideka Akunyili, Antunes, Leonor, Naumann, Henrike, Varejão, Adriana, *Interiorities* (Haus der Kunst, 2019)

ARTICLES

'Fluid Dynamics: The Art of Adriana Varejão', *Artforum*, January 2012 (www.artforum.com/print/201201/fluid-dynamics-the-art-of-adriana-varejao-29820)

MEDIA

Gagosian, 'Adriana Varejão and Pedro Alonzo | In Conversation via Gagosian', 18 June 2021 (https://www.youtube.com/watch?v=YM-j8rvOl8Ho)

UPENDING ALL CONVENTION

JULIE MEHRETU

NOTES

p. 420 '"The information can be so layered and disintegrated that it becomes a dust-like atmosphere"', quotation by Julie Mehretu cited from Sollins, Susan, 'To Be Felt as Much as Read, Julie Mehretu', *Art21*, 2008 (https://art21.org/read/julie-mehretu-to-be-felt-as-much-as-read/)

p. 421 '"came to an abrupt end after the Twin Towers fell"', cited from Hessel, Katy, *The Great Women Artists Podcast*, 'Julie Mehretu', 13 April 2021 (https://soundcloud.com/thegreatwomenartists/julie-mehretu)

BOOKS

De Zegher, Catherine, *Julie Mehretu: Drawings* (Rizzoli, 2007)

Kim, Christine Y. and Hockley, Rujeko, *Julie Mehretu*, (Prestel, 2019)

ARTICLES

Biswas, Allie, 'Julie Mehretu with Allie Biswas', *The Brooklyn Rail*, February 2019 (https://brooklynrail.org/2019/02/art/JULIE-MEHRE-TU-with-Allie-Biswas)

MEDIA

Much of the information cites KH discussion in Hessel, Katy, *The Great Women Artists Podcast*, 'Julie Mehretu', 13 April 2021 (https://podcasts.apple.com/gb/podcast/julie-mehretu/id1480259187?i=1000517027501)

SARAH SZE

NOTES

p. 422 '"a sort of exploded iPhone"', quotation by Zadie Smith, cited from Smith, Zadie, 'The Tattered Ruins of the Map', *Feel Free* (Hamish Hamilton, 2018), p. 204; ed. Enwezor, Okwui, *Sarah Sze Centrifuge* (Verlag der Buchhandlung Walther König, 2018), p. 46

BOOKS

Buchloh, Benjamin H. D., Enwezor, Okwui, Hoptman, Laura, *Sarah Sze* (Phaidon, 2016)

ARTICLES

Earnest, Jarrett, 'Sarah Sze Paints a Picture', Victoria Miro Gallery, 2018 (www.victoria-miro.com/sarah-sze-paints-a-picture-jarrett-earnest)

Obrist, Hans Ulrich, 'Sarah Sze in conversation with Hans Ulrich Obrist', *The Hero Winter Annual 2020* (https://sarahsze.com/Sarah%20Sze_HERO_WINTER_ANNUAL_2020.pdf)

TALK

Sarah Sze and Zadie Smith, Victoria Miro Gallery, July 2019

KATHARINA GROSSE

NOTES

p. 423 '"reset the idea of what a painting can be"', Katharina Grosse, cited from Dowling, Susan, and Sollins, Susan, 'Fiction', *Art21: Art in the Twenty-first Century*, Season 7, 14 November 2014 (https://art21.org/series/art-in-the-twenty-first-century/s7/)

BOOKS

Volk, Gregory, *Katharina Grosse – Contemporary Painter* (Lund Humphries, 2020)

ARTICLES

'"I'm Talking to the World While Painting on It": Watch Artist Katharina Grosse Transform Vast Spaces Into Three-Dimensional Paintings', *Artnet News*, 27 May 2021 (https://news.artnet.com/art-world/katharina-grosse-art21-2-1973857)

CAO FEI

p. 425 '"traditional Chinese brush painting"', cited from *Bloomberg Quicktake*, Brilliant Ideas, The Tenacious Alchemy of China's Cao Fei', 6 January 2017

ARTICLES

Judah, Hettie, 'Cao Fei: *Blueprints* review – would you trade love for progress?', *Guardian*, 4 March 2020 (www.theguardian.com/artanddesign/2020/mar/04/cao-fei-blueprints-review-would-you-trade-love-for-progress)

EXHIBITIONS

Cao Fei: Blueprints, Serpentine Galleries, 4 August–13 September 2020

MEDIA

London, Barbara, *Barbara London Calling* podcast, '1.05 Cao Fei', 22 September 2020 (https://podcasts.apple.com/us/podcast/1-05-cao-fei/id1525626178?i=1000492148105)

HITO STEYERL

BOOKS

Steyerl, Hito, *Hito Steyerl: I Will Survive: Espaces physiques et virtuels* (Spector Books, 2021)

ARTICLES

Bradley, Kimberly, 'Hito Steyerl Is an Artist With Power. She Uses It for Change', *The New York Times*, 15 December 2017 (www.nytimes.com/2017/12/15/arts/design/hito-steyerl.html)

Lissoni, Andrea, '*How Not to Be Seen: A Fucking Didactic Educational .MOV File* (2013) by Hito Steyerl', Tate, January 2015

MEDIA

Droitcour, Brian, 'Artist Talk: Hito Steyerl', Art Gallery of Ontario, 5 November 2019 (https://ago.ca/events/artist-talk-hito-steyerl)

UTOPIAN DREAMS

NOTES

p. 426 '"My warrior sculptures manifest themselves through the female figure, but the potential of the woman is infinite…"', quotation by Bharti Kher, from a phone conversation between KH and Bharti Kher, September 2021

EXHIBITIONS

The Shadows Took Shape, The Studio Museum in Harlem, 14 November 2013–9 March 2014

MEDIA

Tate, 'Afrofuturism's Others' (www.tate.org.uk/context-comment/audio/afrofuturisms-others)

Definition of Afrofuturism cites information discussed in Van Der Pool, James, 'Dark Matter: A History of the Afrofuture', BBC 4, 23 May 2021 (https://www.bbc.co.uk/programmes/m000wfcj)

ELLEN GALLAGHER

BOOKS

Mac Giolla Léith, Caoimhín, *Ellen Gallagher* (Lund Humphries, 2021)

ARTICLES

Lordi, Emily, 'The Black Artists Leaving America', *The New York Times Style Magazine*, 20 August 2021 (www.nytimes.com/2021/08/20/t-magazine/black-artists-expatriates.html)

EXHIBITIONS

Ellen Gallagher: Ecstatic Draught of Fishes, Hauser & Wirth, 21 May 2021–31 July 2021

MEDIA

Luke, Ben, *A Brush With…*, 'A brush with… Ellen Gallagher', 30 June 2021 (https://www.theartnewspaper.com/2021/06/30/a-brush-with-ellen-gallagher)

WANGECHI MUTU

NOTES

p. 428 '"It was a lot of taking these posed…"', Wangechi Mutu in 2014, cited from Willis, Deborah, 'Wangechi Mutu by Deborah Willis', *Bomb Magazine: Oral History Project*, 28 February 2014 (https://bombmagazine.org/articles/wangechi-mutu/)

p. 428 'exude nobility in commanding poses. Challenging Eurocentric busts and monuments', referencing garments from high-ranking African women, as seen in *The New Ones, will free Us*, Wangechi Mutu's 2019 commission for The Met's façade (www.metmuseum.org/exhibitions/listings/2019/facade-commission-wangechi-mutu)

BOOKS

Schoonmaker, Trevor, *Wangechi Mutu: A Fantastic Journey* (Duke University Press, 2013)

EXHIBITIONS

Wangechi Mutu: I am Speaking, Are You Listening?, Legion of Honor Museum, 7 May 2021–7 November 2021

MEDIA

Wangechi Mutu, *Art21*, 21 July 2021 (https://art21.org/artist/wangechi-mutu/)

Interview: Princenthal, Nancy, 'Wangechi Mutu: A New Face for the Met', *The New York Times*, 5 September 2019 (www.nytimes.com/2019/09/05/arts/design/wangechi-mutu-metropolitan-museum.html)

Interview: KH in conversation with Wangechi Mutu, March 2022

SIMONE LEIGH

ARTICLES

Molesworth, Helen, 'Art is Medicine: Helen Molesworth on Simone Leigh', *Artforum*, March 2018 (www.artforum.com/print/201803/helen-molesworth-on-the-work-of-simone-leigh-74304)

EXHIBITIONS

The Hugo Boss Prize: Simone Leigh, Loophole of Retreat, Guggenheim, 19 April 2021–27 October 2021

Simone Leigh: Brick House, The High Line, 5 June 2019–May 2021 (www.thehighline.org/art/projects/simoneleigh/)

MEDIA

Kenney, Nancy, 'Simone Leigh, now in the spotlight, contemplates the theme of invisibility', *The Art Newspaper*, 24 April 2019 (www.theartnewspaper.com/2019/04/24/simone-leigh-now-in-the-spotlight-contemplates-the-theme-of-invisibility)

MAGDALENE ODUNDO

Katy Hessel in conversation with Magdalene Odundo, *The Great Women Artists Podcast*, March 2022

LEILAH BABIRYE

Katy Hessel in conversation with Leilah Babirye, *The Great Women Artists Podcast*, September 2021

BHARTI KHER

NOTES

pp. 430–31 '"get an idea of truth from the body, not just physically but psychologically"'; '"carry with her the energy of masculinity"'; '"the potential to go anywhere, to move things, to transform themselves, to become shamans and have magical possibilities…"'. All quotes from Katy Hessel in conversation with Bharti Kher, September 2021

EXHIBITIONS

Contemporary Female Identities in the Global South, Joburg Contemporary Art Foundation, 16 September 2020–20 January 2021

Indian Highway, Serpentine Gallery, 10 December 2008–22 February 2009

MEDIA

Bloomberg Quicktake, Brilliant Ideas, 'Bharti Kher, episode eight', 2015

CHAPTER SEVENTEEN: FIGURATION IN THE TWENTY-FIRST CENTURY

NOTES

p. 433 '"figuration is still important today because people want to see themselves in art…"', Katy Hessel email conversation with Chantal Joffe, September 2021

p. 433 discussion around Mexican Muralism/Weimar Era information cited from Wetzler, Rachel, 'The Work of Realist Art', *Art in America*, 1 September 2020 (www.artnews.com/art-in-america/features/realism-art-work-1234569541/)

BOOKS

Deitch, Jeffrey, Gingeras, Alison, *Unrealism: New Figurative Art: New Figurative Painting*, (Rizzoli International Publications, 2018)

MICKALENE THOMAS

NOTES

p. 434 '"Portraits are very powerful…"', Mickalene Thomas, quoted in 'Artist Interview with Mickalene Thomas', Artnet, 13 December 2013

p. 434 '"not only to me as a young Black girl from Camden, New Jersey…"', Cascone, Sarah, '"I Use It as a Way of Drawing and Seeing": Artist Mickalene Thomas on How Photography Became the Center of Her Practice', *Artnet*, 26 October 2018 (https://news.artnet.com/art-world/mickalene-thomas-icp-spotlights-1381297)

BOOKS

Jones, Kellie, Gay, Roxane, *Mickalene Thomas* (Phaidon, 2021)

p. 435 '…for *La Leçon d'amour*, she reworked Balthus's notorious painting, *The Guitar Lesson*, 1934…', referencing Phaidon, *The Art of the Erotic* (Phaidon, 2017)

MEDIA

KH in conversation with Mickalene Thomas, Hessel, Katy, *Dior Talks* podcast, '[Feminist Art] The celebrated African American artist discusses representing the strength and beauty of black women', 31 July 2020 (https://podcasts.dior.com/feminist-art-mickalene-thomas)

NJIDEKA AKUNYILI CROSBY

BOOKS

Mitter, Siddhartha, Crosby, Njideka Akunyili, *The Beautiful Ones* (Victoria Miro, 2019)

ARTICLES

Ando, Erica, 'Njideka Akunyili Crosby', *BOMB Magazine*, 15 September 2016 (https://bombmagazine.org/articles/njideka-akunyili-crosby/)

MEDIA

Tate, 'Njideka Akunyili Crosby – Inhabiting Multiple Spaces', *TateShots*, October 2016 (https://www.youtube.com/watch?v=UeYP8ssD_BM)

Whitley, Zoé, 'Njideka Akunyili Crosby: In Conversation', *Tate Talks*, 29 September 2016 (https://www.youtube.com/watch?v=x-nAvC5utKaM)

LISA BRICE

NOTES

p. 439 '"gloaming hour"', referencing Aïcha Mehrez in conversation with Hessel, Katy, *The Great Women Artists Podcast*, 'Aïcha Mehrez on Lisa Brice' October 2019 (https://soundcloud.com/thegreatwomenartists/aicha-mehrez-on-lisa-brice)

BOOKS

Bailey, David A., and Farquarson, Alex, *Life Between Islands: Caribbean-British Art 1950s–Now* (Tate Publishing, 2022)

van Noord, Gerrie, and Horrocks, Jonathan, *Lisa Brice: Smoke and Mirrors* (Stephen Friedman Gallery, 2021)

ARTICLES

Mehrez, Aïcha, and Brice, Lisa, 'Q&A Lisa Brice', *Tate Etc.*, 1 May 2018, (www.tate.org.uk/tate-etc/issue-43-summer-2018/lisa-brice-art-now-interview-aicha-mehrez)

EXHIBITIONS

Art Now: Lisa Brice, curated by Aïcha Mehrez, Tate Britain, 26 April 2018–27 August 2018

Life Between Islands: Caribbean-British Art 1950s–Now, Tate Britain, 1 December 2021–3 April 2022

Lisa Brice: Smoke and Mirrors, Charleston Trust, 19 May 2021–30 August 2021

LYNETTE YIADOM-BOAKYE

BOOKS

Maidment, Isabella, Schlieker, Andrea, *Lynette Yiadom-Boakye: Fly In League With The Night* (Tate Publishing, 2020)

ARTICLES

Sargent, Antwaun, and Yiadom-Boakye, Lynette, 'Lynette Yiadom-Boakye: Speaking through Painting', *Tate Etc.*, 13 October 2020 (www.tate.org.uk/tate-etc/issue-50-autumn-2020/lynette-yiadom-boakye-antwaun-sargent-interview)

EXHIBITIONS

Lynette Yiadom-Boakye: Fly In League With The Night, curated by Isabella Maidment and Andrea Schlieker, Tate Britain, 18 November 2020–9 May 2021

MEDIA
Tate, 'Lynette Yiadom-Boakye in conversation with Thelma Golden', *Tate Talks*, 13 May 2021 (https://www.youtube.com/watch?v=cHbT-D9DYrqk)

TOYIN OJIH ODUTOLA

NOTES
p. 440 '"writing tool first"', cited from *Toyin Ojih Odutola: A Countervailing Theory*, Barbican Centre, 10 August 2020–January 2021

p. 440 '"I think narrative helps people…"', Toyin Ojih Odutola in conversation with Katy Hessel, *The Great Women Artists Podcast*, 'Toyin Ojih Odutola', 6 October 2020 (https://soundcloud.com/thegreatwomenartists/toyin-ojih-odutola)

Hessel, Katy, 'An interview with Zadie Smith and Toyin Ojih Odutola', *National Portrait Gallery Blog*, 6 July 2020 (https://www.npg.org.uk/blog/zadie-smith-and-toyin-ojih-odutola)

ARTICLES
Hockley, Rujeko, and Lang, Melinda, 'Toyin Ojih Odutola: By Her Design', 2017 (https://whitney.org/essays/toyin-ojih-odutola)

Smith, Zadie, 'Toyin Ojih Odutola's Visions of Power', *The New Yorker*, 10 August 2020 (www.newyorker.com/magazine/2020/08/17/toyin-ojih-odutolas-visions-of-power)

EXHIBITIONS
Toyin Ojih Odutola: To Wander Determined, Whitney Museum of American Art, 20 October 2017–25 February 2018

MEDIA
Smith, Zadie, 'In Conversation, Toyin Ojih Odutola and Zadie Smith', The Drawing Center, 7 December 2018 (www.youtube.com/watch?v=C8w4i3e953Q&t=4142s&ab_channel=TheDrawingCenter)

MARÍA BERRÍO

NOTES
p. 441 '"the imagined people in my paintings are displaced, and are seen in preparation for their travels, in moments of transition, and in states of uncertainty"', María Berrío, quoted in 'Artist Statement' (unpublished), 2019

ARTICLES
Bartunek, C. J., '"As Complicated and Elusive as Reality": María Berrío's Many-Layered Collages', January 2019 (https://thegeorgiareview.com/posts/as-complicated-and-elusive-as-reality-maria-berrios-many-layered-collages-with-an-interview-by-c-j-bartunek/)

EXHIBITIONS
María Berrío, Caroline Walker, Flora Yukhnovich, Victoria Miro in collaboration with *The Great Women Artists*, 7 June–27 July 2019

MEDIA
'María Berrío in conversation with Katy Hessel', Victoria Miro Gallery, 29 October 2020 (https://vimeo.com/473805230)

CHANTAL JOFFE

NOTES
p. 444 '"Sometimes when I start..."' Chantal Joffe via email, September 2021

ARTICLES
Laing, Olivia, '"Painting is a high-wire act": Olivia Laing on sitting for the artist Chantal Joffe', *Observer*, 12 May 2018 (www.theguardian.com/books/2018/may/12/chantal-joffe-paints-olivia-laing-mutual-portraits-words-and-paint)

In conversation with Katy Hessel: Chantal Joffe, 2019–present

CELIA PAUL

NOTES
p. 444 '"I am not a portrait painter. If I'm anything, I have always been an autobiographer and chronicler of my life and family"', cited from Paul, Celia, *Self-Portrait* (Jonathan Cape, 2019), p. 1

BOOKS
Paul, *Self-Portrait*

ARTICLES
Smith, Zadie, 'The Muse at Her Easel', *The New York Review*, 21 November 2019 (https://nybooks.com/articles/2019/11/21/muse-easel-celia-paul-lucian-freud/)

MEDIA
Celia Paul in conversation with Hessel, Katy, *The Great Women Artists Podcast*, 'Celia Paul', November 2019 (https://soundcloud.com/thegreatwomenartists/celia-paul)

JENNIFER PACKER

BOOKS
ed., Blanchflower, Melissa, *Jennifer Packer: The Eye is Not Satisfied with Seeing*, (Walther Konig, 2021)

EXHIBITIONS
Jennifer Packer: The Eye is Not Satisfied with Seeing, curated by Melissa Blanchflower and Natalie Grabowska, Serpentine Galleries, 19 May 2021–22 August 2021

MEDIA
Serpentine Galleries, 'Jennifer Packer in Conversation with Hans Ulrich Obrist', 2021 (https://www.serpentinegalleries.org/whats-on/jennifer-packer/)

TRACEY EMIN

In conversation with Katy Hessel: Tracey Emin

ZANELE MUHOLI

NOTES
p. 448 '"through which I could speak about whatever was inside…"', cited from O'Hagan, Sean, 'Zanele Muholi's queer South Africa: "I do not dare shoot at night. It is not safe', *Guardian*, 2 November 2020 (www.theguardian.com/artanddesign/2020/nov/02/zanele-muholi-interview-queer-photographer-lgbtq-south-africa-tate)

p. 448 'For *Only Half the Picture*, 2002–6, Muholi took their camera into townships across South Africa, capturing with sensitivity those subjected to violence… "so that future generations will note that we were here"', cited from Tate, 'Zanele Muholi, Exhibition Guide', 2020 (www.tate.org.uk/whats-on/tate-modern/exhibition/zanele-muholi/zanele-muholi)

BOOKS
Allen, Sarah and Nakamori, Yasufumi, *Zanele Muholi: exhibition book* (Tate Publishing, 2020)

EXHIBITIONS
Zanele Muholi, Tate Modern, 5 November 2020–31 May 2021

KHADIJA SAYE

NOTES
BBC Three, 'Khadija Saye: The Artist Who Tragically Died In Grenfell Tower', 1 September 2017 (https://www.bbc.co.uk/programmes/p05dx3yb)

p. 449 '"the deep-rooted urge to find solace in a higher power"', cited from 'Khadija Saye: in this space we breathe', Victoria Miro, 2020 (https://online.victoria-miro.com/khadijasaye/)

MEDIA
Logan, Nicole, Callaghan, Shanelle, Odubanjo, Pelumi, *Tate Podcast*, 'The Art of Healing', 13 November 2020 (www.tate.org.uk/art/artworks/saye-nak-bejjen-t15140/art-healing)

Thank you to Nicola Green for reading this passage.

CHAPTER EIGHTEEN: THE 2020S

JADÉ FADOJUTIMI

NOTES
p. 453 '"I feel like I see paint as a living thing in itself…"' Jadé Fadojutimi in conversation with Hessel, Katy, *The Great Women Artists Podcast*, 'Jadé Fadojutimi', February 2020 (https://soundcloud.com/thegreatwomenartists/jade-fadojutimi)

p. 454 '"My paintings seem to be aware of the present whilst colliding with the past"', quoted from Higgie, Jennifer, 'From Life – Thoughts on the paintings of Jadé Fadojutimi' in *Jadé Fadojutimi: Jesture* (Anomie Publishing, 2021), p. 11

ARTICLES
Hessel, Katy, '27-Year-Old Painter Jadé Fadojutimi Is In A League Of Her Own', *British Vogue*, 31 Aug 2020 (vogue.co.uk/arts-and-lifestyle/article/jade-fadojutimi-interview)

EXHIBITIONS
Jadé Fadojutimi: Jesture, Pippy Houldsworth Gallery, 16 September–31 October 2020

FLORA YUKHNOVICH

NOTES
p. 454 '"painting is a way of making sense of all the images that bombard us minute by minute…"', Katy Hessel email conversation with Flora Yukhnovich, September 2021

MEDIA
Flora Yukhnovich in conversation with Hessel, Katy, *The Great Women Artists Podcast*, 'Flora Yukhnovich', 19 May 2020 (https://soundcloud.com/thegreatwomenartists/flora-yukhnovich)

SOMAYA CRITCHLOW

BOOKS
Renshaw, Amanda, *Somaya Critchlow: Paintings* (Skira, 2021)

MEDIA
Somaya Critchlow in conversation with Hessel, Katy, *The Great Women Artists Podcast*, 'Somaya Critchlow', 21 July 2020 (https://soundcloud.com/thegreatwomenartists/somaya-critchlow)

LIST OF ILLUSTRATIONS AND PHOTOGRAPHIC ACKNOWLEDGEMENTS

Every effort has been made to contact all copyright holders. The publishers will be pleased to amend in future printings any errors or omissions brought to their attention.

8 Alice Neel, *Linda Nochlin and Daisy*, 1973. Oil on canvas. 141.9 × 111.8 cm. © The Estate of Alice Neel. Courtesy The Estate of Alice Neel and David Zwirner.

21 Properzia de' Rossi, *Grassi Family Crest*, 1510–30. Silver filigree and carved peach and plum stones. Museo Civico Medievale, Bologna, Italy.

22 Properzia de' Rossi, *Joseph and Potiphar's Wife*, 1525–6. Marble. Museo di San Petronio, Bologna. Photo: Picture Art Collection/Alamy.

24–5 Plautilla Nelli, *The Last Supper*, c.1560. Oil on canvas. Museum of Santa Maria Novella, Florence. Reproduced with the kind permission of the Municipality of Florence – Museums, Libraries, Archives Service. Photo: AWA/Rabatti & Domingie.

26 Sofonisba Anguissola, *The Chess Game*, 1555. Oil on canvas. National Museum, Poznań, Poland. Photo: Artefact/Alamy.

27 Sofonisba Anguissola, *Self-Portrait with Bernardino Campi*, 1550. Oil on canvas. Pinacoteca Nazionale, Siena. Photo: Artefact/Alamy.

28 (left) Lavinia Fontana, *Portrait of Bianca degli Utili Maselli with six of her children*, 1605. Oil on canvas. Private Collection. Photo: Sotheby's/Alamy.

28 (right) Lavinia Fontana, *Self-Portrait at the Virginal with a Servant*, 1577. Oil on canvas. Accademia Nazionale di San Luca, Rome. Photo: Heritage Image Partnership/Alamy.

29 Caterina van Hemessen, *Self-Portrait at the Easel*, 1548. Oil on panel. Kunstmuseum, Basel, Schenkung der Prof. J. J. Bachofen-Burckhardt-Stiftung 2015 (Inv. 1361).

31 Clara Peeters, *Still Life with a Vase of Flowers, Goblets and Shells*, 1612. Oil on board. Staatliche Kunsthalle, Karlsruhe. Photo: akg-images/Erich Lessing.

32 Fede Galizia, *Portrait of Paolo Morigia*, 1592–5. Oil on canvas. Pinacoteca Ambrosiana, Milan. Photo: Picture Art Collection/Alamy.

33 (above) Giovanna Garzoni, *Dog with a Biscuit and a Chinese Cup*, 1640s. Tempera on vellum. Galleria Palatina di Palazzo Pitti, Florence. Photo: Nicolò Orsi Battaglini/Bridgeman Images.

33 (below) Giovanna Garzoni, *Still Life with Bowl of Citrons*, late 1640s. Tempera on vellum. The J. Paul Getty Museum, Los Angeles. Photo: Digital image courtesy of the Getty's Open Content Program.

34 Giovanna Garzoni, *Portrait of Prince Zaga Christ*, 1635. Watercolour and bodycolour on vellum mounted on card. Allen Memorial Art Museum, Oberlin College. Photo: © Philip Mould Ltd, London.

36 Artemisia Gentileschi, *Susanna and the Elders*, 1610. Oil on canvas. Schloss Weißenstein, Pommersfelden. Photo: Artexplorer/Alamy.

39 Artemisia Gentileschi, *Judith Slaying Holofernes*, 1612. Oil on canvas. Galleria degli Uffizi, Florence. Photo: incamerastock/Alamy.

40 Elisabetta Sirani, *Timoclea Kills the Captain of Alexander the Great*, 1659. Oil on canvas. Museo Nazionale di Capodimonte, Naples. Photo: Picture Art Collection/Alamy.

41 Elisabetta Sirani, *Portia Wounding Her Thigh*, 1664. Oil on canvas. Collezioni d'Arte e di Storia della Fondazione della Cassa di Risparmio, Bologna. Photo: Picture Art Collection/Alamy.

43 (left) Judith Leyster, *The Merry Drinker*, 1629. Oil on canvas. Rijksmuseum, Amsterdam.

43 (right) Judith Leyster, *The Serenade*, 1629. Oil on panel. Rijksmuseum, Amsterdam.

44 Judith Leyster, *Self-Portrait*, 1630. Oil on canvas. National Gallery of Art, Washington, DC. Gift of Mr and Mrs Robert Woods Bliss (Acc. No. 1949.6.1).

46 Rachel Ruysch, *Still Life with Flowers on a Marble Tabletop*, 1716. Oil on canvas. Rijksmuseum, Amsterdam.

47 Maria Sibylla Merian, *Crocodile of Surinam*. Illustration from *Metamorphosis insectorum Surinamensium*, 1719.

48 (left) Maria Sibylla Merian, *A pomegranate tree showing both its flowers and fruit, a caterpillar, its chrysalis, and two butterflies*. Illustration from *Metamorphosis insectorum Surinamensium*, 1719.

48 (right). Maria Sibylla Merian, *Pineapple with Australian and German Cockroaches*. Illustration from *Metamorphosis insectorum Surinamensium*, 1719.

49 Joanna Koerten, *The Virgin and Child with St John*, c.1703. Miniature, cut paper between crystals. Victoria and Albert Museum, London. Photo: © V&A Museum, London.

50 Mary Delany, *Sea daffodil (Pancratium maritimum)*, 1778. Collage of coloured papers, with bodycolour and watercolour, on black ink background. British Museum, London. Photo: © Trustees of the British Museum, London.

55 Rosalba Carriera, *Françoise-Marie de Bourbon as Amphitrite*, c.1720. Watercolour on ivory. Royal Collection Trust. Photo: © Her Majesty Queen Elizabeth II, 2022/Bridgeman Images.

56 Rosalba Carriera, *A Young Lady with a Parrot*, c.1730. Pastel on blue laid paper. Art Institute of Chicago, Regenstein Collection, 1985.40. Photo: Art Institute of Chicago.

58 Johann Zoffany, *The Academicians of the Royal Academy*, 1772. Oil on canvas. Royal Collection. Royal Collection Trust. Photo: © Her Majesty Queen Elizabeth II, 2022/Bridgeman Images.

59 Angelica Kauffman, *Zeuxis Selecting Models for His Painting of Helen of Troy*, 1778. Oil on canvas. Annmary Brown Memorial Collection, Brown University, Providence, R.I. Photo: Brown University Library.

60 Angelica Kauffman, *Design*, 1778–80. Oil on canvas. 126 × 148.5 cm. © Royal Academy of Arts, London. Photo: John Hammond.

62 Elisabeth Vigée Le Brun, *Marie Antoinette in a Chemise Dress*, 1783. Oil on canvas. Museum Schloss Fasanerie, Eichenzell. Photo: © Hessische Hausstiftung, Kronberg im Taunus.

63 Elisabeth Vigée Le Brun, *Marie Antoinette and Her Children*, 1787. Oil on canvas. Musée National des Châteaux de Versailles et de Trianon. Photo: Bridgeman Images.

64 Adélaïde Labille-Guiard, *Self-Portrait with Two Pupils, Marie Gabrielle Capet and Marie Marguerite Carreaux de Rosemond*, 1785. Oil on canvas. Metropolitan Museum of Art, New York. Gift of Julia A. Berwind, 1953 (Acc. No. 53.225.5).

66 Marie-Guillemine Benoist, *Portrait of Madeleine*, 1800. Oil on canvas. Musée du Louvre, Paris. Photo: Josse/Bridgeman Images.

67 Marie Denise Villers, *Marie Joséphine Charlotte du Val d'Ognes*, 1801. Oil on canvas. Metropolitan Museum of Art, New York. Mr and Mrs Isaac D. Fletcher Collection, Bequest of Isaac D. Fletcher, 1917 (Acc. No. 17.120.204).

72 Rosa Bonheur, *The Horse Fair*, 1852–5. Oil on canvas. Metropolitan Museum of Art, New York. Gift of Cornelius Vanderbilt, 1887 (Acc. No. 87.25).

73 Lady Butler (Elizabeth Southerden Thompson), *Calling the Roll after an Engagement, Crimea*, 1874. Oil on canvas. Royal Collection Trust. Photo: © Her Majesty Queen Elizabeth II, 2022/Bridgeman Images.

75 Emma Civey Stahl, *Woman's Rights Quilt*, c.1875. Cotton. Metropolitan Museum of Art, New York. Funds from various donors, 2011 (Acc. No. 2011.538).

76 Ellen Harding Baker, *Solar System Quilt*, 1876. Cotton, silk, wool. Division of Cultural and Community Life, National Museum of American History, Smithsonian Institution. Gift of Patricia Hill McCloy and Kathryn Hill Meardon.

77 Harriet Powers, *Pictorial Quilt*, 1895–8. Cotton. Museum of Fine Arts, Boston. Bequest of Maxim Karolik. Photo: © 2022 MFA Boston. All rights reserved/Bridgeman Images.

78 Nampeyo, *Polacca polychrome water jar*, c.1895–1900. Clay and pigment. Metropolitan Museum of Art, New York. The Charles and Valerie Diker Collection of Native American Art, Gift of Valerie-Charles Diker Fund, 2017 (Acc. No. 2017.718.8).

80 Edmonia Lewis, *Forever Free*, 1867. Marble. Howard University, Washington, DC. Photo: Granger/Alamy.

82 Katsushika Ōi, *Display Room in Yoshiwara at Night*, 1840s. Hanging scroll, colour on paper. Ota Memorial Museum of Art, Shibuya City, Japan.

83 Katsushika Ōi, *Girl Composing a Poem under the Cherry Blossoms in the Night*, c.1850. Hanging scroll, colour on silk. Menard Art Museum, Komaki, Japan. Photo: Matteo Omied/Alamy.

85 Anna Atkins, *Dictyota dichotoma, in the young state and in fruit*, from *Photographs of British Algae: Cyanotype Impressions (Part XI)*, c.1843–c.1853. Cyanotype. New York Public Library, New York.

87 Emily Mary Osborn, *Nameless and Friendless*, 1857. Oil on canvas. Private Collection. Photo: Bridgeman Images.

89 Joanna Boyce Wells, *Elgiva*, 1855. Oil on canvas. Private Collection. Photo: courtesy National Portrait Gallery, London.

90 Joanna Boyce Wells, *Study of Fanny Eaton*, 1861. Oil on paper laid to linen. Yale Center for British Art, New Haven. Paul Mellon Fund (Acc. No. B1991.29).

91 Julia Margaret Cameron, *Mnemosyne (Marie Spartali)*, 1868. Albumen print from wet collodion negative. The Cleveland Museum of Art. Andrew R. and Martha Holden Jennings Fund (1974.52).

93 Marie Spartali Stillman, *The Enchanted Garden of Messer Ansaldo*, 1899. Watercolour on paper. Pre-Raphaelite Inc., London. Photo: courtesy of Julian Hartnoll/Bridgeman Images.

94–5 Evelyn de Morgan, *Night and Sleep*, 1878. Oil on canvas. De Morgan Collection, courtesy of the De Morgan Foundation. Photo: De Morgan Foundation/Bridgeman Images.

97 Margaret Macdonald Mackintosh, *The May Queen*, 1900. Inlaid gesso panel. Installation photo, Secession Exhibition, Vienna, 1900. Photo: © Hunterian Museum and Art Gallery, Glasgow.

98 Margaret Macdonald Mackintosh, *The Opera of the Sea*, 1902. Inlaid gesso panel. Photo: The Fine Art Society, London/Bridgeman Images.

101 Georgiana Houghton, *Glory be to God*, c.1860/70. Watercolour. Courtesy The Museum + The Gallery of Everything and courtesy of the Victorian Spiritualists' Union Inc. Melbourne, Australia.

103 Hilma af Klint, *Group X, No. 1, Altarpiece*, from *Altarpieces*, 1915. Oil and metal leaf on canvas. Moderna Museet, Stockholm. © Stiftelsen Hilma af Klints Verk. Photo: Moderna Museet, by courtesy of the Hilma af Klint Foundation.

113 Berthe Morisot, *Reclining Woman in Grey*, 1879. Oil on canvas. Private collection. Photo: Heritage Image Partnership/Alamy.

114 Berthe Morisot, *The Cradle*, 1872. Oil on canvas. Musée d'Orsay, Paris, France. Photo: Bridgeman Images.

115 Berthe Morisot, *In the Garden at Maurecourt*, c.1884. Oil on canvas. Toledo Museum of Art, Ohio. Purchased with funds from the Libbey Endowment. Gift of Edward Drummond Libbey (1930.9).

116 Mary Cassatt, *In the Loge*, 1878. Oil on canvas. Museum of Fine Arts, Boston. The Hayden Collection, Charles Henry Hayden Fund (Acc. no. 10.35). Photo: © 2022 MFA Boston. All rights reserved/Bridgeman Images.

117 Marie Bracquemond, *Trois femmes aux ombrelles (Three women with parasols)*, 1880. Oil on canvas. Musée d'Orsay, Paris. Photo: © 2022. RMN-Grand Palais/Dist. Photo SCALA, Florence.

118 Marie Bashkirtseff, *Self-Portrait with a Palette*, 1883. Oil on canvas. Musée des Beaux-Arts Jules-Chéret, Nice. Photo: Picture Art Collection/Alamy.

119 Camille Claudel, *The Waltz*, 1905. Bronze. 43 × 33 × 18.5 cm. Private collection. Photo: akg-images/Erich Lessing.

121 (left) Helene Schjerfbeck, *Self-Portrait, Black Background*, 1915. Oil on canvas. Ateneum Art Museum, Finnish National Gallery, Helsinki. Herman and Elisabeth Hallonblad Collection. Photo: Finnish National Gallery/Bridgeman Images.

121 (right) Helene Schjerfbeck, *Self-Portrait with Red Spot*, 1944. Oil on canvas. Ateneum Art Museum, Finnish National Gallery, Helsinki. Photo: Finnish National Gallery/Bridgeman Images.

123 (left) Gwen John, *A Corner of the Artist's Room in Paris*, c.1907–9. Oil on canvas. Sheffield Galleries and Museums Trust, Sheffield. Photo: Museums Sheffield/Bridgeman Images.

123 (right) Gwen John, *Self-Portrait*, 1902. Oil on canvas. Tate Gallery, London. Photo: Tate.

124 Paula Modersohn-Becker, *Self-Portrait, Sixth Wedding Anniversary*, 1906. Paula Modersohn-Becker Museum, Bremen. Photo: Fine Art Images/Bridgeman Images.

126 Florine Stettheimer, *A Model (Nude Self-Portrait)*, 1915. Oil on canvas. Art Properties, Avery Architectural & Fine Arts Library, Columbia University in the City of New York, Gift of the Estate of Ettie Stettheimer, 1967. Photo: Abbus Archive/Alamy.

127 Georgette Chen, *Self-Portrait*, c.1934. Oil on canvas. Collection of National Gallery Singapore. Gift of Lee Foundation.

128 Pan Yuliang, *Self-Portrait in Red*, c.1940. Oil on canvas. 安徽博物院 Anhui Provincial Museum, Hefei, China.

131 (left) Käthe Kollwitz, *Need*, sheet 1 from the cycle *A Weavers' Revolt*, 1893–7. Crayon and pen lithograph with scratch technique. Kollwitz Collection, Cologne (Kn 33 II). Photo: © Käthe Kollwitz Museum, Köln.

131 (right) Käthe Kollwitz, *Woman with Dead Child*, 1903. Line etching, drypoint, sandpaper and soft ground with imprint of ribbed laid paper and Ziegler's transfer paper. Kollwitz Collection, Cologne (Kn 81 VIIIa). Photo: © Käthe Kollwitz Museum, Köln.

132 Käthe Kollwitz, *The Widow II*, sheet 5 of the series *War*, 1922. Woodcut. Kollwitz Collection, Cologne (Kn 178 VII c). Photo: © Käthe Kollwitz Museum, Köln.

133 Gabriele Münter, *Marianne von Werefkin*, 1909. Städtische Galerie im Lenbachhaus, Munich. © DACS 2022. Photo: Bridgeman Images.

134 Suzanne Valadon, *The Blue Room*, 1923. Oil on canvas. Musée National d'Art Moderne, Paris. Photo: Painters/Alamy.

135 Jacqueline Marval, *L'Odalisque au Guépard* (*Cheetah Odalisque*), 1900. Oil on canvas. Private collection, courtesy Comité Jacqueline Marval, Paris. Photo: © Nicolas Roux dit Buisson.

136 Jacqueline Marval, *Les Odalisques*, 1902–3. Oil on canvas. Musée de Grenoble, Grenoble. Photo: Ville de Grenoble/Musée de Grenoble–J. L. Lacroix.

137 Marie Laurencin, *Les Jeunes Filles* (*The Young Girls*), 1910. Oil on canvas. Moderna Museet, Stockholm. The Rolf de Maré Collection. © Fondation Foujita/ADAGP, Paris and DACS, London 2022. Photo: Moderna Museet, Stockholm.

138 (left) Amrita Sher-Gil, *South Indian Villagers Going to Market*, 1937. Oil on canvas. 147 × 90 cm. Collection Vivan and Navina Sundaram, New Delhi.

139 Vanessa Bell's former studio at Charleston. Photo: © The Charleston Trust. Photo: Lee Robbins.

140 Vanessa Bell and Duncan Grant, *The Famous Women Dinner Service*, 1932–4. Each plate titled. 50 hand-painted Wedgwood blank ceramic plates. Collection of The Charleston Trust. © Estate of Vanessa Bell. All rights reserved, DACS 2022. / © Estate of Duncan Grant. All rights reserved, DACS 2022. Photo: courtesy PIANO NOBILE, Robert Travers (Works of Art) Ltd.

141 Sonia Delaunay, *Prismes électriques* (*Electric Prisms*), 1914. Oil on canvas. Musée National d'Art Moderne, Centre Pompidou, Paris. © Pracusa. Photo: © 2022 Scala, Florence.

142 Natalia Goncharova, *Cyclist*, 1913. Oil on canvas. State Russian Museum, St Petersburg, Russia. © UPRAVIS/DACS 2022. Photo: Bridgeman Images.

143 (left) Valentina Kulagina, *International Women Worker's Day*, 1930. Poster. © ARS, NY and DACS, London 2022. Photo: Universal History Archive/UIG/Bridgeman Images.

143 (right) Liubov Popova, *Painterly Architectonic*, 1918. Gouache and watercolour with touches of varnish. Yale University Art Gallery. Gift of the Estate of Katherine S. Dreier (1953.6.92).

144–5 Benedetta Cappa Marinetti, *Speeding Motor Boat*, 1923–4. Oil on canvas. Galleria d'Arte Moderna, Rome. © Benedetta Cappa Marinetti, used by permission of Vittoria Marinetti and Luce Marinetti's heirs. Photo: Album/Alamy.

149 (left) Gluck by Howard Coster, c.1932. Photograph. Courtesy The Fine Art Society.

149 (right) Gluck, *Ernest Thesiger*, 1925/6. Oil on canvas. 14 ¼ × 10 ⅛ in. (36 × 25.7 cm). Private collection. © Gluck Estate. Photo: Courtesy The Fine Art Society, London.

150. Gluck, *Medallion* (*YouWe*), 1936. Oil on canvas. 12 × 14 in. (30.5 × 35.6 cm.). Private collection. © Gluck Estate. Photo: Courtesy The Fine Art Society, London.

151 Romaine Brooks, *Self-Portrait*, 1923. Oil on canvas. Smithsonian American Art Museum, Gift of the artist. Photo: © 2022 Smithsonian American Art Museum/Art Resource, NY/Scala, Florence.

152 Tamara de Lempicka, *Group of Four Nudes* (*Irene and Her Sisters*), 1925. Oil on canvas. Private collection. © Tamara de Lempicka Estate, LCC/DACS 2022. Photo: Christie's/Bridgeman Images.

154 Marcel Moore, *Untitled* (Claude Cahun in *Le Mystère d'Adam*), 1929. Gelatin silver print; 4 × 3 in. (10.16 × 7.62 cm). San Francisco Museum of Modern Art. Fractional and promised gift of Carla Emil and Rich Silverstein. © Estate of Claude Cahun. Photo: Katherine Du Tiel/courtesy SFMOMA.

155 Claude Cahun, *Self-Portrait Reflected in a Mirror*, 1928. Courtesy of Jersey Heritage Collections.

159 Hannah Höch, *Cut with the Dada Kitchen Knife through the Last Weimar Beer-Belly Cultural Epoch in Germany*, 1919. Nationalgalerie, Staatliche Museen zu Berlin. © DACS, 2022. Photo: © 2022 Scala, Florence/bpk, Bildagentur fuer Kunst, Kultur und Geschichte, Berlin.

161 Sophie Taeuber-Arp, *Dada Head*, 1920. Oil on wood with glass beads on wire. Museum of Modern Art, New York. Mrs John Hay Whitney Bequest (by exchange) and Committee on Painting and Sculpture Funds. Photo: © 2022 MoMA, NY/Scala, Florence.

162 Unknown photographer, *Baroness von Freytag-Loringhoven*, c.1920–25. George Grantham Bain Collection, Library of Congress, Prints & Photographs Division, Washington, DC.

164 Jeanne (Gertrud) Mammen, *She Represents*, c.1928. Watercolour and pencil on paper. Private collection. © DACS, 2022. Photo: akg-images.

165 Lotte Laserstein, *At the Mirror*, 1930. Oil on canvas. 124.5 × 88.8 cm (49 × 35 in.). Property of a Family. © DACS, 2022.

167 Unknown photographer, *Bauhaus Students of the Weaving Workshop in a Loom*, 1928. Silver gelatine on barite paper. Bauhaus-Archiv/Museum für Gestaltung, Berlin (Inv. Nr.: 2007/13.14).

168 Anni Albers, *Wall-Hanging*, 1926. Mercerized cotton,

silk. 80 × 47 ½ in. (203.2 × 120.7 cm). Metropolitan Museum of Art, New York. Purchase, Everfast Fabrics Inc. and Edward C. Moore Jr. Gift, 1969. © 2022 The Josef and Anni Albers Foundation/Artists Rights Society (ARS) New York/DACS, London. Photo: © 2022 Met, NY/Art Resource/Scala, Florence.

169 Gertrud Arndt, *Maskenfoto, Dessau*, 1930. Art Institute of Chicago. David Travis Fund. © DACS, 2022. Photo: Bridgeman Images.

170 Marianne Brandt, *Teapot*, c.1924. Metalwork, silver. Metropolitan Museum of Art, New York. The Beatrice G. Warren and Leila M. Redstone Fund, 2000 (Acc. No. 2000.63a-c). © DACS, 2022. Photo: © 2022 Met, NY/Scala, Florence.

173 Dora Maar, *The Years Lie in Wait for you*, c.1935. Photograph. The William Talbott Hillman Collection © ADAGP, Paris and DACS, London 2022. Photo: Kris Graves.

174 Lee Miller, *Tanja Ramm under a Bell Jar, Paris, France*, 1930 by Lee Miller [NC0103-8]. © Lee Miller Archives, England 2022. All rights reserved. leemiller.co.uk.

175 Lee Miller, *Portrait of Space, Al Bulwayeh, near Siwa, Egypt*, 1937 by Lee Miller [E1905]. © Lee Miller Archives, England 2022. All rights reserved. leemiller.co.uk.

177 Meret Oppenheim, *Object* (*Le dejeuner en fourrure*), 1936. Fur-covered cup, saucer and spoon. Cup, 4 ⅜ in. (10.9 cm) diameter; saucer, 9 ⅜ in. (23.7 cm) diameter; spoon, 8″ (20.2 cm) long; overall height 2 ⅞ in. (7.3 cm). Museum of Modern Art, New York. Purchase. © DACS 2022. Photo: MoMA, NY/Scala, Florence.

178 Eileen Agar, *Angel of Anarchy*, 1936–40. Plaster, fabric, shells, beads, diamante stones and other materials. Tate Gallery, London. Presented by the Friends of the Tate Gallery 1983. © The Estate of Eileen Agar. Photo: Tate, London.

180 (left) Unknown photographer, *Leonor Fini at Arcachon*, 1940. Photo: Courtesy of the Estate of Leonor Fini.

180 (right) Leonor Fini, *Autoportrait au scorpion* (*Self-Portrait with Scorpion*), 1938. Oil on canvas. 31 ⅝ × 23 ½ in. (80.3 × 59.8 cm). Courtesy Weinstein Gallery, San Francisco. © Estate of Leonor Fini. Photo: courtesy Weinstein Gallery.

181 Leonor Fini, *Self-Portrait with Nico Papatakis* (*L'Alcove*), 1941. Oil on canvas. 28 ¾ × 38 ½ in., 73 × 97.8 cm. Rowland Weinstein, courtesy Weinstein Gallery. © Estate of Leonor Fini. Photo: Nicholas Pishvanov.

182 Leonora Carrington, *Portrait of Max Ernst*, 1939. Oil on canvas. National Galleries of Scotland, Edinburgh. © Estate of Leonora Carrington/ARS, NY and DACS, London 2022. Photo: photosublime/Alamy.

183 Frida Kahlo, *Henry Ford Hospital*, 1932. Fundacion Dolores Olmedo, Mexico City. © Banco de México Diego Rivera Frida Kahlo Museums Trust, Mexico, DF/DACS 2022. Photo: © 2022 Photo Schalkwijk/Art Resource, NY/Scala, Florence.

185 Dorothea Tanning, *Birthday*, 1942. Oil on Canvas. Philadelphia Museum of Art. 125th Anniversary Acquisition. Purchased with funds contributed by C. K. Williams, II, 1999, 1999-50-1 © ADAGP, Paris and DACS, London 2022.

186 Gertrude Abercrombie, *Countess Nerona #3*, 1951, Oil on Masonite. 4 ½ × 7 in. (11.4 × 17.8 cm); 9 × 11 ½ in. (22.9 × 29.2 cm) (framed). Courtesy Karma, New York.

187 Gertrude Abercrombie, *Doors, 4* (*5 ½*), 1957. Oil on board. 6 × 8 in. (15.24 × 20.32 cm); 11 ¼ × 13 ¾ in. (28.6 × 34.9 cm) (framed). Collection of Jonas Wood and Shio Kusaka. Courtesy Karma, New York. Photo: Marten Elder.

190 Tarsila do Amaral, *Carnaval Em Madureira*, 1924. Oil on canvas. Pinacoteca do Estado, São Paulo. © Tarsila do Amaral Licenciamentos.

191 Tarsila do Amaral, *Abaporu*, 1928. Oil on canvas. Private collection. © Tarsila do Amaral Licenciamentos.

192 Tarsila do Amaral, *Composição (Figura só)*, 1930. Oil on canvas. São Fernando Institute Collection, Rio de Janeiro. © Tarsila do Amaral Licenciamentos.

193 Tina Modotti, *Woman with Flag, Mexico City*, 1928. Photograph. Photo: © Galerie Bilderwelt/Bridgeman Images.

194 Tina Modotti, *Diego Rivera and Frida Kahlo in the May Day Parade, Mexico City, 1st May 1929*, 1929. Photograph. Photo: © Galerie Bilderwelt/Bridgeman Images.

197 Meta Vaux Warrick Fuller, *Ethiopia*, c.1921. Paint on plaster. 13 × 3 ½ × 3 ⅞ in. (33 × 8.9 × 9.8 cm). Collection of the Smithsonian National Museum of African American History and Culture, Gift of the Fuller Family. © Meta Vaux Warrick Fuller.

198 Augusta Savage, *The Harp*, 1939. Installation view, New York World's Fair, Flushing Meadows, New York, 1939. Photo: Sherman Oaks Antique Mall/Getty Images.

200 Unknown photographer, *Selma Burke with her bas-relief portrait of President Franklin D. Roosevelt*, c.1940s. Photograph. John W. Mosley Photograph Collection,

Charles L. Blockson Afro-American Collection, Temple University Libraries, Philadelphia, PA.

201 Loïs Mailou Jones, *Les Fétiches*, 1938. Oil on linen. Smithsonian American Art Museum, Washington, DC. Museum purchase made possible by Mrs Norvin H. Green, Dr R. Harlan, and Francis Musgrave. Photo: © Smithsonian American Art Museum/Art Resource/Scala, Florence.

202 Elizabeth Catlett, *Sharecropper*, 1952. Linocut, published 1968–70. Museum of Modern Art, New York. The Ralph E. Shikes Fund and Purchase. © Catlett Mora Family Trust/VAGA at ARS, NY and DACS, London 2022. Photo: © MoMA, NY/Scala, Florence.

205 Georgia O'Keeffe, *Black Mesa Landscape, New Mexico/Out Back of Marie's II*, 1930. Oil on canvas mounted to board. Georgia O'Keeffe Museum, Santa Fe. Burnett Foundation Gift. © Georgia O'Keeffe Museum/DACS 2022. Photo: © Georgia O'Keeffe Museum/Art Resource, NY/Scala, Florence.

206 Agnes Pelton, *Star Gazer*, 1929. Oil on canvas. Private collection. Photo: Peter Palladino/The Agnes Pelton Society/Bridgeman Images.

207 Emily Carr, *Sombreness Sunlit*, c.1938–40. Oil on canvas. 111.9 × 68.6 cm. Courtesy of the British Columbia Archives (PDP00633).

210 Dorothea Lange, *Migrant Mother*, 1936. Photograph. Still Picture Records Section, Special Media Archives Services Division (NWCS-S). U.S. National Archives and Records Administration, Washington, DC.

211 Dorothea Lange, *Turlock, California, May 2, 1942*, 1942. Photograph. Still Picture Records Section, Special Media Archives Services Division (NWCS-S). U.S. National Archives and Records Administration, Washington, DC.

212 Lee Miller, *Fire Masks, 21 Downshire Hill, London, England*, 1941. Photograph [3840-8]. © Lee Miller Archives, England 2022. All rights reserved. leemiller.co.uk.

213 Lee Miller with David E. Scherman, *Lee Miller in Hitler's bathtub, Hitler's apartment, 16 Prinzregentenplatz, Munich, Germany*, 1945. Photograph. © Lee Miller Archives, England 2022. All rights reserved. leemiller.co.uk.

216 Hannah Ryggen, *6 October 1942*, 1943. Woven rug in wool and linen, 1.7 × 4.2 m. Nordenfjeldske Kunstindustrimuseum, Trondheim. © Hannah Ryggen/VG Bild-Kunst, Bonn and DACS, London 2022. Photo: Ute Freia Beer.

217 Charlotte Salomon, from the series, *Life? Or Theatre?*, 1941–2. Gouache. Collection Jewish Museum, Amsterdam. © Charlotte Salomon Foundation.

218 (left) Charlotte Salomon, from the series *Life? Or Theatre?*, 1941–2. Gouache. Collection Jewish Museum, Amsterdam. © Charlotte Salomon Foundation.

218 (right) Charlotte Salomon, from the series *Life? Or Theatre?*, 1941–2. Gouache. Collection Jewish Museum, Amsterdam. © Charlotte Salomon Foundation.

220 Barbara Hepworth, *Sculpture with Colour and Strings*, 1939/61. Bronze. © Bowness.

221 (left) Val Wilmer, *Barbara Hepworth at work on the plaster for Oval Form (Trezion)*, 1963. Photograph. © Bowness.

221 (right) Barbara Hepworth, *Winged Figure*, 1961–2. Aluminium with steel rods. John Lewis Building, Oxford Street, London. © Bowness.

222 (left) Wilhelmina Barns-Graham, *Island Sheds St Ives II*, 1940. Oil on hardboard. 33 × 40.6 cm. © Wilhelmina Barns-Graham Trust.

222 (right) Wilhelmina Barns-Graham, *View of St Ives*, 1940. Oil on canvas. 63 × 75 cm. © Wilhelmina Barns-Graham Trust.

223 Marlow Moss, *Untitled* (*White, Black, Blue and Yellow*), c.1954. Oil on canvas. Private collection. © Reserved.

226 Madge Gill, *Untitled*, 1951. Ink on paper. 60.4 × 50.6 cm. Collection Hannah Rieger. © All rights reserved. Photo: © DETAILSINN FOTOGRAFIE/www.detailsinn.at.

227 Aloïse Corbaz, *Carrousel fait tourner la tête*, c.1951. Gouache, pencil, thread on paper. 94 × 59.5 cm (37 ⅛ × 23 ⅜ in.). Photo: courtesy The Museum + The Gallery of Everything. © Association Aloïse, Chigny.

228 (left) Aloïse Corbaz, *Général Guisan sous le bouquet final* (recto), between 1951 and 1960. Coloured pencils on paper, 59.5 × 42 cm. Collection Hannah Rieger. © Association Aloïse, Chigny. Photo: © DETAILSINN FOTOGRAFIE/www.detailsinn.at.

228 (right) Aloïse Corbaz. *Général Guisan sous le bouquet final* (verso), between 1951 and 1960. Coloured pencils on paper, recto, verso, 59.5 × 42 cm. Provenance: Jacqueline Porret-Forel, CV 355, Gottlieb und Greta Guntern. Collection Hannah Rieger. © Association Aloïse, Chigny. Photo: © DETAILSINN FOTOGRAFIE/www.detailsinn.at.

229 Sister Gertrude Morgan, *Jesus is my Air Plane*, c.1970.

Tempera, ballpoint pen and ink and pencil on paper. 18 × 26 ⅜ in. Smithsonian American Art Museum, Washington, DC. Gift of Herbert Waide Hemphill, Jr., and museum purchase made possible by Ralph Cross Johnson. Photo: © 2022 Scala, Florence/Smithsonian American Art Museum.
230 Clementine Hunter, *Going to Church*, c.1963. Oil on board. Morris Museum of Art, Augusta, Georgia. © Clementine Hunter. Photo: Bridgeman Images.
239 Janet Sobel, *Milky Way*, 1945. Enamel on canvas. 44 ⅞ × 29 ⅞ in. (114 × 75.9 cm). Museum of Modern Art, New York. Gift of the artist's family (Acc. no. 1311.1968). Photo: © 2022 Digital Image, MoMA, NY/Scala, Florence.
241 (left) Unknown photographer, Lee Krasner at the Hans Hofmann school, c.1940. Photograph. © The Pollock-Krasner Foundation/ARS, NY and DACS, London 2022. Photo: courtesy Kasmin.
241 (right) Lee Krasner, *Shellflower*, 1947. Oil on canvas. 24 × 28 in.; 61 × 71.1 cm. © The Pollock-Krasner Foundation/ARS, NY and DACS, London 2022. Photo: courtesy Kasmin. Photography by Diego Flores.
242–3 Lee Krasner, *The Eye is the First Circle*, 1960. Oil on canvas. 92 ¾ × 191 ⅞ in. (235.6 × 487.4 cm). © The Pollock-Krasner Foundation/ARS, NY and DACS, London 2022. Photo: courtesy Kasmin.
245 Alfred Eisenstadt, Elaine de Kooning in her studio at work on her *JFK* series, 1964. Photograph. Photo: Alfred Eisenstadt/Shutterstock Premium/Time Life Archive.
247 Joan Mitchell, *12 Hawks at 3 O'Clock*, c.1962. Oil on canvas. 116 ¼ × 78 ¾ in. (295.275 × 200.025 cm). Private collection. © Estate of Joan Mitchell.
248–9 Joan Mitchell, *Edrita Fried*, 1981. Oil on canvas. 116 ¼ × 299 ½ in. (295.275 × 760.73 cm). Collection Joan Mitchell Foundation, New York. © Estate of Joan Mitchell.
250 Helen Frankenthaler, *Mountains and Sea*, 1952. Oil and charcoal on unsized, unprimed canvas. 86 ⅜ × 117 ¼ in. (219.4 × 297.8 cm). Helen Frankenthaler Foundation, New York, on extended loan to the National Gallery of Art, Washington, DC. © Helen Frankenthaler Foundation, Inc./ARS, NY and DACS, London 2022. Photo: courtesy the National Gallery of Art, Washington, DC.
251 Helen Frankenthaler, *Flood*, 1967. Acrylic on canvas. 124 ¼ × 140 ½ in. (315.6 × 356.9 cm). Whitney Museum of American Art, New York. Purchased with funds from the Friends of the Whitney Museum of American Art (68.12). © Helen Frankenthaler Foundation, Inc./ARS, NY and DACS, London 2022.
252 Louise Nevelson, *Sky Cathedral*, 1958. Wood construction, painted black. 11' 3 ½' × 10' ¼' × 18 in. (343.9 × 305.4 × 45.7 cm). Museum of Modern Art, New York. Gift of Mr and Mrs Ben Mildwoff (136.1958.1-57). © ARS, NY and DACS, London 2022. Photo © 2022 MoMA, NY/Scala, Florence.
254 Anni Albers and Alexander Reed, *Necklace*, c.1940. Aluminum strainer, paper clips, and chain. 20 in. (50.8 cm) long; strainer 3 in. (7.6 cm) diameter. The Josef and Anni Albers Foundation (1994.14.16). © 2022 The Josef and Anni Albers Foundation/Artists Rights Society (ARS) New York/DACS, London 2022. Photo: Tim Nighswander/Imaging4Art.
255 Anni Albers, *Intersecting*, 1962. Cotton and rayon, 15 ¾ × 16 ½ in. (40 × 41.9 cm). Josef Albers Museum, Quadrat, Bottrop. © The Josef and Anni Albers Foundation/Artists Rights Society (ARS), New York and DACS, London 2022. Photo: Tim Nighswander/Imaging4Art.
257 Ruth Asawa, *Untitled (S.310, Hanging Five-Lobed Continuous Form Within a Form with Spheres in the 2nd, 3rd, and Bottom Lobes)*, c.1954. Hanging sculpture, steel and brass wire. 64 × 15 × 15 in. (162.6 × 38.1 × 38.1 cm). Artwork © 2022 Ruth Asawa Lanier, Inc./Artists Rights Society (ARS), New York and DACS, London 2022. Photo: courtesy David Zwirner.
259 Atsuko Tanaka wearing her *"Electric Dress"* suspended from the temporary beam at the 2nd Gutai Art Exhibition in Ohara Hall, Tokyo, 1956. © Kanayama Akira and Tanaka Atsuko Association.
261 Ishiuchi Miyako, *Yokosuka Story #98*, 1976–7. Gelatin silver print. © Ishiuchi Miyako, courtesy the Michael Hoppen Gallery, London.
265 Marisol, *Dinner Date*, 1963. Painted wood, plaster, textiles, oil on canvas, metal fork, leather boots, paint, graphite. 139.7 × 135.9 × 111.8 cm (55 × 53 ½ × 44 in.). Yale University Art Gallery, New Haven. Gift of Susan Morse Hilles (1973.86). © Estate of Marisol/ARS, NY and DACS, London.
266 Marisol, *Love*, 1962. Plaster and glass (Coca-Cola bottle), 6 ¼ × 4 ⅛ × 8 ⅛ in. (15.8 × 10.5 × 20.6 cm). Museum of Modern Art, New York. Gift of Claire and Tom Wesselman (Acc. no. 1405.1974). © Estate of Marisol/ARS, NY and DACS, London. Photo: © 2022 MoMA, NY/Scala, Florence.
267 Martha Rosler, *Cleaning the Drapes*, from the series *House Beautiful: Bringing the War Home*, c.1967–72. Photomontage. © Martha Rosler. Courtesy the artist

and Mitchell-Innes & Nash, New York.
270 Pauline Boty, *The Only Blonde in the World*, 1963. Oil on canvas. Tate Gallery, London. Courtesy of the Pauline Boty Estate.
271 Pauline Boty, *It's a Man's World #1*, 1964. Oil on canvas with collages. Courtesy of the Pauline Boty Estate.
272 Evelyne Axell, *Valentine*, 1966. Oil paint, zip-fastener and helmet on canvas. Tate Gallery, London. © ADAGP, Paris and DACS, London 2022. Photo: © Tate, London.
275 Emma Amos, *Sandy and her Husband*, 1973. Oil on canvas. 112.4 × 127.6 cm (44 ¼ × 50 ¼ in.). Cleveland Museum of Art, Ohio. John L. Severance Fund (2018.24). © Emma Amos/VAGA at ARS, NY and DACS, London 2022.
276 Elizabeth Catlett, *Black Unity* (front and back view), 1968. Cedar. 21 × 12 ½ × 23 in. Crystal Bridges Museum of American Art, Bentonville, Arkansas, 2014.11. Photography by Edward C. Robison III.
278–9 Faith Ringgold, *American People Series #20: Die*, 1967. Oil on canvas. 72 × 144 in. © 2022 Faith Ringgold/ARS, NY and DACS, London. Courtesy ACA Galleries, New York.
280 Barbara Jones-Hogu, *Unite*, 1971. Screen print. 22 ½ × 30 in. Art Institute of Chicago. Gift of Judy and Patrick Diamond. © Estate of Barbara Jones-Hogu. Photo: Bridgeman Images.
281 Ming Smith, *Grace Jones at Studio 54*, 1978. Archival silver gelatin print. Image courtesy the artist and Pippy Houldsworth Gallery, London. © Ming Smith 2022.
285 Agnes Martin, *Friendship*, 1963. Incised gold leaf and gesso on canvas. 6 ft 3 in. × 6 ft 3 in. (190.5 × 190.5 cm). Museum of Modern Art, New York. Gift of Celeste and Armand P. Bartos (502.1984). © Agnes Martin Foundation, New York/DACS 2022. Photo: © 2022 MoMA, NY/Scala, Florence.
286 Yayoi Kusama, *Infinity Nets (1)*, 1958. Oil on canvas, 125.3 × 91 cm. Copyright: © YAYOI KUSAMA. Courtesy of Ota Fine Arts and Victoria Miro.
287 Yayoi Kusama, *Kusama's Peep Show or Endless Love Show*, 1966. Mixed media. Copyright © YAYOI KUSAMA. Courtesy of Ota Fine Arts and Victoria Miro.
289 Alma Thomas, *Blast Off*, 1970. Acrylic on canvas. National Air and Space Museum, Smithsonian Institution, Washington, DC. Gift of Vincent Melzac.
290 Alma Thomas, *Cherry Blossom Symphony*, 1972. Acrylic on canvas. 69 × 54 ¼ in. (175.3 × 137.8 cm). Collection of halley k harrisburg and Michael Rosenfeld, New York. Courtesy of Michael Rosenfeld Gallery LLC, New York.
291 (left) Carmen Herrera, *Black and White*, 1952. Acrylic on canvas. 121.9 × 121.9 cm (48 × 48 in.). (HERR520001). © Carmen Herrera; courtesy Lisson Gallery, London.
291 (right) Gego (Gertrud Goldschmidt), *Columna (Reticulárea cuadrada)*, 1972. Installation view as part of the exhibition *Gego: Autobiography of a Line*, Dominique Lévy Gallery, London, 2016. © Fundación Gego.
292 Etel Adnan, *Untitled*, 2014. Oil on canvas. 13 ¾ × 10 ⅝ in. (35 × 27 cm); 15 ⅜ × 12 ³⁄₁₆ × 1 ¾ in. (39 × 31 x 4.5 cm) (framed). © Succession Etel Adnan. Photo © White Cube (George Darrell).
293 Monir Shahroudy Farmanfarmaian, *Sunset*, 2015 (detail). Mirror and reverse-glass painting on plaster and wood, 130 × 100 cm, 110 cm diameter. Private Collection, United Arab Emirates. Courtesy of the artist and The Third Line, Dubai.
295 Lina Bo Bardi (architect), interior view at MASP, São Paolo. Photo: © Romulo Baratto.
296 Lygia Pape, *Book of Creation*, 1959–60. Artist's book with sixteen unbound pages, some with gouache on board, paper, and string. Museum of Modern Art, New York. Gift of Patricia Phelps de Cisneros. © 2022 Projeto Lygia Pape. Photo: © 2022. The Museum of Modern Art, New York/Scala, Florence.
301 Eva Hesse, *Ringaround Arosie*, 1965. Varnish, graphite, ink, enamel, cloth-covered wire, papier-caché, unknown modeling compound, Masonite, wood. 67.5 × 42.5 × 11.4 cm (26 ½ × 16 ¾ × 4 ½ in.). Museum of Modern Art, New York. Fractional and promised gift of Kathy and Richard S. Fuld, Jr., 2005. © The Estate of Eva Hesse. Courtesy Hauser & Wirth. Photo: Abby Robinson, New York.
302 Eva Hesse, *Right After*, 1969. Fiberglass, polyester resin, wire. 548.6 × 121.9 cm (60 × 214 × 48 in.), 3 sections. Installation view at Yale University Art Gallery, 1992. Milwaukee Art Museum, Wisconsin. Gift of Friends of Art, 1970. © The Estate of Eva Hesse. Courtesy Hauser & Wirth.
303 (left) Alina Szapocznikow, *Lampe-bouche (Illuminated Lips)*, 1966. Coloured polyester resin, light bulb, electrical wiring and metal. 48 × 16 × 13 cm (18 ⅞ × 6 ¼ × 5 ⅛ in.). © ADAGP, Paris and DACS, London 2022. Courtesy the Estate of Alina Szapocznikow/Piotr Stanislawski/Galerie Loevenbruck, Paris/Hauser & Wirth. Photo: Fabrice Gousset.
303 (right) Alina Szapocznikow, *Deser IV (Dessert IV)*, 1971. Coloured polyester resin, glass, light bulb, electrical wiring and metal, 16.5 × 16 × 13.5 cm (6 ½ × 6 ¼ × 5 ⅜ in.).

© ADAGP, Paris and DACS, London 2022. Courtesy the Estate of Alina Szapocznikow/Piotr Stanislawski/Galerie Loevenbruck, Paris/Hauser & Wirth. Photo: Thomas Barratt.
305 Niki de Saint Phalle, Jean Tinguely and Per Olof Ultvedt, *Hon – en katedral (She – A Cathedral)*, 1966. Installation view at the Moderna Museet Stockholm, 1966. © 2022 NIKI CHARITABLE ART FOUNDATION, All rights reserved. ADAGP, Paris and DACS, London 2022. Photo: Hans Hammarskiöld/© Hans Hammarskiöld Heritage.
306 Niki de Saint Phalle, *The Empress*, Giardino dei Tarocchi, Garavicchio, Italy. © 2022 Fondazione Il Giardino Dei Tarocchi, All rights reserved. © 2022 NIKI CHARITABLE ART FOUNDATION, All rights reserved. Photo: Katrin Baumann.
307 (left) Louise Bourgeois, *Femme Maison*, 1946–7. Oil and ink on linen. 36 × 14 in. (91.4 × 35.6 cm). © The Easton Foundation/VAGA at ARS, NY and DACS, London 2022. Photo: Christopher Burke.
307 (right) Louise Bourgeois, *Personages*, 1946–50. Installation view of *Louise Bourgeois: Sculptures*, exhibited at the Peridot Gallery, New York, 1950. © The Easton Foundation/VAGA at ARS, NY and DACS, London 2022. Photo: Aaron Siskind.
308 Louise Bourgeois, *Janus Fleuri*, 1968. Bronze, gold patina. 10 ⅛ × 12 ½ × 8 ⅜ in. (25.7 × 31.8 × 21.3 cm). © The Easton Foundation/VAGA at ARS, NY and DACS, London 2022. Photo: Christopher Burke.
309 Yoko Ono, *Cut Piece*, 1964/1965. Performed by the artist as part of New Works of Yoko Ono, Carnegie Recital Hall, New York City, March 21, 1965. Filmed by David and Albert Maysles. Duration: 8 min. 27 sec. Mono sync sound, b/w. © Copyright © Yoko Ono 1964. Used by Permission/All Rights Reserved.
310 Marina Abramović, *Rhythm 0*, Performance, 6 hours, Studio Morra, Naples, 1974. © Marina Abramović. Courtesy of the Marina Abramović Archives/DACS 2022. Photo: Donatelli Sbarra.
311 Anna Maria Maiolino, *É o que sobra (What is Left Over)*, from *Fotopoemação (Photopoemaction)* series, 1974. Black and white digital print. © Anna Maria Maiolino. Courtesy the artist and Hauser & Wirth.
314 Ferdinand Boesch, *Lenore Tawney's studio at 27 South Street studio, New York*, 1962. Courtesy Lenore G. Tawney Foundation.
315 Sheila Hicks, *Escalade Beyond Chromatic Lands*, 2016–17. Installation view, Venice Biennale 2017. Natural and synthetic fibres, cloth, slate, bamboo, 600 × 1600 × 400 cm (236 ¼ × 629 ⅞ × 157 ½ ins). Courtesy Alison Jacques, London. © Sheila Hicks. Photo: Michael Brzezinski.
316 Cecilia Vicuña, *Quipus Visceral*, 2017. Site-specific installation of dyed, unspun wool, dimensions variable. Courtesy the artist and Lehmann Maupin, New York and Hong Kong. Photo: Matthew Herrmann.
317 Mrinalini Mukherjee with her work, *PRITHVI (Woman on a swing)*, 1989. Hemp. 255 × 99 × 70 cm. © Mrinalini Mukherjee Foundation.
318 Judith Scott, *Untitled*, 2004. Mixed media sculpture, 29 × 16 × 21 in. Courtesy of Creative Growth Art Center. Photo: Benjamin Blackwell.
320 Faith Ringgold, *Tar Beach 2*, 1990, from the *Woman on a Bridge* series, begun 1988. Multicolored screenprint on silk plain weave, printed cotton plain weave, black and green synthetic moire. Produced at The Fabric Workshop and Museum, Philadelphia. Philadelphia Museum of Art. Purchased with funds contributed by W. B. Dixon Stroud, 1992. © Faith Ringgold/ARS, NY and DACS, London, Courtesy ACA Galleries, New York 2022. Photo: Philadelphia Museum of Art/Bridgeman Images.
321 Rosie Lee Tompkins, *Untitled*, 1996. Cotton, cotton flannel, cotton feed sack, linen, rayon, flocked satin, velvet, cotton-synthetic blend, cotton-acrylic jersey, acrylic double weave, cotton-polyester, polyester double knit, acrylic and cotton tapestry, silk batik, polyester velour, rayon or acrylic embroidery on cotton, wool, needlepoint, and shisha mirror embroidery. 88 × 146 in. University of California, Berkeley Art Museum and Pacific Film Archive. Bequest of The Eli Leon Living Trust. © Estate of Effie Mae Howard. Photo: Sharon Risedorph.
322 Sue Willie Seltzer and Gee's Bend Quiltmakers, *Housetop—Nine-Block 'Half-Log Cabin' Variation*, c.1955. Cotton and synthetic blends. 80 × 76 in. Metropolitan Museum of Art, New York. Gift of the Souls Grown Deep Foundation. © Estate of Sue Willie Seltzer/ARS, NY and DACS, London 2022. Photo: Stephen Pitkin/Pitkin Studio.
329 Faith Ringgold, *Woman Freedom Now*, 1971. Offset Print. 28 ½ × 19 in. © 2022 Faith Ringgold/ARS, NY and DACS, London, Courtesy ACA Galleries, New York.
330 Sylvia Sleigh, *A.I.R. Group Portrait*, 1977–8. Oil on canvas. 75 × 82 in. (190.5 × 208.3 cm). Whitney Museum of American Art, New York. Gift of the Estate of Sylvia Sleigh (2016.234). © Whitney Museum of American Art.
333 Judy Chicago, *Heaven is for White Men Only*, 1973.

Sprayed acrylic on canvas. 80 × 80 in. (203.2 × 203.2 cm). New Orleans Museum of Art, New Orleans. Gift of the Frederick R. Weisman Art Foundation. © Judy Chicago. ARS, NY and DACS, London 2022. Photo: Donald Woodman.

334 Suzanne Lacy and Leslie Labowitz, *In Mourning and in Rage*, 1977. Photo by Maria Karras.

336. Ana Mendieta, *Untitled: Silueta Series, Iowa*, 1977. Colour photograph. © The Estate of Ana Mendieta Collection LLC; Courtesy Galerie Lelong & Co. Licensed by the Artist Rights Society (ARS), NY and DACS, London 2022.

337 Mierle Laderman Ukeles, *Washing/Tracks/Maintenance: Outside*, 1973. Part of the *Maintenance Art* performance series, 1973–4. Performance at Wadsworth Atheneum, Hartford, CT. © Mierle Laderman Ukeles. Courtesy the artist and Ronald Feldman Gallery, New York.

338 Mary Kelly, *Study for Post-Partum Document: Introduction (Prototype II)*, 1973. Cotton, graphite, plexiglass, unique. 14 × 11, 35.6 × 27.9 cm each (H8205). Private Collection, New York. Courtesy the artist and Pippy Houldsworth Gallery, London.

339 (above) Senga Nengudi, *Performance Piece*, 1978, silver gelatin prints, triptych, overall dimensions 168.9 × 189.2 cm. © Senga Nengudi, 2021. Courtesy Sprüth Magers, Thomas Erben Gallery, and Lévy Gorvy.

339 (below) Carolee Schneemann, *Interior Scroll*, 1975. Beet juice, urine and coffee on screenprint on paper. Private collection. © Carolee Schneemann Foundation/ARS, NY and DACS, London 2022.

340 Hannah Wilke, *S.O.S Starification Object Series*, 1974. Lifetime silver gelatin print. 33.65 × 21.59 cm, 13 ¼ × 8 ½ in. Courtesy Hannah Wilke Collection & Archive, Los Angeles and Alison Jacques, London. © Marsie, Emanuelle, Damon and Andrew Scharlatt, Hannah Wilke Collection & Archive, Los Angeles. Licensed by VAGA at Artist's Rights Society (ARS), New York & DACS, London.

341 Adrian Piper, *Catalysis IV*, 1970. Performance documentation. Five silver gelatin print photographs. Each 16 × 16 in. (40.6 × 40.6 cm). Detail: photograph #3 of 5. Photo credit: Rosemary Mayer. Collection of the Generali Foundation, Vienna, Permanent loan to the Museum der Moderne Salzburg. © Adrian Piper Research Archive Foundation Berlin and Generali Foundation.

342 Howardena Pindell, *Untitled #69*, 1974. Watercolour, crayon, paper collage. 8 × 6 in. Collection High Museum of Art, Atlanta; Purchase, 1983.78. Courtesy the artist and Garth Greenan Gallery, New York.

343 Howardena Pindell, *Free, White and 21*, 1980. Video (colour, sound), 12:15 min. Courtesy the artist and Garth Greenan Gallery, New York.

344 Faith Ringgold, *For the Women's House*, 1971. Oil on canvas. 96 × 96 in. © Faith Ringgold/ARS, NY and DACS, London. Courtesy ACA Galleries, New York 2022. Image courtesy of the artist and Rose M. Singer Center, New York.

345 Dindga McCannon, *Revolutionary Sister*, 1971. Mixed media construction on wood. 62 × 27 in. (157.5 × 68.6 cm). Brooklyn Museum, Gift of R. M. Atwater, Anna Wolfrom Dove, Alice Fiebiger, Joseph Fiebiger, Belle Campbell Harriss, and Emma L. Hyde, by exchange, Designated Purchase Fund, Mary Smith Dorward Fund, Dick S. Ramsay Fund, and Carll H. de Silver Fund, 2012.80.32. Photo: Collection of Dindga McCannon.

346 (left) Alice Neel, *Margaret Evans Pregnant*, 1978. Oil on canvas. 57 ¾ × 38 ½ in. (146.7 × 97.8 cm). © The Estate of Alice Neel. Courtesy The Estate of Alice Neel and David Zwirner.

346 (right) Alice Neel, *Benjamin*, 1976. Acrylic on board. 29 ⅞ × 20 ¾ in. (75.9 × 52.7 cm). © The Estate of Alice Neel. Courtesy The Estate of Alice Neel and David Zwirner.

347 (left) Alice Neel, *Andy Warhol*, 1970. Acrylic and oil on canvas. 60 × 40 in. (152.4 × 101.6 cm). © The Estate of Alice Neel. Courtesy The Estate of Alice Neel and David Zwirner.

347 (right) Alice Neel, *Self-Portrait*, 1980. Oil on canvas. National Portrait Gallery, Smithsonian Institution. © The Estate of Alice Neel. Courtesy The Estate of Alice Neel and David Zwirner.

349 Sylvia Sleigh, *Imperial Nude: Paul Rosano*, 1977. Oil on canvas. 42 × 66 in. (107 × 168 cm). Private collection. © The Estate of Sylvia Sleigh.

350 Joan Semmel, *Intimacy–Autonomy*, 1974. Oil on canvas. 50 × 98 in. (127 × 248.92 cm). Courtesy Alexander Gray Associates, New York. © 2022. Joan Semmel/ARS, NY and DACS, London.

351 (left) Maria Lassnig, *Transparentes Selbstportrait (Transparent Self-Portrait)*, 1987. Oil on canvas. Museum of Modern Art, New York. Promised gift of Marie-Josée and Henry R. Kravis. © Maria Lassnig Foundation/Bildrecht, Vienna & DACS, London 2022.

351 (right) Maria Lassnig, *Du oder Ich (You or Me)*, 2005. Oil on canvas. Private Collection. Courtesy Hauser &

Wirth Collection Services. © Maria Lassnig Foundation/Bildrecht, Vienna & DACS, London 2022. Photo: Stefan Altenburger Photography, Zürich.

352 Huguette Caland, *Bribes de corps (Body Parts)*, 1973. Oil on linen. 152.4 × 152.4 cm. Courtesy Huguette Caland Estate.

353 Judy Chicago, *The Dinner Party*, 1974–9. Ceramic, porcelain, textile. 576 × 576 in. (1463 × 1463 cm). Brooklyn Museum, Gift of the Elizabeth A. Sackler Foundation (2002.10). © Judy Chicago. ARS, NY and DACS, London 2022. Photo: Donald Woodman.

357 Guerrilla Girls, *Do Women Have to be Naked to get into the Met. Museum?*, 1989. Copyright © Guerrilla Girls, courtesy guerrillagirls.com.

358 Guerrilla Girls, *How Many Women Artists Had One-Person Exhibitions In NYC Art Museums Last Year?*, 1985. Copyright © Guerrilla Girls, courtesy guerrillagirls.com.

359 Guerrilla Girls, *The Advantages of Being a Woman Artist*, 1988. Copyright © Guerrilla Girls, courtesy guerrillagirls.com.

360 Barbara Kruger, *Untitled (Your body is a battleground)*, 1989. Photographic silkscreen on vinyl. 284.5 × 284.5 cm (112 × 112 in.). Courtesy The Broad Art Foundation.

361 Jenny Holzer, from *Truisms*, 1982. Spectacolor electronic sign. 20 × 40 ft (6.1 × 12.2 m). Times Square, New York. Organized by Public Art Fund, Inc. Text: *Truisms*, 1977–9. © Jenny Holzer. ARS, NY and DACS, London 2022. Photo: Lisa Kahane/Art Resource, NY.

362 Cindy Sherman, *Untitled Film Still*, 1979. Gelatin silver print, 20.3 × 25.4 cm (8 × 10 in.). © Cindy Sherman. Courtesy the artist and Hauser & Wirth.

363 Cindy Sherman, *Untitled Film Still*, 1977. Gelatin silver print. 25.4 × 20.3 cm (10 × 8 in.). © Cindy Sherman. Courtesy the artist and Hauser & Wirth.

364 Cindy Sherman, *Untitled*, 2008. Chromogenic colour print. 259 × 176 cm (101 ⅞ × 69 ¼ in.) (frame). © Cindy Sherman. Courtesy the artist and Hauser & Wirth.

366 (left) Francesca Woodman, *Self-Portrait at 13*, Antella, Italy, 1972. Gelatin silver print. 17.2 × 16.8 cm. © Woodman Family Foundation/Artists Rights Society (ARS), New York and DACS, London. Courtesy The Woodman Family Foundation and Victoria Miro.

366 (right) Francesca Woodman, from *Space²*, Providence, Rhode Island, 1976. Gelatin silver print. 16.2 × 16.2 cm. © Woodman Family Foundation/Artists Rights Society (ARS), New York and DACS, London. Courtesy The Woodman Family Foundation and Victoria Miro.

367 Carrie Mae Weems, *Untitled (Woman and daughter with makeup)*, 1990. Gelatin silver print. 27 ¼ × 27 ¼ in. © Carrie Mae Weems. Courtesy the artist and Jack Shainman Gallery, New York.

368 Nan Goldin, *Nan and Brian in Bed, New York City*, 1983. Courtesy of the artist and Marian Goodman Gallery. © Nan Goldin.

369 Nan Goldin, *Misty and Jimmy Paulette in a Taxi*, 1991. Courtesy of the artist and Marian Goodman Gallery. © Nan Goldin.

370 Paz Errázuriz, *Evelyn, La Palmera, Santiago, Chile*, 1981. © Paz Errázuriz.

371 Claudia Andujar, *A jovem Susi Korihana thëri em um igarapé – Catrimani, Roraima (The young Susi Korihana thëri swimming, Catrimani, Roraima)*, from the series *A floresta*, 1972–4. Collection of the artist. © Claudia Andujar. Courtesy Galeria Vermelho.

372 Agnes Denes, *Wheatfield – A Confrontation: Battery Park Landfill, Downtown Manhattan – With New York Financial Center*, 1982. Performance, Edge Biennial, Madrid. Courtesy Alexander Gray Associates, New York. © Agnes Denes, courtesy Leslie Tonkonow Artworks + Projects, New York.

373 (left) Lorraine O'Grady, *Art Is … (Girlfriends Times Two)*, 1983/2009. C-print in 40 parts. 16 × 20 in. (40.64 × 50.8 cm). Edition of 8 + 1 AP. Courtesy Alexander Gray Associates, New York. © Lorraine O'Grady/ARS, NY and DACS, London 2022.

373 (right) Lorraine O'Grady, *Art Is … (Troupe with Mlle Bourgeoise Noire)*, 1983/2009. C-print in 40 parts. 16 × 20 in. (40.64 × 50.8 cm). Edition of 8 + 1 AP. Courtesy Alexander Gray Associates, New York. © Lorraine O'Grady/ARS, NY and DACS, London 2022.

376 Coco Fusco, *Couple in the Cage: Two Undiscovered Amerindians Visit the West*, 1992–4. Performance, Edge Biennial, Madrid. Courtesy Alexander Gray Associates, New York. © Coco Fusco/ARS, NY and DACS, London 2022.

377 Emily Kame Kngwarreye, *Anwerlarr angerr (Big yam)*, 1996. Synthetic polymer paint on canvas. Four panels, each 159.0 × 270.0 cm, overall 245.0 × 401.0 cm. National Gallery of Victoria, Melbourne. Purchased by the National Gallery Women's Association to mark the directorship of Dr Timothy Potts, 1998. © Emily Kame Kngwarreye/Copyright Agency. Licensed by DACS 2022. Photo: National Gallery of Victoria.

379 Zoe Leonard, *I want a president*, 1992. Typewritten text on paper. 27.9 × 21.6 cm (11 × 8 ½ in.). © Zoe

Leonard. Courtesy the artist, Galerie Gisela Capitain, Cologne and Hauser & Wirth.

380 Zoe Leonard, *Strange Fruit*, 1992–7. Installation view, Whitney Museum of American Art, New York. Orange, banana, grapefruit, lemon, and avocado peels with thread, zippers, buttons, sinew, needles, plastic, wire, stickers, fabric, and trim wax, 295 parts, dimensions variable. Collection Philadelphia Museum of Art; purchased with funds contributed by the Dietrich Foundation and with the partial gift of the artist and the Paula Cooper Gallery. © Zoe Leonard. Courtesy the artist, Galerie Gisela Capitain, Cologne and Hauser & Wirth. Photograph by Ron Amstutz, courtesy the Whitney Museum of American Art, New York.

381 Catherine Opie, *Self-Portrait/Cutting*, 1993. C-print. 40 × 30 in. 101.6 × 76.2 cm. © Catherine Opie. Courtesy the artist, Regen Projects, Los Angeles and Thomas Dane Gallery.

382 Lorna Simpson, *Five Day Forecast*, 1988. 5 silver gelatin prints, 15 engraved plastic plaques. Overall: 62.2 × 246.4 cm / 24 ½ × 97 in. Each framed print: 61 × 50.8 cm / 24 × 20 in. Ed. of 3 + 1 AP. © Lorna Simpson. Courtesy the artist and Hauser & Wirth.

383 Shirin Neshat, *Rebellious Silence*, 1994, from *Women of Allah*, 1993–7. RC print & ink. © Shirin Neshat. Courtesy of the artist and Gladstone Gallery.

384 Pipilotti Rist, *Ever is Over All*, 1997. Audio video installation by Pipilotti Rist (video still). © Pipilotti Rist. Courtesy the artist, Hauser & Wirth and Luhring Augustine.

385 Marlene Dumas, *Naomi*, 1995. Oil on canvas, 130 × 110 cm. Collection De Heus-Zomer, The Netherlands. By courtesy of the artist. © Marlene Dumas. Photo: Peter Cox, Eindhoven.

386 (above) Marlene Dumas, *The Image as Burden*, 1992–3. Oil on canvas. 40 × 50 cm. Private Collection, Flanders. By courtesy of the artist. © Marlene Dumas. Photo: Peter Cox, Eindhoven.

386–7 Shahzia Sikander, *The Scroll*, 1989–90. Watercolour and gouache on tea-stained wasli paper. 33 × 162 cm. Collection of the artist. © Shahzia Sikander.

388 Lisa Yuskavage, *Big Blonde with Hairdo*, 1994. Oil on linen. 72 × 72 in. (182.9 × 182.9 cm). © Lisa Yuskavage. Courtesy the artist and David Zwirner.

389 Cecily Brown, *The Tender Trap II*, 1998. Oil on linen. 193 × 249.5 cm (76 × 98 ¼ in.). © Cecily Brown. Courtesy the artist and Thomas Dane Gallery.

390 Paula Rego, *Dog Woman*, 1994. Pastel on paper on aluminium. 120 × 160 cm. 47 ¼ × 63 in. © Paula Rego. Courtesy the artist and Victoria Miro.

391 Paula Rego, *Untitled #2*, 1998. Pastel on paper on aluminium. Private collection. © Paula Rego. Courtesy the artist and Victoria Miro.

394 Lubaina Himid, *A Fashionable Marriage*, 1986. Installation view, The Place Is Here, Nottingham Contemporary, 2017. © Lubaina Himid. Image courtesy the artist, Hollybush Gardens, London and Nottingham Contemporary. © Nottingham Contemporary. Photo: Andy Keate.

395 Lubaina Himid, *Naming the Money*, 2004. Installation view of Navigation Charts, Spike Island, Bristol 2017. © Lubaina Himid. Courtesy of the artist, Hollybush Gardens, London and National Museums, Liverpool. © Spike Island, Bristol. Photo: Stuart Whipps.

396 Sonia Boyce, *Lay back, keep quiet and think of what made Britain so great*, 1986. Charcoal, pastel and watercolour on paper. © Sonia Boyce. All Rights Reserved, DACS/Artimage 2022. Photo: © Arts Council Collection, Southbank Centre, London.

397 (left) Claudette Johnson, *Trilogy (Part One) Woman in Blue*, 1982–6. Watercolour, gouache paint and pastel on paper. 156 × 94 cm. © Claudette Johnson. Arts Council Collection, Southbank Centre, London. Image courtesy the artist, Arts Council Collection, Southbank Centre, London, and Hollybush Gardens, London.

397 (centre) Claudette Johnson, *Trilogy (Part Two) Woman in Black*, 1982–6. Watercolour, gouache paint and pastel on paper. 157 × 126 cm. © Claudette Johnson. Arts Council Collection, Southbank Centre, London. Image courtesy the artist, Arts Council Collection, Southbank Centre, London, and Hollybush Gardens, London.

397 (right) Claudette Johnson, *Trilogy (Part Three) Woman in Red*, 1982–6. Watercolour, gouache paint and pastel on paper. 156 × 103 cm. © Claudette Johnson. Arts Council Collection, Southbank Centre, London. Image courtesy the artist, Arts Council Collection, Southbank Centre, London, and Hollybush Gardens, London.

398 Maud Sulter, *Hysteria*, 1991. On exhibition with accompanying marble plaque, Street Level Photoworks, Glasgow, 2015. © Estate of Maud Sulter. All rights reserved, DACS/Artimage 2022. Image courtesy Street Level Photoworks, Glasgow.

400 Rachel Whiteread, *House*, 1993 (destroyed 1994). Concrete, wood and steel. Commissioned by Artangel. Sponsored by Beck's. © Rachel Whiteread.

401 Carl Freedman, *The Shop, Sarah Lucas and Tracey Emin*, 1993. © Carl Freedman.

403 Sarah Lucas, *Self-Portrait with Fried Eggs*, 1996. C-print, site size: 151 × 103 cm / 59 ½ × 40 ½ in.; frame size: 154.4 × 106.3 × 6 cm / 60 ¾ × 41; ⅞ × 2 ⅜ in. © Sarah Lucas, courtesy Sadie Coles HQ, London.

404 Tracey Emin, *My Bed*, 1998. Courtesy Saatchi Gallery, London. © Tracey Emin. All rights reserved, DACS 2022. Photo: Prudence Cuming Associates Ltd.

405 Jenny Saville, *Juncture*, 1994. Oil on canvas 132 × 72 in. (335 × 183 cm). © Jenny Saville. All rights reserved. DACS, London 2022. Courtesy Gagosian.

406 Cornelia Parker, *Cold Dark Matter*, 1991, Wood, metal, plastic, ceramic, paper, textile and wire. Image courtesy the artist, The Whitworth, The University of Manchester and Frith Street Gallery, London. © The artist. Photograph: Michael Pollard.

407 Mona Hatoum, *Light Sentence*, 1992. Galvanised wire mesh lockers, electric motor and light bulb. 198 × 185 × 490 cm. Installation view at Chapter, Cardiff. © Mona Hatoum. Courtesy Chapter, Cardiff. Photo: Edward Woodman.

408 Gillian Wearing, *Signs that say what you want them to say and not Signs that say what someone else wants you to say: I'M DESPERATE*, 1992–3. C-type print on aluminium. 44.5 × 29.7 cm. © Gillian Wearing, courtesy Maureen Paley, London, Tanya Bonakdar Gallery, New York and Regen Projects, Los Angeles.

409 (left) Gillian Wearing, *Signs that say what you want them to say and not Signs that say what someone else wants you to say: EVERYTHING IS CONNECTED IN LIFE THE POINT IS TO KNOW IT AND TO UNDERSTAND IT.*, 1992–3. C-type print on aluminium. 44.5 × 29.7 cm. © Gillian Wearing, courtesy Maureen Paley, London, Tanya Bonakdar Gallery, New York and Regen Projects, Los Angeles.

409 (right) Gillian Wearing, *Signs that say what you want them to say and not Signs that say what someone else wants you to say: BEST FRIENDS FOR LIFE! LONG LIVE THE TWO OF US.*, 1992–3. C-type print on aluminium. 44.5 × 29.7 cm. © Gillian Wearing, courtesy Maureen Paley, London, Tanya Bonakdar Gallery, New York and Regen Projects, Los Angeles.

416 Doris Salcedo, *Untitled*, 2003. 1,550 wooden chairs. Installation for the 8th International Istanbul Biennial 2003. © The artist. Photo: © Sergio Clavijo / Courtesy White Cube.

417 Doris Salcedo, *Shibboleth*, 2007. Crack in the floor of Tate Modern Turbine Hall. Installation, 9 October 2007 – 24 March 2008. © The artist. Photo: © Stephen White / Courtesy White Cube.

418 (left) Kara Walker, *A Subtlety, or the Marvelous Sugar Baby, an Homage to the unpaid and overworked Artisans who have refined our Sweet tastes from the cane fields to the Kitchens of the New World on the Occasion of the demolition of the Domino Sugar Refining Plant*, 2014. Polystyrene foam, sugar. Approx. 35.5 × 26 × 75.5 ft (10.8 × 7.9 × 23 m). Installation view, Domino Sugar Refinery, A project of Creative Time, Brooklyn, NY, 2014. © Kara Walker, courtesy of Sikkema Jenkins & Co., New York. Photo: Jason Wyche.

418 (right) Kara Walker, *Fons Americanus*, 2019. Non-toxic acrylic and cement composite, recyclable cork, wood, and metal. Main: 73.5 × 50 × 43 ft (22.4 × 15.2 × 13.2 m); Grotto: 10.2 × 10.5 × 10.8 ft (3.1 × 3.2 × 3.3 m). Installation view, Tate Modern, London, UK, 2019. Hyundai Commission. © Kara Walker, courtesy of Sikkema Jenkins & Co., New York. Photo: © Tate / Matt Greenwood.

419 Adriana Varejão, *Azulejaria Verde em Carne Viva (Green Tilework in Live Flesh)*, 2000. Mixed media on canvas. © Adriana Varejão. Photo: Eduardo Ortega.

421 Julie Mehretu, *Stadia II*, 2004. Ink and acrylic on canvas. 108 × 144 in. (274.3 × 365.8 cm). © Julie Mehretu. Photo: © Richard Stoner / Courtesy White Cube.

422 Sarah Sze, *Centrifuge*, 2017. Mirrors, wood, bamboo, stainless steel, archival pigment prints, ceramics, acrylic paint, salt, suitcase, lights, fans, video projectors, and speaker system. Overall: 457.2 × 480.1 × 373.4 cm (147 × 180 × 189 in.). © Sarah Sze. Courtesy of Tanya Bonakdar Gallery, New York and Victoria Miro, London / Venice.

423 Katharina Grosse, *The Horse Trotted Another Couple of Metres, Then it Stopped*, 2018. Installation view at Carriageworks, Sydney, January 6–April 8, 2018. © DACS, 2022. Photo: Zan Wimberley.

424 Cao Fei, *Whose Utopia?*, 2006 (still). video. colour, with sound, 20:00 min. © Cao Fei, 2022. Courtesy Cao Fei, Vitamin Creative Space and Sprüth Magers.

425 (above) Cao Fei, *RMB City: A Second Life City Planning*, 2007–11 (still). Video, colour, with sound 5:57 min. © Cao Fei, 2021. Courtesy Cao Fei, Vitamin Creative Space and Sprüth Magers.

425 (below) Hito Steyerl, *How Not To Be Seen: A Fucking Didactic Educational .MOV File*, 2013. HD video, single screen in architectural environment, 15 min. 52 sec. Image

CC 4.0 Hito Steyerl. Images courtesy of the Artist, Andrew Kreps Gallery, New York and Esther Schipper, Berlin.

427 Ellen Gallagher, *Ecstatic Draught of Fishes*, 2019. Oil, ink, gold leaf and paper on canvas. 97 ⅞ × 79 ½ in. (248 × 201.9 cm) (unframed). © Ellen Gallagher. Photo: Thomas Lannes. Courtesy Gagosian.

428 Wangechi Mutu, *a dragon kiss always ends in ashes*, 2007. Ink, paint, mixed media, plant material and plastic pearls on Mylar. 233.7 × 134.6 cm (92 ⅛ × 53 in.). © Wangechi Mutu. Courtesy the artist and Victoria Miro.

429 Wangechi Mutu, *Mama Ray*, 2020. Installation view from *Wangechi Mutu: I am Speaking, Can You Hear Me?*, 2021, Fine Arts Museums of San Francisco, Legion of Honor Museum. Courtesy the Artist and Gladstone Gallery, New York and Brussels. Photography by Gary Sexton. Images courtesy of the Fine Arts Museums of San Francisco.

430 Simone Leigh, *Brick House*, 2019. A High Line Plinth commission. On view June 2019 – May 2021. Photo by Timothy Schenck. © Simone Leigh, Courtesy the High Line and Matthew Marks Gallery.

431 Bharti Kher, *Warrior with Cloak and Shield*, 2008. Resin, banana leaf, cotton, stainless steel. 241 × 170 × 196 cm. (94 ⅞ × 66 ⅞ × 77 ¼ in.). Courtesy the artist and Hauser & Wirth. Photo: Stefan Altenburger, Zürich.

435 Mickalene Thomas, *La Leçon d'amour*, 2008. Rhinestones, acrylic, and enamel on wood panel. 96 × 120 in. (243.84 × 304.8 cm). © Mickalene Thomas.

436 Njideka Akunyili Crosby, *When the Going is Smooth and Good*, 2017. Acrylic, transfers, colour pencil, charcoal and collage on paper. 256.5 × 212.1 cm (101 × 83 ½ in.). © Njideka Akunyili Crosby. Courtesy the artist, Victoria Miro, and David Zwirner.

437 Lisa Brice, *After Ophelia*, 2018. Synthetic tempera, ink, water soluble crayon and gesso on canvas, 244 × 120 cm (96 ⅛ × 47 ¼ in.). Tia Collection, Santa Fe, New Mexico. © Lisa Brice. Courtesy the artist and Stephen Friedman Gallery, London.

438–9 Lynette Yiadom-Boakye, *Harp-Strum*, 2016. Oil on canvas. Diptych: 71 × 79 in. each. © Lynette Yiadom-Boakye. Courtesy of the artist, Jack Shainman Gallery, New York, and Corvi-Mora, London.

440 Toyin Ojih Odutola, *Representatives of State*, 2016–17. Charcoal, pastel and pencil on paper. 75 ½ × 50 in. (paper). 78 ⅞ × 56 ¾ × 2 ½ in. (framed). © Toyin Ojih Odutola. Courtesy the artist and Jack Shainman Gallery, New York.

442–3 María Berrío, *Wildflowers*, 2017. Collage with Japanese paper and watercolour paint on canvas. 243.84 × 355.6 cm (96 × 140 in.). © María Berrío, courtesy the artist and Victoria Miro, London / Venice.

444 Chantal Joffe, *Esme on the Blue Sofa*, 2018. Oil on canvas. 152.3 × 305 cm (60 × 120 ⅛ in.). © Chantal Joffe. Courtesy of the artist and Victoria Miro, London / Venice.

445 Celia Paul, *Painter and Model*, 2012. Oil on canvas. 137.2 × 76.2 cm (54 × 30 in.). © Celia Paul, courtesy the artist and Victoria Miro, London / Venice.

446 (left) Jennifer Packer, *Tia*, 2017. Oil on canvas. 25 × 39 in. (63.5 × 99 cm). © Jennifer Packer, courtesy of Sikkema Jenkins & Co., New York, and Corvi-Mora, London.

446 (right) Jennifer Packer, *Say Her Name*, 2017. Oil on canvas. 48 × 40 in. (121.9 × 101.6 cm). © Jennifer Packer, courtesy of Sikkema Jenkins & Co., New York, and Corvi-Mora, London.

447 Tracey Emin, *You Kept it Coming*, 2019. Acrylic on canvas. © Tracey Emin. All rights reserved, DACS / Artimage 2022.

448 Zanele Muholi, *Qiniso, The Sails, Durban*, 2019. © Zanele Muholi. Courtesy of the Artist and Stevenson, Cape Town / Johannesburg and Yancey Richardson, New York.

449 Khadija Saye, *Peitaw*, 2017. From the series *Dwelling: in this space we breathe*. Wet plate collodion tintype on metal. 250 × 200 mm. Image courtesy of the Estate of Khadija Saye. © Estate of Khadija Saye.

450 Amy Sherald, *Michelle LaVaughn Robinson Obama*, 2018. Oil on linen. © National Portrait Gallery, Smithsonian Institution; gift of Kate Capshaw and Steven Spielberg; Judith Kern and Kent Whealy; Tommie L. Pegues and Donald A. Capoccia; Clarence, DeLoise, and Brenda Gaines; Jonathan and Nancy Lee Kemper; The Stoneridge Fund of Amy and Marc Meadows; Robert E. Meyerhoff and Rheda Becker; Catherine and Michael Podell; Mark and Cindy Aron; Lyndon J. Barrois and Janine Sherman Barrois; The Honorable John and Louise Bryson; Paul and Rose Carter; Bob and Jane Clark; Lisa R. Davis; Shirley Ross Davis and Family; Alan and Lois Fern; Conrad and Constance Hipkins; Sharon and John Hoffman; Audrey M. Irmas; John Legend and Chrissy Teigen; Eileen Harris Norton; Helen Hilton Raiser; Philip and Elizabeth Ryan; Roselyne Chroman Swig; Josef Vascovitz and Lisa Goodman; Eileen Baird; Dennis and Joyce Black Family Charitable Foundation; Shelley Brazier; Aryn Drake-Lee; Andy and Teri Goodman; Randi Charno Levine and Jeffrey E. Levine; Fred M.

Levin and Nancy Livingston, The Shenson Foundation; Monique Meloche Gallery, Chicago; Arthur Lewis and Hau Nguyen; Sara and John Schram; Alyssa Taubman and Robert Rothman. Courtesy the artist and Hauser & Wirth. Photo: Joseph Hyde.

451 Deborah Roberts, *Baldwin's Promise*, 2017. Mixed media and collage on paper. 76.2 × 55.9 cm (30 × 22 in.). © Deborah Roberts. Courtesy the artist and Stephen Friedman Gallery, London. Photo by Philip Rogers.

454 Jadé Fadojutimi, *There exists a glorious world. Its name? The Land of Sustainable Burdens*, 2020. Oil and oil stick on canvas. 74 ¾ × 90 ½ in. (189.9 × 229.9 cm). The Studio Museum in Harlem; gift of Heather and Theodore Karatz. Courtesy Pippy Houldsworth Gallery, London.

455 Flora Yukhnovich, *Warm, Wet N' Wild*, 2020. Oil on linen. 210 × 180 cm (82 ⅞ × 70 ⅞ in.). © Flora Yukhnovich. Courtesy the artist and Victoria Miro.

456 Flora Yukhnovich, *Out of the Strong Came Forth Sweetness*, 2019. Oil on linen. 258.5 × 170 cm (102 ⅜ × 66 ⅞ in.). © Flora Yukhnovich. Courtesy the artist and Victoria Miro.

457 Somaya Critchlow, *Figure Holding a Little Teacup*, 2019. Oil on linen. 8.35 × 5.83 in. (21.1 × 14.8 cm). © Somaya Critchlow. Image courtesy the artist and Maximillian William, London. Collection of Laura & Barry Townsley, London. Photo: Point 101, London.

Thank you to: Chloe, Elizabeth and Max at Maximillian William; Pippy and Poppy at Pippy Houldsworth; Bea, Kathy, Erin, Hannah at Victoria Miro; Tamsin and Jon Horrocks at Stephen Friedman; Alice Haguenauer, Johanna Rietveld, Tiffany Wang, Jennifer Voiglio, Sabrina Blaichman at Hauser & Wirth; Hannah Rieger; James Brett and the team at Museum of Everything; Lorraine at the Victorian Spiritualist Union; Sophie Bowness; Rob Airey and the Wilhelmina Barns-Graham Trust; Anton Kras and the Jewish Historical Museum; Ami Bouhassane, Antony Penrose, Lori Inglis Hall at Farley's Farm; India Young; Sarah Hardy; Aretha Campbell and the team at Bridgeman; Jennifer Camilleri at the Royal Academy; Laura Mitchell and Olivia Stroud at the V&A; Romilly Dtout and Emily Smith at Philip Mould; Tarsila do Amaral; Charlotte Call; Natalie Duff, Nathaniel Hepburn, Darren Clarke at Charleston Trust; Camille Roux dit Buisson; Christian Nitz from Kathe Kollwitz Museum; Vivan and Navina Sundaram; Anna Blum, Isabella Falla Paz at Karma; Richard Overstreet; Patrick Duffy, Florrie Evans at Fine Art Society; Antony Critchton Stuart; the team at Ryan Lee Gallery; Francesca Charlton-Jones and all at Whitford Fine Art; Isabelle Hogenkamp from Mitchell Innes and Nash; Martha Rosler; Amy Jean Porter at Anni Albers Foundation; Grady O'Connor and Elizabeth Smith at the Helen Frankenthaler Foundation; Andrew Beccone, Laura Morris, and Jenny Gill at Joan Mitchell Foundation; Alexander Richards at Stevenson Gallery; Nicola Green, Lucy and the Estate of Khadija Saye; Harry Weller and Tracey Emin; Brandon Foushee at Jack Shainman Gallery; Steph at Njideka Akunyili Crosby Studio; Lynette Yiadom-Boakye; Lisa Brice; Alex at Mickalene Thomas Studio; Bharti Kher; Astrid and Wangechi Mutu at Wangechu Mutu Studio; Ellen Gallagher studio; Ariel Finch and Rose Eastwood at Sadie Coles; Hillary Halter at Andrew Kreps Gallery; Monika Simm and Hannes Schroeder Finckh at Spruth Magers; Agata Rutkowska and Alex O'Neill at White Cube; Daniela Sevillano and Annabelle Birchenough Frith Street Gallery; Gemma Colgan at Cristea Roberts Gallery; Nick Willing and Paula Rego; Charlotte Brooks at Pilar Corrias Gallery; Jacob Daughterty and Sara Chan at David Zwirner; Giulia Theodoli at Shirin Neshat Studio; Niamh Brogan at Goodman Gallery; Krista Scenna; Wade Nobile; Paz Errázuriz; Agnes Denes; Rachel Garbade and Howardena Pindell; Joanna Ortner and the Maria Lassnig Foundation; Doug at Sylvia Sleigh; Stephanie Tallering; Rachel Churner; Rachel and Suzanne Lacy Studio; Clarice De Veyra at Lehmann Maupin; Kathleen Nugent Mangan at Leonore G. Tawney Foundation; Sammy Howard; Hannah Robinson, Tess Charnley and team at Alison Jacques Gallery; Sarah Galender Meyer and all at Creative Growth.

ACKNOWLEDGEMENTS

There are so many individuals and organisations who have been instrumental in making this book possible. Not only is this publication thanks to the work of so many brilliant art historians, curators and writers working today, but also that of those whose indefatigable and meticulous research in the past enabled us to have access to these stories today. I want to start by thanking my editor, Helen Conford, who has been an incredible support and extremely patient as I undertook this vast project. Thank you to everyone at Cornerstone: particularly Venetia, Rebecca, Etty, Lydia, Joanna, Nicky and Catherine, for believing in this and helping to guide me throughout the whole process; Tom Etherington; my US editor, Melanie Tortoli; George Lucas and the team at Nurnburg; Profile Books, who worked on this right at the beginning. A special thank you to my fantastic and enthusiastic agent, Karolina Sutton, and her team at Curtis Brown, Joanna Lee and Caitlin Leydon; Vanessa Fogarty and Thomas Caulton. Thank you to my excellent and insightful editors/copyeditors: Shan Vahidy, Claire Péligry, Helena Caldon and Sarah Coward.

This book has been read, checked by, and discussed with countless historians, writers, artists and artists' estates, who have been incredibly generous with their time, expertise and support. I can't stress enough that this book is the result of so many brilliant minds. While I must thank some very key people – Eleanor Nairne, Gilda Williams, Diane Radycki – as well as every single guest who has given their time for *The Great Women Artists Podcast*, the names below are thanked in order of the book's chronology.

PART ONE: Letizia Treves, Chloe Stead, Joanna Moorhead, Dr Maria Loh, Babette Bohn, Sheila Barker, Nina Cahill, Yuriko Jackall, Richard Taws, Lisa Small, Francesca Whitlum-Cooper, Elizabeth Lev, Jennifer Swope, Hillary Olcott, Diane Dittemore, Dr Rosina Buckland, Sarah Hardy, Jan Marsh, Alison Smith, Dr Carol Jacobi, Lachlan Goudie, Freya Spoor, Alice Strang, Simon Grant, Julia Voss, Tracey Bashkoff and Cindy Kang. **PART TWO:** Horatio Hsieh, Hui Min, Dr Shulamith Behr, Dr Isabelle Jansen, Frances Carey,

Nancy Ireson, Camille Roux dit Buisson, Beverly Held, Patrick Duffy, Florrie Evans, Diana Souhami, Dorothy Price, Linda Lapplin, Irene Gammel, Anthony Critchton-Stuart, Emma Ridgway, the team at Bauhaus Archiv, Laura Smith, Alyce Mahon, Ami Bouhassane, Emma Lewis, Pamela Johnson and Mimi Johnson, Susan Weininger, Richard Overstreet, Dr Sofia Gotti, Victoria Nerey, Leslie Ramos, Melanie Herzog, Rebecca K. VanDiver, India Rael Young, Wanda M. Corn, Rachel S. Zebro, Alona Pardo, Stephanie Straine, Helen Atkinson, Sara Matson, Lucy Howarth, Robert Airey, James Brett, Hannah Rieger. **PART THREE:** Alice Sebrell and the team at Black Mountain College, Ming Tiampo, Flavia Frigeri, Sue Tate, Rachel Taylor, Ena Morita, Bridget R. Cooks, Griselda Pollock, Jo Applin, Briony Fer, Bloum Cardenas, Ann Coxon. **PART FOUR:** Dindga McCannon, Howardena Pindell, Rachel Garbade, Richard Saltoun, Niamh Coghlan, Guerrilla Girls (Frida Kahlo, Kathe Kollwitz, Shigeko Kubota), William J Simmons, Katarina Jerinic, Paz Errázuriz, Alexandra Schwartz, Nick Willing, Tracey Emin, Harry Weller, Waldemar Januszczak. **PART FIVE:** Julia Peyton-Jones, Lydia Yee, Martin Coomer, María Berrío, Chantal Joffe, Celia Paul, Nicola Green, Jadé Fadojutimi, Flora Yukhnovich.

With around 300 illustrations, this book is the product of extremely generous artists, gallerists, artists' estates and museum workers (see p. 500 for the full list). Thank you to Cecilia Mackay and Danielle Nihill, fantastic picture researchers who helped me assemble countless images.

Thank you to the team at the London Library for always welcoming me; everyone at Victoria Miro (especially Kathy, Martin, Bea); my art history teachers (Ben Street, Jacqueline Cockburn, Benjamin Walton); my family: Mum, Dad, Sarah, Felix, Katie, Michael, Victoria (Jesse, Phoebe, Thea); Simon and Harley for all your wisdom; my wonderful friends Elle, Gracie, Flo B, Flo D, Joel, Alice, Derya, Bella, Grace Wyld, Slugs – all of you! Jordan and Isabelle. Chantal for the discussions. Viva Ruggi for being the most fantastic research assistant; the Alighieri team; Natasha Fairweather; Ruth Chatto; Carrie Rees and Andrew Bonacina; Jack Beeston for reading every passage and answering every question. I am greatly indebted to you all and feel so lucky to have you all in my life.

ABOUT THE AUTHOR

Katy Hessel is a British art historian, broadcaster and curator. She runs @thegreatwomenartists, an Instagram account that has celebrated women artists on a daily basis since October 2015. She hosts and writes *The Great Women Artists Podcast*, where she has interviewed guests from Turner Prize-winner Lubaina Himid to writers Ali Smith and Deborah Levy. British *Vogue* and the *Evening Standard* listed it among their recommended podcasts. She is also the host of *Dior Talks – Feminist Art*, a podcast which includes interviews with artists such as Tracey Emin and Judy Chicago.

Katy has written extensively on the subject of women artists for British *Vogue* and *Harper's Bazaar*, curated exhibitions at Victoria Miro Gallery, Stephen Friedman Gallery, Kasmin Gallery, and more, and runs the annual The Great Women Artists Residency at Palazzo Monti, Brescia. She once took over a floor of Tate Modern for a Tate Late. She has lectured at the National Gallery and Cambridge University, fronted films for the Tate, Barbican and Royal Academy of Arts, as well as writing and presenting arts documentaries for the BBC.

In 2021, she was selected for the *Forbes* 30 Under 30 list in Art & Culture, and, since 2022, she has held the position as the curatorial trustee of Charleston, the modernist former home and studio of the Bloomsbury Group. Writing and speaking about art history in an accessible and fun manner, her goal is to readdress the gender imbalance in the art world by reinserting women back into the canon of art history. *The Story of Art without Men* is her first book.

INDEX